DEGAS Pastels, Oil Sketches, Drawings

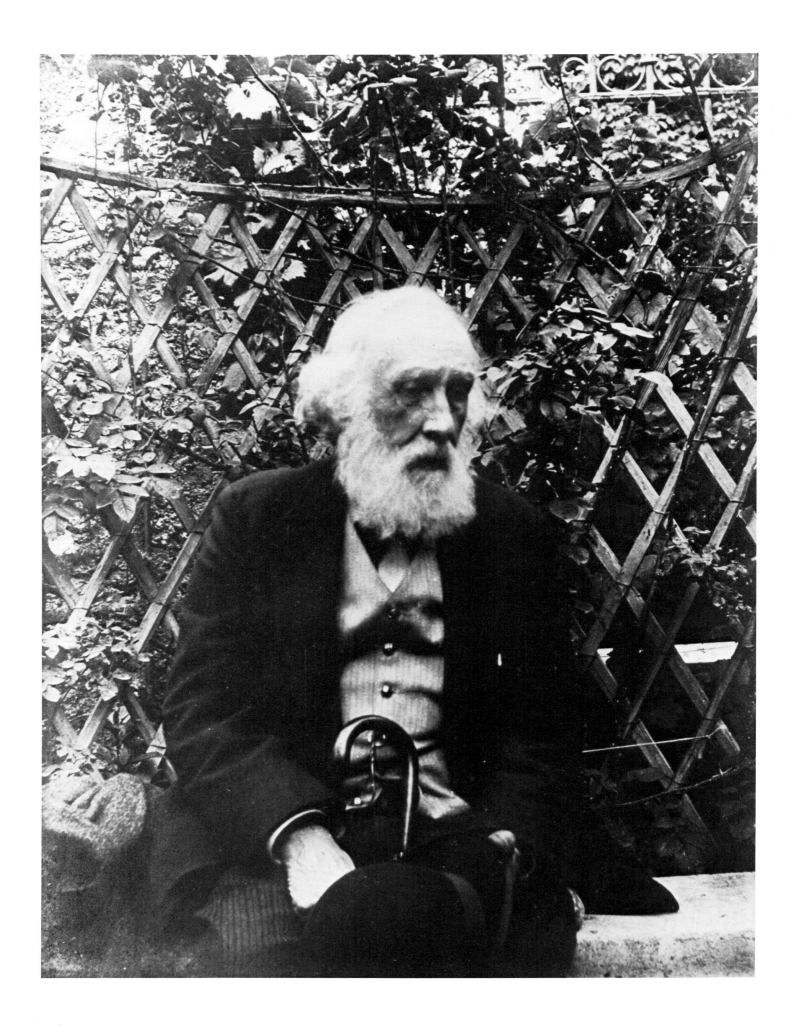

Götz Adriani

DEGAS

Pastels, Oil Sketches, Drawings

Abbeville Press, Publishers, New York

JACKET FRONT: *At the Milliner's* 1882 (pl. 141)
pastel 31½ × 33⅜ in.
Collection Thyssen-Bornemisza, Lugano.

JACKET BACK: *Dancer at the Bar* 1871–2 (pl. 82)
thinned oil paint on red paper 11 × 9 in.
Stephen Hahn, New York.

FACING TITLE-PAGE: *Edgar Degas at Auteuil* 1915
(Photo Albert Bartholomé, Bibliothèque Nationale, Paris).

Translated by Alexander Lieven

This edition © 1985 Abbeville Press, New York
and Thames and Hudson Ltd, London

© 1984 DuMont Buchverlag, Cologne

This book was first published on the occasion of the exhibition
'Edgar Degas, Pastelle, Ölskizzen, Zeichnungen'
held in 1984 at the Kunsthalle, Tübingen, and the
Nationalgalerie, Berlin.

Contents

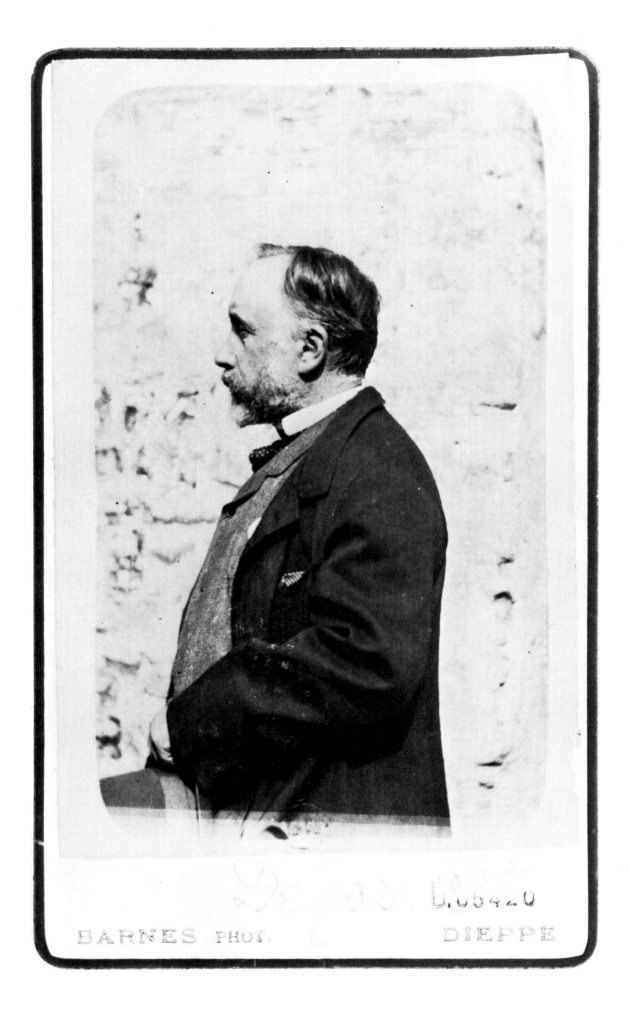

Edgar Degas, Dieppe, 1885
(Photo Barnes, Bibliothèque Nationale, Paris)

The Dedicated Draughtsman

*'He portrays life as I would have
wished to portray it.'*[1]

MAUPASSANT

'Who knows Degas? Nobody? That would be an exaggeration. Only a few, anyway. I mean what is called knowing well. . . . Only painters admire Degas, many through fear, others through respect.'[2] This opening question and answer, in a short essay written by Gauguin early in 1903, may seem paradoxical, since it concerns an artist who had little difficulty in securing recognition during his lifetime. The demand among dealers and collectors for his paintings, pastels and drawings came early. The art public was able to acquaint itself thoroughly with his latest output at each of the exhibitions held regularly from 1874 to 1886 by the Impressionists, since he was one of their leaders. Even those press critics who poured scorn on the Impressionists usually favoured his contributions. His dancing-girls were one of the most popular nineteenth-century subjects and continue to be so even now: the turnover of sugary colour repros on postcards and calendars tells its own story.[3]

But this popularity is something of a handicap when one sets out to explore the diversity of Degas' art.[4] Enough is known, or so one thinks, about 'the painter of delicate ballerinas', and one tends to forget the wealth of his output as a whole. It spans half a century or more, and reaches even deeper than it is wide, thanks to the directness of Degas' perception. The lovely freshness of these images often disguises the strict discipline that went into their creation, as well as the intellectual power and analytical perspicacity manifested in them. The mastery of their eminent maker is patent, and one is inclined to leave it at that. It needs a closer study to show how little is known about the uniqueness of his pictorial imagination and the range of his modernity. Even when due allowance has been made for his restricted thematic field and his austere visual approach, the rich variety of his idiom and his untiring interest in experimentation in particular remain astonishing. Degas is usually labelled as an Impressionist, but it is often overlooked that the clarity of his expression and his painstaking technique are deeply rooted in the great French classical tradition. He portrayed the spirit of his time by means of representative psychological combinations and extreme aesthetic solutions which barely touch upon the fringes of Impressionist thinking. Last but not least, his later output is wholly free from explicit actuality: it reaches out uncompromisingly and masterfully into the twentieth century. Degas' wish, to be at once famous and unknown,[5] has obviously come true in an output, available to all, which is nevertheless anything but well understood.

Gauguin was also right in assuming that it is artists above all who admire Degas, be it through fear or respect, and indeed regard him as unique even today. In 1883, Pissarro already saw him as 'the greatest artist of the era'. He added in 1898 that Degas 'constantly pushes ahead, finding expressiveness in everything around us'.[6] Toulouse-Lautrec informed his mother in 1891 with a touch of pride that Degas, the unapproachable elder who represented his only model, 'has encouraged me by saying that my work this summer wasn't too bad',[7] and added rather shyly, 'I'd like to believe it.' Van Gogh wrote to Emile Bernard in 1888 of Degas' mastery in reproducing the true and deeply felt animality of the human body,[8] while Odilon Redon stressed in 1889 that Degas' 'proud spirit of endeavour will bind him to freedom throughout his life. . . . The principle of independence will always be mentioned in connection with his name. . . . Reverence, unquestioning reverence is required here.'[9] The tally of twentieth-century artists for whom the human figure has been a main theme, and who therefore feel deeply indebted to Degas,[10] runs from Rodin, who admitted that 'He is better at it than I am', to Henry Moore, the fortunate owner of a large charcoal drawing by Degas; from George Grosz[11] to Francis Bacon,[12] David Hockney,[13] and George Segal, who was inspired by Degas to produce several impressive pastels. Not the least among them was Picasso in his unforgettable tribute to the old master, with whom he appears to have identified himself towards the end of his life, in his last graphic series of thirty-five drawings, produced between 11 March and 14 June 1971, in which he aptly summed up Degas' experience of the relation between artist and model.[14] Once again, and for the last time, a superbly relaxed procession of female nudes files past under the stern eye of the observer (p. 13).

Degas reacted very sceptically to any attempts at making theoretical statements about his work, but the very first monograph devoted to it, by the German painter Max Liebermann in the periodical *Pan*[15] in 1896 – still valid in many respects today because of the soundness of its judgment – further demonstrates that Degas' modern quality was most subtly appreciated by artists, while Paul Valéry probably gave the most perceptive amount of his personality.[16]

Strangely enough, art historians seldom include Degas among the artists who significantly influenced the development of the twentieth century, even though he portrayed city dwellers in a way which has retained all its authenticity. He summed up contemporary life in these images, although – or perhaps just because – these eye-witness reports bear on relatively restricted areas of reality. He was cool towards his fellow human beings, with few exceptions, yet he is among the most effective of interpreters of humanity and moulded the image of modern man as only Daumier before him, Manet in his time and Toulouse-Lautrec after him were able to do. Still unsurpassed, their images even now people the city with symbolic characters.

Degas elaborated the perspectives most appropriate to the contemporary way of life, as well as the correspondingly fragmented visual effects. Never polluted by sentiment, his line systematically analysed forms down to their essential meaning. He was able to impart a timeless quality to the contemporary scene by fracturing the artistic conventions of his day – though not, be it stressed, the social ones. Quite unlike Courbet or Manet, he deliberately withdrew behind his work, shunning publicity the better to examine the true shape of his time. Life had failed to meet his expectations, and

so he set out to explore its limitations and to counter them by a total involvement in art. His outwardly uneventful existence developed against a background of political and social upheavals, from the 1848 revolution to the First World War; the even tenor of his life supplied the background for an abundance of existential statements, but he wisely avoided any profitless temptation to indulge in topical comment. Degas became a legend in his own lifetime precisely because he shunned publicity more and more as he

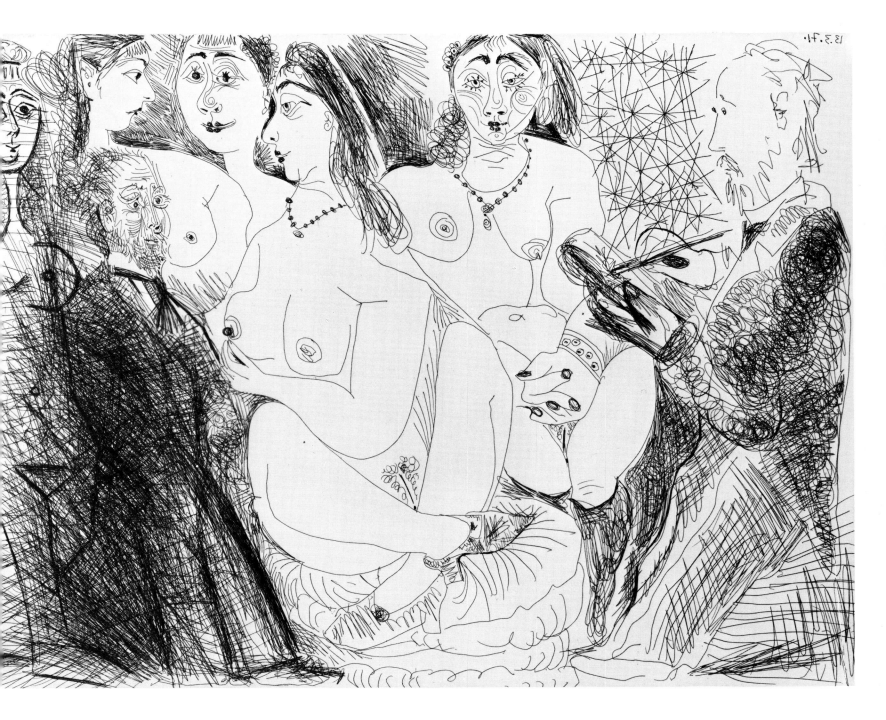

Pablo Picasso *Degas Drawing* 1971
(Bloch No. 1936)

grew older. He regarded all vanity as tantamount to mediocrity and so this man, who was withdrawn to the point of being solitary by nature, was now driven even further into himself by success and fame.[17] His demands on himself and others were too absolute to permit any show of sociability. The Impressionists rambled idyllically about the surburban countryside. Cézanne and Van Gogh imposed their vision on the landscape of Provence, and Gauguin dreamt of discovering new exotic lands. But Degas withdrew entirely into the dark stillness of the Montmartre studio to which only a few friends were admitted. Yet such seclusion was essential in order to carry out a lifelong task pursued, despite grave handicaps, with relentless determination. He was untiring, but did not wish it to be known how hard it was for him to get his work done. In fact, the lightness of his touch, resulting in a beauty that resides in the simplest formulations, was often achieved only through very great labour. It was only when the paintings, pastels and drawings he had kept were sold at four consecutive auctions after his death that his tremendous productivity and the significance of his hidden output became common knowledge.[18] Given his indifference to publicity, general approval was a matter of no concern to him. He was already fulminating against the so-called art trade when he was barely twenty: 'It seems to me that if one wishes to engage seriously in art nowadays and make one's special little corner in it, or at any rate preserve the most modest personality of one's own, one must refresh oneself through solitude. There is too much chatter around. One might think that pictures are made like deals on the stock exchange by people jostling each other, greedy for profit. It might be said that one needs the wit and ideas of the man beside one to get anything done just as much as these businessmen need other people's capital to earn a penny. All this trade sharpens the wit and impairs the judgment.'[19]

Degas kept faith with himself throughout by turning down all offers of official recognition and every mark of public prestige. His sole endeavour was to improve his own performance and his sternest critic was his own incorruptible judgment. Liebermann called him 'a proud solitary, a jealous egoist, not in the cause of success, but in that of art'.[20] Only Cézanne was as demanding about his own output. By his origins, training and aims he was poles apart from Degas, but they were linked by an attitude which demanded extreme seclusion, whether amid nature or in the studio, to make work possible. Both accepted the modern painter's obligation to be alone and entirely dependent on his own resources in the fullest – indeed, most tragic – sense. In order to innovate, both rejected the innovations promoted by the prevailing spirit of progressive positivism. And Degas, just as much as Cézanne, clearly understood that whatever is new can only be meaningful in terms of whatever went before it, in other words, that art without a past has nothing to offer the present or the future. Long before the furore caused by the Futurists' demand to burn down museums, Pissarro had wanted to set the Louvre alight so as to cut the connection between the new ideas and their historical roots. On the other hand, Cézanne and Degas, who had little in common beyond a vast, but well-concealed regard for each other, both reached out to these roots in order to achieve their purpose.[21]

Degas guarded his independence with outright suspiciousness. Nothing could move him to enter upon any form of compromise. The determination to remain responsible to himself alone, to be accountable to nobody but himself, led him to explore the

options available on his own, independently from his circle of Impressionist friends. Clear-sighted and shrewd, he gained a measure of freedom by keeping aloof. He derived from the classics, yet successfully evaded scholarly attempts to pigeon-hole him stylistically, revered Delacroix and – though a spokesman for the Impressionists – lampooned open-air painting. He was determined to forge ahead without any concessions to taste whatsoever and never allowed himself to be beguiled into any course that might lead to mere shallow routine.

Valéry has stressed the absolutism of Degas' opinions, which: 'concealed I know not how much self-doubt and despair of ever satisfying himself'.[22] He was very vulnerable, but sheltered his inherent doubts and uncertainties behind a much-feared sarcasm, including a degree of petulance and intemperance.[23] Once he had convinced himself of the soundness of certain principles, he embraced them so firmly that he occasionally became overtly intolerant of anyone who thought otherwise. The 'series of [mathematical] operations' to which he liked to refer in connection with his imagery thus often inhibited ordinary human reactions.[24] There was not much warmth wasted between himself and his models. Degas denied himself any private life for the sake of his work. His relationship with the opposite sex was entirely restricted to the search for subjects for his art, the mainspring of his existence. He has often been described as a ferocious misanthropist, but it may be that he deliberately discounted the interest shown towards him by others, in order to be free to devote himself without encumbrance to his specialized interest in them. In 1856, the young painter wrote: 'The heart is an instrument which rusts when it is not in use. Can one be an artist without heart?' and, in the same notebook: 'The people one loves most are those one could hate most'.[25] Years later, he returned to the same subject in some letters: 'The heart is like many instruments: one must look after it and use it fairly often if it is to shine and work well', and again, very wistfully, in 1886: '. . . with the exception of the heart it seems to me that everything within me is growing old in proportion. And even this heart of mine has something artificial. The dancers have sewn it into a bag of pink satin, pink satin slightly faded, like their dancing shoes'.[26]

Degas' mind was certainly sharp enough, but one comes to feel that it was riddled with prejudices, yet capable of bringing an objective eye to bear on the people around him; and that a revolutionary spirit was concealed behind the reactionary mask. He upheld pictorial traditions, yet contested their conventions even more doggedly than his Impressionist friends. He ruthlessly queried the hierarchical art establishments of his time, but wholeheartedly supported a social order most perfectly realized in so far as he was concerned in the monarchy of Louis Philippe. Gauguin had very deliberately flaunted his own artistic character and described Degas as the reserved and correct patrician: 'With his silk hat and his blue-tinted glasses he looks a real lawyer, a citizen of Louis Philippe's day, umbrella included. And if there is a man who does not care whether he looks like an artist, it is Degas, because he is an artist, through and through!'[27] This somewhat shy and distinguished-looking gentleman, who perfectly fits Baudelaire's description of the 'modern hero' in tail-coat and patent leather shoes,[28] and whose unaffectedness sprang from his upbringing in an old family, preferred an inconspicuous and discreet existence to Bohemian ways or a leading position in the art world.

For him, self-discipline and sense of duty came first in an artist's life. In this he agreed with Baudelaire that 'the most imaginative and effective artists, those whose vision and statements reach out to the uttermost limits, are often people who very quietly pursue lives regulated down to the smallest detail. . . . How often has one not had the opportunity to establish that nothing more closely resembles a perfect bourgeois than an artist of genius intent upon his work?'[29] Degas, of course, neither toyed with iconoclasm nor wished to play the part of a class-proud bourgeois. He hated show of any sort. He refused to provoke the public as Manet and Cézanne, for instance, had once loved to do as part of their juvenile urge to produce acts of faith and existential statements.[30] Degas had nothing but disapproval for such aggressive behaviour. Rather like Toulouse-Lautrec, his upper-class origins enabled him to stand back and view whatever attracted his notice with detachment. Yet, while Lautrec was forced by circumstances to seek companionship, in order to secure some measure of participation by others in his experiences, Degas remained at all times a remote observer and cool diagnostician. He laid bare the underlying form, whereas Lautrec, who was less radically committed to objectivity and whose insight was, in any case, less practised, peeped out from the shadow of his subject whenever he laid bare its psyche.

His eyes were to let Degas down badly in the long run, but his single passion, restrained only by scepticism, was to visualize. For this purpose, he hardly looked beyond that part of Paris where he had been born and where he died, aged eighty-three. He was at home in Montmartre, then still something of a suburb, and could find his way about it even when he was old and virtually blind.

The principles that shaped Degas' upbringing, and to which he remained faithful at all times, involved a high degree of artistic integrity. The features of this were a search for truthfulness and an ability to gauge form with insight: vividness but without the obtrusiveness that inevitably results from mannered virtuosity. As Liebermann put it: 'With him everything comes down to intuition, hence the sudden, direct, striking effect.'[31] This can best be seen in his drawing, in the broadest sense of the word, which came to represent the essence of Degas' output and made him into an artist who believed that one might become a painter, but must be born a draughtsman.[32] One should necessarily be chary of classifying an artist as a draughtsman, rather than a painter, or vice versa, but in Degas' case one might be justified in giving the draughtsman priority, since the painter was set distinctly stricter limits.[33] Pencil, chalk, pastel, charcoal and paper did not have nearly as crucial a part to play in determining the character of a representation for any of his contemporaries. And none of these was able to distil the combined essence of Ingres, Delacroix and Daumier, the three greatest draughtsmen of the nineteenth century according to Degas,[34] in an incredibly prolific output which also foreshadowed the great experimental drive through which Picasso established himself as the leading exponent of line in the twentieth century.[35] Line was to Degas what colour was to Manet and the Impressionists. It was the only medium he consistently used throughout fifty years of output, while painting, printing, monotype and sculpture were confined to particular periods or distinct types of work. Drawing brought him closest to his model. It also enabled him to embody his stylistic purpose to greatest effect, while progressing furthest from his starting point. This strongly inhibited personality found line an unimpeded means of expression.

As Valéry summed it up: 'The sheer labour of drawing had become a passion and a discipline to him, the object of a mystique and an ethic all sufficient in themselves, a supreme preoccupation which abolished all other matters, a source of endless problems in precision which released him from any other form of inquiry. He was and wished to be a specialist of a kind that can rise to a sort of universality.'[36] As early as 1876, Stéphane Mallarmé saw in Degas a master of drawing: 'He has sought delicate lines and movements exquisite or grotesque, and of a strange new beauty, if I dare employ towards his works an abstract term, which he himself will never employ in his daily conversation.'[37]

Predictably, the artist – who put the discipline of his craft before everything else – was far more modest in this respect. Thus, in one of his notebooks, 'Dessiner beaucoup. Ah! le beau dessin' is followed by two exclamation marks. He also once confided to Sickert: 'Once I have caught the line, I hold it fast and don't let it go again.' And added, concerning his relations with the Impressionists: 'I have always tried to urge my colleagues to seek for new combinations along the path of draughtsmanship, which I consider a more fruitful field than that of colour. But they wouldn't listen to me and have gone the other way.'[39] Moreover he is reported as saying that he was passionate only about black-and-white work, that his use of colour was determined by his treatment of line and that he would like to devote himself to drawing for the whole of one year.[40] The dedicated draughtsman, who constantly affirmed the primacy of the line that had been neglected by the Impressionists, kept on telling his younger colleagues: 'Make a drawing, make it again, give it a rest, make it again and pause once more', and 'one must copy the old masters on and on'.[41] He thought that some of his drawings might last, and wrote about his unwavering love for drawing.[42]

In 1855, Degas portrayed himself pencil in hand in his first self-portrait, and drawing always remained for him far more than an occasional activity. It was the most important tool at his command in clarifying a conception and testing, ordering and composing what he had perceived. It was the seam connecting visual experience with its ultimate pictorial interpretation, thereby providing this artist, endowed with unique powers of recall, with a testing-ground for the necessary formulation. The directness of this medium, the combined speed and accuracy of its command, fascinated not only the painter, but the graphic artist and the sculptor in Degas and he always remained first and foremost a draughtsman at heart. As compared with all other media, drawing offered the widest scope for experimentation with an idea, an opportunity to vary it, transform, invert or formulate it completely afresh until a thoroughly integrated result had been achieved.

In such drawing entirely ruled by the artist's intention, the eye is led to subject what it sees to a strict analysis and a powerful synthesis of forms. Not a single line, nor one set of strokes strikes one as redundant. Liebermann described this as 'amazing, verging on caricature (related as he is indeed to the cartoonist Daumier), invariably hitting the nail on the head; he consistently rejects the pretty stroke, the act of calligraphy'.[43] Degas' line never congeals into mere decoration and escapes all irrelevance. It maintains its effect notwithstanding all refinements of colour. His drawings seldom flow smoothly: they tend to be restrained and definite, never anecdotal, and to display a certain dryness and astringency all of their own. Delacroix's enthralling gift for improvisation is

undoubtedly absent, as well as Ingres' polish, let alone Adolph Menzel's – occasionally pedestrian – obsession with detail. Degas esteemed Menzel, but the latter felt compelled to fill in the gaps in his less than accurate representations and got lost in the detail which his French colleague dominated in masterly fashion.[44] Degas' perfectionism, unlike Menzel's, never degenerates into pedantry. The unchecked impetus of the initial stroke carries it right through to completion. It remains gripping and inspiring throughout the process of abstraction. And it retains its incomparable clarity throughout.

It would be inappropriate to deal with drawing in isolation since Degas was undoubtedly the most experimentally minded member of his generation of artists and was always at pains to apply new techniques to whatever he had in hand. He set store by the stimulating juxtaposition of nature and artifice, illusion and hard-headedness, formal patterns and psychological insights, just as he prized the contrasting jumble of drawing and painting, colour and apt linear statement which could only be resolved on the sheet. He seized upon the opportunities offered by pastel and diluted oil colours, or by the contrasts arising from the juxtaposition of black-and-white and colour, in so many different ways that the borderlines between drawing, painting and etching become blurred.[45] This is exemplified by the inclusion of Degas' pastels in the picture galleries of many museums, because they are effective as paintings, while elsewhere they are kept in the graphic collections. Much the same is true of monotypes which can be classified as paintings, drawings or prints with equal justification. Taking the output as a whole, however, it is clear that pencil, chalk, pastel and charcoal, together with turpentine-thinned oil paints used for purposes rather closer to drawing than painting, have priority over painting on canvas. The works assembled in the present volume all use paper as their working surface and are markedly linear in character. Even the pastels, in which colour plays the leading part to a certain extent, and which Paul André Lemoisne has grouped with the paintings in his catalogue raisonné,[46] are based on coloured drawings. The specific openness of the drawing is not obliterated by the – sometimes heavy – overlay of colour.

The functions assigned to drawing by Degas are as varied as the means of representation to which he resorts. The use made of these functions and the ways in which they are brought into play are equally diverse and lend themselves as little to any attempt at a common definition. Drawing may provide an inconspicuous point of departure in the first rapid formulation of a sketch or represent an end-product in its own right within a fully finished work. It would be hard to imagine a more extreme contrast than that between the meticulously worked early pencil studies and the furious late 'black-and-white paintings' in charcoal. Within the output as a whole, large pastels in which the colour is swept along by the drawing and fleeting chalk sketches on scraps of paper that might hardly seem worth picking up all have their appointed place and function. Much of what came to light at the auctions in 1918–19 after the artist's death was never intended to be seen. A good deal of it was unfinished, some was scrap. But this accumulation of seemingly spontaneous sketches done on the spur of the moment, detailed studies and compositional projects, copies and pictorial designs provides an enlightening insight into the painstaking preparatory method of an artist who refused to adopt any kind of short cut. Far from it: any botched sheet was not simply discarded, but carefully put aside for necessary corrections on some later occasion. It would be a

16

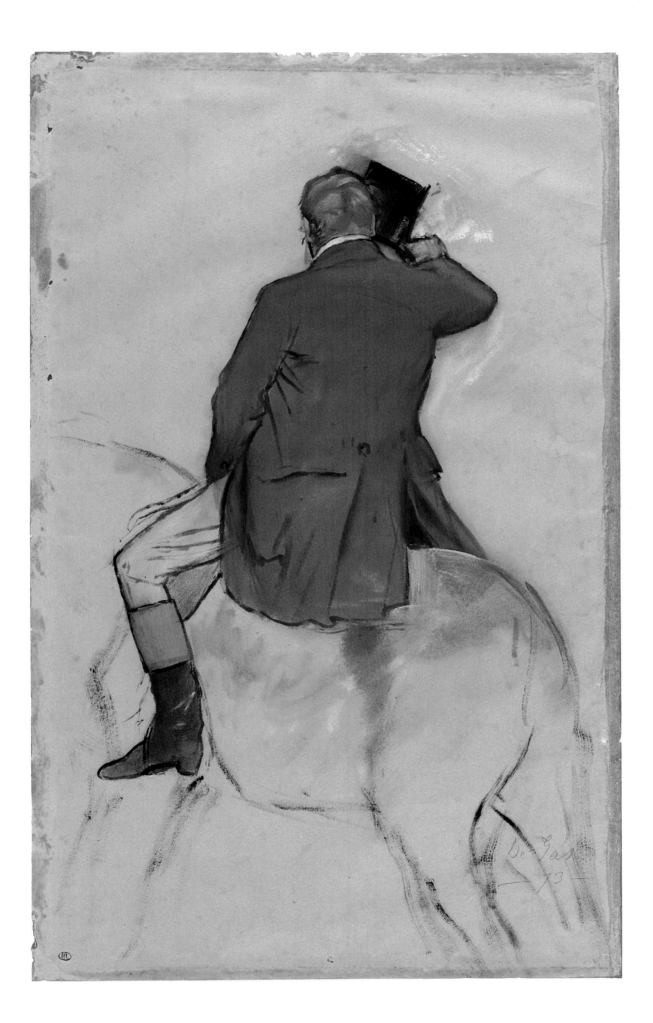

Horseman in Red Coat 1866–8 (pl. 64)

cumbersome, perhaps even impossible task to attempt to establish a chronology for works which hardly ever bear a date anyway, because a given theme may be reworked over a period of years so that the possible existence of even much later versions can never be ruled out. Only portraits can help in this sense, since the age of the sitter and the style of the clothes provide an approximate date.

Thirty-eight sketch- and notebooks used by Degas and covering a period from about 1853 to 1886 were catalogued and edited in 1976 by Theodore Reff:[47] twenty-eight of these are kept in the Cabinet des Estampes of the Bibliothèque Nationale in Paris as a result of a gift by the artist's brother, René de Gas. These documents enable one to trace the artist's stylistic development much more accurately than would individual sheets scattered all over the world, and provide the basis for a relatively reliable chronology. This stack of paper, meant for Degas' strictly personal use and largely worked-in pencil, comprises some 2000 sheets of drawings, studies of details, copies and caricatures, together with about 500 pages of manuscript, all of it of great artistic and documentary value. These books, the nearest equivalent of which is Cézanne's so-called Carnet Violet Moiré, are mostly pocket-sized so as to be easy to carry and readily available at all times. They run in size from 56 × 97 mm to 251 × 345 mm, the seven largest sketchbooks presumably being intended for studio use. Although many existing individual sheets, identical with these in format and quality of paper, probably came from similar pads or sketchbooks which had been unpicked, the bulk of Degas' note- and sketchbooks escaped stripping and piecemeal sale. One is thus uniquely placed to discover from them the artist's aims as they developed. They identify the sources on which he drew, the methods of work peculiar to him, his environment, his interests and his personal opinions. Significant theoretical propositions occur side by side with ephemeral memoranda, the record of events at exhibitions with lists of addresses and accounts. One might have expected the drift of the notes and the purpose to which the books were put to change as three decades went by. In fact, there were diary-like entries at the start, containing a sequence of arguments bearing on a relatively short-term period of only a few months. From the 1860s on, however, a somewhat hastily jotted down jumble of notes tended to predominate, spanning longer period of time, but also leaving some more or less prolonged gaps.[48] All these books have a strictly personal character, reflecting an intimate connection with whatever was uppermost in the artist's mind at the time of writing. But although they certainly provide an understanding of Degas' thinking and activity, at least during particular periods, they do not enable one to apply the conclusions he had reached in terms of style and development direct to his graphic output as a whole. Even when the notebooks deal with similar subjects, only a speculative connection can be established between casual graphic impressions on one hand and the independent tendencies displayed in a number of single sheets on the other.

The importance attributed to his drawings as a class of representation in its own right by 'the most intelligent, the most reflective, the most merciless draughtsman in the world'[49] can be gauged by his careful preservation, not only of a multiplicity of separate sheets but of sketchbooks that extend from his early years until failing eyesight forced him to give them up because he could by then only cope with large sheets of paper. Degas also meticulously selected the quality, texture, format and shade of his paper.[50] 18

This was particularly true of drawings and pastels intended for intimate friends and sometimes provided with a holograph dedication. The sketchbooks are usually made up of middle-weight smooth surfaced paper, white or off-white, occasionally lined or squared in light blue, while single sheets come in grey, pink, ochre, deep green or brilliant blue, in addition to white and cream. Lastly, he set great store by the proper

Dancer
(Photo Edgar Degas, Bibliothèque Nationale, Paris)

framing of drawings, sometimes assembled in groups of two, three or four. The art dealer Ambroise Vollard reported on this at first hand: 'If ever he allowed himself to be parted from anything in what he called his "stock-in-trade", he would either hand it over ready-framed or, if he believed he could trust the customer far enough to let the thing go without a frame, he never failed to impress on the buyer: "Go to Lezin", the only framemaker to whom he entrusted his larger works, "and I'll drop by to pick a frame." He favoured the old wrapping paper from sugar cones, which is such a lovely blue, for the passepartout on his drawings and would arrange to have the drawings set off from the passepartout by a white strip half a centimetre wide. He would say: "On no account let it be a passepartout with a slanting edge which cuts up the subject." As to framing, he had a special liking for 'coxcomb' frames, with indentations like a cock's comb, and designed the outline himself. He also selected the colours for his frames and chose for this purpose the same [white] paints as those used for garden furniture. One can imagine Degas' rage if his "art lover" replaced the frame he had picked out with such loving care by a golden surround in the belief that this would enhance the value of the picture. Nothing could then prevent relations being broken off. Degas returned the money and took away the picture.'[52]

It is worth pointing out in this connection that Degas was an extremely knowledgeable connoisseur of drawings, as well as one of the greatest graphic artists of all time. His main interests in this field are indicated by the contents of his lovingly assembled collection, which involved a sizeable financial investment and, in fact, represented the only luxury he allowed himself. It contained, apart from the bulk of Daumier's graphic output, a very choice assembly of drawings, pastels and watercolours by Delacroix, Ingres and Manet, represented respectively by 194, 86 and 14 works.[53]

It is therefore not surprising that the first authorized publication of his works should have consisted of drawings. At the beginning of 1898, the art publishing firm of Boussod, Manzi & Joyant issued an album entitled *Degas. Vingt Dessins 1861–1896*, produced by a process specially invented for this purpose by Manzi.[54] Pissarro commented on it enthusiastically in a letter of 23 January 1898: 'Yesterday I saw at Joyant's an album of reproductions of Degas' drawings published by Manzi. It is superb! It is here that one can see what a real master Degas is; his drawings are more beautiful than Ingres', and, damn it, he is modern. One doesn't feel that element of official art which offends me . . .'.[55] Attention was not drawn again to Degas' graphic work until 1914, when Vollard published a book of pictures consisting mainly of drawings and pastels.[56] The bulk of the drawings discovered after the artist's death was listed and illustrated in the catalogues of the four posthumous auctions mentioned earlier. Shortly afterwards, in 1921, Lemoisne described the twenty-eight sketchbooks left to the Bibliothèque Nationale,[57] while in 1922–3 Henri Rivière brought out a two-volume facsimile edition of one hundred drawings by Degas which remains unequalled in the standard of its production and presentation.[58] When Lemoisne published his catalogue of pastels and paintings in 1946, he indicated that a similar list of drawings, containing over three thousands items, was being prepared. It is all the more lamentable that even yet it has not proved possible to implement this project when one recalls that only few recent academic publications have dealt with Degas as a draughtsman.[59] 20

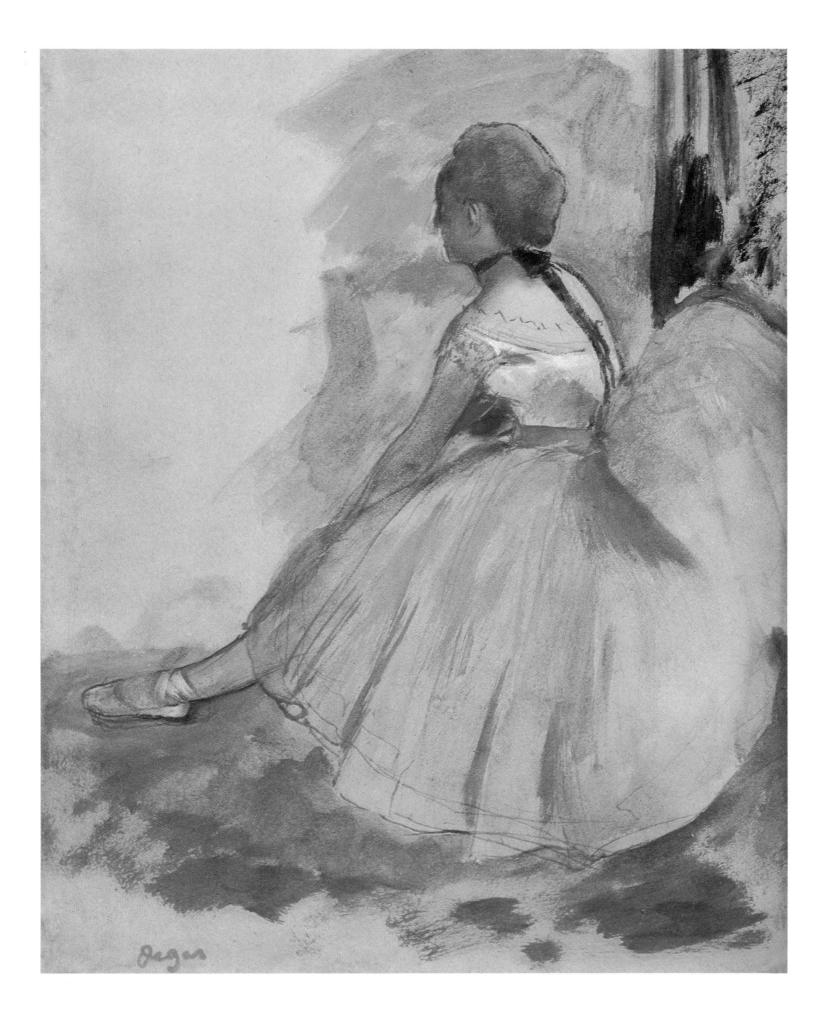

Seated Dancer with Left Leg Stretched Out 1871–2 (pl. 83)

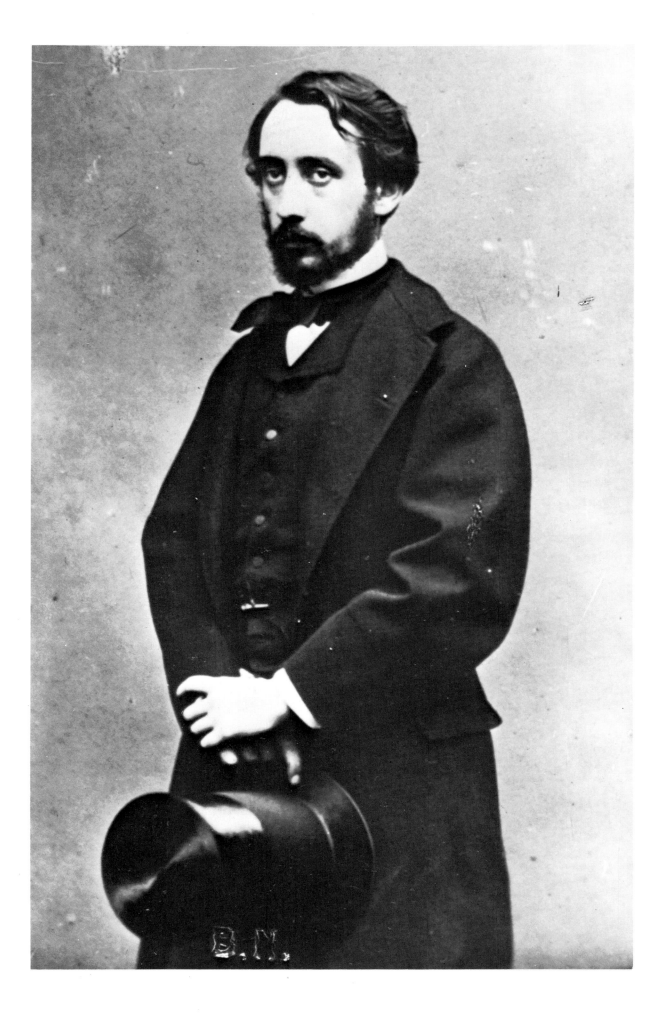

Edgar Degas, about 1862
(Photo Bibliothèque Nationale, Paris)

Hilaire Germain Edgar Degas, who was to become the very model of a Parisian in due course, was certainly nothing of the sort by family origin. Although he was born on 19 July 1834 in the rue Saint-Georges, at the foot of Montmartre, his father Auguste de Gas was a Neapolitan, while his mother Célestine Musson came from New Orleans.[61] René Hilaire de Gas, the head of the family, had fled to Naples from Orléans in 1793 to escape the guillotine during the Terror. He became a banker, but remained a convinced royalist and would refuse when visiting Paris many years later ever to set foot in the Place de la Concorde, where the king's head had fallen under the guillotine. Germain Musson, the maternal grandfather, was a Creole born on Haiti, who had traded in cotton from New Orleans since 1810 and died in Mexico hoping to make a fortune in silver. He lived in France for some time with his five children, where the eldest daughter Eugénie married into the de Rochefort family, while the seventeen-year-old Célestine married Auguste de Gas, the young banker who headed the Paris branch of the family business, in 1832.

Edgar was their eldest child, followed by Achille, Thérèse, Marguerite and René. Their mother died in 1847 and the responsibility for their upbringing thus devolved on their father. Edgar attended the well-established Lycée Louis-le-Grand from 1845 to his baccalauréat in 1853 and proved to be no more than average as a pupil, except for art in which he won a First Prize for drawing in 1852.[62] He acquired a thorough humanist education there and contracted lifelong friendships with Paul Valpinçon, the brothers Henri and Alexis Rouart, as well as the writer Ludovic Halévy.

Degas acquired an early interest in art and grew up in a liberal, patrician environment which was very aware of it. Some of his schoolfriends indulged in artistic activities. Auguste de Gas himself was more drawn to music and painting than to the business interests which were the sole concern of his relatives in Naples and New Orleans. And so it often happened that father and son would visit museums together or be received by leading collectors of the day, such as Edouard Valpinçon, the father of Degas' schoolfriends and a patron of Ingres, the Romanian Prince Soutzo, Louis Lacaze and the corn merchant Marcille with his large collection of Rococo paintings. The banker was no doubt pleased that his eldest son completed his law studies at the Ecole de Droit,

undertaken without any great enthusiasm, but the young man's determination to make his way in art certainly did not take him by surprise. His understanding attitude does credit to his cultured outlook, and he was also generous and thoughtful enough to ensure that during the family's frequent moves there was always somewhere for the budding artist to practise without interference from his younger brothers and sisters.

It was probably on Edouard Valpinçon's advice that Edgar Degas, after a short period of tuition under Félix Joseph Barrias in April 1853, went on to the studio of Louis Lamothe, a devoted pupil of Ingres who had made a name for himself as a portrait painter and ecclesiastical artist, where he spent a little over a year mastering the basic principles of his craft. The first sketchbook, dating from 1853, contains, for example, notes and sketches from Jean Cousin's then very popular manual, *L'Art de Dessiner* (Paris 1821)[63], as well as studies from reproductions of Italian High Renaissance works. A short interlude followed in April 1855, at the Ecole des Beaux-Arts where Lamothe had sent his pupil to another pupil of Ingres, Hippolyte Flandrin. Probably because he found the excessively close classroom supervision irksome, Degas then turned his back on further, more elaborate academic study and chose to go his own way.

Two events may have helped him in this decision. The first of these was a crucial meeting with Ingres – of which Degas loved to give constantly fresh accounts well into his old age – when the seventy-five-year-old master told the beginner to 'make lines . . . many lines, be it from memory or from nature'.[64] The second was the impact of the burst of enthusiasm for progress which Napoleon III so brilliantly reflected in the display at the Second World Exhibition in 1855. This was the first of those 'places of pilgrimage for prestige merchandise'[65] at which, among the 24,000 exhibitors, space had also been found for the pictorial arts from all over the world. Twenty-eight nations were represented by more than 5000 paintings crammed from floor to ceiling on the walls of the Ecole des Beaux-Arts. France supplied the bulk of the exhibits, in sets selected by the artists themselves, with the explicit intention of putting French supremacy in art on a firm foundation for precisely a century to come. Ingres had not shown anything for twenty years and was therefore given pride of place with a retrospective exhibition. Degas later liked to boast that old Valpinçon had yielded solely to his entreaties in making available the famous *Valpinçon Bather*, painted in 1808, for display[66] alongside more than forty other paintings and innumerable drawings housed in a separate gallery. Delacroix, Ingres' chief rival, had provided a set of thirty-five works covering all his different creative periods. Courbet opened his own Pavillon du Réalisme near the official exhibition as a protest against the rejection of two important works of his by the jury. Despite all this, it was Ingres who fascinated Degas to the exclusion of all others. No less than ten notebook pages carry painstaking studies from the master's compositions and record details of secondary figures apparently picked at random, mainly from religious and mythological scenes,[67] while one searches in vain for references to Delacroix or Courbet. Degas was learning to discriminate, as his drift away from his rather mediocre teachers, Lamothe and Flandrin, and his use of – though not slavish conformity with – Ingres' formal discipline suggest. He must have been aware by this stage how right Baudelaire had been in lambasting the eclectics who flocked about Ingres for their 'modish and facile daubs which verge on the meretricious'.[68] He must similarly have learned that drawing from plaster casts in 24

museums and the Ecole des Beaux-Arts, from old master originals and reproductions and from nature provided the basis of any promising artistic work. He kept strictly to this precept by ceaseless detailed studies from antique models, reproductions of Raphael, Fra Bartolomeo, Leonardo, Marcantonio Raimondi and the works of Ingres and Flandrin (pls 1 (back), 4, 6–10). Most important of all, such work taught him to handle a pencil, that compound of graphite and slaked lime patented in Paris as recently as 1795, but very quickly put into mass production. First the Classicists, then Ingres and later Cézanne switched almost entirely to it for purposes of drawing, not least because it was cheap. Following Ingres, Degas initially preferred to use pencils with different grades of hardness. He learned to render the finest shading and thinnest outlines with hard leads resembling the former silver point and to use softer grades for dark or broad strokes. Degas' earliest drawings of his own consist of portraits dating from 1853–5.[69] The models are drawn from his immediate environment: his father, brothers and sisters (pls 2, 3, 5). Whenever these were not available, he drew himself; during this period, in search of his own identity he painted a whole series of self-portraits.[70] But this phase lasted only until the mid-1860s and was not revived until his late period when the advent of photography stimulated him to further experiments in this direction. Probably the earliest instance of the artist face-to-face with himself is provided by an unpublished pencil drawing (pl. 1) of the then twenty-year-old youth. This is by no means a mere beginner's piece and suggests that everything he had learned is being utilized and made to tell. The head, presented frontally with a slight turn towards the onlooker, and the lightly sketched torso fill the sheet nearly to its edges. The features still have a childlike softness, with a high, broad forehead and well arched eyebrows centred on a penetrating silvery glance, and lightly indicated lips.

Tension is achieved by the leftward setting of the pose and the portrait owes its animation to the delicate shading around the eyes, nose, mouth and chin, while the bolder strokes are confined to the hair and torso, the whole against a background which is only hinted at. The graphic treatment was less self-conscious in the two – presumably contemporary – portraits of his sister Marguerite and a boy, who may well be the nine-year-old René de Gas (pls 2,3). Marguerite was twelve in 1854 when a number of portrait studies of her, this among them, were made on the occasion of her first Communion. The oval of the face recalls portrait studies by Ingres by its almost old-masterlike precision, while the pensive charm of the head harmoniously set on the sheet suggests sketches by Perugino or Raphael. Outline and inner detail are carefully contrasted. The marked outline of the head on the left is deliberately offset by the shaded part of the face on the right, where fine differences of shading are achieved by delicate cross and parallel hatching.

These three drawings, which can hardly have been intended as preliminary studies for paintings, are stylistically very different from sketchbook entries where the original outlines of the printed models still largely dictate a none too self-confident treatment. Despite classical and neo-classical echoes, the three portraits display marked psychological insight and astonishing assurance in formulation. All attitudinizing is totally rejected: there is no expression of childish joy, no smile in the features of the sitters. Everything is focused on essentials. It is particularly significant that right from the start Degas only portrayed people he knew through constant contact, of whose

character he was intimately aware and whose smallest peculiarity was familiar to him. This is why portraits of his family predominate; they remained its property and changed hands only in the 1920s and 1930s.[71]

One obligatory stage on the way to success as a portrait painter, a career clearly indicated by his training and inclination, remained: a study tour in Italy which every leading painter of the period without exception, from Ingres to Manet, had undertaken. After Degas has travelled in 1855 to the South of France and Lyons, where Lamothe and Flandrin had worked for a while in their native city, he set out for the country already familiar to him from his father's stories to study the quattro- and cinquecento masterpieces in their homeland. Family connections first took him to Naples. Degas spoke Neapolitan as fluently as French and had his share of the family's Italian possessions throughout his life. He stayed in the Baroque Palazzo Pignatelli di Monte Leone with his grandfather and unmarried uncles Henri, Edouard and Achille, or in their country house near San Rocco di Capodimonte. The family also included his widowed aunt Rosa Adelaida, Duchessa di San Angelo a Frosolone, with her sons Alfredo, Adelchi and Edmondo (who later married the artist's sister) and his aunt Stefanina, with her husband Gioacchino Primicile Carafa, Marchese di Cicerale and Duca di Montejasi, together with their daughters Elena and Camilla. The young guest shared in all the family feeling proper to southern Italy, and felt so happy in his grandfather's care, surrounded by uncles, aunts and cousins, that he spent a whole three months acquainting himself with Naples and its superb art treasures.[72]

He stayed longest, however, in Rome, from early October 1856 until the following July and, after another visit to Naples that summer, from November 1857 to July 1858. Rome had been the goal of French art students for many centuries and the Villa Medici, the location of the Académie de France, their main meeting place. This particular visitor was overwhelmed by the wealth of art he encountered, and wrote: 'Let me din it well into myself that I know nothing at all. That is the only way to get ahead.' Elsewhere, he jotted down: 'Oh, how doubt and uncertainty do weary me.'[73] Fortunately, he was soon able to make contact with some compatriots, most of whom had done well at the Ecole des Beaux-Arts and were now completing their studies after winning the Prix de Rome. Degas' circle of friends in Rome included, among others, Joseph Tourny, Léon Bonnat and Emile Lévy, as well as Elie Delaunay, a former fellow student at Lamothe's, Georges Bizet and Gustave Moreau, eight years his senior, with whom he was specially friendly. Neither Degas nor Moreau held Villa Medici bursaries, but they were welcomed as guests by the liberally-minded Victor Schnetz who had succeeded Ingres as the Director of the Academy. Studies of Roman landscapes survive in which both artists worked together on subjects taken from the Villa Borghese, the Villa Medici and Tivoli. There are also similarities in their choice of items to copy and they used the same male model in an identical pose (pl. 16).[74] Degas later told his friend Evariste de Valernes: 'It was the most extraordinary period of my life. Apart from a few words jotted down to send news to my family, I wrote nothing. I drew.'[75]

In July 1858, he travelled to Florence, stopping at Viterbo, Orvieto, Perugia, Assisi, Spello and Arezzo. There are enthusiastic references in the notes to the journey and the beauty of the landscape, but the diarist was repeatedly forced to admit that he could ultimately make little use of it all. Apart from this, the entries provide enlightening

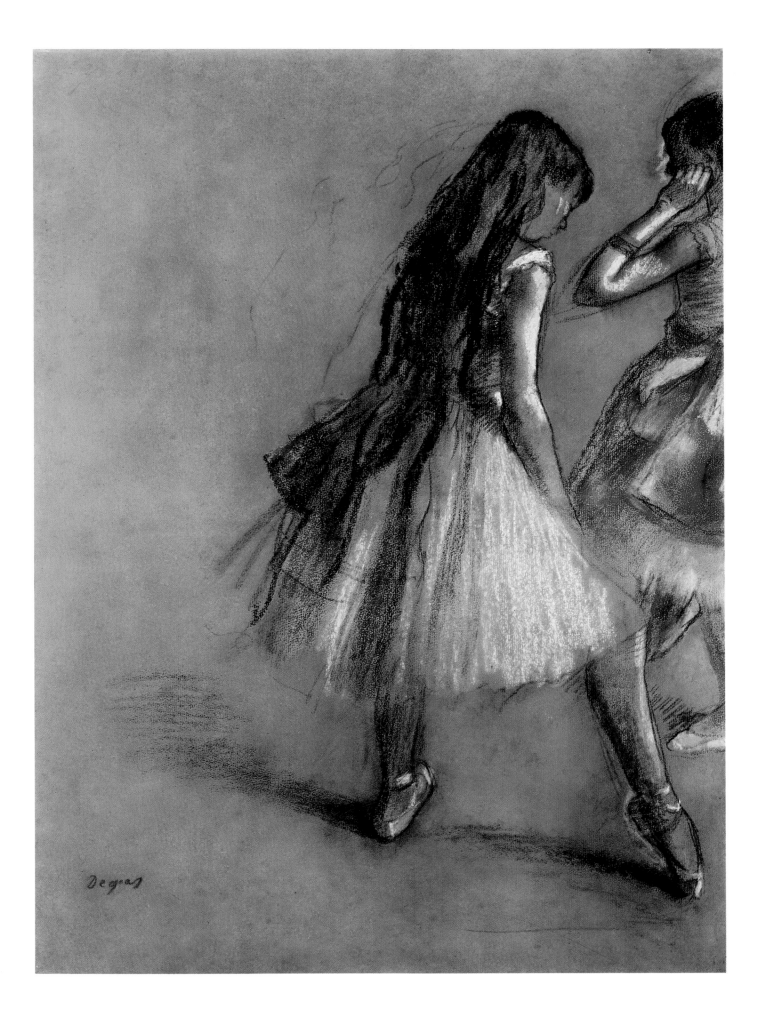

Two Dancers 1878–80 (pl. 112)

insights into the young Degas' emotional responses, his sensitivity, his sharp judgment and a view of art which was then beginning to come into focus. Much of his eventual position was already formulated here, for instance, an indication that he was primarily interested in the human figure. He noted in the cathedral of Orvieto: 'I feel no urge to go drawing from nature. I am passionate about Luca Signorelli. I must think about figures above all, or at least think while I study them.'[76] And two pages later, there is a blunt reference to the boredom induced in him by the landscape: 'I think of France which is not beautiful, but my love of home and of work in a little corner still gets the better of any wish constantly to enjoy this beautiful nature. . . . If one is to travel alone, one must cross countries where there is life or which are full of objects of art. Boredom soon overcomes me when I contemplate nature.'[77]

Assisi clearly provided the climax of the journey. These are some of his comments on the paints in the lower church and Giotto's frescos in the upper one: 'I have a conscience at having already seen so many beautiful things. I will leave. Everything is prayerful. Everything is beautiful, the details and the whole. I would rather do nothing than do a cursory sketch without having looked closely at anything. My memories will be worth having. Giotto commands a power of expression and an astonishing sense of drama. He is a genius. . . . I have never been moved to such an extent. I will not stay, my eyes are full of tears. . . . If I were to be fifty, alone, childless or unmarried, I would settle here, perhaps even in a monastery.'[78] Degas was carried away by individual figure paintings, praising their 'antique posture' and comparing them with the beauty of the wall-paintings in Pompeii: 'Oh, how these people felt life, a life which they never denied. . . . If only I could have been one of them! If I become dedicated and stable enough to paint something equal to sermons. . . ! How irresolute I am after all. . . . I would like to return to Assisi, but I am afraid to do so: I am afraid of backsliding into dreams that may benefit me some day, but which now rob me of all enterprise.'[79] And a final wish is added to the praise of the city of St Francis: 'Just to find a good simple little woman who would understand my foolish mind and with whom I would spend a modest working life! Is that not a lovely dream? I shall return to industriousness and Paris. Who knows what may happen? But I will always be a decent man. I hope my memory will be able to keep alive what I have noted. It is not even a summary of all that has gone through my mind. I have foregone even the smallest sketch.'[80]

When Degas arrived in Florence at the beginning of August 1858 to stay with his aunt, Laura Bellelli, his father's third sister, she had left shortly before to nurse his grandfather, who was dying in Naples. Only her two daughters were at home and her husband, the journalist and lawyer Gennaro Bellelli. He was something of a liberal freak in an otherwise legitimist family and was regarded as a leading revolutionary in Naples, his city of origin, owing to his friendship with Cavour. He had been sentenced to death *in absentia* after Cavour's defeat and forced into exile in Florence with his family, from which he returned home only in 1860, after the fall of the Bourbons, as a senator of the new kingdom of Italy. During the eight months he spent in Florence, Degas made a large number of pencil and chalk studies (pl. 30) required, together with some compositional designs, for a proposed group portrait of the *Bellelli Family* (p. 345).[81] He spent as much time at the Caffè Michelangelo, where intellectuals earnestly discussed current political and artistic events, as in the Uffizi and other museums and churches in

the city.[82] In his letters, Auguste de Gas encouraged his son to study the masters of the early Renaissance, thoroughly commit them to memory and, when appropriate, sketch details, because 'the masters of the fifteenth century provide the only true models; once one has taken them in . . . one cannot fail to achieve a result.'[83]

Such advice was, in fact, quite unnecessary. Drawing after old masters had been one of Degas' main activities ever since he had first registered as a copyist at the Louvre on 7 April and the Cabinet des Estampes on 9 April 1853 (pls 1 (back), 4, 6–13, 15, 18, 19, 34–39).[84] In so far as he – and Cézanne – were concerned, the Paris museums and the Imperial Library (now the Bibliothèque Nationale) – the best place for getting to know reproductions of masterpieces before the 'age of technical replication of art' had set in – were the real Ecole des Beaux-Arts. They offered ample opportunity to draw from selected models. The study trip to the South of France and work from originals in Italy undoubtedly helped Degas to develop a *musée imaginaire* – a museum in the mind – especially through his sketchbooks. The range of his interests widened while he was in Italy: it eventually extended from works by Signorelli, Uccello, Gozzoli, Botticelli and Ghirlandaio, through the Florentine Mannerists Pontormo and Bronzino, to the Venetian style of painting which Moreau, who loved Titian, would undoubtedly have brought home to him. This may also have appealed to his father who wrote to him in Florence towards the end of November 1858: 'I am very happy that you have studied Giorgione so much – your colouring, though true, needs warming up a little bit. And beware of gingerbread. . .'.[85]

Unlike Cézanne, who even in his later years constantly turned to work by other artists in order to assess his own, Degas indulged in this only while he was still studying, from 1853 to the end of that decade.[86] No fewer than 740 copies survive from this relatively short period, elements of which have found their way into his own work. They were used by Degas to absorb a knowledge of the pictorial methods of earlier periods and convert it into an essential yardstick for his own benefit. His area of interest in the art of the past differed from that of Cézanne, who sought out the Baroque elements in classical art, as well as in the seventeenth, eighteenth and nineteenth centuries, while Degas took his models mainly from the Italian Early and High Renaissance, as well as French classicism.[87] Exceptionally, he may pick up a Baroque element in a few drawings after Van Dyck, Velasquez and Rembrandt or within the French classical tradition, as in the case of Poussin.

A striking feature of the copies whose subjects were chosen entirely by Degas, rather than set by a teacher, is that they are almost exclusively concerned with portraits and figures derived from religious, historical or mythological subjects, while landscape, still-life and genre work is largely absent. Degas tended to isolate certain figural themes and details of compositional significance in order to test body attitudes. It is particularly significant in terms of his later organization of space that marginal detail is awarded far greater attention in these copies than the hierarchic build-up of a given composition. Three drawings which have little else in common, grouped together and still in their original frame, go to show that the artist concentrated on these particular figures precisely because of their stance: one of the thieves from Mantegna's Crucifixion (pl. 15) and Michelangelo's sculpture of the *Dying Slave* (pl. 39), both in the Louvre, together with the figure of Venus from Botticelli's *Birth of Venus* in the Uffizi (pl. 38). These were

produced within a period of five years and have in common the accurate modelling of light and shaded parts, as well as precision in the treatment of hatching. On the other hand, Uccello's *Fighting Horsemen* (pl. 36) and Poussin's *Triumph of Flora* (pl. 37) are among the very few complete compositions copied. These clearly mark the poles between which the copyist's probing lay: in the former, the whole monumentally plastic quality of the Early Renaissance painting is conveyed, despite the small dimensions of the sheet, while in the *Triumph of Flora* the artist's determination to reproduce the bold *chiaroscuro* of the Baroque original with pencil, pen and brush is obvious.

The years in Italy brought perceptible progress to Degas' graphic work. There is increasing self-confidence and spontaneity. The strokes are stronger, the shading bolder, the cross-hatching more relaxed and, in general, there is a greater emphasis on pictorial effect (pl. 27). In this case, Degas secured painterly effects even in black and white by the use of strong shading to bring out the plasticity of the head. This revulsion against a thin-blooded classicism instilled in him at second hand was probably due not only to the manifold effects of Italy, but equally to his friendship with Moreau and Tourny, who had drawn his attention to the work of the Venetians and Rembrandt, as well as to that of their French contemporaries, Fromentin and Delacroix.[88]

Increasing self-confidence gave him a constantly improving command over a very wide range of techniques. Nothing stood in his way in combining the use of pencil and sanguine or chalks with that of clear or opaque watercolours, as in the portrait of his aunt Rosa Morbilli, probably produced in Naples during the summer of 1857 (pl. 31). This full-length portrait combines the use of pencil and brush drawing with watercolour and gouache in a wealth of different ochre, grey and reddish tonalities. The restrained colouring fits in with the directness of the composition and the unassuming personality of the sitter. The Duchess is presented in strictly frontal view, but positioned very slightly to the left of the vertical line of symmetry, in front of a wall mirror which reverses her image. Soon afterwards, her sister Laura was juxtaposed, in a similarly monumental pose, with a mirror image in the *Bellelli Family* portrait.[89] The intimate character of Degas' family portraits contrasts with the practice of the officially approved Second Empire portrait painters whose sitters insisted upon a display, as the case might be, either of position and dignity or beauty and charm. Here, on the contrary, we have members of a clan who do not deem it necessary to be shown to the greatest advantage. They are sure enough of their own standing not to make a show of it and so appear in their domestic surroundings in everyday clothes. Since the portraitist was lucky enough never to be obliged to accept commissions, he was free to follow his own ideas and develop his technique in this field as the spirit moved him.[90]

A note of warning in a letter to Edgar in Florence indicates that this in no way coincided with the ideas of Auguste de Gas, who would have liked to see his son follow in the footsteps of the officially recognized painters: 'You stress the boredom you experience when painting portraits; you will, at a later stage, have to overcome it, because this [work] will be the finest jewel in your crown. The question whether the ledger balances is of such weight in this world, is so urgent and menacing, that only fools can allow themselves to overlook it or treat it with contempt. It is not a matter of lowering yourself to this level, but rather that you should be capable of coming to terms with the distaste involved. As I have told you over and over again one has to pay dearly

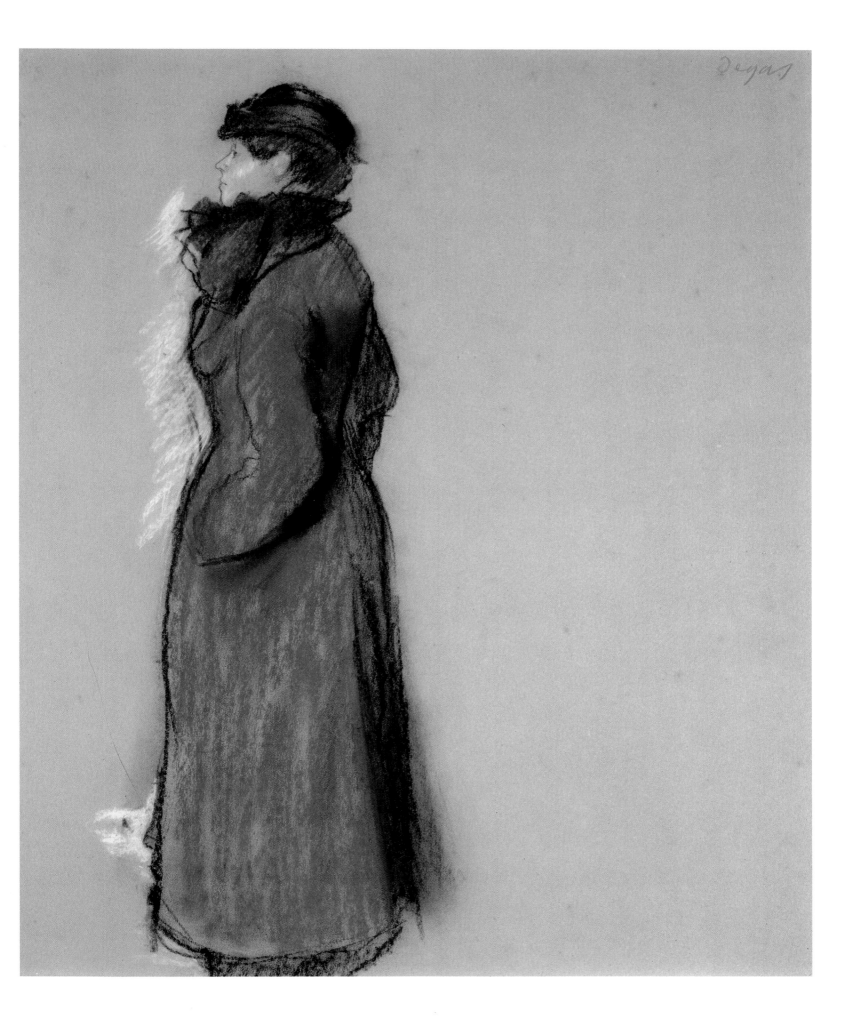

Ellen Andrée circa 1879 (pl. 135)

for the foolishness of believing that one can always follow one's own inclination in this world.'[91]

Despite a growing mastery of his craft and improved self-confidence, doubts about a career in art continued to beset Degas, or so it would seem from a somewhat disheartened letter to Moreau in September 1858: 'The stony path I have chosen demands great patience. Your words of encouragement have reached me, but I nevertheless begin to despair a little, as I had done earlier. I recall our discussion in Florence [Moreau was there in August 1858] about the unhappiness that becomes the lot of anyone who devotes himself to art. There was less exaggeration in what you then said than I realized. There is hardly anything to make up for this unhappiness. It gets worse with age and experience, while youth does offer a little consolation by way of hopes and illusions. With all one's love for one's family and all one's passion for art, a void remains which even the latter cannot fill. I think you will understand me, even though I cannot express what I feel.'[92]

Yet it was once again his father who assessed his progress accurately and wrote to him in Florence, on 11 November 1858, in connection with some work he had sent home: '. . . I was very pleased and can tell you that you have taken a tremendous step forward in art: your drawing is strong and your tonality correct. You have sloughed off that slack and trivial Flandrinian and Lamothian way of drawing and that dull grey colour. . . . You have no further reason to torment yourself, my dear Edgar. You are on an excellent path. Calm your troubled mind and follow this path that you have opened for yourself by working quietly but steadily, without flagging. It is yours, no one else's. Work quietly while you keep to this path, I suggest, and you can be sure of achieving great things. You have a fine destiny before you; don't lose heart, don't fret.'[93]

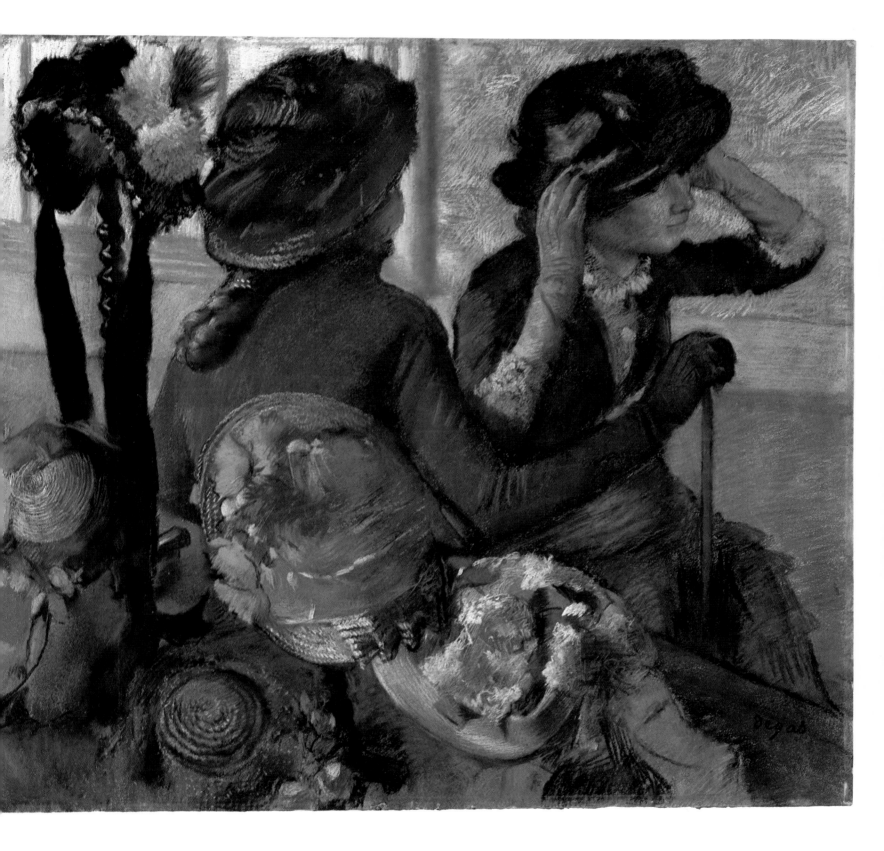

At the Milliner's 1882 (pl. 141)

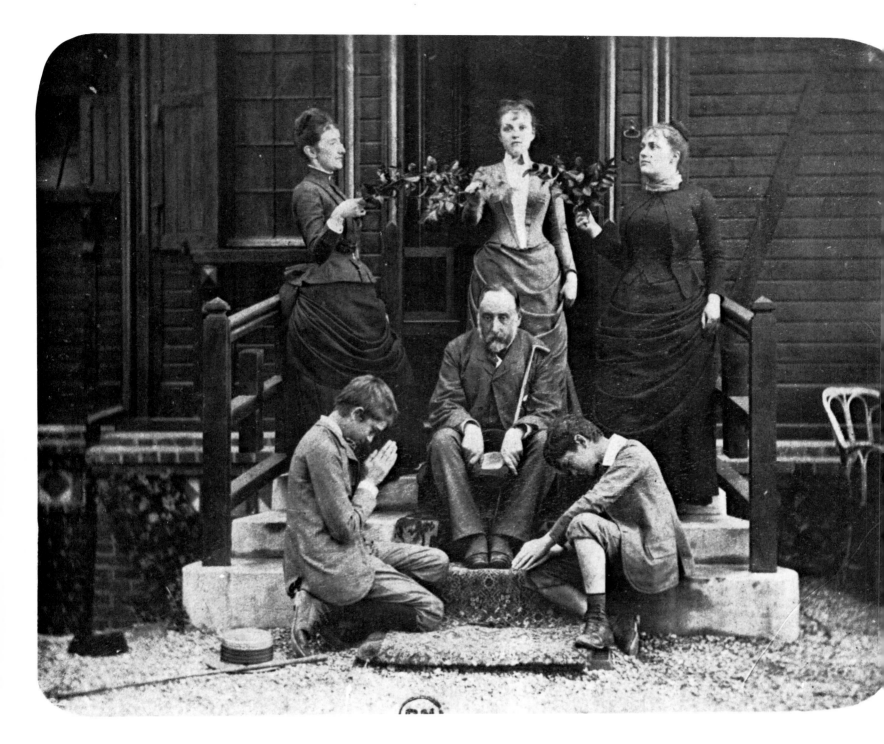

Edgar Degas, Skit on Ingres' *Apothéose d'Homère* at Bas-Fort-Blanc near Dieppe, 1885.
(Photo Barnes, Bibliothèque Nationale, Paris)
Degas wrote in September 1885 about this photograph: 'It would have been better if I had
placed my three Muses [the Lemoisne sisters] and my two choirboys
[Elie and Daniel Halévy] in front of a white or light coloured background.
The detail of the ladies' dresses is lost. It would have been better
if the figures had been moved more closely together.'
(Guérin 1945, p. 112).

When Degas returned to Paris at the end of April 1859 at his father's request, his actual period of studies was over. He could now set out to apply what he had seen and learned during these seven years to thematic areas of his own choice and in more ambitious ways, following the precepts of the old masters in new personal directions. The decade that followed was to provide him with fruitful inspirations, a struggle for perfection and his first new departures in the pictorial field. Auguste de Gas had shown forethought when he leased a studio in the rue Madame large enough to accommodate big canvases. The *Bellelli Family* portrait, for which so many studies had been prepared in Florence, was now carried out in the more familiar environment of Paris as a 2 × 2.5 metre canvas (p. 345). In this painting, probably completed and presented to the Italian family in 1860, Degas successfully applied all the hard work he had done over so many years to qualify as a sound portrait painter. He had produced his trial piece. The psychologically accurate and technically acute record of underlying divergencies, tensions and clashes provided by this picture is at odds with the complacent middle-class domesticity of Dutch Baroque portraiture, as well as with the stereotype of family bliss reflected in Rococo genre painting. Degas' inclusion, as a picture within the picture, of a sanguine portrait of his grandfather (which has not survived) also says something about his confidence in his own graphic capabilities.95

Very soon, he set about imposing a deliberate restraint on the 'painterly' idiom of many of his drawings which had reached a peak towards the end of the 1850s. Degas was again using hard, sharp pencils on smooth white paper, just as he had done at the start. Strongly marked outlines are usually complemented by neat, parallel shading strokes. This style, derived from Ingres but endowed with greater powers of expression, is characterized by economy in the treatment of inner detail and great accuracy in rendering facial features, while everything else is dealt with very fleetingly (pls 46, 47, 53, 55). Degas even went so far as to emphasize such stylistic divergencies by the introduction of different techniques. Moreover, this unorthodox application of Ingres' stylistic achievements was modified, as a result of his friendship with Moreau and Tourny, by ideas derived from Delacroix which came to play a crucial part in his work. Auguste de Gas' attempt, as a supporter of Ingres, to bring his son back to his senses in connection with Delacroix had clearly not borne fruit: 'You know I am far from sharing your opinion of Delacroix, that painter who has wholly surrendered to his

flood of ideas and has – to his own detriment – neglected the art of drawing, that Ark of the Covenant on which everything rests. He has completely lost his way. Ingres, on the other hand, has risen through drawing. . . . One cannot but admit that if painting is to be born again during the present century, Ingres will have made a powerful contribution to this by pointing the way to perfection for those capable of understanding him or, better, by stimulating those capable of achieving it.'[96]

Ingres and Delacroix each stand for one of two tendencies which became polarized after the French Baroque and which have been carried on into the twentieth century under the conventional labels of – respectively – graphic and pictorial, or classical and Romantic. In the novel *Manette Salomon*, published in 1866, the brothers Goncourt wrote that '"Ingres" and "Delacroix" are the two battlecries of art', a reference to the conflict in which the supporters of Poussin confronted those of Rubens and which reached its climax in the feud between Ingres and Delacroix, so aptly lampooned by Daumier. Degas was among those few who refused to side with either artist, although his interest in Delacroix came later than his feeling for Ingres. In fact, it developed only in Italy when his fellow students made him aware of 'the most original painter of both ancient and modern times', as Baudelaire put it.[97] The controversy involving these two figures raged so strongly even within the Villa Medici, that stronghold of French classicism and the Ingres cult, that Georges Bizet, then a mere music scholar, wrote home on 16 May 1858: 'The painters are permanently split into two camps: colourists and draughtsmen.' Degas prized Ingres' mastery of line and strove to acquire Delacroix's sense of colour and power of composition, but he was chary of falling too deeply under the influence of either. He used references to Ingres from his earliest beginnings well into the 1870s. The impact of Delacroix's emotional approach, on the other hand, clearly emerges during the first half of the 1860s, and then reappears in the late pastels, where unfettered dynamism and an opulent tonal range, derived from the Romantics rather than the Impressionists are dominant. But Degas only seldom allowed himself calligraphic liberties such as those taken by Delacroix, who was carried away by his creative impulses and drew with the eyes of a painter. In so far as he was concerned line was for connecting, bridging and condensing, while Ingres and Degas mainly used it to clarify, establish and define.

In accordance with Ingres' suggestion,[99] Degas had so far used the portrait as his main vehicle of expression. He was well aware, however, that he must also undertake narrative painting, since this type of work had led the field in pictorial terms for many centuries. Artistic doctrine favoured it, so did official taste, and it therefore represented an essential ingredient of any prospective career. To put it at its lowest, Degas had demonstrated his ability as a portraitist to his own and his family's satisfaction by his drawings and the *Bellelli Family*. But nothing had so far come from him on religious, historical or mythological subjects, except for some very tentative work in that direction, such as *Dante and Virgil* and *John the Baptist with the Angel* (pls 21–23).[100] After his return to Paris, however, between 1859 and 1865, there was an extremely productive run of such pictures, all of them very ambitious in their thematic and compositional conception: *Spartan Girls Taunting Boys* (p. 345); *Semiramis Building Babylon* (p. 345); *Alexander and his Horse Bucephalus*; *Jephtha's Daughter* (p. 346); and *Scene of Medieval Warfare* (p. 346).[101] Some statistical information will clarify the part played in the

36

conception and formulation of these narrative works by the draughtsman, since many single sheets and sketches in the notebooks, together with further information provided in the latter by notes, copies and drawings of details, enable us to accompany the artist on his painstaking search for each subject. The earliest figure composition, *John the Baptist with the Angel*, and the single figure of the *Baptist* were produced in Rome in 1856–7, as a small watercolour and a canvas respectively. Although the outcome remains unconvincing in both cases and a final version was probably never undertaken, preparatory work for this took up more space in seven notebooks than that devoted to later and more elaborate figure compositions.[102] Texts scattered over a total of twenty-three pages – including some quotations from the Book of Revelation – and figures to accompany them are intended to familiarize him with the subject and lightly fill in some details of the figures. A single sheet, on the other hand, worked on both sides is entirely devoted to minute execution (pl. 22). The nude figure of John the Baptist with his right arm raised (probably drawn from life in Rome) and, on the back, of an angel blowing a trumpet, still owe the delicate treatment of the figures and the refinement of their modelling to Ingres' influence. Degas drew a grid over the figure of St John to facilitate its transfer to canvas.

A curious discrepancy comes to light when one searches the notebooks for material relevant to the five large narrative pictures painted in Paris. There is only one sketch and a single relevant note concerning the *Spartan Girls*, but several single sheets (pls 40, 41). Even the *Building of Babylon*, for which there are no fewer than thirty-six drawings (possibly extracted from a larger-sized sketchbook) in the Louvre alone,[103] is represented in the existing notebooks by a total of only four compositional and figure sketches. Two designs, five landscapes and eight sketches of figures and horses can be identified in connection with *Alexander and Bucephalus*, but there is no reference whatsoever to *Medieval Warfare*, the last of the narrative compositions. The artist clearly confined his preliminary sketches for this work to single sheets (pl. 56), of which the Louvre has thirty-four, with figure, costume and detail studies on variously coloured papers.[104] In the case of *Jephtha's Daughter* (pl. 43), Degas' largest canvas, which sums up his entire experience as a narrative painter, the situation is very different.[105] No other work of his was so thoroughly prepared: there are thirteen compositional studies, some fifty-three figure studies, together with a few details of their grouping, six landscape studies and sixteen marginal notes with colour indications distributed over seven notebooks. He had had this ambitious painting in mind since 1859–60 and it therefore bears the marks of conflicting influences. Dürer and Mantegna share in its conception on a par with Veronese and Delacroix. A synthesis of graphic and pictorial styles is enshrined in the maxim 'Attempt Mantegna's insight and love combined with Veronese's sweep and colour.'[106] The affinity with Delacroix is displayed in the insistence on linear rhythms and the intensely vivid *chiaroscuro*. A marginal note on a small sketch is relevant in this connection: 'A grey and blue sky with a tonal value such that the bright areas naturally stand out against the brightness, and the shadows against the dark. For the red of Jephtha's robe, bear in mind the orange red tonalities of the old man in Delacroix's painting.'[107]

Degas' concern with narrative painting was for all intents and purposes restricted to the period between 1860 and 1865, and proved entirely ephemeral in so far as achieving

recognition was concerned. He had dealt in exemplary fashion with a wide range of subjects, but shirked publicity for his efforts. Yet these works and the graphic preparation underlying them may have proved important for him in other respects. For instance, he had been able to concentrate exclusively on the body language and mobility of the human figure. This may explain why one occasionally feels that he was far less interested in the correct historical interpretation of each of the incidents in question than in the individuals involved, the most natural representation possible of their attitudes in movement and the interaction between the various groups of figures. The 'practised' portrait painter was intent on eliminating all traces of imitative idealism. With Delacroix's example in mind, he wished to liberate his statement from the standard classicist mould. He had grasped the dichotomy of lofty claim and slender significance implicit in nineteenth-century cultural narrative work, and countered it by an attempt to restore relevance to narrative painting, treating its idealistic content in a conspicuously sketchy way.

Or it might be that the event in question had attracted attention as part of a stage production, such as the *Building of Babylon*, probably inspired by Rossini's opera *Semiramide* which had recently been put on in Paris: the classicists' grandiose event could be transformed into an irrelevant backstage anecdote. But the conflict between bathos and authenticity ultimately proved unbridgeable. Shocking aspects, such as the naturalistic treatment of the faces in the *Spartan Girls*, simply could not satisfy the public's expectation of a classical significance in such a picture.[108] But these narrative pictures, which were not produced in response to a commission, may nevertheless represent important landmarks in the evolution of modern figure treatment, since the *Spartan Girls* was picked out as a key work for the Fifth Impressionist Exhibition in 1880, all of twenty years after it had been painted. And the author of these narrative works retained a feeling for carefully planned and prepared compositional articulation long after the high-flown meaning of the paintings had been lost.

Degas made his début in 1865, with the *Scene of Medieval Warfare*, at the Salon, the most important exhibition in Paris. It was held annually at the Palais de l'Industrie, a well-established institution against which Ingres had already thundered in vain: '. . . the Salon stifles and corrupts the feeling for the great, the beautiful; artists are driven to exhibit there by the attractions of profit, the desire to get themselves noticed at any price, through the supposed good fortune of an unusual subject. Thus the Salon is literally no more than a picture shop, a bazaar in which the number of objects is overwhelming, and business rules instead of art.'[109] Degas believed that he had gauged public taste accurately by submitting his latest narrative work, since it tallied admirably with the views of the selecting jury. The public at large was in no way disturbed by a collection of tastefully grouped nudes, provided that there was some colourable historical or literary excuse for their presence and they conformed with the accepted aesthetic standards.

Yet this first offering in which such great hopes were invested attracted no attention whatsoever. Degas had a very clear understanding of the attitudes prevailing within his own class and tried to circumvent them by disguising the formal innovations perceptible in his early work and by painting 'according to the rules'. Cézanne and Manet, meanwhile, the latter supported by Zola, sought a way out by shocking the jury.

They ruthlessly broke with aesthetic patterns which had become mere platitudes and conventional themes, while Degas approached this problem with great caution. Manet hoped to secure recognition by issuing a challenge and unleashed a storm of indignation among the press and public by his *Olympia*, a recumbent female nude with a negro servant girl and a black cat. Cézanne wrote to Pissarro that he intended to hand in to the jury pictures that would make the Institute blush with rage and despair'.[110] Both vehemently rebelled against an official art establishment which the critic Théophile Gautier had denounced long since: 'Art nowadays only has stillborn ideas and forms in store, which no longer answer its needs. Hence that timorousness, that indecisiveness, that prolixity, that talent for falling from one extreme into its opposite, that eclecticism and internationalism, an undiscriminating dabbling in all possible worlds, from the Byzantine to that of the daguerreotype, from the graceful sweep of Mannerism to a deliberate cult of brutality. It is clear that something must be done. But what?'[111]

In the end, Degas found a straightforward answer to Gautier's question, which had remained as topical as when it had first been put. He probably came to recognize that narrative painting had degenerated beyond all hope of recall. He was also disappointed by his failure at the Salon. He drew the only possible conclusion from this and gave up past themes for present ones. The speed with which he introduced this switch is illustrated by his successive contributions to the Salon between 1866 and 1870. *Scene of Medieval Warfare* was followed in 1866 by *Steeplechase Scene* (p. 353). In 1867, during the Second Paris World Exhibition, when Courbet and Manet showed their works in a separate hall and Ingres was again commemorated by a retrospective exhibition, Degas submitted two portraits. One of these was praised by the critic Jules Antoine Castagnary, a supporter of the authentic tendencies in contemporary art: 'The *Two Sisters* [p. 354] by Monsieur Degas, a beginner showing remarkable talents, is a work which displays its author's accurate feeling for nature and life.'[113] *Mlle Fiocre in the Ballet La Source* (p. 354) followed in 1868. Emile Zola, a friend of Cézanne since youth and an eloquent supporter of Manet, wrote about Degas' second 'stage picture' on 9 June 1868 in the magazine *Evénement Illustré*: 'When I look upon this slightly tenuous and singularly elegant painting, I am put in mind of those Japanese woodcuts which are so artistic in the directness of their colouring.'[113] In 1869, Degas showed a portrait of the dancer Joséphine Gaujelin (p. 355) and a year later, for the last time, a pastel portrait of Berthe Morisot's sister, Mme Yves Gobillard (p. 356).[114] This was accompanied by a portrait of Mme Camus about which Théodore Duret, later a spokesman for the Impressionists, wrote on 2 June 1870 in the *Electeur Libre*: 'In the likeness of Mme C . . . provided by M. Degas, which is taken straight from modern life, we have another picture that escapes from the well-trodden ways. The lady in the picture is a credible, real person, very alive, very feminine, very Parisian. . .'. The portrait 'reveals an artist who will certainly make a name for himself as soon as he resolutely sets out along the path which he has so successfully entered upon this year . . . a portrait which in the truest sense reflects the endeavour and the achievement of an artist.'[115]

Degas' feeling for modern life which Duret stressed can probably not be attributed to any single cause. There are many reasons which made him turn to contemporary themes, intermittently up to 1865 and consistently thereafter, not all of them fully understood even now. They spring from the outlook of an artist in search of free forms

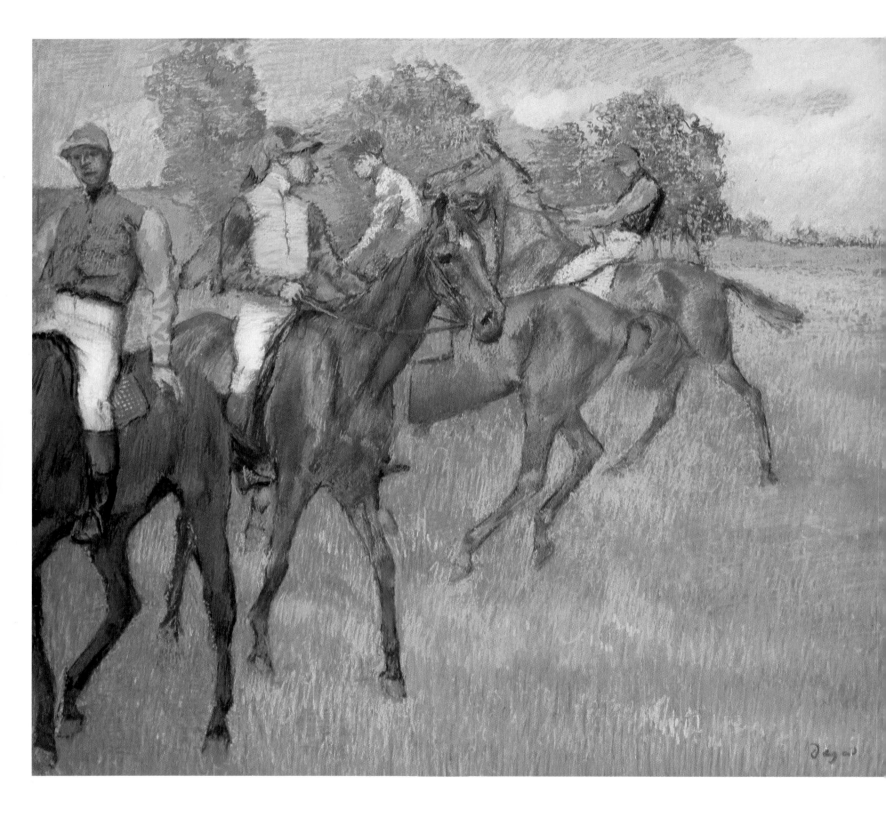

Before the Race 1883–5 (pl. 148)

of expression, but can also be identified with external influences which found fertile ground in him. His interest in the life around him did not spring from landscape, as it did for the Impressionists, but much more circuitously through portraiture and narrative. He was very far removed from those rebels who were interested only in breaking with the past and with established traditions. He sought reassurance that what he had found valid during his extensive years of study would be preserved and brought into accord with the discoveries he had made during the 1860s. The wish quoted earlier could serve as a motto for this: 'Ah Giotto, make me see Paris, and Paris, let me see Giotto!'

What Pissarro brought Cézanne at the start of the 1870s – an interest shared with an experienced colleague who could act as adviser, and, in a sense, as arbiter – Manet had given Degas a decade earlier. Though both of them were mainly concerned with the urban scene, they – oddly enough – first met in the Louvre when they both registered as copyists in 1861–2. Degas was attracted to his slightly older colleague partly because they both belonged to high society by origin, upbringing and sentiment, and Manet was completely part of this environment. He caused a scandal in 1863 – and attracted attention – by his first exhibition and his participation in the Salon des Refusés. This cannot have failed to affect Degas and probably encouraged him to turn to contemporary reality, though not necessarily to incorporate Manet's teachings directly into his own output. Precisely because Manet's social dexterity and unshakeable self-assurance were alien to him, while his own scepticism was less unrestrained, he both admired and secretly envied his friend. Manet provided an intellectual focus for a circle of writers, art critics, painters and sculptors who met first in the centre of town at the Café de Bade and then regularly, from 1866, at the Café Guerbois in Montmartre. Degas jealously guarded his independence and preferred to keep to himself. He therefore stayed on the outer fringes of this novelty-seeking, noisy group of artists which included Fantin-Latour, Renoir, Bazille, as well as the writers Astruc, Duranty, Duret, Burty and Zola. These were also occasionally joined by Guys, Cézanne, Sisley, Monet and Pissarro, together with the cartoonist and photographer Nadar. Animated discussions took place about true realism and an understanding of nature derived from landscape painting. Monet recalled that 'nothing could be more interesting than these *causeries* with their perpetual clashes of opinions. They kept our wits sharpened, they stimulated us with reserves of enthusiasm that kept us going for weeks and weeks until an idea had been given its final shape. We emerged from them with our determination greater and our thoughts clearer and sharper.'[116] Degas who, according to the journalist Théophile Silvestre, 'never stayed at the Café long, was '. . . an innovator of sorts whose ironic modesty of bearing saved him from the hatreds that attach themselves to the boisterous ones.'[117]

Among the writers of the Guerbois group, Degas found in Emile Duranty the kind of support that Baudelaire and Zola had given to Manet. Duranty made his name as the founder of the short-lived periodical *La Réalisme*, which resolutely attacked both classicist and Romantic trends in art. He pointed out to painters that 'in antiquity man created what he saw: create what you see.'[118] At a later stage he urged them to depict everyday life – 'a form of society, various actions, and events, professions, faces, and milieux.' He pinpointed 'comedies of gestures and countenances that were truly

paintable', formed by 'relations among people, where they met on different levels of life – at church, in the dining room, the drawing room, the cemetery, on the parade ground, in the studio, the Chamber of Deputies, everywhere.' Duranty also pointed out that 'differences in dress . . . corresponded to the variations in physiognomy, carriage, feeling, and action.'[119] *Manette Salomon*, the Goncourts' novel about artists, which had greatly impressed Degas, if his later assertions about it are to be believed, similarly demanded that painters should tackle the subjects offered by city life, including 'the elusive beauty of the woman of Paris'. As soon as they had sloughed off 'the brown sauce of academicism', they were to resort to the bright tonal range of the Japanese woodcut and catch the modern face in mid-flight. 'There must be found a line that would precisely render life, embrace from close at hand the individual, the particular, a living, human, inward line in which there would be something of a modelling by Houdon, a preliminary pastel sketch by La Tour, a stroke by Gavarni – a drawing truer than all drawing – a more human drawing.'[120]

Although the ideas of Duranty and the Goncourts greatly diverged, their common fountainhead was Baudelaire, who had already promoted a 'heroism of modern life' in his Salon reviews dating from 1845–61: 'Nobody bends an ear to the wind that will whistle tomorrow. There is no shortage of either subjects or colours for new epics. The painter, the true painter will be he who can pick out the epic aspect of modern life, who can make us see and understand by colour and drawing how great we are and poetic in our neckties and patent leather boots.'[121] Baudelaire also wrote that 'the majority of artists who have applied themselves to modern subjects have been satisfied with public and official themes, with our victories and political performances. This they do, in fact, only reluctantly and knuckle under to the government that pays them. And yet there are unofficial subjects which bear witness to quite another form of heroism. The pageant of elegant life and the countless dubious ways of earning a living which animate the underground areas of a great city – the *Gazette des Tribunaux* and the *Moniteur* make it plain that we only need to open our eyes to become aware of our heroic quality. . . . And so modern heroism and a modern beauty really do exist. . . . Parisian life is rich in poetic and splendid subjects. Splendour envelops and impregnates us like the surrounding air, and yet we do not perceive it. The nude, the naked figure so beloved by painters, and which has contributed so much to their success, is just as common and inescapable in our lives as it was for the ancients – in the bed, the bath, the operating theatre. The resources and reasons for painting are no less numerous or varied than in the past; but a new element has been added to them – modern beauty.'[122]

Even if Degas had been unaware of this early pronouncement by Baudelaire, he would certainly have read the critic's article about the painter Constantin Guys, which was published in *Le Figaro* in 1863 under the telling title *Le Peintre de la Vie Moderne*, and attracted much attention among painters. Guys' output consisted of what Baudelaire had been demanding for many years from the modern artist, thousands upon thousands of pen and ink drawings, touched up with washes and watercolours, which provided a realistic picture of all aspects of social activity under the Second Empire and were eagerly collected by Gavarni, Daumier and Nadar. Baudelaire was therefore moved to state his faith in 'modernity' once again and in 'a beauty born of reason and deliberate intention.' He pointed out that it was far easier 'to label everything clothed in the

trappings of a particular period as totally ugly', than to seek to discover 'the mysterious beauty it contains, however inconspicuous or modest it may be. Modernity is the transitory, the fugitive, the contingent, one half of art of which the other half is the eternal and the immutable.'[123] Baudelaire noted – a feature later applauded by Degas – that Guys did not work from nature, but 'from memory, like every truly great painter', in other words from the view that his power of imagination made available to him.[124]

Degas considered that the work of Daumier admirably met the requirements of such writers, because nobody could more perfectly convey *la vie parisienne* with all its peculiarities. His lithographs were published in the press and were as much part of a Parisian breakfast as a croissant, thereby gaining a penetration and currency among the ordinary readership which remains unequalled even in our age of proliferating and suspect mass media. The nineteenth century's 'great myth-maker' joined Ingres and Delacroix as the third main influence on Degas by his unorthodox approach to drawing, his unusual angles of vision and his unlimited range of subjects.[125] Baudelaire's praise of Daumier's 'uncompromising, direct genius' applies equally well to Degas' graphic intentions: 'He draws as the great masters did. His drawing is imaginatively effortless ... but it never verges on the facile. He has a marvellous, almost godlike memory, on which he draws for a model. All his figures are firmly planted and always accurately in movement. His power of observation is so sure that not a head is to be found in his output which fails to fit the body on which it is placed. And the same goes for nose, forehead and eye, foot and hand. Here erudite logic has been transmuted into a light and fleetfooted art that rivals life itself in motion. . .'.[126]

Baudelaire himself referred to Ingres, Delacroix and Daumier – the draughtsmen from whose conflicting approaches Degas learned to elaborate his own – jointly in a single sentence: 'We know of only two men in the whole of Paris who draw as well as Delacroix, one of them by a method related to his own, the other by opposite means. The caricaturist Daumier is the first of these; Dominique Ingres, Raphael's prolific admirer, is the other. Such a statement might well baffle both friend and foe, admirer and detractor, but steady and careful inspection will make it plain to anyone that these three methods of drawing have one feature in common: they perfectly and completely encompass whatever aspect of nature they set out to render, and they state precisely whatever they wish to state. Daumier may be a better draughtsman than Delacroix, if one values the capabilities of a healthy individual who feels fit above the unusual, staggering powers of a great genius sickening of his genius; and Ingres, so much in love with detail, may – if that were possible – draw even better than either, if one rates the elaboration of refinement above the composition but ... best of all, let us have all three of them to love.'[127]

Manet, Duranty, Goncourt, Baudelaire, Guys, Daumier and Nadar define an environment which decisively influenced Degas in the 1860s. Perhaps it was Duranty's ironic remark that Degas was 'on the way to becoming the painter of high-life'[128] which propelled the artist into subjects better calculated to satisfy the demand for modernity in Parisian art circles than family portraits and narrative paintings. Admittedly, he had already taken the first steps in this direction in 1860–61 with single racecourse scenes and pictures of horsemen, still influenced by narrative paintings involving horses and riders (pl. 43), but now brought up to date (pl. 49).[129]

43

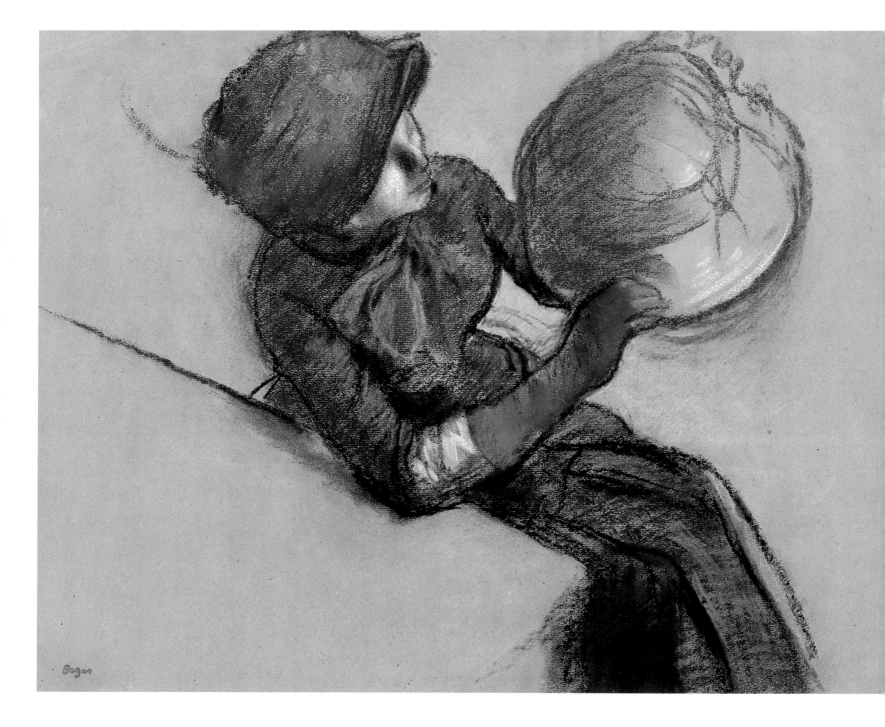

At the Milliner's circa 1885 (pl. 160)

When horse racing came into fashion in France under Louis Philippe and Napoleon III, various painters did well in this category of representation, among them De Dreux, Eugène Lami, John Lewis Brown, Princeteau and Auguste de Clermont. They drew their inspiration from the mass-produced prints dealing with this sport and imported from England since the middle of the nineteenth century. They met the entire demand for a fashionable treatment of this subject, which offered pleasant opportunities for genre paintings of various incidents such as weighing-in, saddling, the start, the race and the finish, together with the spectators' terraces. Degas' interest in everything connected with horses, jockeys and racecourses probably originated partly from copies of horses in the Parthenon frieze during the history of art studies (pl. 9), and partly from studies of work in this line by Traini, Gozzolli, Uccello (pl. 36) and Van Dyck, as well as from small sketches of races he had attended in Rome in 1856–7. He did not, however, develop this thematic area at the Longchamps racecourse inaugurated in 1857, but rather from pictures of horses by Vernet, Géricault and De Dreux, or drawings and prints by Herring and Alken, two English painters of horses.[131] What ultimately tipped the scales in his case was probably a visit to the Valpinçons' estate at Mesnil-Hubert near Ornes in Normandy during the autumn of 1861. This eighteenth-century house stood near one of the leading studs of the time, at Haras-du-Pin, where Degas found ample opportunity to observe horses and riders. His notes mention walks with Paul Valpinçon to Haras-du-Pin and further afield, where 'one hoped to see the horses run'. Several landscape studies are accompanied by a note that the view from the terrace of the Château du Pin 'is absolutely comparable to that seen in English coloured racing and hunting prints'.[132] Although there is nothing to suggest that Degas was ever a passionate punter or a devotee of racing and its attendant social occasions, watching horses stimulated him to produce constantly new variations on this theme. He was still visiting racecourses in the 1890s, searching for ideas and ascertaining details. Over forty-five paintings, some twenty pastels, about 250 drawings and seventeen surviving maquettes were devoted to this subject matter in the course of more than four decades (pls 48–51, 62–64 (p. 17), 65–68, 90, 142–148 (p. 40), 149–152, 192 (p. 72)).[133] The pictorial compositions, however, were not painted from nature, but assembled by means of sketches Degas had made on the spot, or with the help of small maquettes, or from copies of other pictures of horses.[134] Manet did the same when he briefly turned his attention to horses, probably under the influence of Degas, and admitted to Berthe Morisot: 'As I am not in the habit of painting horses, I have copied mine from those who know best how it is done.'[135] Manet's early racing scenes of 1864–5 were later followed by the picture of a gallop in the Bois de Boulogne in which one may see Degas from the back and slightly in profile wearing a silk hat and watching the event from the right foreground.[136] This was presumably retribution for his friend earlier depicting him as a spectator at the races (pl. 58).

During the first half of the 1860s, Degas generated an entire repertoire of horse and rider studies in pencil and chalk which provided a ready source of material for pictorial compositions. Among these are a drawing of a stationary horse and another of a horse and rider (pls 48, 49) which were not used in any surviving painting. The quiet, static mood of these drawings is indicative of a lack of concern with the excitement of the race and the lively atmosphere on the stands and among the spectators, with a far greater

interest in the horse in its own right and the relationship between man and beast. The artist concentrated on motion that was held back or just starting, in order to provide a striking sense of animal vigour. He particularly liked to show horses waiting for the start because of the wide range of attitudes this moment offered. He was much concerned with the controlled interplay of moving sequences and had already dealt with the tensions arising from it in his narrative paintings (pl. 43). The horse as a fiery steed rearing upwards, which Géricault had raised to the status of a power-charged, fighting demon, had always remained alien to Degas. Even in moments of intense danger, the drama is hardly noticeable, as for instance in the *Steeplechase Scene* with a fallen jockey (p. 353), based on some twenty preliminary studies from English prints and a sketch of his brother Achille, who was forced to act as a recumbent model.[137] Topographical information is largely omitted and the venues can therefore seldom be identified, except for a few works depicting the course at Longchamps. Horses and riders, stylized and raised by Delacroix into symbols of art at its highest, were translated by Degas into a contemporary idiom. After Princeteau, only Toulouse-Lautrec could still add significantly to this important nineteenth-century subject before the horse, mankind's companion since the dawn of time, was replaced by the motor car.

One might have thought that it was no more than a step from racecourses to landscapes, especially as the artist dealt in depth with landscape impressions in his notebooks, taking great care to accompany them with colour indications and notes about the state of the light and the time of day. Circumstances would seem to have favoured his progress towards landscape painting on Impressionist lines. But this did not happen. His interests lay elsewhere. They were directed at people and allowed the landscape – labelled a *genre inférieur* by Baudelaire and Daumier – to dwindle into mere background. Degas firmly supported the existence of a hierarchy of pictorial categories in which landscape – together with still-life, which he totally disregarded – came right at the bottom of a scale of art established over many centuries. He perceived nature as the tourist does, taking in the landscape and registering detailed impressions from it. The Impressionists sought for a wealth of experience in nature and Cézanne imparted a transcendental significance to it, but it was no more than an instructive experience in so far as Degas was concerned. He was able to give a most articulate account of an environment in all its fullness without needing to interpret it pictorially. He could not reconcile open-air painting as practised by Pissarro, Monet, Renoir and Sisley with his belief that art was a matter of inspiration, imagination and power of recall. This confirmed city dweller felt out of his element in the open when confronted with objects of nature; he had a horror of his colleagues 'painting on the highroad'.[138] Degas was essentially a studio painter: he needed the seclusion of these surroundings which offered him his only congenial venue for creative activity and artistic concentration. That is also why his experience was entirely confined within this refuge.[139]

Three sets of landscapes, produced in 1869, 1890–92, and 1895–8, might seem to make nonsense of this statement. These were, however, largely worked form memory; they did not necessarily tally with observed detail; and they represent notable exceptions in an output centred on figures and largely confined to interiors. Degas had spent July–August 1869 on the Channel coast at the seaside resorts of Villers-sur-Mer and Etretat. He was probably moved by the unfamiliar countryside intersected by

dunes and the coastline to produce a first series of pastels (pls 77, 78) which distantly recall Boudin's crayon drawings made some ten years earlier and a few similar pieces by Whistler. Ideas which he had jotted down as early as 1855–6 about the need for courage to 'tackle nature along its great lines' and the cowardice of 'seeking refuge in mere detail'[141] were now translated into action. The specific attraction of this set of landscape works derives from the matt, velvety sheen of the layers of paint rubbed down to delicate shades of colour. The fragrant tonalities – frequently broken – convey a vibrant vitality by their gentle transitions, but these impressions of sky, sea and coastline were probably the artist's first and last works taken direct from nature. In fact, only two years later, a letter of 30 September 1871 to his friend the painter Jacques Joseph Tissot already suggests that Degas was living in constant fear for his eyesight and felt forced to forgo work in the open for this, if for no other reason: 'I have just had – and continue to have – difficulties with my eyes. It started at the Château, on the beach, in full sunlight while I was working on a watercolour, and it has cost me nearly three weeks; I could neither read nor work, and could hardly go out; I trembled with fear that this condition might last.'[142]

It is worth noting that the earliest use of pastel, in 1869, coincides with the first instance of landscape work.[143] Pastel provided a medium well suited for developing the restrained tonality and linear arabesque of a landscape profiled by means of quickly applied strokes of colour. Pastel supplied the artist with the perfect answer to Baudelaire's criticism that 'Ingres' influence on landscape painting could not produce satisfactory results. Line and style are no substitute for light and shade, highlights and surrounding colour, which have too great a part to play in the poetry of nature to fit in with this treatment.'[144] Drawing in colour, which had been common in France ever since Leonardo and the Clouets, enabled Degas to combine his love for drawing with the application of colour in every possible way. He had come to know and appreciate eighteenth-century pastel work both in his father's house and the collections of Marcille and Lacaze. The sticks of ground pigments mixed to a paste and compressed had proved singularly appropriate to the powdered ideal of Maurice Quentin de La Tour, Jean-Baptiste Perroneau and Jean-Etienne Liotard. Thereafter, pastel fell into disrepute as a technique typical of the *ancien régime*, identified with Rococo frivolity and court portraiture. First Delacroix, and then the brothers Goncourt who had set out to rehabilitate the eighteenth century, restored its reputation and pastel found its unique culmination in the output of Degas.[145] Cézanne discovered his most congenial medium in watercolour, but Degas had concentrated on pastel, together with pencil, chalk and charcoal, ever since the set of landscapes dating from 1869.[146] He soon found that it was easy to combine line in this medium with density of colour and to contrast solid texture with delicate transparencies which brought the grain of the paper into play. He used sticks of varying hardness and secured painterly effects by means of fingertips, soft brushes and rags.[147] In pastel, as opposed to watercolours and oils, overdrawing is easy, though the blending of colours is not, except by smudging superimposed layers. The colour is helped to retain its grittiness by the rough, long-fibred grain of the paper, which enables the dry pigment, with a water-soluble rather than oil-based binder, to secure a hold. Virtually all Impressionists – and especially Manet and Renoir – used pastel for its ability to afford an immediate check on colour effects, but only Degas, in

47

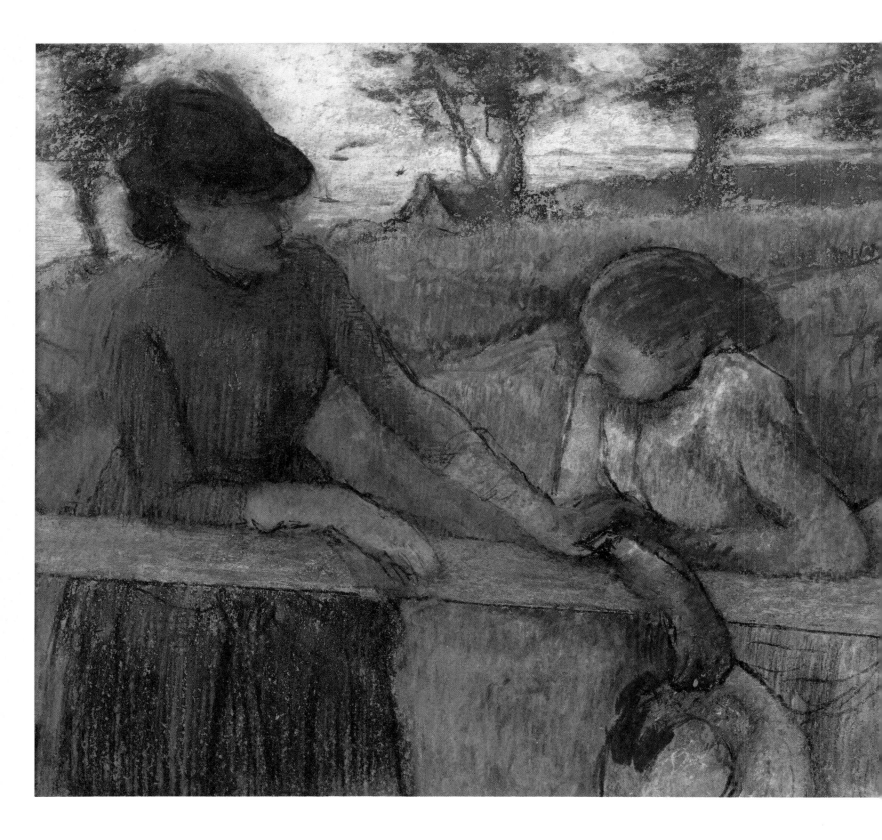

The Conversation circa 1890 (pl. 174)

the course of three whole decades, fully exploited all its artistic and material opportunities and thereby set an unsurpassed model for Toulouse-Lautrec, Bonnard, Vuillard, Redon, Picasso and many others.

Edgar Degas, Ludovic Halévy and Albert Cavé, about 1885, in Dieppe
(Photo Barnes, Bibliothèque Nationale, Paris)

'*The intensity of human attention
increases as it narrows and its
field of vision becomes restricted.
Grasp too much, and it eludes you.*'[148]

BAUDELAIRE

The Franco-Prussian war interrupted Degas' output. He was called up in the artillery and served in one of the Paris forts under his schoolfriend Henri Rouart. Military and political events in 1870–71 – siege and famine, the bloody rule of the Commune, from which he fled to Mesnil-Hubert in spring 1871, and its equally bloody repression – have left no mark on his work. But he was clearly affected by it all, as can be seen by a number of references to the war and the Commune in one of his notebooks.[149]

Hardly, however, had these terrible events gone by, and the Republic replaced the Empire, when Paris reverted to its customary daily life. It may well be that the deeply moving experiences of privation and the fear of death prompted this most sensitive of artists to concentrate with increased intensity on the realities of the city's renewed daily round: nothing would now escape his notice. This is the only explanation for the surge of creativity which burst forth in 1871 and made the decade that followed the most active, imaginative and investigative in Degas' career. Manet was clearly aware of this when he approached Duret on his friend's behalf and claimed that Degas was forging ahead and stood on the brink of success.[150]

To portray this compendium of modern humanity one had to be born in Paris, like Manet and Degas, or identify with it unreservedly, like Daumier and Toulouse-Lautrec. In this self-contained universe created by the nineteenth century, harsh social and cultural conflicts generated terrible cross-currents. To a now almost unimaginable extent, the real life of this capital, so lovingly conveyed by Offenbach in *La Vie parisienne*, involved theatres and music-halls, cafés, circuses, brothels, museums and racecourses, where the Paris bourgeoisie, from grand-monde to demi-monde, foregathered. These were the haunts of the *flaneurs* – the idlers – who had become the essential purveyors of Second Empire culture as they lounged about the boulevards and open-air exhibitions. Among the most brilliant representatives of this type was Degas' former schoolmate Ludovic Halévy (p. 52), who saw himself as more of a spectator than an actor in life.[151] Many of Offenbach's librettos, as well as that of Bizet's *Carmen*, resulted from Halévy's collaboration with Henri Meilhac. This young government official, to whom Offenbach dedicated *Orpheus in the Underworld*, was well versed in backstage gossip and court intrigue. Lionized in society and a frequenter of fashionable Bohemian circles, Halévy nevertheless secured election to the august Académie Française. Theatre had become second nature to him, and Degas shared his addiction to

ballet and opera. Halévy's house, which Degas often visited until the outbreak of the Dreyfus Affair, provided him with introductions to a number of composers, musicians, writers and journalists, among them the singer Rose Caron (pls 157, 158) and the 'always simple and delightful' Charles Haas,[152] who was to serve as a model for Proust's Swann. Degas and Halévy shared a liking for observing life by stealth: idling had become a way of life for Halévy, while Degas lay in ambush to snatch an artistic idea from a fleeting glimpse of a passer-by.

The city scene and its highlights had come to occupy the centre of Degas' field of vision from the beginning of the 1870s. It became the sole source of his artistic idiom. Though he travelled a good deal, he merely needed to take a few steps in his home neighbourhood to find a likely subject. Only in this familiar environment was he able to penetrate the surface, fathom the underlying tensions and evolve a form of representation appropriate to each case. He now painstakingly set about transmuting a seemingly random image into its essential content and converting what was regarded as trivial into the central element of a formal ideal entirely committed to reality. Degas' decision to pick on a few themes, treated with idiosyncratic repetitiveness, generated a wholly personal iconography and involved the deliberate rejection of the histories, allegories, and effete genre subjects favoured in the Salons. He was convinced that authenticity in treatment required relentless concentration and wrote to a friend, the Danish painter Lorentz Frölich, in 1872: 'There are so many projects whirling about my head! . . . But I reject them without a thought. All I wish for is to see my own corner and devotedly explore it with dedication. Art is concentrated, not diffuse. And if you insist on a simile, I would point out to you that one must be trained as an espalier to bear good fruit. And so one spends one's whole life, arms spread wide and mouth open, to snatch anything that passes or is near, so as to feed on it.'[153]

Degas' art found its venue behind closed doors, far from Impressionism's wide open spaces. What fired his imagination were the more concealed hide-outs of a class-conscious bourgeois society: theatres and café-concerts, racecourses, dress shops, fairs and museums, brothels and houses of assignation. The artist whom Duranty had suspected of being a 'painter of high-life' was now almost entirely concerned with the world of dancers, music-hall artistes and dressmakers, jockeys, washerwomen, streetwalkers and brothel girls, so that he accurately identified their haunts as places of remoteness and alienation. His interiors shut off his models from the world of everyday experience. They allow hardly one look outwards through an imaginary window, but instead draw the eye inwards as to a showcase. As opposed to landscapes, these areas are on a human scale, and meaningless unless peopled by figures.

The places picked by Degas for his solitary dialogue are so-called places of entertainment, which convey a pretence of abandon and diversion. They strike one as artificial, and so do the figures moving within them, inward-turned, and usually half-hidden behind the sensuous sheen with which the artist's technique endows their bodies. The rhythms that prevail in the ballerinas' rehearsal rooms or beneath the harsh gaslight of the *café-chantant*, in the hall of the brothel or the washerwoman's cellar, are habitual and leave little room for naturalness or spontaneity. There is no place for the thrilling finish, or the lavish first night on Degas' stretches of racecourse or his backstage tangle of wings, and so there is no place either for the champion jockey in his

moment of triumph, the prima ballerina or the stage star whose innermost nature Toulouse-Lautrec was later to lay bare. Degas was content with the walk-ons, the grace learned by the dancers in the sweat of their brows, the sinews of the hard-trained jockeys, the worn out bodies of prostitutes and working women. Their common fate was to form a group dedicated to the reconciling of incompatibles. Their lives belonged to the consumers – this is true of actresses, dancers and prostitutes, but also of jockeys in their strictly segregated male world – and they provided the artist with uncompromising instances of disposable human beings, victims of indifference, irrelevance and apathy. One senses that they are there in their finery purely because they are waiting for a stage call, a start, a spectator or a customer. It was from these more or less anonymous performers, in surrogate worlds open for consumption and exploitation, that Degas derived his vision of reality. He made of them the sole embodiment of what he had discovered during his unblinkered forays into the city's manifold aspects. His sharp mind set a distance between himself and his surroundings and avoided excessive involvement with the latter – unlike Toulouse-Lautrec – so that he was able to approach his subject with less of a tendency to transfigure it than did his Impressionist friends.

Their optimistic empathy with their surroundings encouraged them to withdraw from the realities of the city into a nature that could exist only in citydwellers' minds. It is significant that they seized upon the crowded avenues, the parks and the popular excursions into the countryside. They foregathered at weekends on the river banks or in open-air cafés. They endowed an unregenerate world with the wholesomely intimate bourgeois character of nature in its Sunday best, Degas, on the other hand – who had himself never been cast in the role of an outsider or a misunderstood artist – elaborated a most radical account of the individual human being depersonalized and alienated by isolation amid the masses of humanity. He replaced living space by working space, and lively sociability by the working unit. Festive impressionism was brought face to face with everyday reality, the stroller with the worn-out wretch, the fun of a dance in the open air with the tension of a professionally disciplined body offered for public display. It would be hard to imagine a greater contrast than that between Renoir's *Dance at the Moulin de la Galette* and Degas' ballerinas.

Woman as an available article of urban leisure became the main object of the artist's creative drive for decades to come. She provided him with an excuse for a secret dialogue with nature. The female body, its attitudes and movements, rather than landscapes or still-life, came to represent life as a whole in so far as he was concerned. Degas explored it according to the rules of his art. He had an exceptional capacity to identify with the female psyche; it is precisely because personally he was reserved in relation to the opposite sex that he was thus able to sublimate suppressed desires, traumas, fantasies and feelings of aggression.[154] Woman came to stand for the human image cast in the beauty of commensurate form. Formal strictness and tonal discipline prevented any decline into the anecdotal reaches of popular genre.

From now on, Degas less and less frequently depicted women with whom he was in any way closely connected, but turned to 'Assunta' under the big top (pl. 134) and Bathshebas or Susannas at their bath (pls 179, 180, 181 (p. 61), 182, 185, 191, 210, 211, 212 (p. 88), 213–217). Even Picasso could not improve upon the image of the woman

ironing, which Degas created, and his concept of the ballet dancer remains valid even in the era of the Merce Cunningham Dance Company. He relentlessly followed his women from public life into privacy, from stage to dressing room, from the 'priestesses of grace', as he once described ballerinas in a sonnet, to those of poverty, deeply scarred by the marks of their trade. His road led from portraits of sisters and cousins, by way of historical heroines and ladies of fashion, to middle-aged women washing their bodies, heavy and scored. He ranged from the dainty blossoming of little dancers – the *rats d'Opéra* – to the listless availability of trollops, the professionals of love devoid of all shame (pl. 128).[155] Man is a marginal figure throughout, cut off from feminine concerns and appearing only occasionally as a silent participant or watcher. Even in the ballet scenes the male dancer is as good as ignored or, at most, tolerated as a choreographer. Where, one might well ask, is the male arrogance that Ingres sought to immortalize in his *Apotheosis of Homer*?[156]

Yet Degas' purpose was not social comment on his models' environment. The secret of dynamic relationships in motion fascinated him far more than the social background against which this motion developed. Princess Metternich provided just as good a pictorial subject as a washerwoman at work, and the artist treated them both as equally valid elements of his surroundings. He felt no obligation whatsoever to take sides or to point to class conflicts. No more was needed to reveal the daily grind of their profession than a dancer rubbing her bruised ankle or a woman yawning at the ironing board. Degas had no use for Courbet's revolutionary sentiments, nor for his determination to publicize social themes through art. Neither sympathy, nor Millet's philosophy of people at work and the heroism of their behaviour, stimulated Degas' art. Like Daumier, he salvaged the reporting of unrelieved monotony in everyday working life from a cloying treatment that was at once socially conscious and suspect in its motives.

No doubt Degas' record of urban reality must be considered incomplete, since he did not attempt the encyclopaedic treatment given to it in wide-ranging sets of illustrations by Gustave Doré and many others. On the other hand, the contemporary scene had never been so authentically rendered. For it, he drew directly upon the everyday events which similarly provided Daumier's material. He also avoided events that concerned him personally, such as Cézanne had found well-nigh irresistible when he was young. Yet he was the first to impart 'respectability' to subjects earlier reserved for cartoons and popular prints (pp. 352, 357, 370). He assembled them into novel formal relationships and promoted them from the trivial to a higher level of art, thereby launching a trend that was constantly to open new fields of exploration for the art of modern times. His achievement lay not only in developing new and previously neglected thematic areas, nor in the invention of new pictorial idioms, but first and foremost in the conviction with which these innovations were put to use and logically interconnected. It becomes easier to define the thematic areas to which Degas devoted himself during the 1870s once their setting has been defined.

Significantly enough, it was a group portrait which brought dancing into his repertoire. He had already dealt with theatrical subjects in his painting based on Rossini's *Semiramide* (p. 345) and the portrait of the dancer Eugénie Fiocre in Delibes' ballet *La Source* (p. 354). He produced the famous *Orchestra of the Opéra* (p. 357) in 1869, followed in 1872 by the similarly constructed *Ballet from 'Robert le Diable'* (p. 359). *The*

Orchestra of the Opéra is divided into three horizontal bands of unequal weight. The upper band carries a group of dancers on the brightly lit stage, their heads lopped off by the picture's edge. The musicians in the orchestra pit are hemmed in at the front by a parapet and at the back by the apron of the stage.[157] The pose of Gouffe, the bass player on the right, was worked out in a crisp drawing on a notebook sheet (pl. 75). Both drawing and picture were at one time owned by the concert singer Marie Dihau, the sister of the bassoonist Desiré Dihau portrayed in the centre of the painting. The Dihaus were distant relatives of Toulouse-Lautrec and close friends of Degas, who handed over the unfinished work to Desiré Dihau at the outbreak of the Franco-Prussian war. Dihau removed it to Lille, his home town, for safety. This composition may well have been derived from Daumier's cartoon *Orchestra during the performance of a Tragedy* of 1857 (p. 357). Toulouse-Lautrec later used this painting as an excuse to retain his connection with the Dihaus, who had kept it, and eventually used the neck of the bass and the head of the player as a surrounding pattern in his Jane Avril poster of 1893.

This group portrait of Degas' musician friends embodies a characteristic formulation, whereby the sitters are shown in the attitudes pertaining to their profession, rather than as individuals. Their positions and gestures are intended to tally with their expressions. Degas had given much thought over a long period to the language of facial expressions and the theories put forward in this connection over the previous three centuries. He finally jotted down his conclusions on the subject in one of his 1869 notebooks, possibly under the influence of 'Sur la Physionomie', an article published by Duranty in *La Revue Libérale* in 1867: 'Turn the expressive bust (in the academic mode) into a study of modern sensibility. – This is Lavater, but a modified Lavater. . . .'[158] Study the observations of Delsarte concerning the impassioned movement of the eyes.[159] – Its beauty must be no more than a certain cast of features. . . . Draw a great deal. Oh, the beautiful drawing. . . . Portray people in relaxed and typical attitudes, especially imparting to their faces the same means of expression as to their bodies. So that if laughter is part of someone's nature, let them laugh. Naturally, there are sentiments one cannot render for reasons of decency: the portrait is not merely there for you as a painter to convey sensuous shades of feeling.'[160]

Remarkably quickly, just in the course of 1871, the dancers evolved from their headless, marginal existence in the *Orchestra of the Opéra* into the central subject for the next decade.[161] Degas concentrated on them with uncommon single-mindedness. A modern observer may find such an exclusive interest in an aspect of the theatre which had become highly formalized during the eighteenth century very hard to understand. But the ballet was an integral element of the life of a Parisian of Degas' standing, even though its great romantic era had long since faded in France. The divas of the beginning of the century – Marie Taglioni, Carlotta Grisi, the world famous Fanny Elssler – and Jules Perrot, a world famous dancer and choreographer whom Degas still caught sight of as an old, but active *maître de ballet* had all gone. One had to make do with mediocre talents performing purely spectacular numbers until Diaghilev revolutionized the ballet in France. Ballet was almost exclusively a subject for popular prints (p. 370), despite its popularity or perhaps because of it. Degas was by now already thirty-seven, but found himself breaking new ground in his attempt to secure 'pictorial recognition' for this field, no doubt an added reason for entering it.

The old opera building had stood in the rue le Peletier until it burnt down in 1873. It was the first opera house with gas lighting and open gas lamps in the footlights. The dancers' rehearsal room – Le Foyer de la Danse – was thrown open during the intervals and after the performance to privileged subscribers, among whom Degas had been since he was twenty. It was here that he located his first major work on the subject in 1872, *The Opéra's Foyer de la Danse in the rue le Peletier* (p. 358), with the figures grouped within a large space. This masterly piece of choreographic composition is doubly significant, because Degas' ballet scenes are very seldom set in identifiable venues (despite all his realism he set little store by documentary accuracy), and also because it signals the start of his commitment to a subject matter in which illusion and disenchantment are fascinatingly juxtaposed.

The Opéra's ballet performances, with stylized movements formalized decades ago, were highly drilled collective artistic experiences which painters came to regard as the most perfect expression of the superiority of artifice over naturalness. As Gauguin put it: 'Everything there is false – the light, the settings, the dancers' hair styles, their busts and their smiles. Only the effects achieved by these means are genuine, the bones, the human frame, the movement, a tangle of arabesques.'[162] Degas was particularly interested in the actual appearance of the artificial, and he found it in the rehearsal rooms where he saw 'the combined movements of the Greeks',[163] rather than at the performances which aimed at harmonious perfection. It was in rehearsal that the dancers had to prove their mettle, in exhausting exercise under the ballet-master's rule. The elevations, batteries, pirouettes and pointes performed on stage were worked out in exercises that wiped the smiles off the faces of these little suburban enchantresses. The functional bodies of the girls decorated with fluffed-out tutus were ground down to stage props, their souls to get gestures and their movements to pliancy.[164] The uniformity of their motion gave their faces, which in no way reflected the spirit of their theme, a collective anonymity. They were eight or nine when they started their training and they only too often became the prey of idle lechers without ever achieving the coveted membership of the corps de ballet.

Degas had an empathy with these scraggy half-grown ballerinas who turned into delicate objects of art on stage, and this may have been partly caused by his taxing and wearisome path which, like theirs, led to apparently effortless achievement. They had to spend merciless years of training in endlessly repeated exercises in order to be selected, someday, for a *petit sujet*; Degas never wearied of recording it all. He followed every one of their most convoluted gestures, of their daring balancing acts, of their strenuous stances, studied the stereotyped mechanics of their movements and learned them by heart with the unrelenting watchfulness demanded by a search for assurance. Nothing now escaped this eye trained in tracing both facial characteristics and the gait of horses. Every observation was stored in his phenomenal memory until each detail was available for instant recall and a natural composition could be elaborated from single studies, both direct from the model in all its fullness and after formal analysis in the studio.[165]

In order to complete a composition many trial runs were needed, working step by step from detail to whole. This involved either work on the spot in graphic shorthand, or the aid of models in the studio to secure greater accuracy in rendering a particular position, such as the curve of a hip or the set of individual limbs. Compositional studies 56

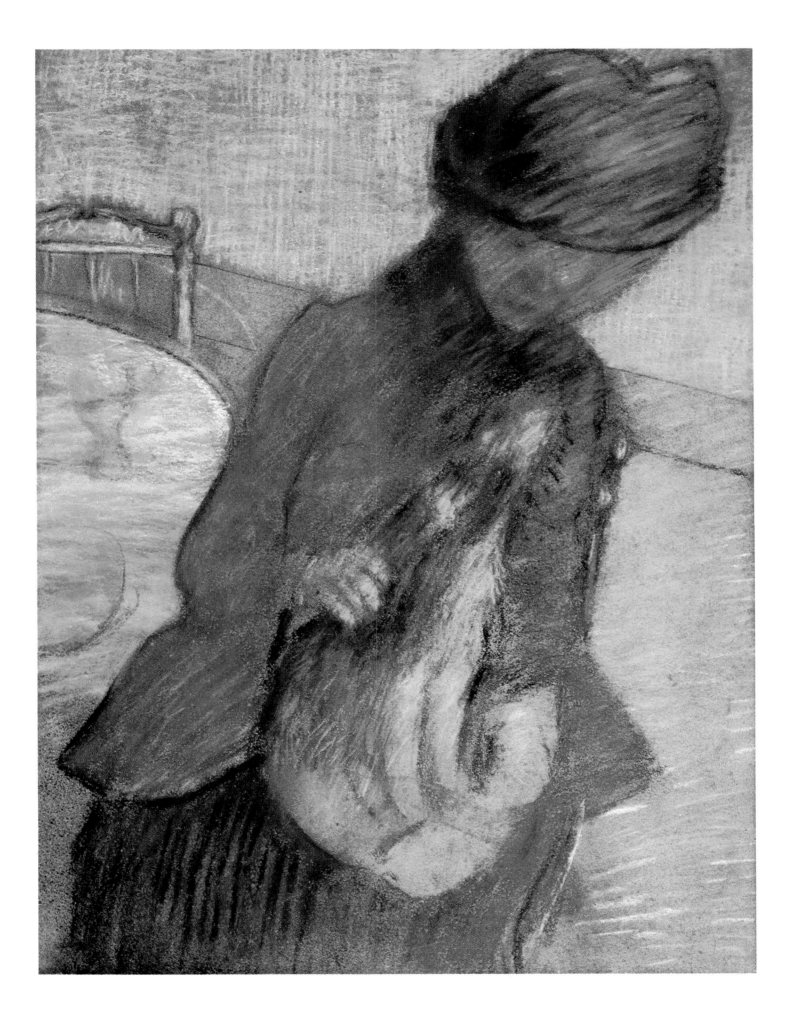

Mary Cassatt with Small Dog circa 1890 (pl. 173)

were largely abandoned from the 1870s on. The artist only noted occasional references to special positions or alterations, for use as reminders (pls 104, 108, 115, 116). This procedure, so blatantly contrary to Impressionist practice, of reconstruction and compilation in the studio on the strength of earlier studies never meant that contact with reality was lost or in any way lacking from the finished work. Thought and feeling, intuition and reflection never proved incompatible. The painstaking arrangement of the composition hardly ever impaired the immediacy of the observation; on the contrary, their interaction was intensified by this. While the Impressionists sought the greatest possible spontaneity by the notation of visual effects, Degas' spontaneity sprang from the exact analysis of what he saw. As soon as one is confronted with the assembled mosaic of his detailed studies, the formative urge underlying every one of his works becomes clear: 'There was never a less spontaneous art than mine. What I do is the outcome of reflection and the study of the great masters. . . . Of inspiration, spontaneity, temperament . . . I know nothing.'[167] And he advised the graphic artist Georges Jeanniot that: It is all very well to copy what one sees. It is much better to draw what one no longer sees, except in memory. A transformation is effected in the course of which imagination collaborates with memory. You reproduce only what has struck you, that is to say, what is necessary. Then your recollections and your fancy are freed from the tyranny which nature exerts. That is why paintings done in this way by an artist with a trained memory, one who is well acquainted with both the masters and with his craft, are almost always remarkable works – witness Delacroix.'[168]

Degas prepared four single figure studies for the *Foyer de la Danse*: a seated dancer and another standing with her leading leg drawn back (pls 83 (p. 21), 80), and three dancers at the parallel bars (pls 81, 82). These studies, which are more lively than their equivalents in the finished composition, form part of the preparatory material built up by the artist for reference and reminder in a process which increasingly involved closely observing a subject in action and later rendering it in the studio with the aid of a model. In some cases, however, Degas clearly intended such studies as works in their own right. This assumption is supported by his use of various colours of paper about this time, as well as by the lavish application of oil paint over pencil and chalk drawing. This so-called *peinture à l'essence*, which he often used in full-length portraits and studies of riders during the second half of the 1860s, (pls 59–61, 64 (p. 17), 68, 73, 74), lent itself well to flowing, delicately graded brush sketches, as well as a dry, almost chalk-like application of colour, owing to the fluidity produced by the use of turpentine as a dilutant. These four studies for the *Foyer de la Danse* translate mere outward attraction into artistic expression in a way that has nothing in common with the facile charm which so often attaches to the subject in popular prints. Degas retained these works, which were rubber-stamped in red with his signature before the posthumous sales, along with most of the remainder of his drawings. Meantime, the canvas based on them had already been shown in London in 1872. Paul Durand-Ruel, the Paris art dealer who backed Pissarro, Monet, Sisley and Renoir, had also been buying Degas' works since the beginning of that year and showed the painting he had bought in August at his gallery in New Bond Street. Sidney Colvin, the art critic of the *Pall Mall Gazette*, wrote on 28 November that it was a real masterpiece '. . . without the shadow of a shade of that sentiment which is ordinarily implied by a picture having the ballet for its subject'.[169]

The unexpectedly favourable press coverage, together with the sale of both this picture and a smaller version of it, encouraged the artist to continue working with dancers.

Before this, however, in October 1872, he carried out a long-cherished plan and accompanied his brother René, who had lived there since 1865, to New Orleans in order to visit his mother's American homeland.[170] He travelled by way of London, where he met Whistler and Deschamps, Durand-Ruel's manager, then Liverpool and New York, to the capital of Louisiana, where his brothers Achille and René had founded the wine importing firm of De Gas Brothers. Degas was impressed by their success and wrote: 'They earn much money and have gone astonishingly far for their age. They are universally loved and respected, and I am very proud of them'.[171] He stayed in the large house of his uncle Michel Musson, a wealthy cotton dealer, which also accommodated Musson's daughters: Désirée, who was unmarried; Mathilde and her family; and Estelle, who was blind and had married her cousin René de Gas in 1869. Edgar Degas lost no time in reporting on this extended family to Désiré Dihau on 11 November 1872: 'What a good thing a family is. . . . I am among my dear relatives all day long, painting and drawing family portraits' (pl. 87).[172] He wrote to Tissot a few days later: 'Nothing is as difficult as doing family portraits. To make a cousin sit for you who is feeding an imp of two months is quite hard work. . . . It is a really good thing to be married, to have good children, to be free from the obligation of courtship. Ye Gods, it is really time one thought about it!'[173] One also gathers how much he liked his family from a letter to Frölich: 'My eyes are much better. I work little, to be sure, but at difficult things. The family portraits, they have to be done more or less to suit the family taste, by impossible lighting, very much disturbed, with models full of affection but little sans-gêne and taking you far less seriously because you are their nephew or their cousin. I have just messed up a large pastel and am somewhat mortified. . . . If I have time I intend to bring back some crude little thing of my own, but for myself, for my room. It is not good to do Parisian art and Louisianna art indiscriminately, it is liable to turn into the Monde Illustré. – And then nothing but a really long stay can reveal the customs of a people, that is to say, their charm.'[174]

All the letters from New Orleans to Tissot, Frölich and Henri Rouart were similar in mood. The writer was entranced by the city's range of colours, but longed to get back to Paris, and not merely because the strong southern light affected his eyes. 'Everything attracts me here,' he admitted to Frölich, 'I look at everything, I shall even describe everything to you accurately when I get back. I like nothing better than the negresses of all shades, holding in their arms little white babies, so white, against white houses with columns of fluted wood and in gardens of orange trees and the ladies in muslin against the fronts of their little houses and the steam boats with two chimneys as tall as factory chimneys and the fruit vendors with their shops full to bursting, and the contrast between the lively hum and bustle of the offices with this immense black animal force etc etc. And the pretty women of pure blood and the pretty 25 year olds and the well set up negresses! And so I am heaping up plans which it would take ten years to carry out. I shall abandon them without regret in six weeks' time and come back again to my home never to move from it again.'[175] The drift of a letter to Tissot was much the same: 'One does nothing here, it lies in the climate, nothing but cotton, one lives for cotton and from cotton. The light is so strong that I have not yet been able to do anything on the

river. My eyes are so greatly in need of care that I scarcely take any risk with them at all. A few family portraits will be the sum total of my efforts, I was unable to avoid that and assuredly would not wish to complain if it were less difficult, if the settings were less insipid and the models less restless. Oh well, it will be a journey I have done and very little else. Manet would see lovely things here, even more than I do. He would not make any more of them. One loves and gives art only to the things to which one is accustomed. New things capture your fancy and bore you by turns. . . . I see many things here, I admire them. I make a mental note of their appropriation and expression and I shall leave it all without regret. Life is too short and the strength one has only just suffices. – Well then, long live fine laundering in France. . . . You see my dear friend, I dash home and I commence an ordered life, more so than anyone excepting Bouguereau [a well-known historical painter] whose energy and make up I do not hope to equal. I am thirsting for order. – I do not even regard a good woman as the enemy of this new method of existence. – A few children for me of my own, is that excessive too? No. I am dreaming of something well done, a whole, well organised (style Poussin) and Corot's old age.'[177]

The five-month-long absence had clearly only strengthened his longing for Parisian subjects. When Degas returned from America in March 1873 he took up exactly where he had left off in the previous autumn, at the ballet. Impressions gathered on the journey were discarded and dancers remained his favourite objects of study after the Opéra burned down, first at the temporary accommodation in the Salle Ventadour and, after January 1875, in the ornate new opera house built by Garnier (pls 89–112 (p. 27), 113–116, 118, 119). The onset of his cousin and sister-in-law Estelle's blindness must have been a nightmare to him and he constantly returned to the subject of his own disturbed vision: 'My eyes are fairly well,' he wrote to Tissot in 1873, 'but all the same, I shall remain in the ranks of the infirm until I join the ranks of the blind. It really is bitter, is it not? I sometimes feel a shiver of horror.'[178] But this constant fear undoubtedly drove forward his creative power. He was drawing more than ever. The stock of studies grew dramatically and the standards he set developed from a perfection of technique.

A full-length pencil figure study inscribed in black chalk '1873/Josephine Gaujelin/autrefois danseuse à l'opéra/puis actrice au Gymnase' (pl. 91) is one of the few more closely annotated and dated works from this period. The model had left the ballet for the stage and had sat for Degas on several occasions six years earlier (pl. 72).[179] Since she was no longer dancing in 1873, she presumably acted as a studio model for Degas for this drawing in the *en quatrième derrière pointe tendue* position. The slanting left foot provides a firm base for the evenly poised figure. It also provides the starting points for two perpendicular charcoal lines which define the central area of the sheet. The contrasts are constructed contrapuntally about this area and the balancing relationships between more heavily shaded and lighter areas also proceed from it. The contours are stressed wherever it is important to impart line and solidity to the figure.

If one compares the study of Josephine Gaujelin with a study, dated 1878, of a dancer holding a fan (pl. 109), shown frontally and strictly aligned on a central axis, significant differences emerge despite all similarities in construction. A broader soft charcoal technique has replaced the pencil work which predominated up to the beginning of the 1870s. This reflects a more summary graphic approach and offers a more richly

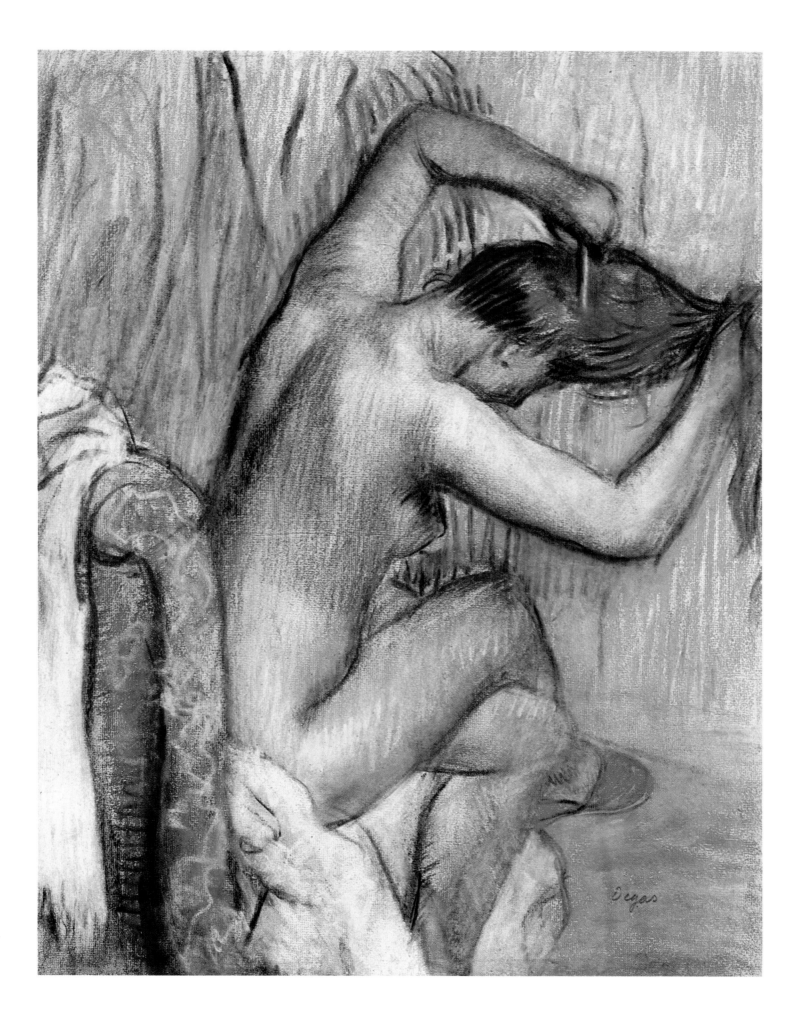

Seated Nude Combing her Hair 1887–90 (pl. 181)

contrasted, less brittle effect. Degas at one time used the rubber to indicate highlights (pl. 3), but the concentrations of dark strokes are now more noticeably segregated from the clearer areas, occasionally marked by white highlights on which the light focuses. The construction is even more definitely articulated by the limbs than it had been before. Every outline is assured. The segment hinted at by the bell-shaped knee-length skirt has the fan that masks two-thirds of the bodice as its reduced counterpart. The drawing stands out on the blue-grey background. Generally speaking, the interplay of dark shading, clear highlights and coloured paper, only too often sadly faded, had now become the basic standard for Degas' graphic medium which, though it remained black and white, was increasingly shot with brilliant painterly effects.

These two works confirm that Degas worked out his pictorial solutions with the aid of figures first seen separately and later 'conjoined'. The elimination of whatever suggested separateness in the figures that make up a group, and its cancellation within a stage composition, soon developed what had started by being the representation of dancers into that of the dance itself, in which the greatest possible variety of inter-relations between figures was included. The resulting greater openness and liveliness of the drawing gave increased scope for compositions no longer primarily concerned with the initial and intermediate positions of the figures, which had predominated until now, but brought movement itself to the fore as the subject (pls 105–107). As the artist's confidence in his absolute command over the modelling of his figures increased, he became ever more proficient at bringing them into formal relations with each other and came closer to them. Posing seldom produced a posed effect in this case. He now combined freedom of draughtsmanship with that characteristic discipline which enabled him to extract what he needed from the full range of opportunities open to him and, circumventing all difficulties, render whatever was simple with simplicity.

The definition and texture of contours picked out by the fall of the light were combined with a functional, minutely organized internal structure so as to make the subjects themselves provide the pictorial form. The artist had learned from life that harmony of line was an illusion. Strokes must be less smooth – spasmodic, brittle, dented and jagged – to do justice to reality. The linear strictness apparent in earlier drawings, with the rather tight formal complexes it generated, was increasingly relaxed, but this new, more open graphic treatment, with its suggestion of dynamism, lost none of its aptness. The Impressionists had allowed colour to drown line, which Cézanne went so far as to define in terms of colour values. Yet Degas went on using it to set and organize his object on the picture surface. 'No theme, only the lines, the lines and once more the lines', as Gauguin put it, who saw in the ballerinas 'working machines with utterly graceful lines, and miraculously balanced'.[180]

Once Degas had fully mastered black-and-white technique, he turned enthusiastically to colour for the exploration of a new graphic approach. He used pastel sticks which he wholeheartedly adopted during the second half of the 1870s. It was only now that pastel, which he had used very intermittently in the past (pls 77, 78), was extended to all thematic areas, including major compositions (pl. 107). The pastels, worked in ever more complex techniques, had been preceded by monochrome chalk drawings with clear highlights, more and more frequently touched up with colour. Pencil had inevitably restricted the artist's scope, but he discovered ample opportunities for

experiments, variations and combinations in the conjunction of dark chalk and pastel with watercolours or diluted oils.[181] As part of a new way of applying pastel, for instance, the sticks were softened in steam until a paste-like consistency resulted. Or the layers of colour in certain parts of a picture might themselves be sprayed with steam and the softened areas reworked with sticks or an assortment of brushes.

Hardened accumulations of colour on pictures still reveal the use of this new technique, which made it possible to render physical differences of texture in the subject by varying the grain of the medium. Thus the ballerinas' flesh colour was rendered in normal pastel, while their costumes were subjected to thickening steam treatment. The flesh-coloured tights and tulle skirts of the dancers were tonally rather neutral, and so the artist fitted his models out with silk bows, velvet ribbons, kerchiefs and sashes which they would normally not have worn on stage. He had dreamed of doing wall-paintings, and not the least of his achievements was to produce dry colour effects in pastel reminiscent of fresco work. Renoir replied to a question from Vollard about Degas' colour: 'When one sees his pastels! . . . To think that with a medium which is so unpleasant to handle, he has succeeded in rediscovering the tone of frescos.'[182]

The usual practice is to treat pastel as a relatively quick and lightly applied medium, but Degas took his time over it. He fixed each new layer of colour separately and strokes of varying width could be added without any fear that these different bands of unevenly applied matter might smear or blend unfavourably with underlying tonalities. The exact composition of the fixative, which originated from the Italian painter and architect Chialiva, whom Degas had met in Rome, has never yet been fully analysed.[183] It was the only formula he trusted, because he considered that every commercial preparation interfered with the luminosity of the colours and introduced an unpleasant sheen. It seems paradoxical that someone who set so much greater store by experimentation than by the finished article, and who often displayed a singular indifference to the demands of his materials, should go to such trouble over the fixing of his colour drawings. Thanks to this special preparation, however, pastels which had been put aside, often for years, for ultimate correction, or which had been retrieved from their owners, could be gone over without trouble, or completely reworked.[184]

There were also some financial reasons for the adoption of pastel. Auguste de Gas, more of an art lover than a businessman, had died in Naples on 23 February 1874. Things were not going well at the bank after De Gas Brothers had transferred blocks of capital to America to bolster their enterprises, while a drop in the price of cotton yielded an inadequate return on the investment. Every effort on the part of the family in both France and America was needed in order to get finances under control and as the eldest, unmarried son, Degas had to bear the brunt of this. He was forced to sell not only the collection of La Tour pastels which he had inherited,[185] but also some of his own colour drawings, because these took less time to produce than paintings and fetched a better price at Durand-Ruel's. Thus suddenly driven into production, Degas complained most bitterly: 'I cannot cope with my pictures, pastels etc. . . . How long it all takes, and so my last good years are wasted in mediocrity! I often weep over my wretched life!'[186] Yet he avoided referring openly to his financial diffculties. There is little in his correspondence to point to them: 'I must first earn my substance for this dog's life; although I was daily afraid that they would be sent back, it was nevertheless important

to turn out a few small pastels', he wrote to reassure a friend of Manet, the singer Faure, who had commissioned some paintings from him. 'Your pictures would have been ready long ago if I had not found myself forced to do something every day in order to earn money. You have no conception of the cares of every kind that press in on me.' But when Faure enquired more closely about this, he was fobbed off: 'Why start out on the chapter of reasons that have set me back so? It would profit you nothing.'[187]

Monotype must be mentioned in connection with colour drawings since Degas used this long-neglected small-format medium[188] among other things as a black and white basis for the majority of his pastels from 1874–5 on (pls 123, 124, 127, 128, 131).[189] Monotype was his most ultimately personal form of expression, samples of which seldom left his studio and then only after he had coloured them. He described them as 'drawings carried out in thick ink and printed'.[190]

As *dessins à la presse* they technically come somewhere between drawing and printing, but although no sets of prints can be drawn it has become customary to classify them as graphics, because the process of pulling two – or at the very most three – copies intervenes between that of drawing with ink or thinned oil paint on plates of copper, zinc or glass and the finished article.[191] Degas elaborated positive and negative processes. In the first, a brush was used to convey the drawing in black ink direct on to the plate, which was then pressed.[192] In the second, the whole plate was covered with layers of dark colour and the representation outlined, scratched out and wiped over by means of various implements – brushes, rags, pointed objects and fingers – so that it emerged as a lighter feature against a dark background. These methods were often combined (pls 124, 127). The artist learned his generous treatment of light and shade complexes from work on monotypes. He constructed the most varied gradations of semi-tones from the light and shade effects, which he then structured by means of colour drawing. The first prints were usually left untouched, while the second and third copies were reworked in colour, often at a much later date. This brought a totally different kind of representation into being, in which the character of the original monotype solution is often more or less lost. More than eighty pastels, nearly a quarter of those identified, are based on second or third monotype copies.

Monotypes are also thematically distinct: they include no racecourse pictures, while brothel scenes are exclusively based on them.[193] From dancers on and off stage Degas went on to produce theatre and café-concert scenes from about 1877 on, mostly unconventional and very varied representations more concerned with the actors than the audience (pls 123, 124). There then followed towards the end of the decade, apart from elaborately coloured female nudes at their toilet (pl. 127), a large number of scenes observed in brothels (pl. 128). These pictures of dismal dead ends reached from what had started with such promise for many of the ballerinas were ironically described by the artist as his 'petits plats du jour'.[194] These scenes mostly lack a warming touch of colour and the professionals of flesh and love are set in groups where the availability of bodies tells its own story. This concern to put the sellers and the sale, the goods and those who offer them on an equal footing to some extent conflicts with Degas' bourgeois outlook. It may originate from an unusually large sketchbook which Degas filled with pencil studies on the subject in connection with visits to Ludovic Halévy in 1877.[195] Huysmans had published *Marthe, Histoire d'une fille* in 1876 and Edmond de

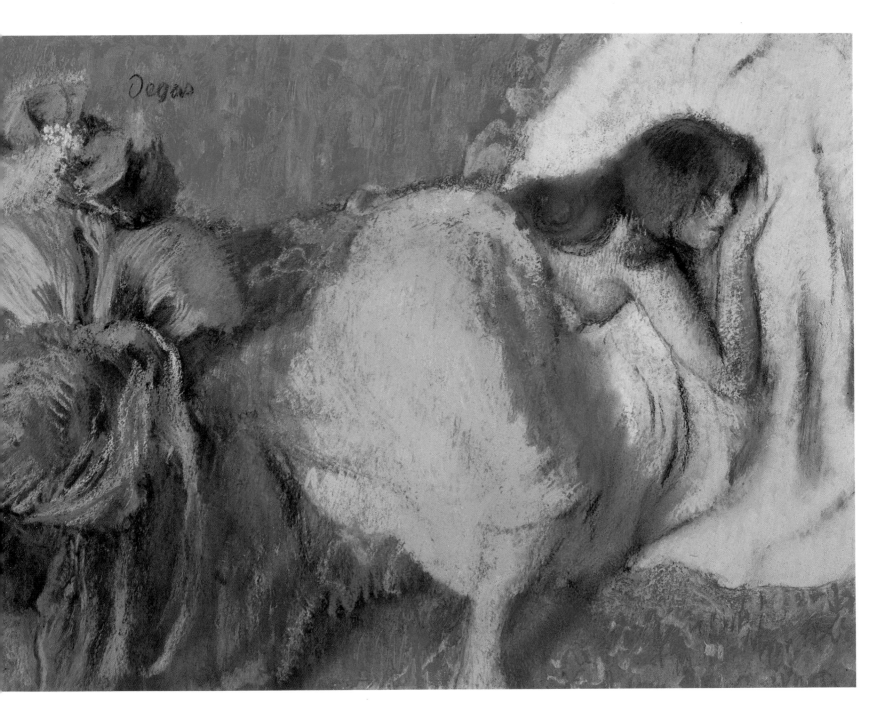

Girl Resting on Bed circa 1893 (pl. 186)

Goncourt *La Fille Eliza*, inspired by Guys, a year later. Prostitution was certainly discussed in Halévy's house in connection with these books and he may have encouraged Degas to take up this subject, especially as the pencil studies refer to *La Fille Eliza*. Later on, the two friends may also have discussed a joint project, though nothing came of it. Halévy had published two collections of stories, *Mme et M. Cardinal* and *Les Petites Cardinal*, dealing with the goings-on in the corridors and dressing-rooms of the Opéra. The story hinges mainly on the two daughters of a Parisian lower middle-class couple who are trying their luck as *rats* – or juniors – at the ballet. The mother has the makings of a procuress and sees Pauline, her single-minded daughter, rise to become the Marquise Cavalcanti, while Virginie uses her winsome talents much more indiscriminately. Early in the 1880s Degas prepared some monotypes as illustrations for a combined edition under the title *La Famille Cardinal*, but Halévy did not like them for this purpose and they remained unpublished until after the artist's death (pl. 131 and pp. 373–4). Following this unsuccessful departure, Degas' interest in monotype quickly waned and only revived briefly during the next decade with a few colour-printed landscapes, partly with over-laid drawing.

A scene from the theatre with two singers on stage (pl. 124) may serve to demonstrate the supremely successful effects that could be achieved within the tiny compass of many reworked monotypes. The actors have been brought near, as though by an opera glass, and the spectator feels that he has been projected on to the stage close to the two singers. He becomes a participant in the action, drenched in the shimmering light that suits Degas' needs so well, because it offers constantly new and surprising glimpses of sectors of space that seem to have been picked out or entered at random. The singer on the right in her pale blue dress is haloed by the stage lighting, while her partner's dark silhouette stands out against the audience crowding the stalls, tiers and red-and-gold boxes on the sides. Their male counterparts are the conductor and the prompter with his book, both looking up in worm's-eye view. The brilliant streak of light drawn diagonally across the stage and the scarcely differentiated black blocks of the audience generate violent clashes. Sources of light and effects of light are harshly contrasted. Impressionist luminosity was broken down by Degas into lighting, a city phenomenon free from the effects of nature and embodied for him in the sharp upward flood of the footlights. It etches revealing highlights and deep shadows, wipes off make-up, strips – instead of bathing in an atmospheric glow. One of the notebook entries reads: 'Work a great deal with evening effects, a lamp, a candle, etc. The tantalizing thing is not always to show the source of light, but the effects of light. This sector of art could grow vast nowadays. How can one fail to see this?'[196]

The dazzling effects of naked light and shaded light perceived at this moment in the theatre by a restlessly roving eye virtually set the scene in motion. The plunging view from the artist's favourite position in a small box close to the stage condenses the action, indeed telescopes it.[197] An extremely careful organization of the surface does its utmost to convey the experience of interlocking sections of space, each with its fractured perspective and grating insights from above and below. The concept of space arranged in accordance with a centrally ordered perspective handed down from the Early Renaissance is called in question by the discontinuity of these jumbled areas intersected at a slant by the band of garish light. This represents its deliberate rejection, aimed at

66

Edgar Degas, Mme Straus, Albert Cavé and Léon Ganderax, Paris, circa 1886
(Photo Bibliothèque Nationale, Paris)

approaches for it. It wholly merges with the aim and remains the inseparable companion of the idea. And so the sequence of new ideas has primarily taken shape in the mind of a draughtsman [Degas], one of us, one of those who are showing their works in these halls, a man of the rarest talent and rarest spirit.'[217]

Zola also dealt briefly with Degas in his review of the third exhibition of the group, in *Le Sémaphore de Marseille* of 19 April 1877. On this occasion the artist was represented, among other works, by some monotypes with superimposed colouring. The reviewer was forced to admit that this was 'a draughtsman of admirable precision, whose least important figures take on a striking plasticity'.[218]

In the first number of the short-lived periodical *L'Impressioniste, Journal d'Art* founded by Georges Rivière in 1877 to support his friends, Degas is described as 'an essentially Parisian artist, each of whose works contains as much literary and philosophic talent as linear art and knowledge of colouring. With a single stroke he says better and more quickly everything one can say about him, because his works are always witty, delicate and sincere. He does not set out to attempt to convince one of a naiveté which he could not possess; quite on the contrary his prodigious knowledge shines out everywhere; his most attractive and unusual ingenuity sets out his figures in the most unforeseen and amusing way, yet he always remains true and normal. . . . He is observant, he never looks for over-statement, the effect is always achieved by nature itself, without undue stress. This is what makes him the most valuable chronicler of the scenes he displays for us. You no longer need to go to the opera once you have seen the pastels with the ladies of the *corps de ballet*. The studies of the café-concert have a far greater impact on you than the place itself, because the artist has a knowledge and an art that you do not possess.'[219] Burty wrote in the same sense: 'After using oils for a long time, he now resorts to tempera and pastel. . . . He has picked on peculiar corners of Paris life. . . . He goes into them as a man gifted with feeling, wit and a power of ironic observation, a quick and tutored draughtsman. It is a delicate subtle output of outstanding originality. Salons nowadays are too pompous to accept his fine studies, which are the equivalents in literature of a crisp and short novella.'[220]

Pastels, in fact, provided the bulk of the entries at the fourth exhibition in 1879, together with five fans. Degas had at that time discovered the fragmentary compositional focus that these made possible and tried out some twenty versions by 1885, partly from Japanese models (pls 117, 120–122, 157).[221] In *La Vie Moderne* of 24 April 1879, the critic Armand Silvestre ascribed to the artist: '. . . a thoughtful mastery, the domination of which defies definition. . . . It is a supple, correct and clear alphabet cast into the workshop of the calligraphers whose curlicues had made reading unbearable.'[222] And Huysmans in his review of the Salon gave the 'much maligned spoil-sports, the Independents', preference over what was being done officially: 'I find the urge to come to terms with the life of our time in the work of the Independents, and only there. And among them, M. Degas . . . is undoubtedly the most independent and bold. He was among the first to take up the portrayal of the woman of the world and the woman of the people; he was among the first to grapple with the problems of artificial lighting, the dazzle of the footlights in which artistes in low-cut gowns shriek and dancers wrapped in tulle hop about. Here you will see no unnaturally white, smooth flesh, but real, powdered flesh made up for the stage or garnished for the bedroom, seen

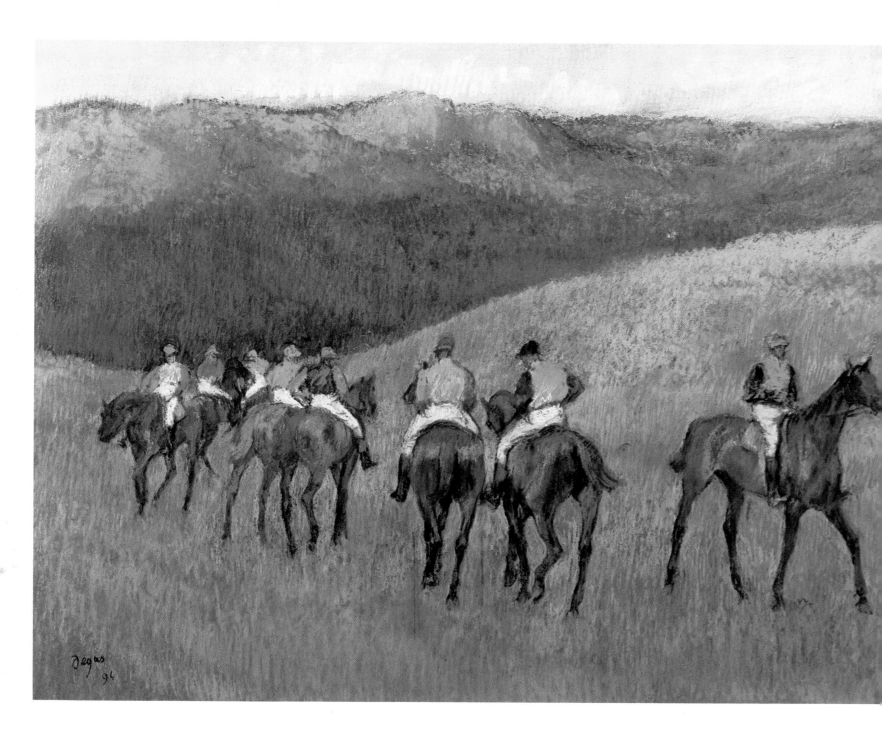

Jockeys Training 1894 (pl. 192)

with a surer hand. He knows how to see and render the jockeys glued to their saddles on the racecourse, the cheering crowd, the horses at the start. If he were to paint Nausicaa instead of emaciated and pale washerwomen, one would credit him with a marked sense of harmony. And, indeed, no one had until now portrayed the dancer as he has done, the coryphée in tulle as well as flesh and blood, with her thin arms, her fragile waist, the balanced body, the beautiful legs, all belonging to a professional order of beauty whose manifold facets combine in the collective beauty of a social group. . . . This is, in any case, a man whose spirit of observation, delicacy as an artist and taste are revealed in the least of his works.'[211]

Once the subject of this eulogy had decided to throw in his lot with the Impressionists even though he did not share all their aims,[212] he stood by them as a main driving force from the first exhibition to the very last in 1886.[213] Their spirit of independence impressed him and he despised as opportunists all defectors, such as Renoir and Monet, who occasionally favoured the official Salon. He expressed an optimistic hope that: '. . . the Realist movement no longer needs to contend with the others; it is there, it exists, it must stand out clearly, there must be a Salon of the Realists. Manet [who boycotted the Impressionist exhibitions because of his contributions to the Salon] does not understand this. I really do believe that his vanity exceeds his intelligence.'[214]

Even Degas was not spared by the critics at the second exhibition of the group, held in the Galerie Durand-Ruel. Albert Wolff, the essayist of the *Figaro*, suggested on 3 April 1876 that M. Degas should be made to see sense: '. . . Tell him that there are in art certain qualities called drawing, colour, treatment, intention. He will laugh in your face and call you a reactionary.'[215] Zola was also noticeably cool. He did note in his review that Degas was enamoured of 'modernity, of everyday life with its everyday types.' But added that 'the trouble with this artist is that he spoils everything when he comes to putting a finishing touch to a work. His best pictures are among his sketches. In the course of completing a work, his drawing becomes weak and woeful. . . . His artistic perceptions are excellent, but I fear that his brushes will never become creative.'[216] Yet what Duranty wrote in 1876 in his brochure *La Nouvelle Peinture. A propos d'un Groupe d'Artistes qui expose à la Galerie Durand-Ruel* largely tallied with Degas' own ideas, with whom the author had probably discussed them: 'What one is attempting to achieve today is not a calligraphy of line or contour, not a decorative elegance of outline, an imitation of figures from Greece and the Renaissance. . . . What drawing strives for in its new endeavours is precisely such an accurate recognition of nature, such a close involvement with it as to be above reproach where forms are concerned, to be conversant with the inexhaustible multiplicity of types of humanity. . . . What we need is the individual accent of modern man, in his clothes, in the midst of his social life, at home or in the street. . . . What we ask of a human back seen in a picture is that a temperament, an age of life, a social position should be manifested by it. We must convey an official or a tradesman by a single handshake and a whole set of emotions by one gesture alone. . . . The stylus will now be dipped into the sap of life. One will no longer just see lines measured out with a compass, but living, expressive forms that have evolved logically out of each other. . . . But drawing is both so individual and so essential as a medium that one cannot demand any set methods, techniques or

71

the mechanicaly generated, stylistically neutral data into his personal stylistic elements. Yet he remained very much aware of the differences between these pictorial media and was at pains not to graft the newly acquired visual experiences directly on to his own treatment.[208]

We are completely conditioned nowadays to think, feel and react in terms of instantaneous photography and it is therefore almost impossible for us to imagine the risks run by an artist when he first set out to bring the camera's unconventional angles, its seemingly unnatural distortions, the dryness of its statements and the perverse logic of space relationships inherent in photography gradually into the ambit of his own pictorial system. The visual data first provided by instant photography inevitably meant that objects located near the edges of pictures, such as passers-by, carriages, horses and carts in views of streets and public places, would be intersected or eliminated.[209] A comparable fragmentation of details leading into or out of compositions at their fringes can be found in 1860–62 in Degas' early racing scenes, as well as in narrative paintings such as *The Building of Babylon* (p. 345) and, especially, in *Scene of Medieval Warfare* (p. 346). This sort of treatment came fully into its own, however, only about 1875, with unaccustomed angles and unusual settings for stage and café-concert scenes (pls 107, 117, 120–122), which also undoubtedly carry echoes of popular prints widely circulated by the newspapers. A few random examples indicate both the similarities in question and the extent to which Degas had progressed beyond them (pp. 353, 357, 370). Predictably, the artist's modernity and the power of his graphic treatment were noted by some of the more clear-sighted critics in the 1870s and occasionally led to interesting comments. Edmond de Goncourt's diary entry for 13 February 1874 deserves pride of place: 'I spent my afternoon yesterday in the studio of a painter called Degas. After many attempts, experiments, reconnaissances in every direction, he has become enamoured of the modern way and has made washerwomen and dancers his own. I cannot disapprove of his choice, I who have acclaimed these two professions in *Manette Salomon* as providing the most pictorial models of women of the present day for a modern artist. . . . This is up to the present the man who has seemed best to me in catching the spirit of modern life within a copy of that life. . .'. And the diarist asked in conclusion: 'Now, will he ever produce something completely finished? I know not. He seems to me a very restless spirit.'[210]

Degas was restless just then above all because of the need to prepare the first exhibition of that group of painters who had come together in December 1873 and been pilloried as Impressionists. Among the founding members were Monet, Renoir, Sisley, Pissarro and Degas, who was respected by his colleagues, although his intransigence was to prove a threat to the cohesion of the group. After much to-ing and fro-ing the exhibition was eventually held in the former studio of the photographer Nadar from April to mid-May 1874 under the title of Société Anonyme des Artistes, Peintres, Sculpteurs, Graveurs, etc., with the participation, at Degas' insistence, of painters fully qualified by Salon standards. His own contribution consisted of ten works, including drawings and pastels; it offered, for the first time, a committed interpretation of modern life extending from dancers and racecourses to washerwomen. This was explicitly recognized by Philippe Burty in *La République Française*: 'Should M. Degas not be a classic someday? It would be impossible to convey a representation of modern elegance

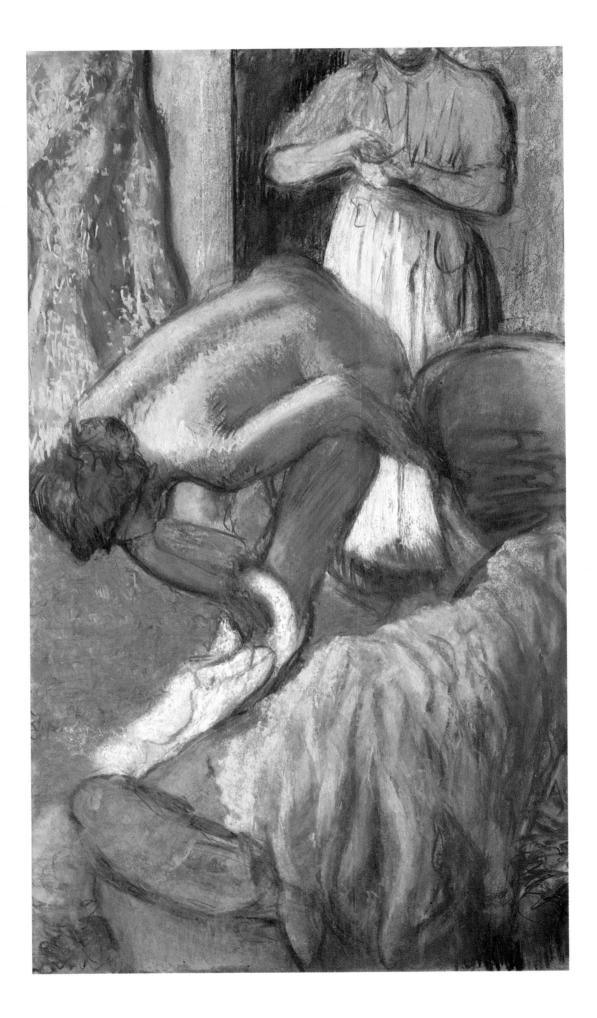

Refreshments after the Bath circa 1894 (pl. 189)

special research and somewhat overstated in their importance. Bracquemond, Whistler, Legros, Tissot and Manet among others of the artist's friends early took notice of Japanese prints which reached Paris towards the middle of the nineteenth century, originally as packing material for Chinese porcelain.[201]

Specialized shops – La Porte Chinoise and L'Empire Chinois – in the rue Vivienne, as well as the shop of the Desoye couple in the rue de Rivoli, after 1867, became meeting places for lovers of Japanese art, including Baudelaire, Zola, Champfleury and the Goncourts. A large sales exhibition of Japanese prints also formed part of the 1867 Exposition Universelle. What Philippe Burty called 'Japonisme' was therefore in the air when Degas first met it. Unlike most of his colleagues, who revelled in the exoticism of East Asian work, Degas concentrated on the distinctive allocation of space and the balance between blank and worked areas in Japanese woodcuts. The technical perfection, and, above all, the subtle handling of line in works by Utamaro, Hiroshige, Hokusai, Kiyonaga and others which he decided to collect,[202] were congenial to him and in no way conflicted with his classicist origins. He could see that many visual experiences of city life tallied with an approach long established in Japan and based, unlike illusionary European perspectives, on very close viewing, spatial distribution forcefully adjusted to the given pictorial surface and raised horizons (p. 389). Degas' love for *Ukiyo-e* subjects is understandable, since he was looking for new ways of injecting dynamic tension into the relation between figure and space, image and spectator. Since the seventeenth century, *Ukiyo-e* had provided the Japanese with popular 'pictures of the transitory, fleeting world'.[203] The leading exponents of this school entirely confined to woodcuts dealt with scenes from the life of dancers, actresses and musicians of the Kabuki theatres, as well as courtesans and bathhouse beauties in everyday situations, at their toilet or on walks (p. 388).

In addition to the fashion for Japanese art prevalent in Parisian art circles, Degas was also vividly aware of the opportunities offered by photography.[204] The competition between naturalism in art and photography had prompted Baudelaire to write in 1859 that the latter was assisting in 'the impoverishment of French artistic genius, already so scarce'.[205] The early photographic work of Disderi and others soon afterwards did in fact compete with painting and adopt its approach, especially in portraits. When Degas had on very few occasions worked from photographs, he had always retranslated the poses into a pictorial idiom.[206] When instantaneous photography, however, was perfected during the 1870s and sufficiently clear pictures of momentary events became available, the artist adapted his vision to what this revealed to such an extent that Jacques-Emile Blanche was later quite justified in referring to his 'oeil photographique'. He was among the first to acknowledge the emergence of a new medium capable of conveying space two-dimensionally by mechanical means and adept at capturing the flow of existence in quick, unrehearsed glimpses and angles often contrary to traditional aesthetic practice. The abrogation of continuous space – a sort of intermittent foreshortening of relations in space – and the authenticity made possible in rendering incidental detail were very much in line with Degas' own ideas. He wrote in 1872 that the instantaneous view was the concern of photography and went on to provide a radical adaptation of its achievements to art.[207] He substituted his own subjective and creative vision for the camera's apparent objectivity, and transformed

replacing the traditional view by new laws derived from momentary and fleeting effects. Such scenes snatched from real life exemplify the modern character of Degas' work. They make plain the extent to which Degas stressed the random nature of the image selected, the way in which the perspectives are handled and the importance of colour in rendering the effects of artificial light. A casually perceived event of this kind leaves hardly any scope for an organic approach and often testifies to the artificial character of Degas' reality. It is perceived in a purely fragmentary way, in passing, and therefore slots only occasionally into a predetermined whole, while the shimmering brilliance of artificial light imparts an additional sense of impermanence to this view of reality.

'The frame of a painting by Mantegna holds the world, while the moderns are only in a position to produce a small corner of it, a mere moment, a detail.'[198] This illuminating statement by Degas can be disproved by his own output, or be given a positive meaning, since he certainly knew how to find the images to portray modern life, to define his view of the world from 'a small corner' and to create valid insights through the instant reality of bodies, space and time. Effective artistic devices were needed if the constantly overtaken moment was to be caught and the bonds tethering the 'Realists' to objects were to be broken by resorting to objectless areas of experience. Among such devices Degas included off-centre composition arranged along diagonal axes, the dismantling of effects based on centrally directed perspective and the frequent overlapping and fragmentation of figures. All this combined within a single frame tends to convey a random and momentary effect. The outlying figures intersected by the artist's razor-sharp edge, as in the superb study of two young dancers (pl. 112 (p. 27)), come to carry the sense of the representation. They stand for the transitory element in the otherwise fixed pictorial structures.

As we have seen, Degas' spontaneity is closely accompanied by great discrimination in composition, attention to formal detail and graphic definition. That which is incidental is stated without touching on what is irrelevant, while visual and pictorial forms are brought into agreement. Degas' thoroughly conventional personality made a model of eccentricity. The central area of a picture is often planned from its edges inwards and left open. Elements perceived as formally and thematically peripheral are condensed into the substance of the representation. But it would be wrong to assume that the casual effect produced by snatches of action and fragments of figures is merely the outcome of a facile approach to the theme. On the contrary, Degas cultivated immediacy in order to strip away all pretence. The authentic details which so perfectly expressed the fragmentation of a splintered reality were the result of a study that reached to the very heart of the subject. The artist constantly stressed in his output that visual perception could only be rendered in fragmentary fashion. This is true of all forms of composition but applies to vision most of all. The observer is called upon to extrapolate beyond the picture in order to grasp what has not been stated and even take account of chance as a factor.[199]

In addition to off-centre composition, bold foreshortening, fragmentation and a steep perspective which tended to flatten out the representation all became integral elements of Degas' pictorial approach (pls 107, 189 (p. 69)). His contemporaries already knew that Japanese prints and the recent achievements of photography had exerted a determining influence on this approach,[200] both of which have since been the subject of

close to in its gooseflesh harshness, and far off in its sickly sheen. M. Degas is a master in the art of conveying what I would call the flesh colour of civilization. And furthermore he is a master in the art of conveying woman, of representing the allure of her movements whatever the level of society to which she belongs.'[223]

A percipient analysis by Charles Ephrussis appeared in the *Gazette des Beaux-Arts* on 1 May 1880 in connection with the fifth exhibition. It stressed that '. . . the artificial atmosphere of the theatre has never been more knowledgeably rendered'. The critic picked out 'the boldness of the foreshortening', as well as 'an astonishing power in the drawing'. Bearing in mind 'a woman's torso drawn on yellowish paper and the study of a head', he recognized in Degas 'not only a more than notable draughtsman, but a pupil of the great Florentines, Lorenzo di Credi and Ghirlandaio, and above all of a great Frenchman, M. Ingres.'[224] Finally, Zola contributed an enlightening explanation in *Le Voltaire* of July 1880 as to why, in his opinion, Degas took part in the Impressionist exhibitions and acted as their indefatigable organizer: 'Ultimately, it is only Degas who has derived real profit from the Impressionists' special exhibitions. The reasons for this must be sought in this painter's special talent. M. Degas was never numbered among the genuinely persecuted at the Salon. He was accepted and hung in a relatively good position. But as his artistic temperament is of a delicate nature and he certainly does not impose himself by main force, the crowd passed by his pictures without paying attention to them. This caused the artist very justifiable irritation, since he realized how advantageous it would be for him to show in a smaller and more intimate space, where his carefully prepared and delicate works could be seen and appreciated at their own worth. And, in fact, as soon as he was no longer overwhelmed by the stampede in the Salon, everybody knew him. A circle of earnest admirers formed around him. What is more, the somewhat hasty works of the other Impressionists particularly drew attention to the careful preparation of his contributions. And he was able to show sketches, small studies, simple outline drawings, which are his forte, but which would not have been accepted for the Salon. Degas is therefore right to keep to the exhibitions of the Impressionists.'[225]

Also in 1880, Huysmans praised Degas as '. . . the painter of modern life . . . who is indebted to nobody but himself, who is unlike anyone else, who has produced something entirely new, a technique which belongs to him alone'; in fact, he nominated Degas as 'the greatest artist we have in France today', in the same sense 'as Baudelaire was the poetic genius of the nineteenth century and Flaubert's *Education Sentimentale* represents the summit of the contemporary novel'.[226]

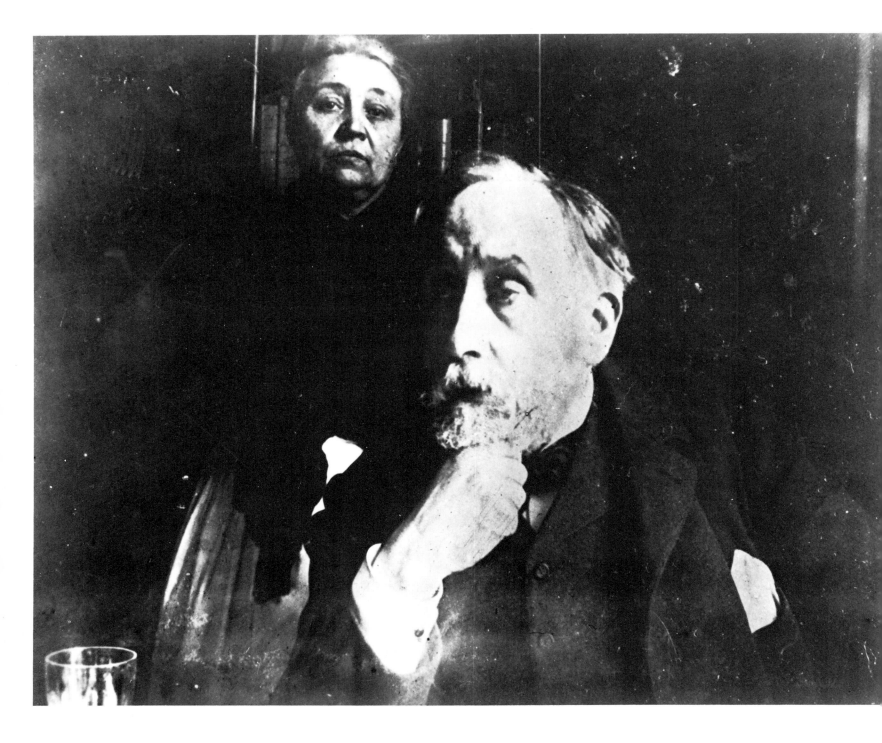

Edgar Degas and his housekeeper Zoé in Paris, at the rue Victor Massé, about 1890
(Photo René de Gas, Bibliothèque Nationale, Paris)

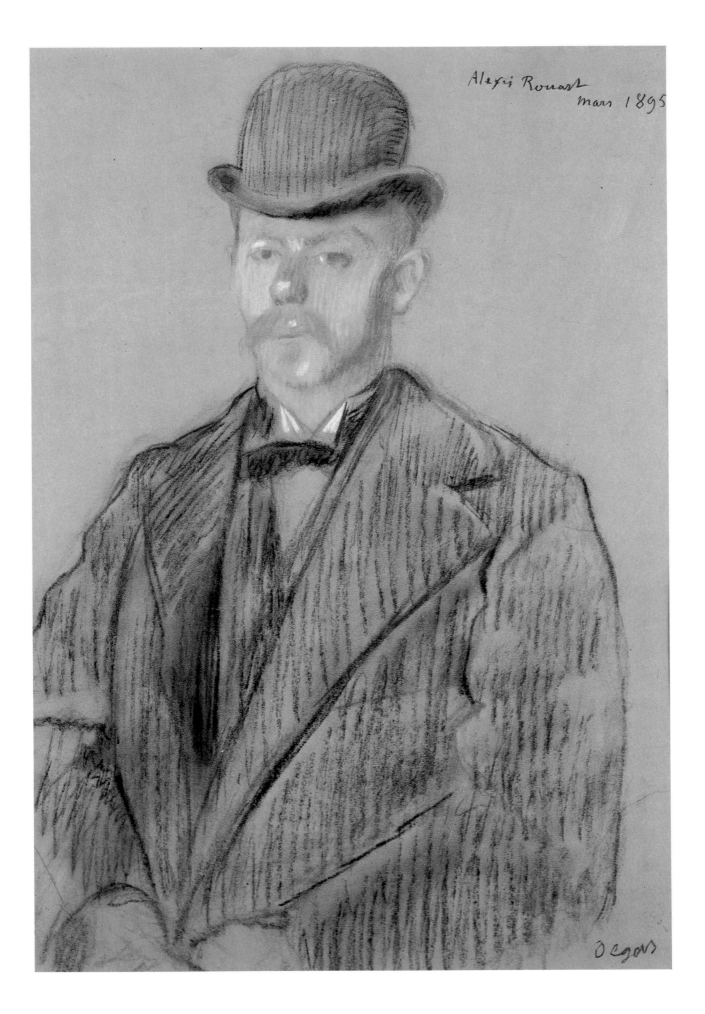

Alexis Rouart 1895 (pl. 193)

His models, unless wax figures took their place, were subjected to the unremitting discipline, imposed by the artist, of holding rigidly to transitory attitudes. Nothing was to be left to chance in translating the static quality of their positions into the dynamic effect of the graphic studies. Degas claimed in 1886 that it was 'important to tackle the same subject over and over again, ten times, a hundred times. Nothing in art must verge on chance, not even movement'.[248] And Vollard was told, in connection with the accurately harmonized continuity of move and countermove in dancing: 'They call me the dancers' painter. They do not understand that the dancer has been no more for me than an excuse to paint pretty materials and convey movements.'[249]

The constantly increasing intensity in the movement of figures was matched by a continuing contraction of the space available. When in Italy, the artist had acknowledged Giotto and his circle as geniuses of construction who, having discarded medieval methods of representation, had created recognizable areas of space on the picture surface, provided depth, and grouped figures within spatial enclosures. He worked hard to equal them, yet was forced to admit thirty-four years later: 'I imagined that I knew a little about perspective: I know nothing at all', and added this enlightening statement: 'I thought one could replace it by a set of vertical and horizontal lines, by measuring angles in space, by good intentions alone.'[250]

The assumptions which had arisen some six centuries earlier, with the acceptance of as accurate a perspectival conception of space as possible – and which still remained valid, save for a few scientific modifications – were now suddenly called in question by Degas and Cézanne in particular, who brought their own points of view to bear on the relationship between space, object and surface. Cézanne very carefully dismantled the centrally focused and unilaterally applied methods of perspective by a tonal differentiation of spatial bands. Degas, on the other hand, attacked ingrained illusionism from the opposite pole, through his concept of inner space, in which an understanding of East Asian spatial organization and the extreme distortions of photographic perspective played a part. These two artists started from different positions and came to conflicting conclusions, but they both strove to give full value to space, not by contrasting but by matching and intimately interweaving it with the surface. And both allowed the picture as an object in its own right more freedom in relation to the subject than was the case for the Impressionists as a whole.

During the 1870s, Degas' somewhat disturbing spatial arrangements came to have a formal effect on the figures operating within them. The steep perspectives often seemed to shrink the performers, seen from a high angle, and to foreshorten distances. The continuous floors, which are projected more in depth than on the flat, tend to resemble the picture backgrounds so closely that they seem incapable of offering a foothold to the actors, as though they might allow them to slide off (pl. 107). Max Liebermann aptly described this as composing 'not merely in space, but with space'.[251] As years went by, there was a marked withdrawal from spatial illusion. The number of figures displayed in each work decreased. Those remaining grew so that their volume tended to block out the picture surface, while the rest of the space available tended to be related to the figures, rather than to the composition as a whole (pls 154, 173 (p. 57), 180, 181 (p. 61), 185, 191). By now, the tussle between space and picture surface had been resolved entirely in favour of the latter. Neutral areas of background set off the wealth of

movement and colour in the figures, which are often arranged in friezes in line with Degas' growing interest in relief (pls 197, 203, 220, 221).[252]

The start of the 1880s was marked in Degas' output not only by this concern with relief and the portrayal of movement, but also by a substantial extension of his subject matter. Starting from his study of female nudes and his lively scenes from Parisian fashion houses, he developed in 1881–2 two thematically contrasted – but not equally important – series of subjects. True to his motto of 'looking at everything'[253] he had explored dressmakers' and milliners' establishments to discover the fashion ideas of some of his models and the elegance of the materials so highly prized by Parisian women. These expeditions were undertaken with the painter Mary Cassatt or with Madame Straus, a cousin of Ludovic Halévy, who had, as a letter of his put it, dragged him off to 'a high class couturier to be present at the fitting of a most impressive *toilette*'.[254] They resulted in about twenty superb pastels, some of them picture-sized (pl. 141 (p. 33)). In these, the arrangement of hats on stands, in showcases or in the hands of customers, achieves a life of its own far more impressive than the singularly anonymous, partly or wholly concealed faces of the customers. The fragile floral fantasies represented by these hats, as artificial as the everlasting paper flowers in Cézanne's still-lifes, are invariably associated with a particular individual; otherwise they might be categorized as stray contributions to the European art of the still-life. The way in which a clever composition, for instance, has been derived from minimal material – a young lady seated at a table and appraising a hat – is truly admirable (pl. 160 (p. 44)). The balanced juxtaposition on the sheet of areas worked over and left free (though not empty), of rounded volumes and diagonal divisions, has become the actual subject.

Similarly, in the more than 280 mostly coloured drawings of nudes at their toilet, which, together with numerous ballet pictures, are central in Degas' later output, the female figure is treated as an object devoid of sensual connotations in its own right, thus enabling the artist to concentrate entirely on the sensual effects of drawing and colour. The restricted thematic framework of models getting in and out of the bath, drying themselves, brushing their hair or being helped by a maid offers an incomparable wealth of material in terms of motive and style (pls 179–181 (p. 61), 182–185, 187–189 (p. 69), 190, 191, 210–212 (p. 88), 213–217). This prompted Gauguin to write: 'Drawing had been lost, it needed to be rediscovered; and when I look at these nudes, I am moved to shout – it has indeed been rediscovered!'[255]

The emaciated dancers now found a counterpart and a contrast in these powerful single figures whose physical presence often stretches tensely across the picture surface. Yet beauty – defined by T. W. Adorno as 'arising from ugliness, rather than the other way about'[256] – is seen here in the sweep of long hair or the sustained lines of a back which reflects even the slightest movement. One is carried away by the flood of form and colour which causes one to overlook the ungainliness, indeed monstrosity and vulgarity, embodied in these representations of matrons beside their bathtubs, no longer young and running to fat. Degas had baths, tubs and basins installed in his studio which the models were obliged to use, so as to remain authentically lifelike. Nothing was to intervene between the artist and his subject, neither literary allusions nor idealistic theories. The bodies were set so as to allow light and shade to give the flesh its

full visual value and mould limbs and rumps into configurations that completely matched the proposed pictorial structure.

This was not the offering of a moralist, but of a searching analyst of a form that had been stripped of all restraint and embellishment. Never before had human shapelessness been so perfectly converted into pictorial excellence, nor had intimate behaviour been shown at such obvious close range, yet with the utmost accuracy and without unnecessary intrusion. The nudity is neither brazen nor tantalizing, but justified in itself. Courbet's troubled waters, and the Impressionist streams speckled with shimmering light in which Renoir's nudes sport, have safely found their level here in a round wash-tub, or been poured into basins with soapsuds. Cézanne's ideal was the human figure engulfed in nature together with its companions. Degas on the contrary preferred to confine his solitary nudes to the familiar environment of their dressing room. This asserted the supremacy of the human image, in its plenitude, over its inclusion in an artificially devised group; of the domestic interior over the public open space; and of the body's warmth over frippery, cosmetics and modish vignettes. Degas had progressed from the products of civilization to creatures so full of life that their recurrently all-embracing character easily outdoes the myth of nature that underlies both Cézanne's bathers and Monet's landscape sequences.

At the eighth and last Impressionist exhibition in 1886, Degas showed, apart from two works dealing with dressmakers, ten pastels described in the catalogue as *Sequence of female nudes bathing, washing, drying themselves, combing their hair and having it dressed.* The reaction was mixed. The critic Felix Fénéon, an admirer of Seurat, dealt in considerable detail with Degas' latest treatment of the human form: 'The skin acquires a strong, individual life of its own in M. Degas' works. His art is thoroughly realistic, and is not the outcome of simple observation: as soon as a living being feels that it is being observed, it loses its natural candour. And so Degas does not work from nature: he accumulates a multiplicity of sketches about the selfsame object from which his work derives an unassailable veracity; no pictures have ever produced less of a painfully posed effect than his. His colour is masterly in a highly personal way: while previously the garishly chequered clothes of the jockeys, the ribbons and lips of the ballerinas provided the source of his colouring, his tonality now derives muted, one might say latent effects from the reddish sheen of a strand of hair, the bluish folds of damp linen, the pink of a wrap.

Fénéon subjected the sometimes contorted attitudes of nudes at their bath to strict analysis: 'Women crouched like melons, swelling in the shells of their bathtubs; one, chin against her breast, scrubs her neck, another's whole body is sharply contorted, her arm clutches her back and she addresses her coccygeal regions with a soapy sponge. A bony spine sticks out; upper arms shoot past juicy pear-shaped breasts and plunge straight down between the legs to wet a face cloth in the tub of water where the feet are soaking. There's a collapse of hair on shoulders, bosom on hips, stomach on thighs, limbs on their joints, and viewed from above as she stands on her bed, with her hands pressed against her buttocks, the slut looks like a series of bulging jointed cylinders.'[257]

Such treatment, which robbed nineteenth-century voyeurism – and especially its Impressionist offshoots – of its cult object, obviously tended to alienate the public, as well as the academic rearguard. An idealized female image was necessary to enable one

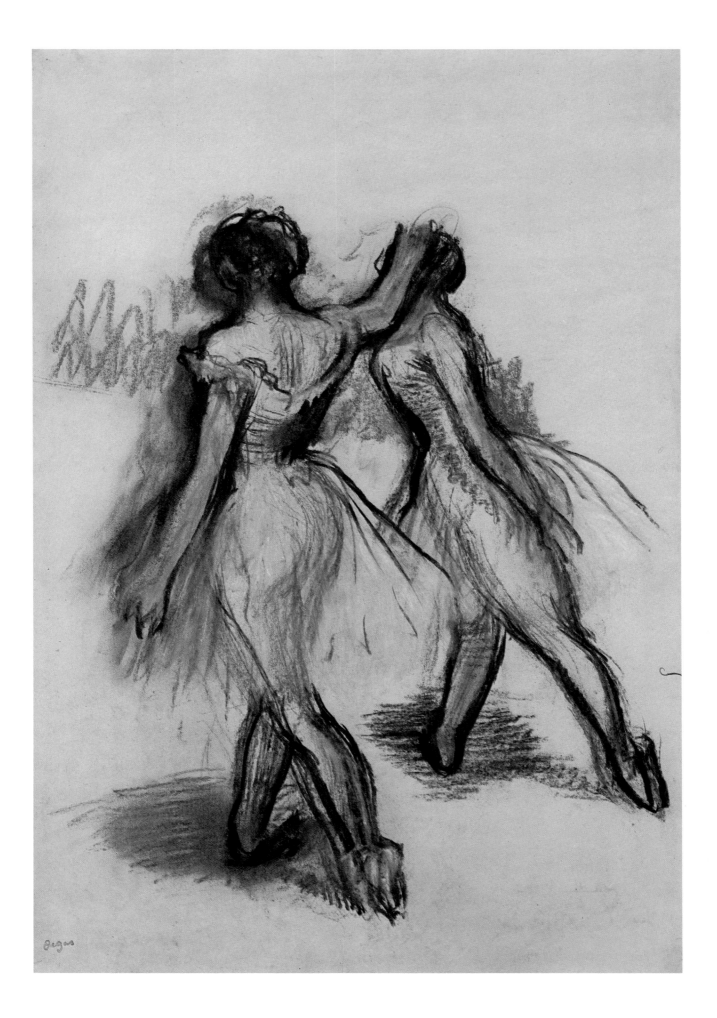

Two Dancers 1890–95 (pl. 199)

to gloat pleasurably over the natural contortions of a woman's body, which were perceived as obscene. Lasciviousness skilfully presented in the Salon was enjoyable – just as it remains a money-spinner in the art trade to this day, though now downgraded to the level of pseudo-realistic kitsch – provided it had a literary garnish or was dressed in the romantic fascination of seduction and terror, lust and the Sphinx. But Degas' individual point of view proved even more of an irritant than his subject. Nobody could have released the representation of woman so uncompromisingly from all the conventions that surrounded it. It would have been impossible to turn away more radically from all the conventions of charm. Huysmans was quite clear about this, though his conjectures far outrun the artist's intentions: 'M. Degas, who in the past in his admirable paintings of dancers conveyed quite remorselessly the decline of the hired girl, coarsened by her mechanical skipping and monotonous jumping, furnishes us now in these nude studies with a lingering cruelty and a patient hatred. It seems as though he is tormented by the baseness of the society he keeps and has determined to retaliate and fling in the face of his century the worst insult he can devise, overturning that cherished idol, woman, degrading her by showing her actually in the bath in the humiliating posture of her initimate toilet.'[258]

In fact, the artist had nothing like this lurid literary interpretation in mind. He once told a visitor: 'Until now the nude has always been presented in poses which assume the presence of an audience, but these women of mine are decent simple human beings who have no other concern than that of their physical condition. . . . It is as though one were watching through a keyhole.'[259] All the essentials are contained in those few words. As they suggest, the most important thing is that the model should feel unobserved. The keyhole view in question had always been the voyeur's chosen vantage-point, but in this case it became exclusively an opportunity for unusual themes and unfamiliar points of view. For Degas, proximity had nothing to do with prying. His candour is never intrusive. The bodies are naked, but not exposed. They have nothing in common with either the amatory or the genre themes much favoured in the more trivial trends of French eighteenth- and nineteenth-century art. They are unashamed, but not degraded by suggestiveness. Surprisingly enough, Degas – a portraitist – made no attempt to convey them as individuals. These nudes display plenty of individual features, but they are wholly identified with their activities. Dancers, actresses, prostitutes and jockeys were locked in a relationship with the public, not of their own choosing, but forced upon them because their professional success depended upon it. These opulent, introverted symbols of female beauty, on the other hand, have no male counterparts and are entirely concerned with themselves alone. Though close at hand, they remain inaccessible. Hardly any of the poses convey an invitation. Contact with an outside world appears to have been broken off. Even the spectator remains a casual witness of the event, an intruder into a hermetically sealed habitat. He no longer even belongs to a partnership with the face looking out of the picture, since direct eye-to-eye contact hardly ever occurs in Degas' output after the 1860s. By their withdrawal into a privacy to which the spectator only has conditional access, these unselfconscious figures are alien to the display of the nude consecrated over the centuries by religion and myth in the harmonious classical conception that runs from Titian's *Venus of Urbino* to Ingres' *La Source*. The traditional relaxed nude, as the ideal image of the naked woman, had

86

been desecrated into a *pose profane* at the bathtub; and yet, Renoir once said that these images had remained in his mind's eye because they might have been taken from the Parthenon.[260] Degas made a modern pictorial theme out of the nude in action; but he nevertheless forms part of the classical tradition, along with Cézanne, Picasso and Matisse, because the female body became for him the main subject of art and he rendered it obsessively in constantly new ways as the ultimate expression of volumes moulded by light from dark contours. Nature and artifice, humanity and object, space and body, formal ideal and reality, were to be indissolubly united, in the spirit of Titian and Rembrandt. Degas was too much of a modern to burden his nudes with any claim to immortality, such as that made by Cézanne on behalf of his bathing men and women: the activity in which they are engaged and the prosaic actions of their limbs forbid it. On the other hand, they have recovered something of that straightforwardness which the nineteenth century had tried so hard to recapture in its unclothed narrative works. There is a history of the nude yet to be written, including a fascinating chapter on the modern approach, from Ingres' *Turkish Bath* to Manet's *Olympia*, from Cézanne's *Large Bather* to Picasso's *Demoiselles d'Avignon*, and from Delacroix's odalisques to those of Matisse; and, in this, Degas' women at their toilet would provide a crucial element.

When Degas looked back in 1884, after his fiftieth birthday, on what he regarded as a bungled life, he felt that much of what he had planned only a few years earlier remained undone. He wrote to the narrative painter Henri Lerolle: 'If you were single, 50 years of age (for the last month), you would know similar moments when a door shuts inside one and not only on one's friends. One suppresses everything around one, and once all alone one finally kills oneself, out of disgust. I have made too many plans, here I am blocked, impotent. And then I have lost the thread of things. I thought there would always be enough time. Whatever I was doing, whatever I was prevented from doing, in the midst of all my enemies and in spite of my infirmity of sight, I never despaired of getting down to it someday. I stored up all my plans in a cupboard and always carried the key on me. I have lost that key. In a word I am incapable of throwing off the state of coma into which I have fallen. I shall keep busy, as people say who do nothing, and that is all.'[261]

The sculptor Bartholomé must have reproved his friend for such fits of depression, because Degas replied quite sharply: 'Do you want to be my pawnbroker, dear friend? What pawnable object can one find in the abominable human heart? I don't know where my friends can sit; there are no more chairs left. Only the bed is still there; it is not for pawning and I really do sleep a lot in it. . . . Yes, I am becoming ungrateful, and the sleepiness that overwhelms me seems to make this defect incurable. Now that I have cut art in two, as you remind me, I will also cut off my jolly head and Sabine [Degas' housekeeper] can store it in a preserving jar to keep things tidy. Is it life in the country, is it the burden of my fifty years which makes me as dull and listless as I am? I am considered witty because I smile in a foolish, resigned sort of way. I am reading *Don Quixote*. Oh, what a happy man that was and what a beautiful death he found! . . . I make stupid jokes, but am not really in the mood for them. Oh, where has the time gone when I felt strong, when I was full of reasoning and many plans! I am sliding fast down the slope and roll away, whither I know not, bundled into many bad pastels as it might be wrapping paper.'[262]

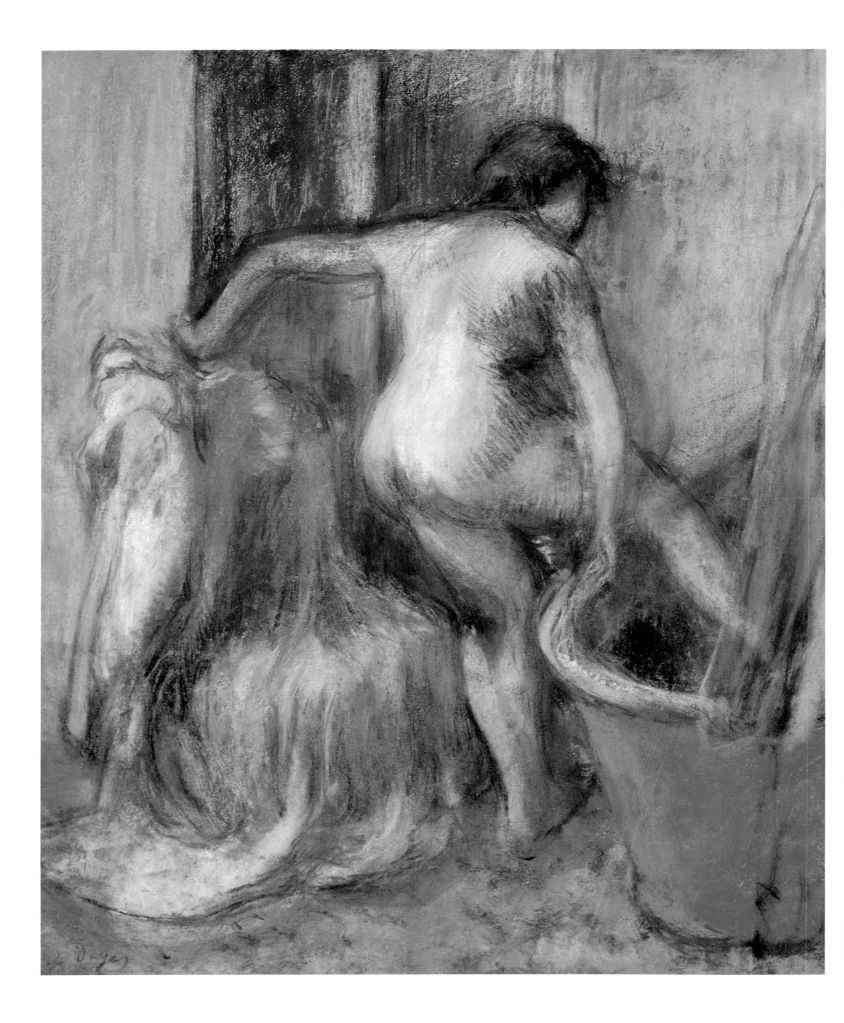

Nude Stepping into Bath 1895–1900 (pl. 212)

He found comfort only in his expeditions around the city in search of 'the great truth', as he reported in a more optimistic letter to Henri Rouart: 'Long live the suburbs! I continually revert to this because I feel that in my hand lies the key to a great truth, and this hand is not quite closed.' And later, once more to Rouart: 'It is not all that bad in town if one likes it, and you know that, at bottom, I do rather like it. One must continue to look at everything, the small and the large boats, the stir of people on the water and on the dry land too. It is the movement of people and things that distracts and even consoles, if there is any consolation to be had for one so unhappy. If the leaves of the trees did not move, how sad the trees would be, and so would we too!'[263]

Edgar Degas, Boulevard de Clichy, Paris, about 1910
(Photo Sacha Guitry, Bibliothèque Nationale, Paris)

Degas' last creative period, which covered the 1890s and continued until about 1910, when failing eyesight forced him to give up work, began most auspiciously. First, seven pastels – largely coloured monotypes – from the legacy of Gustave Caillebottes were offered to the Musée du Luxembourg in 1884 and gladly accepted by the French State.[268] Then, at nearly sixty, he had his first and only one-man exhibition at the Galerie Durand-Ruel, much as Vollard had given his chance to Cézanne at nearly the same age, a fact hard to credit in these days of ever younger stars promoted by the art trade.

It says a good deal for Degas' independent spirit that he was clearly not interested in a retrospective show, but chose landscape work instead, a field which he had so deliberately neglected in the past, and in which he therefore had so little to fall back on, that one would hardly have credited him with any mastery of it or, at any rate, expected none. In fact, however, he had produced numerous small monotypes in 1890–92, mostly printed in diluted oils and overlaid with pastel, a selection of which were to be seen at Durand-Ruel's (pls 175–178).[266] Pissarro reported on them to his son on 2 October 1892 with his usual feeling for novelty: 'Degas is having an exhibition of landscapes; rough sketches in pastel that are like impressions in colours, they are very interesting, a little ungainly, though wonderfully delicate in tone . . . these tones so harmoniously related, aren't they what we are seeking? . . . Let me add that these landscapes are very fine.'[267]

Georges Jeanniot's reminiscences provide the best account of how these 'colour prints' done from memory had come about. Degas had looked him up at Dienay on 7–12 October 1890, during a twenty-day trip with Bartholomé by horse and carriage through Burgundy.[268] 'Degas was enchanted by the journey. He had retained various impressions of nature in his astonishing memory and reconstructed them during the few days he spent with us. Bartholomé was dumbfounded when he saw him drawing these landscapes as though they were there in front of his eyes: "And on top of everything else, he never even stopped me once to look at them at leisure!"' According to Jeanniot, the artist dealt most competently with the production of the monotypes: '"Have you got copper or zinc plates? Splendid! The only other thing I would ask you for is a rag I could make into a swab for my own purposes – I have been wanting to make a set of monotypes for such a long time." And after he had been provided with

everything he required, he went to work without allowing anything to distract him. His hand with its strong well-shaped fingers reached out for these things, the implements of his genius, handled them with uncanny skill and very gradually a valley took shape on the surface of the metal, a sky, white houses, fruit trees with black branches, birches and oaks, cartwheel tracks with splashes of water from the latest downpour, shreds of orange-coloured clouds in a moving sky above the red and green earth. All this linked and merged together, the colours met in a most comradely way and the handle of the brush traced clear shapes in the freshly applied paint. These lovely things seemed to emerge without difficulty, as though he had the objects in front of him. Bartholomé recognized the places past which they had trotted behind the white horse. After half-an-hour, hardly more, Degas proposed: "Now we will draw a proof, if you agree. Is the paper damp? Have you the sponge? Sized paper is best, you know!" "Don't worry, I have strong rice paper." "Rice paper! Let's have it!" I put a large roll of it on the table cloth. When everything was ready, with the plate on the press and the paper on the plate, Degas said: "Oh, how frightening! Turn it, turn it!" It was one of those old-fashioned presses with a heavy cross-handled flywheel. When he had drawn the print, we hung it on a line to dry. We made three or four every morning. Then he asked for pastels to touch up the monotypes, and I now came to admire his taste, his imagination and the freshness of his memory even more than when he was drawing on the plates. He had everything in mind, the multiplicity of forms, the structure of the ground, the surprising constructions that defied the rules, and the contrasts. He was spell-binding.'[269]

The pleasant trip to Burgundy had suddenly prompted the artist to take up landscape painting again after shunning it for more than twenty years, largely because he was against the Impressionist approach.[270] It subjected the visual impact to a systematic treatment, while Degas was content to let nature keep its secret and art its artifice. His comment to Jeanniot was significant: 'What you are trying to convey is the outside air, the air that we breathe, the open air. Very well! But a painting is first and foremost a product of the artist's power of imagination – it must never be mere imitation. . . . The air that you see in the paintings of the old masters is not an air you can breathe.'[271] And indeed, Degas' recollected landscapes wherever they were painted – in Burgundy, or at the Valpinçons at Mesnil-Hubert, at Henri Rouart's in Queue-en-Brie, or in Dieppe, at the Halévys' – always appear to be unconnected with any particular location, to be brought into being by an elemental act of creation. They fuse indeterminate colourful distances, heights and depths, sky, water and earth into coherent pieces of nature in a way substantially governed by the technique employed. Strange vegetation springs up from brilliant highlights and crepuscular shadows, where, among rocks and woods, grottos, coastlines and rivers, there is hardly any room left for man. The colouring is developed almost without any linear linking in an attractive conjunction of two radically different media, coloured printing ink and pastel. There is nothing in late nineteenth-century landscape, neither in the Impressionist addiction to light, nor in Cézanne's obsession with an immutable order of nature, remotely like these unattainable, primeval areas with their high horizons. One would have to go back to Hercules Seghers in the Dutch seventeenth century to encounter such fantastically conceived, yet technically accomplished visions in print.

But this love affair with landscape, stimulated by the pleasant trip to Burgundy, was short-lived. Very soon it was again overshadowed by the growing fear of blindness. The anxiety about no longer being able 'to hold things together in the eye' was indicated in a letter to Henri Rouart in 1884: 'In the first place my sight (health is the first of the worldly goods) is not behaving properly. Do you remember saying one day, we were speaking of someone I cannot remember whom, who was growing old, that he could no longer connect. . . . This word, I always remember it, my sight no longer connects, or it is so difficult that one is often tempted to give it up and to go to sleep for ever.'[272] Advancing age now forced this uniquely dedicated perfectionist who, in order to achieve certainty frequently went over his work again without ever becoming repetitive, to substitute for the unreliability of his vision a power of concentration which a memory developed over many decades had instilled in him. He had set out to command his craft as the old masters had done and remained able to draw on his abundant experience, but now found himself hemmed in by ever growing limitations.

He knew that he was losing his race with blindness; and his inflexibility tempted him to give in and withdraw from an age in which he no longer felt at home. Instead of operas and operettas, it was now Le Moulin Rouge, Le Jardin de Paris and the Folie-Bergères which provided the world with a stage, and the stars so uniquely presented on posters by Toulouse-Lautrec had names such as La Goulue, Jane Avril and Aristide Bruant. He confessed to Madame Fleury about 1887: 'I shut myself up too much in my studio. I do not see the people I love often enough and I shall end by suffering for it.' And he wrote five years later: 'I no longer have a direction of my own. Others are lucky enough to be guided by their passions. Of passions, I have none.'[273] Many of his relations and friends died during the 1890s and his own uncompromising position in the Dreyfus Affair, when he expressed his disapproval of a way of life that struck him as unseemly and reacted to it with unbridled anti-semitism, helped to isolate him further as a hardened Anti-Dreyfusard.[274] All that was left to him was his work and the hope that he would be able to carry it on as long as possible.

A series of letters dating from 1891 to 1904 reflects a jumble of apprehension and hope. He wrote in 1891: 'I am seeing worse than ever this winter. I do not read the newspapers, even a little, it is Zoé, my maid, who reads to me during lunch. . . . Ah, Sight! Sight! Sight! My mind feels heavier than before in the studio and the difficulty of seeing makes me feel numb. And since man happily does not measure his strength, I dream neverthelesss of enterprises. I am hoping to do a suite of lithographs, a first series on nude women at their toilet and a second with nude dancers [neither set was ever begun]. In this way one continues to the last figuring things out. It is very fortunate that it should be so.' Two years later he wrote about the fear of staying in his room 'without work, without being able to read, staring into space. My sight too is changing for the worse.' He wrote much in the same sense to Hortense Valpinçon in 1900: 'I was not unwell and felt young, but things have changed. I have been seeing nothing these last eight days, and it is hard for me not to be able to walk a little outside in the evening after working in the studio. And if I have not done a few hours of work, I feel guilty, stupid, worthless.' And work was once again extolled as the only ultimate object in life when he wrote in 1903 and 1904 to Alexis Rouart and Durand-Ruel: 'I do not like writing, my dear friend! I can only talk, even when I do not know what to say. Always here in the

studio, at work on a wax figure. How sad old age would be without work!' and 'I am working like a galley slave, so as to be able to give you something soon. I am reflecting bitterly on the art, with which I managed to grow old without ever having found out how to earn money. All the same, you will see some new things very far advanced.'[275]

Only the new departures initiated by Cézanne and Van Gogh can compare in importance with the indicators provided by Degas' late output, to which Baudelaire's description of an almost blind Goya's work equally applies. The critic saw in it 'new proof of that peculiar law which governs the fate of great artists, whereby life works in a reverse ratio to understanding and they secure with one hand what they lose with another, so that they undergo a renewal of youth and gain in strength, delight and daring right up to the brink of the grave.'[276] Degas would have found a similar sentiment in Delacroix's diaries, extracts from the three-volume edition of which, published in 1893, were regularly read to him: 'There is something at once naive, but also daring, in the dawn of talent, reminiscent of the charm of childhood and its lack of concern about all the conventions introduced by adults. This makes the daring displayed by famous masters at an advanced age all the more surprising. To be daring when one is gambling with one's past is the greatest sign of strength.'[277]

By the time some of a younger generation of artists had laid claim to a new conception of art at the beginning of the twentieth century, Degas had, almost unnoticed, already prepared the ground for the art of his old age, full of serenity and striving for perfection. He had explored most searchingly the formal potential available in all that is imperfect, rudimentary and fragmented, and had stood out against the style of the day, the triumphantly harmonious Art Nouveau line, by his radical simplification of form and his disconcertingly rugged material idiom. In this connection his determination to break through to the very centre of human experience and grasp it in its complete, even repellent physical nature remained unimpaired.

Ever more robust modelling and splendid colouring endowed this late work with a lasting distinctive character. It was now no longer a matter of formulating the subject in every particular detail. All that mattered was the formal integration of a pictorial entity which was to lead in due course to a liberation of form, just as Cézanne's and Monet's treatment of colour were to open the way to giving the tonal system its freedom. Moreover, never before had such directness been imparted to representational techniques, freedom of formulation made so fundamental or the process of generating form so frankly revealed as in the continuous development of Degas' late output. Degas now concentrated almost exclusively on dancers and women at their toilet, but he pursued these themes with all the determination, firmness and seriousness inherent in his character. All constraints of clever colour treatment and elegance of line were discarded and eclecticism set aside. The old draughtsman had found that 'everything that turns truth into magic lends it an appearance of madness'[278] and therefore felt at liberty to neglect a meaningless organization of the picture surface. One becomes aware of the lapidary effects of this work when faced with its massively sculptural quality and the underlying effort involved. Movements become more cumbersome, distances further foreshortened and the substance of the impasto is ever more palpable.

In his solitary monologues about the simplest pictorial themes and the most exalted artistic standards, the purblind artist now cut down his conceptions to bare, closely

94

packed combinations of forms which hardly referred to any spatial or scenic background. The bodies are rendered by staccato lines, drawn together by something very like the effect of a camera zooming in on its subject and then projected sculpturally on to the sheet. The ailment which robbed his eye of sharpness, combined with his supreme technical mastery, stimulated an even more sensitive approach to subjects in his mind and an even more intense struggle to endow them with shape. The eye which had once been directed wholly outwards now came to rest on an inner power of representation that drew on an inexhaustible store of visual perceptions. His use of the senses had switched from an accurate view of pictorial techniques to tactile handling in the fullest sense. Degas in his late period was completely driven back on his own resources, but never lost faith in his task, despite moments of self-doubt, and derived enduring benefit from his earlier detailed exploration of his models. This gave him a correspondingly greater degree of freedom in dealing with his subjects and priority – including a neglect for detail – to the free treatment of form over thematic content.

Painting was already increasingly giving way to drawing, in Degas' output, during the 1880s, with a range extending from fleeting graphic notes that captured a quick moment of observation to pastel pictures featuring a degree of luminosity and free treatment of colour which influenced his work in oils. He was able, by converting pastel into a complete colour medium, to reconcile Ingres' command of line with Delacroix's radiant colouring. A draughtsman with colour and painter with pastel sticks, he succeeded in making the line carry the colour and colour to become an integral element in line. The subtle tonal gradations modulating light and shade effects so prevalent in the 1870s, and the use of line to analyse form, were replaced as time went on by a more independent concentration of coloured shading strokes, sparkling networks of short, mainly vertical or oblique hatching, which tended to go beyond pure representation. The application of many layers of parallel- or cross-hatching generated intense surface textures, largely free from erasure, such as could hardly have been achieved in oil or tempera techniques. The effect of this is at once open and transparent, as well as firmly implanted in the coloured reticulation.

Degas stood well aside from the very smooth application of colour prevalent in the Rococo period and favoured broken, rhythmically animated structures. In order to produce particular 'transparencies', the naturally opaque pastel was applied unevenly so as to allow underlying layers, or the paper itself, to produce such effects by shimmering through. The mosaic-like network of partly revealed and partly covered strokes on mostly yellow paper thereby produced an ever more daring interlacing of colour. Complementary or equivalent layers of colour were juxtaposed, and backgrounds were contrasted with surfaces, depending on whether it was a matter of intensifying or neutralizing the colour constellations. Yet there was not the slightest tendency to dissolve form through colour, which continued mainly to impart substance to form. The objective figurative elements are explored for purposes of form by a tonality that merely seems unconnected with the object represented and gushes in brilliant cascades or spurts from whirlpools of colour. In fact, the artist did not hesitate to model the medium with the palms of his hands and draw within the layers of colour with his fingertips. His experiments with a heavy, viscous impasto painted or dabbed on with a brush ultimately brought forth uncommonly lively coloured reliefs. These were mainly

applied to provide local concentrations of colour and encased the figures like heavy armour (pl. 220). The use of heavily soaked pastel squashed on to the sheet had almost become a sort of modelling and, in a sense, turned the artist into a sculptor in the medium of colour on paper.

Since 'everything takes too long for a blind man who wants people to believe that he can see',[279] Degas worked out techniques which allowed him to work with even greater directness and react with even more immediacy to a pictorial idea. After 1885, this involved the use of charcoal to replace chalk in laying down the ground pattern. His mastery of formal representation based on long experience now resulted in extremely tense, actually ungainly schematizations by means of heavy, coarsely drawn outlines. The light and shade effects worked out by Degas in the small format of the monotype were now carried over to paper or card with charcoal (pls 196, 198, 200, 210, 213–215, 217, 225, 226). Only a few, often halting and constantly retouched strokes were needed, on which the draughtsman could build so as to unite the surface and create volumes and body forms. One perpetually feels that the raw, even coarse flow of the charcoal releases plastic energies which leave their mark on the sheet. Strokes partly wiped off with fingers or a rag mould contours and shapes into powerful channels of shadow that strike a modern eye as highly effective. The drawing has clawed deep into the fearfully massive embodiment of the figures. Paradoxical as this may sound, Degas was at his greatest as a painter when working in charcoal with a minimum of colour (pls 182, 185). The dark delineation and rough blacks of the hatching are all that is required to reveal the most delicate differences in shading or bring to life powerful contrasts of light and shade. Vollard had frequently heard Degas say that if he had been able to go his own way he would always have stayed with black and white. And Renoir had seen a drawing in a shop window, 'a simple charcoal outline, in a golden frame which should have killed whatever was in it. But how it stood out! I have never dreamt of a finer drawing by a painter.'[280]

Many of Degas' pastels and charcoal drawings were transferred to lightly moistened paper, on which they appeared as inverted proofs (pls 179, 206, 207), in order to make them easier to correct and alter. These inversions provided a new point of view on the original object, and so the 'print' was often reworked, while the 'original' was left untouched. Studies and their carefully traced copies were also occasionally used together in the same compositions.

Finally, Degas transferred some of his own work to tracing paper which he then pasted on to a strong card base.[281] Both procedures provided an opportunity to start again on the design, enlarge or supplement it. Vollard wrote: 'It was that ceaseless research which explains all the tracings that Degas made of his drawings and which caused the public to say: "Degas is repeating himself." The tracing paper only helped the painter to correct his work; Degas made these corrections by starting off his new drawing outside the initial outline. So that with one correction after another it might happen that a nude no larger than one's hand grew to be life-sized, and was then abandoned in the last resort.'[282]

Inevitably, picture sizes followed such increases in the figures. The artist had always been at pains to locate the representation on the sheet effectively, and balance worked and open areas, so that lines of direction and squaring proved useful in this respect

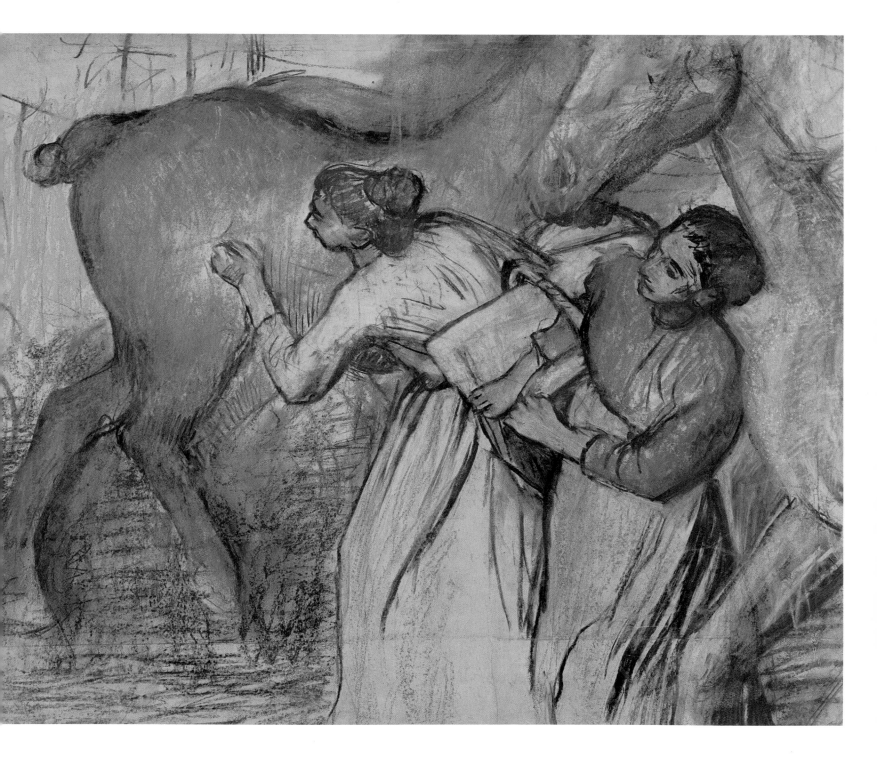

Two Washerwomen and Horse circa 1902 (pl. 218)

when transferring a design from paper to canvas (pls 22, 59, 88, 104, 106, 133, 134, 166, 168). But the larger the format, the harder it became for the artist, with his poor eyesight, to preserve proportions and keep the size of pictures under control. As it happens, it was particularly the later drawings which proved to need more space after further work had introduced new ideas into them. Paper, however, would only be available in certain sizes that were not large enough for the reproduction that Degas envisaged and he would then simply tack on additional pieces wherever he happened to need them. The seams above, below and at the sides were later carefully gone over so that they hardly showed (pls 185, 198, 217, 218 (p. 97), 219 (p. 101), 222). Degas quite automatically started from the head and this habit was partly to blame for the odd fact that large pastels might consist of as many as seven individual pieces,[283] despite the statement in a letter dated 1897 that, like a beginner, 'he repeated every morning and told himself afresh that one must draw from below upwards, starting with the feet, because the figure can be shaped much better working towards the top than downwards.'[284]

Etienne Moreau-Nélaton recalled accompanying Degas to the framemaker Lézin in December 1907 in order to bring a pastel into correct balance by trimming it: 'When he had unfolded the pastel on the framemaker's table, its author asked himself whether a few centimetres should not be pared off the lower edge. He hesitated, then said: "Just so. Two centimetres, no more." He kindly asked for my opinion and I voted for leaving it intact. "And yet," he replied immediately, "look – the maid's head touches the upper edge. Something must be taken off below. Otherwise there is an imbalance." I learned from his observations that the drawing spread out in front of me was no more than a project; once it had been "contracted", it would be easier to complete the sketch. The fixative had fastened the colour firmly to the paper on which it was laid. To convince me of this, he vigorously rubbed the pastel with his finger, and it stood up to the test.'[285]

The last reference to graphic work occurs in a letter to Alexis Rouart written in 1907: 'I am still here working. Here I am back again at drawing and pastel. I should like to succeed in finishing my articles. At all costs it must be done. Journeys do not tempt me any more. – At about 5 o'clock one dashes out into the surroundings. There is no lack of trams to take you to Charenton or elsewhere.' By 1908, he wrote: 'Soon one will be a blind man. Where there are no fish, one should not try to fish. And I, who want to do sculpture. . .'. In the last of his letters to survive he wrote on 11 March 1910 once more to Alexis Rouart: 'No, my dear friend, I am no longer of these artists who race to the Italian frontier [he had travelled to Naples for the last time in 1906]. One remains in the damp, facing the Bal Tabarin [a nearby dance hall]. I do not finish with my damned sculpture.'

And so the embittered struggle against failing eyesight became pointless by 1908. The draughtsman was forced to give up, while still active on reliefs that could be felt by the fingers. When his oldest friend Henri Rouart died and his collection was auctioned in December 1912, Degas' name was suddenly on everybody's lips because his works fetched prices unprecedented for those of a living artist.[287] He dismissed this fact with the sardonic aside that he felt like a horse that had won the Grand Prix and been rewarded with a bag of oats.[288]

The old man, now condemned to inactivity, spent his last years in the care of his

niece, Jeanne Fèvre. When he died on 27 September 1917, the only words spoken at his graveside, in accordance with his will, were: 'Il aimait beaucoup le dessin' – He greatly loved drawing.[289]

'. . . the painter of modern life . . . who is indebted to nobody
but himself, who is unlike anyone else, who has produced
something entirely new, a technique which belongs to
him alone . . . the greatest artist we have in France today.'

HUYSMANS ON DEGAS (1880)

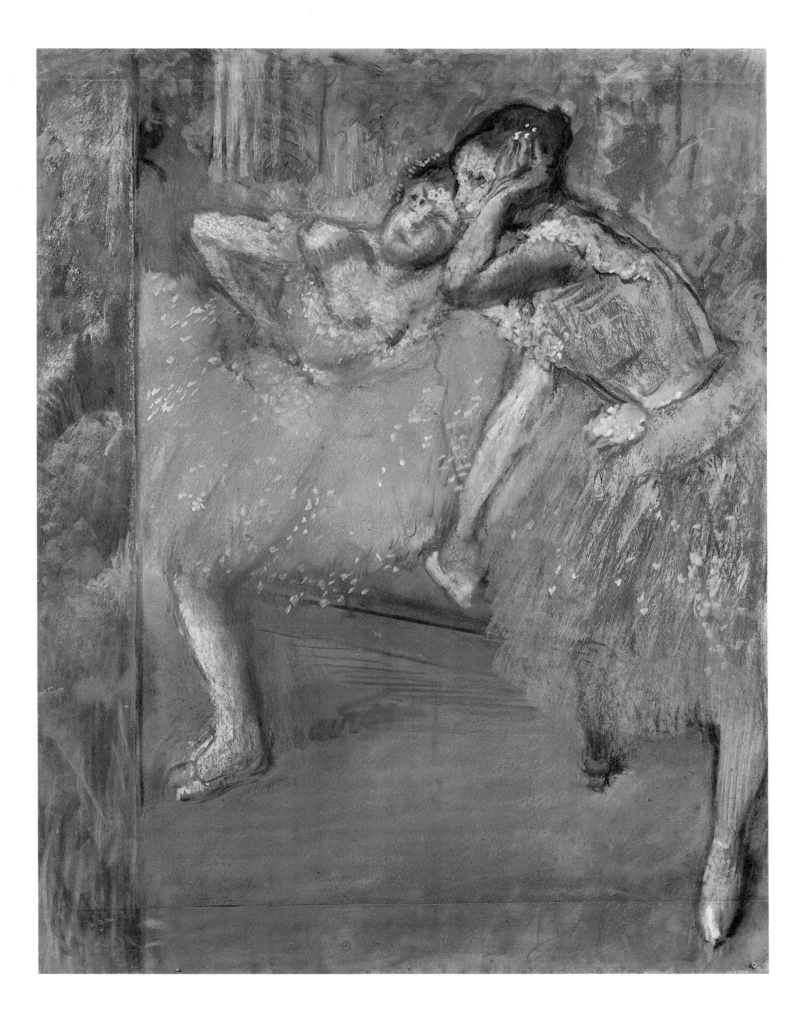

Two Dancers in the Wings circa 1901 (pl. 219)

Notes

1 Jeanne Fèvre, *Mon Oncle Degas*, Geneva 1949, p. 73.

2 Paul Gauguin, 'Degas', in *Kunst und Künstler*, X, March 1912, p. 333.

3 P. A. Lemoisne, *Degas et son Oeuvre*, I–IV, Paris 1946; the catalogue of Degas' paintings and pastels includes 500 entries concerned with dancing, out of a total of 14,666.

4 The artist wrote with foresight in one of his notebooks: 'There is something shameful about being known mostly by people who do not understand one. And so, a big reputation is something shameful'; Notebook 30, p. 20. All Degas' surviving sketch and notebooks were edited by Theodore Reff, *The Notebooks of Edgar Degas. A Catalogue of the Thirty-Eight Notebooks in the Bibliothèque Nationale and other Collections*, Oxford 1976.

5 Lemoisne, I, p. 1.

6 John Rewald (ed.), *Camille Pissarro, Letter to his Son Lucien*, London 1943, pp. 65, 322f.

7 Lucien Goldschmidt and Herbert Schimmel (ed.), *Unpublished Correspondence of Henri de Toulouse-Lautrec*, London and New york 1969, p. 133.

8 Ambroise Vollard, *Vincent van Gogh, Correspondence*, Paris 1911, p. 106; *The Complete Letters of Vincent van Gogh*, London 1958, repr. 1978, vol. III, p. 503.

9 Redon wrote about the fifth Impressionist exhibition in 1880: 'M. Degas, certainly the greatest artist in this group, is like Daumier, palette in hand. His observant eye penetrates just as deeply and truly into the life of Paris'; Odilon Redon, *A soi-même. Journal(1867–1915). Notes sur la Vie, l'Art et les Artistes*, Paris 1922, p. 92.

10 Pierre Borel, *Les Sculptures Inédites de Degas. Choix de Cires Originales*, Geneva 1949, p. 11.

11 Grosz mentioned Degas several times in his letters; thus he wrote on 16 October 1937 to Otto Schmalhausen:' '. . . sentimentality, feelings, are just by-products. Art is pure skill – look at Degas or study Ingres. That is where you find construction and form'; Herbert Knust (ed.), Georg Grosz, *Briefe 1913–1959*, Hamburg 1979, p. 264; see also pp. 296, 341, 352, 403.

12 John Russell wrote about Bacon's interest in Degas: 'Bacon has always been a great admirer of Degas' late pastels – both for the unique overtones of complicity which reverberate from even the most down-to-earth image and for the fact that when Degas had new things to say he accepted the challenge of finding new ways of saying them. "You must know", he said in an interview with David Sylvester, "the very beautiful Degas pastel in the National Gallery of a woman sponging her back. You will find at the very top of the spine that the spine almost comes out of the skin altogether, and this gives it such a grip and a twist that you're more conscious of the vulnerability of the rest of the body than if he had drawn the spine naturally up to the top of the neck. He breaks it so that this thing seems to protrude from the flesh. Now, whether Degas did this purposely or not, it makes it a much greater picture, because you're suddenly conscious of the spine as well as the flesh which he usually just painted covering the bones."' John Russell, *Francis Bacon*, rev. edn, London and New York 1979, p. 118. The impulsively smudged features in many of Degas' portraits may also be compared with Bacon's portraiture for their psychological ambiguity.

13 David Hockney made an interesting comparison: 'On the other hand, you have painters like Barnett Newman; if you compare Newman as a painter to, say, Degas, I think you can see that Newman is concerned more with ideas – obsessively so, because he's not as good an artist as Degas. He is more concerned with theory as well, though Degas was too – any good artist is, actually; you can't ignore it. But it's Degas' eye and attitudes that matter, the responses he got, the responses he in part *felt*. In Barnett Newman's work it isn't like that at all. I'm not praising one over another, we all know who is the better artist, I'm sure Barnett Newman wouldn't say he was as good as Degas. He loved Degas, actually, as I do.' Nikos Stangos (ed.), *David Hockney by David Hockney*, London and New York 1976, p. 62.

14 Georges Bloch, Pablo Picasso, *Katalog der graphischen Werke 1970–1972*, IV, Berne 1979, Nos. 1933, 1935–1937, 1939, 1940, 1942, 1944, 1946, 1949–1951, 1958–1962, 1964–1972, 1981, 1983–1985, 1988, 1991, 2006, 2007, 2009. Picasso had bought six monotypes by Degas on the subject of prostitution from an exhibition at the Galerie Lefevre in London in 1958, and later acquired five more.

15 Max Liebermann, *Degas* (offprint from the periodical *Pan*), Berlin 1899.

16 Paul Valéry, *Degas, Manet, Morisot*, London 1960.

17 Pissarro wrote on 18 June 1891: 'You can't imagine how much harm the young artists have done themselves by their desire to advertise themselves. Degas spoke of this to me recently with extraordinary vehemence, and he made no exceptions when he expressed his hatred for people advertising themselves. Speaking of Signac he became violent and poured his spleen out on everyone!' Rewald 1943, p. 175.

18 In connection with the sales held at the Galerie Georges Petit on 6–8 May 1918, 11–13 December 1918, 7–9 April 1919 and 2–4 July 1919, four catalogues were published under the title *Catalogue des Tableaux, Pastels et Dessins par Edgar Degas et provenant de son Atelier . . .*, Iᵉʳᵉ–IVᵉᵐᵉ Vente, Paris 1918–1919. The sales earned a total of more than 8,300,000 francs. The art dealers Bernheim-Jeune, Durand-Ruel and Vollard acted as experts. The four auction catalogues remain the most important source for Degas' graphic output pending the publication of a comprehensive oeuvre list of drawings, which were not included by Lemoisne; they itemize and reproduce some 1270 works, to which should be added 129 offprints of drawings and pastels, 493 pastels and 218 paintings.

19 Reff 1976, Notebook 6, p. 83.

20 Liebermann 1899, p. 23.

21 A remark by Pissarro of 13 April 1891 is interesting in this connection: 'I firmly believe that something of our ideas, born as they are of the anarchist philosophy, passes into our works which are thus antipathetic to the current trend. Certainly I feel that there is sympathy for us among certain free spirits, but the one I can't understand is

Degas, for he loves Gauguin and flatters me so. Friendliness and no more? . . . How to understand him . . . such an anarchist! In art, of course, and without realizing it! Rewald 1943, pp. 161ff.

22 Valéry 1960, p. 5.

23 Degas tried to justify this attitude in a letter of 26 October 1890 to his friend, the artist Evariste de Valernes: 'Here I must ask your pardon for a thing which often comes up in your conversation and more often still in your thoughts: It is to have been during our long relationship to art, or to have seemed to be, hard with you. I have been unusually so with myself, you must be fully aware of this seeing that you were constrained to reproach me with it and to be surprised that I had so little confidence in myself. I was or I seemed to be hard with everyone through a sort of passion for brutality, which came from my uncertainty and my bad humour. I feel myself so badly made, so badly equipped, so weak, whereas it seemed to me that my calculations on art were so right. I brooded against the whole world and against myself. I ask your pardon sincerely if, beneath the pretext of this damned art, I have wounded your very intelligent and fine mind, perhaps even your heart.' Marcel Guérin (ed.), *Lettres de Degas*, Paris 1945; pp. 178ff.; Eng. trs. as *Letters*, Oxford 1947, pp. 171ff.

24 Valéry 1960, p. 5.

25 Reff 1976, Notebook 6, pp. 61, 65.

26 Guérin 1945, pp. 31, 118; see also pp. 78, 99. Guérin 1947 (Eng. edn), pp. 36, 116.

27 Gauguin 1912, p. 333. Degas wrote to the sculptor Paul Albert Bartholomé on 3 October 1884: '. . . you are well aware that there was always a breath of old world gallantry in me. . . . As I grow old, everything carries me back to the Rococo of sixty years ago.' Guérin 1945, p. 92ff.; Guérin 1947 (Eng. edn), p. 93.

28 Baudelaire suggested that the much-maligned tail-coat was the outer shell of the modern hero; see the Salon reviews for 1845–61 in *Curiosités esthétiques, L'Art Romantique et autres Oeuvres Critiques*, ed. Lemaître, Paris 1962, pp. 3–85, 97–200, and *Le peintre de la vie moderne*, ibidem, pp. 453–502.

29 Ibidem.

30 In this connection, Valéry posed a question the importance of which in the context of history of art has continued to grow: 'We have developed a curious habit of supposing that any artist who fails to begin by shocking, by being sufficiently laughed at and insulted, must be third-rate. If he fails to stagger us, or raise our eyebrows, he is non-existent. Whence the necessity of shocking becomes a sacred task. A sound study of modern art, over the past half or three-quarters of a century, would have to expose the fresh solutions that have been devised every five years to the problem of *shock tactics*. . . . All this seems to me to involve a dangerous facility, and I feel that the idea of art is more and more divorced from that of the highest development of one human being and, through him, of a few others.' Valéry 1960, pp. 60f.

31 Liebermann 1899, p. 11.

32 Hans Graber, *Edgar Degas. Nach eigenen und fremden Zeugnissen*. Basle 1942, p. 92.

33 Julius Meier-Graefe set greater store by Degas as a draughtsman than as a painter in his highly critical study *Degas*, Munich 1920. In a conversation with Maurice Denis, Cézanne complained: 'Degas is not enough of a painter'; Maurice Denis, 'Cézanne', in *L'Occident*, September 1907.

34 Georges Jeanniot, 'Souvenirs sur Degas', in *La Revue Universelle*, October–November 1933, p. 171; see Theodore Reff, *Degas. The Artist's Mind*, New York 1976, pp. 37ff.

35 Jakob Rosenberg affirmed his belief that Degas represented the only great draughtsman of the nineteenth century between Watteau and Picasso: 'Degas, after all, remained faithful to the basic ideals of the old masters, but his artistic genius brought him close to the art of our day.'; Jakob Rosenberg, *Great Draughtsmen from Pisanello to Picasso*, Cambridge (Mass.) 1959, p. 117.

36 Valéry 1960, p. 64.

37 Stéphane Mallarmé, 'The Impressionists and Edouard Manet', in *The Art Monthly Review*, I, 30 September 1876. p. 121; see the French translation in: Gazette des Beaux-Arts, LXXXVI, 6, 1975, p. 154.

38 Reff 1976, Notebook 23, p. 45.

39 Walter Sickert, 'Degas', in *The Burlington Magazine*, CLXXVI, XXXI, November 1917, pp. 148ff.

40 Guérin 1945, pp. 273, 268; Guérin 1947 (Eng. edn), pp. 247, 243.

41 Graber 1942, p. 92. Pissarro recommended to his son Lucien to '. . . draw much, much and still more, think of Degas'; Rewald 1943, p. 40.

42 Graber 1942, p. 92.

43 Liebermann 1899, p. 15.

44 Degas owned a detail study for Menzel's *Eisenwalzwerk*; see catalogue *Menzel. Der Beobachter*, Kunsthalle, Hamburg 1982, No. 108 (ill.). Pissarro thought little of the German artist's work: '. . . he is evidently a man of talent, but heavy and bourgeois as the deuce. Degas was at one time enthusiastic about him and sent us to Goupil's to see his canvas *The Ball Room*. I went, of course, hoping to find and admire a masterpiece. I went quite unprejudiced, with Miss Cassatt. We found a muddy canvas, carefully executed, yes, but without art or finesse. We both found it mediocre. Later I saw some of his watercolour that had the same defects, most particularly the same clumsiness and bourgeois spirit. We were then able to make an interesting comparison of this insignificant painter and Degas. Degas, after he had seen the exhibition at Goupil's did a rough copy of Menzel's *Ball*. Returning, we were astonished by the superiority of Degas' sketch. It is true that a sketch has more charm; just the same, Degas' work was there and invited comparison with Menzel's. . . . Degas in examining the canvases of this painter saw in them careful studies of particular types drawn not without art, but the work is uninspired.'; Rewald 1943, pp. 35ff.; see also Meier-Graefe 1920, pp. 32ff.

45 This unusual procedure was noted at an early stage:

'There are examples extant of pictures begun in watercolour, continued in gouache, and afterwards completed in oils; and if the picture be examined carefully, it will be found that the finishing hand has been given with pen and ink.'; George Moore 1890; see Reff, *The Artist's Mind*, London 1976, pp. 270ff.

46 Lemoisne I–IV.

47 Thirty-two notebooks are listed in an inventory of the artist's studio after his death. These all became the property of René de Gas, who presented twenty-eight of them to the Bibliothèque Nationale in Paris on 2 July 1920. Of the four remaining books, one was also lodged there in a fragmentary condition in 1973, two went to the Cabinet de Dessins of the Louvre in 1922, and the last reached the Graphic Collection of the Metropolitan Museum in New York in 1973. Of the six notebooks which had not been in the artist's studio, two are at present in the hands of New York art dealers and four are privately owned; see Reff, 1976, pp. 1ff.

48 Nineteen of the notebooks were in use in 1860–62 or even earlier, seven in 1862–75 and twelve later, until 1886.

49 Valéry 1960, p. 23.

50 Addresses of shops selling papers and inks are noted, among others, in Reff 1976, Notebook 26, pp. 68, 48.

51 A study of a dancer carries the dedication 'à Mr Lezin'; Lemoisne III, No. 1250.

52 Ambroise Vollard *Degas. An intimate portrait*, London 1928, pp. 108–9; see also Guérin 1945, p. 102; Guérin 1947 (Eng. edn), 102.

53 The first sale of Degas' collection was held, like the four sales of his own works, at the Galerie Georges Petit, on 26 and 27 March 1918, and brought in nearly 2,000,000 francs from 247 items; see *Catalogues des Tableaux Modernes et Anciens, Aquarelles–Pastels–Dessins . . . Composant la Collection Edgar Degas*, Paris 1918. The sale included two paintings by El Greco, seven by Cézanne, seven by Corot, thirteen by Delacroix, ten by Gauguin, twenty by Ingres, eight by Manet, three by Pissarro, one by Renoir, one by Sisley and two by Van Gogh. A second sale, the catalogue of which included 264 items, was held in the Hôtel Drouot on 15 and 16 November 1918.

54 See A. Mellerio, 'Un Album de Reproductions d'après les Dessins de Degas', in *L'Estampe et l'Affiche*, 1898, p. 81.

55 Rewald 1943 p. 319.

56 *Degas. Quatre-Vingt-Dix-Huit Reproductions Signées par Degas. Peintures, Pastels, Dessins et Estampes*, Paris 1914.

57 Paul André Lemoisne, 'Les Carnets de Degas au Cabinet des Estampes', in *Gazette des Beaux Arts*, 63, 1921, pp. 219ff. The notebooks were subjected to a new and much more elaborate investigation by Jean Sutherland Boggs, 'Degas Notebooks at the Bibliothèque Nationale', in *The Burlington Magazine*, C, 662–664, May–July 1958, pp. 163ff., 196ff., 240ff.

58 Henri Rivière, *Les Dessins de Degas Reproduits en Facsimile*, I–II, Paris 1922–3.

59 Apart from Theodore Reff's exhaustive publication of all surviving sketch- and notebooks quoted earlier, the exhibition catalogues edited by Jean Sutherland Boggs, *Drawings by Degas*, St Louis, Philadelphia and Minneapolis 1967, and by Ronald Pickvance, *Degas. Pastels and Drawings*, Nottingham 1969, deserve special mention.

60 Vollard 1928, p. 49.

61 For the spelling of the surname, see Lemoisne I, p. 223. The artist preferred the single-word spelling, but occasionally used de Gas or De Gas when he was young.

62 Lemoisne I, p. 226.

63 Reff, Notebook I, pp. 13–26.

64 Valéry 1960. Oddly enough, Degas' praise for Ingres' classical quality increased as he himself moved away from it. In a letter of 1888 he referred to Ingres' drawings as miracles of the human spirit: see Guérin 1945, p. 127; Guérin 1947 (Eng. edn), p. 125. Other notable signs of this lifelong addiction were Degas' collection of paintings and drawings by Ingres, as well as his declared intention to arrange and ultimately catalogue Ingres' drawings in the museum at Montauban. He wrote to Alexis Rouart on 28 July 1896: 'I would like to go down to Montauban . . . and ask the curator to show me the entire set of Ingres' drawings. The production of a list and classifying them etc. would be a matter of a few days. Would you enjoy taking part in this sport?' And on 25 August 1897 he sent an official letter to the mayor of the town: 'I therefore ask you to submit my petition to the commission and, if necessary, to give it your support, with the aim of undertaking an exchange of photographs with the Musée Ingres. The museum holds certain drawings connected with pictures of Ingres of which I am the fortunate owner. I will have photographs made of what I have and the museum would allow me to take photographs. I would add that the reproductions which I am offering have not been published.' Guérin 1945, pp. 211f., 218, and see also pp. 214f.; Guérin 1947 (Eng. edn), pp. 198, 204 and 201f. George Moore remembered seeing a sanguine drawing in Degas' studio about which the artist said: 'Yes, just have a look at that one, I bought it only a few days ago. It is a woman's hand by Ingres. Look at the finger nails, how they are merely indicated! That is my idea of genius: a man who finds a hand so charming, so marvellous, so difficult to render that he locks himself away for the whole of his life and is content to do nothing but sketch fingernails.'; Moore 1908, p. 99.

65 Walter Benjamin, *Illuminationen. Paris, die Hauptstadt des XIX. Jahrhunderts*, Frankfurt am Main 1980, p. 175; see Frank Anderson Trapp, 'The Universal Exhibition of 1855', in *The Burlington Magazine*, CVII, 747, June 1965, pp. 300ff.

66 Valéry 1960. There is a pencil study after the *Baigneuse Valpinçon* in a notebook of 1854–5; Reff 1976, Notebook 2, p. 59.

67 Reff 1976, Notebook 2, pp. 9, 30, 48, 53f., 59, 68, 79, 82.

68 'In a cold, biased and pedantic way these gentlemen have reduced what is unattractive and unpopular in his genius to a system, and pedantry is most noticeable of all. They have noted and studied the artist's curiosity and

erudition. Hence the search for thinness, pallor and all those ridiculous conventions which they have adopted uncritically and without conviction'; Lemaître 1962, p. 154.

69 The earliest dated drawing is a portrait study of Achille de Gas of December 1853; Reff 1976, p. 13, note 6.

70 Lemoisne II, Nos. 2–5, 11–14.

71 Many of these portraits came on the market only when the collections of Henri Fèvre, Marguerite de Gas' husband, René de Gas and Jeanne Fèvre, Marguerite's daughter, were auctioned on 22 June 1925, 10 November 1927 and 12 June 1934 respectively.

72 See R. Raimondi, *Degas e la sua Famiglia in Napoli, 1793–1917*, Naples 1958, and Jean Sutherland Boggs, 'Edgar Degas and Naples', in *The Burlington Magazine*, CV, 723, June 1963, pp. 273ff. For the joint inheritance in Naples, see Guérin 1945, pp. 113ff., 207, 241; Guérin 1947 (Eng. edn), pp. 112ff., 194, 226.

73 Reff 1976, Notebook 7, p. 12; Notebook 8, p. 32.

74 Phoebe Pool, 'Degas and Moreau', in *The Burlington Magazine*, CV, 723, June 1963, pp. 251ff.

75 Fèvre 1949, p. 40, note 1.

76 Reff 1976, Notebook 11, p. 60.

77 Ibidem, pp. 62, 65.

78 Ibidem, pp. 78, 81, 85.

79 Ibidem, pp. 86ff.

80 Ibidem, pp. 94ff.

81 See Jean Sutherland Boggs, 'Edgar Degas and the Bellellis', in *The Art Bulletin*, XXVII, 2, June 1955, pp. 127ff.; Harald Keller, *Edgar Degas, Die Familie Bellelli*, Stuttgart 1962; also the exhibition catalogue compiled by Hanne Finsen, *Degas og Familien Bellelli*, Copenhagen 1983.

82 See Lamberto Vitali, 'Three Italian Friends of Degas', in *The Burlington Magazine*, CV, 723, June 1963, pp. 266ff.; and Norma Broude, 'An early Friend of Degas in Florence. A Newly-Identified Portrait Drawing of Degas by Giovanni Fattori', in *The Burlington Magazine*, CXV, 848, November 1973, pp. 726ff.

83 Lemoisne I, p. 29.

84 Degas is registered as a copyist in the Archives du Louvre, Registre des Cartes d'Elèves, up to 26 March 1868; see Theodore Reff, 'Copyists in the Louvre 1850–1870', in *The Art Bulletin*, XLVI, 4, December 1964, p. 555. Degas' study of the old masters had been chiefly investigated in: John Walker, 'Degas et les Maîtres Anciens', in *Gazette des Beaux Arts*, X, 6, 1933, p. 173ff.; Theodore Reff, 'Degas' Copies of Older Art', in *The Burlington Magazine*, CV, 723, June 1963, pp. 241ff.; Gerhard Fries, 'Degas et les Maîtres', in *Art de France*, IV, 1964, pp. 352ff.; Theodore Reff, 'New Light on Degas's Copies', in *The Burlington Magazine*, CVI, 735, June 1964, pp. 250ff.; Theodore Reff, 'Addenda on Degas's Copies', in *The Burlington Magazine, CVII, 747, June 1965, pp. 320, 323; Theodore Reff, 'Further Thoughts on Degas's Copies', in The Burlington Magazine*, CXIII, 822, September 1971, pp. 534ff.

85 Lemoisne I, p. 31.

86 After 1860 Degas hardly ever drew from other works and, if at all, mainly from contemporaries, such as Whistler: Reff 1976, Notebook 20, p. 17; Meissonier: Notebook 20, pp. 29, 31, Notebook 22, pp. 123, 127, Notebook 23, p. 41; Cézanne: Notebook 28, p. 3; Daumier: Notebook 31, p. 6; Menzel: Notebook 31, p. 47; and Gauguin: Notebook 34, p. 208.

87 Both artists nevertheless drew from the same models, for instance from Bacchiacca's *Portrait of a Young Man* (pl. 1, back), and Michelangelo's *Battle of Cascina*, in other words, from Marcantonio Raimondi's engravings available in the Bibliothèque Impériale, from Michelangelo's *Dying Slave* (pl. 39) and Raphael's *Venus and Psyche* drawing in the Louvre.

88 Reff 1976, p. 14.

89 The mirror in Degas' output as a picture-within-a-picture and a method of encapsulating space deserves separate study. A painter's vain attempt to match reality corresponds to the longing of Narcissus – whom Alberti described as the originator of painting – for the unattainable reversed and alienated image on the reflecting surface.

90 The draft of a letter to Mme Dietz-Monin written about 1880 shows that Degas continued to be strict with his few customers: 'Let us, please, abandon the portrait. I was so surprised by your letter, in which you assert that I had cut it down to a boa and a hat, that I do not propose to reply to you. . . . Need I inform you that I regret having undertaken something in accordance with my own ideas, only to be expected in the last resort to comply entirely with your wishes?' Guérin 1945, pp. 56f.; Guérin 1947 (Eng. edn).

91 Lemoisne I, p. 30.

92 Theodore Reff, 'More Unpublished Letters of Degas', in *The Art Bulletin*, LI, 3, September 1969, pp. 281f.

93 Lemoisne I, p. 30.

94 Reff 1976, Notebooks 22, p. 5.

95 See Reff (*The Artist's Mind*) 1976, pp. 96f.

96 Lemoisne I, p. 229, note 35. Concerning Degas' admiration for both Ingres and Delacroix, see Reff (*The Artist's Mind*) 1976, pp. 42ff., 55ff.

97 See Baudelaire's *Eugène Delacroix. Ses oeuvres, ses idées, ses moeurs* and *L'Oeuvre et la vie d'Eugène Delacroix*, in Lemaître 1962, pp. 417–51.

98 *Lettres de Georges Bizet*, Paris 1908, p. 65.

99 See Jean Sutherland Boggs, *Portraits by Degas*, Berkeley and Los Angeles 1962.

100 Lemoisne II, Nos. 20, 21, 34–36.

101 Ibidem, Nos. 70–74, 82–86, 91–97, 124; see Phoebe Pool, 'The History Pictures of Degas and their Background', in *Apollo*, 80, 1964, pp. 306ff.

102 Reff 1976, pp. 18f.

103 *Degas. Oeuvres du Musée du Louvre. Peintures, Pastels, Dessins, Sculptures* (catalogued by Hélène Adhémar), Orangerie des Tuileries, Paris 1969, Nos. 75–110.

104 Ibidem, Nos. 116–149.

105 See E. Mitchell, 'La Fille de Jephté par Degas,

Genèse et Evolution', in *Gazette des Beaux-Arts*, XVIII, 79, 1937, pp. 175ff.

106 Reff 1976, Notebook 15, p. 40; see Notebook 14, p. 1.

107 Ibidem, Notebook 15, p. 6.

108 A critical remark by Auguste de Gas on 21 November 1863 is probably relevant to this: 'Our Raphael works indefatigably, but he has not yet produced anything perfect, while the years slip by'; Lemoisne I, p. 41. See also Bernd Growe, *Zur Bildkonzeption Edgar Degas'*, Frankfurt am Main 1981, pp. 12ff., in which this interest in topicality is thoroughly examined in the course of analysing Degas' works.

109 John Rewald, *The History of Impressionism*, London and New York 1961, pp. 20f.

110 John Rewald (ed.), *Paul Cézanne, Letters*, London 1941, pp. 68f.

111 Théophile Gautier, 'De l'Art Moderne', in *L'Artiste*, X, 1853, p. 135.

112 Graber 1942, p. 201.

113 Ibidem, p. 202.

114 There are interesting indications about Degas' methods of work and the production of pastels in some letters. On 23 May 1869, for instance, Berthe Morisot's mother wrote: 'Do you know that Monsieur Degas is mad about Yves' face, and that he is making a sketch of her. He is going to transfer to canvas the drawing that he had in his sketchbook. A peculiar way of doing a portrait!' And on 24 June: 'This time he took a large sheet of paper and set to work on the pastel portrait; it seemed to me that he was keen to make something specially nice and he drew excellently. . . . He came to lunch and stayed all day. He was apparently pleased with what he had done and it worried him to part with it. In fact, he worked easily, although it took place in and out of the visits and leave-takings which went on ceaselessly on both days.' The sitter wrote on 26 June: 'The drawing that Monsieur Degas made of me in the last two days is really very pretty, both true to life and delicate, and it is no wonder that he could not detach himself from his work. I doubt if he can transfer it onto the canvas without spoiling it.'; Denis Rouart (ed.), *The Correspondence of Berthe Morisot*, London 1957, pp. 35f.

115 Lemoisne I, p. 62, Note 69. Degas took his leave from the Salon with a detailed open letter to those responsible for the organization of the exhibitions, in which he included advice about improvements in hanging the pictures on future occasions. In particular, he suggested wider spacing and the juxtaposition of paintings and drawings by means of movable screens; Theodore Reff, 'Some Unpublished Letters of Degas', in *The Art Bulletin*, L, I, March 1968, p. 87f.

116 Rewald 1961 p. 197.

117 Ibidem, p. 201.

118 Ibidem, p. 29.

119 Ibidem, p. 376.

120 The leading character in the novel, the painter Corioli, stated conclusions greatly at odds with Courbet's realist notions: 'All ages carry within themselves a Beauty of some kind or other, more or less close to earth, capable of being grasped and exploited – It is a question of excavation – It is possible that the Beauty of today may be covered, buried, concentrated – to find it, there is perhaps need of analysis, a magnifying glass, near-sighted vision, new psychological processes. – The question of what is modern is considered exhausted, because there was that caricature of truth in our time, something to stun the bourgeois: *realism*! – because one gentleman created a religion out of the stupidly ugly, of the vulgar ill-assembled and without selection, of the modern – but common, without character, without expression, lacking what is the beauty and the life of the ugly in nature and in art: *style*! The feeling, the intuition for the contemporary, for the scene that rubs shoulders with you, for the present in which you sense the trembling of your emotions and something of yourself – everything is there for the artist.'; Rewald 1961, p. 174. The relationship between Degas and the Goncourts is dealt with in detail by Reff (*The Artist's Mind*) 1976, pp. 170ff.

121 See Lemaître 1962, pp. 3–85, 97–200.

122 See Lemaître 1962, pp. 197f.

123 Rewald 1961, p. 127.

124 It is by no means clear how Degas as a young man came to notice Guys' works, which had never been shown in public, but it is a fact that in one of the sketchbooks he used in Paris during the first half of the 1860s there are pen studies of individuals in fashionable dress which, judging by their style and techniques, seem to have been borrowed directly from Guys; Reff 1976, Notebook 18, pp. 183, 185, 187.

125 See Reff (*The Artist's Mind*) 1976, pp. 70ff. Degas copied the signatures of Ingres (as well as his monogram), Delacroix and Daumier in the margin of a notebook; Reff 1976, Notebook 27, p. 43.

126 See *Quelques Caricaturistes Français*, in Lemaître 1962, pp. 265–89.

127 Ibidem.

128 Rewald 1961, p. 174.

129 *Jockeys à Epsom*; *Aux Courses, le Départ*; *Sur le Champs de Courses*, Lemoisne II, Nos. 75–77; see the individual sketches in Reff 1976, Notebook 12, pp. 15f., Notebook 13, pp. 14, 23, 60, Notebook 14, p. 79, Notebook 16, pp. 38f., Notebook 19, p. 42. Some sketches were produced even earlier with scenes from the Crimean War, probably drawn from newspaper illustrations in 1855 or early 1856; Reff 1976, Notebook 5, pp. 1, 3, 5, 7, 9, 11, 15, 17, 21.

130 Ibidem, Notebook 8, pp. 24v, 26, 26v, 51v, 52.

131 Ibidem, p. 27, Notebook 13, pp. 60f., 63–9, 71, 98, 108, 118–120, Notebook 18, pp. 5, 9, 93f.

132 Ibidem, pp. 162f.

133 *Degas' Racing World* (catalogue compiled by Ronald Pickvance), Wildenstein Gallery, New York 1968, p. 7.

134 Vollard recalled Degas picking up a small wooden horse from a shelf: 'When I come back from the racecourse, these are my models; how could one make real

horses turn round as one liked in the light?' Vollard 1928, p. 91.

135 J. Richardson, *Edouard Manet. Paintings and Drawings*, London 1958, p. 124.

136 Denis Rouart and Daniel Wildenstein, *Edouard Manet. Catalogue Raisonné*, I, Lausanne and Paris 1975, No. 184.

137 See Paul Henry Boerlin, 'Zum Thema des gestürzten Reiters bei Edgar Degas', in *Jahresbericht der Öffentlichen Kunstsammlungen Basel*, 1963, pp. 45ff.

138 Vollard 1924, p. 58f.

139 For the studio arrangements at 37 rue Victor Massé, where Degas had leased three floors for his living quarters, collection and workroom, see Valéry 1960.

140 Lemoisne II–III, Nos. 199–205, 217–253, 1034–1065, 1212–1219.

141 Reff 1976, Notebook 5, p. 33. 'To set a piece of nature and to draw it are two vastly different things', a note jotted down during the late 1860s, may well have resulted from Degas' work on this first series of landscapes; Reff 1976, Notebook 22, p. 3.

142 Guérin 1947, p. 12: letter available only in the English language edition.

143 There are only a few early pastel studies, viz. Lemoisne II, Nos. 64, 85, 122, 144, 149, 170.

144 For Baudelaire on Ingres, see Lemaître 1962, pp. 222–30.

145 Degas admired Delacroix's pastels. He wrote to Henri Rouart in about 1880: 'Painting in watercolours is a miserable business . . . however, Delacroix! Burty has a tiger of his done in pastel which looks like watercolour under glass. It is nevertheless pastel which has been quite lightly applied to a fairly smooth paper. It is uncannily lifelike, it is a fine technique.' Guérin 1945, p. 60; Guérin 1947 (Eng. edn), p. 62.

146 See Douglas Cooper, *Pastels by Edgar Degas*, New York 1954; Bernard Dunstan, 'The Pastel Techniques of Edgar Degas', in *American Artist*, XXXVI, 362, September 1972, pp. 41ff., as well as Alfred Werner, *Degas Pastels*, New York 1978. The assumption in Boggs 1962, p. 69, that Degas probably regarded his pastel portraits as sketches and only allowed his portraits in oils to be treated as full-scale works of art is hardly correct, since it is precisely the pastel portraits which are usually most carefully carried out and intended to act as pictures.

147 There are precise indications about pastel technique in its traditional form in a letter by Menzel of 23 April 1847: 'You should also try using coloured chalk. At the start, you will find it goes most easily on grey, not very light paper. The main shadows are put in position by means of an estompe [a leather-covered swab] as usual, in the right strength, then the lighter shading is added. The lighter parts and highlights are then set with flesh-coloured chalk, rubbed over with the fingers to supply the modelling, then further outlined in the same chalk to get a clearer definition of the shapes or wrinkles, helping it along with a finger in some places, in short, worked over in this way. Brown chalk is used to draw within the rubbed over shadows as necessary, but not all over them, and black for the deep ones. Ochre or deep red chalk is used for sundry reddish parts, in cheeks and eyelids or corners of eyes, just as all of it is varied according to the tone, more red or white etc. Tones of ochre are excellent for the various colours of hair, but must be thoroughly rubbed (except for blonde). Much of the rest you will of course discover for yourself'; Hans Wolff (ed.), *Adolph von Menzel. Briefe*, Berlin 1914, p. 104.

148 Lemaître 1962.

149 Reff 1976, Notebook 24, pp. 105ff. Degas was also a frequent visitor during the war to the Morisots in Passy, together with Manet. Berthe Morisot's mother wrote about such a visit on 18 October 1870: 'Monsieur Degas was so affected by the death of one of his friends, the sculptor Cuvelier, that he was impossible. He and Manet almost came to blows arguing over the methods of defence and the use of the National Guard, although each of them was ready to die to save the country. . . . M Degas has joined the artillery, and by his own account has not yet heard a cannon go off. He is looking for an opportunity to hear that sound because he wants to know whether he can endure the detonation of guns'; Rouart 1957, p. 48.

150 Graber 1942, p. 42, note 1.

151 See Siegfried Kracauer, *Jacques Offenbach und das Paris seiner Zeit*, Frankfurt am Main 1976, pp. 145ff., 174f., 204ff., 351f.

152 Guérin 1945, p. 190; Guérin 1947 (Eng. edn), p. 180.

153 Guérin 1945, p. 22; Guérin 1947 (Eng. edn), p. 20.

154 'Degas' "hatred" for womankind is almost a cliché. Nobody, on the contrary, has loved woman so much, but a sort of modesty in which there was something like fear kept him at a distance from women; it was this "Jansenist" side of his nature that explains the sort of cruelty he used in the portrayal of woman concerned with her intimate toilet.'; Vollard 1924, pp. 20f. See Norma Broude, 'Degas' Misogyny', in *The Art Bulletin*, LIX, I, March 1977, pp. 95ff.

155 A certain Félicien Champsaur, who described Degas in unflattering terms under the pseudonym of 'Decroix' in his novel *L'Amant des Danseuses*, accused him of being 'a painter of modernities . . . who paints the underclothes of Paris . . ., captures dancers, divas, bareback riders, chorus girls and prostitutes in quick sketches . . . and even though he frequently represents the ballerinas on stage in climaxes of artificial lighting, he also indulges – that is the grey and sordid philosophy underlying his work – in recording their wretchedness, and almost their ugliness.'; Jean Adhémar and Françoise Cachin, *Edgar Degas. Gravures et Monotypes*, Paris 1973.

156 Baudelaire also noted in terms that might apply equally to Degas, that Ingres 'prefers to deal with women; he represents them as he sees them, for one would think that he likes too much to wish to change them; he fastens on their slightest beautiful features with the harshness of a surgeon; he follows the lightest curves of their outlines with the servility of a lover.'; Lemaître 1962, p. 153.

157 An idiom derived from hamburgers and cheeseburgers has led to the apt description of 'sandwiched' for this purpose; Ian Dunlop, *Degas*, London 1979, p. 77.

158 Reff 1976, Notebook 23, pp. 44f. Johann Kaspar Lavater wrote *Die physiognomischen Fragmente*, Zurich 1775–78; see Reff (*The Artist's Mind*) 1976, p. 218.

159 François Delsarte, Professor of Music and Rhetoric, published his *Système de François Delsarte* in 1871; see Reff (*The Artist's Mind*) 1976, pp. 218 f.

160 Reff 1976, Notebook 23, pp. 46f.; in addition, Degas also noted: 'Think about an essay on fashion accessories for women and of women, of their way of picking, assembling and assessing their clothes and all the accessories that go with them. They spend more time than men matching thousands of visible objects.' There are other, earlier references of this sort: for instance: 'Let me not forget to do René [de Gas] full length with a hat, also the portrait of a lady in a hat, ready to go out and in the act of putting on her gloves, very graceful and simple', or 'do a half-figure of a lady in a hat . . . in watercolour, grey and pink, delicate blue. Softly toned, light. As closely drawn as possible. With a muff into which she tucks her handkerchief and purse.' In connection with a proposed portrait of Alfred de Musset, Degas wrote: 'Stick to developing a composition which will represent our own times'; and, finally: 'There are rather badly dressed people, and even more badly groomed ones, I think. . . . Flesh colour provides us, particularly here, with as many different aspects as the rest of nature with its fields, trees, mountains, waters and woods. One can find as much likeness between a face and a stone as between two stones, because everybody knows that one can often enough see two faces in them'; Ibidem, Notebook 14A, p. 599v. Notebook 18, p. 194, Notebook 16, p. 6, Notebook 22, p. 3.

161 See Lilian Browse, *Degas Dancers*, London 1949, as well as the exhibition catalogue *Degas and the Dance* (compiled by Linda D. Muehlig), Smith College Museum of Art, Northampton (Mass.), 1979.

162 Gauguin 1912, p. 338.

163 Daniel Catton Rich, *Edgar Degas*, London and New York 1952, p. 19.

164 Hardly any of Degas' dancers can be identified. Josephine Gaujelin and Melina Darde are the only two names which appear on the drawings (pl. 93); see Browse 1949, p. 60.

165 Degas had also advised Pissarro to draw a great deal from memory, judging by a letter of 13 June 1883 to his son Lucien: 'I mentioned to Degas that you are thinking of taking Legros' course in drawing. Degas says that there is one way of escaping Legros' influence and the way is simply this: to reproduce in your own place, from memory, the drawing you make in class.'; Rewald 1943, p. 35.

166 'You probably imagined that I had worked a great deal in town; in fact, I worked in the studio at least two or three hours a day', Degas wrote to the designer Félix Bracquemond about 1879; Guérin 1947, p. 39. There are numerous entries with the names, addresses and distinguishing features of models in the notebooks, for instance: 'Clara, 21 rue Beauregard, very graceful, tall', or 'Mme Piegler, 27 Faubourg St Jacques, small blonde, 15 years old'; Reff 1976, Notebook 22, pp. 222–201, Notebook 27, p. 1 etc.

167 Moore 1908, pp. 140, 143.

168 Jeanniot 1933, p. 158.

169 See John Rewald, 'Degas' Dancers: 1872–6', in *The Burlington Magazine*, CV, 723, June 1963, p. 257.

170 See John Rewald, 'Degas and his Family in New Orleans', in *Gazette des Beaux Arts*, XXX, 6, 1946, pp. 105ff. and exhibition catalogue *Edgar Degas. His Family and Friends in New Orleans* (compiled by James B. Byrnes), New Orleans 1965.

171 Guérin 1945, p. 24; Guérin 1947 (Eng. edn), p. 21.

172 Guérin 1945, p. 19; Guérin 1947 (Eng. edn), p. 17.

173 Guérin 1947, p. 19.

174 Guérin 1945, p. 23; Guérin 1947 (Eng. edn), p. 20.

175 Guérin 1945, pp. 22f.; Guérin 1947 (Eng. edn), pp. 21f. The longing for Paris is also reflected in other letters: see Guérin 1945, pp. 95, 113, 197; Guérin 1947 (Eng. edn).

176 Guérin 1947, pp. 18f.

177 Guérin 1945, pp. 26ff.; Guérin 1947 (Eng. edn), pp. 24ff. The last surviving letter from New Orleans on 18 February 1873 deals somewhat self-consciously with the major work produced in America, *Portraits dans un Bureau* (Lemoisne II, No. 320), a group portrait of the firm's owners and office workers: 'I have attached myself to a fairly vigorous picture which is destined for Agnew and which he should place in Manchester. For if a spinner ever wished to find his painter, he really ought to hit me. The interior of a cotton buyers' office in New Orleans. Some 15 people more or less busy round a table covered with the precious stuff and two men, one half leaning over the table, the other propped up against it, the buyer and the broker, discussing the goods. A raw picture if ever there was one, and from a better hand, I think, than many others. . . . If I could work for another 20 years, I would make lasting things. . . . The naturalistic movement will prove itself worthy, in its own way, of the great schools and its strength will then be recognized. English art, with its great appeal for us, seems to exploit an artifice. We could be better at it than they are and just as forceful. My mind really is full of many things – if only there were insurance companies for that sort of thing . . . that is, in fact, my greatest field of action. . . . What beautiful things I could have brought forth and quickly made if only bright daylight were less unbearable for me. . . . This Whistler really has something in his sea and water pieces that he showed me. But my strength lies quite elsewhere! I sense that I am collecting myself, and I am glad of it. It takes a long time.' Guérin 1947, pp. 29ff.

178 Ibidem, p. 34. Concerning Degas' poor eyesight, see also Ibidem, pp. 34, 39, 41, as well as Guérin 1945, pp. 39, 41, 67, 95, 155, 180.

179 Lemoisne II, Nos. 165–167; Degas noted her address, rue de Berlin 20, in Reff 1976, Notebook 22, p. 207.

180 Gauguin 1912, pp. 341, 338.

181 See Denis Rouart, *Degas. A la Recherche de sa Technique*, Paris 1945, pp. 16ff.; Lemoisne I, pp. 109ff.; and Reff (*The Artist's Mind*) 1976, pp. 274ff. The artist referred to 'mixtures of water-soluble colours with glycerin and soda; one might make a pastel soap, potash instead of soda' in Reff 1976, Notebook 33, p. 3v.

182 Vollard 1928, p. 95. In another passage, Vollard recalled that the painter B. had once asked him what accounted for Degas' marvellous tonality: 'You know Degas, could you ask him where he buys his pastels? My wife believes that he has some trick for getting this tone which is both matt and brilliant.' When I looked in on Degas some time later, he just happened to have a couple of pastel sticks in his hand: "What a devil of a job it is to get the garishness out of pastel colours. I wash them again and again, put them out in the sun . . .''; he stressed that he achieved the luminosity of his pastels through their own matt quality.'; Ibidem, p. 105.

183 Recent research suggests that this consisted of clear shellac dissolved in methylated spirit; Dunstan 1972, p. 46.

184 Ernest Rouart gives a vivid account of Degas' mania for trying to rework completed pastels: 'When he caught sight again of a relatively old work, he almost always longed to put it back on the easel and work it over. And so Degas was seized by his normal and irresistible compulsion to retouch a delightful and greatly prized pastel, which he saw again and again at my father's house. He kept on and on returning to the subject and after holding out for a long time my father finally handed the picture over. It was never seen again. My father would often ask after his pastel and its fate. His artist-friend would always answer evasively. One day, at long last, he finally confessed that he had totally wrecked the work entrusted to him for a little simple retouching. My father was in despair, because he could never forgive himself for conniving at the destruction of an object that he had loved so much. That was the occasion on which Degas had the famous *Danseuses à la Barre* [Lemoisne II, No. 408] brought to the house to make up for the picture my father had lost. The funny part of this story is that for many long years afterwards we would hear Degas say to my father whenever he came face to face with these *Dancers*: "That can of water is distinctly stupid, I simply must remove it." Taught by experience, my father never agreed to this fresh attempt.'; Graber 1942, p. 179. Degas wrote to Félix Bracquemond in about 1880, probably in connection with the Impressionist exhibition: 'Will you be giving me the list of works that you wish to send in? I am trying to make one out for myself by improving old works and so making new ones out of them.'; Guérin 1945, p. 42; Guérin 1947 (Eng. edn), p. 37.

185 Lemoisne I, p. 173.

186 Guérin 1945, p. 30; Guérin 1947 (Eng. edn), p. 36. This letter dates from 1874, rather than 1873, since it is dated 8 August and the fire at the old Opéra which it mentions occurred in October 1873.

187 Guérin 1945, pp. 39ff.; Guérin 1947 (Eng. edn), pp. 45ff. Three letters from Pissarro of 21, 23 and 25 January 1887 provide an indication of the relatively high prices fetched by Degas' pastels in the 1880s: 'At the moment the only thing for me to do is to sell my Degas pastel. It will be painful to let it go, but it can't be helped. . . . What do you think? If I could get from five to eight hundred francs it would certainly lighten our burden.'; 'Before making up my mind about the Degas, I shall see whether I can do business with Bracquemond's dealer. Just the same I shall look for a buyer. I'll sell the pastel but not the drawing which is a gift from Degas, or an exchange for something of mine. It would be indelicate.' '. . . the more I think of it, the more mortified I feel about parting with the Degas, and the more convinced I am that the only course is to sell it. It is painful to do so, it means losing one of our purest joys. . . . Signac says it is worth at least a thousand francs. Arrange somehow to get it to me undamaged.'; Rewald 1943, pp. 95, 97f.

188 See the exhibition catalogue *The Painterly Print. Monotypes from the Seventeenth to the Twentieth Century*, The Metropolitan Museum of Art, New York 1980.

189 See Hugo Troendle, 'Das Monotype als Untermalung. Zur Betrachtung der Arbeitsweise von Degas', in *Kunst und Künstler*, XXIII, 1925, pp. 357ff.; also, Eugenia Parry Janis, 'The Role of the Monotype in the Working Method of Degas', in *The Burlington Magazine*, CIX, 766–767, January–February 1967, pp. 20ff., 71ff.; and the exhibition catalogue *Degas Monotypes* (compiled by Eugenia Parry Janis), Fogg Art Museum, Cambridge (Mass.) 1968; this carefully prepared catalogue additionally contains a complete list of the 321 known monotypes by Degas.

190 Lemoisne I, p. 131.

191 Adhémar and Cachin 1973, p. XXI.

192 The brush drawings were occasionally preceded by studies of details; see Reff 1976, Notebook 27, pp. 3ff., 97.

193 Over fifty of these are on record; see Cambridge (Mass.) 1968, checklist Nos. 62–118; more were most probably produced, but removed by the heirs before the sales owing to their all-too-explicit subjects.

194 Renoir commented on Degas' brothel scenes: 'When one paints a brothel, it is often pornographic, but it is always desperately sad. Only Degas is able to give such a subject a festive look, as well as the appearance of an Egyptian bas-relief. This near-religious and very chaste aspect, which sets his work on such a high level, becomes even more elevated when it concerns the whore.'; Vollard 1924, p. 60.

195 Reff 1976, Notebook 28, pp. 26f., 29, 31, 33, 35, 45, 65; see Daniel Halévy, *Album des Dessins de Degas*, Paris 1949.

196 Reff 1976, Notebook 23, p. 45. Degas also described the fascination of artificial light in connection with *Femmes devant un Café, le Soir* (Lemoisne II, No. 419): 'If somebody is sitting at the table, its underside is in stark shadow; many points of light of varying strength in the darkness of the street; the hanging globe lamps in the café

reflected in the darkness of the street'; Reff 1976, Notebook 26, p. 33.

197 See Ibidem, Notebook 27, pp. 102–100. There are unusually steep perspectives of interiors in sketches dating back as far as 1855: Ibidem, Notebook 3, pp. 44, 42. This angle of sight also occurs in Degas' plastic works, as William Rubin wrote in his comment on Giacometti's *No More Play* cage sculpture: 'Degas had introduced the idea of sculpture seen from above in certain of his small bathers, an advance which, like many others in modern sculpture, represented a translation of new pictorial devices into the sister art.'; William S. Rubin, *Dada and Surrealist Art*, London 1969, p. 252.

198 Nottingham 1969, No. 4.

199 Franz von Lenbach, a contemporary of Degas, lambasted this way of reacting to the environment in 1886: 'The Impressionists, those cut-throats and head-choppers, despise the integrated human figure taught to us by the old masters.'; see exhibition catalogue *Weltkulturen und moderne Kunst*, Munich 1972, p. 234. Liebermann, on the contrary, although only slightly younger, could analyse Degas' treatment with insight: 'One can tell a Degas from far off by the sector of nature selected. Daringly, he only allows one to see the head of a racehorse in one case, its hindquarters in another; he unexpectedly intersects the apron of the stage by a bass violin with such an accurate sense of the right position that we feel it must be so, it simply could not be otherwise.'; Liebermann 1899, p. 19. See also Ernst H. Gombrich, *Art and Illusion. A Study in the Psychology of Pictorial Representation*, London 1960, as well as Giorgio Giacomazzi, 'Versuch über die Visualität in der Moderne. Benjamin, Degas und der Impressionismus', in *Notizbuch*, 7, 1982, pp. 151ff.

200 See note 113 above concerning Zola's article in *L'Evénement Illustré* of 9 June 1869. Huysmans had already drawn attention in 1880 to the fact that Degas' figures are intersected by the edge of the picture 'as in many Japanese prints'; Joris Karl Huysmans, *L'Art Moderne*, Paris 1902, pp. 129, 250. Liebermann also pointed out analogies with both instantaneous photography and Japanese prints.

201 See Yujiro Shinoda, *Degas. Der Einzug des Japanischen in die Französische Malerei*, Cologne 1957, and Jacques Dufwa, *Winds from the East. A Study in the Art of Manet, Degas, Monet and Whistler 1856–1886*, Uppsala 1981, pp. 39f., 48ff., 83ff., with detailed bibliographical information.

202 Shinoda 1957, p. 97.

203 See Richard Lane, *Ukiyo-e Holzschnitte. Künstler und Werke*, Zurich 1978. Just as during the nineteenth century in France writers and figurative artists brought a new approach to bear on contemporary life at roughly the same time, so a comparable form of fiction – the Ukiyo-zóschi 'books of the flowing world – developed in seventeenth-century Japan in parallel with the Ukiyo-e woodcuts. See also Siegfried Wichmann, 'Bewegung als Eigenexistenz im Werk Hokusai's und in den Pastellen

und Zeichnungen von Edgar Degas', in exhibition catalogue *Weltkulturen und moderne Kunst*, Munich 1972, pp. 202ff.

204 Based on the research of Aaron Scharf, *Art and Photography*, London 1968, pp. 139ff.

205 Rewald 1961, p. 34. Manet, Cézanne and the Impressionists rightly considered that their special strength in relation to photography lay in colour.

206 This may apply in particular in 1861–2 to a portrait of Princess Metternich, a self-portrait *Degas Saluant* and the *Deux Soeurs* double portrait (p. 354), Lemoisne II, Nos. 89, 105, 126: see Scharf 1968, pp. 146f. There is a caricature of a photograph of two fashionably dressed ladies marked 'Disderi Photog.' in Reff 1976, Notebook 18, p. 31; works by the well-known portrait photographer A. E. Disderi were shown in the rue Drouot in December 1861. Degas was probably also referring to a photograph in a letter of 1876: 'Do not omit to remind Mérante [a dancer and, later, choreographer] about the photos which he offered me yesterday. I am keen to see them and will do my best to do something with this talent for dancing.'; Guérin 1945, p. 39; Guérin 1947 (Eng. edn), p. 44.

207 Guérin 1945, p. 23.

208 Delacroix had explicitly warned against this in a diary entry on 1 September 1859: 'The most obstinate realist is still compelled, in his rendering of nature, to make use of certain conventions of composition and of execution. If the question is one of composition, he cannot take an isolated piece of painting or even a collection of them and make a picture from them. He must certainly circumscribe the idea in order that the mind of the spectator shall not float about in an ensemble that has perforce been cut to bits; otherwise art would not exist. When a photographer takes a view, all you ever see is a part cut off from a whole; the edge of the picture is as interesting as the centre; all you can do is to suppose an ensemble, of which you see only a portion, apparently chosen by chance. The accessory is capital, as much as the principal; most often, it presents itself first and offends the sight. One must make more concessions to the infinity of the reproduction in a photographic work than in a work of the imagination. The photographs which strike you most are those in which the very imperfection of the process as a matter of absolute rendering leaves certain gaps, a certain repose for the eye which permit it to concentrate on only a small number of objects. If the eye had the perfection of a magnifying glass, photography would be unbearable: one would see every leaf on a tree, every tile on a roof, and on these tiles, mosses, insects, etc. And what shall we say of those disturbing pictures produced by actual perspective, defects less disturbing perhaps in a landscape, where parts in the foreground may be magnified in even an exaggerated way without the spectator being offended, save when human figures come in question? The obstinate realist will therefore, in his picture, correct that inflexible perspective which falsifies our seeing of objects by reason of its very correctness.' *The Journal of Eugène Delacroix*, New York 1948, pp. 644ff.

110

209 This, all else apart, attracted the derision of caricaturists; see Scharf 1968, p. 155.

210 Lemoisne I, p. 98.

211 Ibidem, p. 102.

212 Degas' pleasure in designing the stage setting of a studio for the comedy *La Cigale* is further proof of his contempt for Impressionist open-air enthusiasm. In this play, staged in October 1877 by Meilhac and Halévy, one of the characters lampooned was an Impressionist painter of landscapes which could be hung either way up. See Guérin 1945, pp. 41, 190; Guérin 1947 (Eng. edn), pp. 47, 180. Also Libby Tannenbaum, 'La Cigale', in *Art News*, 65, 9, January 1967, pp. 55, 71; and Reff (*The Artist's Mind*) 1976, pp. 186ff.

213 Numerous reviews and letters provide indications concerning the individual Impressionist exhibitions; see Reff 1976, Notebook 26, pp. 99, 74, Notebook 27, p. 36, Notebook 31, pp. 33f., 39, 93, 92, 68–64, 59, 58, 56, 54; Guérin 1945, pp. 34ff., 45f., 51f.; Guérin 1947 (Eng. edn), pp. 37ff., 50f., 55f. Also Rewald 1961.

214 Guérin 1947, p. 39.

215 Lemoisne I, p. 103.

216 Rewald 1961, p. 372.

217 Graber 1942, pp. 141ff.: see Joseph Sloane, *French Painting between the Past and the Present. Artists, Critics and Traditions from 1848 to 1870*, Princeton 1951, pp. 206ff.

218 Reff (*The Artist's Mind*) 1976, p. 165.

219 Lemoisne I, p. 240 note 119.

220 Ibidem, p. 243 note 127, p. 105.

221 See Guérin 1945, p. 44; Guérin 1947 (Eng. edn), pp. 49f. See also Monika Kopplin, *Das Fächerblatt von Manet bis Kokoschka. Europäische Traditionen und Japanische Einflüsse*, Saulgau 1981, pp. 61ff.

222 Lemoisne I, p. 246 note 131.

223 Huysmans 1902, p. 118.

224 Lemoisne I, p. 248 note 134.

225 Graber 1942, pp. 208f.

226 Huysmans 1902, pp. 120f.

227 George Moore, *Reminiscences of the Impressionist Painters*, Dublin 1906, pp. 31f.

228 Reff 1976, Notebook 30, pp. 29, 65.

229 Ibidem, p. 210.

230 See Guérin 1945, pp. 45ff., 49ff., 55; Guérin 1947 (Eng. edn), pp. 50ff., 54ff., 59.

231 Reff 1976.

232 Ibidem, pp. 207–204, 202, 196.

233 For Degas as a sculptor, see, among others, the exhibition catalogue *Edgar Degas. Original Wax Sculptures*, Galerie Knoedler, New York 1955 (the first and only exhibition of the original wax maquettes); Leonard von Matt and John Rewald, *Degas, Das plastische Werk*, Zurich 1957; William Tucker, 'Gravity-Rodin, Degas', in *Studio International*, July–August 1973, pp. 25ff.; Charles W. Millard, *The Sculpture of Edgar Degas*, Princeton 1976, with extensive bibliographical information; and Reff (*The Artist's Mind*) 1976, pp. 239ff.

234 Degas' answer to Rodin's advice that he should have his plastic studies cast was that he did not regard them as completed; Victor Frisch and Joseph T. Shirley, *Auguste Rodin*, New York 1939, p. 312. Degas told Vollard that 'it was too great a responsibility to leave behind one anything in bronze, since it was a material that seemed intended for eternity.'; Vollard 1924, p. 112. On the other hand, Bernd Growe (who, oddly enough, includes Cézanne as a 'painter-sculptor' in a set comprising Daumier, Renoir and Gauguin) considered Degas' sculpture to be the culmination of his output as a whole; Growe 1981, p. 146.

235 Matt and Rewald 1957, p. 21. The name and address of the model were spelled 'Van Gutten' in Reff 1976, Notebook 34, p. 4; see Millard 1976, pp. 8f. note 26.

236 Matt and Rewald 1957, p. 21. Paul Mantz also gave an unfavourable account of Degas' contribution to the exhibition in his review for *Le Temps* on 23 April 1881: 'Apart from a few pastels which do not improve his reputation, he is showing the little fourteen-year-old dancer, the wax statuette which he has promised us for a long time. Last year, M. Degas confined himself to showing us the glass case intended to harbour this figurine, for the sculptor is not to be rushed. . . . Now the piece is finished and, let us admit it straightaway, the outcome is almost frightening. One circles this little dancer, and one is not moved. Much that is good and much that is bad will certainly be said about this statuette, which had been publicized well in advance but still remains surprising by its realism pushed to extremes. . . . And yet there is in this unpleasant figurine something that proceeds from an observant and dedicated artist who is impelled by a philosophical mind akin to Baudelaire's; here is the perfect veracity of mime, the texture of near-mechanical movement, the artificial graceful stance, the savage lack of elegance of a schoolgirl who will turn into a woman, and over whom diplomats will go wild. . . . This sight is not without eloquence, but it is disturbing. . . . M. Degas is merciless.'; Lemoisne I, pp. 249 f. notes 140, 141.

237 In Reff 1976, Notebook 31, p. 81, Degas noted the 1878 edition of the periodical *La Nature*. He was probably mainly interested in an article by E. J. Mareys, 'Moteurs Animés. Experiences de Physiologie Graphique', on 5 October 1878, dealing with the movements of horses and their representation in the figurative arts; and also in 'Les Allures du Cheval' about Muybridge's photographs of galloping horses on 14 December 1878; see Scharf 1968, pp. 162ff.; also the exhibition catalogue *Eadweard Muybridge*, Stuttgart, 1976.

238 There is probably a reference to this in a letter in which Degas mentions one of his small models of horses, 'none of whose legs . . . is in the right place'; Guérin 1945, pp. 77f.; Guérin 1947 (Eng. edn), p. 79. Valéry gave the following account of the eye's 'discoveries': 'They showed just how inventive the eye is, or rather how much the sight elaborates on the data it gives us as the positive and impersonal result of observation. Between the state of vision as mere patches of colour and as things or objects, a whole series of mysterious operations takes place, reducing to order as best it can the incoherence of raw

perceptions, resolving contradictions, bringing to bear judgements formed since early infancy, imposing continuity, connection, and the systems of change which we group under the labels of space, time, matter and movement. This was why the horse was imagined to move in the way the eye seemed to see it; and it might be that, if these old-style representations were examined with sufficient subtlety, the law of unconscious falsification might be discovered by which it seemed possible to picture the positions of a bird in flight, or a horse galloping, as if they could be studied at leisure; but these interpolated pauses are imaginary. Only probable positions could be assigned to movements so rapid, and it might be worth while to try to define, by means of documentary comparisons, this kind of creative seeing by which the understanding filled the gaps in sense perception.' Valéry 1960, pp. 36ff.

239 Stuttgart 1976, p. 108.

240 Ibidem, p. 26. Muybridge himself wrote that he had been fortunate in securing a measure of consideration among artists and scientists in Paris which had proved extremely flattering; he suggested that if fame had been his only concern, he would have had no further worries: M. Meissonier had shown great interest in his work and, thanks to his commanding influence, he had been treated in a way which he found extraordinarily flattering and beneficial; Ibidem, p. 116. Degas was, incidentally, also a great admirer of Meissonier's pictures of horses; see Valéry 1960.

241 Stuttgart 1976, p. 81.

242 Among them were Alma-Tadema, Bonnat, Bouguereau, Carolus-Duran, Puvis de Chavannes, Defregger, Gérôme, Kaulbach, Lenbach, Marks, Meissonier, Menzel, Millais, Rodin, Whistler, etc.

243 See Scharf 1968, pp. 159f., 281 note 58; as well as Deren Coke, *The Painter and the Photographer. From Delacroix to Warhol*, Albuquerque 1972, pp. 158ff.

244 Guérin 1945, p. 127; Guérin 1947 (Eng. edn), p. 124.

245 Guérin 1945, p. 122; Guérin 1947 (Eng. edn), p. 120.

246 Guérin 1945, p. 63; Guérin 1947 (Eng. edn), p. 66. He was always concerned not to allow his contact with the Opéra to lapse and wrote in 1882 to Jacques Emile Blanche: 'I shall enquire at the Opéra if they have a seat for the three days . . . the seat will be in my name and I shall have the right to go behind the scenes . . . and then I should like to keep to the right side.'; Guérin 1945, pp. 66f.; see also Ibidem, pp. 72f., 112f.

247 Degas became an enthusiastic photographer in the 1890s. For instance, he wrote on 29 September 1895 to Ludovic Halévy: 'You see that in spite of this stinking heat and the full moon, I cannot leave this filthy studio to which love of glory binds me. One day I shall burst in on you with my camera in my hand. – Greetings to Louise the developer' [Mme Halévy developed Degas' photographs]; and, on 30 June 1898, to Henri Rouart: 'One forgets here a little of one's life. In a word one vegetates

fairly agreeably, because one knows that it will end. In the evenings I digest and take photographs in the twilight.' Guérin 1945, pp. 208, 223f.; Guérin 1947 (Eng. edn), pp. 195f., 209. See Luce Hoctin, 'Degas Photographe', in *L'Oeil*, 65, May 1960, pp. 36ff.; Beaumont Newhall, 'Degas Photographe Amateur. Huits Lettres Inédites', in *Gazette des Beaux-Arts*, LXI, 105, 1963, pp. 61ff.; and Kirk Varnedode, 'The Ideology of Time: Degas and Photography', in *Art in America*, Summer 1980.

248 Guérin 1945, p. 119; Guérin 1947 (Eng. edn), p. 117.

249 Vollard 1924, p. 109. According to Bernard Berenson, *Die Florentiner Maler*, Munich 1925, p. 108, only Degas rivals Leonardo da Vinci in the representation of movement.

250 Guérin 1945, p. 194; Guérin 1947 (Eng. edn), p. 183.

251 Liebermann 1899, p. 16.

252 Reff (*The Artist's Mind*) 1976, p. 255.

253 Guérin 1945, p. 119; Guérin 1947 (Eng. edn), p. 117.

254 Guérin 1945, p. 147; Guérin 1947 (Eng. edn), p. 142. Geneviève Straus, a daughter of Fromentin Halévy, had first married Georges Bizet. Marcel Proust was spellbound as a schoolboy by her charm, paid court to her and later immortalized her as Madame de Guermantes in *A la Recherche du Temps Perdu*.

255 Gauguin 1912, p. 341.

256 Theodor W. Adorno, *Ästhetische Theorie*, Frankfurt am Main 1973, p. 81. Degas wrote in 1872 from New Orleans: 'The women here are almost all pretty and many have, in addition to all their other charms, that touch of ugliness without which there is no satisfaction,'; Guérin 1945, p. 28; Guérin 1947 (Eng. edn), p. 27. And he jotted down a sentence from Barbey d'Aurevilly: 'There is at times in awkwardness a certain ease which, if I am not mistaken, is more graceful than grace itself.'; Reff 1976, Notebook 22, p. 6.

257 Adhémar and Cachin 1974, p. 85.

258 Ibidem, p. 85.

259 Moore 1908, p. 147.

260 Vollard 1928, p. 114.

261 Guérin 1945, p. 80; Guérin 1947 (Eng. edn), pp. 81f.

262 Guérin 1945, pp. 78f., see also p. 99; Guérin 1947 (Eng. edn), p. 79.

263 Guérin 1945, pp. 98, 119; Guérin 1947 (Eng. edn), pp. 97f., 117. Daniel Halévy recalled Degas saying: 'I should like to penetrate into working-class families of the Marais. One enters houses which seem ignoble – with doors as wide as this. . . . And one finds very light rooms, scrupulously clean. . . . The doors onto the landings are opened, everybody is gay, everybody is busy; nor do these people have the servility common among shopkeepers. . . . It is a delightful society.'; Guérin 1945, p. 267; Guérin 1947 (Eng. edn), p. 242.

264 Guérin 1945, p. 166; Guérin 1947 (Eng. edn), p. 160.

265 Lemoisne II, Nos. 419, 420, 422, 491, 547, 605, 658.

The following pastels reached the Louvre through a legacy from Isaac de Camondos in 1911: Lemoisne II–III, Nos. 474, 728, 814, 872, 874, 1121, 1306.

266 See Guérin 1945, pp. 277f.; Guérin 1947 (Eng. edn), pp. 251f. In the exhibition catalogue Cambridge (Mass.) 1968, Janis mentions 48 landscape monotypes which are partly worked over with pastel, checklist Nos. 274–321. See Denis Rouart, 'Degas. Paysages en Monotype', in L'Oeil, 117, September 1974, pp. 10ff., and Howard G. Lay, 'Degas at Durand-Ruel, 1892. The Landscape Monotypes', in The Print Collector's Newsletter, 9, 5, November–December 1978, pp. 142ff.

267 Rewald 1943, pp. 239f.

268 In an unexpectedly cheerful and delighted way Degas kept his friends informed almost daily of every detail of this journey; see Guérin 1945 pp. 159ff.; Guérin 1947 (Eng. edn), pp. 153ff. He wrote to Ludovic Halévy on 16 October 1890, among other things, with a touch of sarcasm: 'The people in the provinces often clean their windows, but they don't look out through these windows.'; Guérin 1945, p. 171; Guérin 1947 (Eng. edn), p. 165.

269 Jeanniot 1933, pp. 291ff.

270 Two letters bring out Degas' dislike for nature particularly clearly. He wrote to Henri Rouart from Ménil Hubert on 22 August 1884: 'I am trying to work a little. The first days I felt stifled and dazed by the amount of air. I am recovering. . . . You love nature more than I do, you will reply. Meanwhile it is I, not you, who am face to face with nature. And in spite of all I am a little beside myself'; and he wrote to Henri Lerolle on 2 March 1887: 'I should like to state a strong idea in conclusion. After holding back for a fairly long time . . . I would like to put this to you: if we love nature, we can never be certain whether this love is returned; how could I make my meaning even clearer?'; Guérin 1945, pp. 83, 125, see also pp. 158, 225; Guérin 1947 (Eng. edn), pp. 83f., 122. Pissarro refers in a letter of 9 May 1894 to 'painting in the open which Degas ridicules so wittily'; Rewald 1943, p. 239.

271 Lemoisne I, p. 100. Degas thought that '. . . judging by the perspective of their paintings, van Eyck and the rest . . . drew trees, flowers and hills of every kind from a suitable window'; Guérin 1945, p. 129; Guérin 1947 (Eng. edn), p. 126f.

272 Guérin 1945, p. 96; Guérin 1947 (Eng. edn), pp. 95f.

273 Guérin 1945, pp. 125, 192; Guérin 1947 (Eng. edn), pp. 122, 197. 'During my cold I am meditating on the state of celibacy, and a good three-quarters of what I tell myself is sad', Degas wrote to Henri Rouart in May 1896; Guérin 1945, p. 209; Guérin 1947 (Eng. edn), p. 197.

274 The anti-semitic paper La Libre Parole was among Degas' as well as Cézanne's, favourite reading material. Pissarro wrote to his son on 21 January 1898: 'I am sending you some newspapers. Read in Les Droits de l'Homme an article by Ajalbert, revealing what Degas, the ferocious anti-semite, thinks . . .'. This paper reported an incident which was supposed to have taken place in Degas' studio: 'A model expressed . . . doubts about Dreyfus' guilt: "You are a Jewess! You are a Jewess!" – "But no, I am a Protestant!" – "No matter, get dressed and get out!" A pretty young Montmartre girl's report on the Old Master . . . Poor Degas! How anti-semitism does make fools of clever men!'; Rewald 1943, p. 318.

275 Guérin 1945, pp. 183f., 194, 228, 234, 236; Guérin 1947 (Eng. edn), pp. 174, 198, 224, 230, 237. When he was seventy, Degas told Ernest Rouart: 'One must have a high opinion, not so much of what one is doing at the moment, but much rather of what one will be able to do some day; it would not be worth working otherwise.'; Valéry 1960.

276 Lemaître 1962, p. 298.

277 Delacroix, 1948. The first edition of Delacroix's diaries appeared under the title Journal de Eugène Delacroix, Paris 1893, in three volumes covering 1823–1850, 1850–1854 and 1855–1863.

278 Guérin 1945, p. 178; Guérin 1947 (Eng. edn), p. 171.

279 Guérin 1945, p. 212; Guérin 1947 (Eng. edn), pp. 198f.

280 Vollard 1928, pp. 114, 95.

281 Ibidem, p. 112.

282 Ibidem, p. 102. Degas also frequently worked beyond the printed area when superimposing pastel on monotypes, so that the reworked copies are often larger in size than the first prints.

283 See the pastel in the National Gallery, London, Après le Bain, Lemoisne III, No. 955.

284 Guérin 1945, p. 219; Guérin 1947 (Eng. edn), p. 206.

285 Lemoisne I, p. 260 note 218.

286 Guérin 1945, pp. 241, 243ff.; Guérin 1947 (Eng. edn), pp. 226, 229.

287 See Catalogue des Tableux Anciens . . . et Modernes . . . Composant la Collection . . . M. Henri Rouart . . ., Ière Vente, Galerie Manzi-Joyant, Paris 9–11 December 1912, Nos. 176–180; and Catalogue des Dessins et Pastels Anciens et Modernes . . . Composant la Collection . . . M. Henri Rouart, IIème Vente, Galerie Manzi-Joyant, Paris 16–18 December 1912, Nos. 70–77. Danseuses à la Barre (Lemoisne II, No. 408), which had originally been sold for 500 francs, fetched the enormous sum of 435,000 francs.

288 Lemoisne I, p. 200. Similarly sensational prices were recently reached when parts of the Havemeyer collection which had remained in private hands were auctioned in New York on 18 May 1983. The L'Attente pastel (Lemoisne II, No. 698), bought by Louisine Havemeyer from Durand-Ruel, fetched 3.74 million dollars and the gouache over monotype Au Café-Concert. La Chanson du Chien (Ibidem, No. 380), 3.41 million dollars. The gouache had been bought by Durand-Ruel, acting for Mrs Havemeyer, at the Rouart collection auction in 1912; see auction catalogue Impressionist Paintings and Drawings from the Estate of Doris D. Havemeyer, Sotheby Parke Bernet, New York, 18 May 1983, Nos. 8, 12.

289 Léon Daudet, Quand Vivait Mon Père, Paris 1940, p. 293.

The Plates

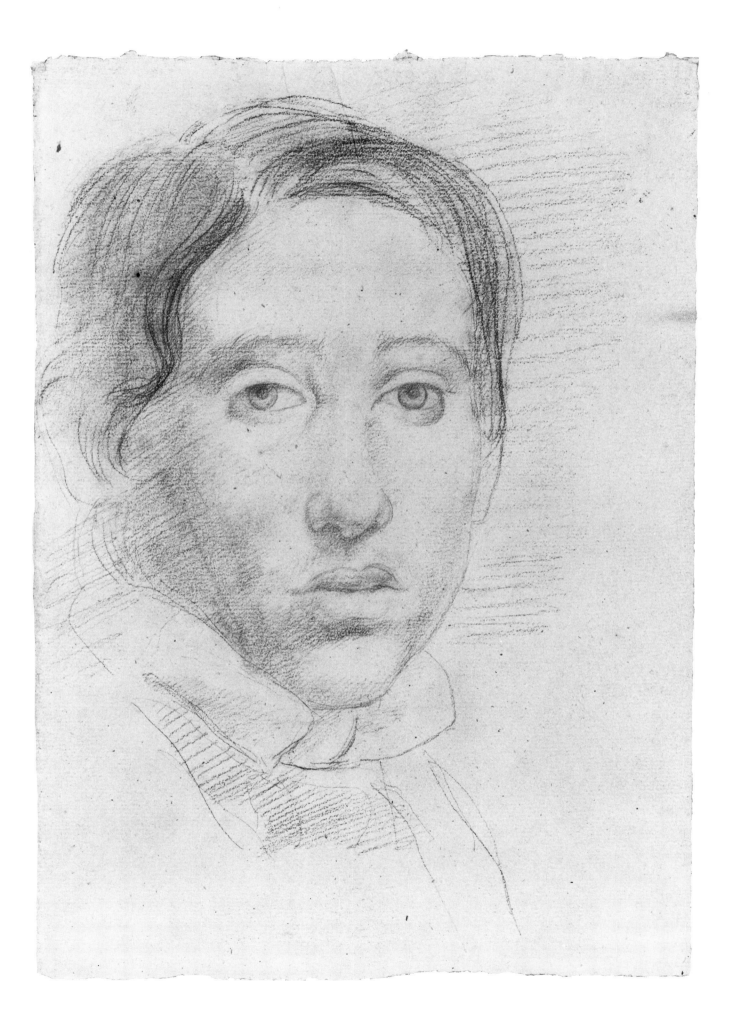

1 *Self-portrait* 1854

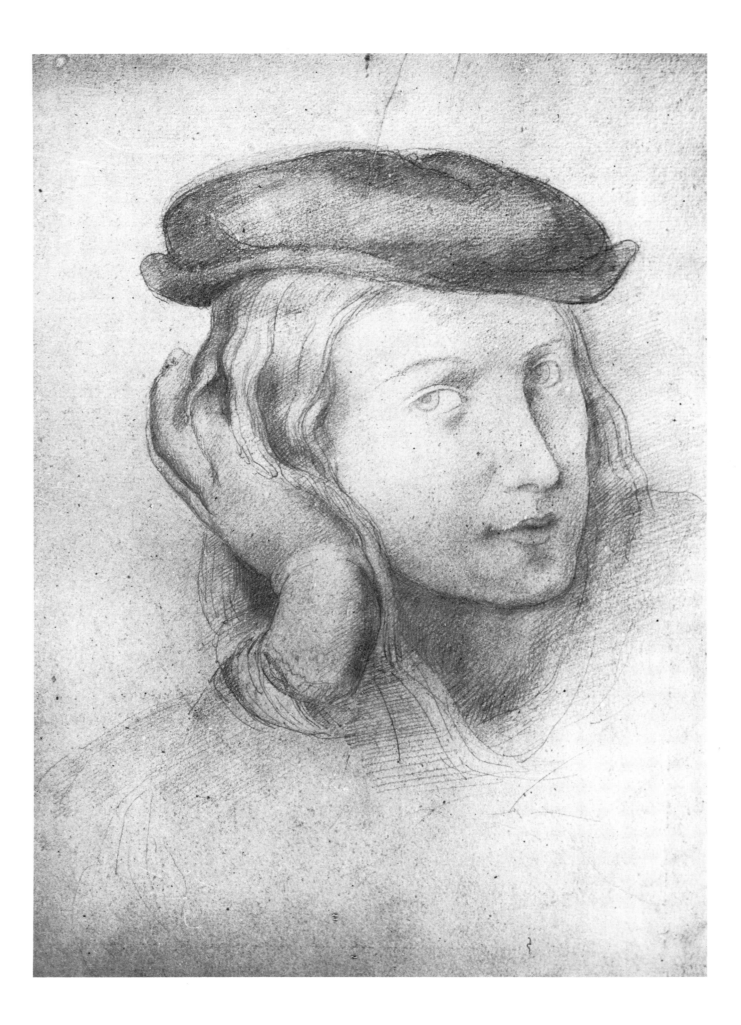

1 (back) *Portrait Study after Bacchiacca* 1854

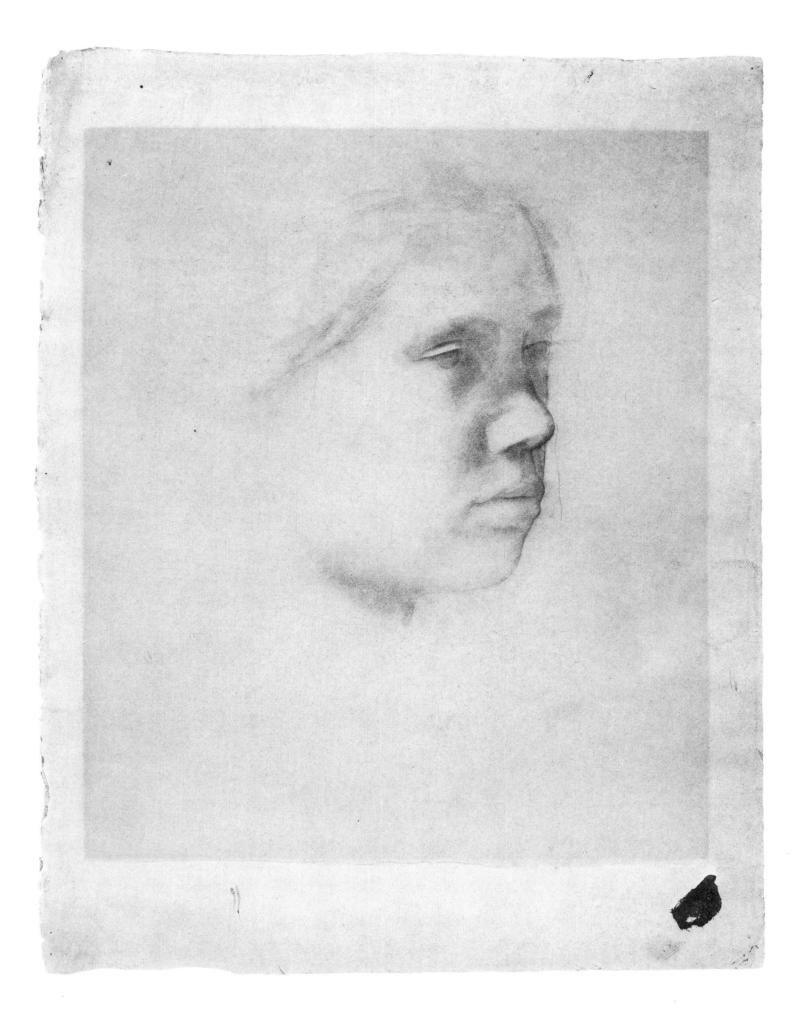

2 *René de Gas*(?) 1854

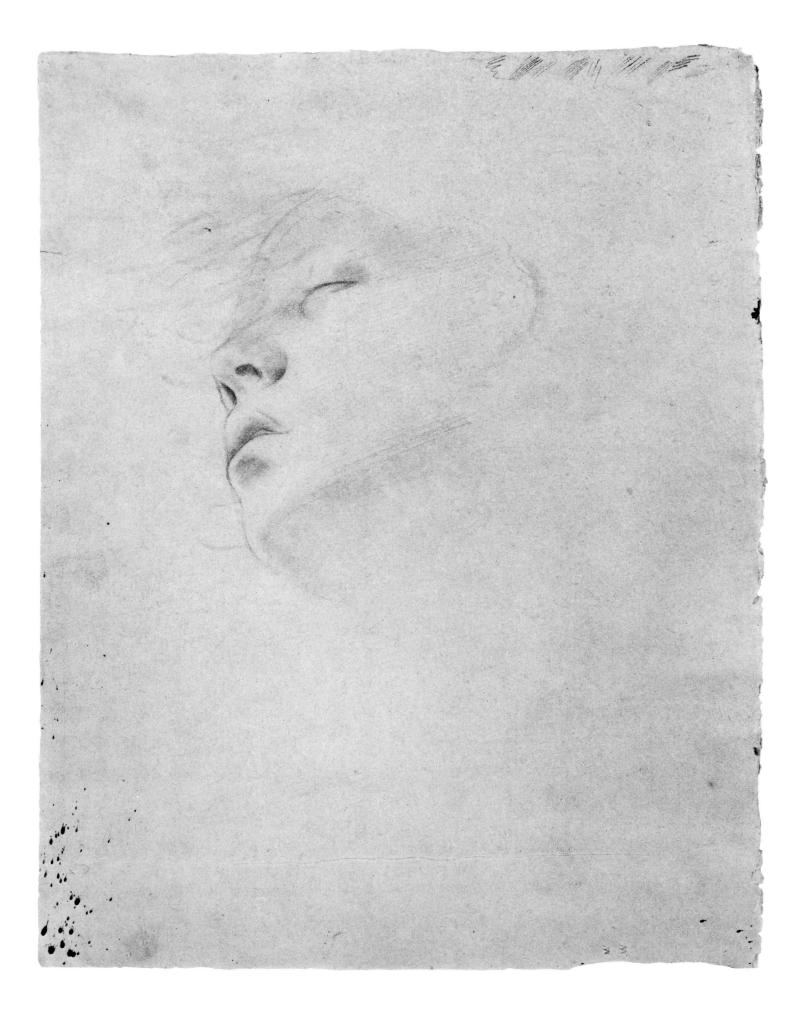

2 (back) *René de Gas*(?) 1854

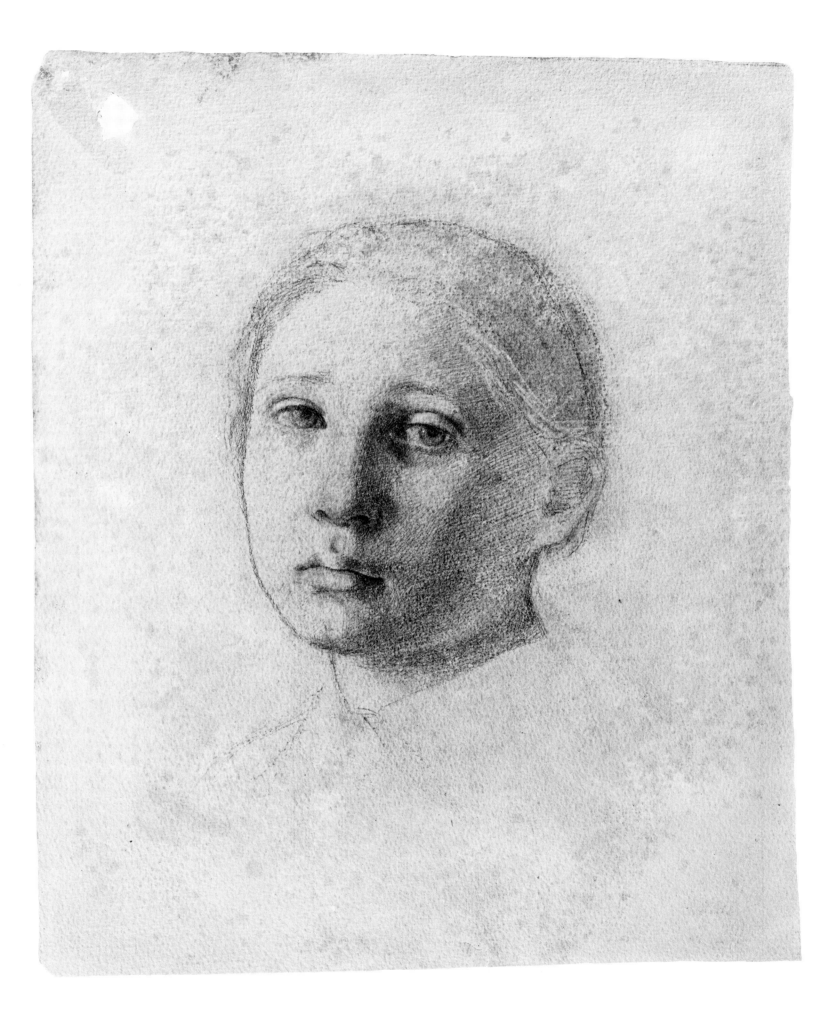

3 *Marguerite de Gas* 1854

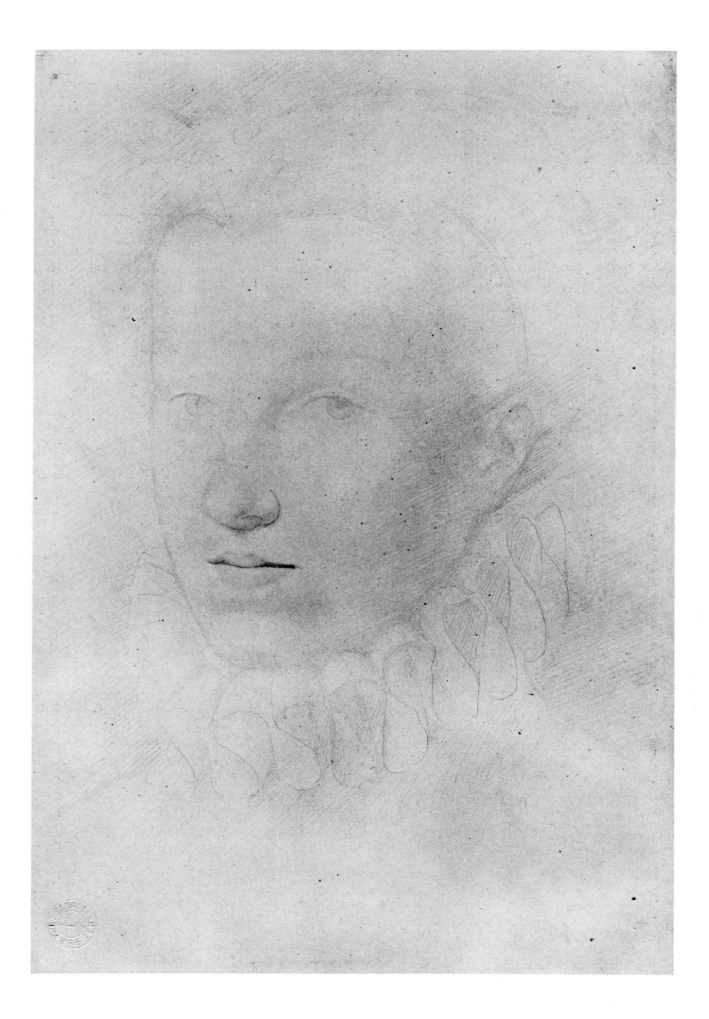

4 *Portrait Study after a French Portraitist 1854–5*

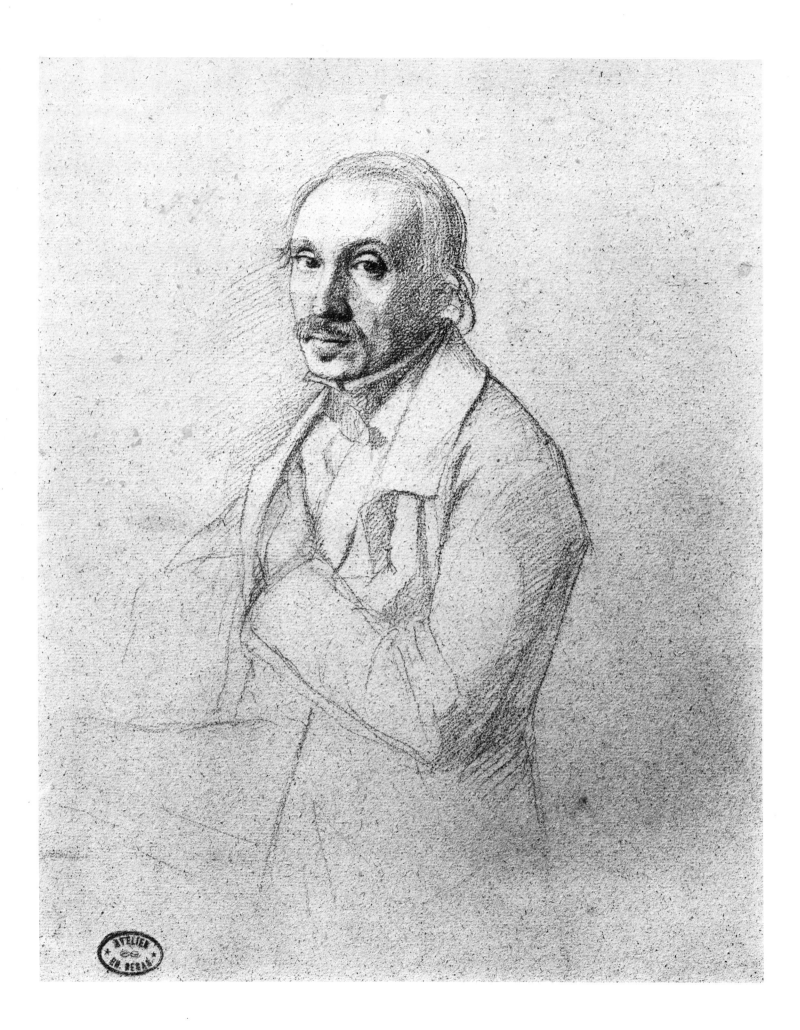

5 *Auguste de Gas* circa 1855

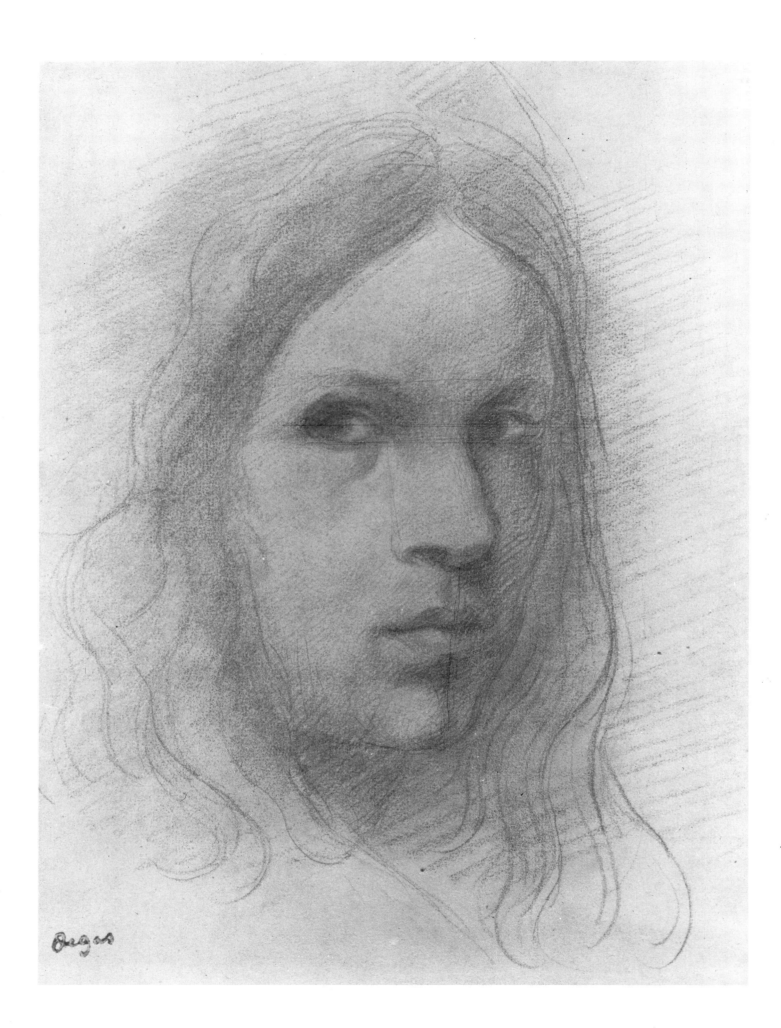

6 *Study of Head after Raphael* 1854–5

7 *Portrait Study after Gentile Bellini* 1854–5

NEPVEU
DEGAS

8 *Study after an Etruscan Head-shaped Pot* 1854–5

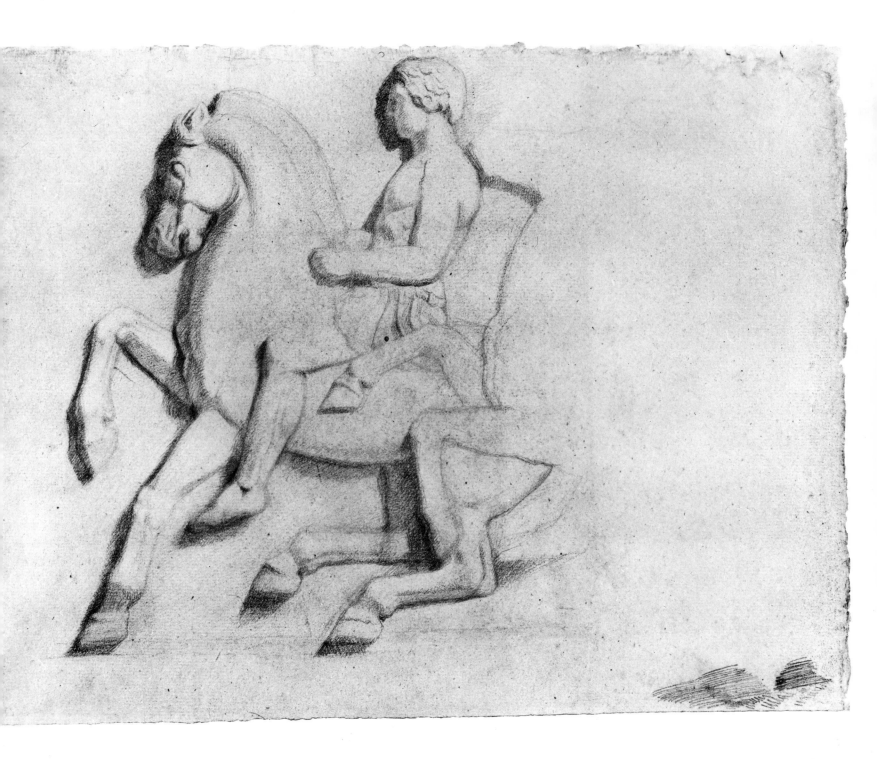

9 *Study after a Rider from the Parthenon Frieze* 1855

10 *Study after a Doorkeeper at the Palace of Assurnasirpal III 1854–5*

NEPVEU
DEGAS

11 *Study after an Antique Head of a Youth, Studies of Legs and Foot* 1854–5

12 *Studies after an Antique Head, Studies of Legs and Feet* 1854–5

21 *Dante* 1857

21 (back) *Drapery Study* 1857

22 *John the Baptist* 1857

22 (back) *Angel Blowing a Trumpet* 1857

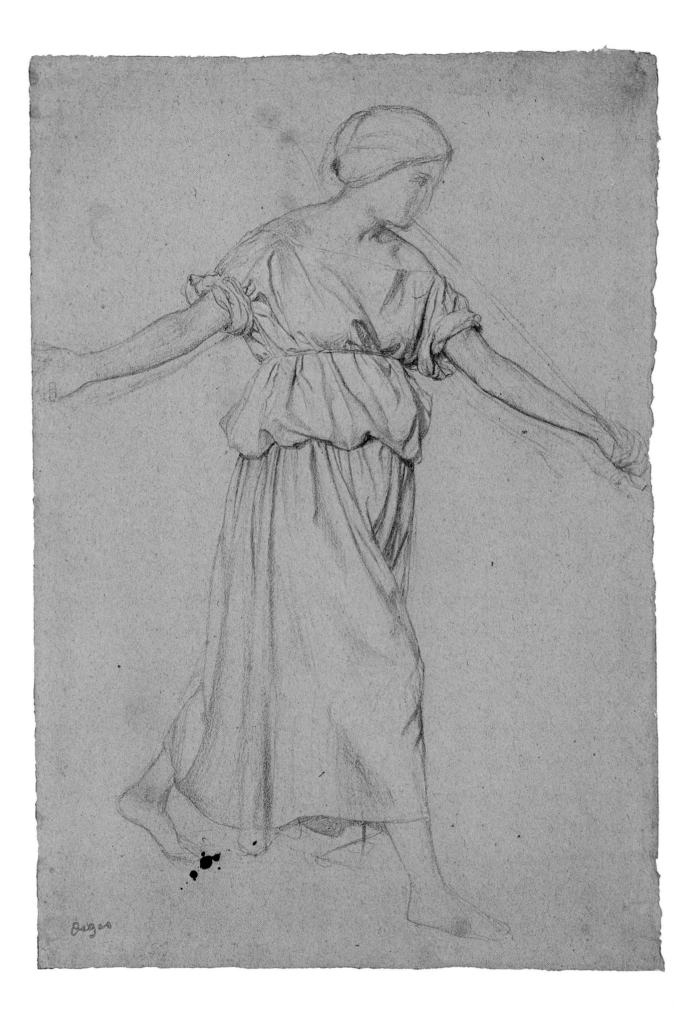

23 *Angel Blowing a Trumpet* 1857

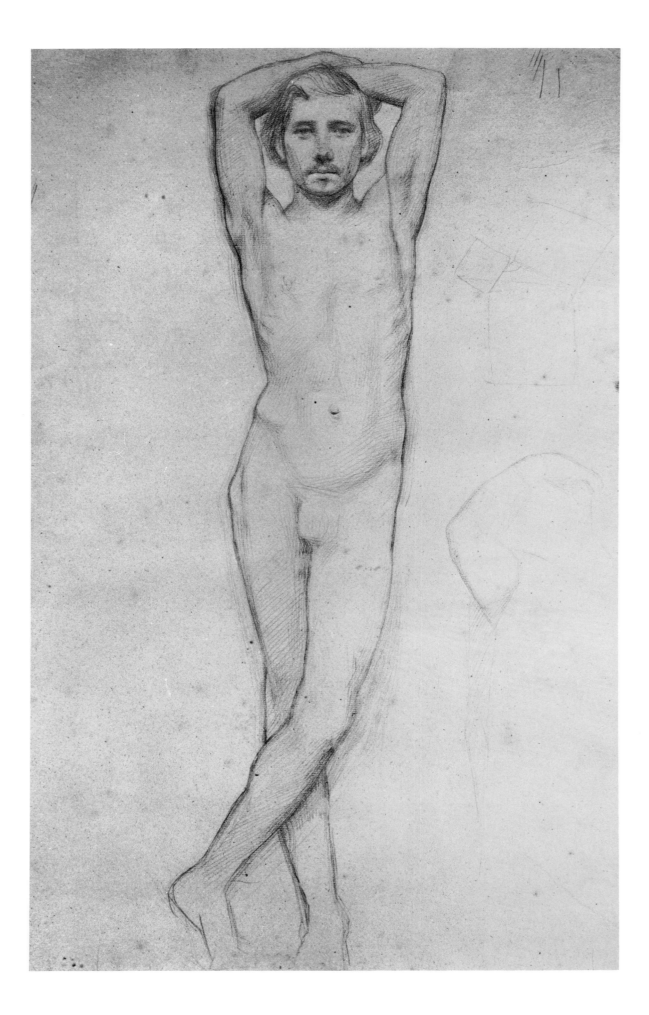

24 *Nude with Arms Crossed Behind Head* circa 1857

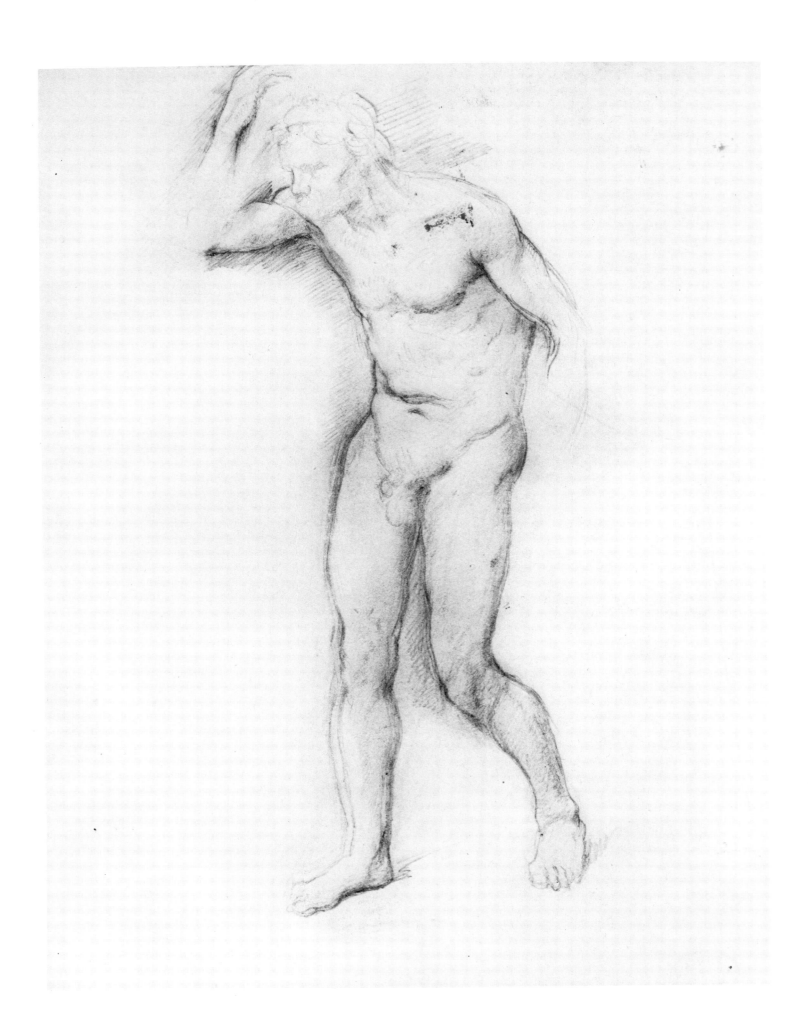

25 *Nude Stepping Forward* circa 1857

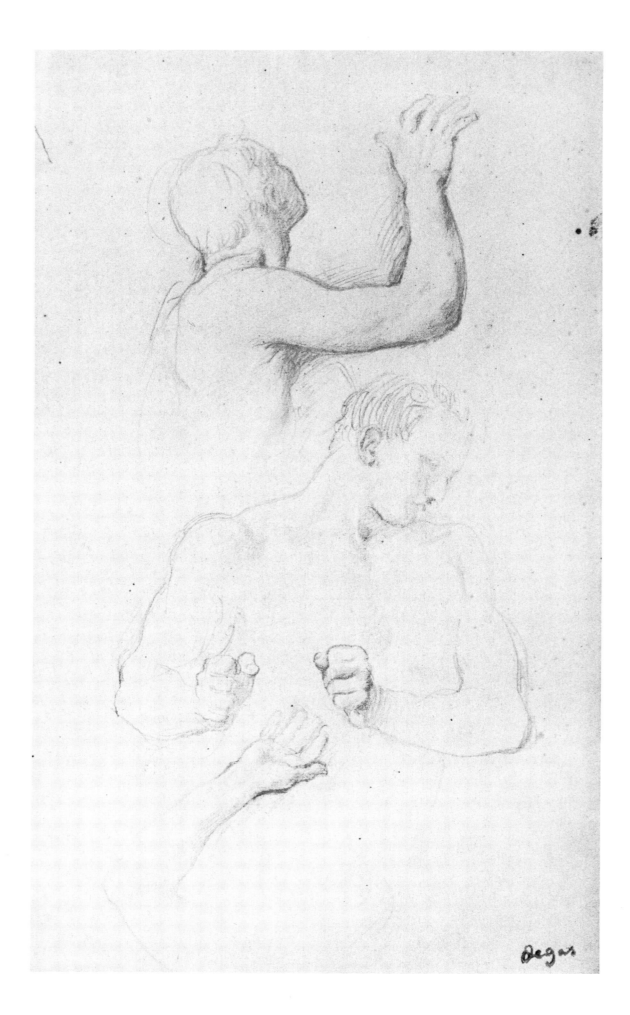

26 *Roman Prizefighter* circa 1857

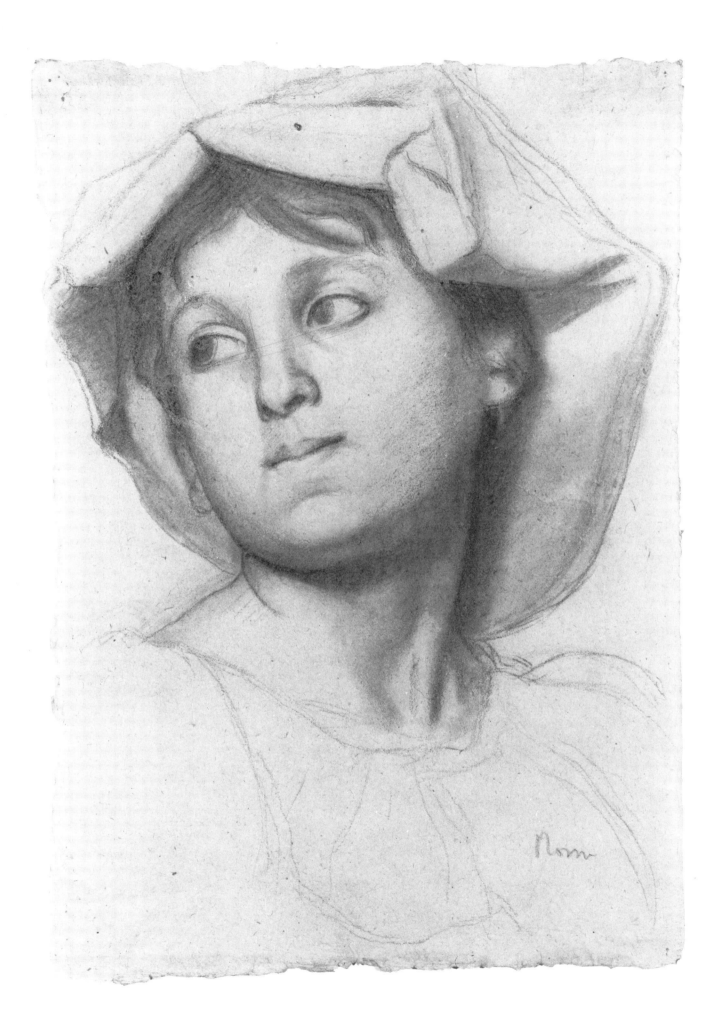

27 *Young Roman Woman* circa 1857

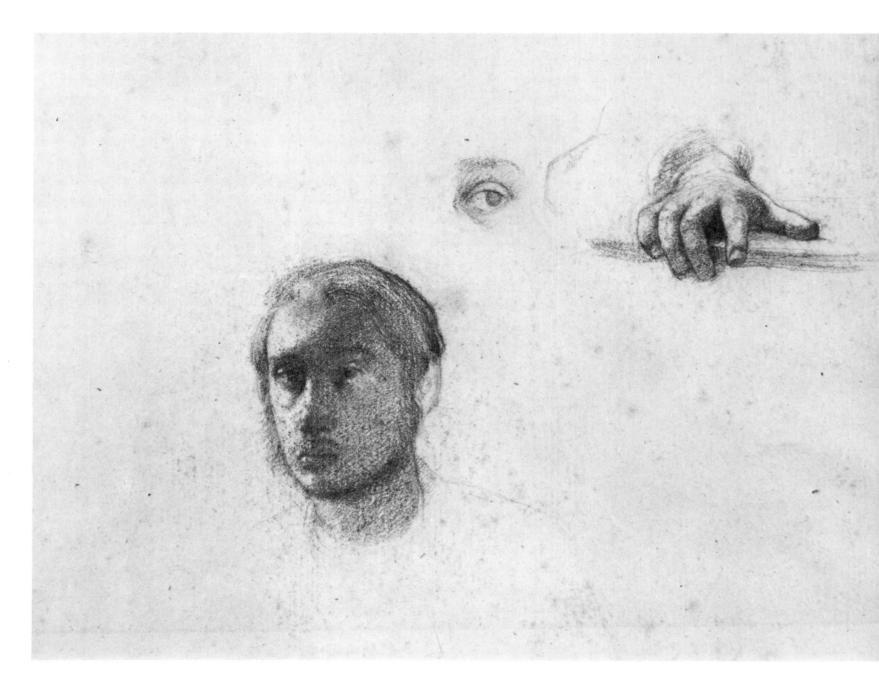

28 *Self-portrait and Studies of Details* circa 1857

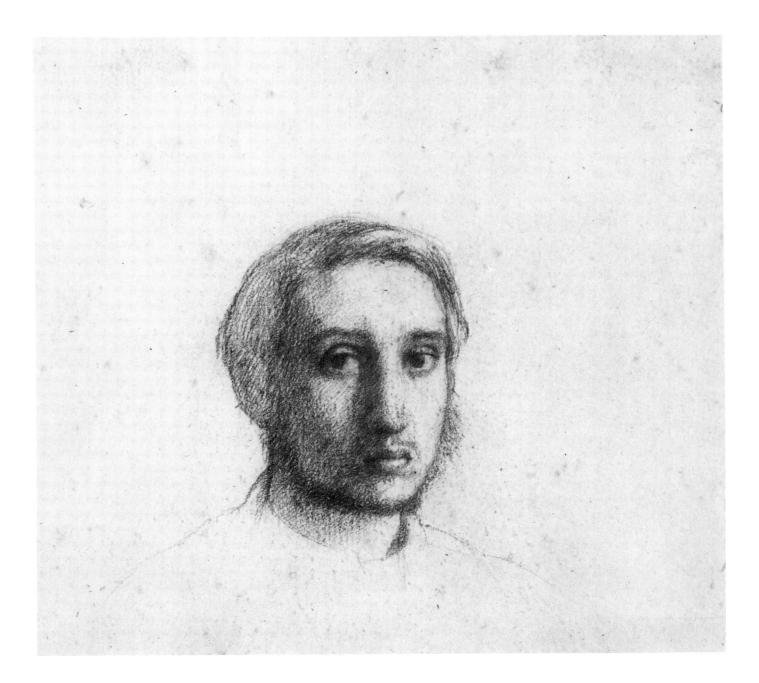

29 *Self-portrait* circa 1857

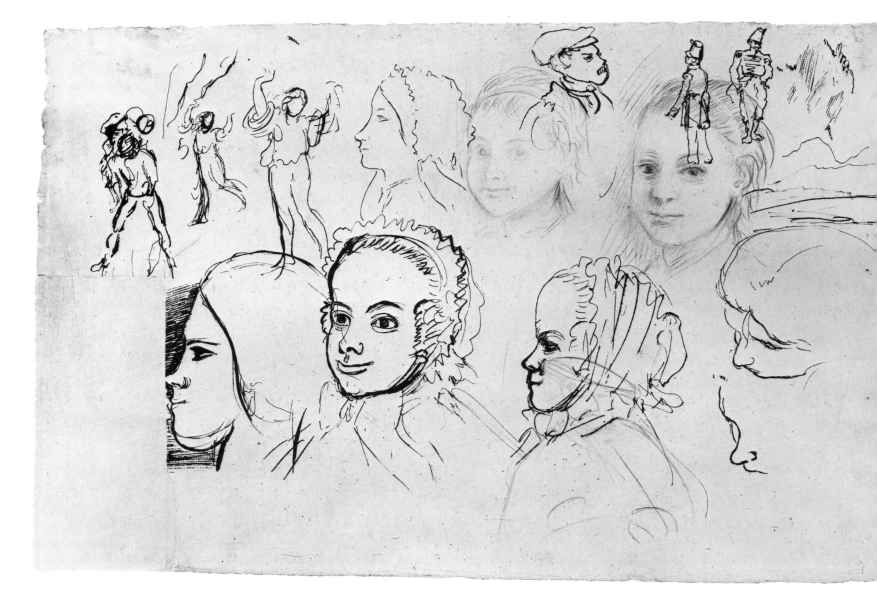

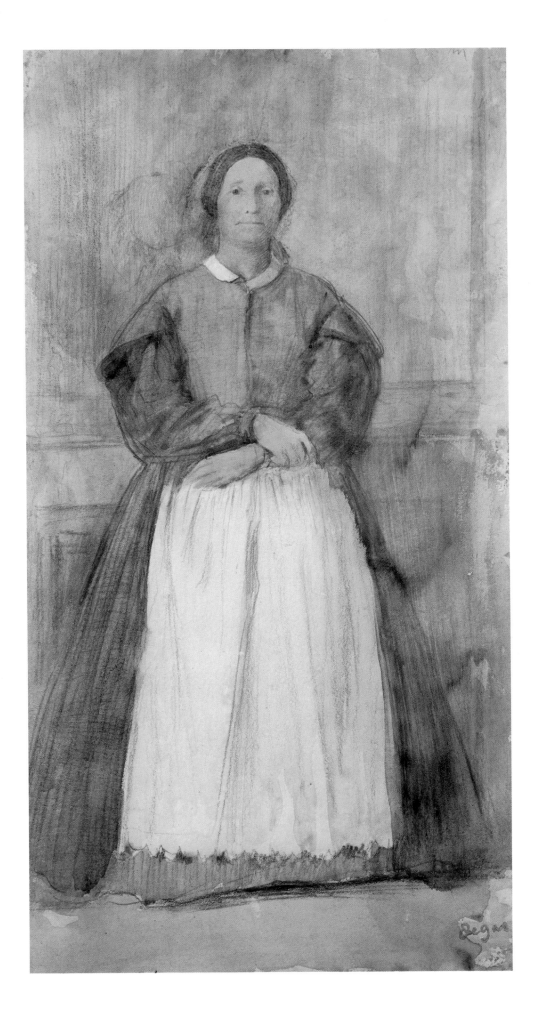

31 *Rosa Adelaida Morbilli* 1857

Ulysse
domestique de
monsieur Bellelli
Florence 1859

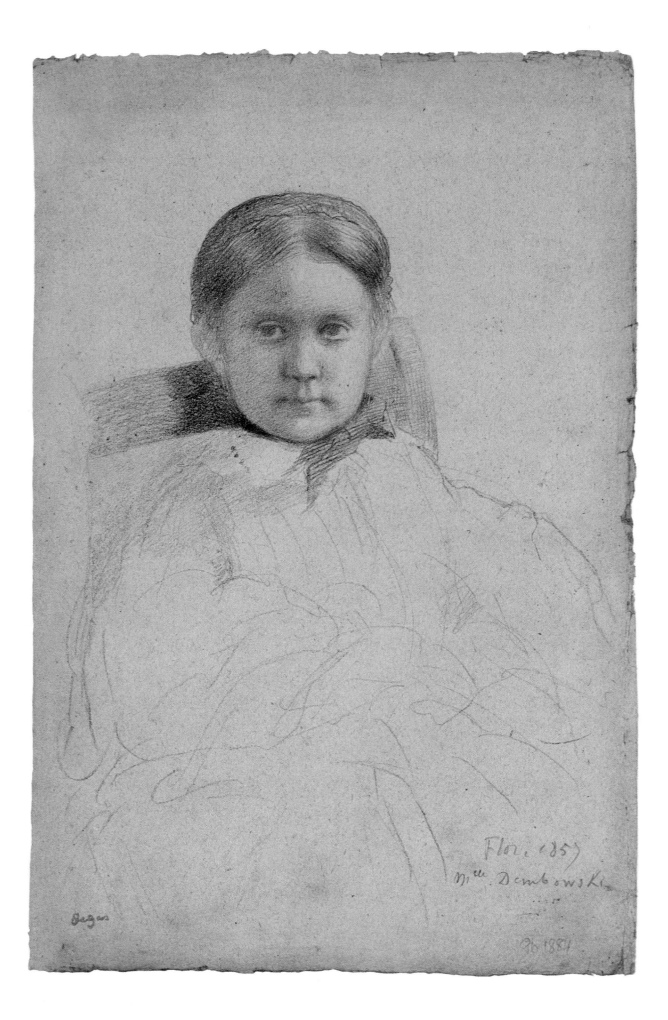

33 *Mlle Dembowski 1858–9*

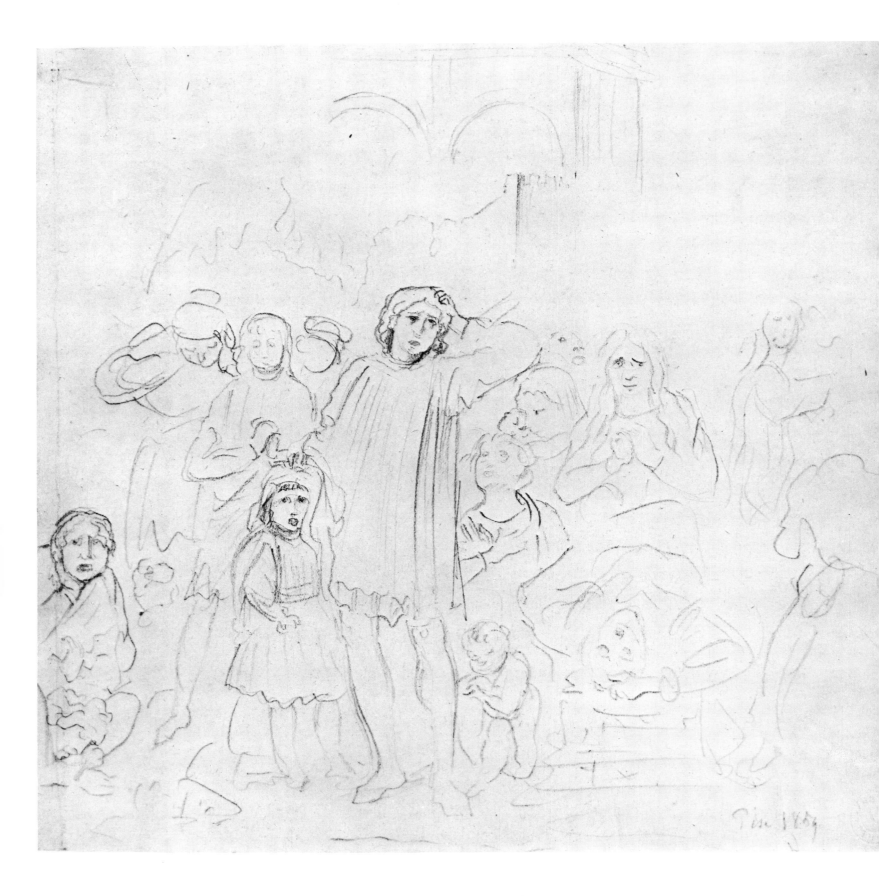

34 *Study after Detail from Benozzo Gozzoli* 1859

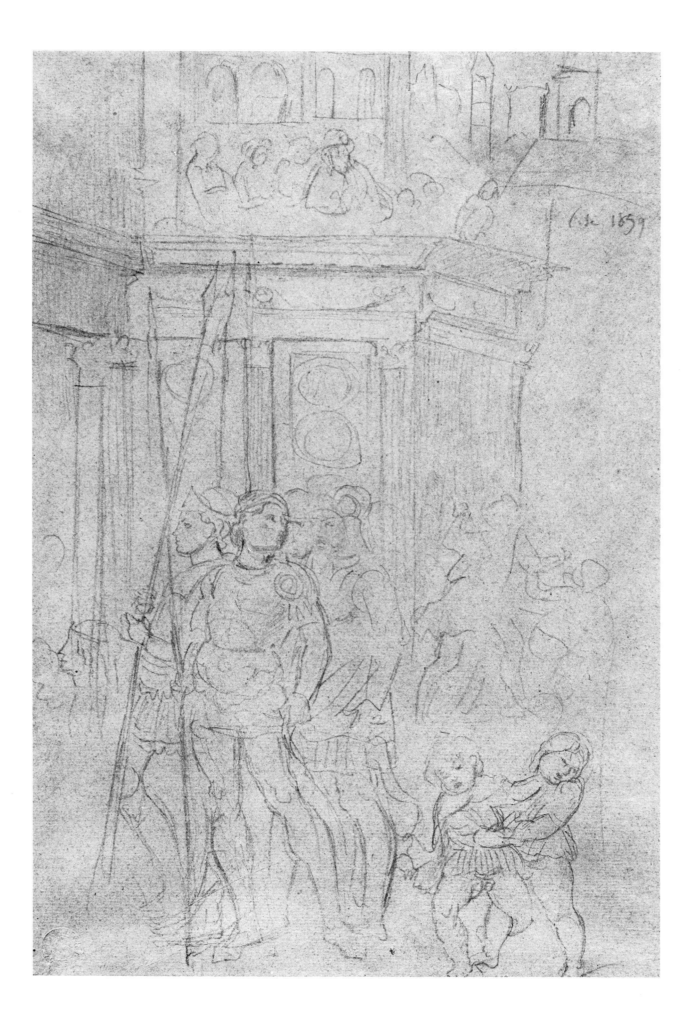

35 *Study after Detail from Benozzo Gozzoli* 1859

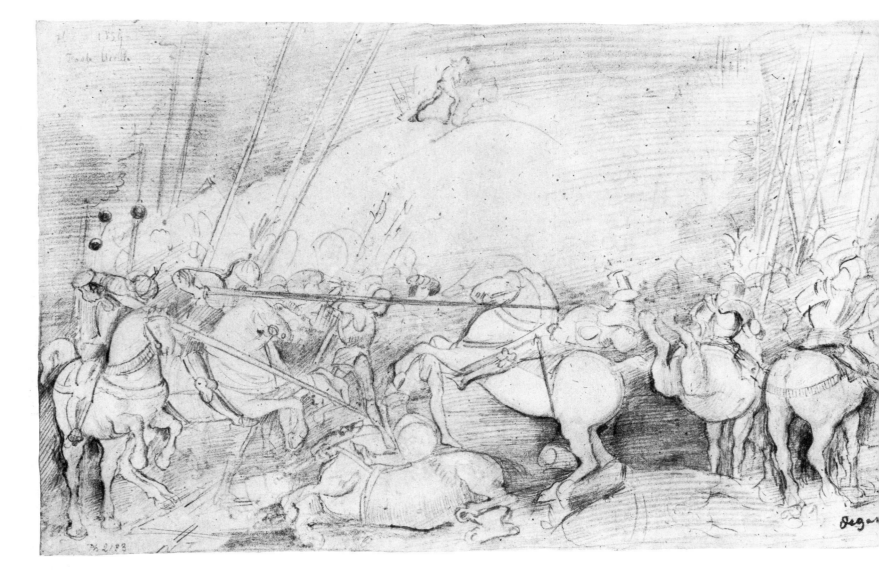

36 *Compositional Study after Uccello* 1859

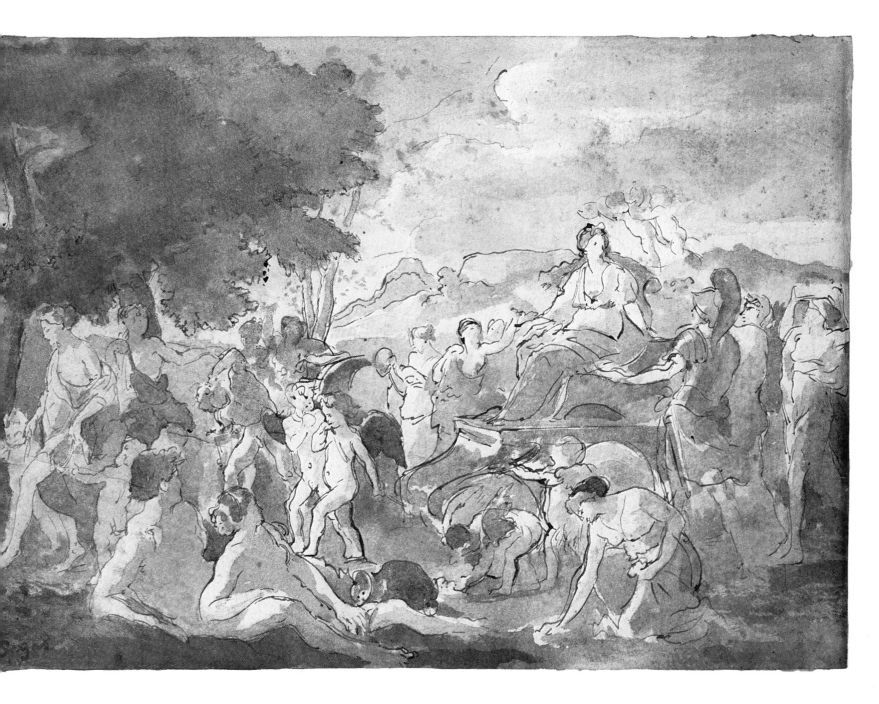

37 *Compositional Study after Poussin* circa 1860

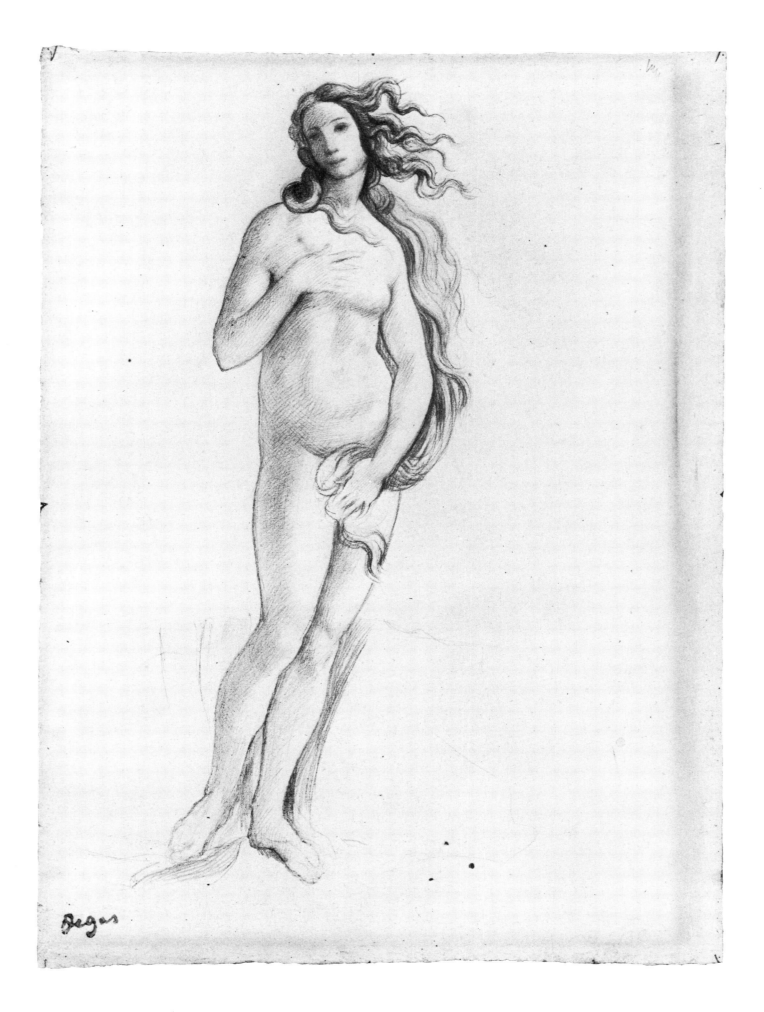

38 *Figure Study after Botticelli* 1858–9

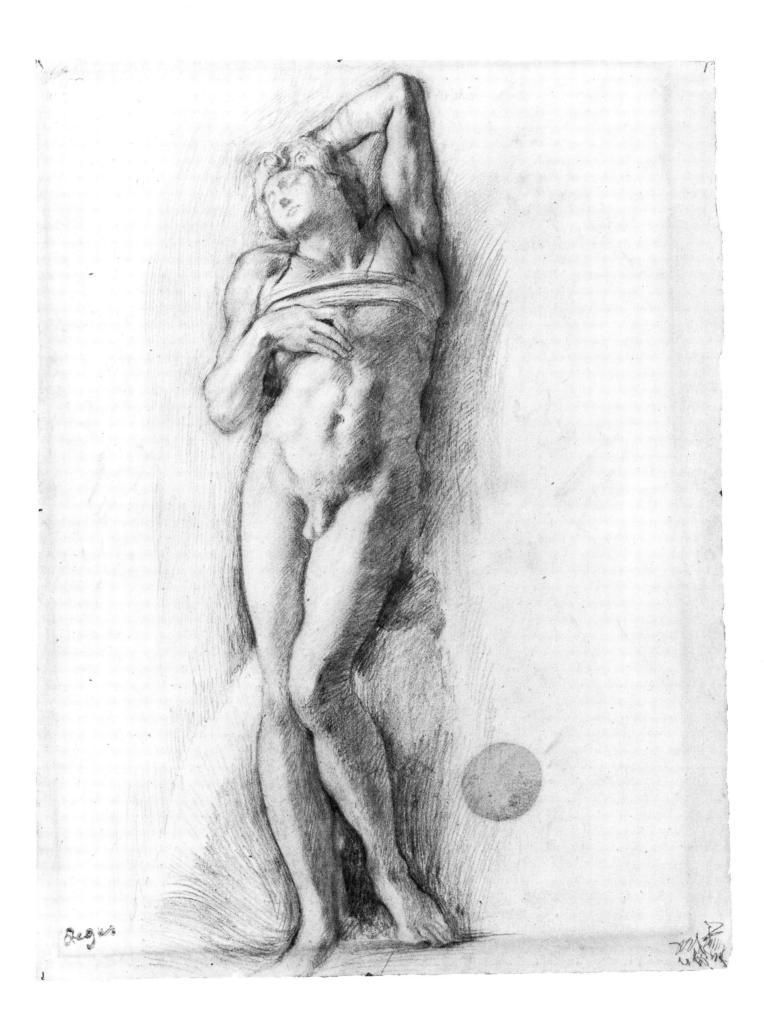

39　*Figure Study after Michelangelo* 1859–60

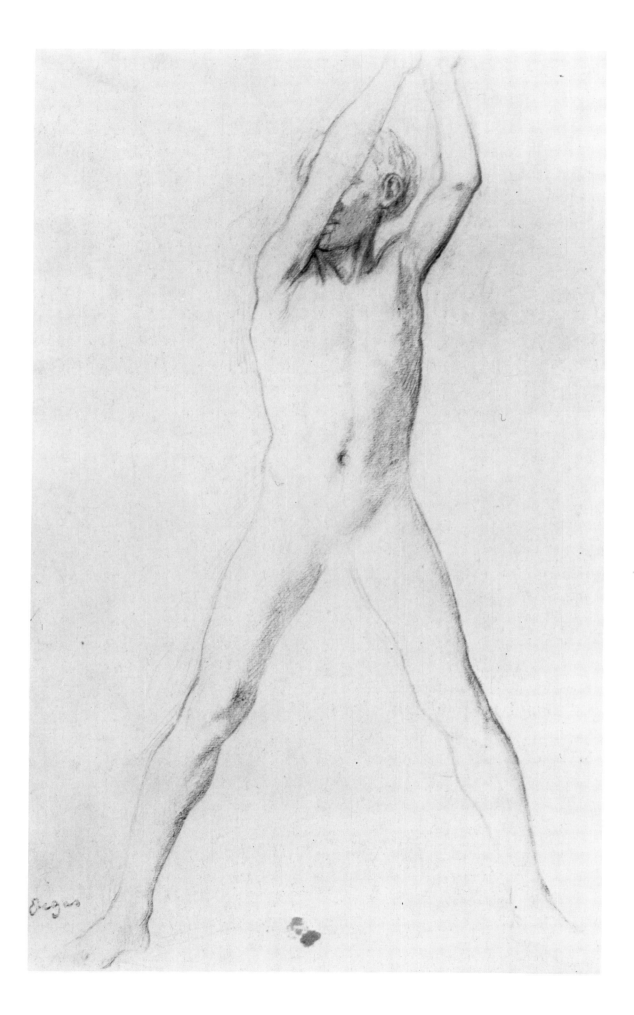

40 *Nude with Arms Raised and Legs Straddled* 1859–60

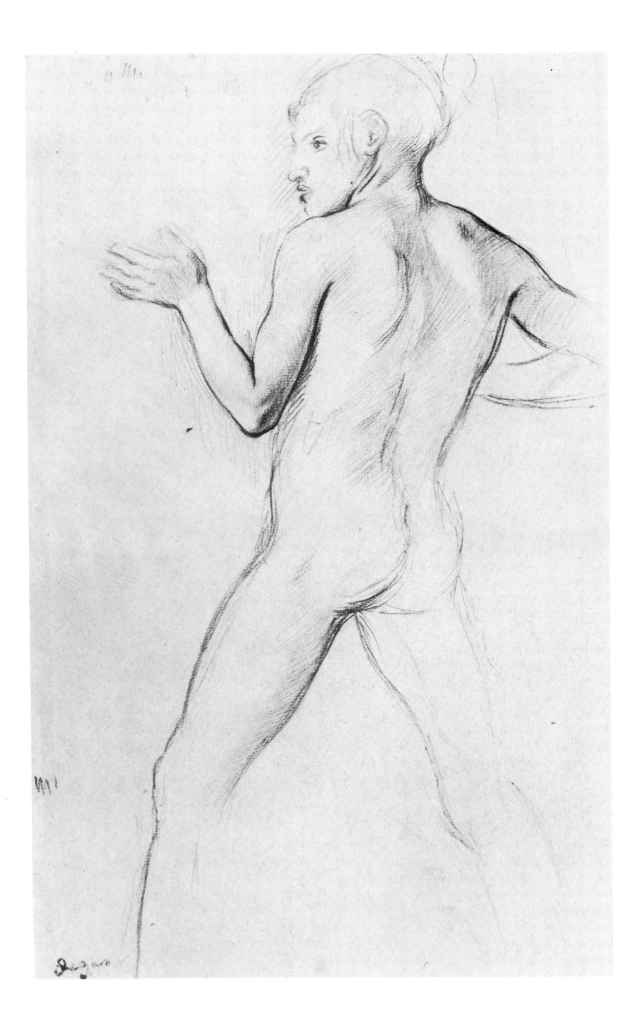

41 *Nude in Profile with Legs Straddled* 1859–60

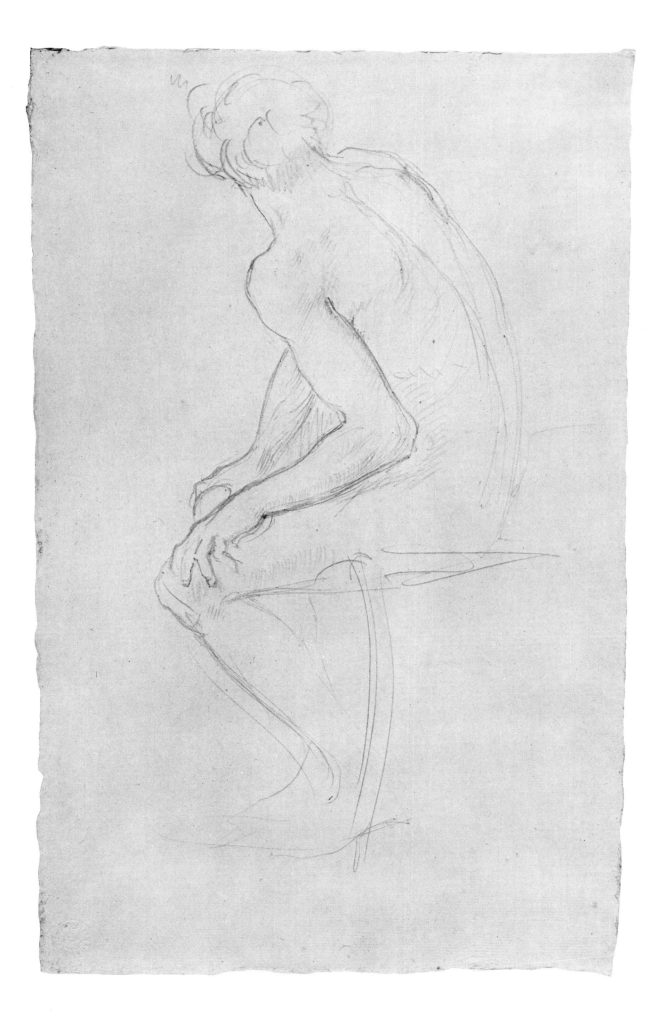

42 *Seated Nude from the Back* circa 1860

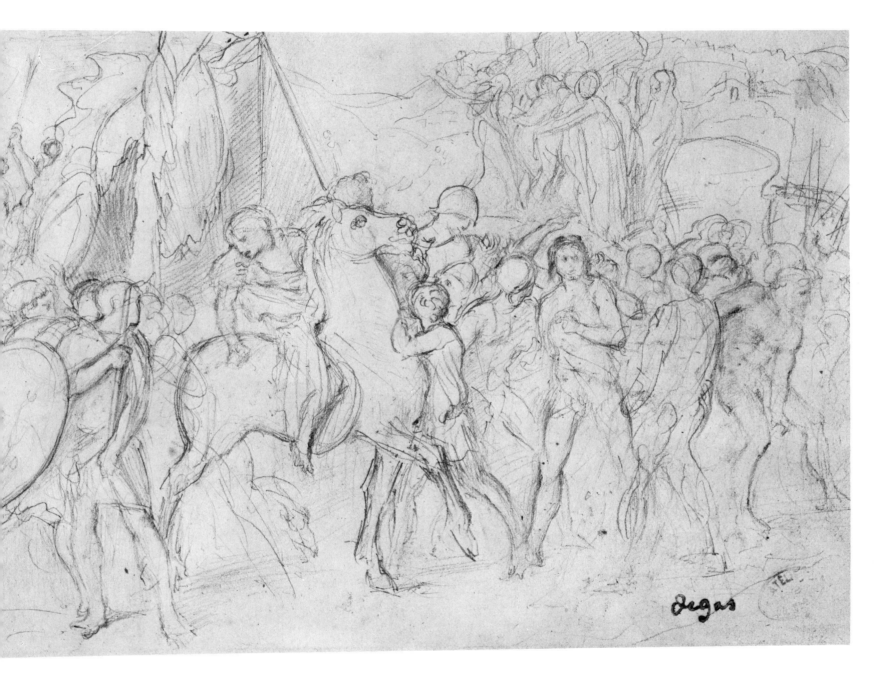

43 *Jephtha's Daughter* 1859–60

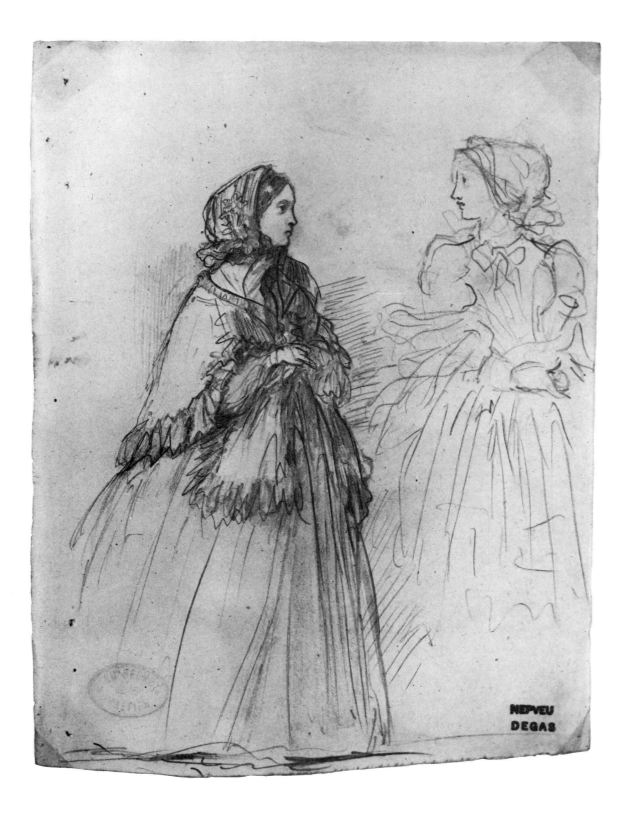

44 *Two Young Ladies in Street Dress* 1859–60

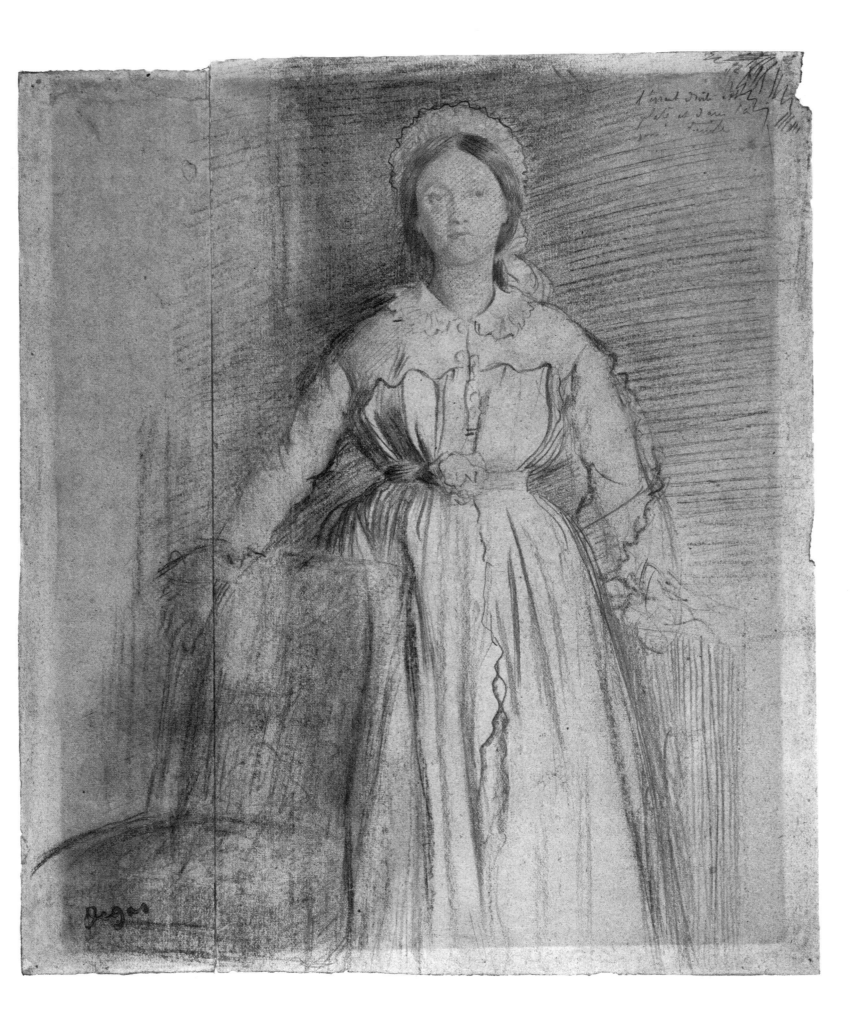

45 *Marguerite de Gas* 1859–60

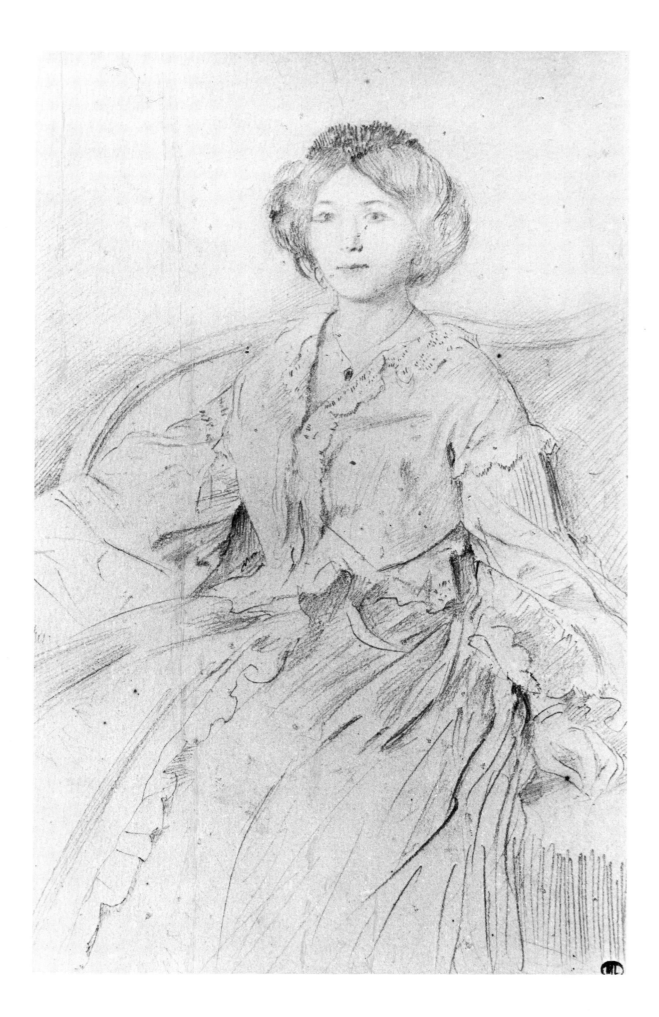

46 *Hélène Hertel* circa 1860

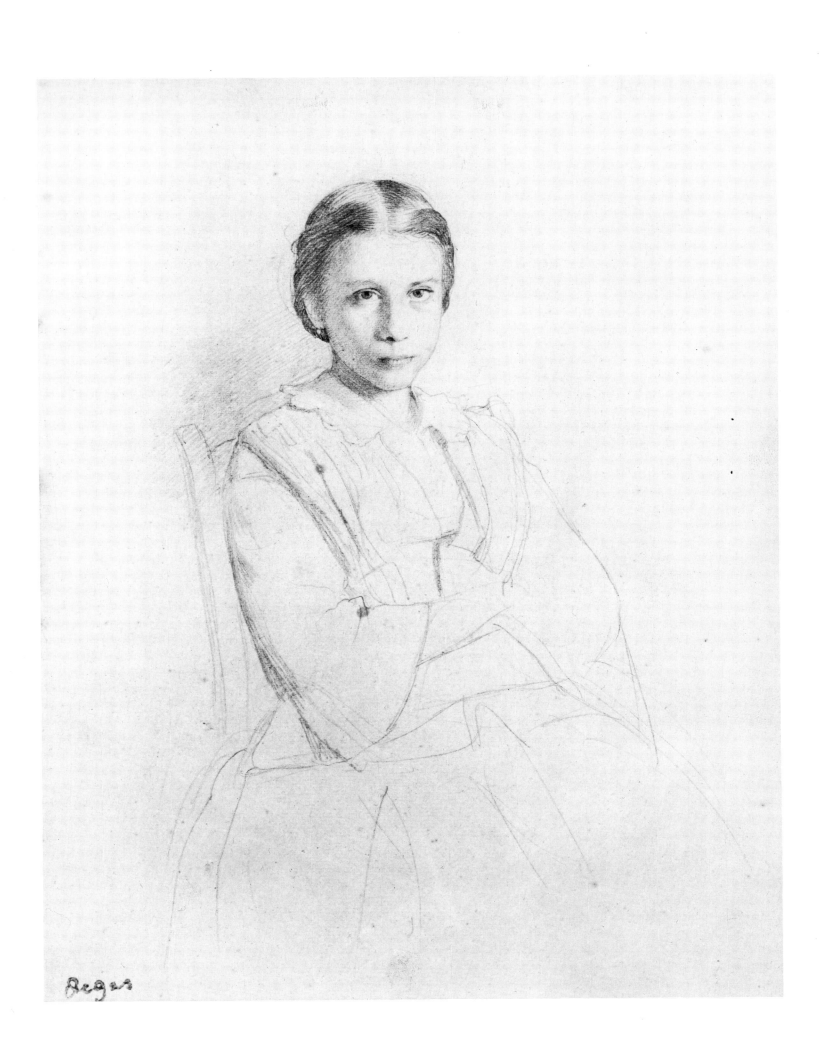

47 *Young Woman Seated with Arms Folded* circa 1860

48 *Standing Horse* 1861–3

Degas

49 *Rider on Standing Horse*

50 *Three Studies of Horses' Hind Legs* 1861–3

51 *Portrait of Rider* 1863–5

NEPVEU
DEGAS

52 *Study of Drapery* 1863–5

53 *Marie Thérèse Morbilli* 1865–7

Degas
1863

Mme Jules Bertin

54 *Julie Burtey* 1863–7

Mme Julie Burtey

Degas

55 *Julie Burtey* 1863–7

56 *Four Willow Trees* 1864–5

57 *Edouard Manet Seated* circa 1865

Degas

58 *Edouard Manet at the Races* 1865–8

59 *Achille de Gas* 1865–6

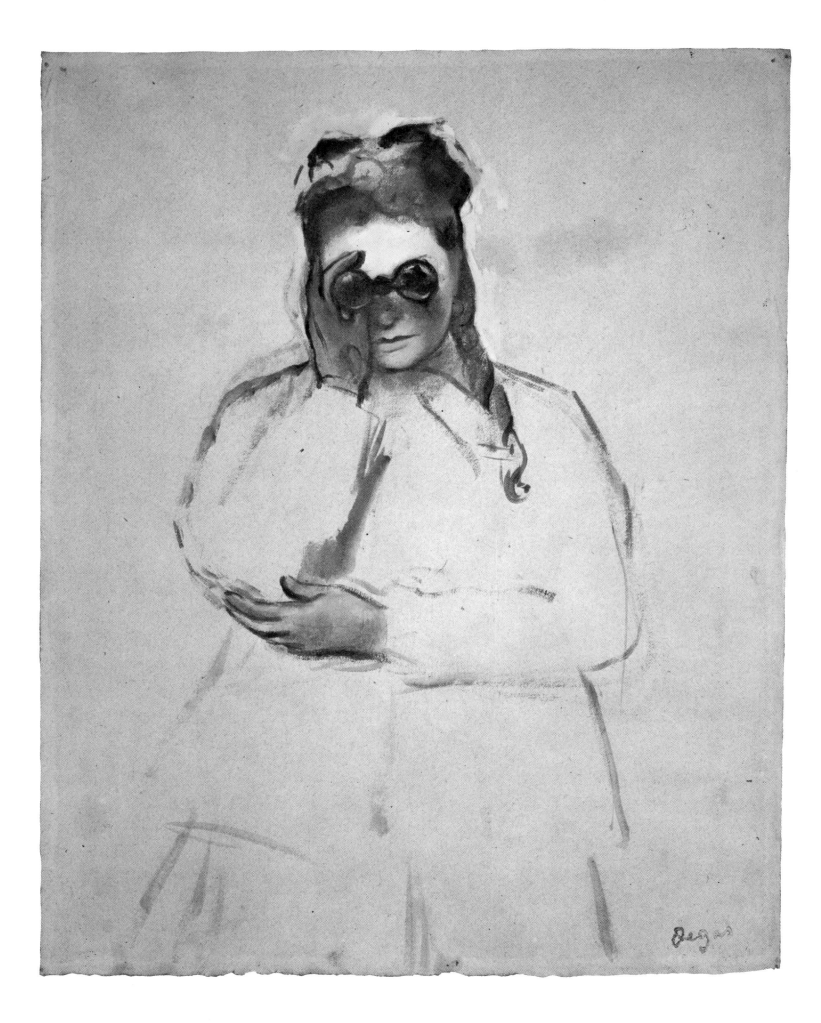

60 *Lady with Binoculars* circa 1865

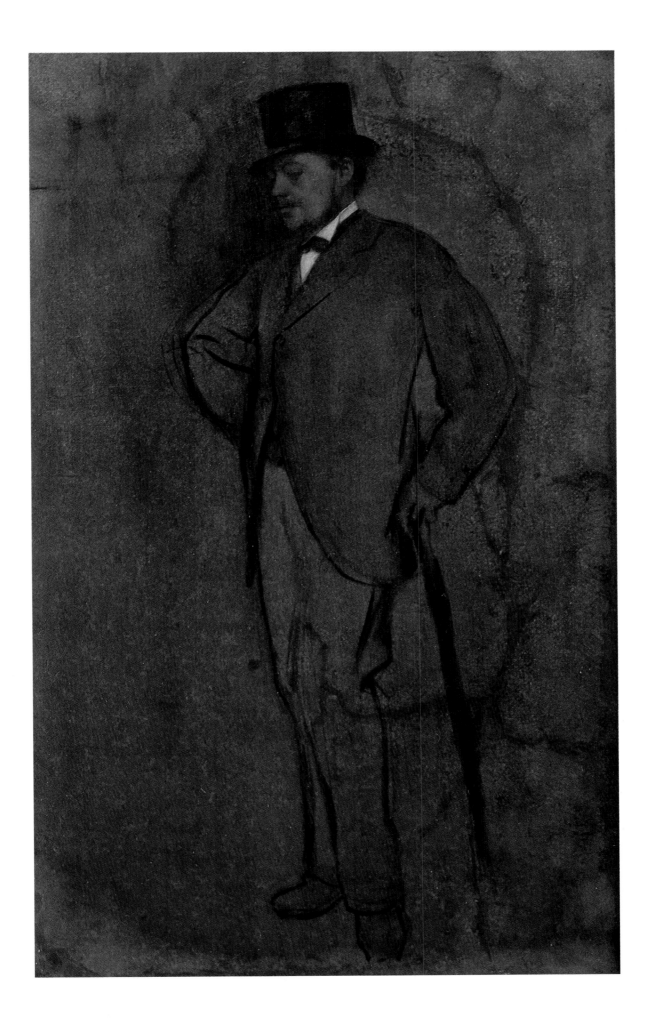

61 *Achille de Gas* 1865–6

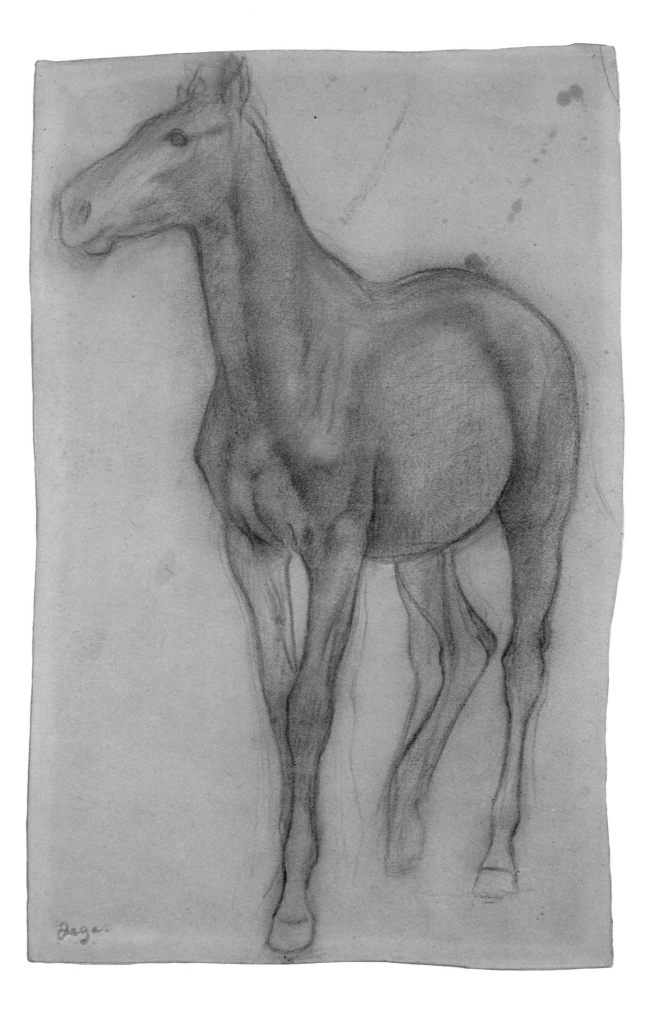

62 *Horse Walking* 1866–8

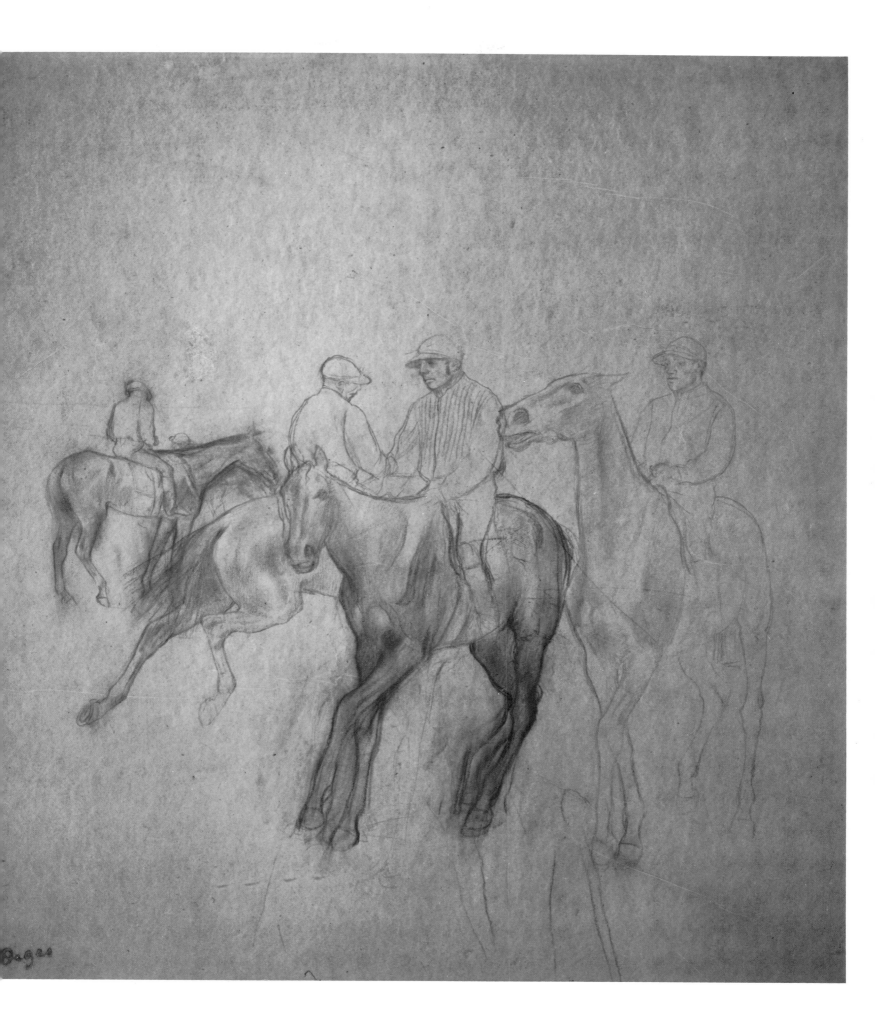

63 *Four Jockeys before the Start* 1866–8

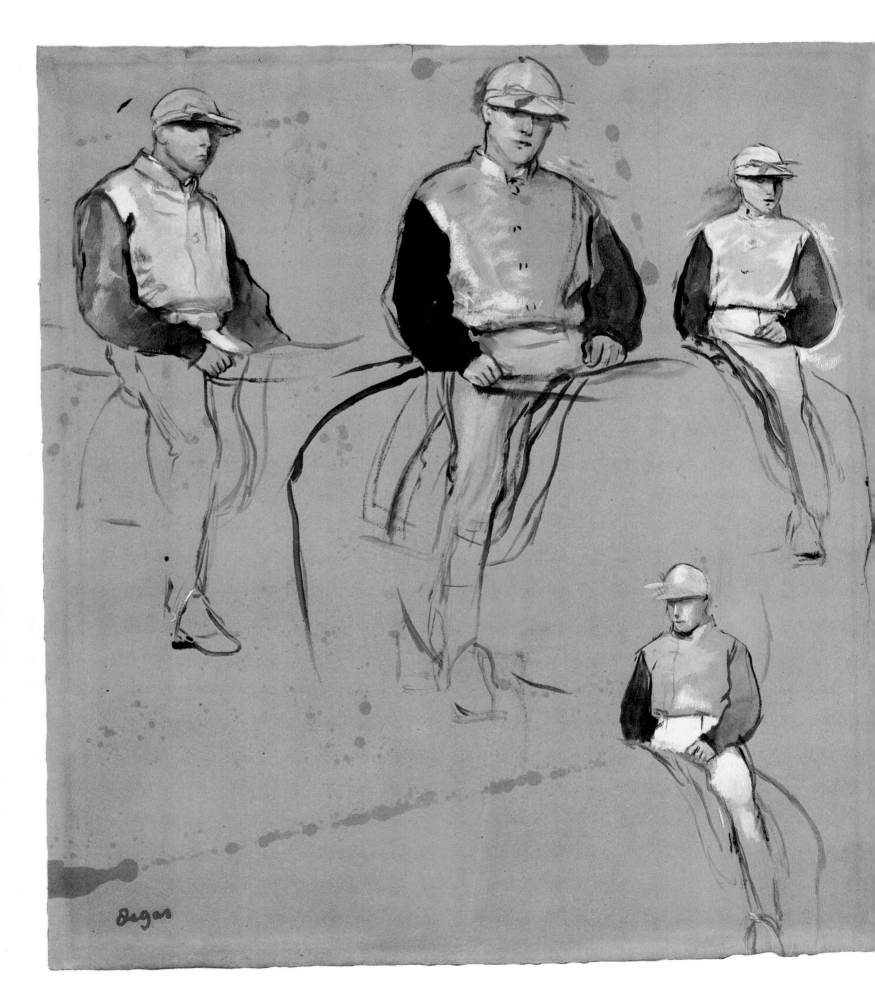

65 *Four Studies of a Jockey* 1866–8

[for pl. 64 see p. 17]

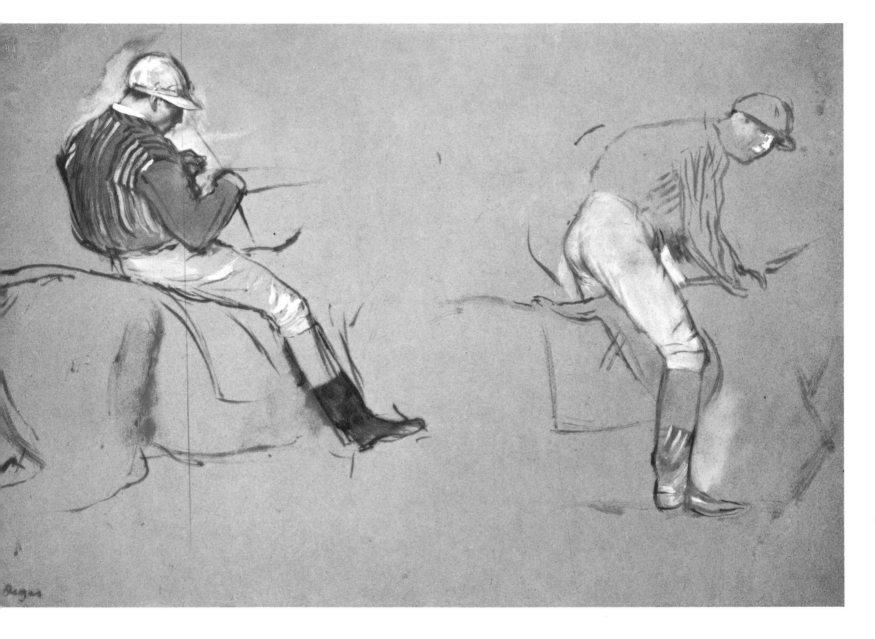

66 *Two Jockeys* 1866–8

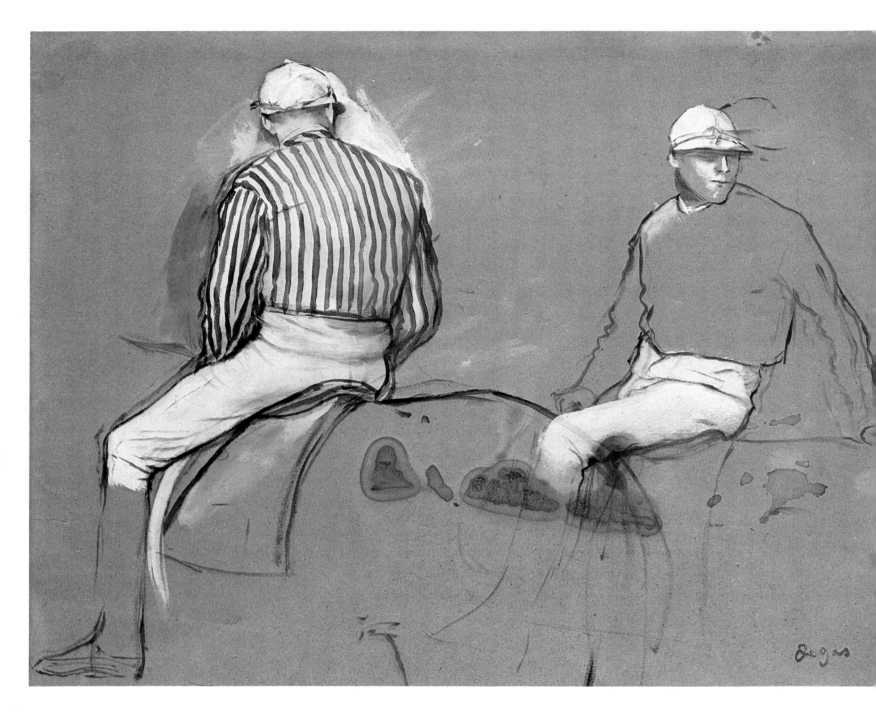

67 *Two Jockeys* 1866–8

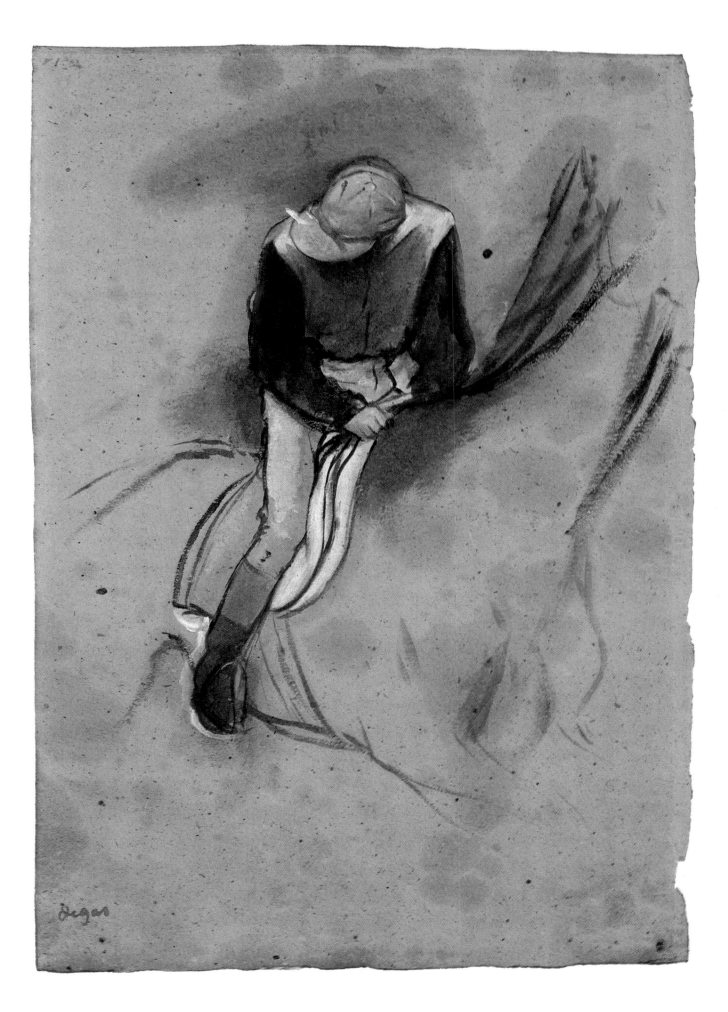

68 *Jockey Leaning Forward and Standing in his Stirrups* 1866–8

69 *Girl with Guitar* circa 1867

70 *Giovanna and Giulia Bellelli* 1865–6

Degas

71 *Marie Lucie Millaudon* 1867

72 *Josephine Gaujelin* 1867

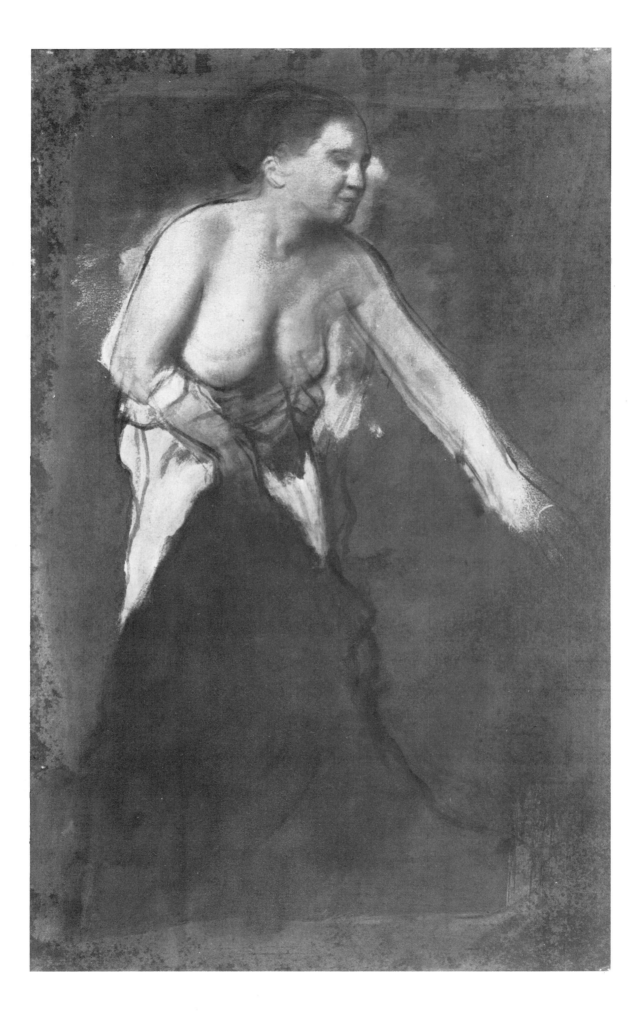

73 *Standing Female Figure with Bared Torso 1867–8*

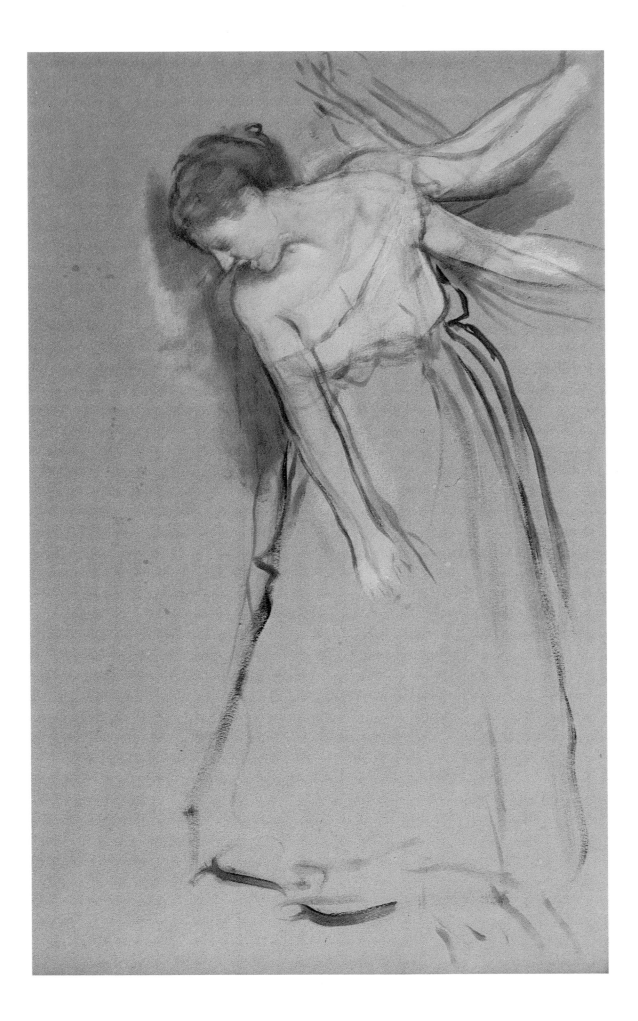

74　*Standing Female Figure with Arms Bent to the Side* 1867–8

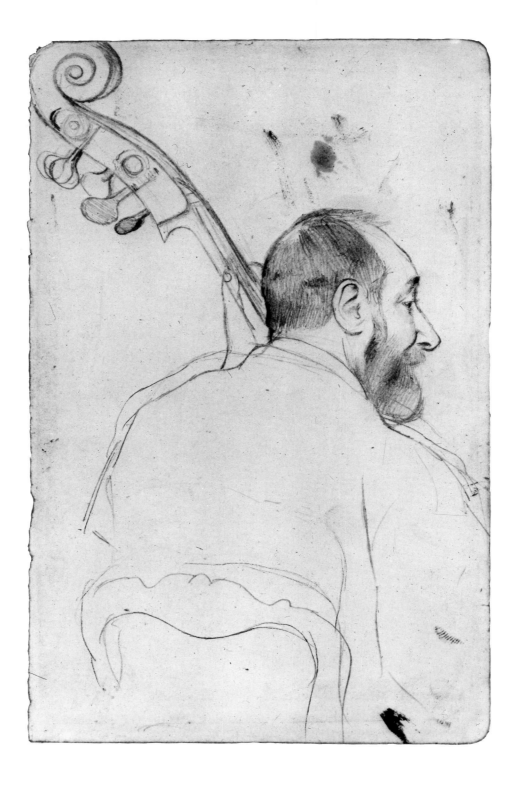

75 *The Double Bass Player M. Gouffé* 1868–9

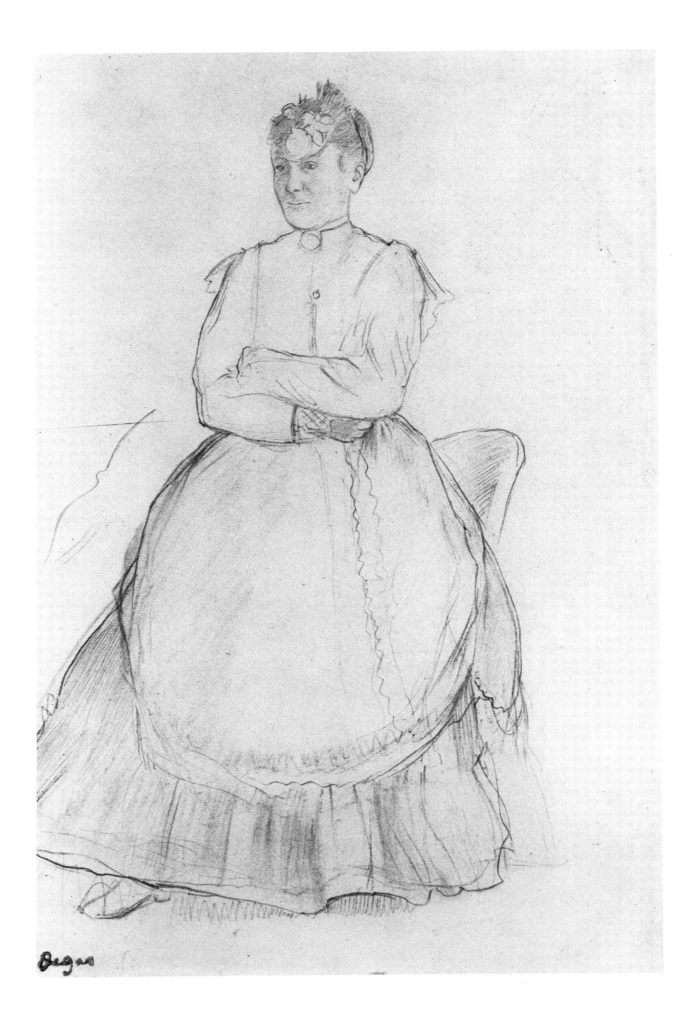

76 *Lady Standing in Front of Easy Chair* 1868–70

77 *Beach at Low Tide* 1869

78 *Strip of Coast at Sunset* 1869

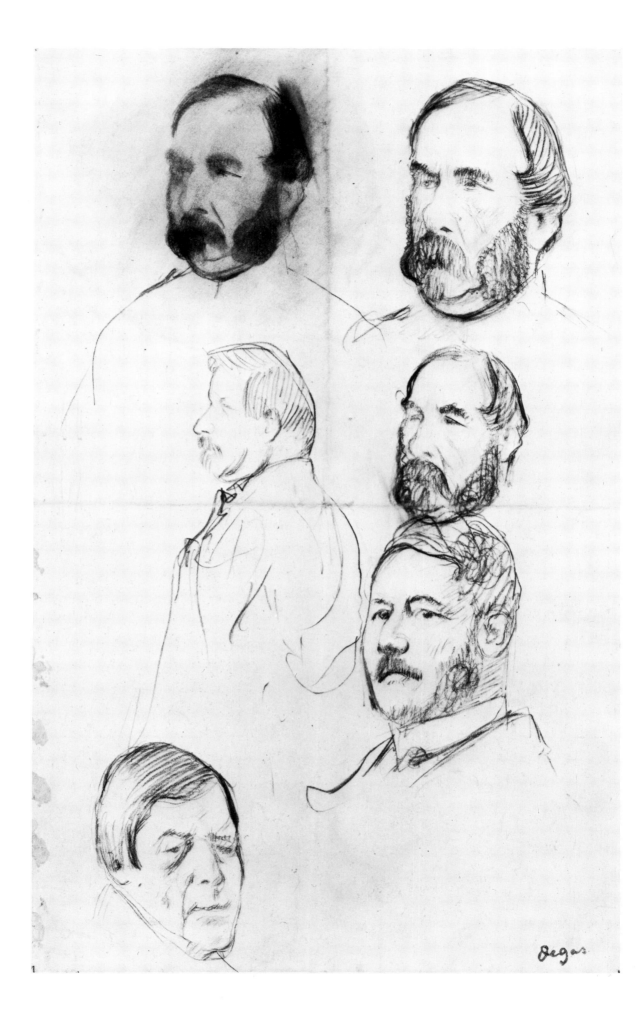

79 *Six Portrait Studies* 1870–71

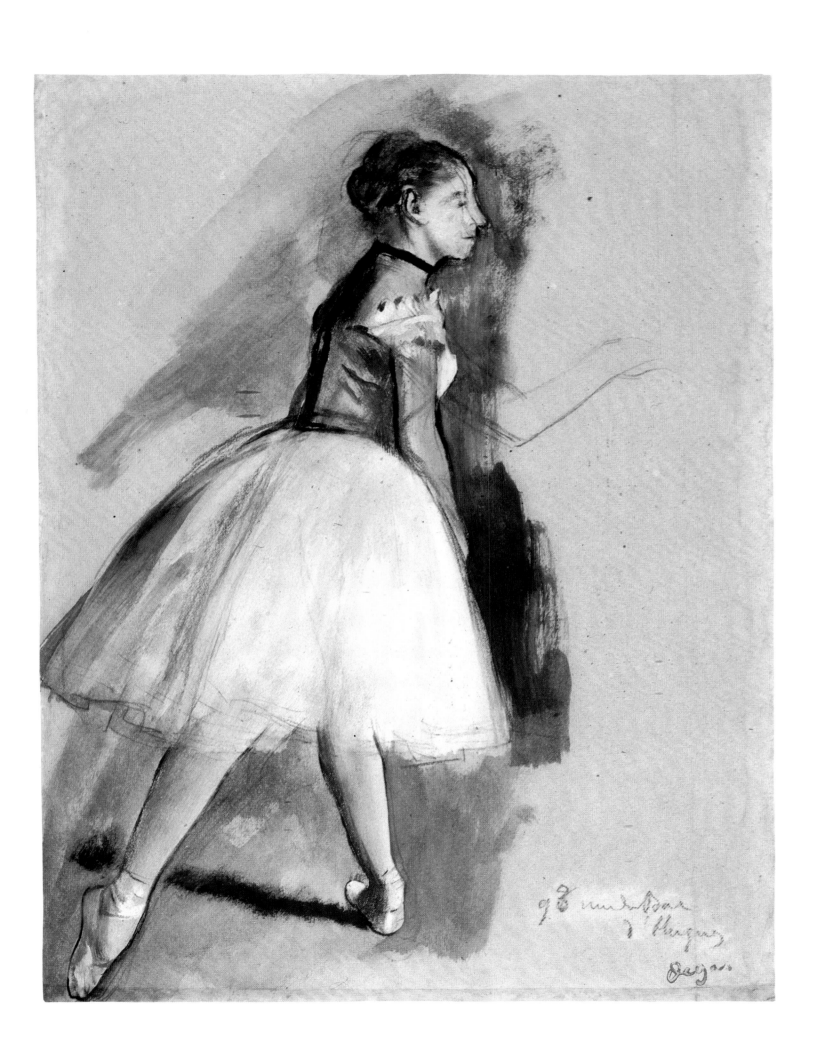

80 *Dancer Poised in Step* 1871–2

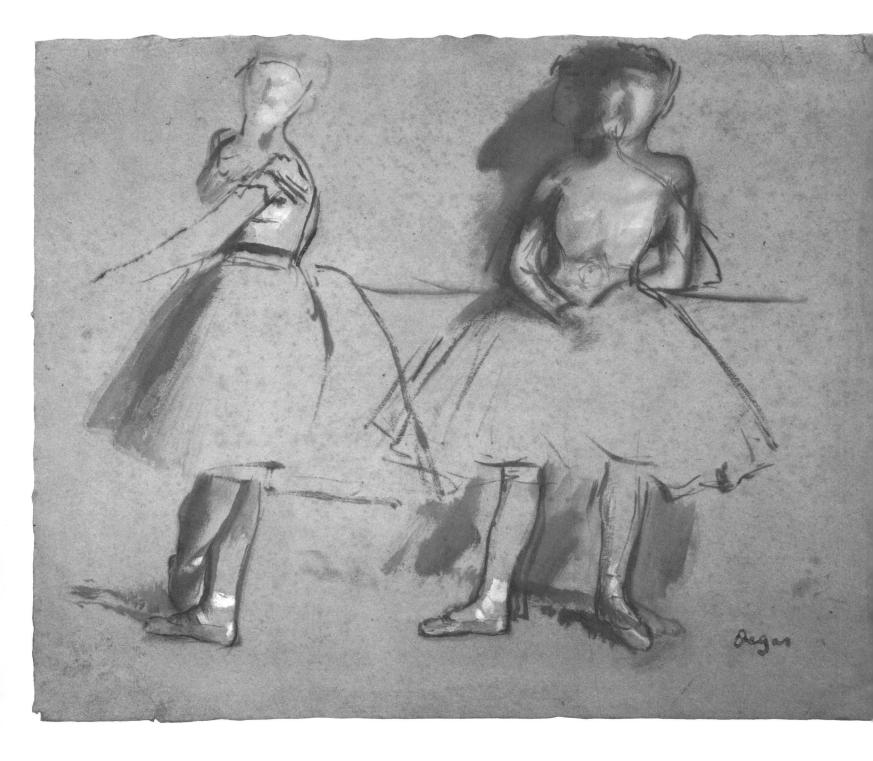

81 *Two Dancers at the Bar* 1871–2

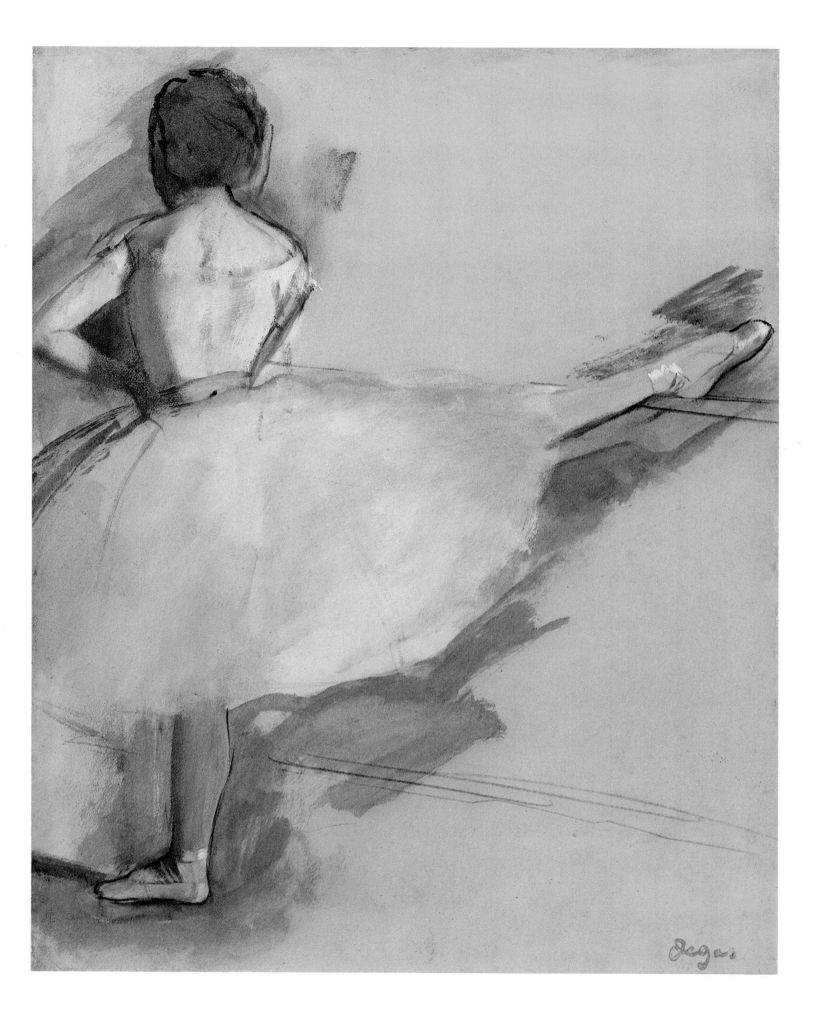

82 *Dancer at the Bar* 1871–2

85 *Three Nuns* 1871

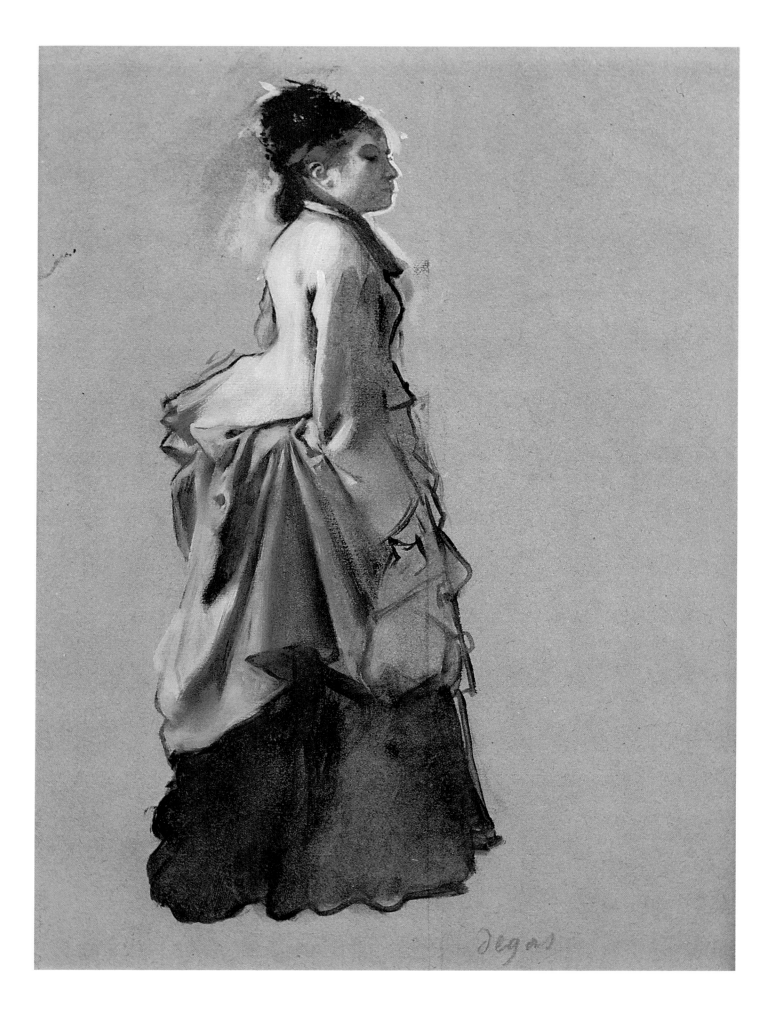

86 *Young Lady in Street Dress* circa 1872

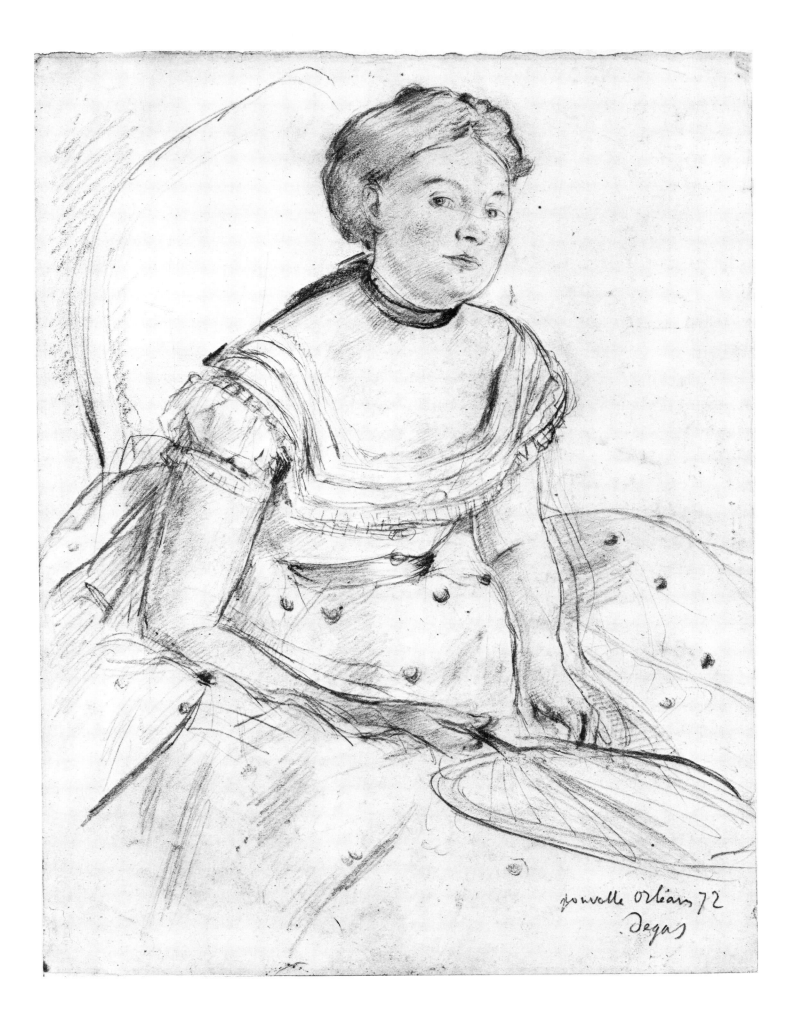

nouvelle Orléans 72
Degas

87 *Mathilde Musson-Bell* 1872

88 *Woman Ironing Seen against the Light* circa 1874

89 *Dancer with Outstretched Arms* circa 1873

90 *Four Studies of a Horseman* circa 1875

1873
Josephine Gaujelin
autrefois danseuse à l'Opéra
puis actrice au Gymnase

Degas

91 *Josephine Gaujelin* 1873

92 *Dancer Leaning Forward with Arms Bent* circa 1873

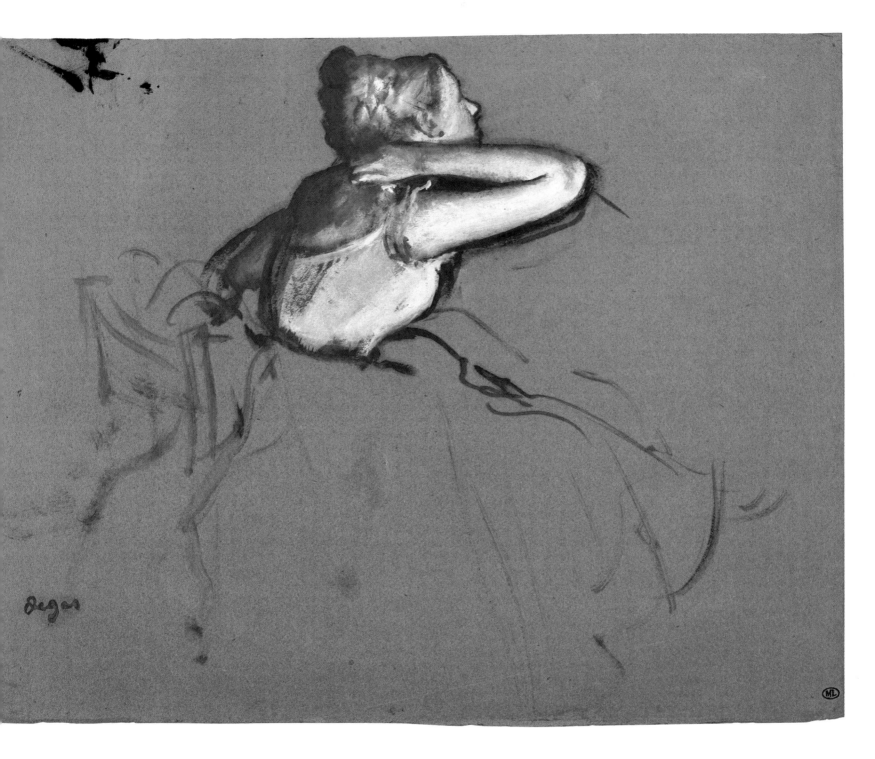

93 *Seated Dancer in Profile with her Hand at her Neck* 1873

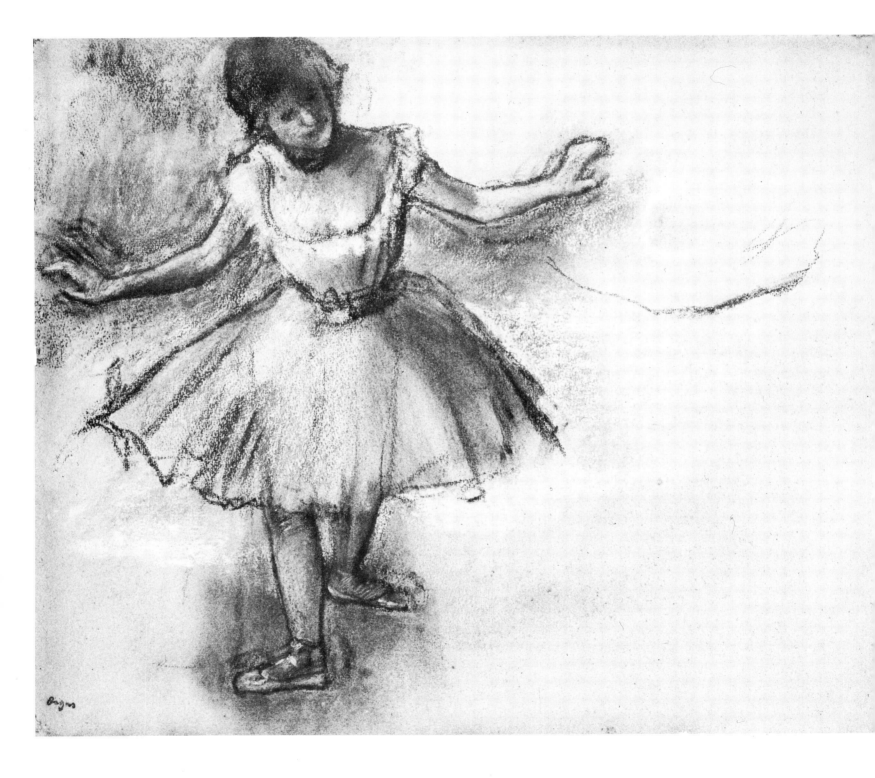

94 *Dancer with Arms Stretched Sideways* 1874

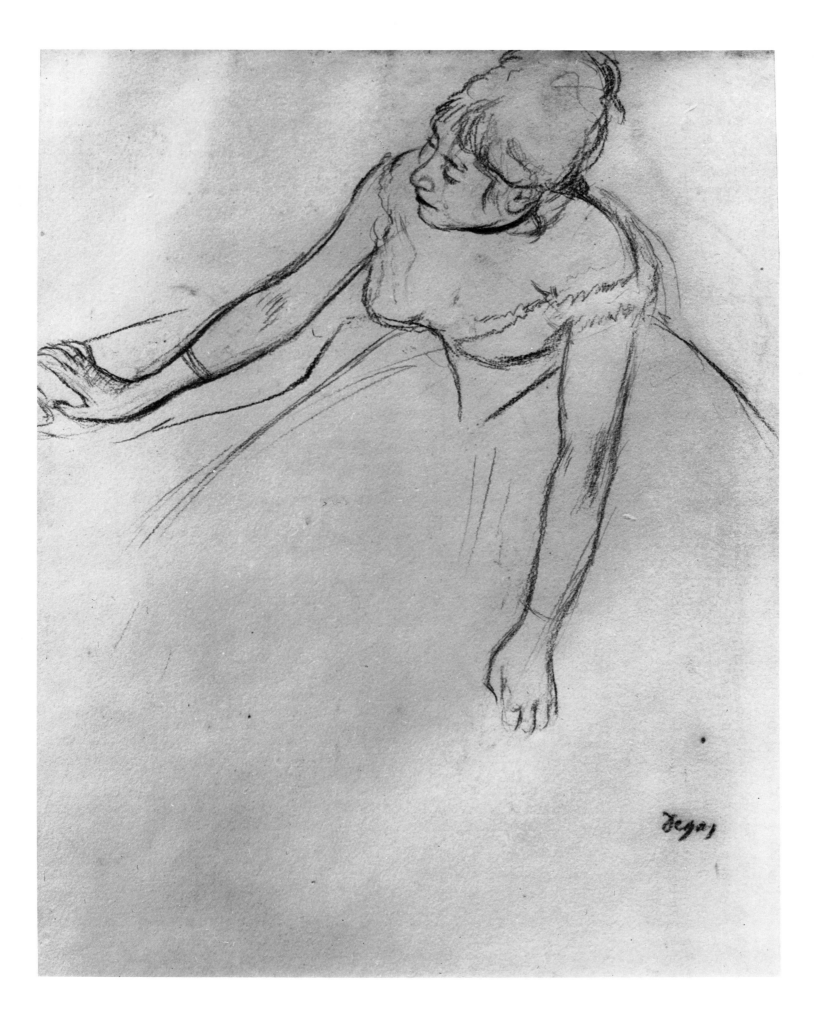

95 *Dancer with Outstretched Arms Leaning Forward* 1874

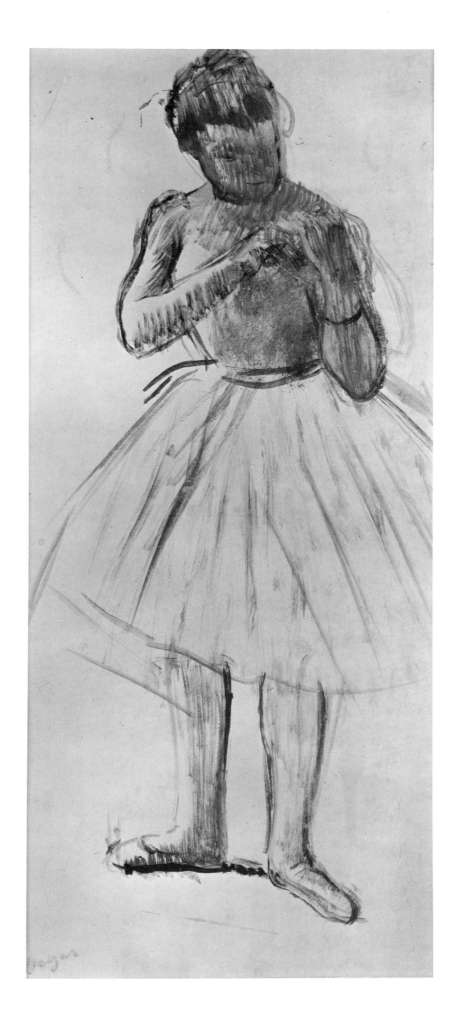

96 *Dancer Attaching her Shoulder Strap* circa 1874

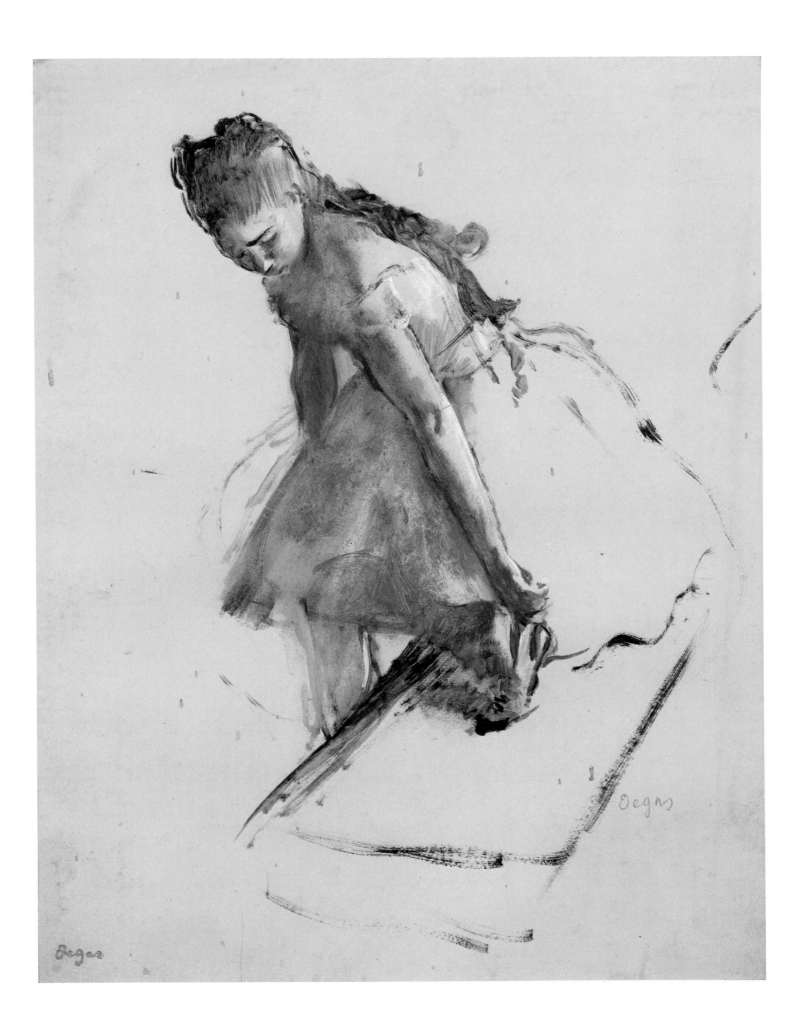

97 *Dancers Putting on their Shoes* circa 1874

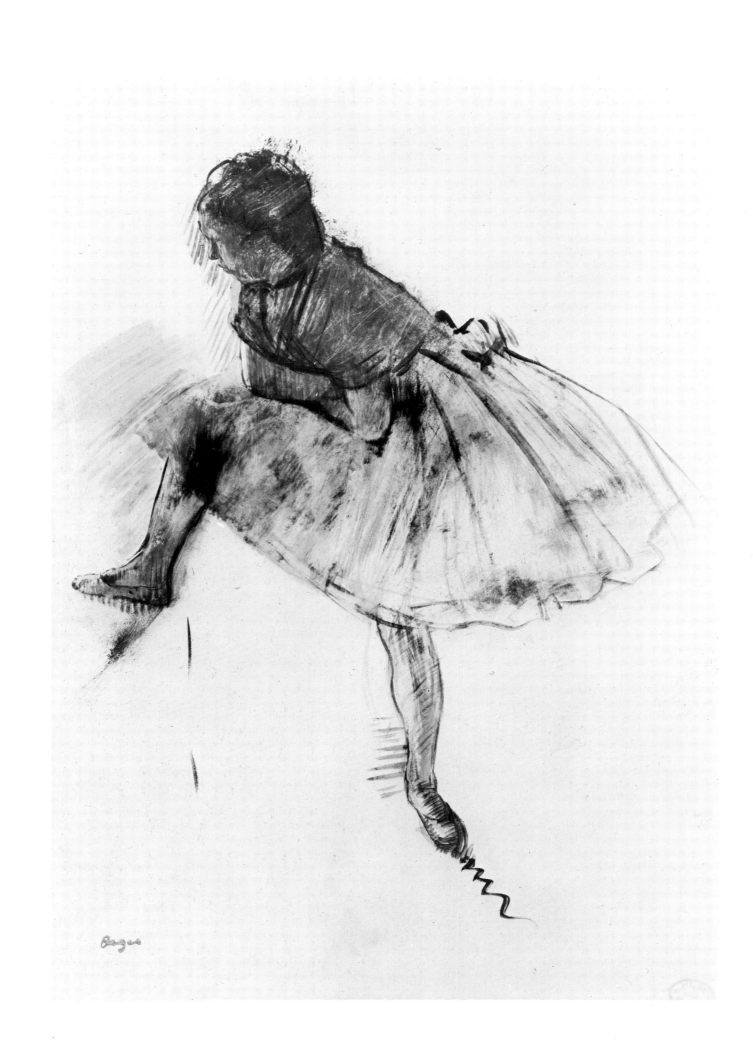

98 *Dancers with Right Leg Raised* circa 1874

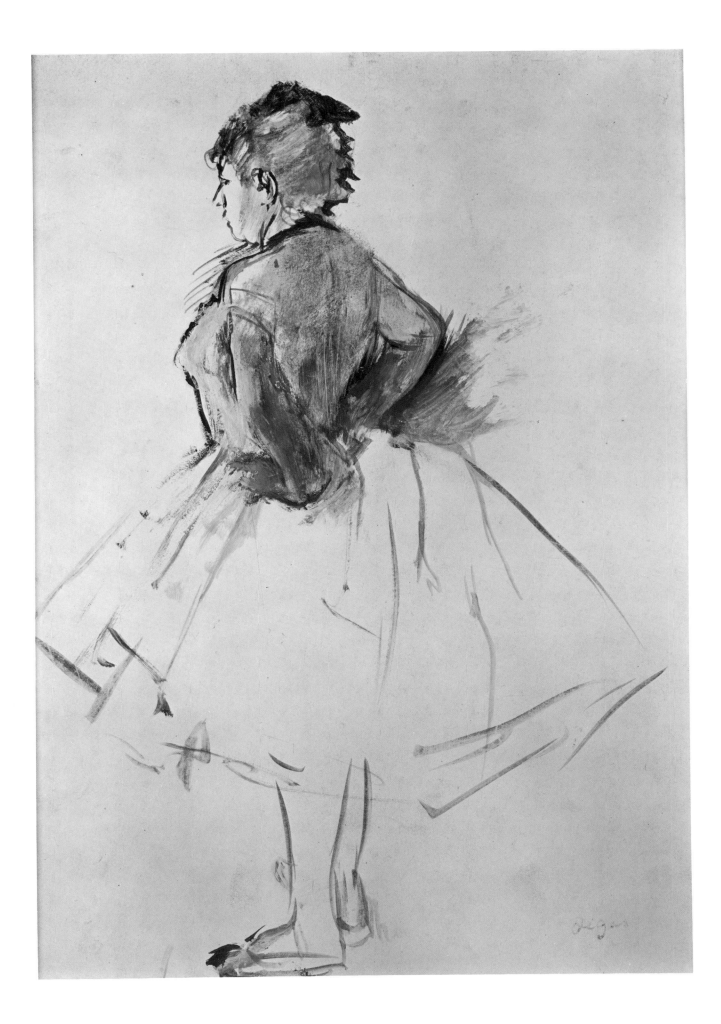

99 *Dancer in Profile, Hands on Hips* circa 1874

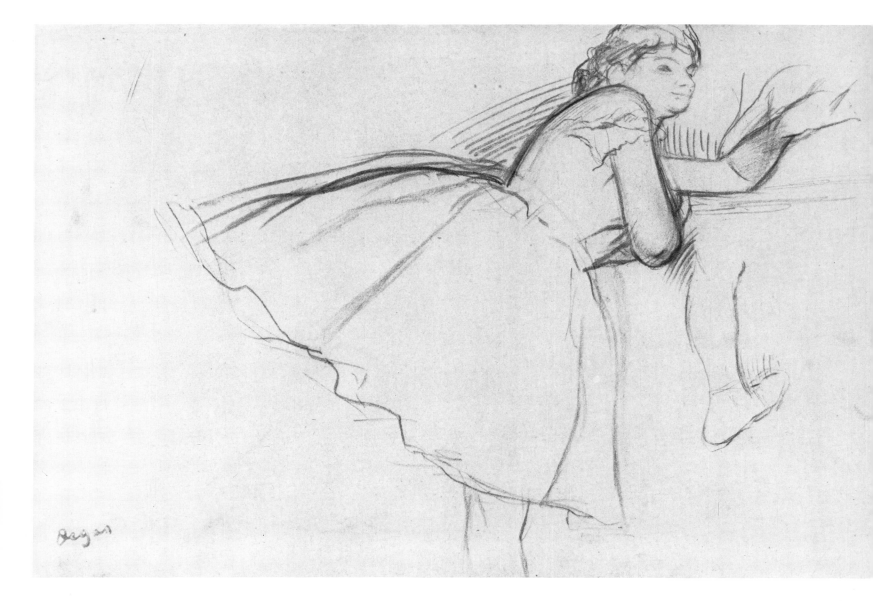

100 *Dancer at the Bar* 1876–7

101 *Dancer Seen from the Back* circa 1876

102 *Dancer at the Bar* (detail study) 1876–7

103 *Dancers at the Bar* 1876–7

106 *Dancer with Bouquet* 1877–9

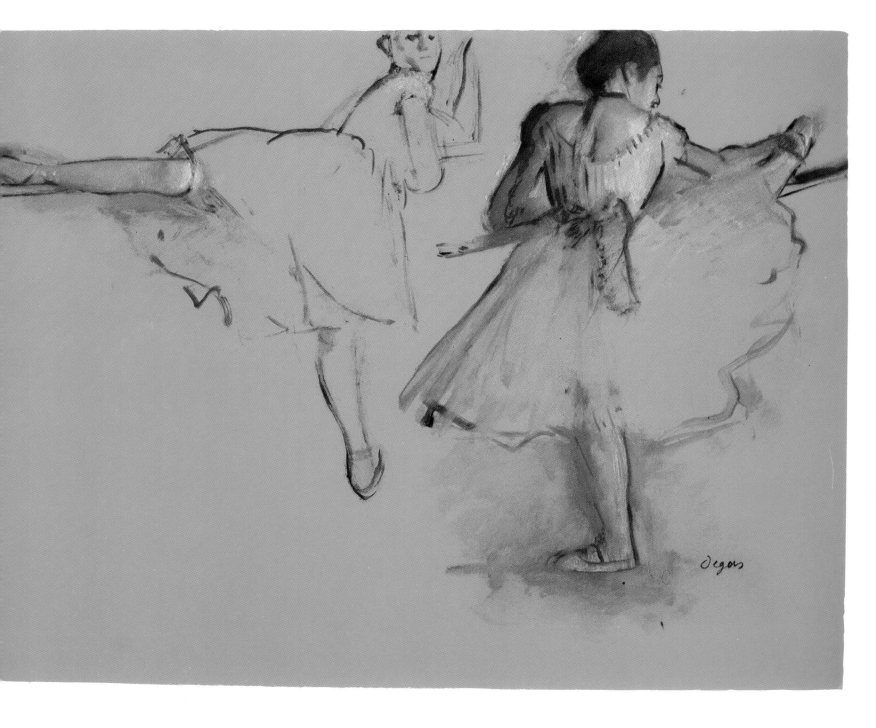

103 *Dancers at the Bar* 1876–7

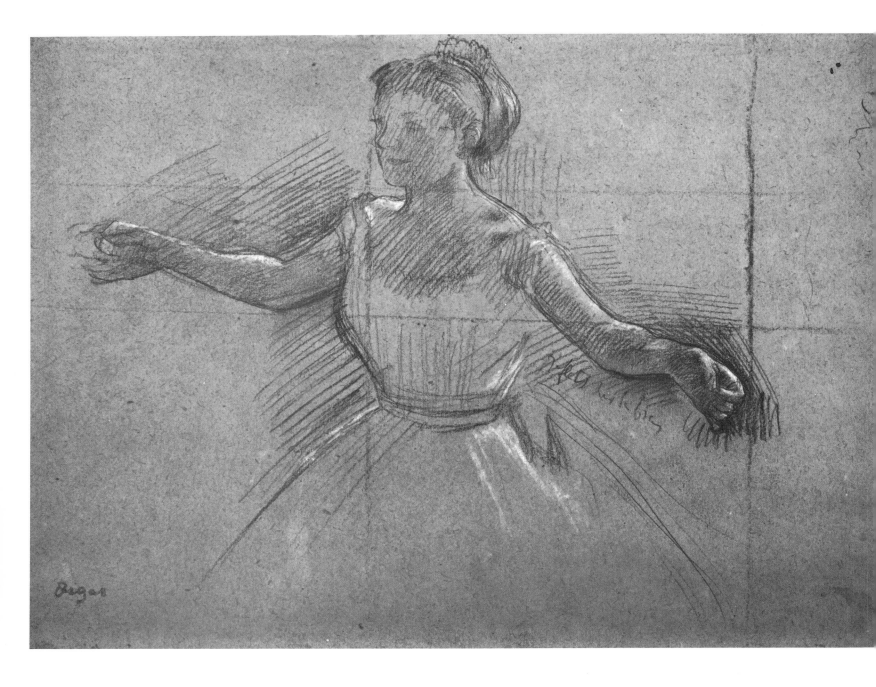

104 *Dancer with Arms Spread* circa 1878

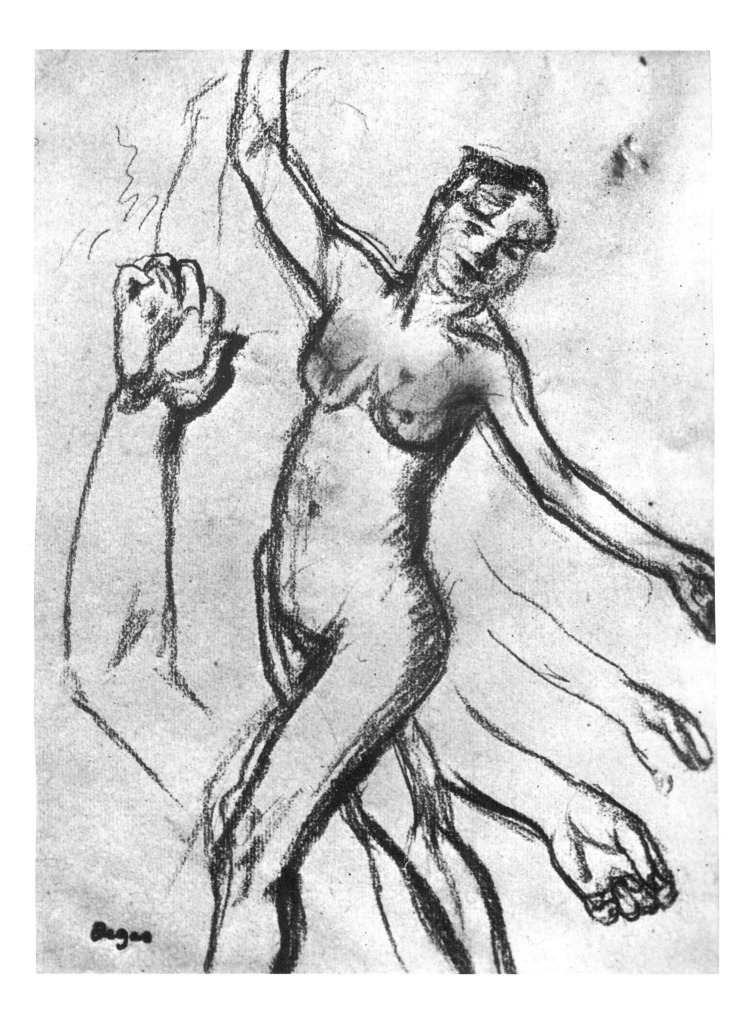

105 *Nude Poised in Step, Studies of Arms* circa 1878

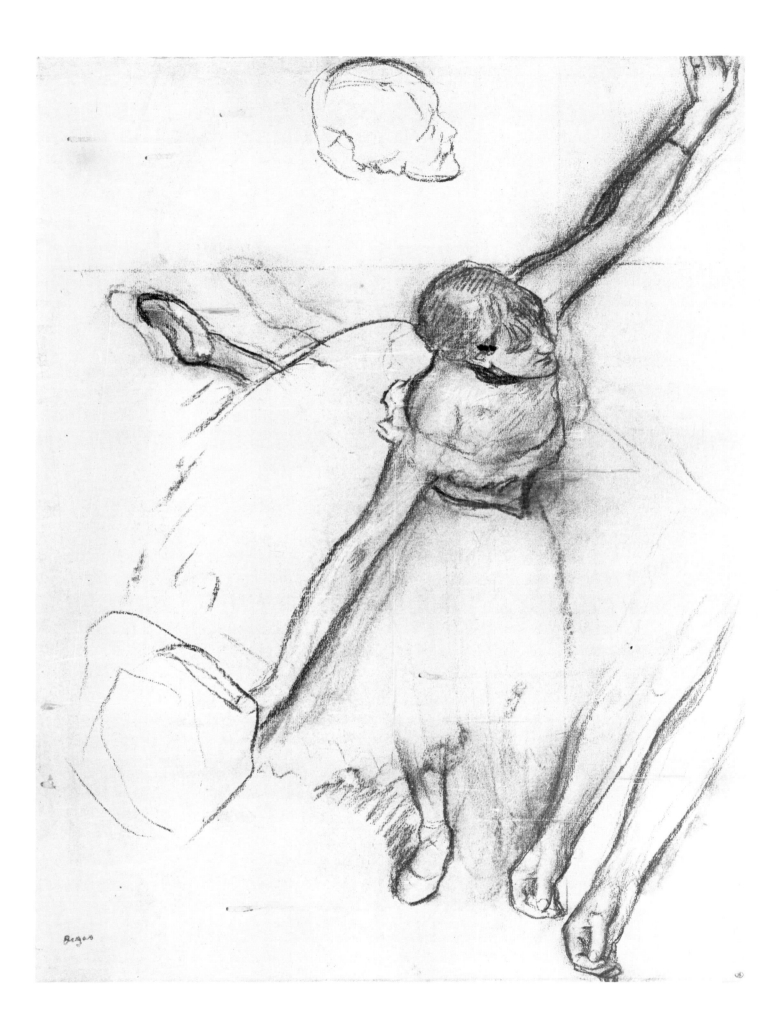

106 *Dancer with Bouquet* 1877–9

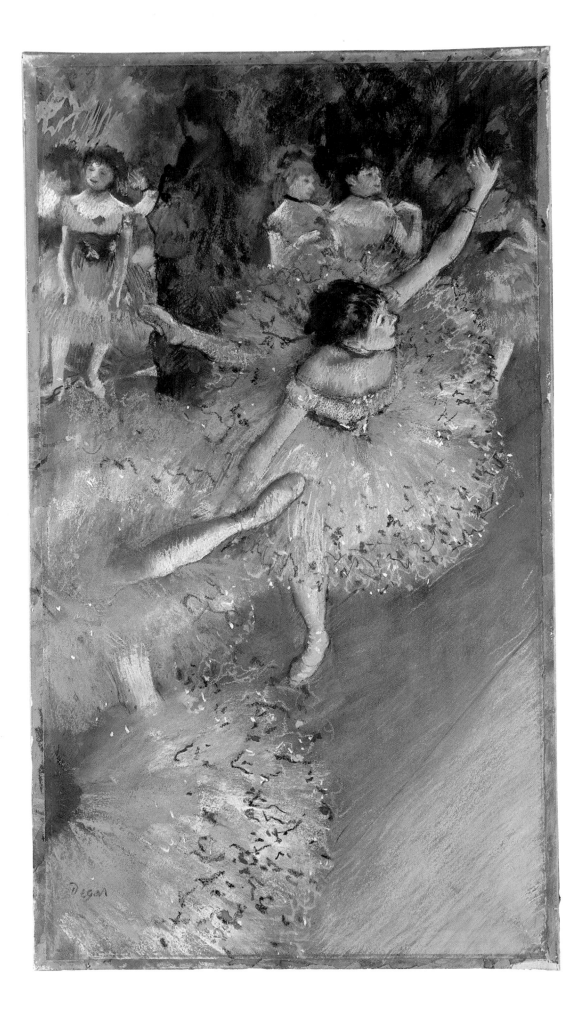

107　*The Green Dancers* 1877–9

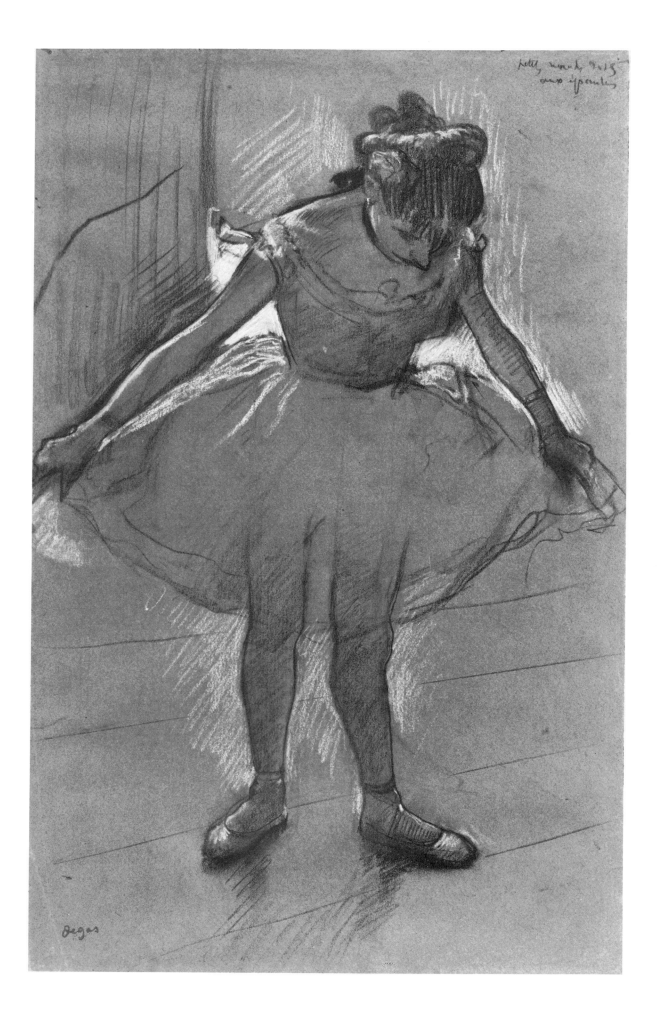

108 *Dancer Seen Against the Light* 1878–80

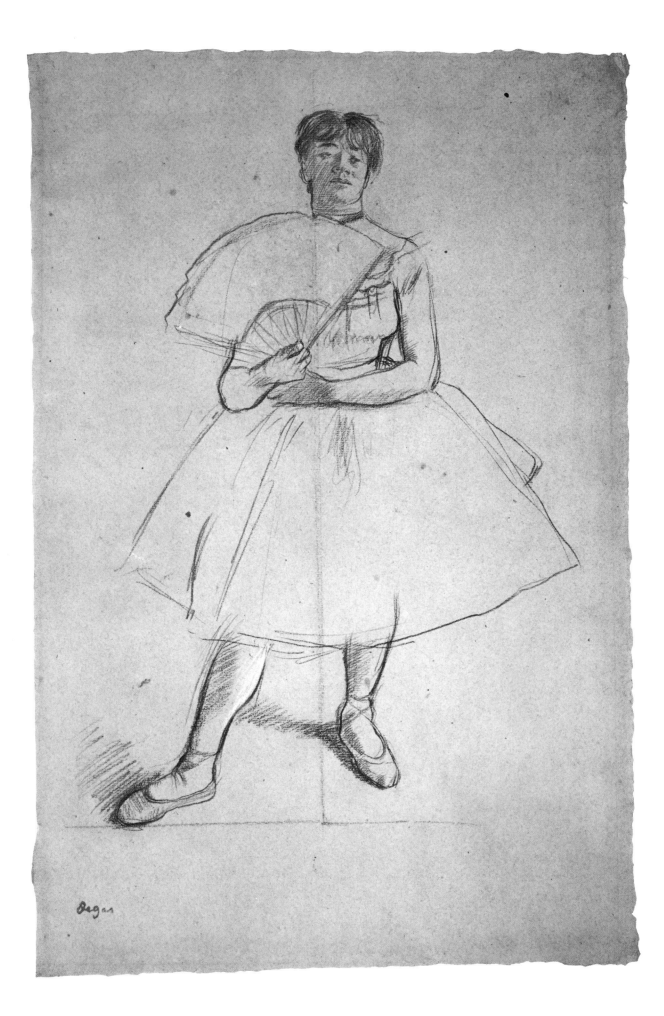

Degas

109 *Dancer with a Fan* circa 1878

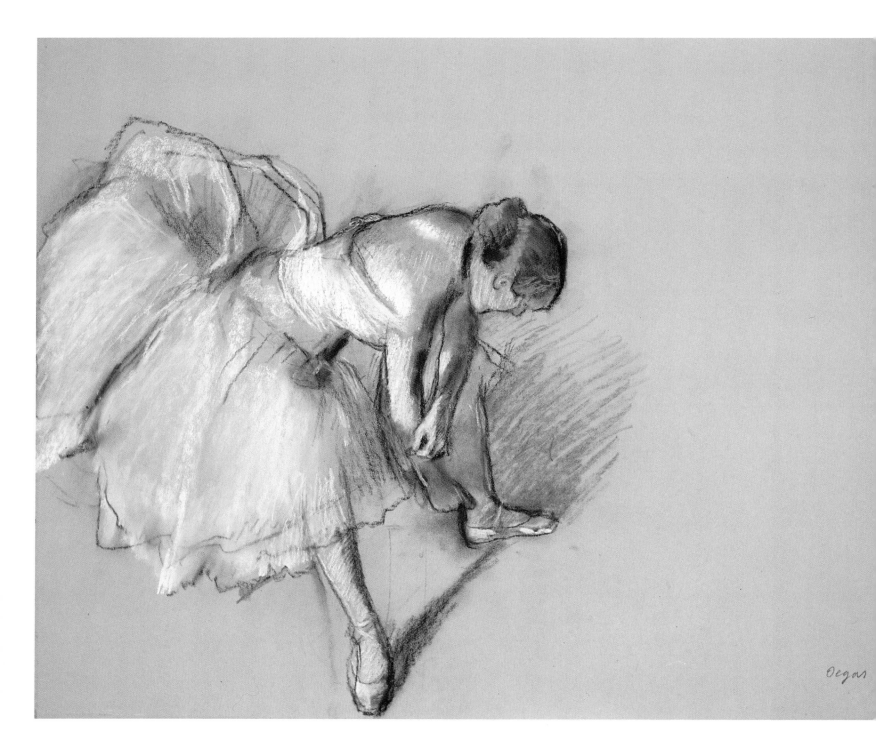

110 *Seated Dancer Fastening her Shoestrap* 1878–80

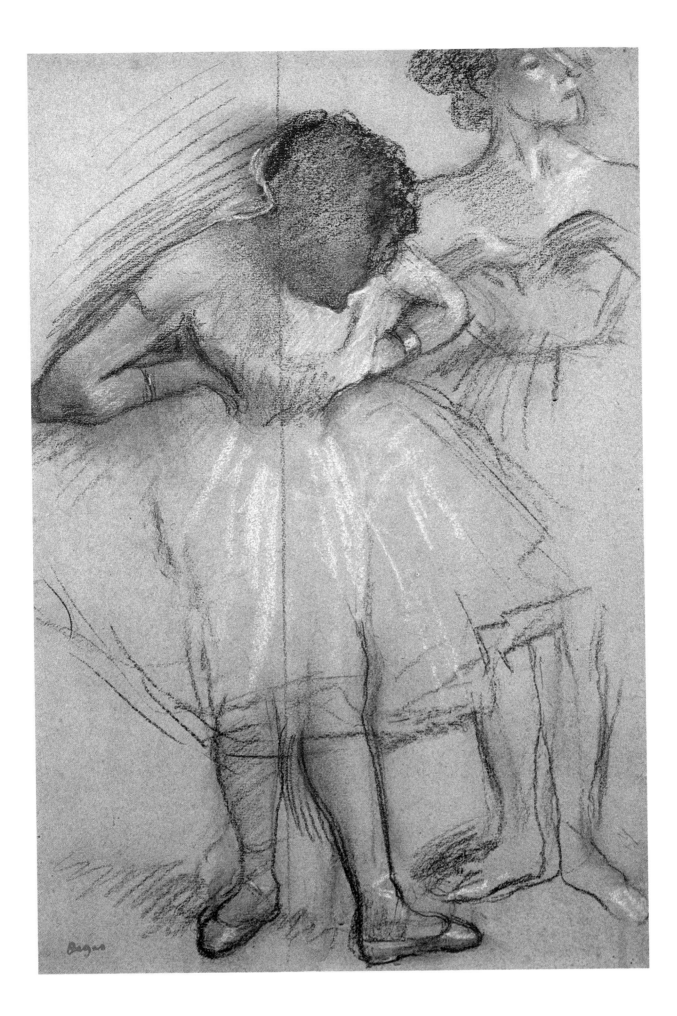

111 *Two Dancers* 1878–80

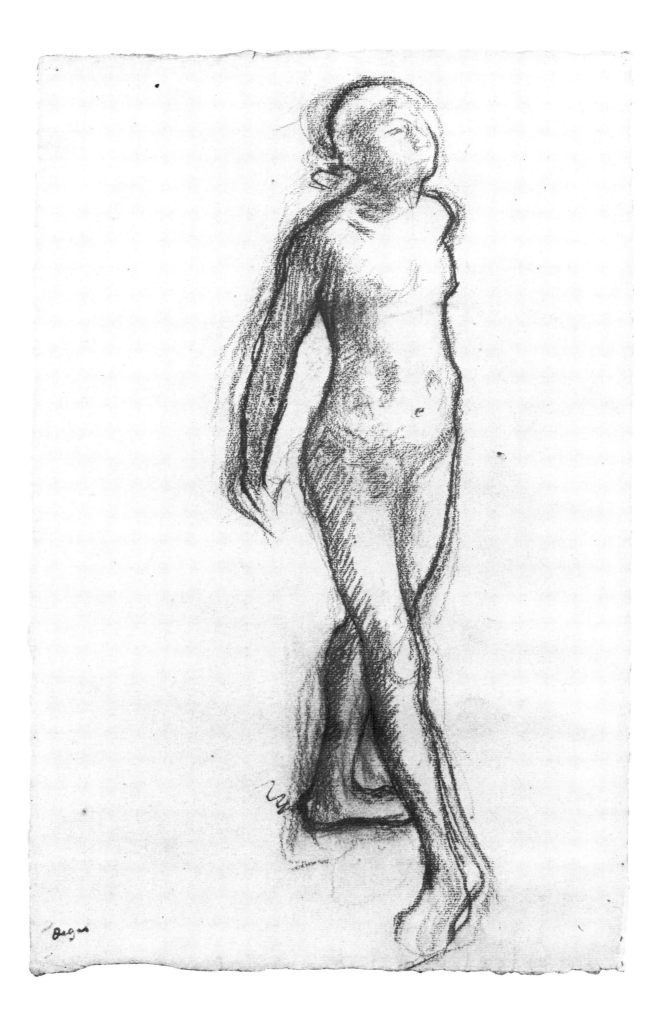

113 *The Fourteen-Year-Old Dancer* circa 1879

[for pl. 112 see p. 27]

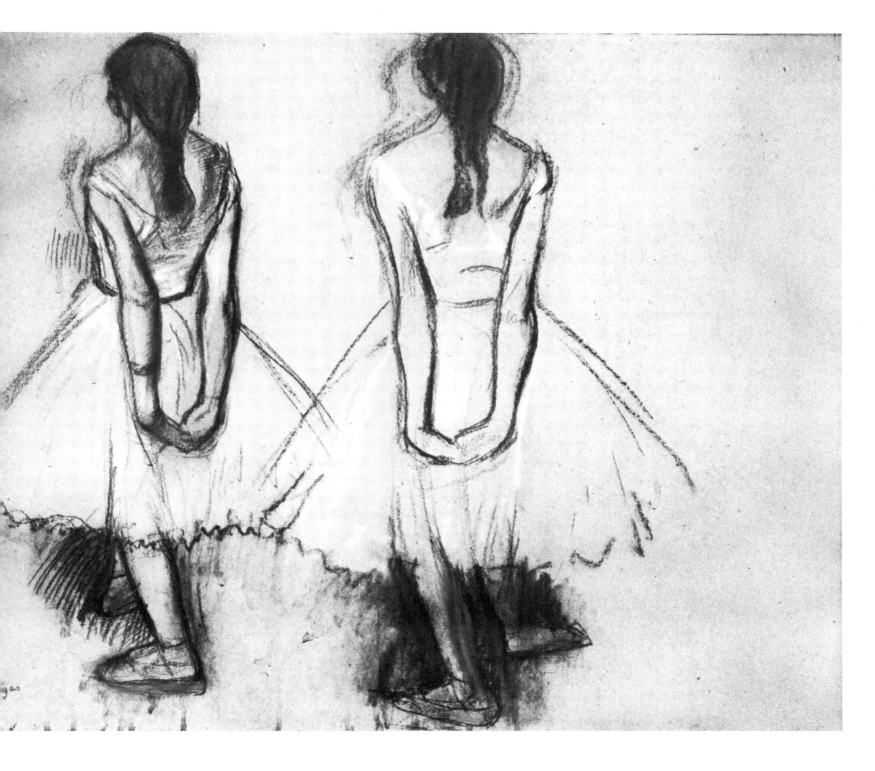

114 *Two Studies of the Fourteen-Year-Old Dancer* circa 1879

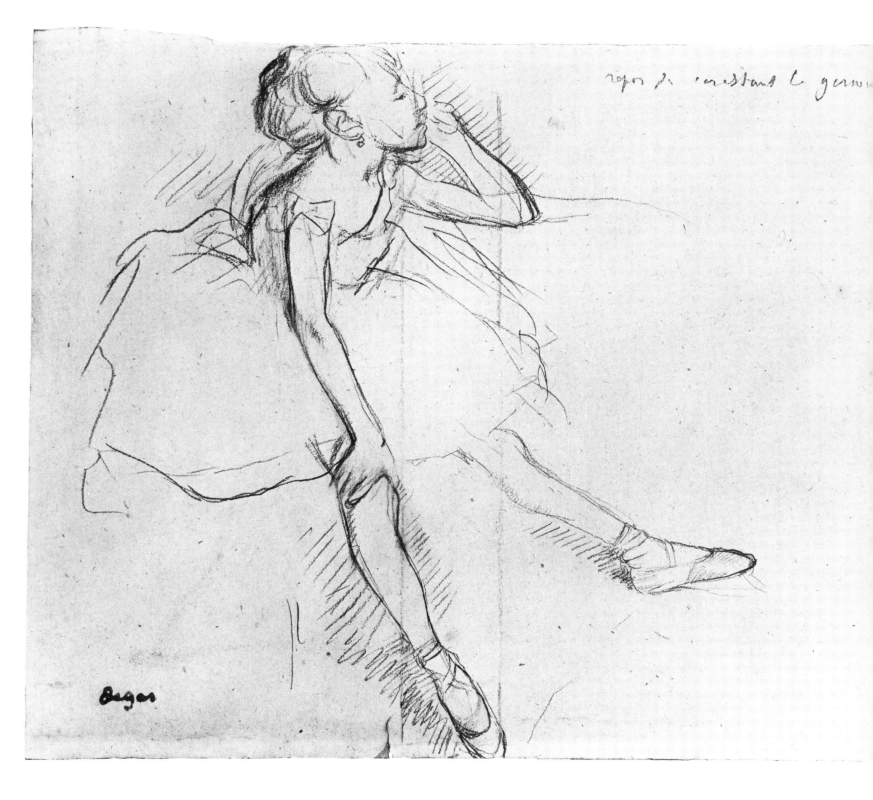

repos ... restant le germe

Degas

115 *Little Dancer Resting* 1878–80

bien accuser
l'os du coude

battements à la seconde
à la barre

Degas

116 *Little Dancer at the Bar* 1878–80

117 *Painted Fan: 'La Farandole'* 1878–9

120 *Fan Painting: Dancers and Stage Scenery* circa 1879

121 *Fan Painting: Dancers* 1878–9

122 *Chanteuse in a Café-Concert* 1880

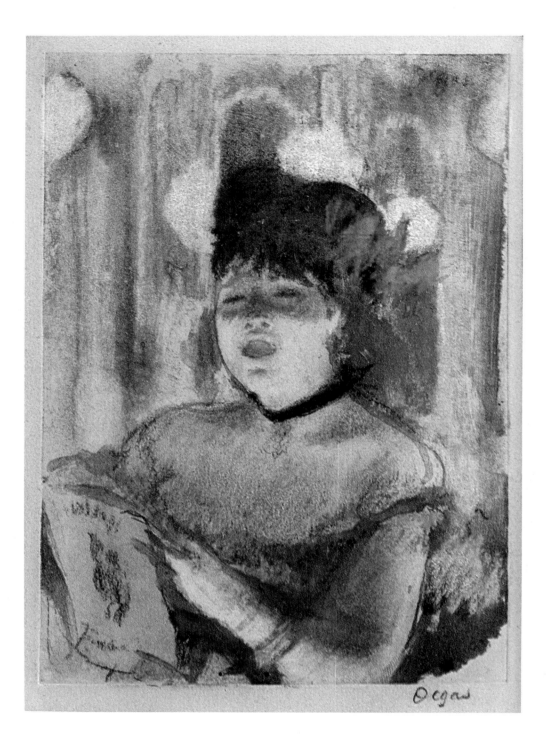

123　*The Chanteuse Victorine Demay* 1877–9

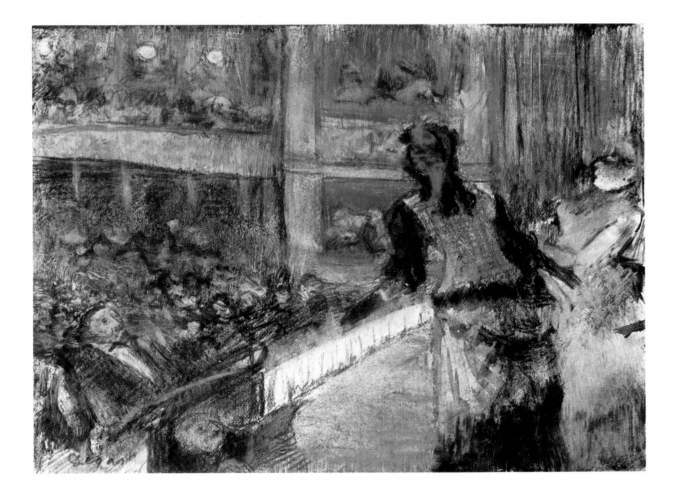

124 *The Duet* 1877–9

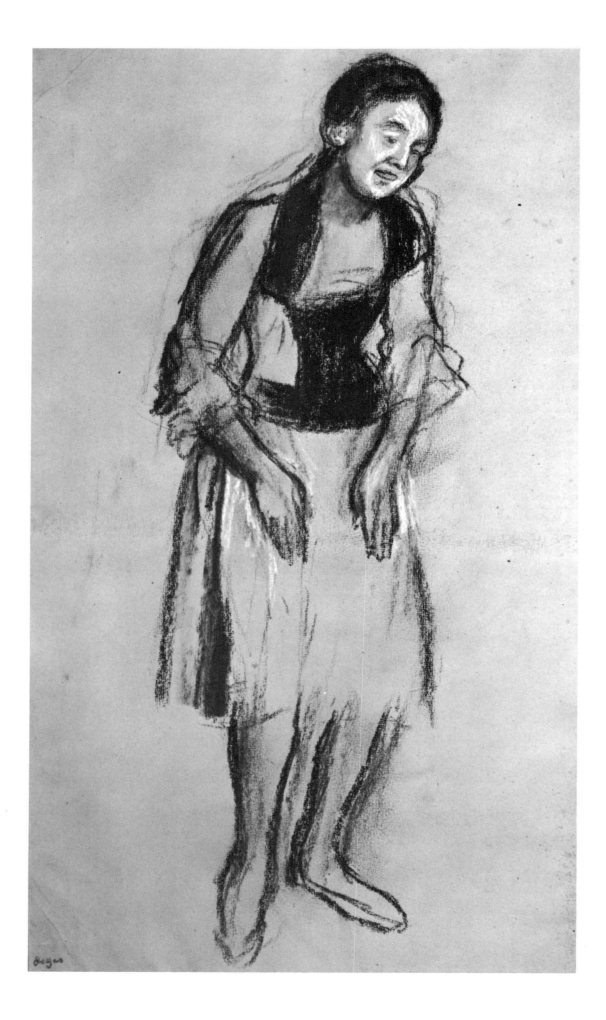

125 *Café-Concert Singer* 1878–9

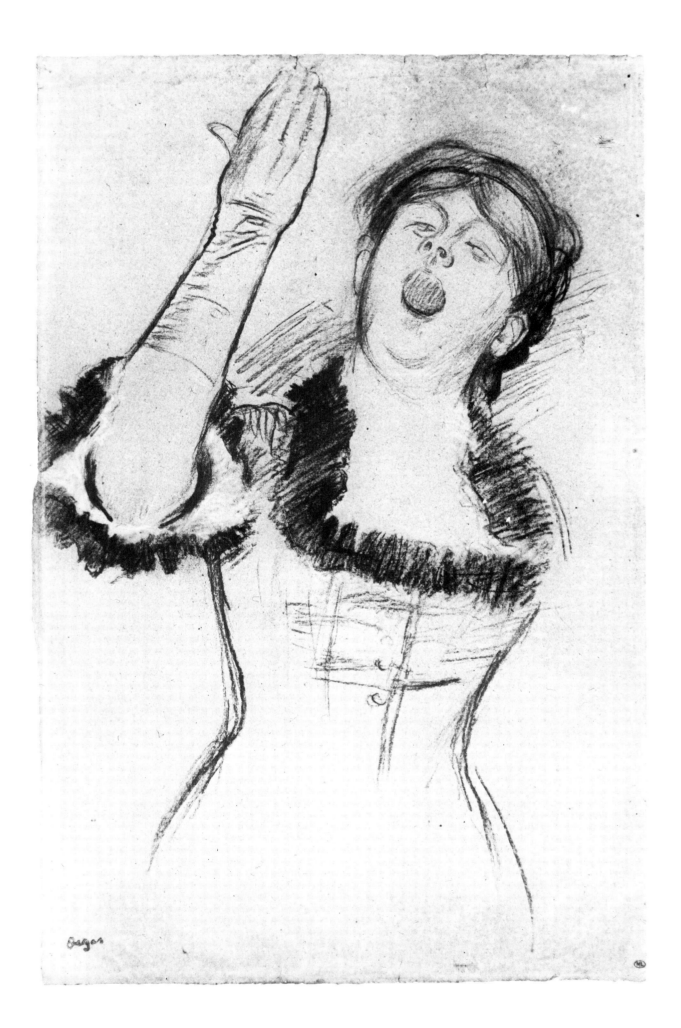

126 *Café-Concert Singer in Performance* 1878–9

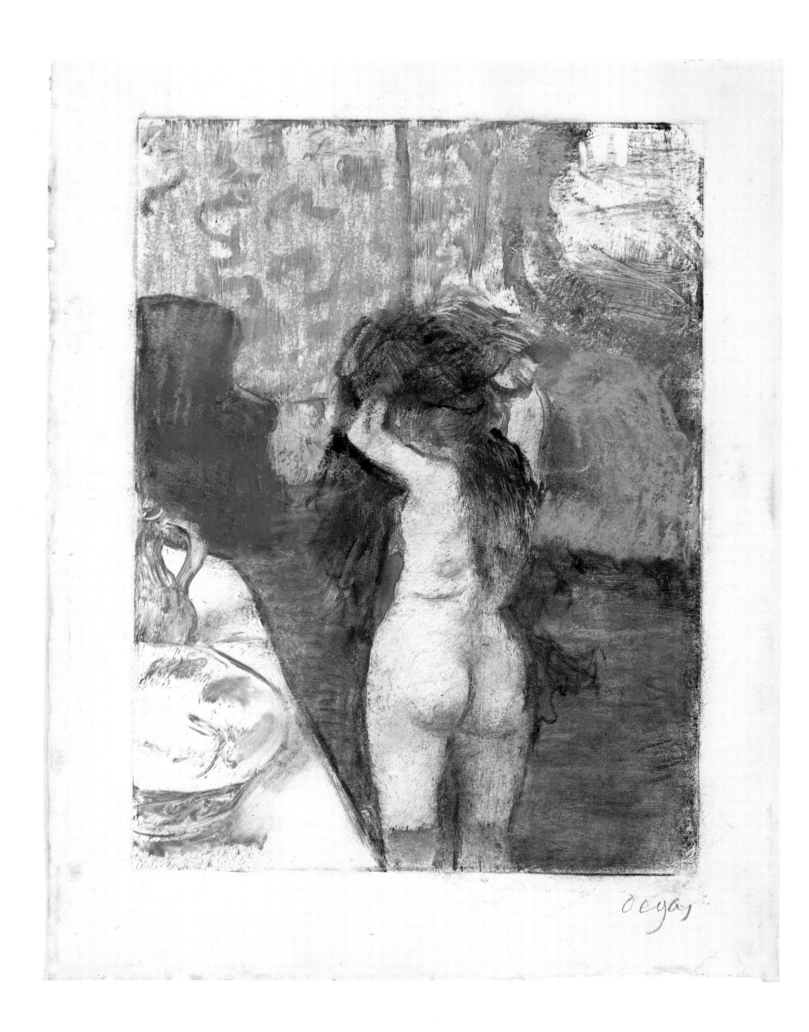

127 *Nude from the Back Putting on a Dress* circa 1879

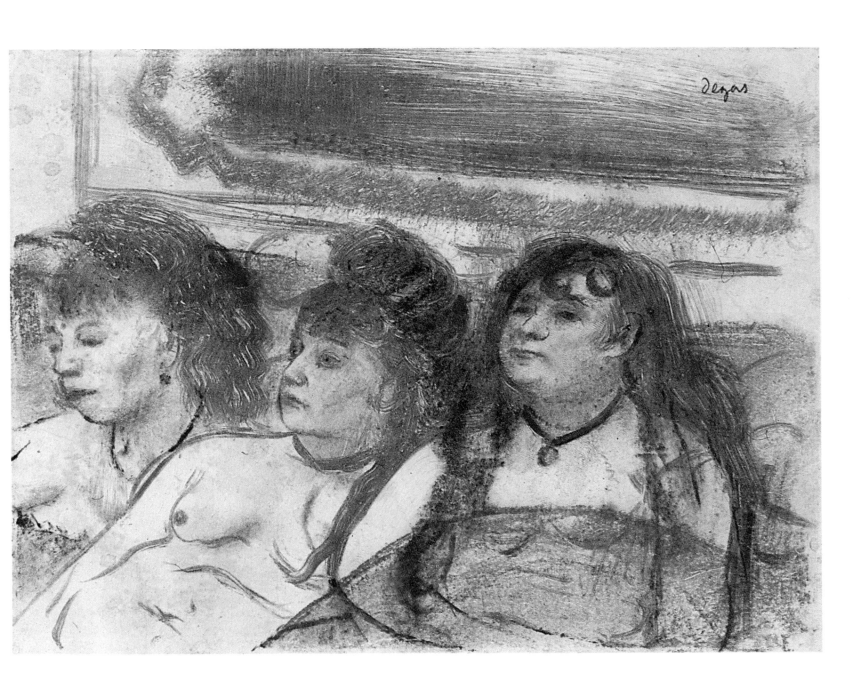

128 *Three Prostitutes on a Sofa* circa 1879

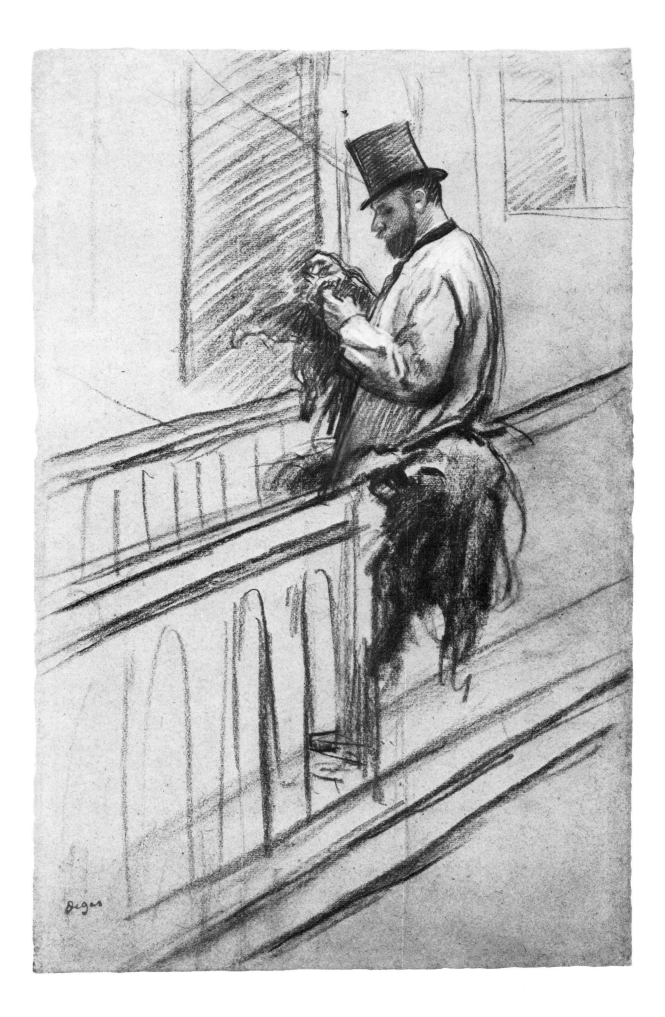

129 *Hermann de Clermont* circa 1879

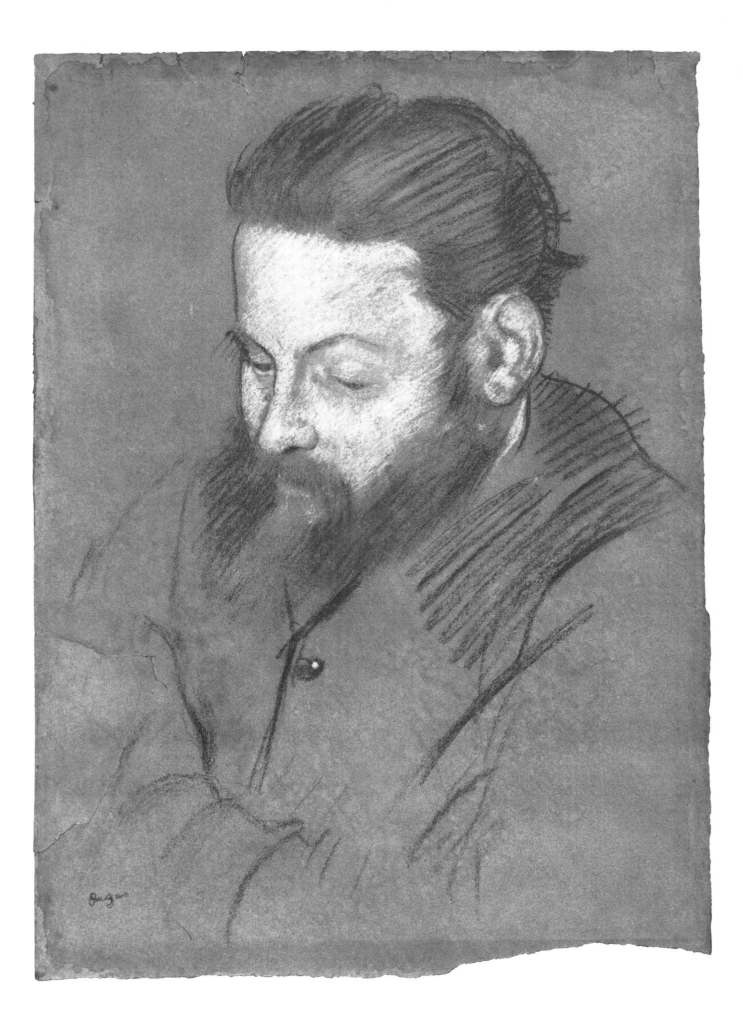

130 *Diego Martelli* 1879

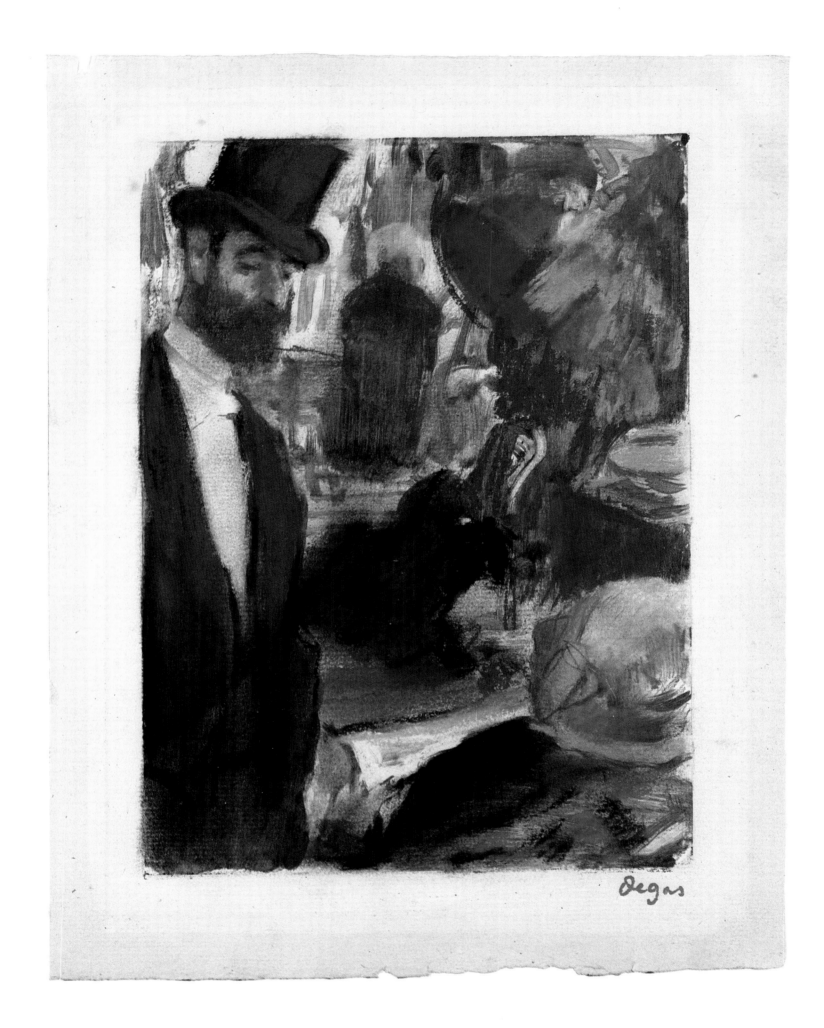

131 *Ludovic Halévy and Mme Cardinal* circa 1880

132 *Ludovic Halévy* circa 1880

133 *Roof Structure of the Cirque Fernando* 1879

134 *Miss Lala at the Cirque Fernando* 1879

[for pl. 135 see p. 31]

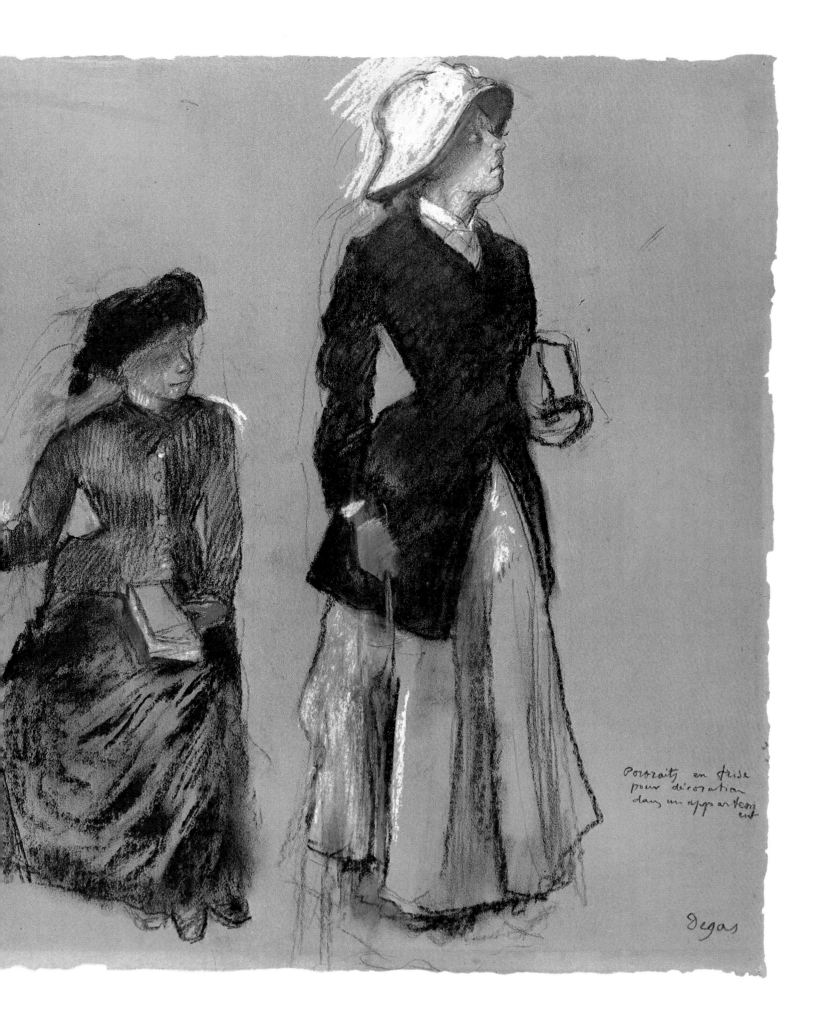

Portraits en frise
pour décoration
dans un appartem
ent-

Degas

136 *Three Young Ladies Arranged in a Frieze* 1879–81

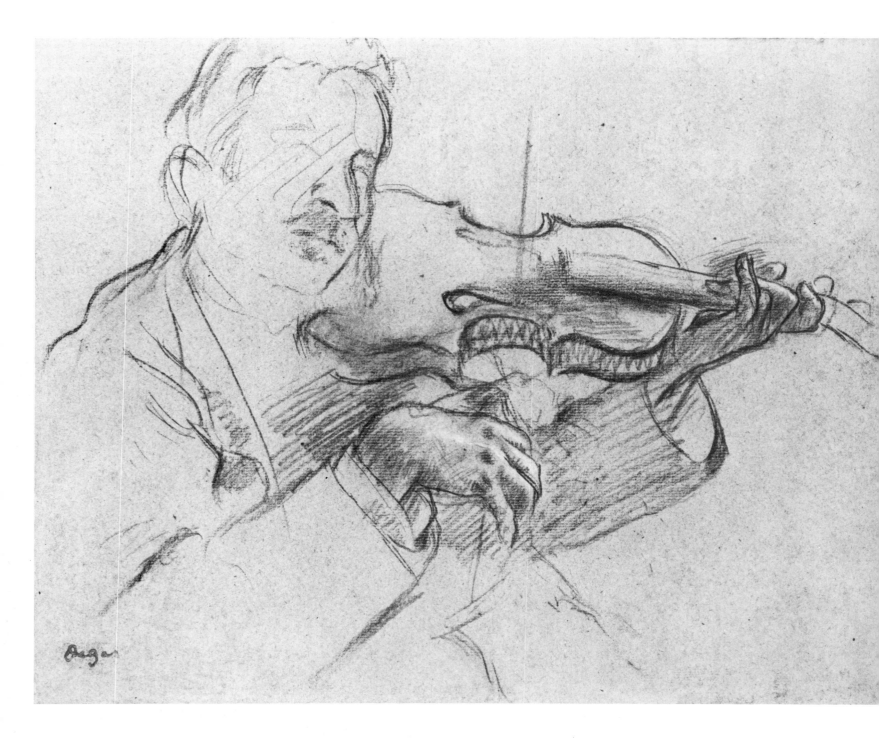

137 *The Violinist* 1878–9

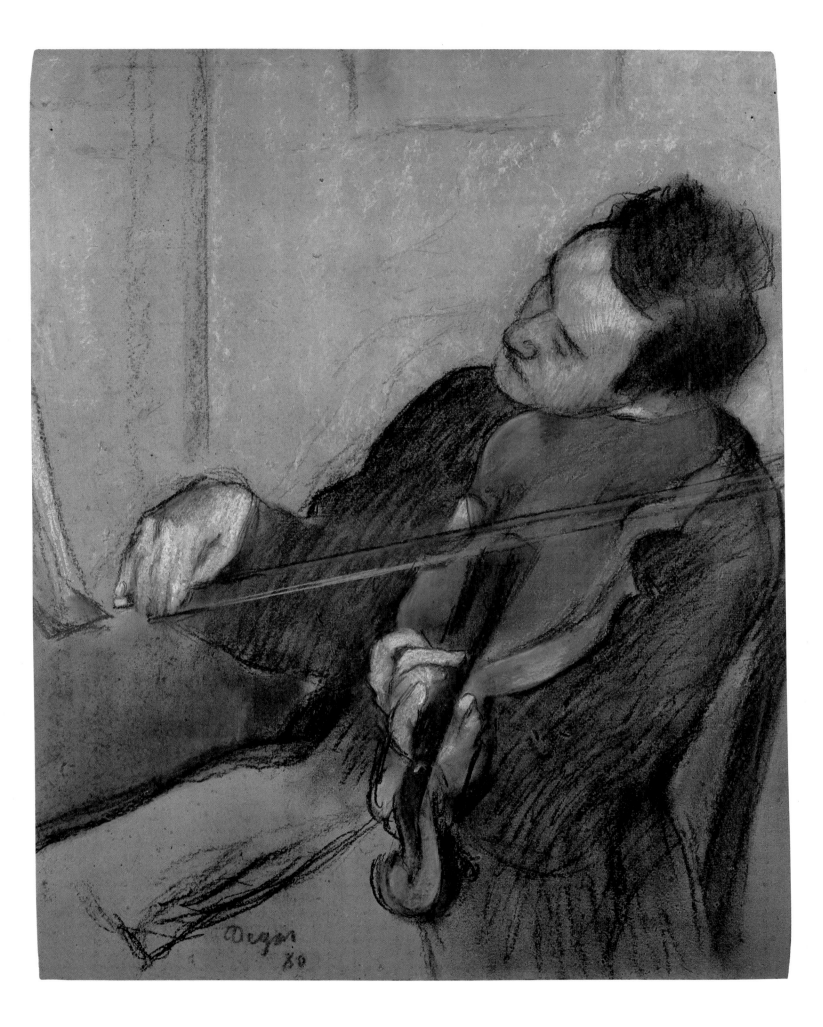

138 *The Violinist* 1880

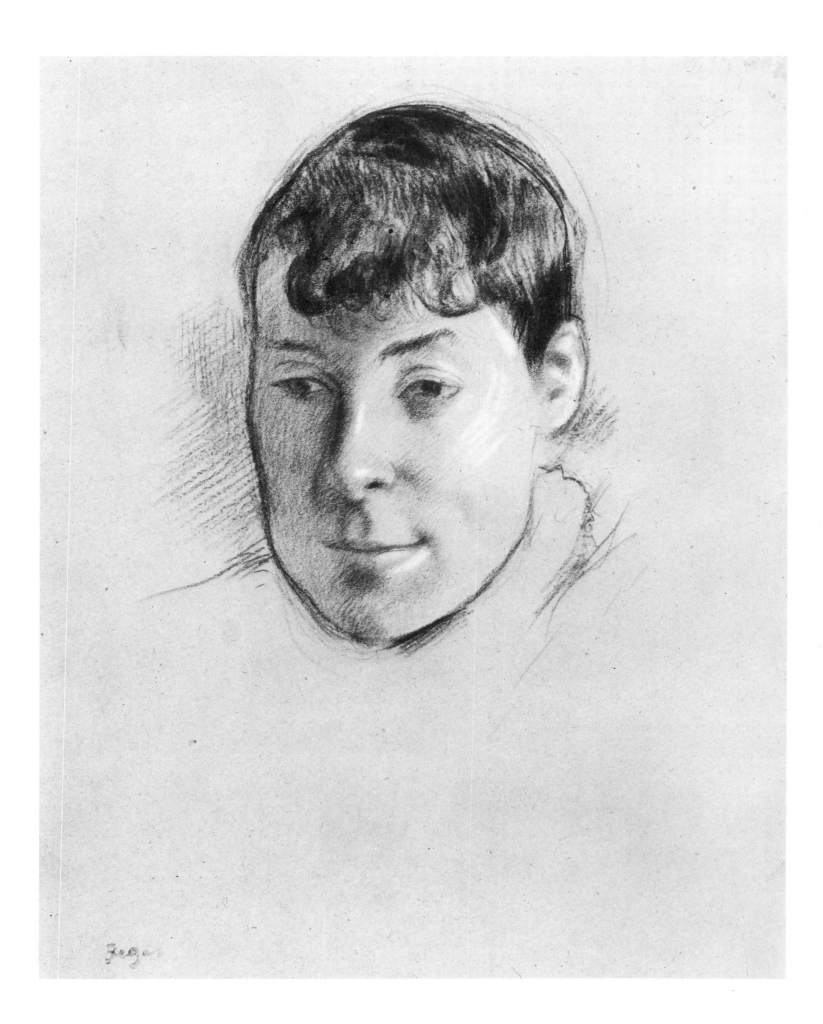

139 *Mme Ernest May* 1881

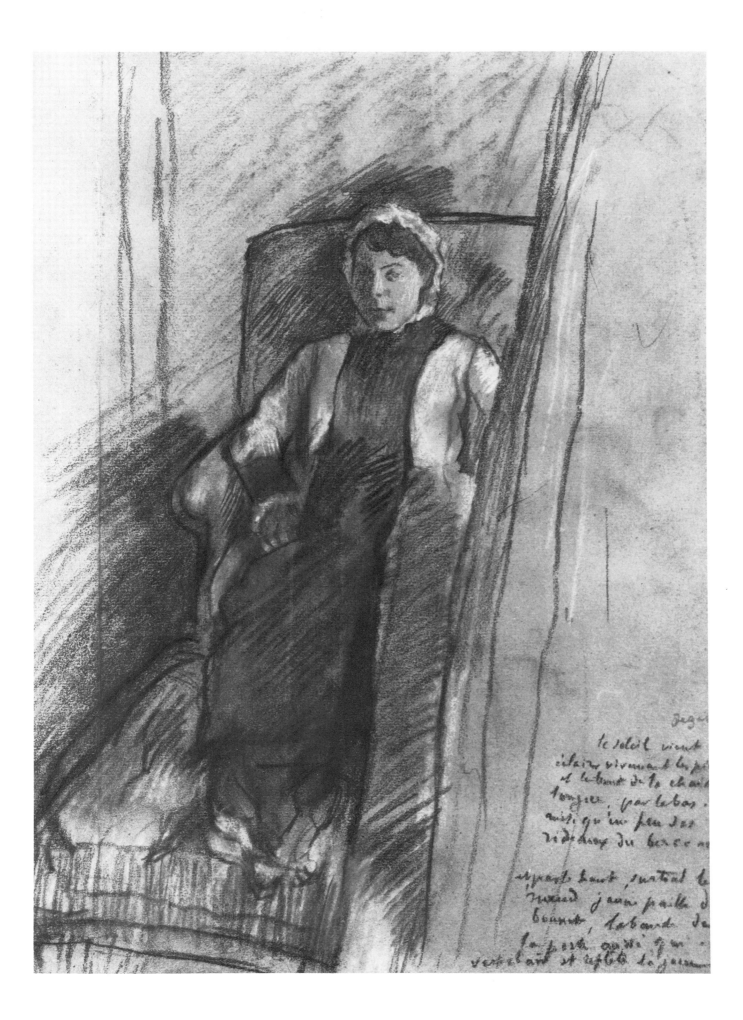

140 *Mme Ernest May Lying-In* 1881

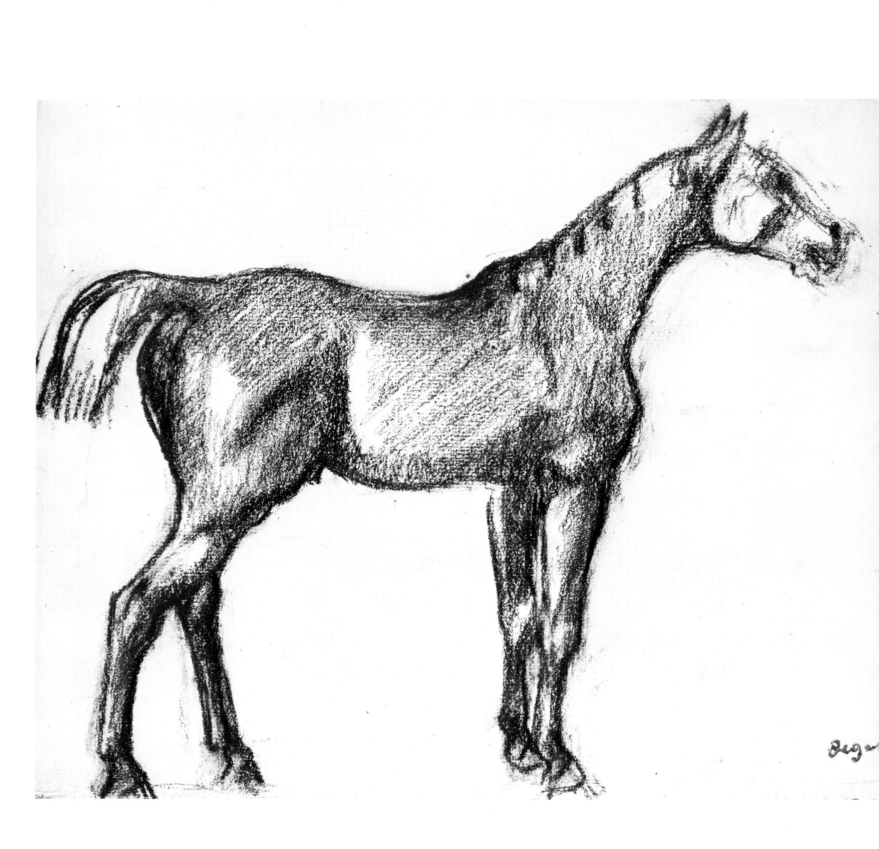

142 *Horse Standing, Profile to the Right* circa 1882

[for pl. 141 see p. 32]

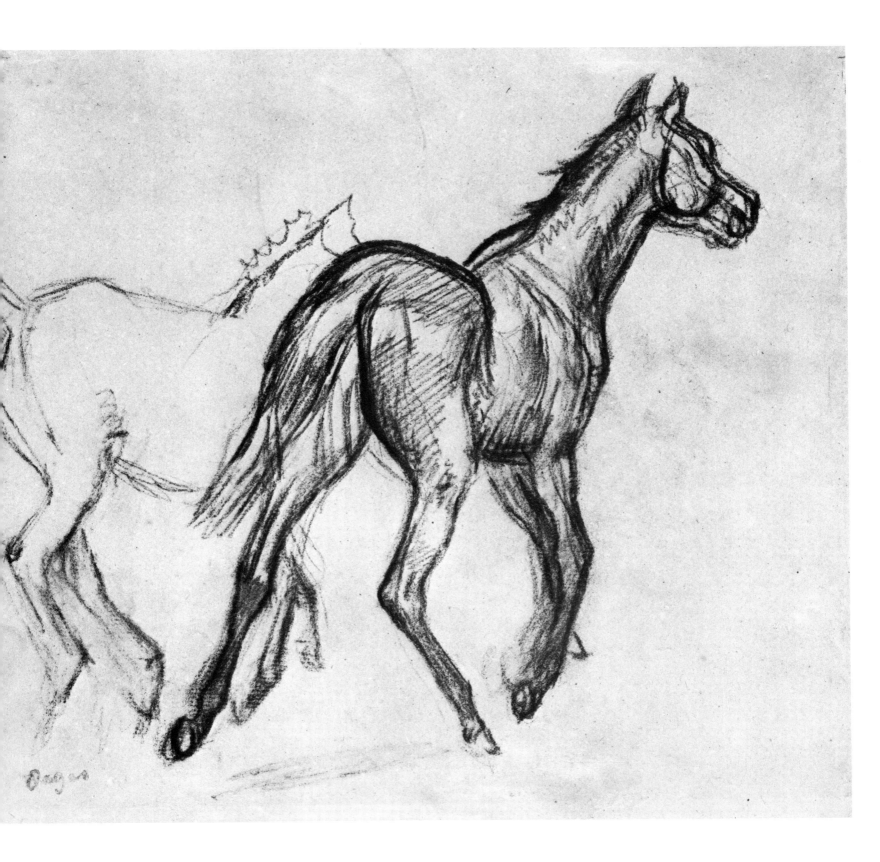

143 *Two Trotting Horses* circa 1882

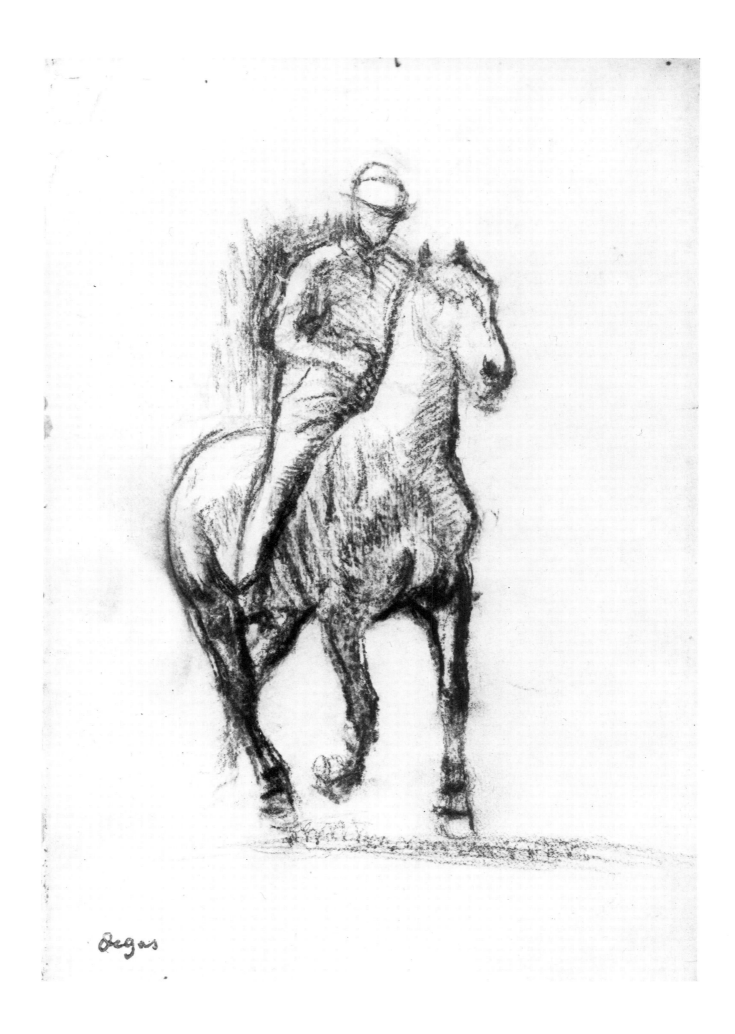

Degas

144 *Rider on Trotting Horse* circa 1882

pied droit quitte terre
devant

145 *Three Horses Seen from the Rear* 1883–5

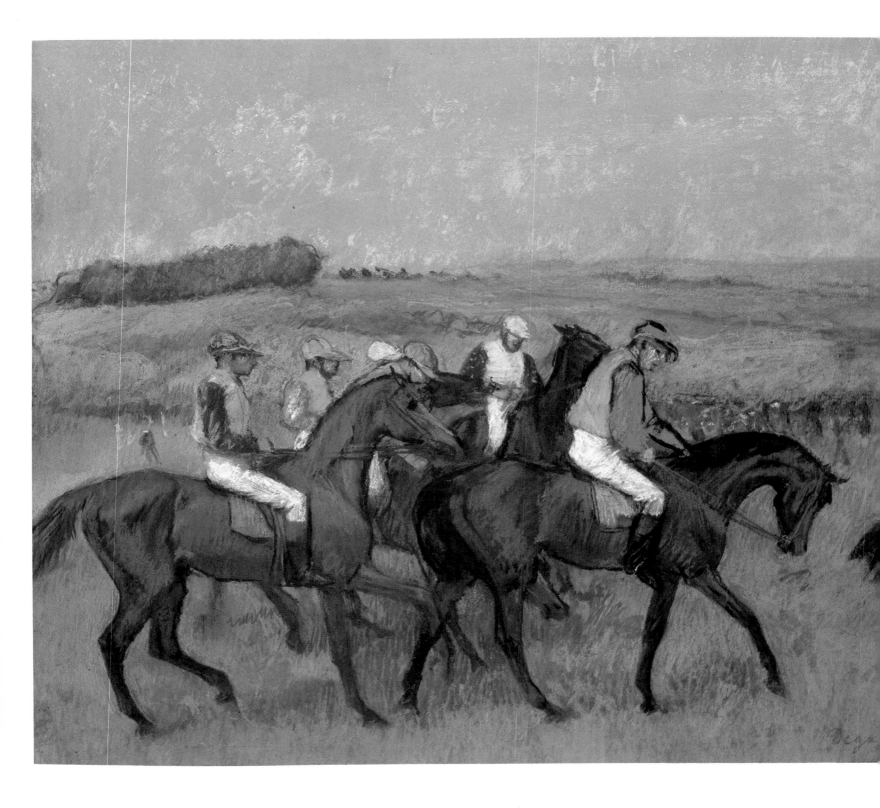

146 *On the Racecourse* 1883–5

147 *Two Jockeys* 1883–5

149 *Nude Rider* 1884–8

[for pl. 148 see p. 40]

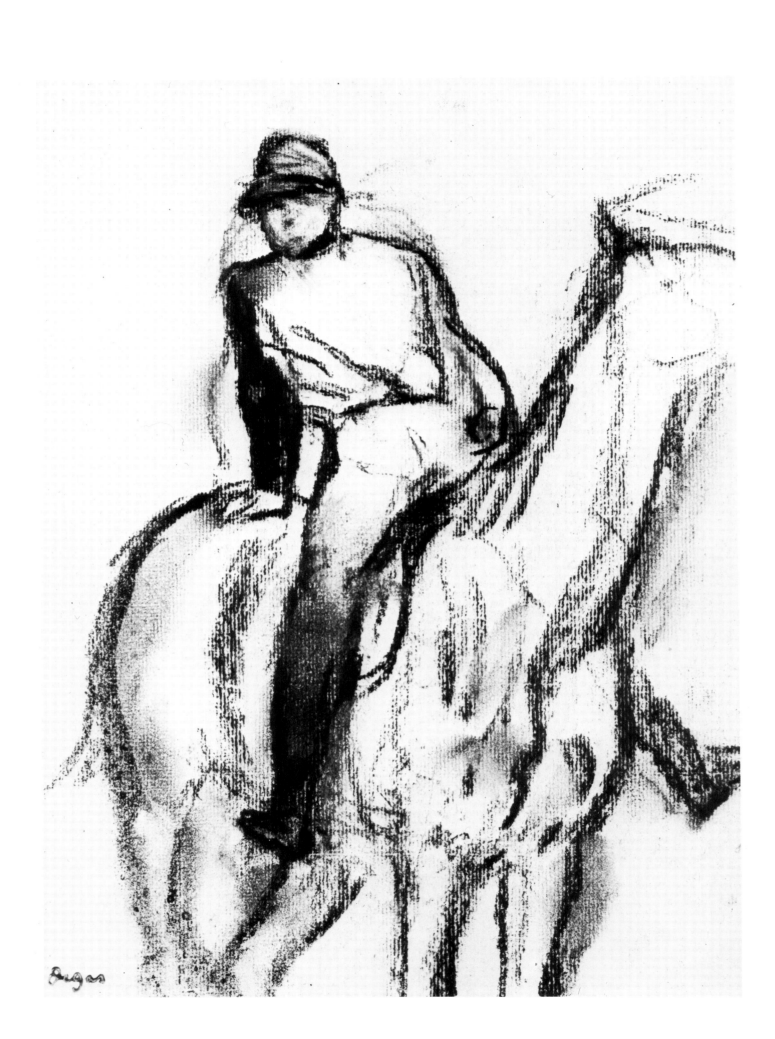

150 *Jockey Leaning Back in the Saddle* 1884–8

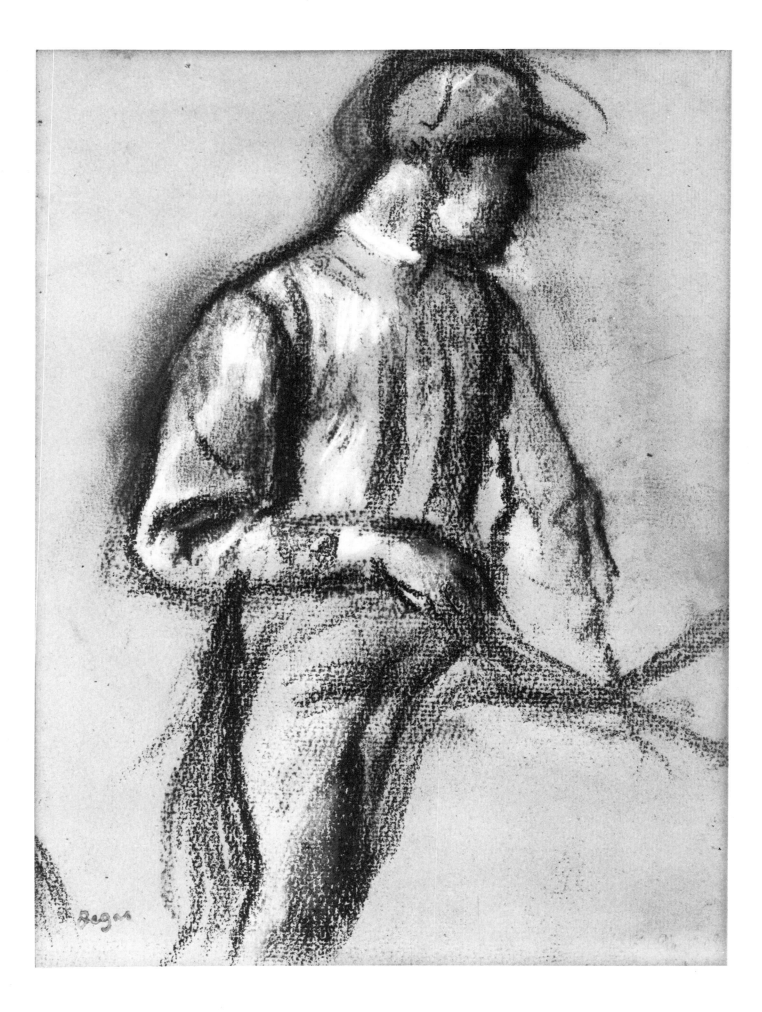

151 *Jockey in Profile to the Right* 1884–8

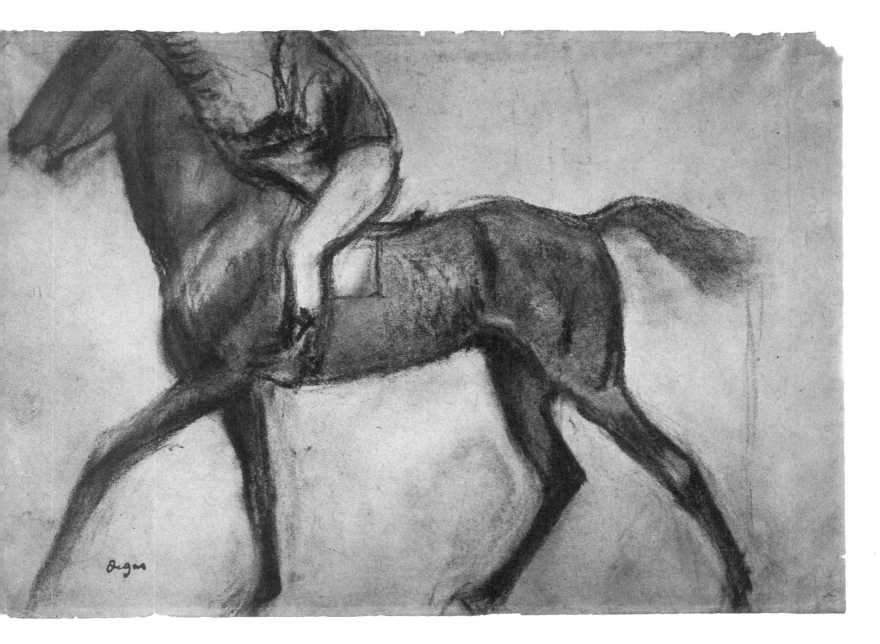

152 *Jockey and Trotting Horse Profiled to the Left* 1887–8

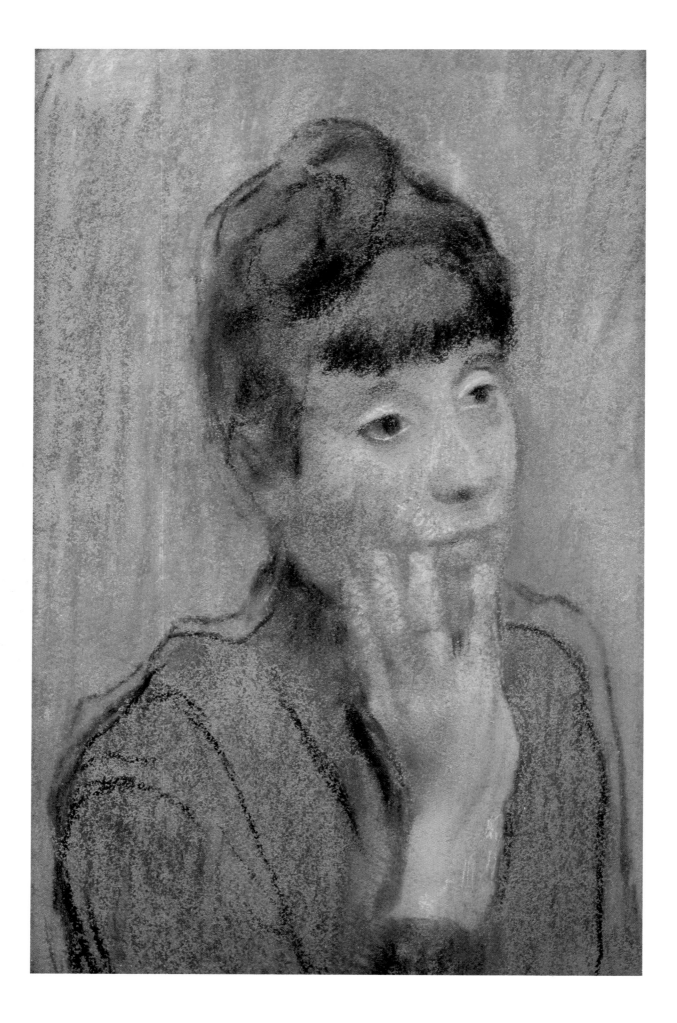

153 *Portrait of a Lady* circa 1884

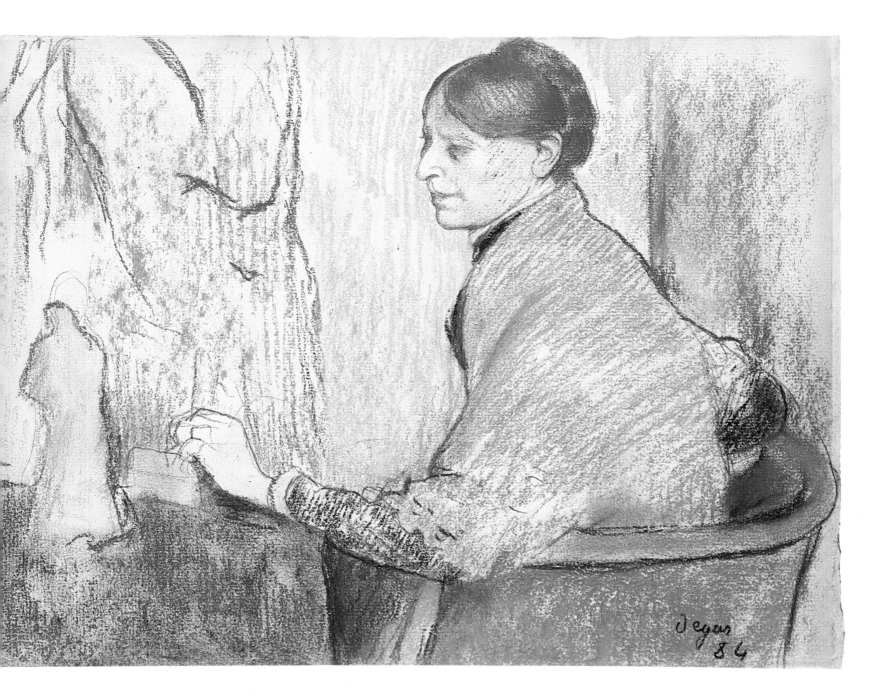

154 *Mme Henri Rouart with a Tanagra Statuette* 1884

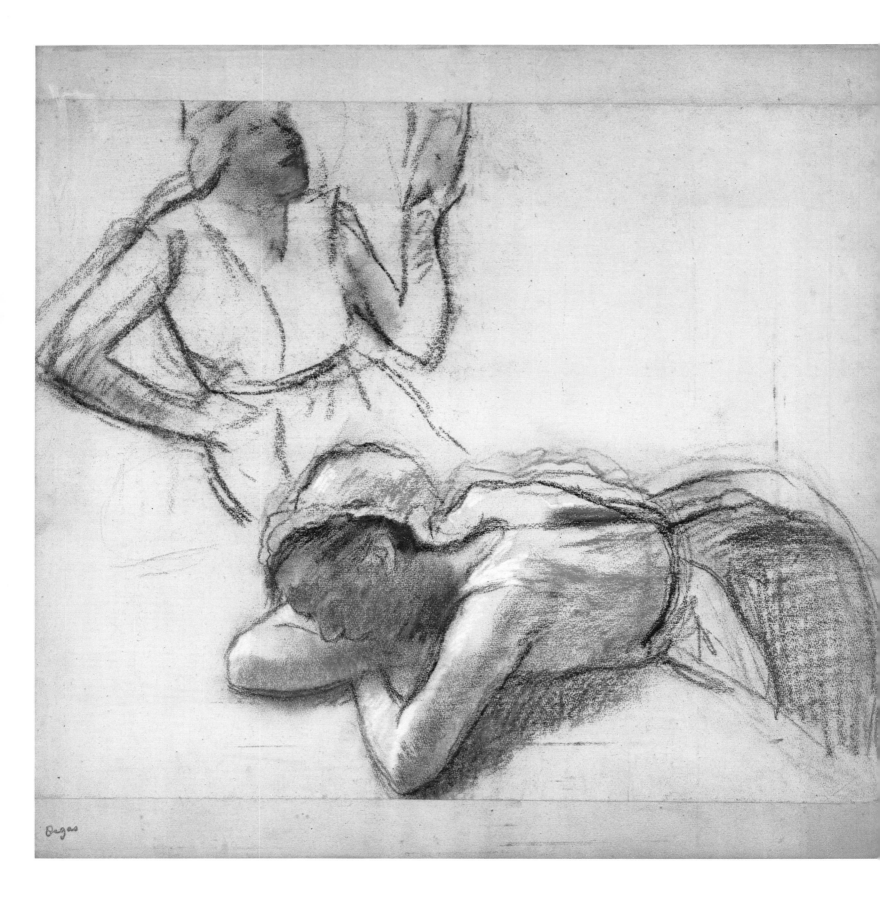

Degas

155 *Two Laundresses Reading a Letter* circa 1884

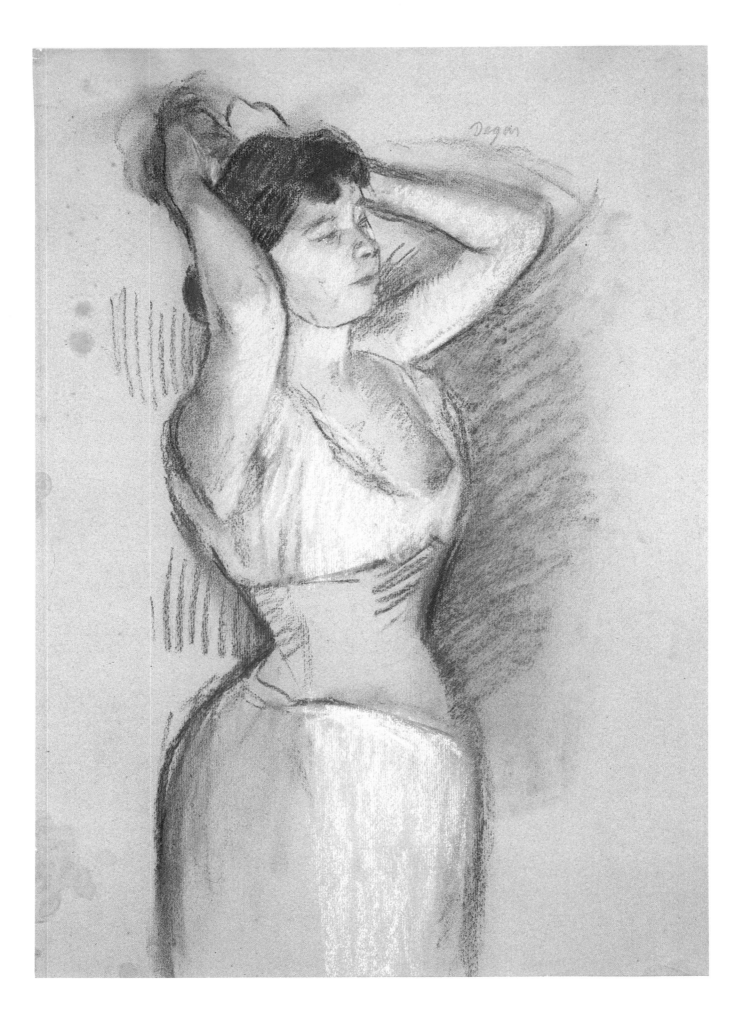

156 *Hairdressing* circa 1885

Degas

157 *Fan: Scene from the Opera 'Sigurd'* 1885

la natte très grosse

158 *The Singer Rose Caron with Left Arm Raised* 1885

159　*The Opera Glass* circa 1885

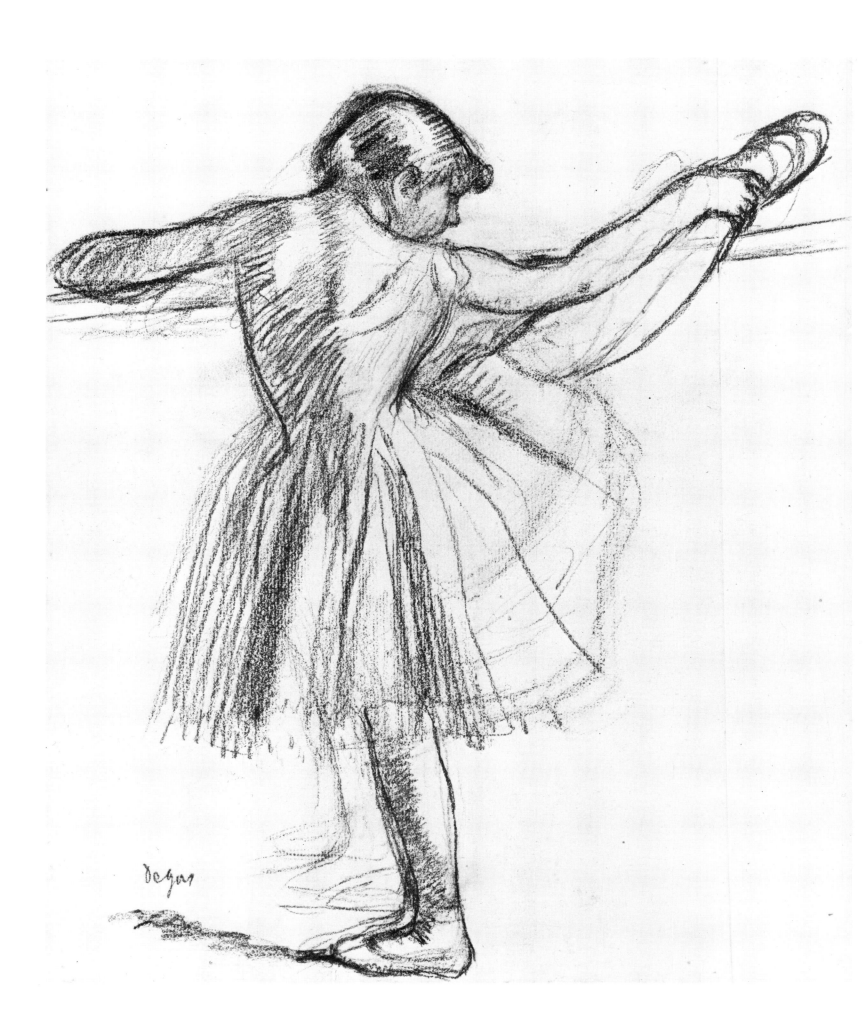

161 *Dancer at the Bar* circa 1885

[for pl. 160 see p. 44]

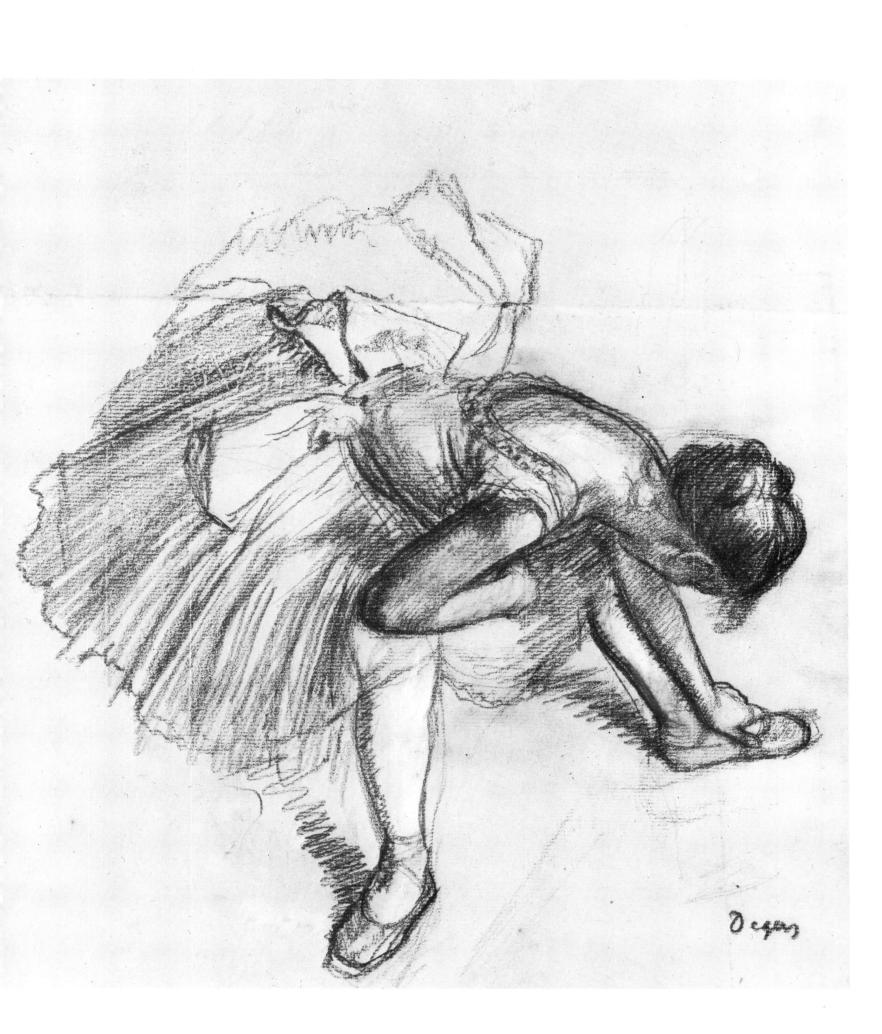

162 *Seated Dancer Fastening her Shoe* 1885–7

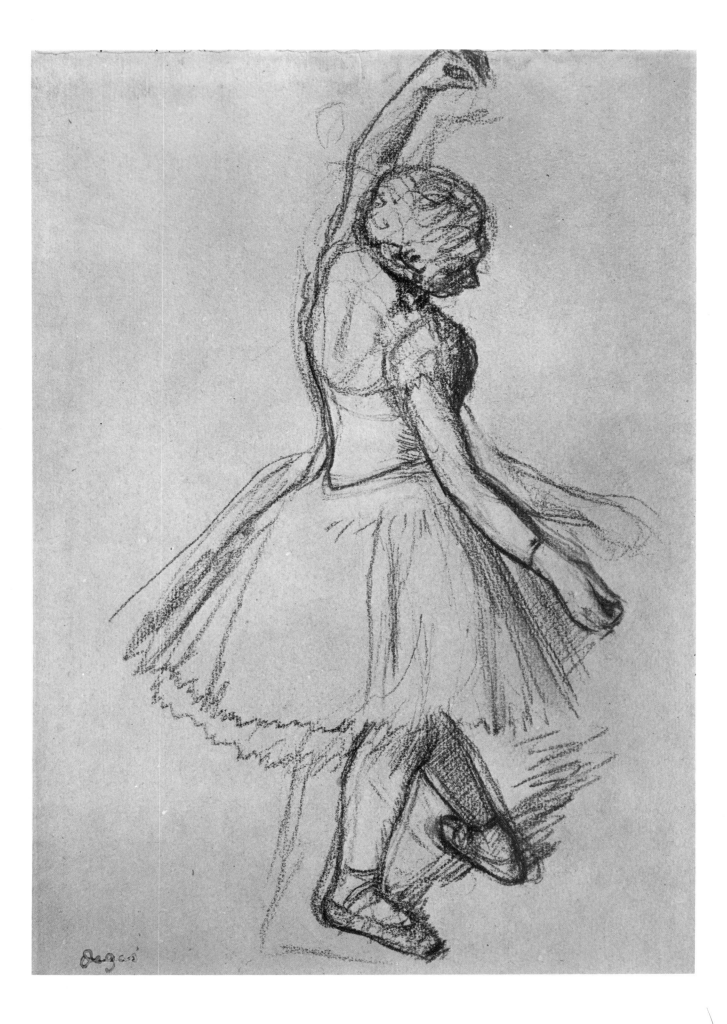

163 *Dancer with Arms Spread* circa 1885

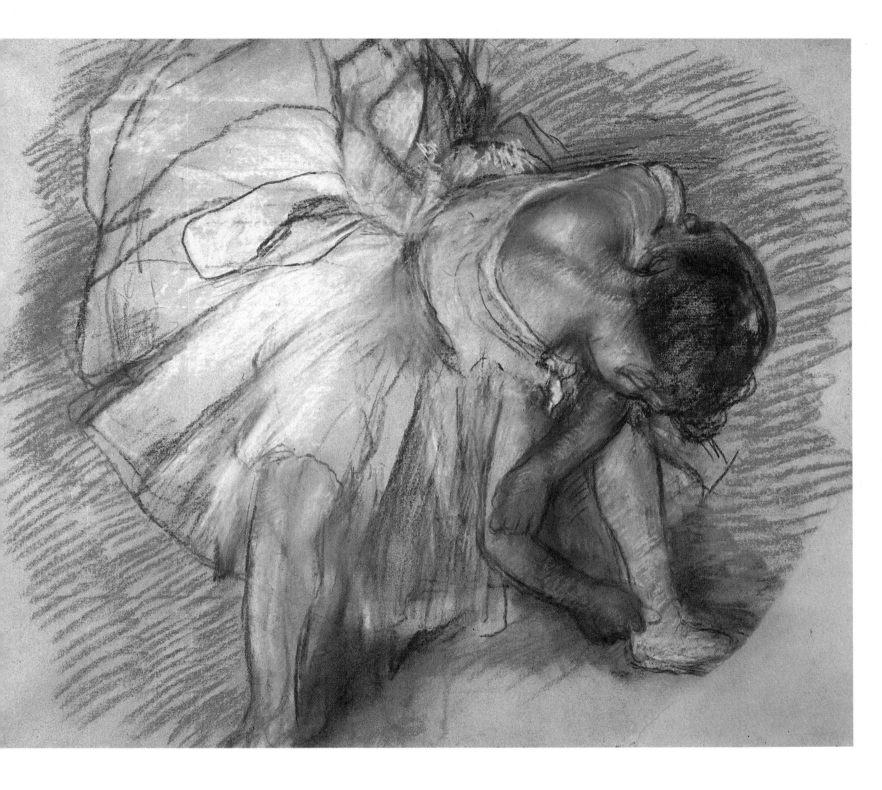

164 *Seated Dancer Tying her Shoelace* 1885-7

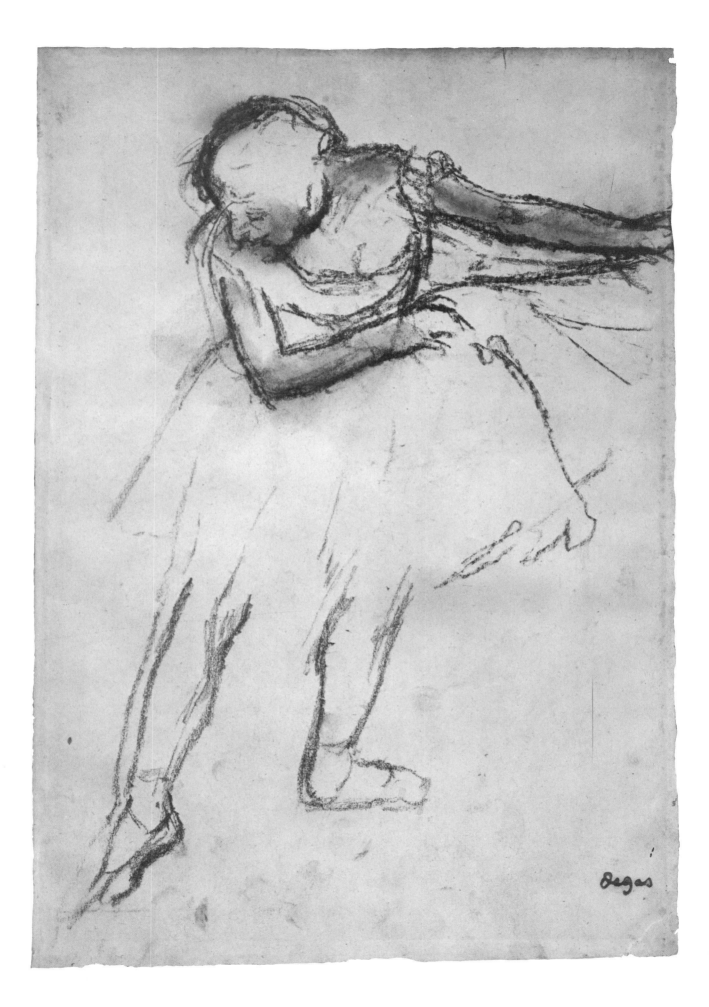

165 *Dancer with Right Leg Stretched Forward* circa 1885

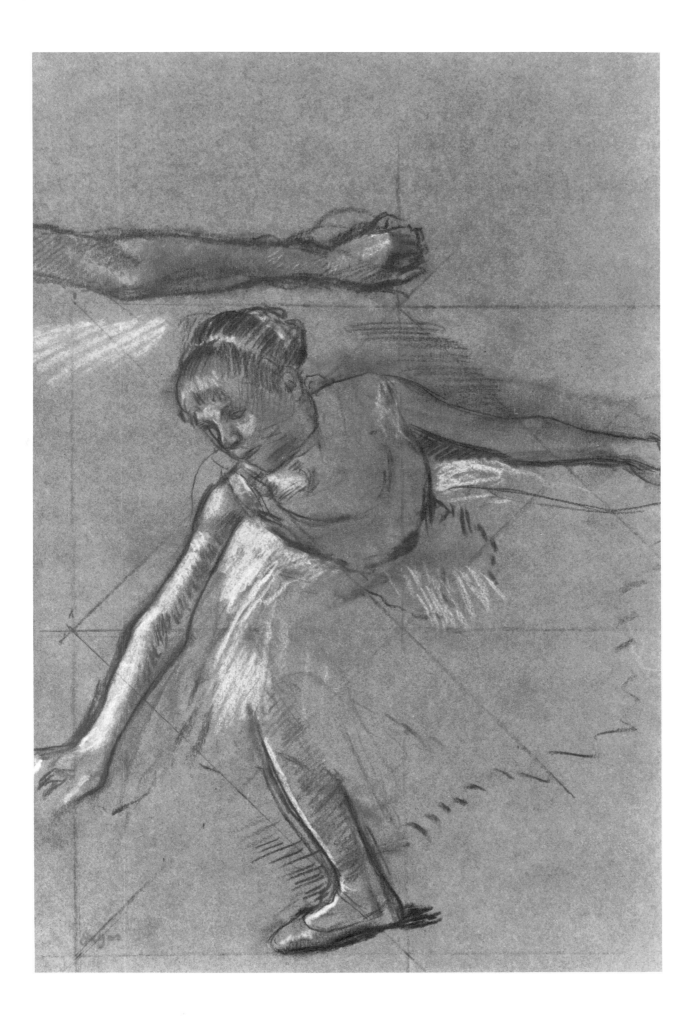

166 *Dancer Curtseying :Study of Arm* circa 1885

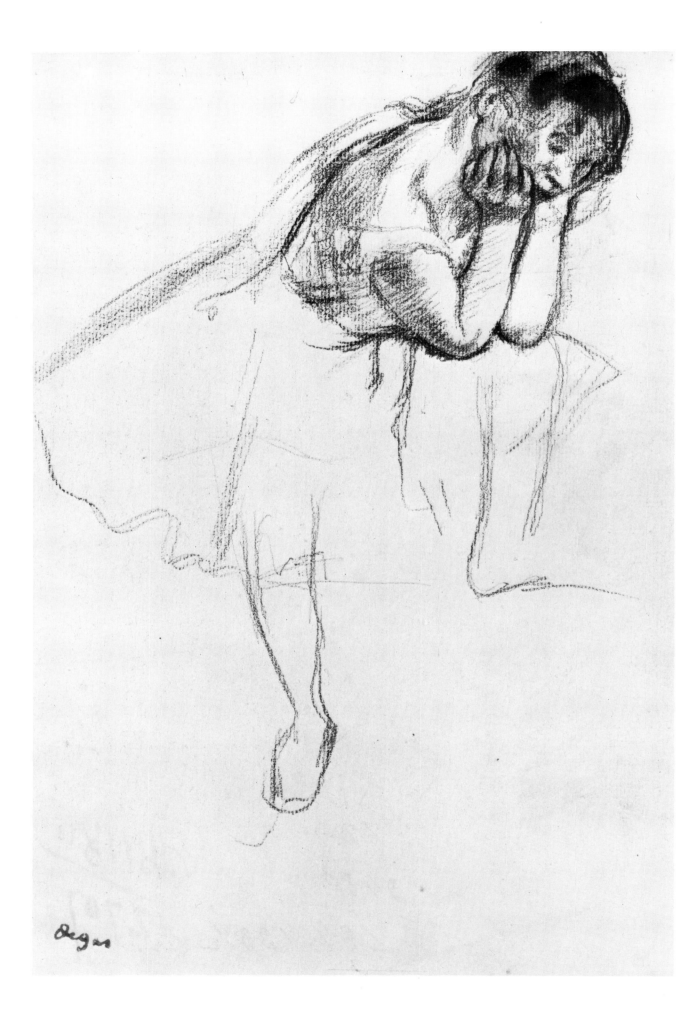

Degas

167 *Dancer with Left Leg Raised*

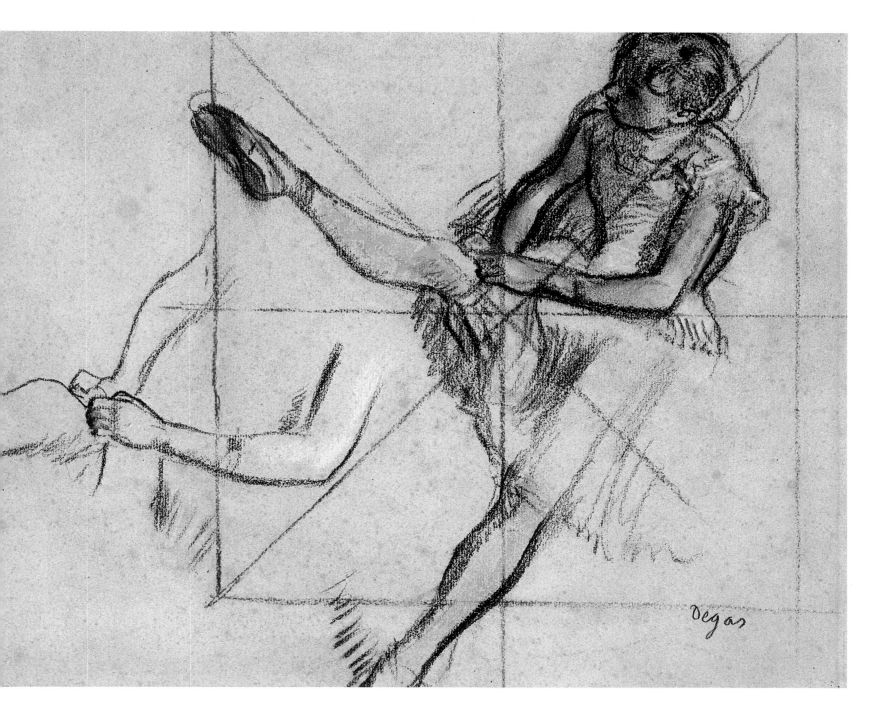

168 *Seated Dancer Pulling on Stocking* 1885–90

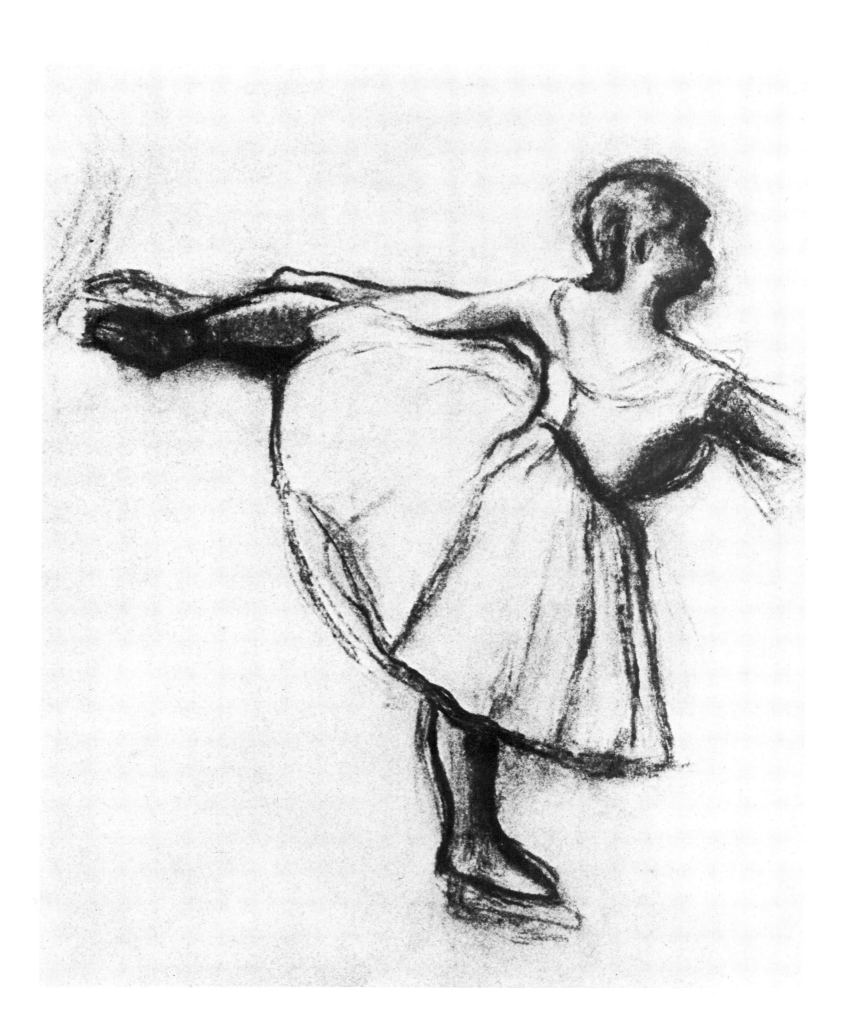

169 *Dancer at the Bar* 1885–90

Degas

170 *Dancer with Double Bass* 1885–7

171 *Dancer Lit from the Side* 1885–90

172 *Dancer Tying her Sash* 1885–7

175 *Crest of Hill* 1890–92

[for pl. 173 see p. 57]
[for pl. 174 see p. 48]

176 *Vesuvius* 1890–92

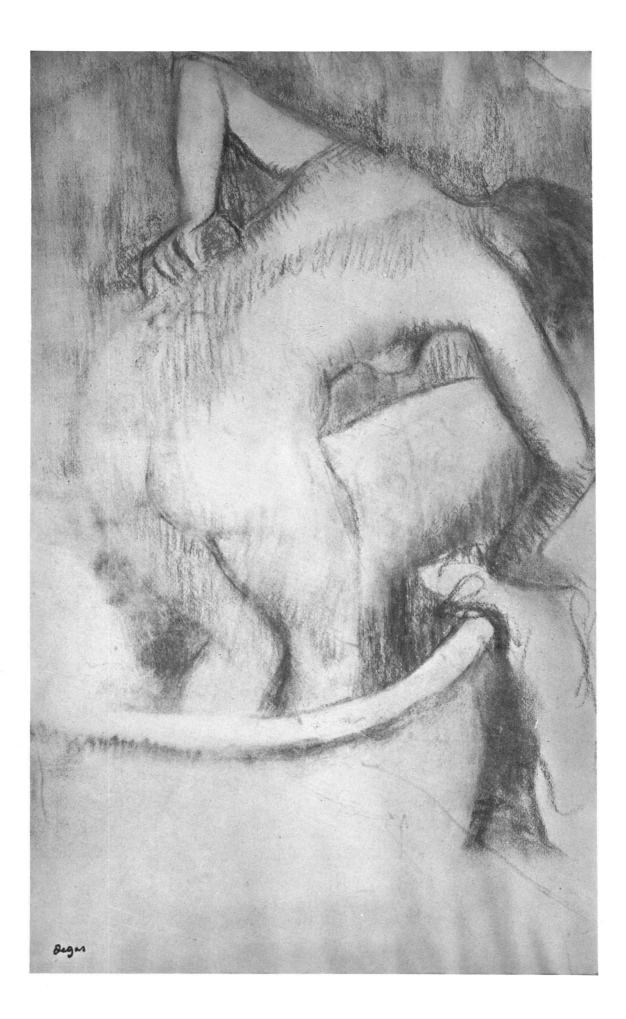

179 *Nude from the Back Washing in a Bathtub* circa 1887

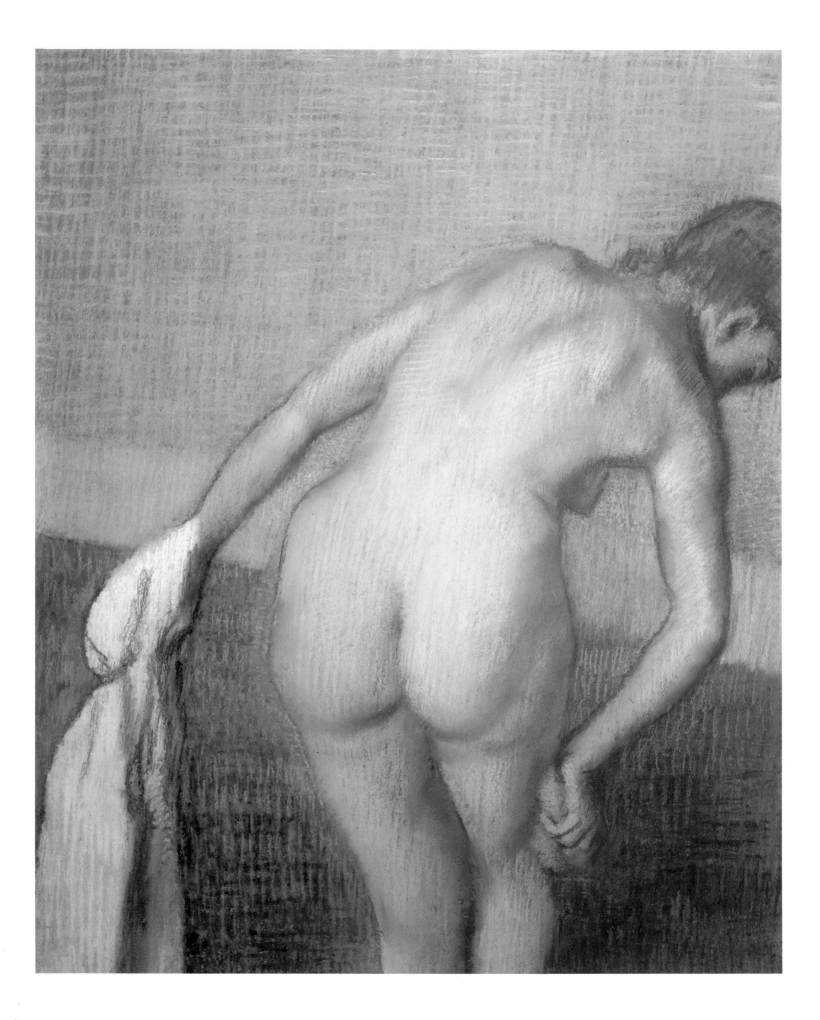

180 *Nude from the Back with Towel and Sponge* 1886–90

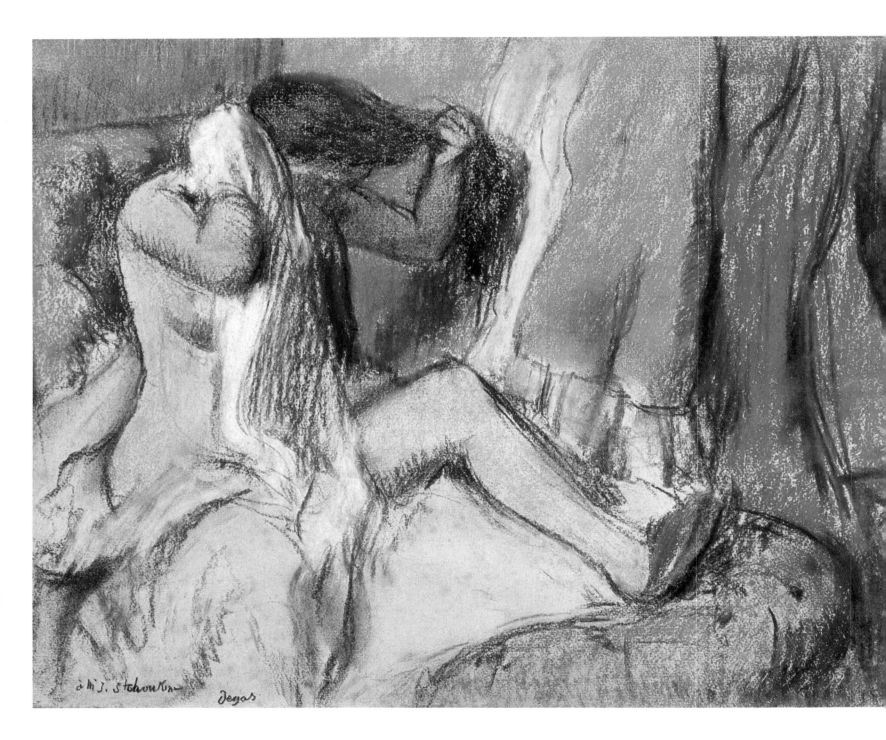

182 *Seated Nude on a Sofa and Drying her Hair* 1888–92

[for pl. 181 see p. 61]

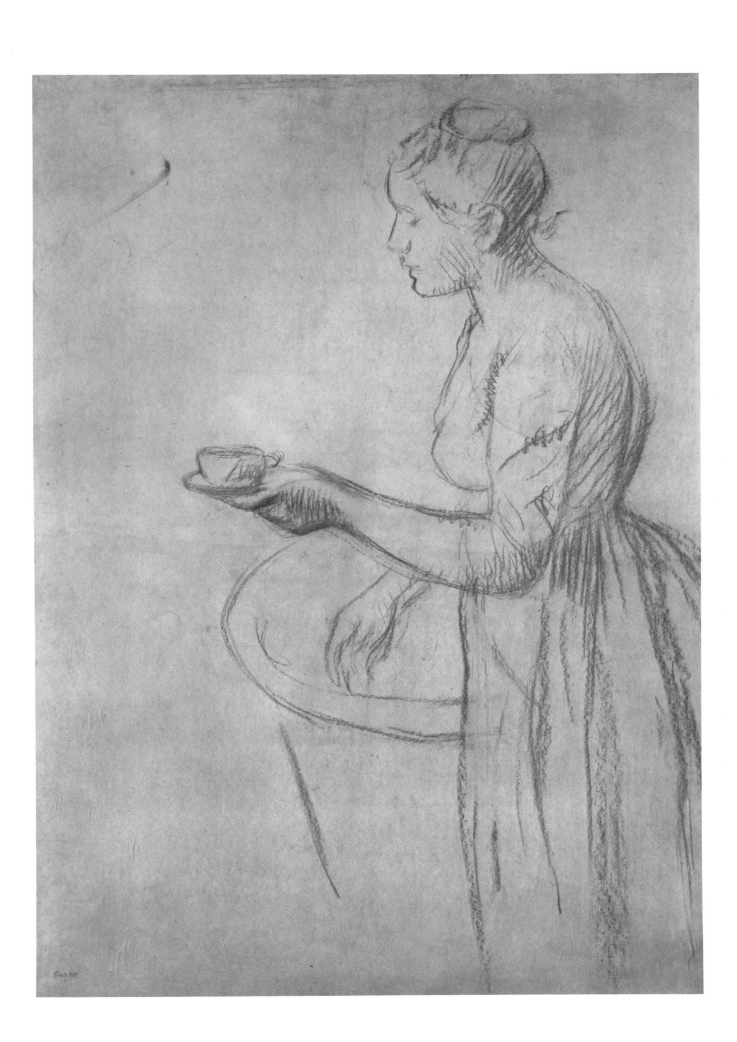

183 *Maid with a Cup* circa 1890

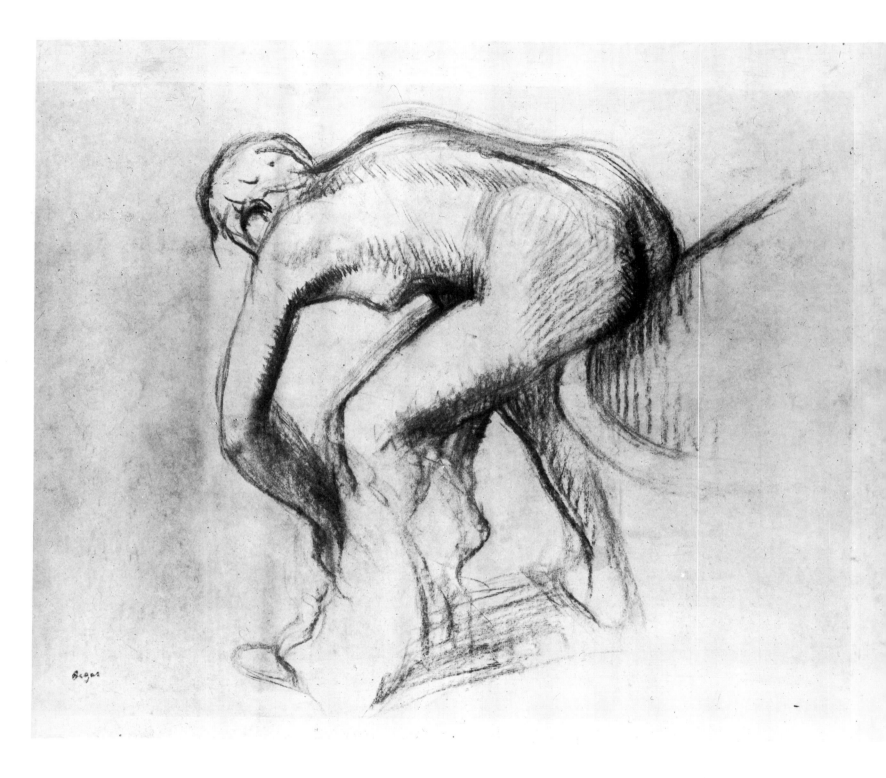

184 *Nude on Edge of Bath Drying her Legs* circa 1890

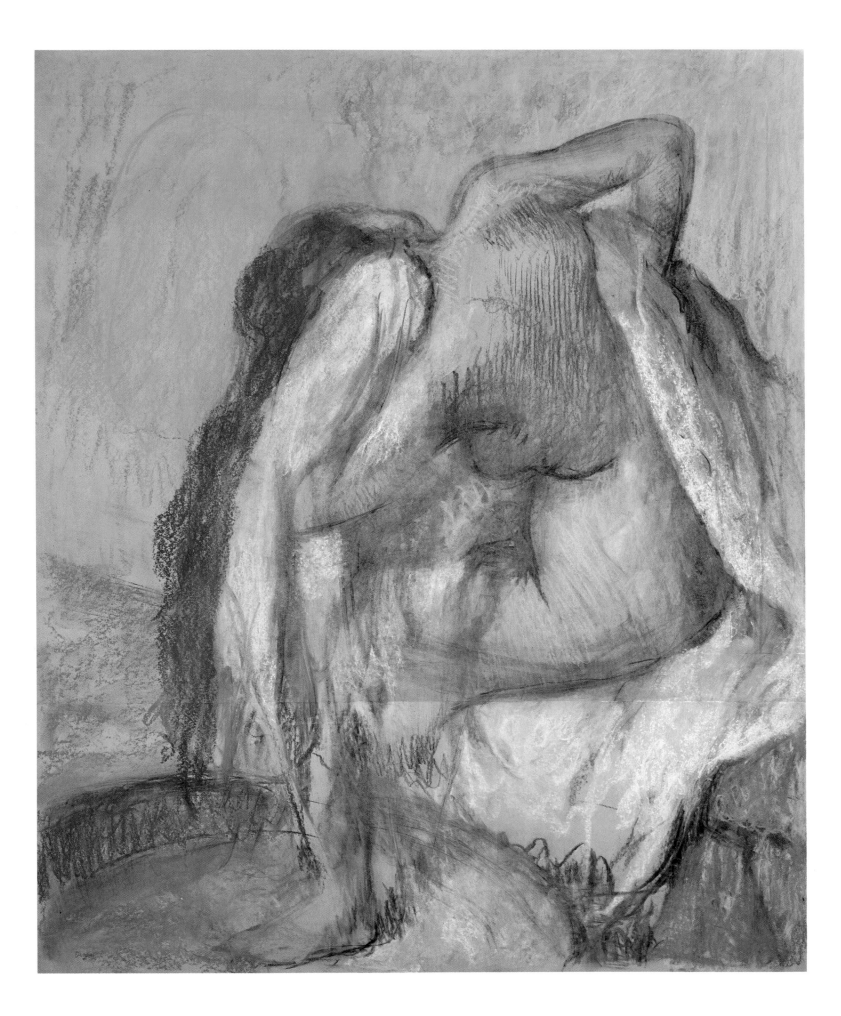

185 *Seated Nude Drying her Neck and Back* 1890–95

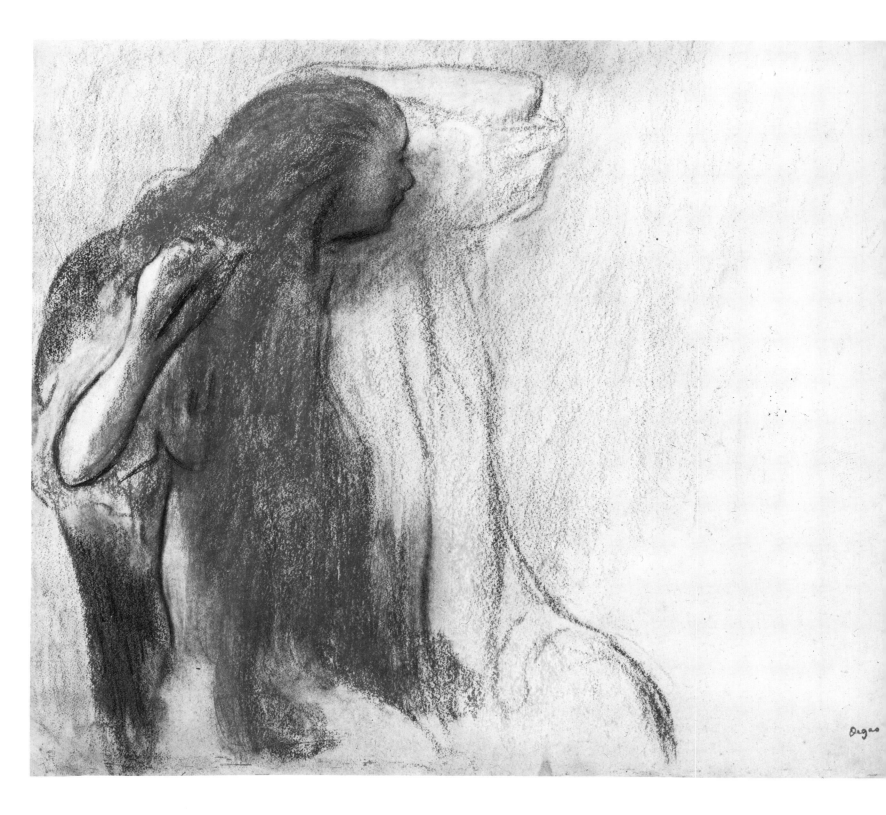

187 *Seated Girl Combing her Hair* circa 1894

[for pl. 186 see p. 65]

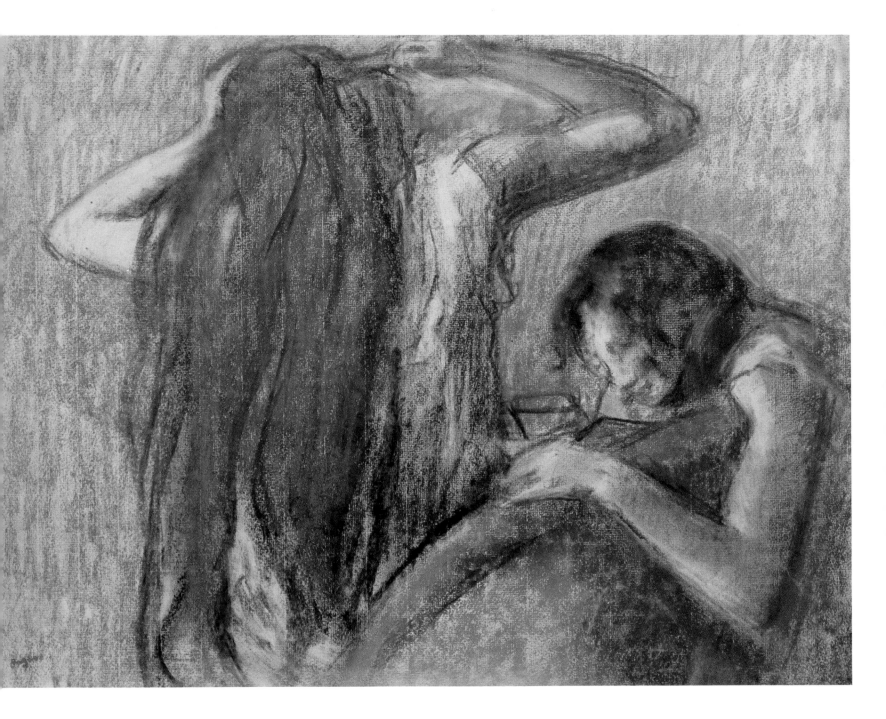

188 *Two Girls Reading and Combing their Hair* circa 1894

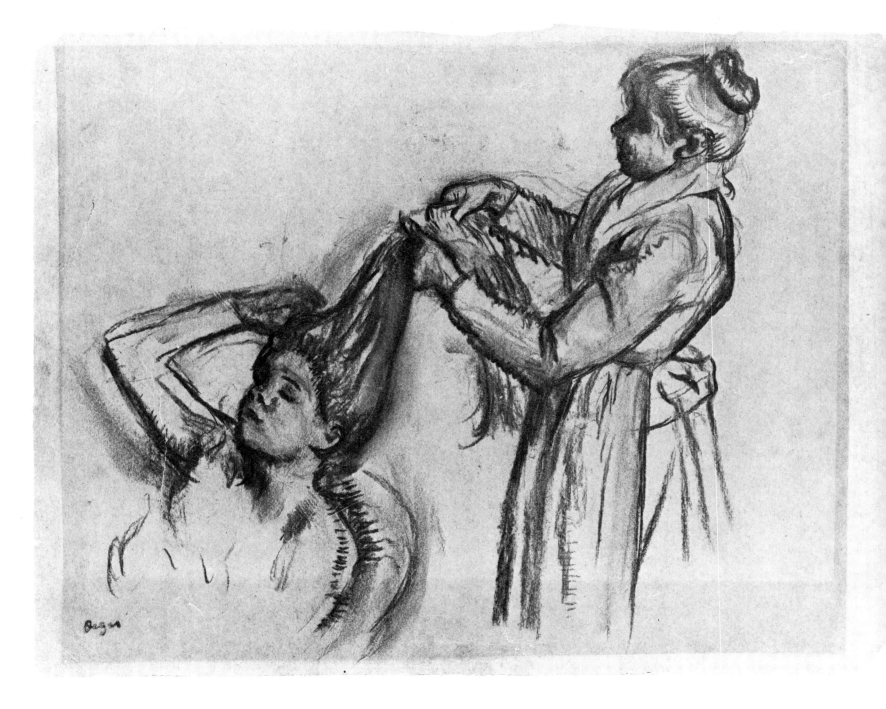

190 *Hairdressing* 1892–5

[for pl. 189 see p. 69]

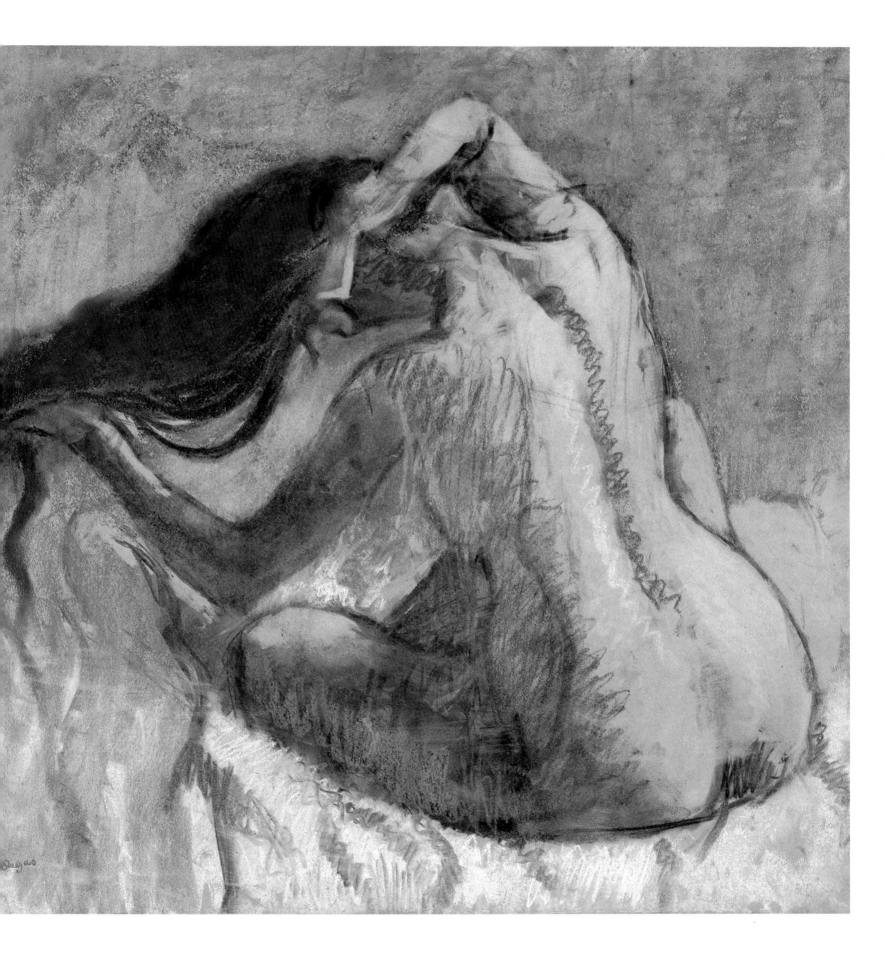

191 *Seated Nude from the Back, Combing her Hair* circa 1897

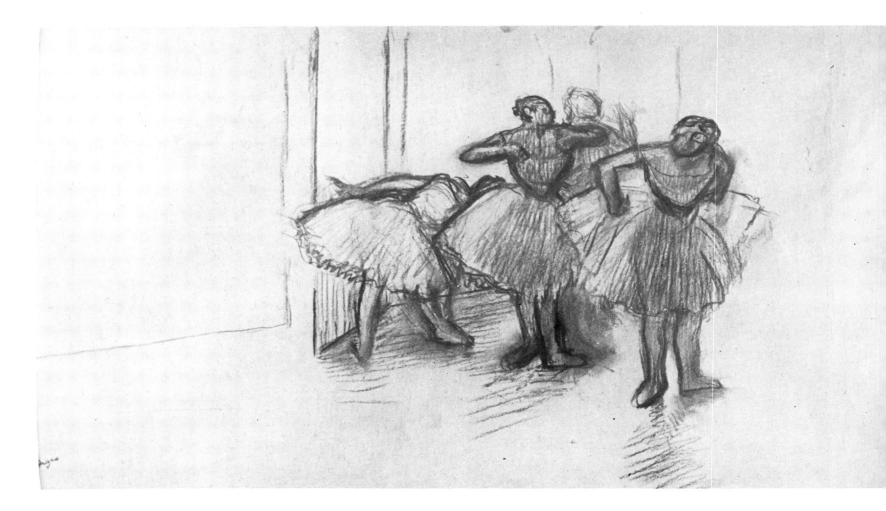

194 *The Dancing Examination* 1890–95

[for pl. 192 see p. 72]
[for pl. 193 see p. 81]

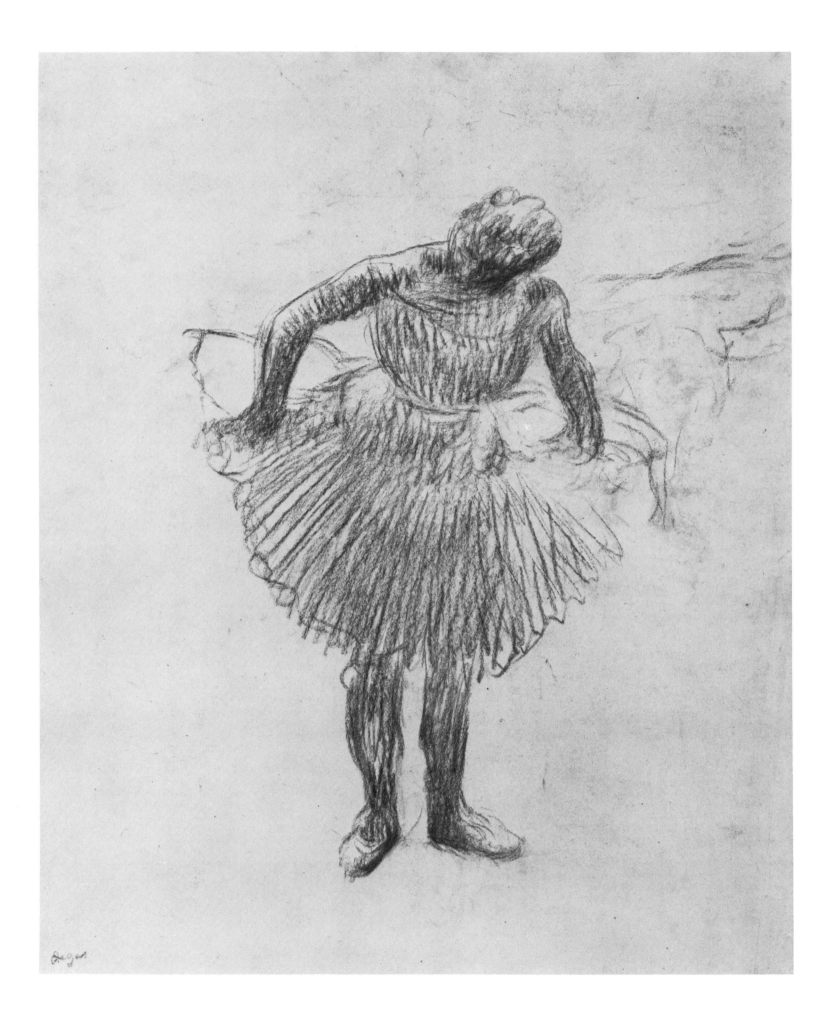

195 *Dancer Slightly Leaning Forward* 1890–95

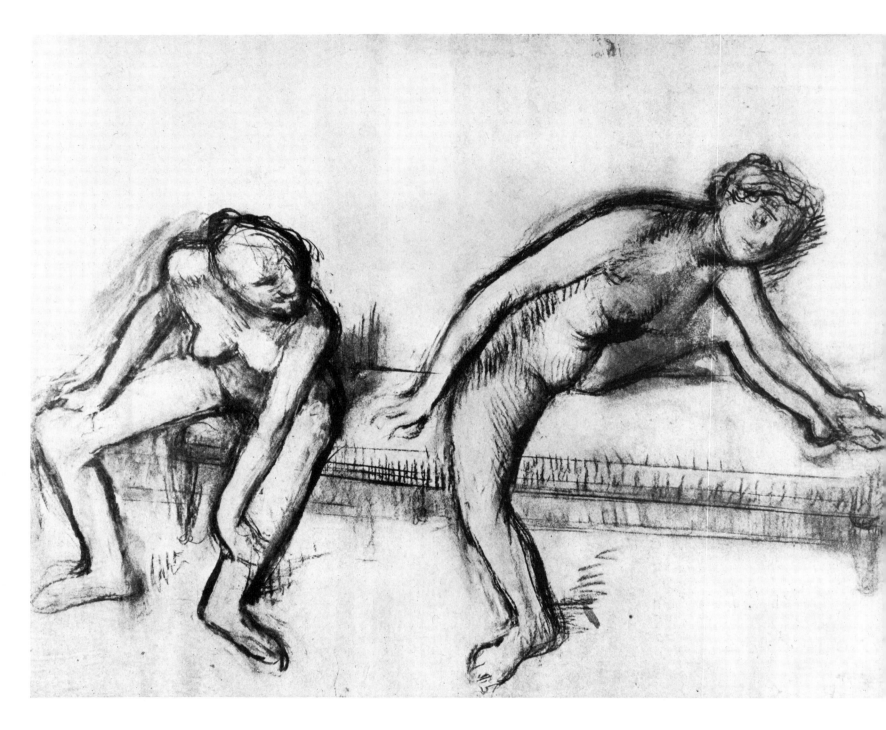

196 *Two Nude Dancers on a Bench* circa 1896

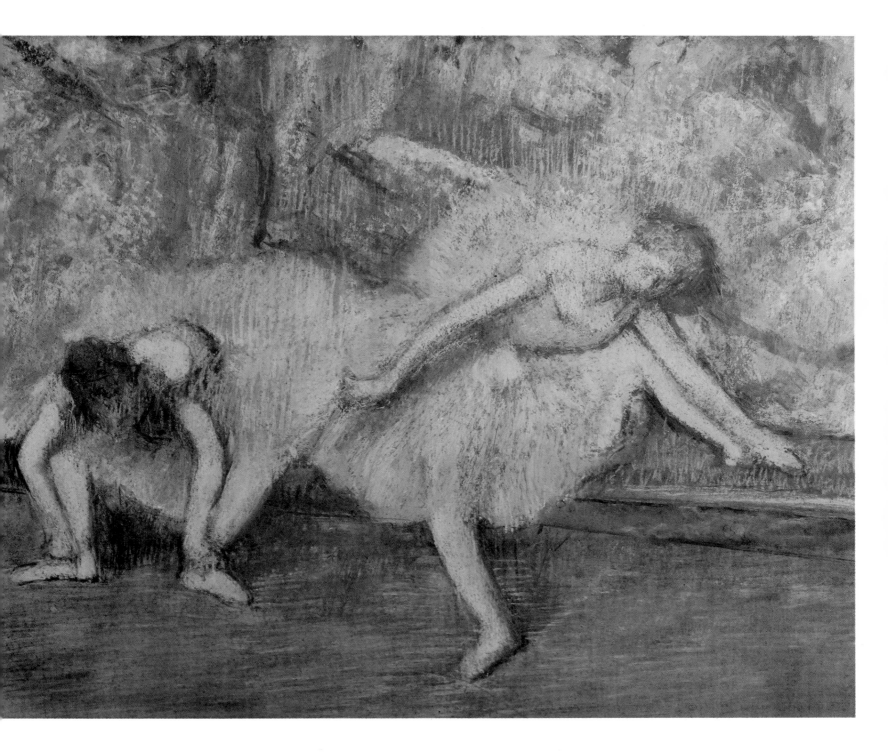

197 *Two Dancers on a Bench* circa 1896

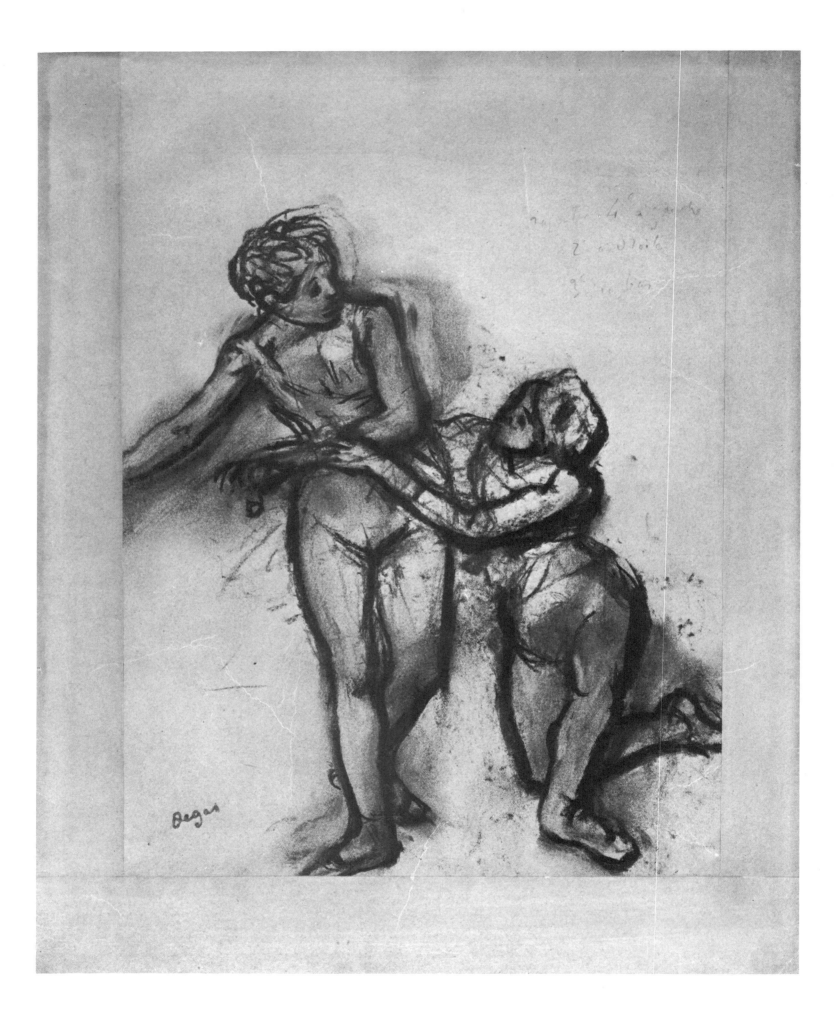

198 *Two Dancers in Body Stockings 1890–95*

[for pl. 199 see p.

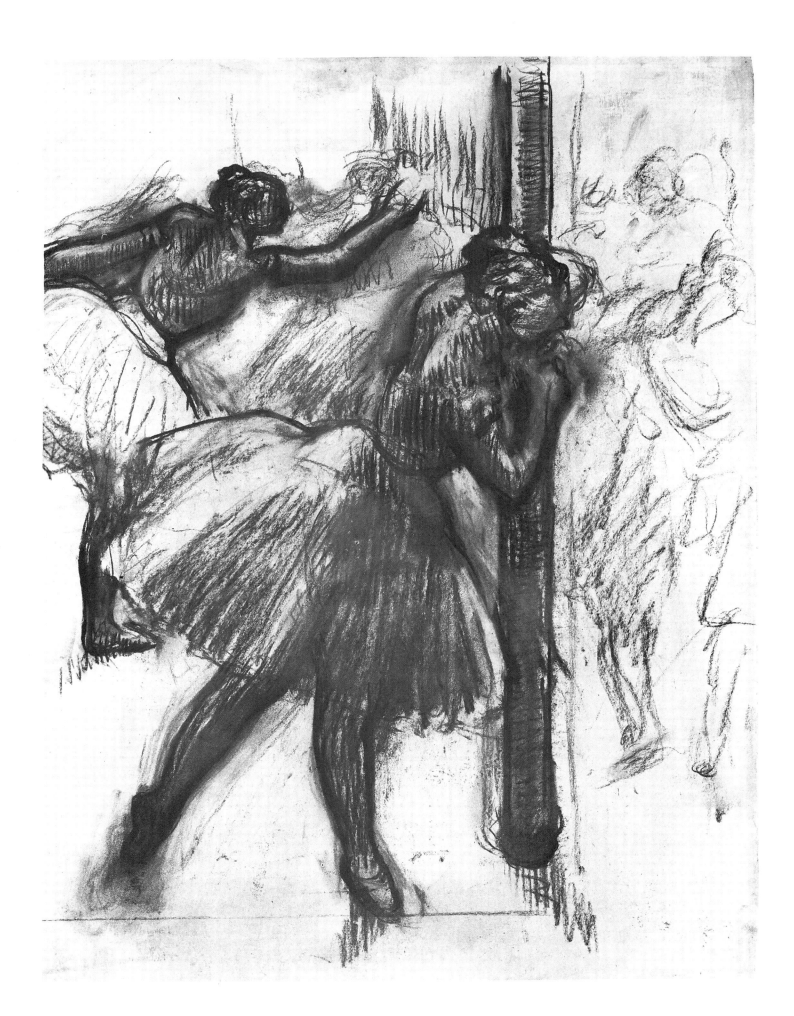

200 *Dancer Leaning on a Pillar* 1895-8

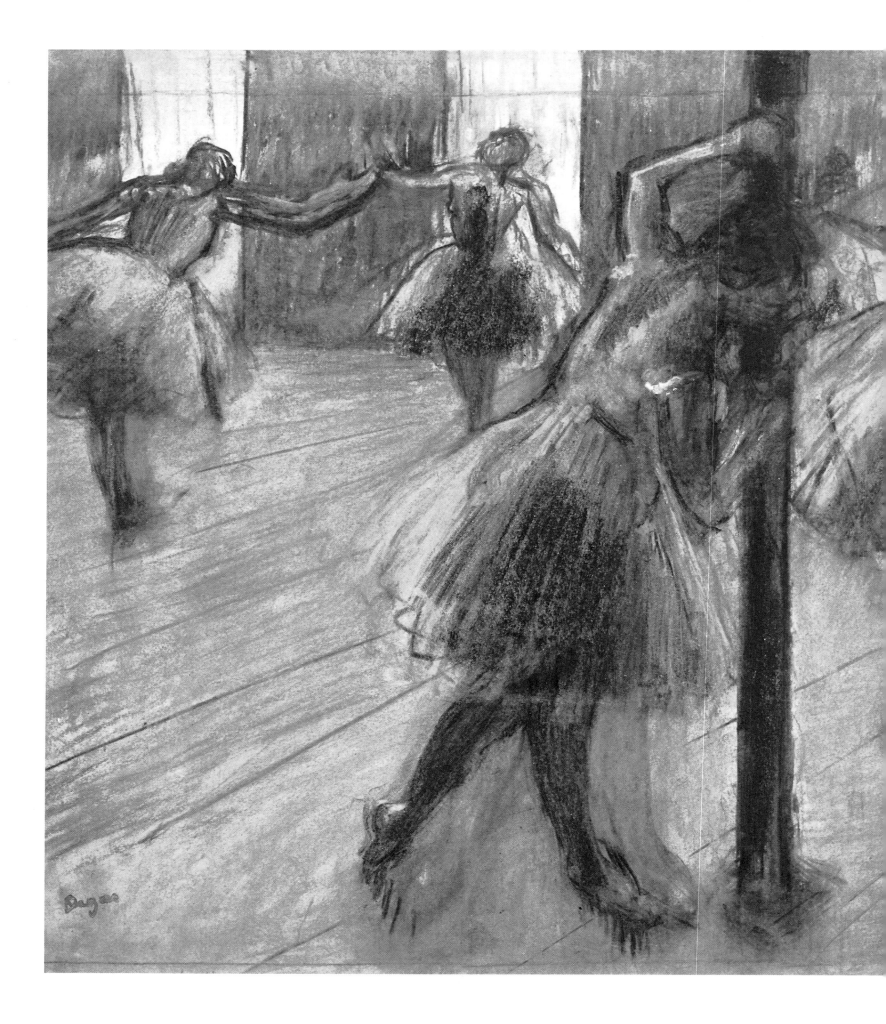

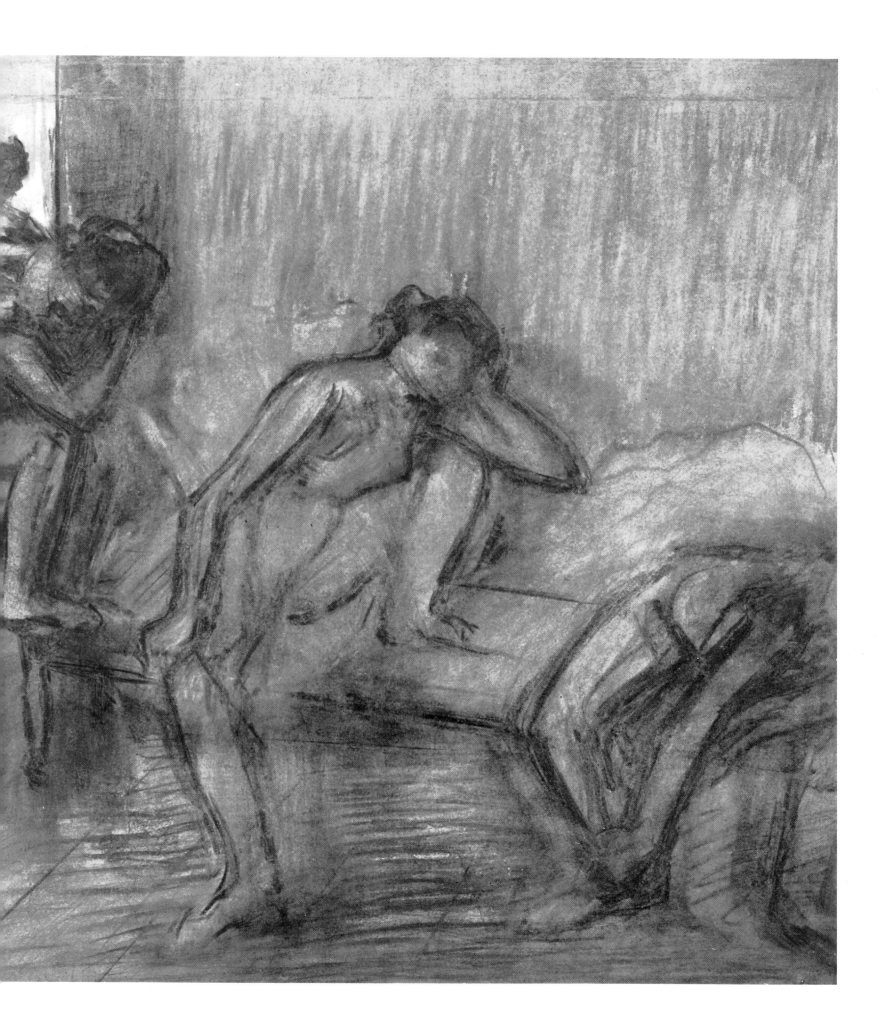

201 *Dancers in a Rehearsal Room* 1895–8

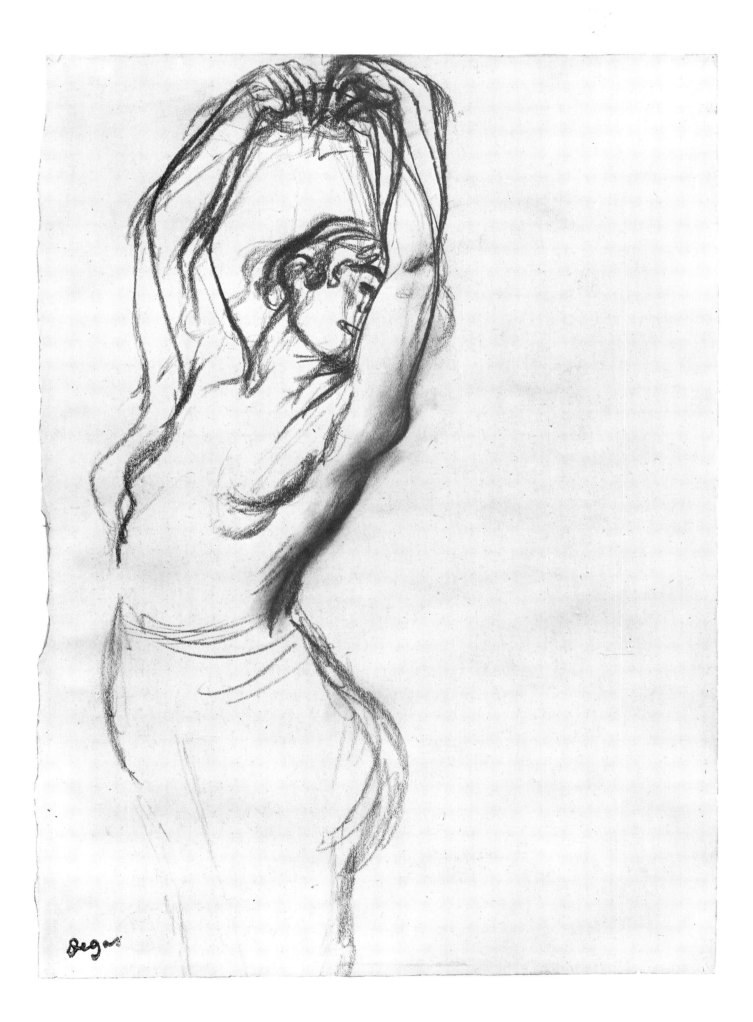

202 *Dancer with Bare Torso and Raised Arms* 1895–1900

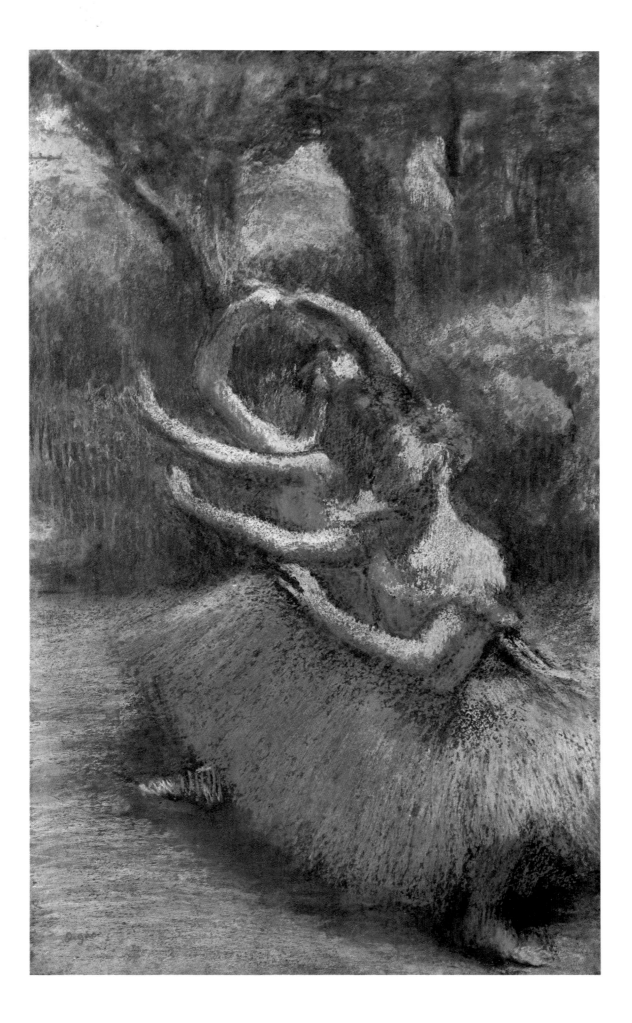

203 *Three Dancers in Front of a Landscape Backdrop* 1895–8

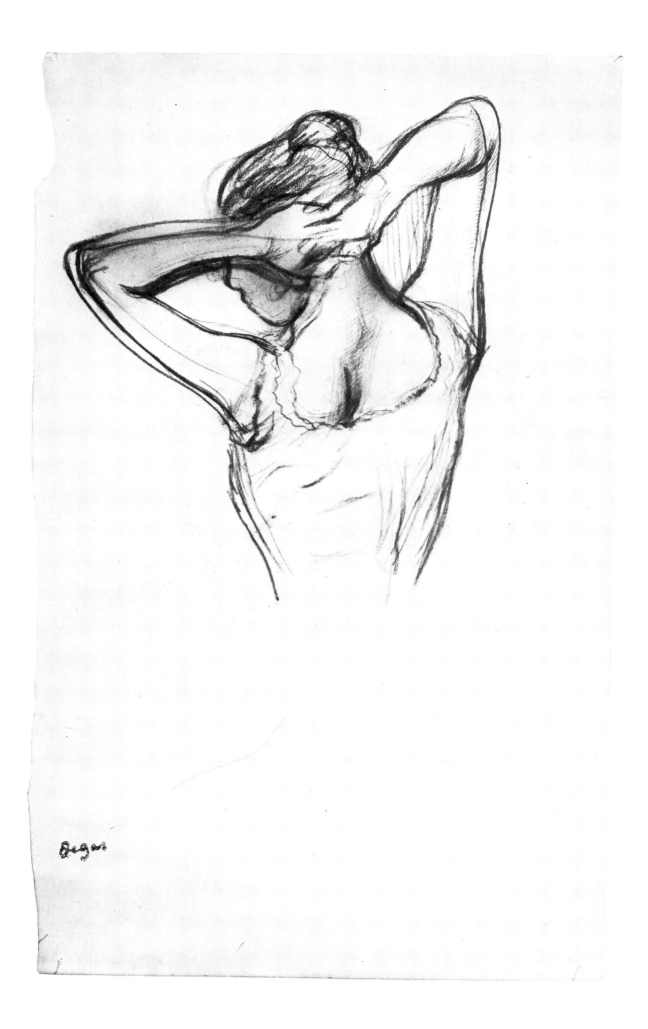

Degas

204 *Torso of Dancer with Arms Crossed Behind her Head* 1895–1900

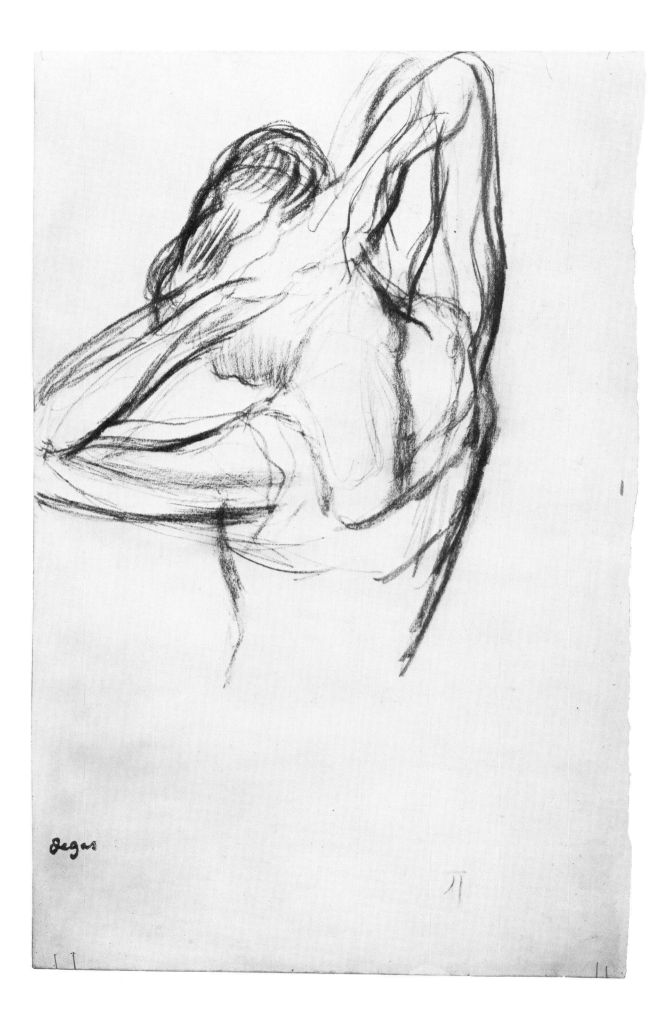

205 *Torso of Dancer with Arms Crossed Behind her Head* 1895–1900

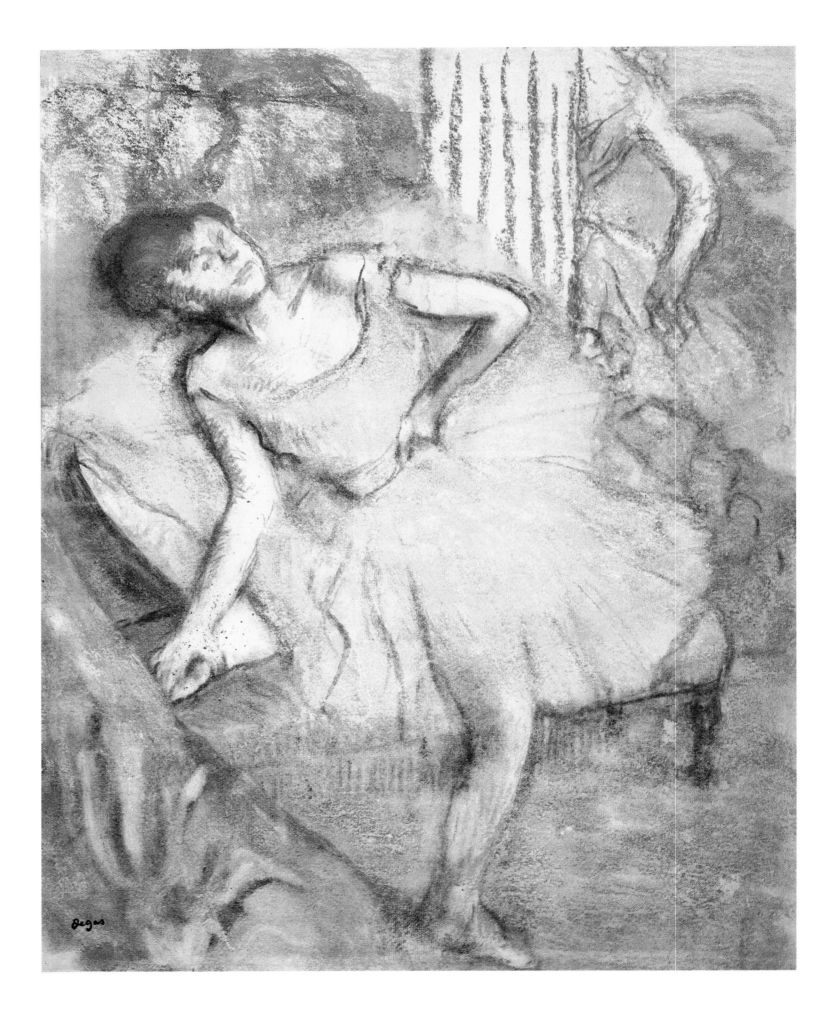

206 *Seated Dancer with Raised Right Leg* 1897–1900

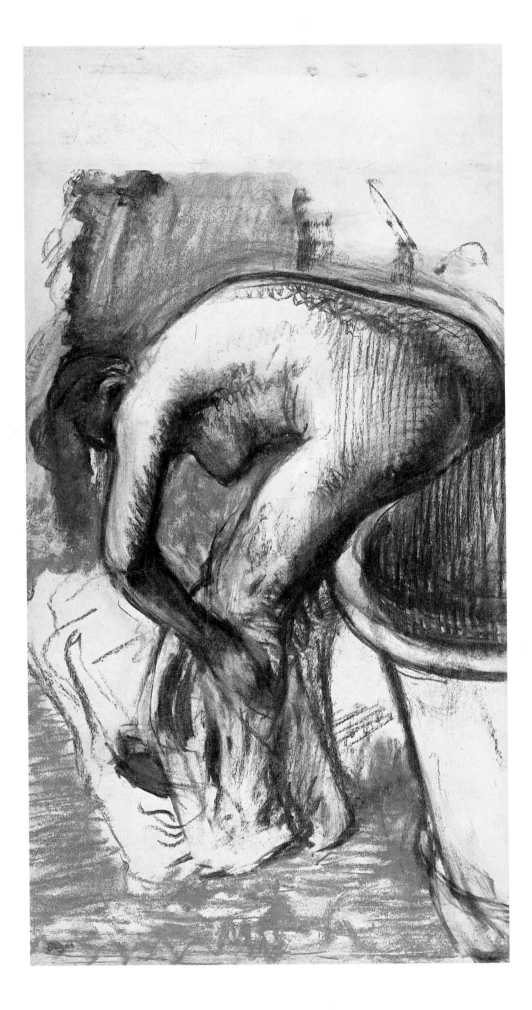

214 *Nude on Edge of Bath Drying her Legs* 1900–05

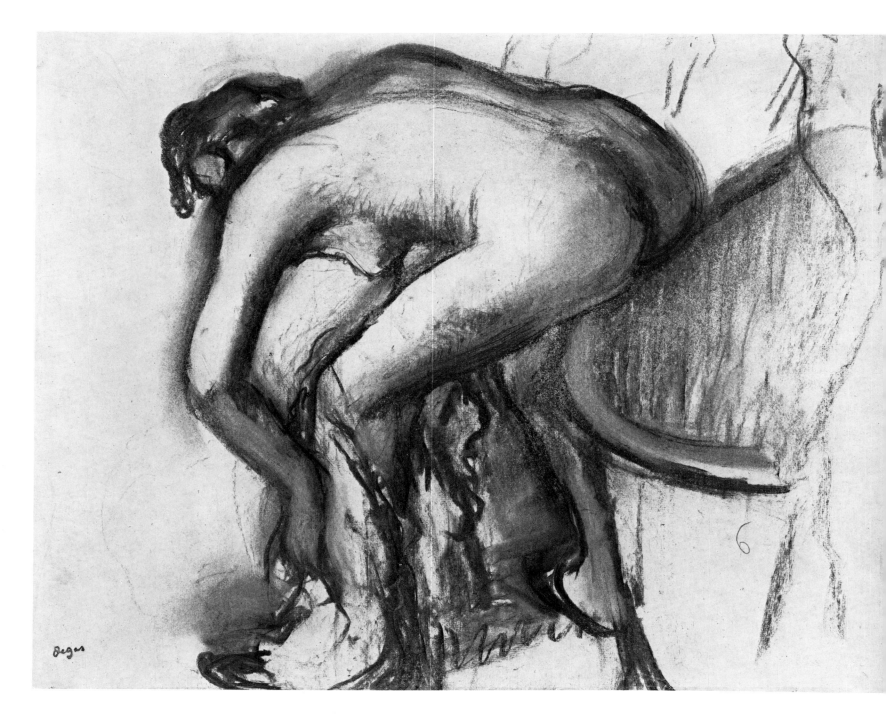

215 *Nude on the Edge of Bath Drying her Legs* 1900–05

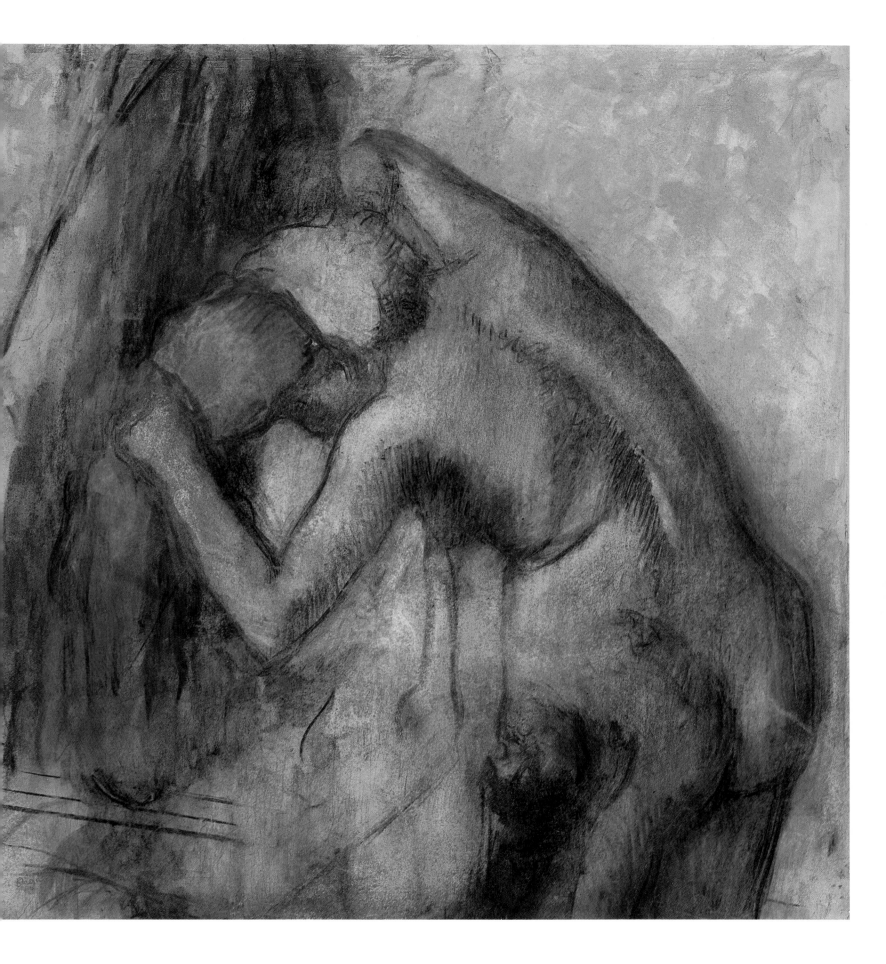

216 *Nude Drying her Hair* 1900–05

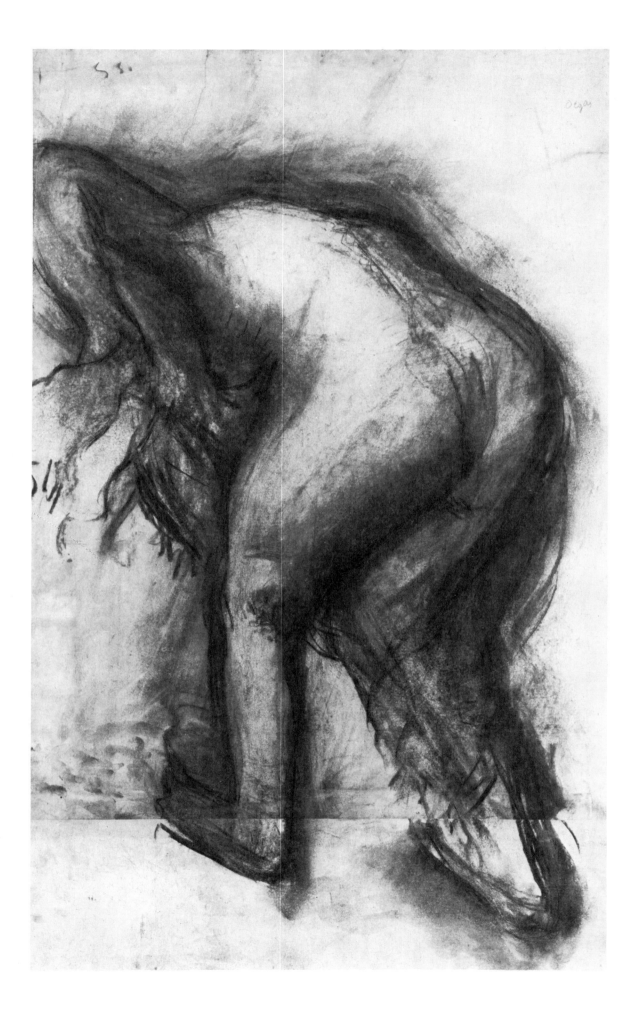

217 *Nude from the Back, Bending Forward and Drying her Legs* 1900–05

[for pl. 218 see p.

[for pl. 219 see p.

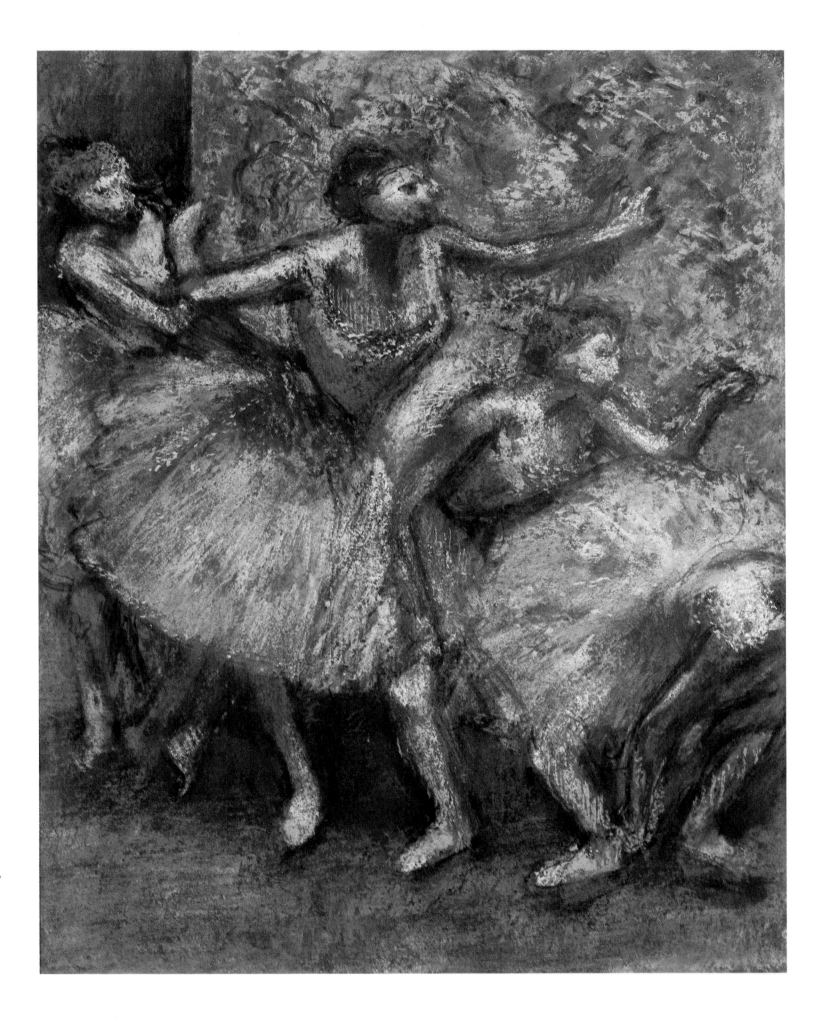

220 *Four Dancers in the Wings* circa 1903

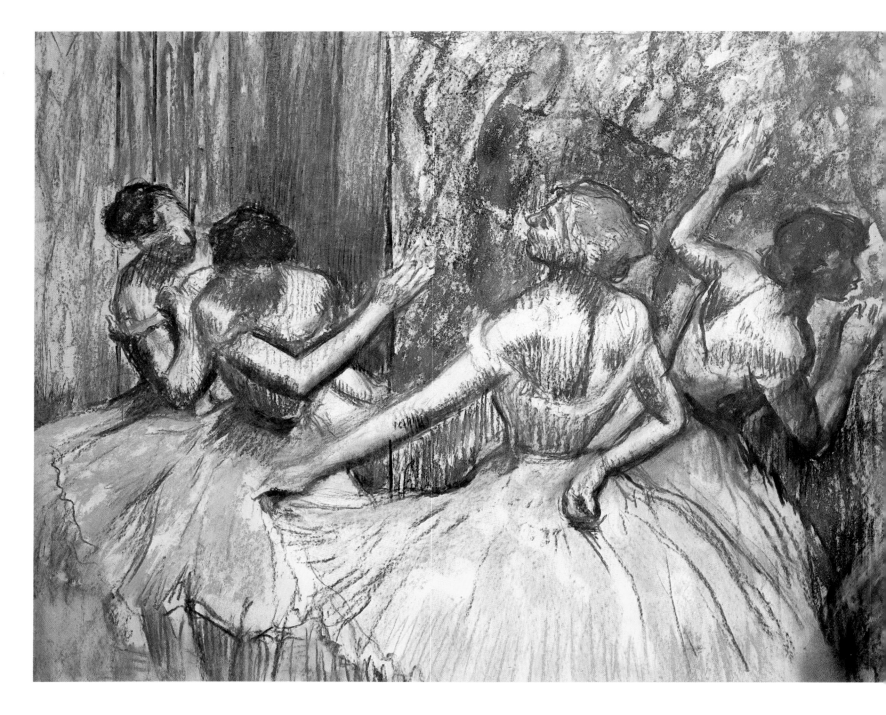

221 *Four Dancers in the Wings* 1900–05

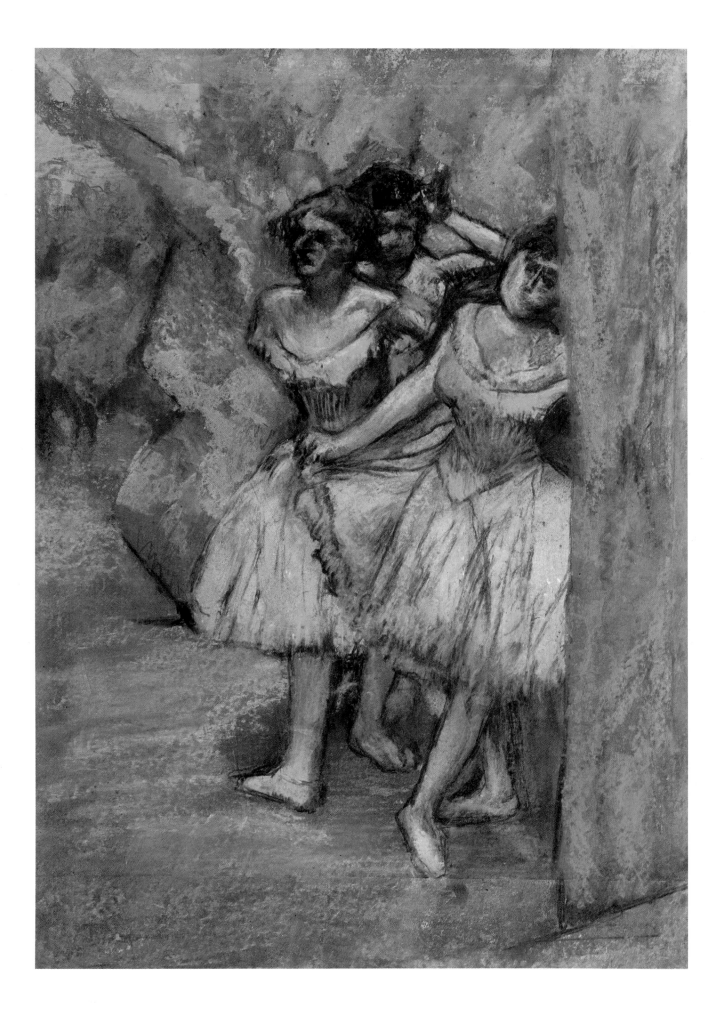

222 *Three Dancers in the Wings* 1904–6

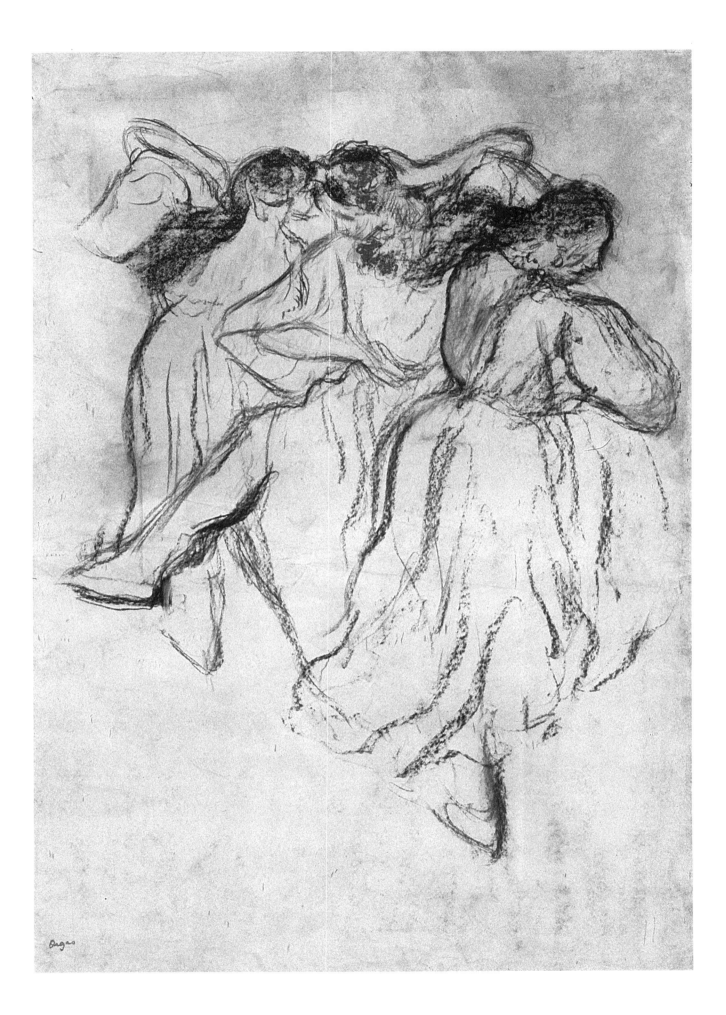

223 *Three Russian Dancers* 1900–05

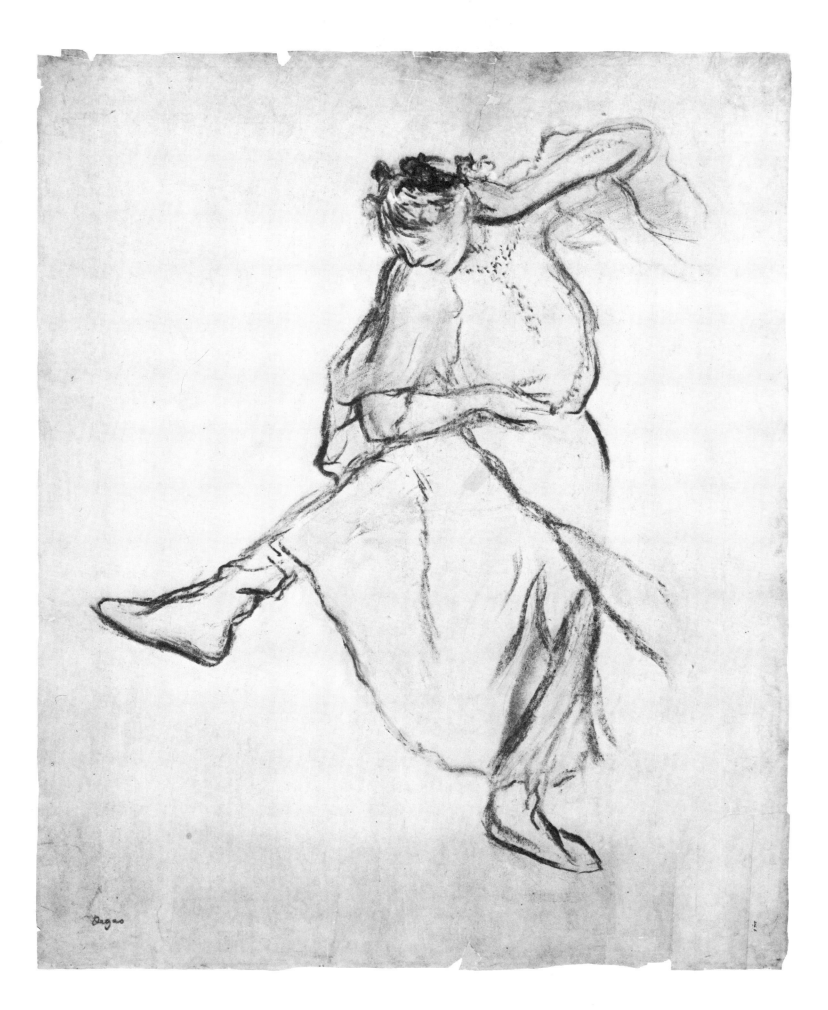

224 *Russian Dancer* 1900–05

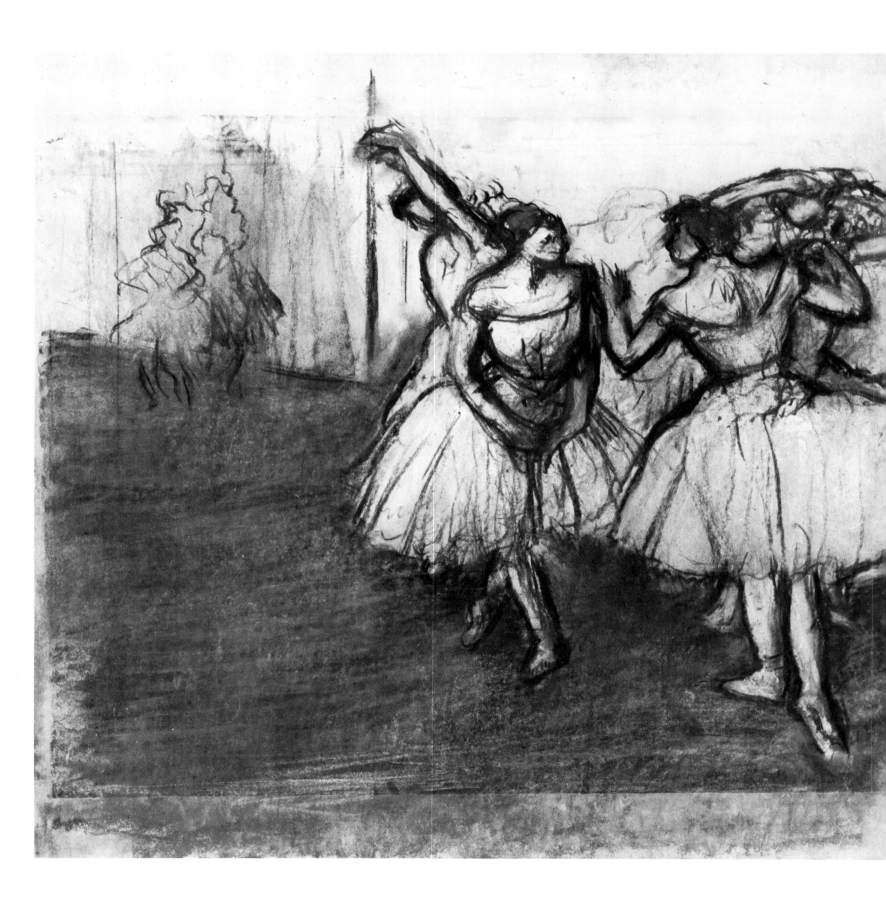

225 *Dancers on Stage* 1906–8

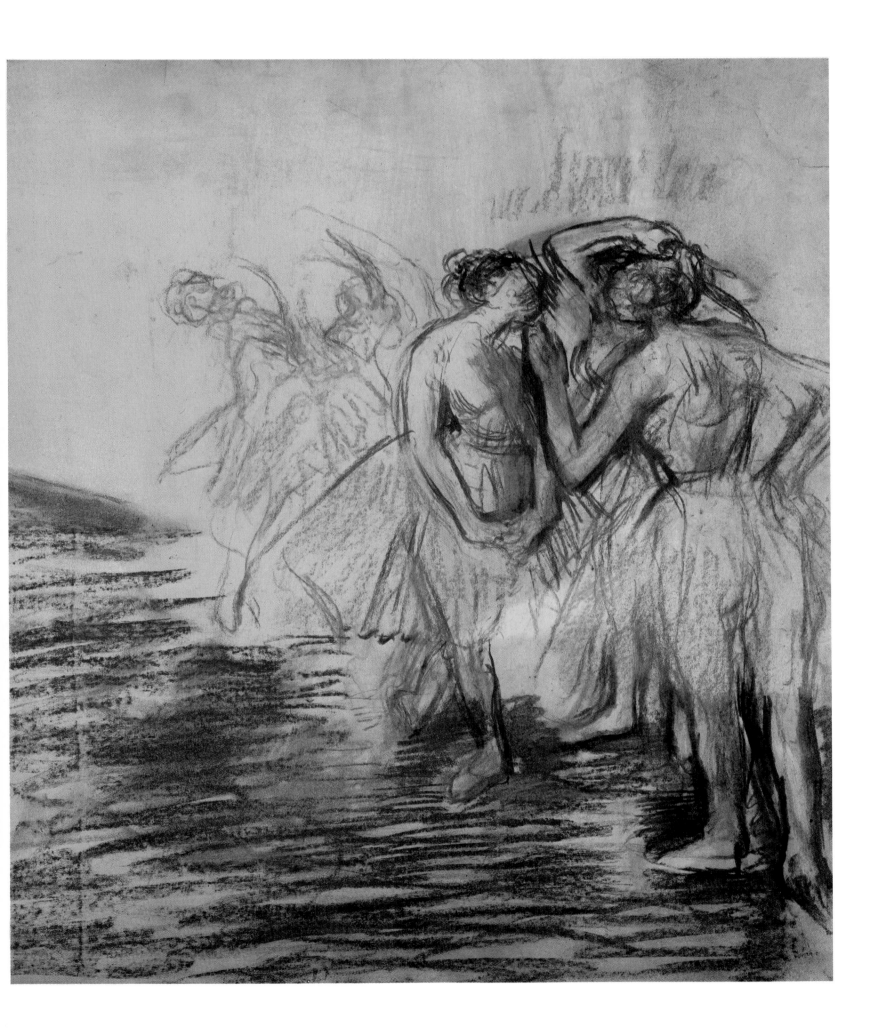

226 *Dancers on Stage* 1906–8

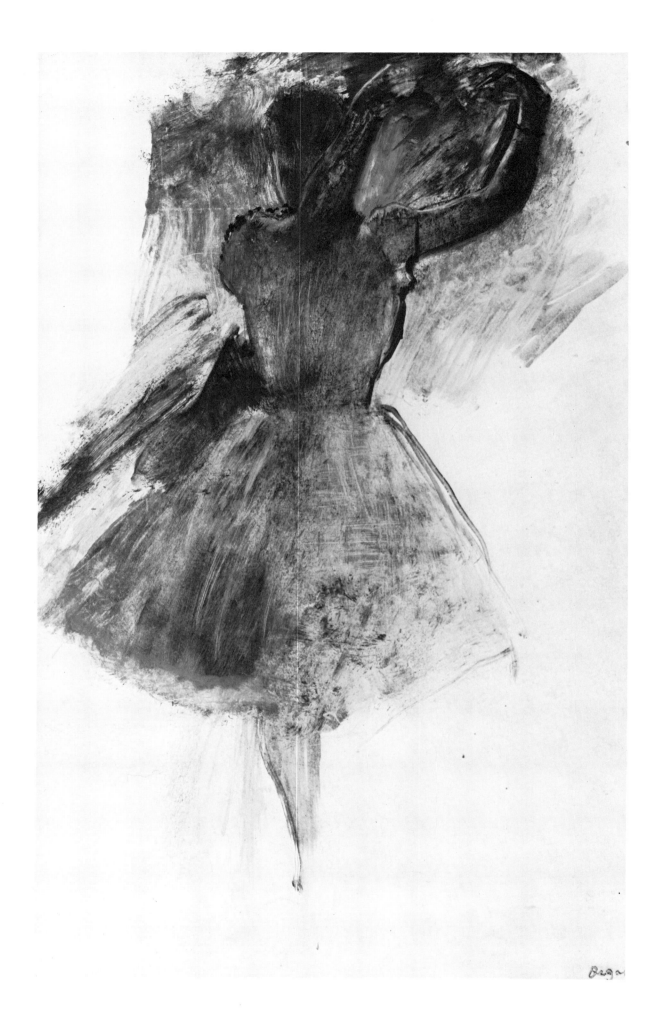

227 *Dancer with Arms Raised* circa 1874

Notes on the Plates

All the works listed below are reproduced in the present volume, and are therefore not individually described. The references allocated to pastels and oil sketches in the Oeuvre list of Paul André Lemoisne (*Degas et son Oeuvre*, I–IV, Paris 1946) have been adopted in so far as no other identifying references are available. Unless otherwise stated, the paper is white or yellowish, though in some cases an ochre tone may be involved. Measurements are in millimetres, height before width, and refer to the dimensions of the sheet concerned; small discrepancies may occur in cases when the works could not be removed from their frames, and precise measurement was therefore impossible. All works included in the four posthumous sales in 1918–19 carry a 'Vente' stamp, red for originals, black for transfers, varying in size according to that of the work (Lugt 658). Many of the works are additionally stamped for the estate with ATELIER ED. DEGAS in red (Lugt 657). For bibliographical abbreviations, see pages 400ff.

1 *Self-portrait* 1854
Pencil 330 × 238 mm.
Back: *Portrait Study after Bacchiacca*, 1854, pencil.
Walter Feilchenfeldt, Zurich.

This unpublished self-portrait was probably produced shortly before, or at the same time as the self-portrait in Lemoisne II, Nos. 2–4; a pencil study reproduced in Guérin 1931 is close to it in style. The portrait on the reverse side of the sheet was drawn after a painting formerly ascribed to Raphael, but now also to either Parmigianino or Francesco Ubertini called Bacchiacca (Musée du Louvre, Paris). Although Degas is entered in the Régistre des Cartes d'Elèves du Louvre on 31 October 1854 as a copyist of this picture (see Reff 1964, p. 250 note 8), the pronounced 'graphic' treatment of the drawing suggests that it was prepared from a reproduction, such as that in *Le Magasin Pittoresque*, 1845, p. 9, rather than after the original. Decades later, Cézanne also drew after this model (see Adrien Chappuis, *The Drawings of Paul Cézanne*, London 1973, Nos. 272, 608).

PROVENANCE: Grete Ring, London; Erich Maria Remarque, Porto Ronco.
BIBLIOGRAPHY: Götz Adriani, *Paul Cézanne, Zeichnungen*, Cologne 1978, p. 256 (ill. of back).

2 *René de Gas* (?) 1854
Pencil on pink paper, 310 × 240 mm.
Back: *René de Gas* (?), 1854, pencil.
Privately owned, Basle.

The portrait studies on both sides of this unpublished sheet probably show the artist's younger brother, Jean-Baptiste René de Gas (born and died Paris, 1845–1926). Judging by the age of the sitter, these studies are probably slightly earlier than the half-length portrait (Lemoisne II, No. 6), Smith College Museum of Art, Northampton (Mass.); there is a pencil study for this painting, dated 1855 (Boggs 1962, pl. 8). Two portrait studies closely resemble the drawing of the sleeping child: IV^{ème} Vente, 1919, No. 121d; see also sketches Reff 1976, Notebook 5, p. 53, Notebook 6, p. 81.

PROVENANCE: Art trade, Basle.

3 *Marguerite de Gas* 1854
Chalk on browning watercolour paper, damaged at top left, 293 × 238 mm.
Staatsgalerie, Stuttgart, Graphische Sammlung (Cat. No. C63/1059).

The artist's sister, Laure Marguerite de Gas (born Paris 1842, died Buenos Aires 1895), was trained as a singer and married the architect Henri Fèvre in 1865. She was portrayed several times by Degas on the occasion of her first Communion. A pencil drawing, subsequently signed and dated 1854, shows her in her communion dress (Boggs 1962, pl. 6; see also pl. 7). The present drawing is closely related to a sanguine drawing in three-quarter profile (Rouart 1948, pl. 1), as well as to a pencil drawing (London 1978, No. 16) in the Fitzwilliam Museum, Cambridge. Ingres' influence is unmistakable in all these works, as well as that of copies from Perugino and Raphael.

PROVENANCE: Marguerite de Gas, Paris; Jeanne Fèvre, Nice; Maurice Loncle, Paris.
BIBLIOGRAPHY: Fèvre 1949, pl. following p. 32; Janis 1967, p. 414; Gauss 1976, No. 168 ill.; Dunlop 1979, pl. 6; Horst Keller, *Aquarelle und Zeichnungen der französischen Impressionisten und ihrer Pariser Zeitgenossen*, Cologne 1980, pp. 34f. ill.
EXHIBITIONS: St Louis – Minneapolis – Philadelphia 1967, No. 2 ill.; Stuttgart 1969, No. 29 ill.

4 *Portrait Study after a French Portraitist* 1854–5
Pencil, 263 × 179 mm.
Back: *Decorative Design*, circa 1854, pencil; below right, estate stamp ATELIER ED. DEGAS.
Kunsthalle, Bremen (Cat. No. 64/610).

Copied from a portrait of Elisabeth of Austria in the Musée du Louvre, Paris, dating from the second half of the sixteenth century and formerly ascribed to François Clouet. It represents the daughter of the Emperor Maximilian II as Queen of France at the age of seventeen. This delicate, somewhat schematic study is certainly earlier than the sketch of the painting (Reff 1976, Notebook 14, p. 67); see also the portrait study (London 1978, No. 24) in the Fitzwilliam Museum, Cambridge. For the *Decorative Design* on the back, see Reff 1976, Notebook 3, pp. 27–25.

PROVENANCE: Kornfeld & Klipstein sale, Berne, 27–29 May 1964, No. 239.
EXHIBITIONS: Bremen 1969, No. 62.

5 *Auguste de Gas* circa 1855
Pencil, 317 × 247 mm.
Below left, estate stamp ATELIER ED. DEGAS.
Privately owned.

Portrait of the artist's father, Laurent Pierre Augustin Hyacinthe de Gas (born and died Naples, 1807–1874).

PROVENANCE: René de Gas, Paris; Vente 1927, No. 11 ill; Galerie Rosenberg, Paris; Wildenstein Galleries, New York; John Nicholas Brown, Providence.
BIBLIOGRAPHY: Mongan 1932, p. 63 ill.; Mongan 1938, p. 295; Boggs 1962, p. 114.
EXHIBITIONS: Cambridge (Mass.) 1929, No. 31; Philadelphia 1936, No. 77 ill.; Boston 1974, No. 64.

6 *Study of Head after Raphael* 1854–5
Pencil, 300 × 230 mm.
Below left, Vente stamp *Degas*.
Mr and Mrs Robert Austin Milch, Baltimore.

This study was drawn after a reproduction of Raphael's *School of Athens* fresco in the Stanza Vaticana della Segnatura, Rome. It is a portrait of a young man looking at the spectator, together with theorem of Pythagoras in the lower left area of the picture.

PROVENANCE: IV^ème Vente 1919, No. 103c ill.: Art trade, London; Feilchenfeldt, Zurich.
BIBLIOGRAPHY: Russoli and Minervino 1970, No. 18 ill.

7 *Portrait study after Gentile Bellini* 1854–5
Pencil, 445 × 295 mm.
Dr Peter Nathan, Zurich.

The drawing is after a double portrait ascribed to Gentile Bellini in the Musée du Louvre, Paris. A complete painted copy of this by Degas (Lemoisne II, No. 59) has been dated 1865–1866 (Reff 1964, p. 255), because the artist was entered under No. 726 in the Régistre des Cartes d'Elèves du Louvre on 26 October 1865 as copying the painting. On stylistic grounds, however, this drawing should be dated much earlier.

PROVENANCE: Marcel Guérin, Paris.
EXHIBITIONS: Tokyo–Kyoto–Fukuoka 1976–7, No. 65 ill.

8 *Study after an Etruscan Head-shaped Pot* 1854–5
Black chalk, 381 × 267 mm.
Below right, stamp NEPVEU DEGAS.
Privately owned, San Francisco.

Degas' interest in portrait work clearly extended to such antique household objects available in the collections of the Louvre, in this case a 32 cm-high fourth-century BC bronze vessel from Gabii.

PROVENANCE: Jean Nepveu-Degas, Paris; Vente 1976, No. 81; Galerie Arnoldi-Livie, Munich.

9 *Study after a Rider from the Parthenon Frieze* 1855
Pencil on grey paper, 235 × 302 mm.
Back: below left, estate stamp ATELIER ED. DEGAS.
Kunsthalle, Bremen (Cat. No. 56/536).

This item is part of a group of studies after figures from the west frieze of the Parthenon, drawn either from prints or from plaster casts in the Ecole des Beaux-Arts at Lyons, where Degas spent July–September 1855; see copies in Reff 1976 Notebook 2, pp. 43, 55, 62, 66, Notebook 3, pp. 41, 39–36, 28, 19, 17.

PROVENANCE: Durand-Ruel, Paris; Klipstein & Kornfeld auction, Berne, 22 November 1956, No. 75.
BIBLIOGRAPHY: Reff 1964, p. 258.
EXHIBITIONS: Bremen 1969, No. 49 pl. 64.

13 (back)

14 (back)

10 *Study after a Doorkeeper at the Palace of Assurnasirpal III* 1854–5
Black chalk on very woody paper, 320 × 247 mm.
Below right, estate stamp ATELIER ED. DEGAS.
Kunsthalle, Bremen (Cat. No. 58/376).

This drawing after a reproduction of an Assyrian alabaster sculpture from Nimrud-Kalach in the British Museum, London, shows how widely the young Degas' interests ranged.

PROVENANCE: Klipstein & Kornfeld auction, Berne 16–17 May 1958, No. 217.
EXHIBITIONS: Bremen 1969, No. 63.

11 *Study after an Antique Head of a Youth, Studies of Legs and Foot* 1854–5
Pencil, 357 × 220 mm.
Below right, stamp NEPVEU DEGAS; underneath it, inscription in an unidentified hand (photograph number).
Privately owned, San Francisco.

See No. 12 below.

PROVENANCE: Jean Nepveu-Degas, Paris; Vente 1976, No. 80; Galerie Arnoldi-Livie, Munich.

12 *Studies after an Antique Head, Studies of Legs and Feet,* 1854–5
Pencil, 320 × 200 mm.
Below left, Vente stamp *Degas.*
Charles Durand-Ruel, Paris.

As later in numerous studies of dancers, attention is centred on different attitudes of the legs and feet shown in a standing position; see No. 11 above.

PROVENANCE: IVème Vente 1919, No. 124e ill.

13 *Studies of Head and Arms* 1854–5
Pencil, 233 × 307 mm.
Back: *Study after a Torso,* 1854–5, pencil; below right, estate stamp ATELIER ED. DEGAS; (ill.).
Privately owned, San Francisco.

See sketches in Reff 1976, Notebook 2, p. 77, Notebook 7, p. 47.

PROVENANCE: Vente 1976, No. 76.

14 *Nude from the Back with Raised Left Leg,* 1855
Charcoal, 595 × 377 mm.
Back: *Nude from the Back with Raised Left Leg* (the same model seen from the right), 1855, pencil; below right, inscription in an unidentified hand; (p. 340).
National Gallery of Canada, Ottawa (Cat. No. 9682).

Typical academic studies, presumably produced with a view to a proposed narrative picture. A compositional

sketch in Reff 1976, Notebook 3, p. 30, with Hero and Leander on the banks of the Hellespont, shows Leander in this pose which may refer back to Ingres' *Oedipus and the Sphinx* in the Musée du Louvre, Paris, painted in 1808.

PROVENANCE: Jeanne Fèvre, Nice; Vente 1934, No. 13; Wildenstein Gallery, London.
BIBLIOGRAPHY: A. E. Popham and K. M. Fenwick, *European Drawings in the Collection of the National Gallery of Canada*, Toronto 1965, No. 272 ill.

15 *Figure study after Mantegna* 1855–6
Pencil and red chalk, 315 × 138 mm.
Below right; Vente stamp *Degas*.
Privately owned.

The figure of the Good Thief from Mantegna's *Crucifixion* in the Musée du Louvre, Paris; see a reproduction of the same detail in Russoli and Minervino 1970, No. 13. Degas probably copied the whole of Mantegna's composition (Lemoisne II, No. 194) in 1868, when he was last registered as a copyist in the Louvre archives, but the present study, with its carefully applied cross and parallel hatching, must be earlier in date. The female figure very lightly indicated on the right of the sheet is an addition by the artist. This study, together with those reproduced in pls. 38 and 39, still has the original frame in which it was sent from the studio for sale in 1919 and was bought by the art dealer Durand-Ruel for 1800 francs.

PROVENANCE: IV^{ème} Vente 1919, No. 99 (3) ill.; Durand-Ruel, Paris; Peytel, Paris.
BIBLIOGRAPHY: Reff 1963, pp. 245 note 22, 248; Vitali 1963, p. 269 note 6; Reff 1967, p. 263; Nottingham 1969, with No. 4.
EXHIBITIONS: St Louis–Philadelphia–Minneapolis 1967, No. 17 ill.

16 *Nude with Left Arm Bent* 1856
Pencil on pink paper, 280 × 200 mm.
Below left, Vente stamp *Degas*.
Charles Durand-Ruel, Paris.

While in Rome from October 1856 to July 1857 Degas drew a great deal from male models, mostly in poses inspired by antique sculptures, as a guest of the French Academy in the Villa Medici. A drawing by Gustave Moreau, who had become friendly with Degas in Rome, shows the same model in an identical pose (Pool 1963, p. 254, pl. 14); in a drawing, later inscribed by Degas 'Rome 1856', this model is represented from the back in the pose of the javelin bearer (IV^{ème} Vente 1919, No. 84d).

PROVENANCE: IV^{ème} Vente 1919, No. 84c ill.
BIBLIOGRAPHY: Champigneulle 1952, pl. 18; Pool 1963, p. 254 pl. 13; Reff 1967, p. 262.
EXHIBITIONS: St Louis–Philadelphia–Minneapolis 1967, No. 8 ill.

18 (back)

340

17 *Seated Nude* 1856
Pencil 445 × 292 mm.
Below right, inscribed: 'Rome'; below left, Vente stamp *Degas*.
The Nelson-Atkins Museum of Art, Nelson Fund, Kansas City, (Cat. No. 49–73).

This nude was drawn from a model in Rome, but the inscription was added later, when the ageing Degas reviewed, identified and sorted his drawings; see Reff 1964, p. 251. The figure holds a stylus in its right hand in the act of drawing; this is a carefully prepared study for a composition sketched out in a notebook, but never carried out: *Cimabue Watching the Young Giotto Drawing* (Reff 1976, Notebook 7, p. 3). The legs of a standing model are visible at the edge, above left.

PROVENANCE: IV^{ème} Vente 1919, No. 69a ill; Rouart, Paris.
BIBLIOGRAPHY: Reff 1976, Notebook 7, p. 3.
EXHIBITIONS: St Louis–Philadelphia–Minneapolis 1967, No. 9 ill., with No. 35.

18 *Figure Studies after Michelangelo* 1856–7
Pencil on pink paper, 284 × 235 mm.
Back: *Figure study after Michelangelo, Seated Man Leaning on his Arm*, 1856–7/1870–71, pencil (p. 340).
Kunsthalle, Bremen (Cat. No. 62/259).

These rather schematic studies after Michelangelo's *Elect*, from his *Last Judgment* in the Sistine Chapel, were probably sketched during the artist's first stay in Rome; see No. 19 below, as well as a similar study (Bremen 1969, No. 56). Degas may have worked side by side with his friend, the Prix de Rome winner Joseph Gabriel Tourny, who also copied frescos by Michelangelo. The lower part of the sheet has some sketches of movement; see Reff 1976, Notebook 10, pp. 57, 60. The lightly indicated portrait sketch, added at a later date to the figure on the back, may represent an initial idea for the central figure in the painting of Degas' three wartime comrades *Jeantaud, Linet, Laine* (Lemoisne II, No. 287), completed in March 1871 and now in the Musée du Louvre, Paris.

PROVENANCE: Klipstein & Kornfeld auction, Berne, 25–26 May 1962, No. 243.
EXHIBITIONS: Bremen 1969, No. 55.

19 *Figure Studies after Michelangelo* 1856–7
Pencil on pink paper, 288 × 231 mm.
Back: *Porter, Seven Cursory Studies of Heads, Decorative Design*, 1856–7 pencil.
Kunsthalle, Bremen (Cat. No. 69/205)

An *Elect*, as in No. 18 above, from Michelangelo's *Last Judgment* in the Sistine Chapel, together with four small sketches of movement. For the decorative design on the back, see Reff 1976, Notebook 3, pp. 27–25.

20 *Figure with Long Draped Garment* 1856–7
Pencil with white highlights added on grey paper, 295 × 180 mm.
Below right, stamp NEPVEU DEGAS.
Privately owned, San Francisco.

The evenly applied pencil work in this study may possibly suggest a still earlier date. The work may have come about in connection with the figure of Virgil in the *Dante and Virgil* etching (Adhémar and Cachin 1973, No. 9). See also the corresponding paintings (Lemoisne II, Nos. 34, 35), as well as the sketches in Reff 1976, Notebook 11, pp. 11, 17.

PROVENANCE: Jean Nepveu-Degas, Paris; Vente 1976, No. 81.

21 *Dante* 1857
Pencil, 329 × 246 mm.
Left, estate stamp ATELIER ED. DEGAS.
Back: *Drapery Study*, 1857, pencil.
Privately owned.

Both sides of this unpublished sheet carry studies of details for the *Dante and Virgil* painting (Lemoisne II, No. 34), which was worked out in autumn 1857 in Rome, together with the etching (Adhémar and Cachin 1973, p. 9); see sketches in Reff 1976, Notebook 9, p. 25, Notebook 11, pp. 9–11, 17, as well as the two studies with the inscription 'Rome 1856' added later (IV^{ème} Vente 1919, Nos. 109f., 116f.). The portrait of his fellow student Joseph Gabriel Tourny (Lemoisne II, No. 26) presumably served as a model for the head of Dante.

22 *John the Baptist* 1857
Pencil, 445 × 290 mm.
Back: *Angel Blowing a Trumpet*, 1857, pencil lightly tinted with watercolour; inscribed, below right, 'Rome' in pencil; below left, Vente stamp *Degas*.
Von der Heydt-Museum, Wuppertal (Cat. No. KK 1960/165)

The nudes at the front and back of the sheet were drawn from a model in Rome. They were carefully done and served as studies for the proposed *Saint Jean-Baptiste et l'Ange* composition; see Reff 1976, pp. 6, 18f. Although numerous sketches, individual figure studies and compositional designs for this project have survived – there are twenty-three pages filled with passages of text and studies in the notebooks devoted to this project alone – no painting ultimately resulted. The side with John as a boy represents a study for a painting (Lemoisne II, No. 21), while the angel relates to a watercolour (Lemoisne II, No. 20; see also Nos. 22, 23), as well as to the drawings IV^{ème} Vente 1919, No. 69b, Nottingham 1969, Nos. 5, 6, and the sketches in Reff 1976, Notebook 5, p. 48, Notebook 7, p. 27, Notebook 8, pp. 5, 7v, 8v, 24, 68v, 70v, 73v,

Notebook 9, pp. 9, 15, 29, 42, 43, 55, Notebook 10, pp. 35, 40, 49, Notebook 11, pp. 34–36, 49.

PROVENANCE: IV^ème Vente 1919, Nos. 70 a, b ill.; Bernheim-Jeune, Paris; Eduard von der Heydt, Ascona.
BIBLIOGRAPHY: Lemoisne II, with No. 20; Wachtmann 1965, No. 38 ill.; Nottingham 1969, with No. 5; Aust 1977, p, 284 pl. 164; Dunlop 1979, pl. 27.
EXHIBITIONS: Berne 1951–2, No. 82; St Louis–Philadelphia–Minneapolis 1967, No. 26 ill., with No. 34.

23 *Angel Blowing a Trumpet* 1857
Black chalk with white highlights added on pink paper, 420 × 285 mm.
Back: Centre, estate stamp ATELIER ED. DEGAS; inscriptions in unidentified hands (photograph and estate numbers).
Kunsthalle, Bremen (Cat. No. 57/98).

This figure study forms part of the planned composition *Saint Jean-Baptiste et l' Ange* (see Lemoisne II, Nos. 20–23). The motif of the angel stepping forward, shown frontally in the drawing above (pl. 22), is reproduced here from the side. The beautiful classical sweep of the garment imparts a strongly three-dimensional effect to the figure; see the head and drapery studies (London 1983, No. 4) in the Ashmolean Museum, Oxford; see also sketches in Reff 1976, Notebook 8, p. 68v, Notebook 10, pp. 40, 49, Notebook 11, pp. 35, 36, as well as a study for the angel's head (IV^ème Vente 1919, No. 100c).

PROVENANCE: IV^ème Vente 1919, No. 81a ill.
BIBLIOGRAPHY: Günter Busch and Horst Keller, *Meister-werke der Kunsthalle Bremen*, Bremen 1959, No. 101 ill.; Nottingham 1969, with No. 5.
EXHIBITIONS: Bremen 1969, No. 50 pl. 58; *Hundertmal Kunst für Jedermann*, Kunsthalle, Bremen 1982, No. 38 ill.

24 *Nude with Arms Crossed Behind Head* circa 1857
Red chalk, 457 × 305 mm.
Back: *Nude with Raised Arms Seen from the Back*, circa 1857, red chalk; below right, estate stamp ATELIER ED. DEGAS. The Nelson-Atkins Museum of Art, Gift of Mr and Mrs Milton McGreery through the Westport Fund to the Nelson Gallery Foundation, Kansas City (Cat. No. F 56–66).

To the right of the nude, study of a raised arm and, above it, sketch for the theorem of Pythagoras.

PROVENANCE: Jeanne Fèvre, Nice; Vente 1934, No. 26; Milton McGreery, Kansas City.

25 *Nude Stepping Forward* circa 1857
Pencil, 290 × 225 mm.
Below right, estate stamp ATELIER ED. DEGAS.
Back: *Study of Drapery*, circa 1857, pencil (ill.).
Privately owned, San Francisco.

PROVENANCE: Galerie Arnoldi-Livie, Munich.

25 (back)

26 *Roman Prizefighter* circa 1857
Pencil, 320 × 200 mm.
Below right, Vente stamp *Degas*.
Charles Durand-Ruel, Paris.

PROVENANCE: IV^{ème} Vente 1919, No. 124a ill.

27 *Young Roman Woman* circa 1857
Black chalk and charcoal on beige paper, 388 × 267 mm.
Below right, inscribed in black chalk 'Rome'.
The Baltimore Museum of Art, the Cone Collection, formed by Dr Claribel Cone and Miss Etta Cone of Baltimore (Cat. No. BMA 1950.12.457).

This impressive drawing belongs to a group of portrait studies produced in Rome; for inscription, see pl. 17 above.

PROVENANCE: René de Gas, Paris; Gustave Pellet, Paris; Maurice Exsteens, Paris; Galerie Aktuaryus, Zurich; Claribel and Etta Cone, Baltimore.
BIBLIOGRAPHY: Reff 1967, p. 262.
EXHIBITIONS: Buenos Aires, 1934, No. 23; Zurich 1935, No. 41 ill. on cover; New York 1945; Kansas City 1955, Baltimore 1962, No. 55; St Louis–Philadelphia–Minneapolis 1967, No. 5 ill; *Paintings, Sculptures and Drawings in the Cone Collection*, Museum of Art, Baltimore 1967, No. 176.

28 *Self-portrait and Studies of Details* circa 1857
Pencil, 153 × 232 mm.
Mr and Mrs Eugene Victor Thaw, New York.

This probably forms the lower half of a 325 × 240 mm. sheet, the top of which carries pl. 29 below; see Guérin 1945, pl. XII. The self-portrait should be considered in conjunction with the portraits (Lemoisne II, Nos. 13, 14) in the Museum of Art, Baltimore, as well as an etching (Adhémar and Cachin, No. 13).

PROVENANCE: Jeanne Fèvre, Nice; Vente 1934, No. 40B, C; Marcel Guérin, Paris; Daniel Guérin, Paris.
BIBLIOGRAPHY: Guérin 1945, pl. XII; London 1983, with No. 1.
EXHIBITIONS: New York–Cleveland–Chicago–Ottawa 1975–6, No. 91 ill.

29 *Self-portrait* circa 1857
Pencil, 157 × 183 mm.
Below right, estate stamp ATELIER ED. DEGAS.
Mr and Mrs Eugene Victor Thaw, New York.

See pl. 28 above. This may be a study for the self-portrait *Degas en Blouse d'Atelier* (Lemoisne II, No. 12), Metropolitan Museum of Art, New York.

PROVENANCE: Jeanne Fèvre, Nice; Vente 1934, No. 40A; Marcel Guérin, Paris; Daniel Guérin, Paris.
BIBLIOGRAPHY: Guérin 1945, pl. XII.

EXHIBITIONS: New York–Cleveland–Chicago–Ottawa 1975–6, No. 90 ill.; *The Classical Ideal*, David Carritt Gallery Ltd, London 1979, No. 29; London 1983, No. 1 ill.

30 *Portrait and Figure Studies* 1858
Pen and brown ink on paper, piece cut-out below left, 226 × 350 mm.
Back: Below right, estate stamp ATELIER ED. DEGAS.
Kunsthalle, Bremen (Cat. No. 56/537)

This sheet includes, among other things, portrait studies and caricatures probably representing the artist's two cousins Giovanna (born and died Naples, 1848–?) and Giulia (born and died Naples, 1851–1922) Bellelli, then living in Florence, where Degas stayed from August 1858; the girls would therefore have been ten and seven; see *La Famille Bellelli* (p. 345).

EXHIBITIONS: Bremen 1969, No. 51 pl. 56.

31 *Rosa Adelaida Morbilli* 1857
Pencil with black chalk, watercolour, gouache and black ink, 350 × 186 mm.
Below right, Vente stamp *Degas*; below left, inscription in an unidentified hand (photograph number).
Mr and Mrs Eugene Victor Thaw, New York.

Rosa Adelaida Morbilli, Duchessa di San Angelo a Frosolone (born and died Naples, 1805–79), an aunt of the artist, who had lost her husband Don Giuseppe Morbilli in 1842, and her eldest son Gustavo during the revolutionary upheavals of 1848, is presented frontally standing before a wall mirror. Degas stayed in Naples July–October 1857.

PROVENANCE: IV^{ème} Vente 1919, No. 102b ill.; Durand-Ruel, Paris; William M. Ivins, Milford; Parke Bernet sale, New York, 24 November 1962, No. 32 ill.
BIBLIOGRAPHY: Lemoisne II, No. 50 bis ill.,; Champigneulle 1952, pl. 22; Boggs 1962, pp. 88 note 49, 105, 125; Boggs 1963, p. 275, pl. 33; Russoli and Minervino 1970, No. 131 ill.; Dunlop 1979, p. 30 pls. 21, 33.
EXHIBITIONS: New York 1964, No. 10; New Orleans 1965, p. 56 pl. IX; St Louis–Philadelphia–Minneapolis 1967, No. 22 ill., with No. 48; New York–Cleveland–Chicago–Ottawa 1975–6, No. 92 ill.

32 *Ulysse* 1859
Pencil, 308 × 233 mm.
Below right, inscribed in pencil: 'Ulysse / Domestique de / mon oncle Bellelli / Florence 1859; left, estate stamp ATELIER ED. DEGAS.
Privately owned.

The sitter was a servant in the Bellelli household in Florence, where Degas stayed from August 1858 to March 1859.

PROVENANCE: Maurice Guérin, Paris.
BIBLIOGRAPHY: Maurice Guérin, 'Remarques sur des Portraits de Famille peints par Degas', in *Gazette des Beaux-Arts*, 70, 1928, p. 373 ill.; Boggs 1962, p, 131.
EXHIBITIONS: *Les Artistes Français en Italie de Poussin à Renoir*, Musée des Arts Decoratifs, Paris, 1934, No. 412; *Le Portrait Dessiné*, Galerie Guyot, Paris 1937, No. 40; Berne 1951–2, No. 84.

33 *Mlle Dembowski* 1858–9

Black chalk on pink paper, 440 × 290 mm.
Below right, inscribed in pencil: 'Flor. 1857/Mlle Dembowski'; below this, inscription in an unidentified hand (photograph number); below left, Vente stamp *Degas*.
Privately owned, San Francisco.

It is clear that the inscription on the present drawing (as opposed to that in pl. 32 above) was added by the artist later and that his memory was at fault, since he reached Florence only in August 1858. The sitter was his cousin by marriage, the eight- or nine-year-old daughter of Baron Ercole Fedrico Dembowski and Enrichetta Bellelli; see the portrait of Enrichetta Dembowski, dated '1858' (Vente 1927, No. 7).

PROVENANCE: IV^ème Vente 1919, No. 98a ill.; privately owned, Paris; Galerie Arnoldi-Livie, Munich.
BIBLIOGRAPHY: Boggs 1962, p. 115; Vitali 1963, p. 266 note 4; Reff 1964, page 251 note 15.

34 *Study after Detail from Benozzo Gozzoli* 1859

Pencil 215 × 236 mm.
Above right, inscribed in pencil: 'Pise 1859'.
Back: above right, estate stamp ATELIER ED. DEGAS.
Kunsthalle, Bremen (Cat. No. 67/523)

A sketch of the lower left part of Gozzoli's fresco *The Destruction of Sodom by Fire*; see pl. 35 below.

PROVENANCE: Kornfeld & Klipstein auction, Berne, 14–17 June 1967, No. 304.
BIBLIOGRAPHY: Reff 1964, p. 251.
EXHIBITIONS: Bremen 1969, No. 54, with No. 52.

35 *Study after Detail from Benozzo Gozzoli* 1859

Pencil on blue-grey paper, 310 × 209 mm.
Below right, inscribed in pencil: 'Pise 1859'.
Kunsthalle, Bremen (Cat. No. 62/258)

Degas visited Pisa twice during spring 1859. It is, however, open to question whether he did in fact draw after the cycle of frescos painted there by Benozzo Gozzoli in the Campo Santo during 1469–85, since this somewhat clumsy study of a detail from Gozzoli's *Adoration of Baal* – as well as the sketches in Reff 1976, Notebook 2, p. 8,

Notebook 8, p. 72, Notebook 9, pp. 27, 31, 33, 35, 37, Notebook 15, p. 10 – may have been done from reproductions in earlier years and the inscription added later by the artist.

PROVENANCE: Klipstein & Kornfeld auction, Berne 25–26 May 1962, No. 242.
BIBLIOGRAPHY: Reff 1964, p. 251.
EXHIBITIONS: Bremen 1969, No. 52 with No. 54.

36 *Compositional Study after Uccello* 1859

Pencil, 245 × 392 mm.
Above left, inscribed in pencil: 'Florence 1859/Paolo Uccello'; below right, Vente stamp *Degas*; below left, inscription in an unidentified hand (photographic number).
Privately owned.

This study was presumably drawn after the *Battle of San Romano* in the Uffizi, painted by Uccello in 1456. There are further studies after Uccello in Reff 1976, Notebook 12, p. 89, Notebook 13, p. 3.

PROVENANCE: IV^ème Vente 1919, No. 92b ill.; Charles Vignier, Paris.
BIBLIOGRAPHY: Walker 1933, p. 185; Vitali 1963, p. 269 note 6; Reff 1964, p. 251 note 16; Russoli and Minervino 1970, p. 21 ill.

37 *Compositional Study after Poussin* circa 1860

Pen and brush with brown ink, 235 × 320 mm.
Below left: Vente stamp *Degas*.
Privately owned.

This study, which embraces the entire picture, was produced after the *Triumph of Flora* in the Musée du Louvre, Paris, painted by Poussin about 1630. Degas often worked after Poussin: see studies IV^ème Vente 1919, Nos. 82c, 85a; Reff 1963, pl. 7; the Lemoisne II, No. 273 copy; and the sketches Reff 1976, Notebook 13, p. 100, Notebook 14A, p. 33. This is probably one of the main reasons for Duranty's mention of his friend in his short story *Le Peintre Louis Martin*, published in 1872. This refers to a young painter (possibly Cézanne) who sets out in the early 1860s to copy Poussin's *Rape of the Sabine Women* in the Louvre and runs into Degas with the same purpose in mind. Duranty described Degas as 'an exceptionally intelligent painter, constantly concerned with ideas which seemed strange to the majority of his colleagues; as there was no method or measure to his keen, effervescent spirit, he was dubbed "the inventor of social *chiaroscuro*"'; Rewald 1961.

PROVENANCE: IV^ème Vente 1919, No. 80c ill.
Walker 1933, p. 184; Reff 1963, p. 246 (as *The Triumph of Venus*); Russoli and Minervino 1970, No. 25 ill.

344

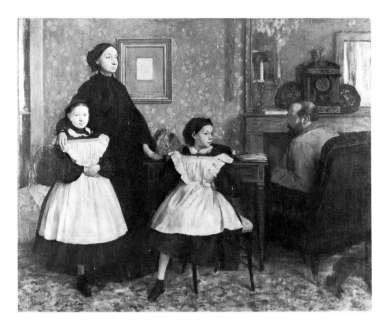

La Famille Bellelli 1859–60
Musée du Louvre, Paris (Lemoisne No. 79)

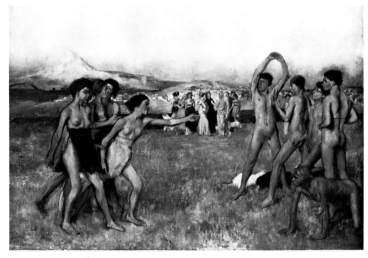

Petites Filles Spartiates Provoquant des Garçons
1859–60
National Gallery, London (Lemoisne No. 70)

Sémiramis Construisant une Ville 1861
Musée du Louvre, Paris (Lemoisne No. 82)

38 *Figure Study after Botticelli* 1858–9
Pencil, 300 × 225 mm.
Below left: Vente stamp *Degas*.
Privately owned.

Degas would have been able to work from Botticelli's masterpiece *The Birth of Venus* in the Uffizi during his stay in Florence, August 1858–March 1859, and the stylistic features of this study suggest that it was produced at this time. A similar emphasis on the outlines and comparable dense shading separated from the lighter areas can be seen in pl. 36 above. For the original frame, see note on pl. 15 above.

PROVENANCE: IV^ème Vente 1919, No. 99(2) ill.; Durand-Ruel, Paris; Peytel, Paris.
BIBLIOGRAPHY: Walker 1933, p. 185; Vitali 1963, p. 269 note 6.
EXHIBITIONS: St Louis–Philadelphia–Minneapolis 1967, No. 16 ill.

39 *Figure Study after Michelangelo* 1859–60
Pencil, 330 × 250 mm.
Below left, Vente stamp *Degas*.
Privately owned.

By comparison with the previous study, pl. 38 above, the artist's command of drawing has noticeably improved. The fine modelling of the body in what is presumably a drawing after Michelangelo's sculpture of *The Dying Slave* in the Louvre faithfully reproduces the varying play of light and shade, and the figure stands out in the round from the differentiated dark shading of the background; see the drawing of *The Dying Slave*, described as *Saint Sébastien*, IV^ème Vente 1919, No. 130b. For the original frame, see note on pl. 15 above.

PROVENANCE: IV^ème Vente 1919, No. 99(1) ill.; Durand-Ruel, Paris; Peytel, Paris.
BIBLIOGRAPHY: Walker 1933, p. 185; Vitali 1963, p. 269 note 6; Reff 1967, p. 261; Russoli and Minervino 1970, No. 9 ill.
EXHIBITIONS: St Louis–Philadelphia–Minneapolis 1967, No. 15 ill.

40 *Nude with Arms Raised and Legs Straddled* 1859–60
Pencil, 317 × 194 mm.
Below left, Vente stamp *Degas*.
Back: estate stamp ATELIER ED. DEGAS.
The Metropolitan Museum of Art, Robert Lehman Collection, New York (Cat. No. 1975.1.609).

A figure study for the *Petites Filles Spartiates Provoquant des Garçons* (p. 345); see Lemoisne II, Nos. 71–73. The treatment of the head deserves special attention: it is partly covered by the right arm and an interesting interplay of light and shade results from this. See pencil study of the

same figure in St Louis–Philadelphia–Minneapolis 167, No. 34; and, for the subject, Reff 1976, Notebook 18, p. 202.

PROVENANCE: I^{ère} Vente 1918, No. 62b (?).
BIBLIOGRAPHY: Burnell 1969, pp. 56f.; Szabo 1980, No. 30 ill.
EXHIBITIONS: Cincinnati 1959, No. 283; New York 1977, No. 6.

41 *Nude in Profile with Legs Straddled* 1859–60
Pencil, 433 × 213 mm.
Below left, Vente stamp *Degas*; back: estate stamp ATELIER ED. DEGAS.
The Metropolitan Museum of Art, Robert Lehman Collection, New York (Cat. No. 1975.1.610)

See pl. 40 above.

PROVENANCE: I^{ère} Vente 1918, No. 62b (?).
BIBLIOGRAPHY: Burnell 1969, pp. 56f.; Szabo 1980, No. 29 ill.
EXHIBITIONS: Cincinnati 1959, No. 282; New York 1977, No. 5.

42 *Seated Nude from the Back* circa 1860
Pencil, 330 × 210 mm.
Back: *Study of a Leg*, circa 1860, pencil.
Kunsthalle, Bremen (Inv.-Nr. 66/561).

Figure study for the *Alexandre et le Bucephale* painting (Lemoisne II, No. 91); see also Nos. 92, 93, as well as the drawing IV-e Vente 1919, No. 124f. There are numerous figure, compositional and landscape sketches in Reff 1976, Notebook 13, p. 142A, Notebook 18, pp. 104, 125, 151, 260, Notebook 19, pp. 27, 29–31, 37, 38, 40, 42, 44, 46, 58, 63.

PROVENANCE: Kornfeld & Klipstein auction, Berne, 9–11 June 1966, No. 188.
EXHIBITIONS: Bremen 1969, No. 58.

43 *Jephtha's Daughter* 1859–60
Pencil, 185 × 260 mm.
Below right, Vente stamp *Degas*, estate stamp ATELIER ED. DEGAS, as well as inscription in an unidentified hand (photograph number).
Privately owned, New York.

A project for the painting *La Fille de Jephté* (ill. – Lemoisne No. 94), differing in detail from the final version. The subject is taken from Judges XI, 30–34: 'And Jephtha vowed a vow unto the Lord, and said, If thou shalt without fail deliver the children of Ammon into my hands, then it shall be, that whatsoever cometh forth of the doors of my house to meet me, when I return in peace from the children of Ammon, shall surely be the Lord's, and I will offer it up for a burnt offering. So Jephtha

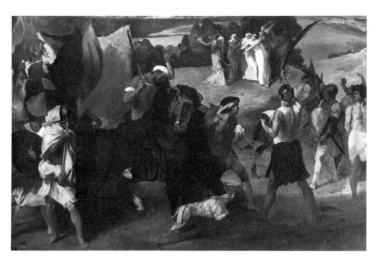

La Fille de Jephté circa 1860
Smith College Museum of Art, Northampton (Mass.)
(Lemoisne No. 94)

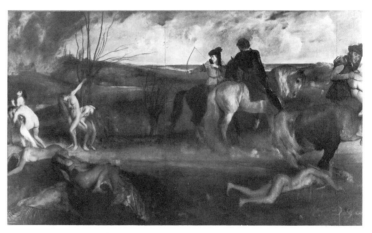

Scène de Guerre au Moyen-Age 1865
Musée du Louvre, Paris (Lemoisne No. 124)

346

passed over unto the children of Ammon to fight against them; and the Lord delivered them into his hands . . . And Jephtha came to Mizpeh unto his house, and, behold, his daughter came out to meet him with timbrels and with dances: and she was his only child; beside her he had neither son nor daughter.' The composition captures the moment when the returning victorious commander first sees from afar his daughter, accompanied by her suite, before the city gates, and turns away in horror at the thought of his vow. The agitated figure composition alone was elaborated in thirteen design sketches: see, in particular, Reff 1976, Notebook 14, p. 1, Notebook 15, p. 6, Notebook 18, pp. 6, 7, 77, 79, Notebook 19, p. 53.

PROVENANCE: IVème Vente 1919, No. 118a ill.; Paul Jamot, Paris, privately owned, Paris; Michel N. Benisovich, New York.

BIBLIOGRAPHY: Jere Abbott, *La Fille de Jephté*, in *Smith College Bulletin*, June 1934, pp. 3ff. pl. I; E. Mitchell, '*La Fille de Jephté* par Degas. Genèse et Evolution', in *Gazette des Beaux-Arts*, XIII, 79, 1937, pp. 181 pl. 10, 183; Rewald 1961, p. 58 ill.; Haverkamp and Begemann etc. 1964, with No. 153; Janis 1967, p. 414 note 3; Reff 1967, p. 258.

EXHIBITIONS: New York 1949, No. 10; Toledo 1950; London 1953, No. 89; New York 1960, No. 76; St Louis–Philadelphia–Minneapolis 1967, No. 28 ill.; County Museum, Los Angeles 1972; Boston 1974, No. 68.

44 *Two Young Ladies in Street Dress* 1859–60
Pencil, 195 × 150 mm.
Below left, estate stamp ATELIER ED. DEGAS; below right, stamp NEPVEU DEGAS.
Privately owned.

A profile similar to that of the figure on the right is also represented in a study (IVème Vente 1919, No. 74b), Museum of Art, Cleveland; it is inscribed 'Flor.1857' in the artist's hand; for this dating, see pl. 33 above.

PROVENANCE: Jean Nepveu-Degas, Paris.
BIBLIOGRAPHY: Jean Nepveu-Degas (ed.), *Huits Sonnets d'Edgar Degas*, Paris 1946, ill. (detail).

45 *Marguerite de Gas* 1859–60
Pencil and black chalk on yellowish paper, with strip stuck on at left, 263 × 227 mm.
Above right, inscribed in pencil: 'l'epaule droite est plate et dans la jeune (?) teinte'; below left, Vente stamp *Degas*.
Museum Boymans – van Beuningen, Rotterdam (Cat. No. MB 1976/T 19)

This is a study for a portrait (Lemoisne II, No. 60), Musée du Louvre, Paris, of the artist's sister at about the age of eighteen; see drawings IIème Vente 1918, Nos. 240 (2), 241 (1, 2) and IVème Vente 1919, No. 89b.

PROVENANCE: IIème Vente 1918, No. 240 (1) ill.; Jeanne Fèvre, Nice; Paul Cassirer, Amsterdam; Vitale Bloch, The Hague.

BIBLIOGRAPHY: Paris 1931, with No. 116; Boggs 1962, p. 118; London 1978, with No. 16.
EXHIBITIONS: Amsterdam 1938, Nos. 44/45; Paris 1952–3, No. 38; Paris 1955, No. 22; Paris–Amsterdam 1964, No. 181 pl. 144; Rotterdam 1978, No. 11 ill.

46 *Hélène Hertel* circa 1860
Pencil, 353 × 263 mm.
Below right, near the edge, inscribed in red chalk: 'Me Hertel/vers 1860'; below left, Vente stamp *Degas*.
Back: estate stamp ATELIER ED. DEGAS.
Musée du Louvre, Le Cabinet des Dessins, Paris (Cat. No. RF 29.294)

The lady seated on a sofa bears hardly any resemblance to the Madame Hertel in the portrait (Lemoisne II, No. 125), The Metropolitan Museum of Art, New York, or the drawing inscribed '1865' (Ière Vente 1918, No. 312), Fogg Art Museum, Cambridge (Mass.). The sitter is probably not the person named in the Paris 1969 Catalogue under No. 49, but her daughter Hélène Hertel, later Contessa Falsacappa, whose address in Rome Degas noted in about 1870 (Reff 1976, Notebook 24, p. 112). See the portrait study of Mademoiselle Hertel dated '1865' (Ière Vente 1918, No. 313) in the Musée du Louvre, Paris.

PROVENANCE: IIIème Vente 1919, No. 159 (1) ill.; Paul Jamot, Paris.
BIBLIOGRAPHY: Rivière 1922, pl. 3 (1973, pl. 5); Jamot, 1924, p. 129 pl. 2; Boggs 1962, p. 119.
EXHIBITIONS: *Rétrospective d'Art Français*, Amsterdam 1926, No. 130; Paris 1931, No. 95; *Biennale*, Venice 1936; Paris 1937, No. 62; *Donation Paul Jamot* (Preface by Maurice Denis), Musée de l'Orangerie, Paris 1941, No. 109 ill.; Paris 1969, No. 49 (as Mme Hertel), with No. 114.

47 *Young Woman Seated with Arms Folded* circa 1860
Pencil on blue paper, 280 × 215 mm.
Below left, Vente stamp *Degas*.
Privately owned.

This delicate pencil drawing derives its charm, reminiscent of Ingres, from the contrast between the careful execution of the head and the sketchy treatment of the clothing.

PROVENANCE: IVème Vente 1919, No. 89e ill.
EXHIBITIONS: Paris 1975, p. IX ill. (detail), No. 49 ill.

48 *Standing Horse* 1861–3
Pencil on grey India paper, 237 × 263 mm.
Below left, Vente stamp *Degas*.
Back: Inscription in an unidentified hand.
Museum Boymans – van Beuningen, Rotterdam (Cat. No. F II 127)

Comparison with the reproduction in the Vente catalogue indicates that the sheet has been pared along the lower

edge, having formerly carried the estate stamp ATELIER ED. DEGAS, and that the surrounding pencil lines are a later addition.

PROVENANCE: IV^{ème} Vente 1919, No. 228a ill.; Georges Viau, Paris; Paul Cassirer, Berlin; Frank Koenigs, Haarlem.
BIBLIOGRAPHY: Longstreet 1964, ill.; Hoetink 1968, No. 80 ill.

49 *Rider on Standing Horse* 1861–3
Black chalk, 302 × 223 mm.
Below left, Vente stamp *Degas*; below right, inscription in an unidentified hand (photograph number).
Museum Boymans – van Beuningen, Rotterdam (Cat. No. F II 124)

This study was framed together with a full-length drawing of Edouard Manet (pl. 58 below) at the sale of the estate and may represent Manet on horseback.

PROVENANCE: IV^{ème} Vente 1919, No. 78a ill.; Georges Viau, Paris; Paul Cassirer, Berlin; Frank Koenigs, Haarlem.
BIBLIOGRAPHY: Rossum 1962, pl. 22; Longstreet 1964, ill.; Hoetink 1968, No. 77 ill., with No. 80.
EXHIBITIONS: Rotterdam 1933–4, No. 51; Amsterdam 1946, No. 59; Berne 1951–2, No. 162, with No. 130; Paris–Amsterdam 1964, No. 182 pl. 146.

50 *Three Studies of Horses' Hind Legs* 1861–3
Pencil, 230 × 180 mm.
Above left and centre, inscribed 'Gauche/Droite' respectively; below right, estate stamp ATELIER ED. DEGAS; below left, stamp NEPVEU DEGAS.
Kunsthalle, Bremen (Cat. No. 76/89).

PROVENANCE: Jean Nepveu-Degas, Paris.

51 *Portrait of Rider* 1863–5
Pencil with white highlights added on dark brown paper, patched in lower left corner, 270 × 235 mm.
Inscribed, top centre, in pencil: 'pas mal plus penché en arrière'; below right, estate stamp ATELIER ED. DEGAS.
Museum Boymans – van Beuningen, Rotterdam (Cat. No. MB 1976/T18)

The artist concentrated entirely on the figure of the horseman, strikingly enlivened by the touches of white, and indicated the mount by just a few pencil strokes. He was clearly not displeased with the result, but noted alterations to be carried out in further work.

PROVENANCE: Paul Brame, Paris; Vitale Bloch, The Hague.
EXHIBITIONS: Rotterdam 1978, No. 12 ill.

52 *Study of Drapery* 1863–5
Pencil, 320 × 230 mm.
Below right, stamp NEPVEU DEGAS.
National Gallery of Canada, Ottowa (Cat. No. 18671)

Study for the kerchief in the unfinished double portrait *M. et Mme Edmond Morbilli* (Lemoisne II, No. 131), National Gallery, Washington; see an almost identical study (London 1978, No. 22) in the Fitzwilliam Museum, Cambridge.

PROVENANCE: Jean Nepveu-Degas, Paris.

53 *Marie Thérèse Morbilli* 1865–7
Pen and black ink, partly washed over, also red chalk and charcoal, 310 × 240 mm.
Below right: estate stamp ATELIER ED. DEGAS.
Back: Inscription in an unidentified hand.
Museum Boymans – van Beuningen, Rotterdam (Cat. No. F II 226)

The artist's sister, Marie Thérèse de Gas (born and died Naples, 1840–97), married her cousin Edmondo Morbilli in April 1863. This drawing was probably made during one of her visits to Paris. Five portraits of her are known (Lemoisne II, Nos. 109, 131, 132, 164, 255). The present project is most closely related to a portrait drawing (Vente 1934, No. 105), as well as to the treatment in the impressive double portrait *M. et Mme Morbilli* (Lemoisne II, No. 164), Museum of Fine Arts, Boston; see also the portrait studies drawn about 1855 (Vente 1927, Nos. 15, 17). The date – 'circa 1860' – proposed by Ronald Pickvance in the Nottingham 1969 catalogue is certainly too early, because there is a slightly matronly look about the sitter, as compared with earlier portraits (Lemoisne II, Nos. 131, 132), and she is clearly older than twenty.

PROVENANCE: Jeanne Fèvre, Nice; Vente 1934, No. 103; Paul Cassirer, Amsterdam; Franz Koenigs, Haarlem.
BIBLIOGRAPHY: Longstreet 1964, ill.; Hoetink 1968, No. 92 ill.
EXHIBITIONS: Amsterdam 1938, No. 43; Amsterdam 1946, No. 70; Nottingham 1969, No. 2 pl. 1.

54 *Julie Burtey* 1863–7
Pencil and dark brown chalk, 308 × 216 mm.
Above right, signed and dated in pencil: 'Degas/1863'; below right, inscription in an unidentified hand ('Mme Jules Bertin').
Sterling and Francine Clark Art Institute, Williamstown (Cat. No. 1406).

A study for a portrait (Lemoisne II, No. 108) owned by Jacques Lindon, New York. The signature and date may have been added later and therefore be incorrect. See pl. 55 below.

PROVENANCE: III^{ème} Vente 1919, No. 304 ill.; Galerie Knoedler, Paris; Robert Sterling Clark, Williamstown.

BIBLIOGRAPHY: Paris 1924, with No. 81; Paris 1937, with No. 69; Lemoisne II, with No. 108; Boggs 1958, p. 243 note 3; Boggs 1962, pp. 90 note 97, 111; Haverkamp and Begemann etc. 1964, No. 156 pl. 153; Cambridge (Mass.)–New York 1965–7, with No. 55; St Louis–Philadelphia–Minneapolis 1967, with No. 47; Reff 1976, p. 110.

EXHIBITIONS: *A Collector's Exhibition*, Knoedler Galleries, New York 1950, No. 2; *Exhibit Ten. Degas*, Sterling and Francine Clark Art Institute, Williamstown 1959, No. 17 pl. Gr. II; *Exhibit Thirty. A Selection of 19th-Century French Drawings*, Sterling and Francine Clark Art Institute, Williamstown 1965, No. 156; *Treasures from the Clark Art Institute*, Wildenstein Galleries, New York 1967, No. 60; Williamstown 1970, No. 16 ill.

55 *Julie Burtey* 1863–7

Pencil, with white highlights added, 361 × 272 mm.
Above right, inscribed in black chalk: 'Mme Julie Burtey';
below left Vente stamp *Degas*.
Fogg Art Museum, Harvard University, Bequest of Meta and Paul J. Sachs, Cambridge (Mass.) (Cat. No. 1965.254).

A full-length study for the portrait (Lemoisne II, No. 108) owned by Jacques Lindon, New York. The almost identical features of the sitter in this and the portrait drawing above (pl. 54) hardly justify the suggestion made in the St Louis–Philadelphia–Minneapolis 1967 catalogue that the two works were produced several years apart. See the detail studies drawn during the second half of the 1860s (Reff 1976, Notebook 22, pp. 37, 39, 41). Reff has also pointed out that Degas' inscription does not read 'Burtin', as had been assumed, but 'Burtey'; a Julie Burtey worked as a seamstress in Paris, rue Basse-du-Rempart 2.

PROVENANCE: II^ème Vente 1918, No. 347 ill.; Reginald Davis, Paris; Mme Demotte, Paris; Paul J. Sachs, Cambridge (Mass.).

BIBLIOGRAPHY: Rivière 1923, pl. 56 (1973, pl. 15); Mongan 1932, pp. 64ff. ill. (on cover); Mongan-Sachs 1940, No. 663 pl. 339; Lassaigne 1945, p. 6 ill.; Lemoisne II, with No. 108; Guérin 1947, pl. 6; Schwabe 1948, p. 8 ill.; James Watrous, *The Craft of Old-Master Drawings*, Madison 1957, pp. 144f. ill.; Rosenberg 1959, p. 108 pl. 201; Boggs 1962, pp. 17f., 111 pl. 35; Haverkamp and Begemann etc. 1964, p. 80 pl. 62; Longstreet 1964, ill.; Theodore Reff, 'The Chronology of Degas' Notebooks', in *The Burlington Magazine*, CVII, 753, December 1965, p. 613 note 88; Daniel Mendelowitz, *Drawings*, New York 1967, p. 343, pl. 15; Dunlop 1979, pl. 41; Gabriel Weisberg, *The Realist Tradition. French Painting and Drawing 1830–1900*, The Musuem of Art, Cleveland 1981, p. 30f. pl. 50.

EXHIBITIONS: Paris 1924, No. 81; Cambridge (Mass.) 1929, No. 30; New York 1930, No. 17; Boston 1935, No. 119; Buffalo 1935, No. 114; Philadelphia 1936, No. 64 ill.; Paris 1937, No. 69 pl. IV; Brooklyn Institute of Arts 1939; Washington 1940; Detroit 1941, No. 16; New York 1945, No. 57; San Francisco 1947, No. 87; New York 1947; Minneapolis 1948; Detroit 1951, No. 33; Richmond 1952; Los Angeles 1958, No. 13 ill.; Rotterdam–Paris–New York 1958–9, No. 160 pl. 155; Cambridge (Mass.)–New York 1965–7, No. 55 ill.; St Louis–Philadelphia–Minneapolis 1967, No. 47 ill., p. 84; Williamstown 1970, No. 17 ill.; Boston 1974; Tokyo 1979 No. 89.

56 *Four Willow Trees* 1864–5

Pencil and watercolour, 380 × 260 mm.
Privately owned.

These are probably studies for the bare willows in the *Scene of Medieval Warfare* painting (p. 346).

PROVENANCE: Vente Anonyme, Hôtel Drouot, Paris 24 May 1950, No. 147.

57 *Edouard Manet Seated* circa 1865

Pencil, 363 × 230 mm.
Below left, Vente stamp *Degas*; below right, inscription in an unidentified hand (photograph number).
Back: Inscription in an unidentified hand (photograph number).
Fogg Art Museum, Harvard University, Bequest of Meta and Paul J. Sachs, Cambridge (Mass.) (Cat. No. 1965.261).

During the 1860s Degas repeatedly portrayed Manet; see pl. 58 below, studies (II^ème Vente 1918, Nos. 210 (1–3), IV^ème Vente 1919, No. 248b, Rivière 1923, pls. 60, 62 (1973, pls. 18, 19), as well as etchings and lithographs (Adhémar and Cachin 1973, Nos. 17–20).

PROVENANCE: IV^ème Vente 1919, No. 248a ill.; Mme de Zayas; Paul J. Sachs, Cambridge (Mass.).

BIBLIOGRAPHY: 'Degas Drawings', in *The Art News*, XXIV, 5, 1930, p. 10; Paris 1931, with No. 105; Mongan 1932, p. 65 pl. 6; Mongan and Sachs 1940, No. 666 pl. 342; Guérin 1947, pl. 11.

EXHIBITIONS: Cambridge (Mass.) 1929, No. 31; New York 1930, No. 57; St Louis 1932, No. 57; Pittsburgh 1933, No. 32; Boston 1935, No. 121; Buffalo 1935, No. 115 ill.; Philadelphia 1936, p. 8, No. 65 ill.; Brooklyn Institute of Arts 1939; Washington 1940; Detroit 1941, No. 19; Cleveland 1947, p. 9, No. 59 pl. L.; New York 1947; Washington 1947, No. 24; Minneapolis 1948; Richmond 1952; *An Exhibition of Drawings*, Colby College, Waterville 1956, No. 30; Cambridge (Mass.)–New York 1965–7, No. 56 ill.

58 *Edouard Manet at the Races* 1865–8

Pencil on yellowish paper, 320 × 241 mm.
Below left, Vente stamp *Degas*.
Back: *Edouard Manet at the Races*, 1865–8, pencil; below right, estate stamp ATELIER ED. DEGAS; above left, inscription in an unidentified hand (photograph number); ill.

Museum Boymans – van Beuningen, Rotterdam (Cat. No. F II 123)

Degas and Manet often went to the races together; see drawing (II^ème Vente 1918, No. 210 (1)). Manet also showed Degas as a spectator in the foreground of a racecourse scene dated '1872'; Denis Rouart and Daniel Wildenstein, *Edouard Manet. Catalogue raisonné*, Lausanne and Paris 1975, No. 184.

PROVENANCE: IV^ème Vente 1919, No. 78b ill; Georges Viau, Paris; Paul Cassirer, Berlin; Franz Koenigs, Haarlem.
BIBLIOGRAPHY: Longstreet 1964, ill.; *Le Vie del Mondo*, XXVI, 1964, p. 755 ill.; G. Picon, *1863 Le Salon des Refusés*, Milan 1966, ill.; Hoetink 1968, No. 76 ill.; Edinburgh 1979, with No. 4.
EXHIBITIONS: Rotterdam 1933–4, No. 50; Basle 1935, No. 152; Amsterdam 1946, No. 68; Berne 1951–2, No. 163; Paris 1952, No. 134; Paris and Amsterdam 1964, No. 183 pl. 147.

59 *Achille de Gas* 1865–6
Thinned oil paint and pencil on dark brown oiled card, 330 × 200 mm.
Below right, Vente stamp *Degas*.
Privately owned, Berne.

Achille Hubert de Gas (born and died Paris, 1838–93), the artist's younger brother, spent some years in New Orleans, returned to Paris in 1874 and again spent 1878–83 in New Orleans. He is represented here probably before his first departure for America in 1866, when he often acted as a model for his brother; see pl. 61 below.

PROVENANCE: II^ème Vente 1918, No. 46 ill.; Georges Viau, Paris; I^ère *Vente Succession George Viau*, Hôtel Drouot, Paris 11 December 1942, No. 92 ill.
BIBLIOGRAPHY: Lemoisne I–II, p. 76, No. 308 ill., with No. 307; Boggs 1962, p. 114; Russoli and Minervino 1970, No. 345 ill.; *Auge und Vision. Die Sammlung Jacques Koerfer*, Berne 1972, No. 3 ill.; Edinburgh 1979, with Nos. 5, 10.
EXHIBITIONS: Berne 1951–2, No. 19; *Europäische Kunst aus Berner Privatbesitz*, Kunsthalle, Berne 1952, No. 21; Winterthur 1955, No. 64.

60 *Lady with Binoculars* circa 1865
Thinned oil paint on pink paper, 280 × 227 mm.
Below right, Vente stamp *Degas*.
The British Museum, Department of Prints and Drawings, London.

Study for the figure in the foreground of *Aux Courses*, painted in 1868 and only recently restored to its original condition; ill. See the full-length oil sketch dated 'vers 1865' by the artist (Lemoisne II, No. 268; also Nos. 269 and 431), as well as drawings (II^ème Vente 1918, No. 210 (3), IV^ème Vente 1919, No. 89f.).

58 (back)

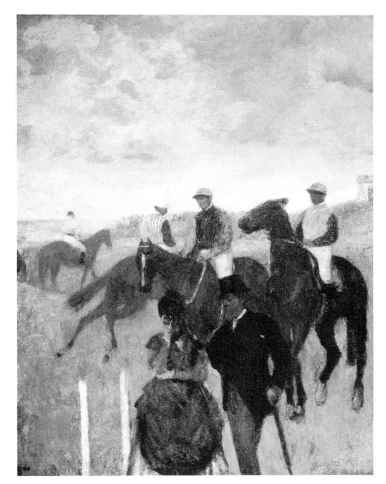

Aux Courses 1868
Weil Enterprise & Investment Ltd, Montgomery
(Lemoisne No. 184)

PROVENANCE: IV^{ème} Vente 1919, No. 261c ill.; Marcel Guérin, Paris; César M. de Hauke, New York.
BIBLIOGRAPHY: *The Art News*, XXVIII, March 1930, ill. on cover; Lemoisne 1931, p. 289 pl. 59; Mongan 1938, p. 295; Rouart 1945, p. 71 note 29; Lemoisne II, No. 179 ill., with Nos. 268, 269, 431; Shinoda 1957, p. 84 note 36; St Louis–Philadelphia–Minneapolis 1967, with No. 55; Russoli and Minervino 1970, No. 232 ill.; Thomson 1979, p. 677.
EXHIBITIONS: Philadelphia 1936, No. 81 ill.; Edinburgh 1979, No. 3, with Nos. 2, 4.

61 *Achille de Gas* 1865–6
Thinned oil paint on yellow oiled card, 377 × 233 mm.
The Minneapolis Institute of Arts, Bequest of Putnam Dana McMillan (Cat. No. 61.36.8).

This representation of Achille de Gas, as well as the figure in pl. 60 above, was used in a modified form in *Aux Courses* (ill.), painted in 1868; see pl. 59 above.

PROVENANCE: René de Gas, Paris, Vente 1927, No. 81 ill.; Chester Dale, New York; Parke Bernet sale, New York 16 March 1944, No. 38; Jacques Seligmann Gallery, New York; Putnam Dana McMillan, Minneapolis.
BIBLIOGRAPHY: Lemoisne II, No. 307 ill., with No. 308; *The Minneapolis Institute of Arts Bulletin*, L, 4, December 1961, pp. 14f. ill.; Boggs 1962, p. 114 pl. 81; Accessions of American and Canadian Museums, in *The Art Quarterly*, XXV, 1, Spring 1962, p. 80; Reff 1967, pp. 255, 258 pl. 5; 'Neun Zeichnungen von Edgar Degas aus amerikanischen Sammlungen', in *Kulturelle Monatschrift*, December 1970, p. 922 ill.; Russoli and Minervino 1970, No. 344 ill.; *European Paintings from the Minneapolis Institute of Arts*, New York 1971, No. 119 ill.; 'Who was Degas' Lyda', in *Apollo*, XCV, 120, February 1972, p. 129 pl. 8; *Auge und Vision. Die Sammlung Jacques Koerfer*, Berne 1972, with No. 3; Thomson 1979, p. 677; Terrasse 1981, No. 189 ill.
EXHIBITIONS: Museum of French Art, New York, 1929, No. 24; Paris 1931, No. 22; Cleveland 1947, p. 9, No. 3 pl. III; Minneapolis 1948; Baltimore 1962, No. 37; Santa Barbara Museum of Art 1963–4; New Orleans 1965, p. 63 pl. XVI; St Louis–Philadelphia–Minneapolis 1967, No. 58 ill.,; New York 1968, No. 32 ill.; New York 1975; *French Nineteenth Century Oil Sketches. David to Degas*, William Hayes Ackland Memorial Art Center, Chapel Hill 1978; Edinburgh 1979, No. 5 ill., with No. 10.

62 *Horse Walking* 1866–8
Charcoal on brown paper, 324 × 205 mm.
Below left, Vente stamp *Degas*.
Mr and Mrs Eugene Victor Thaw, New York.

This drawing, together with the sketch in pl. 63 below, may have been used as a study for the horse on the right in the *Aux Courses* painting (p. 351). See drawing (IV^{ème} Vente 1919, Nos. 223c, 231c).

PROVENANCE: IV^{ème} Vente 1919, No. 232c ill.; Helena Rubinstein, New York; Sotheby Parke Bernet sale, New York 28 April 1966, No. 761 ill.
BIBLIOGRAPHY: St Louis–Philadelphia–Minneapolis 1967, with No. 56; Edinburgh 1979, with No. 8.
EXHIBITIONS: New York–Cleveland–Chicago–Ottawa 1975–6, No. 95 ill.

Grandville, *Petites Misères de la Vie Humaine* 1843

63 *Four Jockeys before the Start* 1866–8
Pencil on brown paper 490 × 420 mm.
Below left, Vente stamp *Degas*.
Mr and Mrs Eugene Victor Thaw, New York.

Design for the *Aux Courses* painting (p. 351). Ronald Pickvance was the first to point out that the connection between this drawing and the painting in its restored original condition. The two standing figures can be seen in merest outline in the foreground; see the figure studies in pls. 60, 61 above. This drawing is a typical instance of the artist's 'compilation' procedure, whereby his compositions are built up from numerous individual studies. It could also possibly be that this drawing was made after the painting, with a view to *Jockeys avant la Course* (Lemoisne II, No. 649), Barber Institute of Fine Arts, Birmingham, a composition which was produced at a later date but is based on the present design.

PROVENANCE: III^{ème} Vente 1919, No. 178 (1) ill.; Howard de Walden, London; Sotheby sale, London 22 April 1971, No. 26 ill.
BIBLIOGRAPHY: Thomson 1979, p. 677 pl. 92.
EXHIBITIONS: New York–Cleveland–Chicago–Ottawa 1975–6, No. 96 ill.; Edinburgh 1979, p. 9, No. 9 ill., with Nos. 2, 8, 10.

64 *Horseman in Red Coat* 1866–8 (p. 17)
Thinned oil paint, sepia and white body colour on bright pink paper, 436 × 276 mm.
Below right, possibly not in the artist's hand, signed and dated: 'De Gas/-73-'.
Musée du Louvre, Le Cabinet des Dessins, Paris (Cat. No. RF 12276).

Study for the saluting rider on the left of the painting in *Le Départ pour la Chasse* (Lemoisne II, No. 119), owned by A. Holder-Barell, Basle; see a similar pencil drawing, which mainly concentrates on the body of the horse, in St Louis–Philadelphia–Minneapolis 1967, No. 59. The painting was dated 'about 1864–1868' by Lemoisne. The study of the horseman was probably also produced around that time since there are close stylistic affinities between it and the studies reproduced in pls. 65–68 below. The inscription, below right, was probably added by a different hand, because Degas himself no longer signed his name in that way by the 1870s.

PROVENANCE: Musée du Luxembourg, Paris.
BIBLIOGRAPHY: Rouart 1945, p. 13; Berger 1949, p. 11 ill.

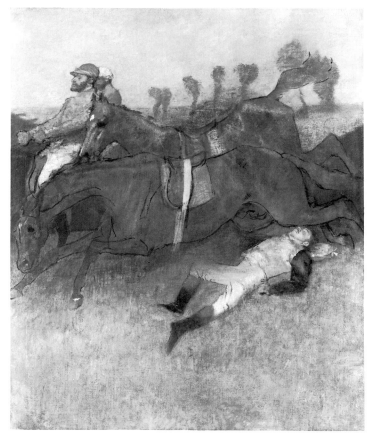

Scène de Steeple-Chase 1866
Mr and Mrs Paul Mellon, Upperville
(Lemoisne No. 140)

(frontispiece); Rosenberg 1959, p. 114 pl. 219; St Louis–Philadelphia–Minneapolis 1967, with No. 59; Nottingham 1969, with No. 13; London 1983, with No. 8.
EXHIBITIONS: Paris 1924, No. 42; Paris 1969, No. 162; *Dessins Français du Louvre d'Ingres à Vuillard*, Musée Bonnat, Bayonne 1979.

65 *Four Studies of a Jockey* 1866–8
Thinned oil paint with sepia and white body colour, 320 × 295 mm.
Below left, Vente stamp *Degas*.
Privately owned.

The artist was at pains to present the jockey from as many angles as possible.
This sheet was originally framed together with pl. 68 below.

PROVENANCE: III^ème Vente 1919, No. 127 (1) ill.; Nunès et Fiquet, Paris; Maurice Loncle, Paris.
BIBLIOGRAPHY: Rouart 1945, p. 71 note 28; Lemoisne II, No. 156 ill.; St Louis–Philadelphia–Minneapolis 1967, p. 80; Nottingham 1969, with No. 12; Russoli and Minervino 1970, No. 185 ill.; Edinburgh 1979, with No. 13; Terrasse 1981, No. 122 ill.; London 1983, with No. 7.
EXHIBITIONS: Berne 1951–2, No. 88, Winterthur 1955, No. 230.

66 *Two Jockeys* 1866–8
Thinned oil paint, sepia and body colour on brown paper, 305 × 433 mm.
Below left, Vente stamp *Degas*.
Back: *Man's Head*, pencil.
Privately owned.

This, together with the oil sketches in pls. 65, 67, 68, belongs to a group of similarly treated groups of jockeys; see Lemoisne II, Nos. 151–162.

PROVENANCE: III^ème Vente 1919, No. 129 (2) ill; Marcel Guérin, Paris.
BIBLIOGRAPHY: Lemoisne II, No. 159 ill.; St Louis–Philadelphia–Minneapolis 1967, p. 80; Nottingham 1969, with No. 12; Russoli and Minervino 1970, No. 181 ill.; Edinburgh 1979, with No. 13; Terrasse 1981, No. 118 ill.; London 1983, with No. 7.
EXHIBITIONS: Paris 1939, No. 42; Paris 1955, No. 41; Paris 1975, No. 8 ill.

67 *Two Jockeys* 1866–8
Thinned oil paint, sepia and body colour on brown paper, 232 × 310 mm.
Below right, Vente stamp *Degas*.
Back: Below right, estate stamp ATELIER ED. DEGAS.
Privately owned.

See pl. 66 above.

PROVENANCE: III^{ème} Vente 1919, No. 141 (4) ill.; G. Vaudoyer, Paris; Marcel Guérin, Paris.
BIBLIOGRAPHY: Rouart 1945, p. 71 note 28; Lemoisne II, No. 154 ill; St Louis–Philadelphia–Minneapolis 1967, p. 80; Nottingham 1969, with No. 12; Russoli and Minervino 1970, No. 182 ill.; Edinburgh 1979, with No. 13; Terrasse 1981, No. 119 ill.; London 1983, with No. 7.
EXHIBITIONS: Paris 1955, No. 40 ill.; Paris 1975, No. 7 ill.

68 *Jockey Leaning Forward and Standing in his Stirrups* 1866–8
Thinned oil paint, sepia and body colour on brown paper, 345 × 245 mm.
Below left, Vente stamp *Degas*.
Privately owned.

The dynamically sketched body of the horse is shown at a gallop, while the jockey, whose face is masked by his cap, looks back. This study was originally framed together with that in pl. 65 above.

PROVENANCE: III^{ème} Vente 1919, No. 127 (2) ill.; Nunès et Fiquet, Paris; Maurice Loncle, Paris; Sotheby sale, London 7 December 1966, No. 36 ill.
BIBLIOGRAPHY: Rouart 1945, p. 71 note 38; Lemoisne II, No. 152 ill; St Louis–Philadelphia–Minneapolis 1967, p. 80; Nottingham 1969, with No. 12; Russoli and Minervino 1970, No. 178 ill.; Keith Roberts, *Degas*, Oxford 1976, pl. 9; Edinburgh 1979, with No. 13; Horst Keller, *The Art of the Impressionists*, Oxford 1980, pl. 138 and jacket; Terrasse 1981, No. 115 ill.
EXHIBITIONS: Paris 1960, No. 7; London 1983, No. 7 ill.

69 *Girl with Guitar* circa 1867
Pencil, 350 × 210 mm.
Below right, Vente stamp *Degas*.
Privately owned.

Figure study for *Mlle Fiocre dans le Ballet de la Source*, a painting (ill.) shown at the 1868 Salon; see the drawing (IV^{ème} Vente 1919, No. 79a) in the Art Institute, Chicago, as well as the sketch in Reff 1976, Notebook 21, p. 12v. Eugénie Fiocre danced at the Paris Opéra in 1861–74, one of her star parts being that of Nouredda in Léo Delibes' ballet *La Source*, first performed on 12 November 1866.

PROVENANCE: IV^{ème} Vente 1919, No. 247a ill.; Erich Maria Remarque, Porto Ronco.
BIBLIOGRAPHY: Browse 1949, with No. 2.
EXHIBITIONS: London 1983, No. 6 ill.

70 *Giovanna and Giulia Bellelli* 1865–6
Pencil and charcoal, 294 × 228 mm.
Below right, Vente stamp *Degas*.
Museum Boymans – van Beuningen, Rotterdam (Cat. No. F II 166).

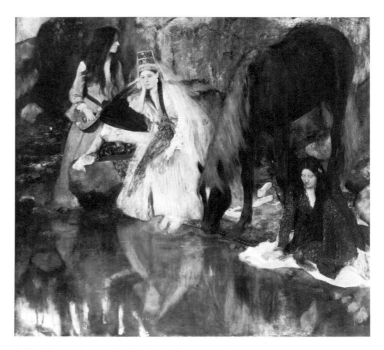

Mlle Fiocre dans le Ballet de la Source 1866–8
The Brooklyn Museum, New York (Lemoisne No. 146)

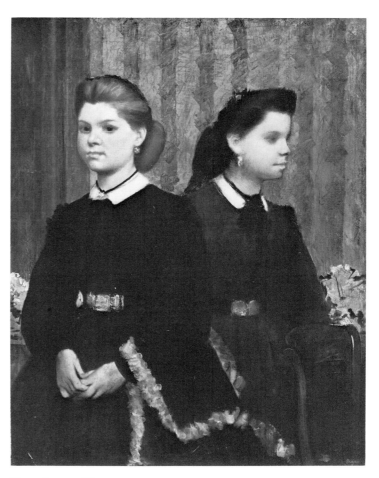

Deux Soeurs 1865–7
Los Angeles County Museum of Art, Mr and Mrs George Gard de Sylva Collection (Lemoisne No. 126)

354

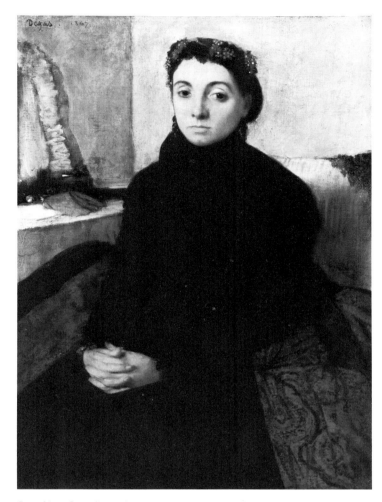

Josephine Gaujelin 1867
Isabella Stewart Gardner Museum, Boston
(Lemoisne No. 165)

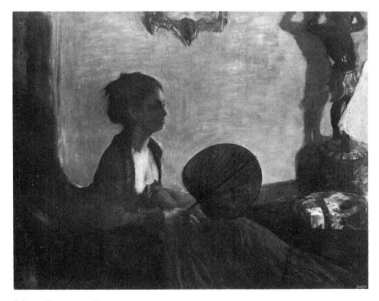

Mme Camus en Rouge 1870
National Gallery of Art, Washington
(Lemoisne No. 271)

This design deviates from the double portrait *Deux Soeurs* (ill.), probably the picture shown at the 1867 Salon, mainly in its details of dress and treatment of background; see drawing (IV^ème Vente 1919, No. 89a). The sitters are Degas' cousins Giovanna and Giulia Bellelli, who look older in this drawing than in the family portrait (p. 345). The design was probably carried out from a photograph. An earlier double portrait of these sisters dates from 1858–9 (Lemoisne II, 65). Degas generally liked double portraits: Lemoisne lists twenty-five of these up to the end of the 1870s.

PROVENANCE: III^ème Vente 1919, No. 156 (3) ill.; Durand-Ruel, Paris; Dikran G. Kélékian, Paris; Paul Cassirer, Amsterdam; Franz Koenigs, Haarlem.
BIBLIOGRAPHY: Lemoisne II, with No. 126; *Art et Style*, 1953, ill.; Boggs 1955, p. 134 pl. 13; Boggs 1962, pp. 89 note 86, 110; Longstreet 1964, ill.; Bouret 1965, p. 55; Hoetink 1968, No. 86 ill.
EXHIBITIONS: Rotterdam 1933–4, No. 47; Amsterdam 1938, No. 47; Amsterdam 1946, No. 66 ill.; Berne 1951–2, No. 85; Paris 1952, No. 131; Copenhagen 1983, No. G. ill.

71 *Marie Lucie Millaudon* 1867
Black chalk, 250 × 180 mm.
Below left, Vente stamp *Degas*.
Museum Boymans – van Beuningen, Rotterdam (Cat. No. F II 218).

Probably a study for the *Mme Millaudon* (Lemoisne II, No. 44) portrait dated 'circa 1857–1859'; see sanguine study (II^ème Vente 1918, No. 239 (1)). As Boggs 1962, p. 124, has pointed out, a date for both drawing and painting during the second half of the 1860s is more likely, on grounds of style and dress. Marie Lucie Millaudon (born Ducros) came from New Orleans and visited Paris in 1867. Both the Millaudons and the Ducros were friends and neighbours of Degas' relatives in New Orleans and therefore visited the de Gas at home during their visit to Europe.

PROVENANCE: II^ème Vente 1918, No. 238 (1); Paul Cassirer, Berlin; Franz Koenigs, Haarlem.
BIBLIOGRAPHY: Paris 1931, with No. 116; Boggs 1962, p. 124; Longstreet 1964, ill.; Hoetink 1968, No. 90 ill.
EXHIBITIONS: Berlin 1929–30, No. 33; Rotterdam 1933–4, 43; Haarlem 1935, No. 41; Berne 1951–2, No. 86.

72 *Josephine Gaujelin* 1867
Charcoal, 362 × 231 mm.
Below right, inscribed in red chalk: 'Mme Gaujelin'; below left, Vente stamp *Degas*.
Privately owned.

Study for the *Mme Gaujelin* portrait (ill.) painted in 1867 and shown at the Salon two years later. The sitter was first a dancer at the Opéra and later an actress at the Théâtre

Gymnase; see pl. 91 below. Degas noted her address – 'rue de Berlin 20' – in a sketchbook (Reff 1976, Notebook 22, p. 207).

PROVENANCE: III^{ème} Vente 1919, No. 405 (2) ill.; Durand-Ruel, Paris; Olivier Senn, Paris.
BIBLIOGRAPHY: Lemoisne II, with No. 165; Browse 1949, p. 60, No. 17a ill., with No. 12; Boggs 1962, p. 118; Hoetink 1968, with No. 88.
EXHIBITIONS: Paris 1924, No. 95; Paris 1931, No. 114.

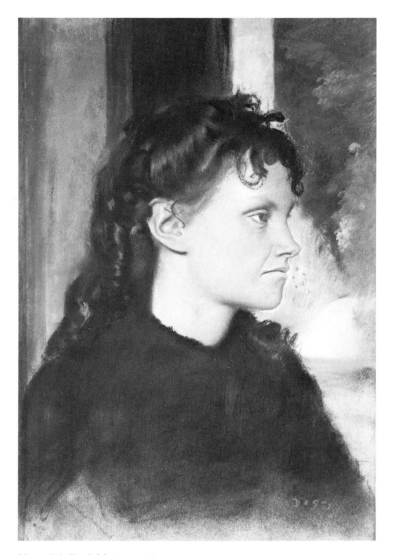

Yves Gobillard-Morisot 1869
The Metropolitan Museum of Art, Bequest of Joan Whitney Payson 1975, New York (Lemoisne No. 214)

73 *Standing Female Figure with Bared Torso* 1867–8
Thinned oil paint on brown oiled paper, 470 × 300 mm.
Öffentliche Kunstsammlungen, Basle (Cat. No. 1924).

Lemoisne suggests that this may represent a first idea, later abandoned, for the female figure in *Le Viol* (Lemoisne II, No. 348), owned by Henry P. McIlhenny, Philadelphia. The subject refers to *Thérèse Raquin*, a novel by Emile Zola published in 1867; the picture was probably painted shortly afterwards; see Reff (*The Artist's Mind*) 1976, 200ff.

PROVENANCE: III^{ème} Vente 1919, No. 23 ill.; Nunès et Fiquet, Paris; Privately owned, Frankfurt am Main; Sale, Frankfurt am Main 17 October 1928, No. 55; Hermann Ganz, Zurich.
BIBLIOGRAPHY: Rivière 1923, pl. 78 (1973, pl. D); Lemoisne II, No. 351 ill.; *Katalog 1946*, Öffentliche Kunstsammlungen, Basle 1946, p. 132; Leymarie 1948, No. 22; *Vom Impressionismus bis zur Gegenwart*, Öffentliche Kunstsammlungen, Basle 1961, p. 14 ill.; Pecirka 1963, pl. 26; Reff 1967, pp. 255, 259f.; Tannenbaum 1967, p. 50 pl. 2; Russoli and Minervino 1970, No. 377 ill.; *Katalog 19./20. Jahrhundert*, Öffentliche Kunstsammlungen, Basle 1970, p. 44 ill.; Terrasse 1974, p. 77 ill.; Lefébure 1981, pl. 53.
EXHIBITIONS: Berne 1951–2, No. 21; Amsterdam 1952, No. 12; St Louis–Philadelphia–Minneapolis 1967, No. 61 ill.

André Disdéri *Cartes de Visite* circa 1860
Bibliothèque Nationale, Paris

74 *Standing Female Figure with Arms Bent to the Side* 1867–8
Thinned oil paint on brown card, 475 × 303 mm.
Mr and Mrs Walter Bareiss, New York.

This figure, like that in pl. 73 above, may have been produced in connection with *Le Viol* (Lemoisne II, No. 348), a painting owned by Henry P. McIlhenny, Philadelphia.

PROVENANCE: Otto Gerstenberg, Berlin; Art Trade, New York.
EXHIBITIONS: Munich 1965, p. 25 pl. 4.

75 *The Double Bass Player M. Gouffé* 1868–9
Pencil, 188 × 120 mm.
Mr and Mrs Eugene Victor Thaw, New York.

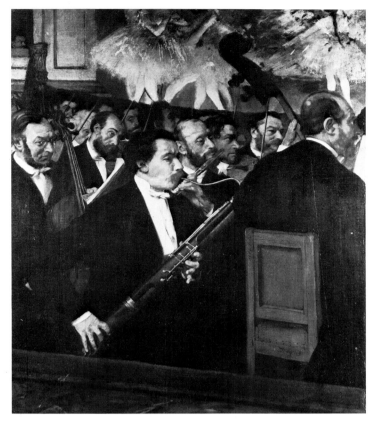

L'Orchestre de l'Opéra circa 1869
Musée du Louvre, Paris (Lemoisne No. 186)

Honoré Daumier L'Orchestre pendant qu'on joue
une Tragédie 1852 (Delteil No. 2243)

The only surviving portrait study for the *L'Orchestre de l'Opéra* painting (p. 357). M. Gouffé was the Opéra orchestra's double bass player. The sheet was probably taken from a sketchbook, being identical in size, though not in type of paper, with Notebook 25 (Reff 1976). Other related single studies occur in Reff 1976, Notebook 24, p. 18, Notebook 25, pp. 29, 35. Ronald Pickvance has recently pointed out (London 1983) that the present portrait drawing was used many years later as a model for the double bass player in the foreground of an etching (Adhémar and Cachin 1973, No. 27).

PROVENANCE: Marie Dihau, Paris; Marcel Guérin, Paris; Denis Guérin, Paris.
BIBLIOGRAPHY: 'Degas, Numéro Spécial', in *L'Amour de l'Art*, XII, July 1931, p. 286 pl. 51; Reff 1976, p. 12, pl. 3; Wilson 1983, p. 713.
EXHIBITIONS: Paris 1924, No. 100; Paris 1955, No. 99; New York–Cleveland–Chicago–Ottawa 1975–6, No. 94 ill.; London 1983, No. 9 ill.

76 *Lady Standing in Front of Easy Chair* 1868–70
Pencil, 317 × 220 mm.
Below left, Vente stamp *Degas*.
Mr and Mrs Eugene Thaw, New York.

This representation of a lady in fashionable clothes was probably connected with the group of paintings listed in Lemoisne II, Nos. 41–43. Jean Sutherland Boggs was first to point out that Lemoisne's dating – 'circa 1857–1859' – and his identification of the sitter were probably incorrect on grounds of style and clothes, both of which suggest a later date. This assumption is further strengthened by the presence in two notebooks used by Degas during the late 1860s of sketches for the picture in Lemoisne II, No. 41: see Reff 1976, Notebook 22, p. 119, Notebook 23, p. 34. The suggestion made in the New York–Cleveland–Ottawa 1975–6 catalogue that the sitter might have been Mme Millaudon is unlikely in view of the lack of resemblance between her and the subject of pl. 71 above.

PROVENANCE: IV^ème Vente 1919, No. 100b ill.; Feilchenfeldt, Zurich; John S. Newberry, New York; Sotheby sale, London 11 April 1962, No. 76 ill.; Arthur Tooth and Sons, London.
BIBLIOGRAPHY: Boggs 1962, p. 91, note 21.
EXHIBITIONS: *The Collection of John S. Newberry*, Institute of Arts, Detroit 1951, No. 12 ill.; New York–Cleveland–Chicago–Ottawa 1975–6 No. 93 ill.

77 *Beach at Low Tide* 1869
Charcoal and pastel on brown paper, 315 × 485 mm.
Below left, Vente stamp *Degas*.
Back: below right, estate stamp ATELIER ED. DEGAS.
Von der Heydt-Museum, Wuppertal (Cat. No. G 960)

Degas started a first series of relatively small landscape pastels; see Lemoisne II, Nos. 199–205, 217–253.

PROVENANCE: IVème Vente 1919, No. 58a ill.; Nunès et Fiquet, Paris; Eduard von der Heydt, Ascona.
BIBLIOGRAPHY: Lemoisne II, No. 249 ill.; Wachtmann 1965, No. 39; Janis (Monotype) 1967, p. 25 note 20; Russoli and Minervino 1970, No. 304 ill.

78 *Strip of Coast at Sunset* 1869
Pastel on brown card, 215 × 300 mm.
Below left, Vente stamp *Degas*.
Marlborough Fine Art Ltd., London.

See pl. 77.

PROVENANCE: IVème Vente 1919, No. 25a ill.; Nunès et Fiquet, Paris: Lefevre Gallery, London; R. A. Peto, Isle of Wight.
BIBLIOGRAPHY: Rouart 1945, p. 71 note 40; Lemoisne II, No. 240 ill.; Janis (Monotype) 1967, p. 25 note 20; Russoli and Minervino 1970, No. 305 ill.
EXHIBITIONS: *European Masters*, Marlborough Fine Art, London 1969–70, No. 13 ill.

79 *Six Portrait Studies* 1870–71
Black chalk, 360 × 230 mm.
Below right, Vente stamp *Degas*.
Back: Inscription in an unidentified hand (photograph number).
Museum Boymans – van Beuningen, Rotterdam (Cat. No. F II 130).

See drawing IVème Vente 1919, No. 131a, which was presumably based on newspaper illustrations and includes portrait studies of Napoleon III and some marshals involved in the Franco-Prussian War. The stylistic affinity between these sheets suggests a similar date for the present drawing, around 1870–71. No certain identification of those represented has as yet proved possible: while Boggs considers that the head in the middle may be a self-portrait, Hoetink believes that the portrait on the left may represent Ingres.

PROVENANCE: IVème Vente 1919, No. 132e ill.; Georges Viau, Paris; Paul Cassirer, Berlin; Franz Koenigs, Haarlem.
BIBLIOGRAPHY: Longstreet 1964, ill.; Hoetink 1968, No. 83 ill.
EXHIBITIONS: Basle 1935, No. 154; Amsterdam 1946, No. 63; Berne 1951–2, No. 165; St Louis–Philadelphia–Minneapolis 1967, No. 67 ill.

80 *Dancer Poised in Step* 1871–2
Thinned oil paint and pencil on light brown paper, 273 × 210 mm.
Below right, inscribed in pencil: '93 rue du Bac/d'Hugues'; also Vente stamp *Degas*.
Privately owned.

Figure study for *Le Foyer de la Danse à l'Opéra de la Rue le Peletier* (p. 358). The inscription provides the name and

Le Foyer de la Danse à l'Opéra de la Rue le Peletier
1872
Musée du Louvre, Paris (Lemoisne No. 298)

358

Ballet de Robert le Diable 1872
The Metropolitan Museum of Art, Bequest of Mrs
H. O. Havemeyer 1929, New York (Lemoisne No. 294)

address of the model, which also occur inside the cover of
Notebook 25 (Reff 1976), although Reff assumes that it is
the address of an officer. This study was framed together
with that in pl. 83 below. Both works together fetched the
considerable sum of 12,900 francs at the II^ème Vente 1918,
and as much as 45,000 francs at the Vente 1927.

PROVENANCE: II^ème Vente 1918, No. 231 (1) ill.; René de
Gas, Paris; Vente 1927, No. 23a ill.; Galerie Georges Petit,
Paris; Wildenstein Galleries, New York; John Nicholas
Brown, Providence.
BIBLIOGRAPHY: Degas 1898, pl. 9; Rouart 1945, p. 71 note
28; Lemoisne II, No. 300 ill., with No. 298; Browse 1949,
p. 53 No. 14 ill., with Nos. 10, 16; Rich 1959, p. 18 ill.;
Pickvance 1963, p. 258 note 24; Russoli and Minervino
1970, p. 294 ill.; Reff 1977, Notebook 26, p. 36.
EXHIBITIONS: Cambridge (Mass.) 1929, No. 21; Philadel-
phia 1936, No. 73 ill.; Boston 1974, No. 77.

81 *Two Dancers at the Bar* 1871–2
Thinned oil paint on red paper, 223 × 283 mm.
Below right, Vente stamp *Degas*.
Museum Boymans – van Beuningen, Rotterdam (Cat. No.
F II 54)

Study for the partly concealed figures in the left
background of *Le Foyer de la Danse à l'Opéra de la Rue le
Peletier* (p. 358).

PROVENANCE: III^ème Vente 1919, No. 395 (2) ill.; Nunès et
Fiquet, Paris; Marcel Bing, Paris; Vente Hôtel Drouot,
Paris 1924, No. 145 ill.; Franz Koenigs, Haarlem.
BIBLIOGRAPHY: Rivière 1922, pl. 29 (1973, pl. 38); Rouart
1945, p. 71 note 28; Lemoisne II, No. 300 bis ill., with No.
298; Browse 1949, p. 53, No. 16a ill., with No. 16;
Pickvance 1963, p. 258 note 24; Pecirka 1963, pl. 29;
Longstreet 1964, ill.; Hoetink 1968, No. 75 ill.; Russoli
and Minervino 1970, No. 293 ill.
EXHIBITIONS: Rotterdam 1933–4, No. 48; Haarlem 1935,
No. 36; Amsterdam 1946, No. 58; Berne 1951–2, No. 91;
Paris, 1952, No. 132.

82 *Dancer at the Bar* 1871–2
Thinned oil paint on red paper, 280 × 230 mm.
Below right, Vente stamp *Degas*.
Stephen Hahn, New York.

As for pl. 81 above; single figure in left background.

PROVENANCE: II^ème Vente 1918, No. 224 ill.; Galerie J. C.
Bellier, Paris.

83 *Seated Dancer with Left Leg Stretched Out* 1871–2 (p.
21)
Thinned oil paint and pencil on red paper, 273 × 210 mm.

Below left, Vente stamp *Degas*.
Privately owned.

As for pl. 81 above; figure in right foreground.

PROVENANCE: II^{ème} Vente 1918, No. 231 (2) ill.; René de Gas, Paris; Vente 1927, No. 23b ill.; Galerie Georges Petit, Paris; Wildenstein Galleries, New York; John Nicholas Brown, Providence.
BIBLIOGRAPHY: Rouart 1945, p. 71 note 28; Lemoisne II, No. 299 ill., with No. 298; Browse 1949, p. 53, No. 15 ill., with No. 16; Pickvance 1963, p. 258 note 24; Russoli and Minervino 1970, No. 295 ill.
EXHIBITIONS: Cambridge (Mass.) 1929, No. 22; Philadelphia 1936, No. 74 ill.; Boston 1974, No. 76.

84 *Three Nuns* 1871–2
Sepia, 280 × 450 mm.
Below left, Vente stamp *Degas*.
Victoria and Albert Museum, London (Cat. No. E. 3687–1919).

Figure studies for the nuns' ballet in the *Ballet de Robert le Diable* painting (p. 359). Giacomo Meyerbeer's opera *Robert le Diable* was revived at the Opéra in autumn 1871 and led to the production of at least four brush drawings; see pl. 85 below, as well as two studies (III^{ème} Vente 1919, Nos. 363 (1, 2)). For sketches of details, as well as written notes concerning the lighting in particular, see Reff 1976, Notebook 24, pp. 7–17, 19–21.

PROVENANCE: III^{ème} Vente 1919, No. 364 (2) ill.; Galerie Knoedler, Paris.
BIBLIOGRAPHY: Browse 1949, No. 6 ill., with Nos. 7–9; Mayne 1966, pp. 148ff., with No. 14.
EXHIBITIONS: St Louis–Philadelphia–Minneapolis, 1967, No. 64 ill.; Nottingham 1969, No. 15.

85 *Three Nuns* 1871
Sepia, 283 × 454 mm.
Below right, Vente stamp *Degas*.
Victoria and Albert Museum, London (Cat. No. E 3688–1919)

See pl. 84 above.

PROVENANCE: III^{ème} Vente 1919, No. 364 (1) ill.; Galerie Knoedler, Paris.
BIBLIOGRAPHY: Mayne 1966, pp. 148ff.

86 *Young Lady in Street Dress* circa 1872
Thinned oil paint, sepia and body colour on reddish-brown paper, 325 × 250 mm.
Below right, signed 'Degas' in blue chalk.
Fogg Art Museum, Harvard University, Bequest of Meta and Paul J. Sachs, Cambridge (Mass.) (Cat. No. 1965. 260).

This work is closely related both in technique and treatment to the oil sketches which began to appear in the 1860s.

PROVENANCE: Durand-Ruel, Paris; Paul J. Sachs, Cambridge (Mass.).
BIBLIOGRAPHY: Degas 1898, pl. 11; Mongan 1938, p. 297 ill.; Mongan-Sachs 1940, No. 669 pl. 345; Lemoisne II, No. 296 ill.; Huyghe-Jacottet 1948, pl. 95; Berger 1949, p. 25 pl. 41; Shoolman-Slatkin 1950, p. 178 pl. 101; Huyghe 1953, No. 8; Rich 1959, p. 10 ill.; Longstreet 1964, ill.; Janis 1967, p. 413; Russoli and Minervino 1970, No. 278 ill.; Katharine Kuh, 'Degas, The Reluctant Impressionist', in *Fine Arts*, 10 May 1974, p. 44 ill.; Dunlop 1979, pl. 68; Terrasse 1981, No. 180 ill.; Nathan Goldstein, *American and European Drawings*, Englewood Cliffs 1982, pl. 16.
EXHIBITIONS: Cambridge (Mass.) 1929, No. 33; St Louis 1932; Northampton 1933, No. 26; Boston 1935, No. 122; Philadelphia 1936, p. 8, No. 76 ill.; Brooklyn 1939; Washington 1940; Detroit 1941, No. 22; *France Forever*, Institute of Modern Art, Boston 1943; Cleveland 1947, No. 66, pl. LIII; New York 1947; Washington 1947, No. 32; New York 1949, No. 24; Richmond 1952; *The Pleasures of Collecting*, Institute of Contemporary Art, Boston 1955; *De David à Toulouse Lautrec. Chefs-d'Oeuvre des Collections Américaines*, Musée de l'Orangerie, Paris 1955, No. 70 pl. 60; Chicago–Minneapolis–Detroit–San Francisco 1955–6, No. 151; Los Angeles 1958, No. 19 ill.; New York 1960, No. 81; Baltimore 1962, No. 36 ill.; Cambridge (Mass.)–New York 1965–7, No. 58 ill.; St Louis–Philadelphia–Minneapolis 1967, No. 62 ill.; Boston 1974, No. 75.

87 *Mathilde Musson-Bell* 1872
Pencil and yellow chalk, 310 × 240 mm.
Below right, inscribed in pencil: 'Nouvelle Orléans 72/Degas'.
Privately owned, New York.

Degas stayed with his relatives in New Orleans from October 1872 to March 1873, where he chiefly painted and drew portraits of members of his family. The sitter is presumably his cousin Mathilde Musson-Bell (born and died in New Orleans, 1841–78), married to William Bell. A letter from the artist to his uncle in New Orleans refers to 'the good and pretty Mathilde' (Lemoisne I, p. 73). This drawing, enlivened by only a few touches of colour, especially in the dress, is a study for a pastel (Lemoisne II, No. 318) in the Ordrupgaardsamlingen, Copenhagen. Lemoisne assumed that the sitter was the blind Estelle Musson-de Gas, but as there is no hint of blindness in either representation, it is likely that the subject was her sister Mathilde.

PROVENANCE: Jeanne Fèvre, Nice; Mme Guillaume-Walter, Paris; John Rewald, New York; Sotheby sale, London 7 July 1960, No. 25 ill.

BIBLIOGRAPHY: Rewald 1961, p. 277 ill.; Boggs 1962, pp. 40, 109; Reff 1967, p. 255.
EXHIBITIONS: *Influence in French Painting*, East Hampton 1952, No. 29; Five Centuries of Drawings, Museum of Fine Arts, Montreal 1953, No. 205; New York 1958, No. 12 pl. VII; New York 1960, No. 82; *The Artist as Draughtsman*, Charles E. Slatkin Galleries, New York 1961–2, No. 48; New Orleans 1965, p. 47 pl. VII; St Louis–Philadelphia–Minneapolis 1967, No. 68 ill.

88 *Woman Ironing Seen against the Light* circa 1874
Charcoal, 425 × 305 mm.
Below left, Vente stamp *Degas*.
Privately owned.

The proportions of this study coincide with those of the *Repasseuse à Contre-Jour* (Lemoisne II, No. 356), The Metropolitan Museum of Art, New York. The drawing is gridded to facilitate its accurate transfer to canvas. This figure was also used in two other paintings (Lemoisne II, Nos, 685, 846), National Gallery, Washington, and Walker Art Gallery, Liverpool. Degas took up the workaday subject of women ironing about 1869, but it covers only a small proportion of his output as a whole.

PROVENANCE: IIIeme Vente 1919, No. 269 ill.
BIBLIOGRAPHY: Lemoisne II, with No. 356; Erich Steingräber, 'La Repasseuse. Concerning the Earliest Version of this Subject by Degas', in *Pantheon*, XXXII, 1, January–March 1974, p. 53 note 17; Edinburgh 1979, with No. 70.
EXHIBITIONS: Paris 1975, No. 58 ill.

89 *Dancer with Outstretched Arms* circa 1873
Black chalk on pink paper, 420 × 310 mm.
Below left, Vente stamp *Degas*.
Back: Inscription in an unidentified hand (photograph number).
Museum Boymans – van Beuningen, Rotterdam (Cat. No. F II 167).

Probably a cursory sketch for the dancer in the centre of the *Ecole de Danse* (Lemoisne II, No. 399), Shelburne Museum, Vermont.

PROVENANCE: IIIeme Vente 1919, No. 326 (2) ill.; Durand-Ruel, Paris; Dikran G. Kélékian, Paris; Paul Cassirer, Berlin; Franz Koenigs, Haarlem.
BIBLIOGRAPHY: Lemoisne II, with No. 399; Browse 1949, No. 37a ill.; Longstreet 1964, ill.; Hoetink 1968, No. 87 ill.

90 *Four Studies of a Horseman* circa 1875
Thinned oil paint and sepia on brown paper, pared along right hand side towards the top, 390 × 250 mm.
Below right, Vente stamp *Degas*.
Privately owned.

See sketches (Lemoisne II, Nos. 382 and 383 bis), the first of these being in the Musée du Louvre, Paris.

PROVENANCE: IIIeme Vente 1919, No. 37 (1) ill.; Nunès et Fiquet, Paris.
BIBLIOGRAPHY: Lemoisne II, No. 383 ill., with No. 383 bis; Russoli and Minervino 1970, No. 402 ill.; Terrasse 1981, No. 244 ill.; Keith Roberts, *Degas*, Oxford 1982, Fig. 26.
EXHIBITIONS: St Louis–Philadelphia–Minneapolis 1967, No. 76 ill.

91 *Josephine Gaujelin* 1873
Pencil and black chalk, 307 × 197 mm.
Below left, inscribed in black chalk: '1873/Josephine Gaujelin/autrefois danseuse à l'Opéra/puis actrice au Gymnase'; below right, Vente stamp *Degas*.
Museum Boymans – van Beuningen, Rotterdam (Cat. No. F II 169)

Josephine Gaujelin was first a dancer at the Opéra and then an actress at the Théâtre Gymnase. She was no longer dancing when she acted as model for this drawing; see pl. 72 above and an oil sketch (Lemoisne II, No. 325), also dated '1873'.

PROVENANCE: IIIeme Vente 1919, No. 156 (1) ill.; Durand-Ruel, Paris; Dikran G. Kélékian, Paris; Paul Cassirer, Berlin; Franz Koenigs, Haarlem.
BIBLIOGRAPHY: Lemoisne II, with No. 165; Browse 1949, pp. 53, 60, No. 12 ill., with No. 10, 17a; Cabanne 1960, p. 31 (?); Boggs 1962, p. 118; Pickvance 1963, p. 256 note 1; Longstreet 1964, ill; Janis 1967, p. 413; Reff 1967, p. 256, Hoetink 1968, No. 88 ill.
EXHIBITIONS: Rotterdam 1933–4, No. 49; Basle, 1935, No. 155; St Louis–Philadelphia–Minneapolis 1967, No. 69 ill., with No. 70.

92 *Dancer Leaning Forward with Arms Bent* circa 1873
Black chalk, 470 × 305 mm.
Below left, Vente stamp *Degas*.
Mr and Mrs Alexander Lewyt, New York.

Sketch for the figure intersected by the left-hand edge of the picture in *Ecole de Danse* (Lemoisne II, No. 399), Shelburne Museum, Vermont; see a similar charcoal drawing, though less sketchily carried out and covered with grid lines (IIeme Vente 1918, No. 357).

PROVENANCE: IVeme Vente 1919, 265a ill.

93 *Seated Dancer in Profile with her Hand at her Neck* 1873
Thinned oil paint and sepia on dark blue paper, 230 × 292 mm.
Below left, Vente stamp *Degas*.
Musée du Louvre, Le Cabinet des Dessins, Paris (Cat. No. RF 16723)

Study for the dancer sitting in the foreground of *Répétition d'un Ballet sur la Scène* (Lemoisne II, No. 400), The Metropolitan Museum of Art, New York; see sketches (IIème and IIIème Vente 1918–19, Nos. 333, 25, 83 (2)). For the dating of the picture and related studies, see Pickvance 1963, pp. 259f.

PROVENANCE: IIIème Vente 1919, No. 132 (3) ill.; Marcel Bing, Paris; Gaston Migeon, Paris.
BIBLIOGRAPHY: Lafond 1919, ill. after p. 36; Rivière 1922, pl. 23 (1973, pl. 40); Rouart 1945, p. 71 note 28; Lemoisne II, with No. 400; Browse 1949, No. 28a ill., with No. 30; Pickvance 1963, p. 260 note 53; Pecirka 1963, pl. 16; Terrasse 1973, p. 27 ill.; Lefébure 1981, pl. 15.
EXHIBITIONS: Paris 1924, No. 107; Paris 1969, No. 184.

94 *Dancer with Arms Stretched Sideways* 1874
Pastel on grey-blue paper, 480 × 620 mm.
Below left, Vente stamp *Degas*.
Privately owned, Switzerland.

This pastel study was most probably produced in connection with *Deux Danseuses en Scène* (Lemoisne II, No. 425), Courtauld Institute of Art, London. Pickvance (1963, p. 264) has conclusively shown that this picture was painted in 1874 and represents one of the first examples of Degas' experiments with the transfer of figures; see a drawing (IIème Vente 1918, No. 313) and its transfer (IVème Vente 1919, 280b).

PROVENANCE: IIème Vente 1918, No. 101 ill.; René de Gas, Paris; Vente 1927, No. 40 ill.; Durand-Ruel, Paris; Galerie Nathan, Zurich.
BIBLIOGRAPHY: Lemoisne II, No. 428 ill., with No. 427; Russoli and Minervino 1970, No. 475 ill.

95 *Dancer with Outstretched Arms Leaning Forward* 1874
Charcoal, 254 × 330 mm.
Below right, signed in charcoal 'Degas'.
Mr and Mrs Alexander Lewyt, New York.

Detail study of the right-hand figure in the pastel *Danseuses au Repos* (Lemoisne II, No. 343), The Metropolitan Museum of Art, New York, produced in 1874. A comparable full-length study is also in The Metropolitan Museum of Art (Cat. No. 29.100.941). The figure was later used again in the composition *Danseuses derrière le Portant* (Lemoisne II, No. 585) in the Norton Simon Foundation, Los Angeles.

96 *Dancer Attaching her Shoulder Strap* circa 1874
Thinned oil paint and sepia, 415 × 180 mm.
Below left, Vente stamp *Degas*.
Privately owned.

This work originally formed part of a single sheet, the dimensions of which were quoted in the IIIème Vente

catalogue as 480 × 630 mm, also containing the sketch in pl. 99 below, and a further figure study (pl. 227 below). The subject, which first emerges in the *Ecole de Danse* (Lemoisne II, No. 398), Corcoran Gallery of Art, Washington, continued to be used in compositions with dancers throughout the 1880s and 1890s.

PROVENANCE: IIIème Vente 1919, No. 212 ill.; Nunès et Fiquet, Paris.
EXHIBITIONS: Paris 1983, No. 112 ill.

97 *Dancers Putting on their Shoes* circa 1874
Thinned oil paint and sepia on pink paper, 400 × 320 mm.
Below right, signed in pencil 'Degas'; below left, Vente stamp *Degas*.
Privately owned.

A comparably complex pose can be found in the pastel dated '1874', *Danseuses au Repos* (Lemoisne II, No. 343), The Metropolitan Museum of Art, New York, and then recurs in compositions with dancers during the 1880s, usually in reversed form; see, among others, Lemoisne II–III, Nos. 587–590, 703, 987, 988.

PROVENANCE: IIème Vente 1918, No. 245 ill.; David-Weill, Paris; Reginald Davis, Paris; Georges Rehns, Paris.
BIBLIOGRAPHY: Rivière 1922, pl. 31 (1973, pl. C); Rouart 1945, p. 71 note 28; Lemoisne II, No. 388 ill.; Leymarie 1948, pl. 19; Pecirka 1963, pl. 34; Russoli and Minervino 1970, No. 495 ill.; Serullaz 1979, p. 89 ill.; Kresak 1979, pl. 23; Terrasse 1981, No. 253 ill.; Lefébure 1981, pl. 19.
EXHIBITIONS: Paris 1924, No. 110; Paris 1975, p. VII (detail), No. 16 ill.

98 *Dancers with Right Leg Raised* circa 1874
Thinned oil paint and sepia on pink paper, 445 × 314 mm.
Below left, Vente stamp *Degas*; below right, estate stamp ATELIER ED. DEGAS.
Back: *Two Studies of a Seated Girl*, circa 1874, thinned oil paint and sepia; below right, Vente stamp *Degas* (p. 363). The Metropolitan Museum of Art, Robert Lehman Collection, New York (Cat. No. 1975.1.611).

PROVENANCE: IIème Vente 1918, No. 235 (1, 2) ill.
BIBLIOGRAPHY: Rouart 1945, p. 71 note 28; Szabo 1980, Nos. 31a ill., 31b ill.
EXHIBITIONS: Exposition de la Collection Lehman de New York, Musée de l'Orangerie, Paris 1957, No. 133; Cincinnati 1959, No. 281; New York 1977, No. 20.

99 *Dancer in Profile, Hands on Hips* circa 1874
Thinned oil paints and sepia on card, 305 × 220 mm.
Below right, Vente stamp *Degas*.
Privately owned.

See No. 96.

362

(back)

PROVENANCE: III^{ème} Vente 1919, No. 212 ill.; Nunès et Fiquet, Paris.
EXHIBITIONS: Paris 1983, No. 113 ill.

100 *Dancer at the Bar* 1876–7
Pencil, 185 × 305 mm.
Below left, Vente stamp *Degas*.
Mr and Mrs Ralph Konheim, USA.

PROVENANCE: III^{ème} Vente 1919, No. 83 (3) ill.; Georges Viau, Paris.
EXHIBITIONS: Paris 1975, no. 61 ill.

101 *Dancer Seen from the Back* circa 1876
Charcoal, 480 × 300 mm.
Below left, Vente stamp *Degas*.
Privately owned.

Browse 1949, No. 11, has dated a representation of very probably the same model in a similar study 'circa 1872', but the stylistic features of the present drawing suggest a later date. The figure by the window in the background of *Ecole de Danse* (Lemoisne II, No. 399), Shelburne Museum, Vermont, is shown in the identical pose.

PROVENANCE: II^{ème} Vente 1918, No. 346 ill.; Jeanne Fèvre, Nice; Vente 1934, No. 21 ill.; Paul Cassirer, Amsterdam; Erich Maria Remarque, Porto Ronco.
BIBLIOGRAPHY: Wilson 1983, p. 713.
EXHIBITIONS: Amsterdam 1938, No. 51; New York 1943, No. 26 ill.; London 1983, No. 11 ill.

102 *Dancer at the Bar* (detail study) 1876–7
Pencil, 309 × 195 mm.
Below right, estate stamp ATELIER ED. DEGAS.
Back: Inscriptions in unidentified hands (photograph and estate numbers).
Mr and Mrs William R. Acquavella, New York.

This slightly paint-spattered sheet with studies of a dancer practising at the bar was produced for the left-hand figure in *Danseuses à la Barre* (Lemoisne II, No. 408), The Metropolitan Museum of Art, New York; see pl. 103 below, as well as a pastel (II^{ème} Vente 1918, No. 234 (1)).

EXHIBITIONS: *Nineteenth Century French Drawings*, Hazlitt, Gooden & Fox Gallery, London 1982, No. 55 ill.

103 *Dancers at the Bar* 1876–7
Thinned oil paint and sepia on green paper, 470 × 625 mm.
Below right, signed in black chalk: 'Degas'.
The British Museum, Department of Prints and Drawings, London.

Oil sketch for *Danseuses à la Barre* (Lemoisne II, No. 408), The Metropolitan Museum of Art, New York; see pl. 102

above, as well as a pastel (Lemoisne II, No. 421) and drawings (II^{ème} Vente 1918, No. 234 (1), III^{ème}–IV^{ème} Ventes 1919, Nos. 133 (4), 278 (4)).

PROVENANCE: II^{ème} Vente 1918, No. 338 ill.; Gustave Pellet, Paris; J. H. Whittemore, Nangatuck; César M. de Hauke, New York.
BIBLIOGRAPHY: Degas 1898, pl. 13; Lafond 1919, after p. 36 ill.; Rivière 1923, pl. 86 (1973, pl. E); Vollard 1936, pl. 5; Grappe 1936, pl. 61 ill.; Rouart 1945, p. 71 note. 28; Lemoisne II, No. 409 ill., with No. 408; Browse 1949, No. 47 ill., with Nos. 46, 48; Cooper 1952, pp. 12f., 16, No. 4 ill.; Rich 1959, pp. 74f. ill.; Rosenberg 1959, p. 112 pl. 208; Pecirka 1963, pl. 36; Hoetink 1968, with No. 75; Paris 1969, with No. 173; Russoli and Minervino 1970, No. 496 ill.; Terrasse 1973, p. 38 ill.; Hüttinger 1981, p. 30 ill.; Lefébure 1981, pl. 22; Kopplin 1981, p. 85.
EXHIBITIONS: Boston 1935, No. 126; Philadelphia 1936, p. 8, No. 80 ill.; Paris 1937, No. 85; Berne 1951–2, No. 23.

104 *Dancer with Arms Spread* circa 1878
Black chalk with white highlights added on brown paper, 235 × 325 mm.
Centre right, inscribed in black chalk 'reflets sur le bras'; below left, Vente stamp *Degas*.
Mr and Mrs Eugene Victor Thaw, New York.

Figure study for *Ecole de Danse* (Lemoisne II, No. 537), Frick Collection, New York. The work has been squared for transfer to canvas. The model was most probably Melina Darde of the Théâtre de la Gaité, whom Degas showed in a number of drawings as a fifteen-year old girl in 1878; see figure studies (II^{ème} Vente 1918, No. 230 (1) and III^{ème} Vente 1919, Nos. 336 (1), 357 (2), 359 (1)).

PROVENANCE: IV^{ème} Vente 1919, No. 284a ill.; Galerie Le Niveau, New York; Averell Harriman, New York; Sotheby Parke Bernet sale, New York 18 May 1972, No. 89 ill.
EXHIBITIONS: *The Development of Impressionism*, County Museum of Art, Los Angeles 1940, No. 19; *Marie and Averell Harriman Collection*, National Gallery of Art, Washington 1961, p. 53 ill.; New York–Cleveland–Chicago–Ottawa 1975–6, No. 97 ill.

105 *Nude Poised in Step, Studies of Arms* circa 1878
Charcoal, 300 × 220 mm.
Below left, Vente stamp *Degas*.
Charles Durand-Ruel, Paris.

Degas was accurate in the preparation of the figures in his paintings and often worked out their presentation from the nude; the present pose was developed further in the *Entrée en Scène* paintings (Lemoisne II, Nos. 453, 454).

PROVENANCE: III^{ème} Vente 1919, No. 82 (3) ill.; Durand-Ruel, Paris.
EXHIBITIONS: Copenhagen 1948, No. 117.

106 *Dancer with Bouquet* 1877–9
Charcoal with added white highlights on beige paper, 609
× 461 mm.
Below left, Vente stamp *Degas*.
Back: Estate stamp ATELIER ED. DEGAS.
Musée du Louvre, Le Cabinet des Dessins, Paris (Cat. No.
RF 4649)

Figure and detail studies for *Danseuse Tenant un Bouquet à la
Main* (Lemoisne II, No. 418), Musée du Louvre, Paris.
The right hand is covered by the bouquet, yet the artist
devoted two separate studies to the exact position of the
fingers holding the flowers. He also went to great trouble
over the dancer's head, seen from above, which reappears
in outline at the top of the sheet and also, in various
attitudes, in the study *Trois Etudes de la Tête d'une Danseuse*
(Lemoisne II, No. 593), Musée du Louvre, Paris. See
similarly conceived paintings, pastels and drawings
(Lemoisne II–III, 490–492, 574, 591, 601, 627, 735, 736,
III^ème Vente 1919, No. 182, 276), in particular, pl. 107
below.

PROVENANCE: III^ème Vente 1919, No. 398 ill.; Musée du
Luxembourg, Paris.
BIBLIOGRAPHY: Lemoisne II, with No. 418.
EXHIBITIONS: Paris 1969, No. 174 pl. 9, with No. 28.

107 *The Green Dancers* 1877–9
Pastel and gouache, 660 × 360 mm.
Below left, signed in black chalk: 'Degas'.
Thyssen-Bornemisza Collection, Lugano.

This composition seen in sharply plunging perspective,
and organized strictly along diagonals, is among Degas'
finest picture-sized ballet pastels. The arms and legs of the
dancers illuminated from below, together with the *tutus*
swinging weightlessly within the quadrangle of the
picture, set up a near-abstract pattern of movement; see
study (IV^ème Vente 1919, No. 269). The Edinburgh 1979
catalogue refers to a number of press reactions in 1888
when this picture was first shown in London. *The Times*
wrote of a wonderful presentation in pastel, while the
critic of the *Kensington News* could find nothing good to
say about it. He criticized the garish and raw colouring, as
well as the discordant effect of the picture as a whole,
adding, for good measure, that a British mother might
well find the subject somewhat shocking. The painter
Walter Sickert was the first owner of the picture: he had
met Degas in Paris in 1883 and was probably instrumental
in bringing it to England so early.

PROVENANCE: Walter Sickert, London; T. Fisher Unwin,
London; Charles Barret-Decap, Biarritz; Alex Reid &
Lefevre Gallery, London; William A. Cargill, Bridge of
Weir; Sotheby sale, London 11 June 1963, No.15 ill.;
Sotheby Parke Bernet sale, New York 6 May 1971, No. 30
ill.
BIBLIOGRAPHY: Moore 1908, p. 150 ill.; André 1934, pl. 19;
Mauclair 1938, p. 138 ill.; R. H. Wilensky, *French Painting*,

London 1941, p. 334 ill.; Lemoisne II, No. 572 ill.; Browse
1949, No. 168 ill.; Douglas Cooper, *The Courtauld
Collection*, London 1954, p. 62; Ronald Pickvance, 'A
Newly Discovered Drawing by Degas of George Moore',
in *The Burlington Magazine*, CV, 723, June 1963, p. 280 note
31; Russoli and Minervino 1970, No. 731 ill.; Reff (*The
Artist's Mind*) 1976, p. 178 pl. 125; Terrasse 1976, p. 10 ill.;
Thomson 1979, p. 677 pl. 96; Gerstein 1982, p. 114.
EXHIBITIONS: *Spring Exhibition*, New English Art Club,
London 1888, No. 18; The International Society of
Sculptors, Painters and Engravers, *Exhibition of In-
ternational Art*, Knightsbridge, London 1898, No. 114 ill.;
London 1928, No. 6 ill.; Tokyo–Kyoto–Fukuoka 1976–7,
No. 28 ill.; Edinburgh 1979, p. 18, No. 29 pl. 5, with No.
28.

108 *Dancer Seen Against the Light* 1878–80
Charcoal with white highlights added on medium-grey
paper, 488 × 306 mm.
Above right, inscribed in charcoal: 'petits noeuds roses
aux épaules'; below left, Vente stamp *Degas*.
Back: Estate stamp ATELIER ED. DEGAS, as well as
inscriptions in unidentified hands (photograph and estate
numbers).
Kupferstichkabinett der Staatlichen Kunsthalle, Karls-
ruhe (Cat. No. 1980–12)

Study for the figure seen against the light in the
background of *La Leçon de Danse* (Lemoisne II, No. 625),
Paul Mellon Collection, Upperville; see also pastel
(Lemoisne II, No. 644), owned by Stavros Niarchos,
London. Degas had been working with effects against the
light since the middle of the 1870s in particular.

PROVENANCE: II^ème Vente 1918, No. 349 ill.; Georges Viau,
Paris; I^ère *Vente Succession Georges Viau*, Hôtel Drouot,
Paris 11 December 1942, No. 54, pl. IV; E. Jannink, Paris;
Galerie Nathan, Zurich.
BIBLIOGRAPHY: 'Staatliche Kunsthalle Karlsruhe, Erwerb-
ungsbericht 1980', in *Jahrbuch der Staatlichen Kunstsamm-
lungen in Baden-Württemberg*, 18, 1981, p. 142 pl. 15.
EXHIBITIONS: *French Art 1200–1900*, Royal Academy,
London 1932, No. 977; Paris–Amsterdam 1964, No. 185
pl. 150; Karlsruhe 1983, No. 76 ill.

109 *Dancer with Fan* circa 1878
Black chalk with white highlights added on blue-grey
paper, 480 × 315 mm.
Below left, Vente stamp *Degas*.
Back: Inscriptions in unidentified hands (photograph and
estate numbers).
Museum Boymans – van Beuningen, Rotterdam (Cat. No.
F II 222).

Before Degas took up fan painting at the end of the 1870s,
he portrayed a few dancers carrying fans; see pastel

(Lemoisne II, No. 545) and the drawing dedicated to the art critic Théodore Duret (Edinburgh 1979, No. 18) in the Musée du Petit Palais, Paris.

PROVENANCE: III^{ème} Vente 1919, No. 339 (1) ill.; Georges Viau, Paris; Paul Cassirer, Berlin; Franz Koenigs, Haarlem.

BIBLIOGRAPHY: Browse 1949, p. 53, No. 57a ill.; *Art et Style*, 1952, ill.; J. Vallery-Radot, *Dessins de Pisanello à Cézanne*, Paris 1952 ill.; Haverkamp–Begemann 1957, No. 77 ill.; Longstreet 1964, ill.; St Louis–Philadelphia–Minneapolis 1967, with No. 75; Hoetink 1968, No. 91 ill. (cover).

EXHIBITIONS: Berlin 1929–30, No. 35 ill. (frontispiece); Rotterdam 1933–4, No. 44 ill.; Amsterdam 1938, No. 50; Amsterdam 1946, No. 69 ill.; Berne 1951–2, No. 92; Paris–Amsterdam 1964, No. 184 pl. 149; Edinburgh 1979, No. 19 ill.

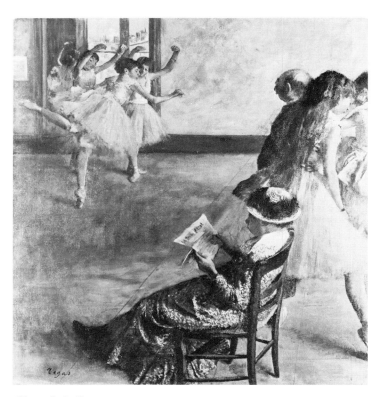

Classe de Ballet 1880
Philadelphia Museum of Art, The W. P. Wilstach Collection
(Lemoisne No. 479)

110 *Seated Dancer Fastening her Shoestrap* 1878–80
Charcoal and pastel on brown paper, 490 × 620 mm.
Below right, signed in black charcoal: 'Degas'.
Privately owned.

Lemoisne dated this work 'circa 1890–1895', but it is probably earlier: the drawing, for example, is comparable in many ways with that of pl. 111 below and the use of white chalk, as well as the treatment of the shadows, is quite similar to the effect in pl. 112 below.

PROVENANCE: Bernheim-Jeune, Paris; Ann Chapman, New York; Anderson Gallery sale, New York December 1924, No. 74; Esther Slater Kerrigan, New York; Knoedler Galleries, New York; Sotheby sale, London 3 December 1975, No. 4 ill.

BIBLIOGRAPHY: Lemoisne II, No. 1069 ill.; Russoli and Minvervino 1970, No. 1065 ill.

EXHIBITIONS: Tokyo–Kyoto–Fukuoka 1976–7, No. 47 ill.; Edinburgh 1979, No. 34 ill.

111 *Two Dancers* 1878–80
Charcoal with white highlights added on reddish-brown paper, 464 × 324 mm.
Below left, Vente stamp *Degas*.
Mr and Mrs Alexander Lewyt, New York.

PROVENANCE: III^{ème} Vente 1919, No. 209 (2) ill.; Georges Viau, Paris.

112 *Two Dancers* 1878–80 (ill. p. 27)
Pastel on brown paper, 600 × 450 mm.
Below left, signed in black chalk: 'Degas'.
Marianne Feilchenfeldt, Zurich.

This study, superbly conceived with a minimum of colouring, as well as the composition *Classe de Ballet* (p.

366

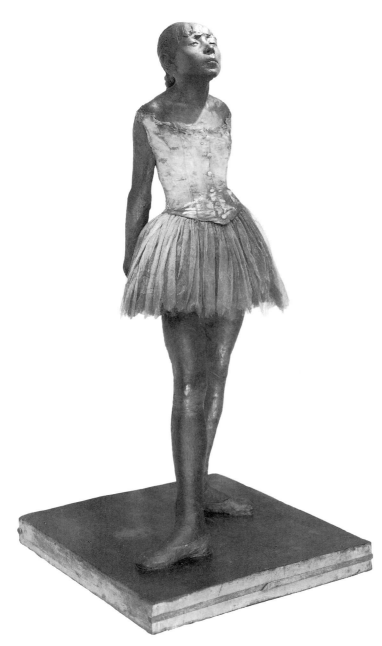

Petite Danseuse de Quatorze Ans (original wax figure)
1880–81
Mr and Mrs Paul Mellon, Upperville

366) derived from it, are textbook examples of the decentralizing presentation developed by Degas, especially during the 1870s. This large drawing derives a good deal of its tension from the contrast between the empty left-hand side of the work and the wealth of figures partly cut off by the edge on the right. The dark tonality of the paper provides a depth of space in which the two figures viewed from a high angle are free to move with a plasticity that owes much to their contrasting colours. See the dancer composition (Lemoisne II, No. 481) in which the main figure is sited in a different pictorial context.

PROVENANCE: Henri Lerolle, Paris; Hector Brame, Paris.
BIBLIOGRAPHY: Lafond 1919, ill. (cover); Rivière 1923, pl. 94 (1973, pl. H); Lemoisne II, No. 480 ill., with No. 479; 'La Danse' in *Du*, May 1950, ill.; Cooper 1952, pp. 12, 19, No. 12 ill.; Janis 1967, p. 413 pl. 42; Reff 1967, pp. 254, 258 ill.; Tannenbaum 1967, p. 52 pl. 11; Leymarie 1969, p. 50 f. pl. 19; Russoli and Minervino 1970, No. 530 ill.
EXHIBITIONS: Paris 1937, No. 91; Amsterdam (Stedelijk Museum) 1938, No. 101; Amsterdam 1946, No. 76; Berne 1951–2, No. 25; ill; Winterthur 1955, No. 232; *De Géricault à Matisse. Chefs d'Oeuvres Français des Collections Suisses*, Petit Palais, Paris 1959, No. 154 pl. 42; Wolfsburg 1961, No. 40 pl. 63; Lausanne 1964, No. 7 ill.; St Louis–Philadelphia–Minneapolis 1967, No. 92 ill.; New York 1978, No. 18 ill.; Edinburgh 1979, p. 17 f., No. 20 ill. (frontispiece), with No. 21.

113 *The Fourteen-Year-Old Dancer* circa 1879
Black chalk on pink paper, 480 × 310 mm.
Below left, Vente stamp *Degas*.
Nasjonalgalleriet, Oslo.

It is not known when Degas started to produce his studies in relief, which he mainly used as working aides. All that is certain is that he only once exhibited a sculpture, at the sixth Impressionist exhibition in 1881, with the 99 cm-high wax statuette *Petite Danseuse de Quatorze Ans* (ill.). This work must have been close to his heart since he carefully prepared it from six drawings, the present one, pl. 114 below, the studies IIIème Vente 1919, Nos. 341 (2), 386 and Lemoisne II, Nos. 586bis, 586ter. In addition, Degas produced a nude maquette of it in red wax. The present drawing is a project for this first unclothed conception of the subject, which differs from it to some extent in the attitude of the limbs and head. As in many of Degas' drawings, his second thoughts about the setting of arms and legs restore something of its actual mobility to the figure.

PROVENANCE: IVème Vente 1919, No. 287a ill.
BIBLIOGRAPHY: Lemoisne II, with No. 586bis; Browse 1949, with No. 95; St Louis–Philadelphia–Minneapolis 1967, with No. 99; Reff (*The Artist's Mind*) 1976, p. 244 note 17.
EXHIBITIONS: Edinburgh 1979, p. 64, No. 74 ill., with Nos. 75, 77.

114 *Two Studies of the Fourteen-Year-Old Dancer* circa 1879
Black and brown chalk with white highlights added on
grey paper, 475 × 590 mm.
Below left, Vente stamp *Degas*.
Lord Rayne, London.

See pl. 113 above. The fourteen-year-old dancer Marie
van Goethem is represented in bodice, skirt and dancing
shoes, very much as she finally appeared in the wax
statuette, dressed in a real linen bodice, a shorter tutu and
dancing shoes (p. 367). The figure is seen on the same level
as in the *Trois Danseuses* (Lemoisne II, No. 579), a drawing
inscribed by the artist: 'vue de dessus'.

PROVENANCE: III^{ème} Vente 1919, No. 277 ill.; M.
Cottevieille, Paris; Sotheby sale, London 4 July 1962, No.
35 ill.
BIBLIOGRAPHY: Lemoisne II, with No. 586bis; Browse
1949, with No. 94; Rewald 1961, p. 450 ill; *Sotheby's
Annual Review*, London 1962, p. 72 ill.; Reff 1967, p. 250;
Reff (*The Artist's Mind*) 1976, p. 244 note 17.
EXHIBITIONS: St Louis–Philadelphia–Minneapolis 1967,
No. 99 ill.; Nottingham 1969, No. 17 pl IX; Edinburgh
1979, No. 77 ill.

115 *Little Dancer Resting* 1878–80
Charcoal on yellowish paper, 250 × 294 mm.
Above right, inscribed in charcoal: 'repos se caressant le
genoux'; below left, Vente stamp *Degas*.
The Minneapolis Institute of Arts, Gift of Julius Boehler
(Cat. No. 26.10).

The first execution of a motif which was to be used in
similar form in the early 1880s in the pastel *Danseuse au
Repos* (Lemoisne II, No. 659), Johnson Collection,
Philadelphia. Although the drawing is somewhat more
cursory, this and the study in pl. 116 below are similar to
the representation of Melinda Dardes sitting on the
ground and rubbing her legs, dated '1878'.

PROVENANCE: III^{ème} Vente 1919, No. 109 (3) ill.;
Bernheim-Jeune, Paris; Julius Boehler, Lucerne.
BIBLIOGRAPHY: Reff 1967, p. 250.
EXHIBITIONS: St Louis–Philadelphia–Minneapolis 1967,
No. 100 ill., with No. 101.

116 *Little Dancer at the Bar* 1878–80
Charcoal with white highlights added on pink paper, 310
× 293 mm.
Above left, inscribed in black chalk: 'bien accuser/l'os du
coude'; and, below right: 'battements à la Seconde à la
barre'; in addition, below right, signed in pencil: 'Degas'.
The Metropolitan Museum of Art, Bequest of Mrs H. O.
Havemeyer, 1929, The H. O. Havemeyer Collection, New
York (Cat. No. 29.100.943).

The model for this and the drawing in pl. 115 above may
well have been the sixteen- or seventeen-year-old dancer

Dugés: see Browse 1949, Nos. 76, 78. A similar position at
the bar – although the dancer concerned is older – occurs
in the pastel *Danseuses à la Barre* (Lemoisne II, No. 460), in
the New York art trade. The present drawing forms part
of Mrs Louisine Havemeyer's famous collection and was
bought from the artist himself. Louisine Waldon Elder
began buying works by Degas in 1875, with the advice of
the American painter Mary Cassatt living in Paris, even
before she married the sugar magnate Henry O.
Havemeyer. When she died in 1929 her collection
contained over 120 works by Degas, most of which were
donated to The Metropolitan Museum of Art, New York.

PROVENANCE: Louisine Havemeyer, New York.
BIBLIOGRAPHY: Browse 1949, pp. 59, 68, No. 77 ill., with
Nos. 76, 78; L. W. Havemeyer, *Sixteen to Sixty. Memoirs of
a Collector*, New York 1961, p. 252; Longstreet 1964, ill.;
L. B. Gillies, 'European Drawings in the Havemeyer
Collection', in *The Connoisseur*, 172, 693, November 1969,
pp. 148, 153 ill.
EXHIBITIONS: San Francisco 1947, No. 88; New York
1977, No. 24.

117 *Painted Fan: 'La Farandole'* 1878–9
Gouache with gold and silver highlights added on silk,
307 × 610 mm.
At left edge, signed in black china ink: 'Degas'.
Privately owned, Switzerland.

Degas wrote to the designer Felix Bracquemond in mid-
April 1879 that there was a whole room full of fans at the
fourth Impressionist exhibition, held 10 April–11 May at
28 Avenue de l'Opéra; Guérin 1945, p. 44. He himself
contributed five fans, which can unfortunately no longer
be identified, while Pissarro showed twelve of them.
Degas only took up fan painting during the late 1870s,
very much due to the influence of Japanese models, except
for two early examples dating from the second half of the
1860s and the insertion of fans in portraits and
representations of dancers; see pls. 87, 109 above. Twenty
fan paintings had been produced by about 1885, most of
them not mounted. Silk was normally the carrier for the
application of the most diverse techniques, variously
combining oils, inks, pastel, gouache and watercolours. In
addition, gold and silver highlights were occasionally
added, after the fashion of the popular Japanese *surimono*
prints. Degas was probably more attracted by the unusual,
semi-circular picture surface, which encouraged experi-
ments in composition and specially daring selections of
detail, than by the functional aspect of these objects, as in
this case, where the movement on stage is entirely
conditioned by the curve of the surface. This panoramic
miniature is viewed from a steep angle and the highest
tier. The picture conveys a scene based on the Provençal
folk dance *La Farandole*, which was inserted as a ballet into
works by Charles Gounod and Georges Bizet. The
sweeping movements of the dancers may possibly be
intended to convey the fluttering of a fan.

PROVENANCE: Durand-Ruel, Paris; Vente Anonyme, Hôtel Drouot, Paris 13 February 1918, No. 77; Gustave Pellet, Paris; Maurice Exsteens, Paris; Klipstein & Kornfeld, Berne.

BIBLIOGRAPHY: Lafond 1919, p. 34; Rivière 1935, p. 157 ill.; Paul Jamot, *Degas*, Paris 1939, No. 186; Rouart 1945, p. 70 note 22; Lemoisne I–II, p. 113, No. 557 ill; Daniel Wildenstein, 'Degas', in *Les Arts*, 8, June 1955, No. 518; Janis 1967, p. 413; Russoli and Minervino 1970, No. 549 ill.; Munich 1972, with No. 811; Terrasse 1981, No. 301 ill.; Kopplin 1981, pp. 63, 79f., 85 pl. 83; Gerstein 1982, p. 110 ff. pl. 3

EXHIBITIONS: Paris 1937, No. 186; *The Dance*, Leicester Gallery, London 1938, No. 77; Paris 1939, No. 20; Paris 1948–9, No. 75; Berne 1951–2, No. 30; Amsterdam 1952, No. 23; Paris 1955, No. 86 ill.; Berne 1960, No. 15 ill. (and cover); *Meisterwerke der Malerei am Bodensee*, Bregenz 1965, No. 306 pl. 10; St Louis–Philadelphia–Minneapolis 1967, No. 95 ill.

118 *Two Dancers* 1878–80
Black chalk on grey-blue paper, 477 × 307 mm.
Below left, Vente stamp *Degas*.
Den Kongelige Kobberstiksamling, Copenhagen (Cat. No. tu 35.3).

This and the sketch in pl. 119 below were framed together at the IV^ème Vente. They may represent cursory studies for possible use in the arc of a fan; see, for instance, fan (Lemoisne II, No. 565).

PROVENANCE: IV^ème Vente 1919, No. 282a ill.
BIBLIOGRAPHY: Borchsenius 1944, p. 11 ill.; Browse 1949, pp. 71 ill., 417; Fischer and Sthyr 1953, p. 102 ill.
EXHIBITIONS: Copenhagen 1939, No. 27; Copenhagen 1948, No. 113; Copenhagen 1967, No. 39.

119 *Dancer Poised in Step* 1878–80
Black chalk on grey-blue paper, 477 × 310 mm.
Below left, Vente stamp *Degas*.
Den Kongelinge Kobberstiksamling, Copenhagen (Cat. No. tu 35.4)

See pl. 118 above.

PROVENANCE: IV^ème Vente 1919, 282b ill.
BIBLIOGRAPHY: Borchsenius 1944, p. 11 ill.; Fischer and Sthyr 1953, p. 102 ill.
EXHIBITIONS: Copenhagen 1948, No. 112; Copenhagen 1967, No. 40.

120 *Fan Painting: Dancers and Stage Scenery* circa 1879
Gouache with gold highlights added on silk, 310 × 610 mm.
At right hand edge, signed in black china ink: 'Degas'.
E. W. Kornfeld, Berne.

Degas' fan paintings recall similar Japanese work, both by the delicate use of the materials and the spaciousness of the perspective revealed. Here the stage trees deeply rooted in amorphous tonalities form a foil which directs the eye to a section of the stage populated by dancers.

PROVENANCE: Durand-Ruel, Paris; Gustave Pellet, Paris; Maurice Exsteens, Paris.
BIBLIOGRAPHY: Lemoisne I–II, p. 113, No. 556 ill.; Shinoda 1957, pp. 87f. pl. 91; Russoli and Minervino 1970, No 551 ill.; Chuji Ikegami, *Ukiyo-e to Inshoshugi*, Tokyo 1975, p. 211 pl. 102; Kopplin 1981, pp. 77f. pl. 79; Gerstein 1982, p. 112.
EXHIBITIONS: Paris 1948–9, No. 77; Berne 1960, No. 14 ill.; Berlin 1965, No. 23 ill.; Munich 1972, No. 811 ill.; *Ein Dokument Deutscher Kunst*, Hessisches Landesmuseum, Darmstadt 1976, No. 432 ill.

121 *Fan Painting: Dancers* 1878–9
Brush with ink, partly washed over, together with black chalk and pastel, 381 × 675 mm.
Below left, Vente stamp *Degas*.
Galerie Kornfeld, Berne.

In this lightly sketched design for a fan, the heads and bodies of some dancers which jut out beyond the limit of the semi-circle are ruthlessly lopped off, so that only their tutu-covered legs dangle in the picture surface. Similar asymmetric compositions are found in other fan paintings (Lemoisne II, Nos. 563, 566).

PROVENANCE: II^ème Vente 1918, No. 59 ill.; Gustave Pellet, Paris; Maurice Exsteens, Paris.
BIBLIOGRAPHY: Lemoisne II, No. 592 ill.; Kopplin 1981, p. 84, pl. 88.
EXHIBITIONS: Paris 1948–9, No. 74; Berne 1960, No. 18 ill.; Berlin 1965, No. 24.

122 *Chanteuse in a Café-Concert* 1880
Watercolour and gouache on silk, 307 × 607 mm.
Below left, in black china ink, signed and dated: 'Degas 80'.
Kupferstichkabinett der Staatlichen Kunsthalle, Karlsruhe (Cat. No. 1976–1).

The sole surviving fan painting on this theme. Café-Concerts became popular around 1840 and developed, in large numbers, into well-established centres of Parisian street life during the second half of the century. They became centres of public life for all classes of society, with stars such as Mlle Thérésa (Emma Valadon), Mlle Bécat or Mlle Demay. The present work shows a garden scene lit by gas globe lights, possibly at the Café des Ambassadeurs in the Champs-Elysées, frequented by Degas. The striking vertical articulation of the curved picture surface, divided in the ratio of one third: two thirds by a pillar in front of the performer, has no architectonic justification, but

recurs in pastels (Lemoisne, No. 419, 649); see also café-concert scenes (Lemoisne II–III, Nos. 380, 405, 814), as well as etchings and lithographs (Adhémar and Cachin 1973, Nos. 29, 30, 33, 41, 42).

PROVENANCE: Durand-Ruel, Paris; Ernest-Ange Duez, Paris; Vente E. Duez, Atelier et Collection, Galerie Georges Petit, Paris 12 June 1896, No. 273; Anne Wertheimer, Paris.

BIBLIOGRAPHY: Lemoisne II, No. 459 ill.; Russoli and Minervino 1970, No. 541 ill.; Staatliche Kunsthalle Karlsruhe, Neuerwerbungen 1976, in *Jahrbuch der Staatlichen Kunstsammlungen in Baden-Württemberg*, 14, 1977, pp. 170, 172, pl. 21; Kopplin 1981, pp. 88f. pl. 95; Gerstein 1982, pp. 110, 112, 114 pl. 7.

EXHIBITIONS: Karlsruhe 1983, No. 75 ill.

Gustave Doré, *Les Différents Publics de Paris* 1854

123 *The Chanteuse Victorine Demay* 1877–9
Pastel over monotype in black 160 × 118 mm (actual size).
Above right, in the picture, and below right on the margin, signed in black chalk: 'Degas'.
Mr and Mrs John W. Warrington, Cincinnati.

See monotypes worked over with pastel (Lemoisne II, Nos. 538, 539, 541) which display the same singer, lit by the footlights, during her performance. There are sketches of this chanteuse in Reff 1976, Notebook 28, pp. 13, 57. Although Lemoisne described the model as Mlle Dumay, Shapiro has shown that there was only one chanteuse with a similar name, Victorine Demay, who made her name during the 1880s.

PROVENANCE: Vente de Tableaux, Estampes, Dessins Modernes, Hôtel Drouot, Paris 15 December 1917, No. 348 ill. (on cover); Maurice Exsteens, Paris; Carroll Carstairs, New York.

BIBLIOGRAPHY: Lemoisne II, No. 540 ill., with Nos. 538, 539; Cabanne 1960, with No. 61; Janis (Monotype) 1967, p. 21 note 9; Adhémar and Cachin 1973, p. 63; Reff 1976, Notebook 28, p. 13; Shapiro 1980, pp. 160, 164 note 23; Kopplin 1981, p. 89; Karlsruhe 1983, with No. 75.

EXHIBITIONS: Paris 1937, No. 103; Cincinnati Art Museum 1939; Cambridge (Mass.) 1968, No. 10 ill., Checklist No. 40 ill.

Grandville, *Petites Misères de la Vie Humaine* 1843

124 *The Duet* 1877–9
Pastel over monotype in black, 117 × 162 mm (actual size).
Below left, in black chalk, signed: 'Degas'.
E. V. Thaw & Co. Inc., New York.

The genre painter John Lewis Brown, greatly liked by Degas for his representations of horses, originally owned this work, which then spent fifty-five years in Robert von Hirsch's collection, first in Frankfurt and later in Basle. Ronald Pickvance (London 1983) believes that the highly

popular singers Emélie Bécat and Thérésa are represented here; the gloved fingers of a third chanteuse, which stretch into the picture from the right, provide a striking feature.

PROVENANCE: John Lewis Brown, Paris; Vente Anonyme, Hôtel Drouot, Paris 22 May 1919, No. 41 ill.; Durand-Ruel, Paris; Knoedler Galleries, New York; Robert von Hirsch, Basle; *The Robert von Hirsch Collection*, Sotheby Parke Bernet sale, London 26–7 June 1978, No. 825 ill.
BIBLIOGRAPHY: Lemoisne II, No. 433 ill.; Cooper 1952, pp. 12, 14, 18 No. 9 ill.; Shinoda 1957, p. 8of. pl. 71; Janis (Monotype) 1967, pp. 72 note 8, 76 note 24; Cambridge (Mass.) 1968, Checklist No. 27 ill.; Russoli and Minervino 1970, No. 418 ill.; Adhémar and Cachin 1973, p. 63; Terrasse 1981, No. 275 ill.; Wilson 1983, p. 713.
EXHIBITIONS: *Basler Privatbesitz*, Kunstmuseum, Basle 1943, No. 218; London 1983, No. 15 ill, with No. 21.

125 *Café-Concert Singer* 1878–9
Black and brown chalk with added white highlights on brown paper, 630 × 380 mm.
Below left, Vente stamp *Degas*.
Privately owned.

Degas portrayed this singer or, at any rate, a singer in a similar dress on several occasions; see Lemoisne II, Nos. 504–506, as well as a drawing (III^{ème} Vente 1919, No. 335 (1)).

PROVENANCE: II^{ème} Vente 1918, No. 140 ill.; Ambroise Vollard, Paris.
BIBLIOGRAPHY: Rivière 1923, pl. 89 (1973, pl. 70); Paris 1924, with No. 166; Lemoisne II, No. 507 ill., with Nos. 504, 505.
EXHIBITIONS: Berne 1951–2, No. 93.

126 *Café-Concert Singer in Performance* 1878–9
Charcoal with white highlights added on grey paper, 475 × 310 mm.
Below left, Vente stamp *Degas*.
Back: Estate Stamp ATELIER ED. DEGAS.
Musée du Louvre, Le Cabinet des Dessins, Paris (Cat. No. RF 4648)

Study for the pastel (Lemoisne II, No. 487bis), Fogg Art Museum, Cambridge (Mass.), which was shown 10 April–11 May 1879 at the fourth Impressionist exhibition; see the painting and pastel (Lemoisne II, Nos. 477, 478), Art Institute, Chicago, and Ordrupgaardsamlingen, Copenhagen. The area covered by the subject constantly shrank, from that represented here to that in the pastel shown at the exhibition, so that the outline of the dark glove finally came to hover almost menacingly over the face illuminated by artificial light. A singer's open mouth had not been so convincingly rendered since Luca della Robbia's *Choir* (photographs of della Robbia's singers are mentioned in Reff 1976, Notebook 34, p. 6); and only

Toulouse-Lautrec was capable of producing something to rival these gloves in his Yvette Guilbert album, 1894. Lemoisne identified the model as Mlle Desgranges, and an Alice Desgranges (born and died Paris, 1854–1925) is also referred to in Reff 1976, Notebook 31, p. 94. Zola mentioned in his review of the fourth Impressionist exhibition: '. . . café-concerts of astonishing veracity with divas bending open-mouthed over flaring footlights' (Adhémar and Cachin 1973, p. 11). Degas himself later commented on one of these performers, when he wrote on 4 December: 'My dear Lerolle, go quickly to hear Thérésa at the Alcazar, Rue du Faubourg-Poissonière. It is near the Conservatoire, and better than it. It has already been said long ago – I cannot remember what man of taste said it – that she should abandon herself to happiness. . . . Now is the right moment to hear this admirable artiste. She opens her great mouth and there springs from it the rawest, finest, most spirited and most tender voice that one can imagine. And where could one find more soulfulness and more taste? It is quite extraordinary!'; Guérin 1945, pp. 74f.

PROVENANCE: III^{ème} Vente 1919, No. 342 (2) ill.; Musée du Luxembourg, Paris.
BIBLIOGRAPHY: Lemoisne II, with Nos. 477, 478, 478bis; Pecirka 1963, pl. 45; Thomson 1979, p. 677; Shapiro 1980, p. 162.
EXHIBITIONS: Paris 1969, No. 181; Edinburgh 1979, No. 42 ill.

127 *Nude from the Back Putting on a Dress* circa 1879
Pastel over monotype in black, 210 × 159 mm (actual size).
Below right, in margin, signed in pencil: 'Degas'.
E. V. Thaw & Co. Inc., New York.

PROVENANCE: Ambroise Vollard, Paris; Maurice Ex-steens, Paris; Albert Henraux, Paris; Paul Brame, New York; Lefevre Gallery, London.
BIBLIOGRAPHY: Degas 1914, pl. XXXI; Lemoisne II, No. 554 ill.; Janis (Monotype) 1967, p. 21 note 9; Cambridge (Mass.) 1968, Checklist No. 178 ill.; Russoli and Minervino 1970, No. 864 ill.; Adhémar and Cachin 1973, p. 64.
EXHIBITIONS: Paris 1924, No. 228; London, 1958, No. 41 ill; London 1983, No. 16 ill.

128 *Three Prostitutes on a Sofa* circa 1879
Pastel over monotype in grey on beige paper, 160 × 215 mm (actual size).
Above right, signed in black chalk: 'Degas'.
Rijksprentenkabinet, Rijksmuseum, Amsterdam (Cat. No. 1967.88)

More than fifty monotypes of brothel scenes survive, but only this and three others have been worked over in colour; see monotype *Trois Filles de Dos* (Lemoisne II, No. 548), Collection Picasso, Paris.

PROVENANCE: Vente Anonyme, Hôtel Drouot, Paris 10 June 1891, No. 17; Maurice Exsteens, Paris; Paul Brame et César de Hauke, Paris; Gaby Schreiber, London; Kornfeld & Klipstein, Berne.
BIBLIOGRAPHY: Meier-Graefe 1920, ill. 59; Ragnar Hoppe, *Degas*, Stockholm, 1922, p. 82 ill.; Troendle 1925, p. 361 ill.; Ambroise Vollard (ed.), *La Maison Tellier*, Paris 1934, after p. 42 ill.; Rivière 1935, p. 171 ill.; Graber 1942, after p. 164 ill.; Lemoisne II, No. 550 ill.; Hausenstein 1948, pl. 35; Rouart (Monotypes) 1948, p. 5; Cooper 1952, p. 22, No. 17 ill.; Rich 1959, p. 19 ill.; Russoli and Minervino 1970, No. 862 ill.; Terrasse 1981, No. 299 ill.
EXHIBITIONS: Paris 1924, No. 229; Paris 1937, No. 200; Copenhagen 1948, No. 96; Berne 1951–2, No. 29; Amsterdam 1952, No. 21; Paris 1955, No. 85 ill.; London 1958, No. 39 ill.; *One Century 1864–1964*, Galerie Kornfeld & Klipstein, Berne 1964, No. 13; Cambridge (Mass.) 1968, No. 16 ill.; Checklist No. 62 ill.; Edinburgh 1979, p. 73, No. 94 pl. 15.

129 *Hermann de Clermont* circa 1879
Black chalk with white highlights added on blue paper, 480 × 315 mm.
Below left, Vente stamp *Degas*.
Den Kongelige Kobberstiksamling, Copenhagen (Cat. No. tu 35.5)

The model, a furrier examining some pelts, and his brother, the painter of horses Auguste de Clermont, were friends of Degas; see the drawing originally framed with the present work and inscribed 'Hermann de Clermont' (IIIème Vente 1919, No. 162 (1)). At the fourth Impressionist exhibition in 1879 Degas showed among other works a portrait of M. and Mme H. de Clermont (Cat. No. 79); see also the reference to this in Reff 1976, Notebook 31, pp. 67f.

PROVENANCE: IIIème Vente 1919, No. 162 (2) ill.; Durand-Ruel, Paris; Ambroise Vollard, Paris; Feilchenfeldt, Zurich.
BIBLIOGRAPHY: Boggs 1962, pp. 113f.; *L'Amerique vue par L'Europe*, Paris 1976, p. 343; Thomson 1979, p. 677 pl. 95.
EXHIBITIONS: Paris 1931, No. 132; Edinburgh 1979, pp. 50f., No. 50 ill.

130 *Diego Martelli* 1879
Charcoal and white chalk on brown paper, 440 × 313 mm.
Below left, Vente stamp *Degas*.
The Cleveland Museum of Art, John L. Severance Fund (Cat. No. CMA 53.268)

A study, in steep downward perspective and with great foreshortening for the portraits, of the art critic Diego Martelli (born and died Florence, 1839–96) (Lemoisne II, Nos. 519, 520), National Gallery, Edinburgh and Museo Nacional des Bellas Artes, Buenos Aires. Degas probably

Au Foyer de la Danse circa 1880
Staatsgalerie, Stuttgart

Pauline et Virginie Cardinal circa 1880
Staatsgalerie, Stuttgart

met Martelli in Florence in 1858–9. He was the first promoter of Impressionism in Italy and visited Paris in 1863, 1868 and 1878–9, when he took part in the opening of the fourth Impressionist exhibition on 10 April 1879, at which the larger version of his portrait, now in Edinburgh, was shown as No. 57. Degas dated a full-length study of Martelli sitting on a folding chair with his arms crossed '3 avril 79' (Ière Vente 1918, No. 326; Elizabeth A. Drey, London); see also two drawings (IIIème Vente 1919, No. 344), Fogg Art Museum, Cambridge (Mass.), as well as the cursory designs in Edinburgh 1979, No. 55 and Reff 1976, Notebook 31, p. 25.

PROVENANCE: IIIème Vente 1919, No. 160 (1) ill.; Georges Viau, Paris; Mme Demotte, Paris; B. Natanson, Paris.
BIBLIOGRAPHY: Rivière 1923, pl. 91 (1973, pl. 76); H. Francis, 'Degas Drawings', in *The Bulletin of the Cleveland Museum of Art*, XLIV, December 1957, p. 216 ill. (on cover); *The Cleveland Museum of Art Handbook*, Cleveland 1958, No. 602 ill.; Boggs 1962, p. 123; Ira Moskowitz and Agnes Mongan, *Great Drawings of all Times*, III, New York 1962, No. 786 ill.; Pecirka 1963, pl. 40; Vitali 1963, p. 269 note 14; *The Cleveland Museum of Art Handbook*, Cleveland 1966, p. 172 ill; Thomson 1979, p. 677.
EXHIBITIONS: St Louis–Philadelphia–Minneapolis 1967, No. 89 ill., p. 154; Edinburgh 1979, p. 51, No. 56 ill., with No. 60; *Idea to Image. Preparatory Studies from the Renaissance to Impressionism*, Museum of Art, Cleveland 1980, No. 71 ill.

131 *Ludovic Halévy and Mme Cardinal* circa 1880
Pastel over monotype in black, 213 × 160 mm (actual size).
Below right, in the margin, Vente stamp *Degas*.
Staatsgalerie, Graphische Sammlung, Stuttgart (Cat. No. D 1961/145)

Ludovic Halévy (see pl. 132 below) had published two volumes of collected stories in 1872 and 1880 – *Mme et M. Cardinal* and *Les Petites Cardinal*. Degas probably produced thirty-three monotypes, only six of which were coloured in pastel, to be reproduced by photogravure as part of a proposed omnibus edition (pp. 373f.). They were, however, turned down as illustrations by the author. The present scene (of which there is an uncoloured print, as well as a variant differing from it in detail; see Cambridge (Mass.) 1968, Checklist Nos. 213, 214) refers to a passage in *Mme et M. Cardinal*, Paris 1872, p. 40: 'In a corner, I discovered Mme Cardinal with two large white corkscrew ringlets framing her patriarchal countenance like a hedge. A snuffbox on her knee and spectacles on her nose, Mme Cardinal was reading the newspaper.'

PROVENANCE: *Catalogue des Eaux-Fortes, Vernis-Mous, Aquatintes, Lithographies et Monotypes par Edgar Degas et Provenant de son Atelier . . .*, Galerie Manzi-Joyant, Paris 22–23 November 1918, under No. 201; Maurice Loncle, Paris.

BIBLIOGRAPHY: Ludovic Halévy, *La Famille Cardinal*, Paris 1938, p. 153 ill.; Christel Thiem, *Französische Maler illustrieren Bücher. Die illustrierten Bücher des 19. und 20. Jahrhunderts in der Graphischen Sammlung der Staatsgalerie Stuttgart*, Stuttgart 1965, with No. 44; Cambridge (Mass.) 1968, Checklist No. 212 ill.; Adhémar and Cachin 1973, with No. 65.

132 *Ludovic Halévy* circa 1880
Charcoal (possibly transfer of a charcoal drawing), 324 × 273 mm.
Below right, Vente stamp *Degas*, as well as estate stamp
ATELIER ED. DEGAS.
The Baltimore Museum of Art, Nelson and Juanita Greif Gutman Fund (Cat. No. BMA 1967.14).

A schoolfriend, the author and librettist Ludovic Halévy (born and died in Paris, 1834–1908) is more usually represented in Degas' output as an observer backstage, a visitor to the dancers' dressing rooms or in the corridors of the Opéra; see pl. 131 above, as well as a pastel (Lemoisne II, No. 526) shown at the fourth Impressionist exhibition and monotypes (Cambridge (Mass.), 1968, Checklist Nos. 195–200, 211, 213–215). For the black Vente stamp, see pl. 179 below.

133 *Roof Structure of the Cirque Fernando* 1879
Pencil with black and red chalk on pink paper, 480 × 313 mm.
Above left, inscribed in black chalk: 'les fermes sont plus/penchées'; below left, Vente stamp *Degas*.
The Barber Institute of Fine Arts, The University of Birmingham.

This accurate architectural drawing of the structure of the dome in the Paris Cirque Fernando, also immortalized by Toulouse-Lautrec, was prepared in connection with *Miss Lala au Cirque Fernando*, (p. 375), a painting shown at the fourth Impressionist exhibition under No. 62; see also pl. 134 below. Ever self-critical, the artist noted in the corner of this sheet, which has a wider angle than the picture, that the roofbeams were more slanted. Degas had also dealt comprehensively with the space involved, seen in worm's-eye view, as well as with some architectural details and additional data about colouring in Reff 1976, Notebook 31, pp. 30, 36–38, 45, 48.

PROVENANCE: IVème Vente 1919, No. 255b ill.; Georges Viau, Paris; Jacques Seligmann, Paris; Thomas Agnew & Sons, London.
BIBLIOGRAPHY: Lemoisne II, with No. 522; *Handbook of the Barber Institute of Fine Arts*, Birmingham 1949, p. 19; *Catalogue of the Paintings, Drawings and Miniatures in the Barber Institute of Fine Arts*, Cambridge 1952, pp. 134f.; Cabanne 1960, p. 121, with No. 95; Reff 1967, p. 260; Reff (*The Artist's Mind*) 1976, p. 180.

Avant de la Garderobe circa 1880
Staatsgalerie, Stuttgart

374

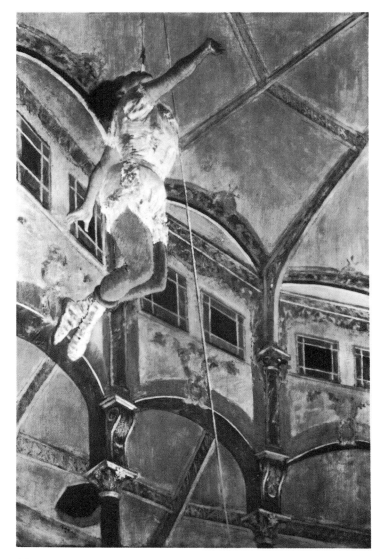

Miss Lala au Cirque Fernando 1879
National Gallery, London (Lemoisne No. 522)

EXHIBITIONS: Cambridge (Mass.) 1931, No. 19b; Paris 1955, No. 91bis; St Louis–Philadelphia–Minneapolis 1967, No. 84 ill.; Edinburgh 1979, No. 46 ill.

134 *Miss Lala at the Cirque Fernando* 1879
Black chalk with a little watercolour on yellowish paper, 470 × 320 mm. Below left, inscribed in red chalk: 'Miss Lala/25 Janv. 79'; below left, Vente stamp *Degas*.
The Barber Institute of Fine Arts, The University of Birmingham.

One of the most carefully prepared paintings of this uncommonly productive period in spring 1879 was *Miss Lala au Cirque Fernando* (ill.). This drawing, which was originally framed together with that in pl. 133 above, is solely concerned with the figure of the coloured girl Lala as 'Assunta' in the dome of the circus. The acrobat, a much admired turn at the circus in the rue des Martyrs, was pulled up to vertiginous heights by a rope which she gripped with her teeth. She is represented in oblique worm's-eye view swinging freely in space. Three further studies dated by the artist show that he observed and recorded this perilous performance on 19, 21, 24 and 25 January 1879 (see Lemoisne II, Nos. 525, 524, 523); see also figure and detail sketches (IV^ème Vente 1919, Nos. 256 a–c), as well as probably the first fleeting sketches in Reff 1976, Notebook 29, p. 27, Notebook 31, pp. 18, 21.

PROVENANCE: IV^ème Vente 1919, No. 255a ill.; Georges Viau, Paris; Jacques Seligmann, Paris; Thomas Agnew & Sons, London.
BIBLIOGRAPHY: Rivière 1922, pl. 38 (1973, pl. 74); Lemoisne II, with No. 522; *Handbook of the Barber Institute of Fine Arts*, Birmingham 1949, p. 19; *Catalogue of the Paintings, Drawings and Miniatures in the Barber Institute of Fine Arts*, Cambridge 1952, pp. 132f.; Cabanne 1960, with No. 95; Pecirka 1963, pl. 39; Pickvance 1964, pp. 162f. ill.; Edinburgh 1979, with No. 45; Lefébure 1981, pl. 49.
EXHIBITIONS: Cambridge (Mass.) 1931, No. 19a; *A Century of French Drawings, Prud'hon to Picasso*, Matthiesen Gallery, London 1938, No. 44; *Nineteenth Century French Drawings*, British Institute of Adult Education, London 1943, No. 13; St Louis–Philadelphia–Minneapolis 1967, No. 83 ill.; Tokyo–Kyoto–Fukuoka 1976–7, No. 72 ill.

135 *Ellen Andrée* circa 1879 (p. 31)
Pastel on grey-green paper, 485 × 420 mm.
Above right, signed in blue chalk: 'Degas'.
Walter Feilchenfeldt, Zurich.

The actress Ellen Andrée was a favourite model who sat for important pictures by Manet and Renoir, as well as Degas. She is represented here clearly silhouetted in her hat, coat and scarf against a neutral background. Of the many competing works produced by Degas in 1879, this is among the most successful of his portraits with its limpid formulation of the figure, the harmonious distribution of

empty and occupied areas, as well as the conjunction of tonalities in paper and pastels. Degas' liking for single standing figures starkly arrested in motion was already evident during the 1850s and 1860s (see pls. 30, 45, 58–61, 76, 86), and reached its height during the late 1870s with representations such as this and pl. 136 below; see also the etching *L'Actrice Ellen Andrée* (Adhémar and Cachin 1973, No. 52) and the pastel *Marie Cassatt et Ellen Andrée* (St Louis–Philadelphia–Minneapolis 1967, No. 87) belonging to Mrs Siegfried Kramarsky, New York.

PROVENANCE: Duc de Cadaval, Pau.
BIBLIOGRAPHY: Thomson 1979, p. 677 pl. 94.
EXHIBITIONS: Tokyo–Kyoto–Fukuoka 1976–7, No. 29 ill.; Edinburgh 1979, p. 58, No. 68 ill., with No. 67.

136 *Three Young Ladies Arranged in a Frieze* 1879–81
Black chalk with white highlights added and pastel on grey paper, 500 × 650 mm.
Below right, inscribed in black chalk: 'Portraits en frise/pour décoration/dans un appartement/Degas'.
Privately owned.

Those represented are probably the actress Ellen Andrée and, seated in the middle, the American painter Mary Cassatt (born Pittsburgh, 1845 – died Paris, 1926); see study of detail (Lemoisne II, No. 533), as well as the pastel *Mary Cassatt et Ellen Andrée* (St Louis–Philadelphia–Minneapolis 1967, No. 87), belonging to Mrs Siegfried Kramarsky, New York. The catalogue of the fourth Impressionist exhibition in 1879 contains under No. 67 an *Essai de Décoration* in watercolour. In view of the different techniques involved this probably does not refer to the present work, as Lemoisne and Reff had assumed. It is more likely that this figure composition was an uncatalogued addition to the sixth Impressionist exhibition in 1881. Elie de Mont wrote on 21 April in *La Civilisation* on this occasion: 'What confuses one is the importance which these gentlemen, headed by Monsieur Degas, ascribe to the least, the most insignificant of their works. Just look at the *Portraits en Frise pour Décorer un Appartement*! Can one really allow oneself to be so blinded as to exhibit a thing of this sort, the proper place for which is at the bottom of a bin. All the little caricatures of café-concert songstresses which appear there would at best deserve some notice in a sketchbook! They are ludicrous in their vanity.' *Le Constitutionnel* of 24 April 1881 wrote in a similar vein: '. . . M. E. Degas appears to be one of such naturalists. His exhibits contain hardly anything more than disagreeable and even repulsive things, the faces of predators, portraits of women which he was to some extent driven to produce, clearly selected for their ugliness bordering on caricature; these have served him – a strange choice – as sketches for the *Portraits en Frise pour la Décoration d'un Appartement*'. Degas had already noted in a sketchbook early in the 1860s: 'Family portrait arranged as a frieze. . . . Height of the figures, hardly one metre.

There could be two compositions, one each side of the door; one of the family in town, the other in the country . . .'; Reff 1976, Notebook 18, p. 204. This note, as well as the *Portraits en Frise* just twenty years later, show that Degas toyed for a long time with ideas about wall decoration. There is another reference to his interests in this in a letter from Pissarro to his son Lucien in 1892: 'As to the decoration by Miss Cassatt, I would have liked you to hear my conversation with Degas about it, and about what he calls 'decoration'. I am entirely of his opinion. In so far as he is concerned a wall decoration is an ornament which must be designed for a definite place and with a sense of the general effect. The painter and the architect must therefore come to an agreement about it. The 'decorative' easel painting is an absurdity, a synthetic painting is not a decoration etc. Apparently even Puvis de Chavannes' [wallpaintings] are not going well etc. etc.' Rewald 1953, p. 246.

PROVENANCE: Gustave Pellet, Paris; D. David-Weill, Paris; Galerie Schmit, Paris.
BIBLIOGRAPHY: Rivière 1922, pl. 28 (1973, pl. 55); Bataille 1930, pp. 403f. ill.; Graber 1942, after p. 108 ill.; Lemoisne II, No. 532 ill., with No. 533; Boggs 1962, pp. 60, 112 pl. 110; Pecirka 1963, ill. 30; St Louis–Philadelphia–Minneapolis 1967, with No. 87; Russoli and Minervino 1970, No. 565 ill.; Adhémar and Cachin 1973, p. 43, with No. 52; Reff 1976, Notebook 31, p. 67, Notebook 34, p. 13; Reff (*The Artist's Mind*) 1976, pp. 255f. pl. 170, 260, 262; Millard 1976, pp. 14, 65 pl. 37; Reff 1977, pl. 50; Thomson 1979, p. 677; Terrasse 1981, No. 304 ill.
EXHIBITIONS: VIème *Exposition des Impressionistes*, Paris 1881; Paris 1931, No. 124; *Les Impressionistes et leurs Précurseurs*, Galerie Schmit, Paris 1972, No. 36 ill.; Edinburgh 1979, No. 67 ill., with No. 107.

137 *The Violinist* 1878–9
Charcoal with white highlights added on grey paper, 245 × 318 mm.
Below left, Vente stamp *Degas*.
Back: Estate stamp ATELIER ED. DEGAS and inscriptions in unidentified hands (photograph and estate numbers).
The Minneapolis Institute of Arts, Gift of David M. Daniels in memory of H. D. M. Grier (Cat. No. 72.59).

A central figure in the ballet rehearsal rooms was the violinist who provided the dance music. This drawing, which principally concentrates on the combined action of the hands, is a study for the violinst placed on the left in *Ecole de Danse* (Lemoisne II, No. 537), Frick Collection, New York. The face is scored through in this drawing and supplemented by the outline of a beard, as in the representation of an older man in the picture shown at the fourth Impressionist exhibition; see both full-length portrait drawings (IIIème Vente 1919, No. 161), Museum of Fine Arts, Boston and Art Institute, Williamstown.

376

PROVENANCE: III^ème Vente 1919, No. 164 (2) ill.; Marcel Guérin, Paris; Charles E. Slatkin Galleries, New York; David M. Daniels, New York.

BIBLIOGRAPHY: Lemoisne II, with No. 537; Browse 1949, No. 35a ill.; Agnes Mongan, *The French Pictures. An Illustrated Catalogue of the Works of Art in the Collection of Henry Clay Frick*, Pittsburgh 1949, pp. 178f.; Wick 1959, pp. 97, 99 pl. 9; Haverkamp–Begemann etc. 1964, pp. 83f. pl. 67, with No. 162; 'Recent Accessions of American and Canadian Museums', in *The Art Quarterly*, XXXV, 2, April–June 1972, p. 449 ill.

EXHIBITIONS: New York 1958, No. 25, pl. XIX; New York 1959, No. 98 ill.; Baltimore 1962, No. 62; *Selections from the Drawing Collection of David Daniels*, The Institute of Arts, Minneapolis 1968, No. 54 ill.; Williamstown 1970, No. 26 ill.; Memorial Exhibition for Harry D. M. Grier, The Frick Collection, New York 1972; Edinburgh 1979, No. 23 ill., with Nos. 22, 24.

138 *The Violinist* 1880
Pastel, 600 × 510 mm.
Below left, signed and dated in green chalk: 'Degas/80'.
Privately owned.

Degas repeated here, with a different model, the pose of a violinist which he had already used in pastels (Lemoisne II, Nos. 450, 451), The Metropolitan Museum of Art, New York; see also a drawing (IV^ème Vente 1919, No. 247b).

PROVENANCE: Galerie Georges Petit, Paris; Paul Cassirer, Amsterdam; Erich Maria Remarque, Porto Ronco; Feilchenfeldt, Zurich.

EXHIBITIONS: Amsterdam (Stedelijk Museum) 1938, No. 103; St Louis–Philadelphia–Minneapolis 1967, No. 98 ill.; Edinburgh 1979, No. 25 ill.

139 *Mme Ernest May* 1881
Black chalk with pastel highlights added, 300 × 235 mm.
Below left, Vente stamp *Degas*.
Privately owned, San Francisco.

See pl. 140 below and a pastel portrait (Lemoisne II, No. 656 bis).

PROVENANCE: IV^ème Vente 1919, No. 262a ill.; Christian Lazard, Paris; Galerie Arnoldi-Livie, Munich.

BIBLIOGRAPHY: Mauclair 1938, p. 51 ill.; Lemoisne II, No. 657 ill., with No. 656; Boggs 1962, p. 123; Hüttinger 1981, p. 7 ill. (incorrectly described).

EXHIBITIONS: Paris 1931, No. 140.

140 *Mme Ernest May Lying-In* 1881
Black chalk with white highlights added on grey-green paper, 450 × 340 mm.
Black right, inscribed in black chalk: 'le soleil vient/éclairer vivement les pieds/et le devant de la chaise/longue par le bas./ainsi qu'un peu des/rideaux du berceau/et par le haut, surtout le/rond(?) jaune paille du/bonnet, la bande de/la veste aussi qui(?) et reflète la jaune'; right, in the margin, Vente stamp *Degas*.
Privately owned.

This drawing was produced at the same time as the somewhat more wide angled pastel *Portrait de Femme près d'un Berceau* (Lemoisne II, No. 656). The wife of the banker and art collector Ernest May is represented here lying-in beside the cradle of her son Etienne, born in May 1881; see the small notebook design (Reff 1976, Notebook 33, pp. 2, 12), as well as the curtain drapery in a detailed study (IV^ème Vente 1919, No. 133 a, c). In the text that accompanies the drawing, the artist paid attention above all to the lighting effects produced on the chaise-longue, the clothes and the curtain of the cradle by the sunlight streaming in from above and below. A letter of 1879 from Degas to Bracquemond stated that May was in the process of getting married, leasing a town house and presenting his small collection in a gallery; Degas described him as a man willing to devote himself to art (Guérin 1945, p. 47).

PROVENANCE: IV^ème Vente 1919, No. 133b ill.
EXHIBITIONS: Paris 1975, No. 65 ill.

141 *At the Milliner's* 1882 (p. 33)
Pastel, 799 × 848 mm.
Below right, signed in black chalk: 'Degas'.
Collection Thyssen-Bornemisza, Lugano.

The Paris art dealer Paul Durand-Ruel bought this superb pastel from the artist in June 1882 and sent it off to be shown in London the very next month. A *modiste* occurs in the catalogue of the second Impressionist exhibition in 1876, but Degas only turned seriously to this particular subject in 1882. In addition to the present work, the principal works devoted to this theme are picture-sized pastels (Lemoisne II, No. 681–683), all dated 1882.

PROVENANCE: Durand-Ruel, Paris; Henri Rouart, Paris; II^ème *Vente de Dessins et Pastels Anciens et Modernes . . . Composant la Collection . . . M. Henri Rouart*, Galerie Manzi-Joyant, Paris 16–18 December 1912, No. 70 ill.; Mme Ernest Rouart, Paris; Robert Lehman, New York; Thomas Gibson Fine Art, London.

BIBLIOGRAPHY: G. W. Thornley, *Quinze Lithographies d'après Degas*, Paris 1889, ill.; Arsène Alexandre, 'La Collection Henri Rouart', in *Les Arts*, 132, December 1912, ill.; Lafond 1919, after p. 46 ill.; Meier-Graefe 1920, pl. 76; Jamot 1924, p. 151 pl. 59; Coquiot 1924, p. 136; Lemoisne I, III, after p. 110 ill. (detail), pp. 123, 146, No. 729 ill.; Hausenstein 1948, pl. 43; François Fosca, *Degas*, Geneva 1954, p. 79 ill.; Cabanne 1960, p. 124 pl. 112; Douglas Cooper, *Great Private Collections*, London 1964, p. 46 ill.; Paul Valéry, *Degas Danse Dessin*, Paris 1965, pl. 87; Russoli and Minervino 1970, No. 602 ill.; Lévêque 1978, p. 154 ill.; Dunlop 1979, p. 155, pl. 142; Kresak 1979, pl. 52; Terrasse 1981, No. 414 ill.

EXHIBITIONS: 13 King Street, St James's, London 1882; Paris 1924, No. 148 ill.; Paris 1937, No. 110 pl. XXII; Edinburgh 1979, p. 58, No. 72 ill.

142 (back)

142 *Horse Standing, Profile to the Right* circa 1882
Black chalk, 242 × 301 mm.
Below right, Vente stamp *Degas*.
Back: *Horse Standing, Profile to the Right*, circa 1882, black chalk; below right, estate stamp ATELIER ED. DEGAS, with inscriptions in unidentified hands to the right and left (photograph and estate numbers) (ill.).
Museum Boymans – van Beuningen, Rotterdam (Cat. No. F II 125)

In 1881–2 Degas set about renewing his fund of horse and rider drawings built up during the second half of the 1860s. He was probably moved to this by Eadweard Muybridge's photographic research into actual stages of motion. Typical of these later works are the use of black and brightly coloured chalks, the accentuation of broad outlines, and heavily marked light and shade effects; see the transfer of the present study IVème Vente 1919, No. 381b), as well as studies (IIIème and IVème Vente 1919, Nos. 106 (4), 204a). Degas also modelled a horse in the identical position in red wax (Matt and Rewald 1957, No. III pl. 6).

PROVENANCE: IVème Vente 1919, No. 213b ill.; Georges Viau, Paris; Paul Cassirer, Berlin; Franz Koenigs, Haarlem.
BIBLIOGRAPHY: John Rewald, *Edgar Degas. Works in Sculpture*, New York 1944, pl. 36; Hoetink 1968, No. 78 ill.
EXHIBITIONS: Haarlem 1935, No. 39; Basle 1935, No. 153; Amsterdam 1946, No. 60; Berne 1951–2, No. 164; Nottingham 1969, No. 22 pl. XII.

143 *Two Trotting Horses* circa 1882
Charcoal, 242 × 267 mm.
Below left, Vente stamp *Degas*.; below right, estate stamp ATELIER ED. DEGAS.
Privately owned, Hamburg.

PROVENANCE: IVème Vente 1919, No. 228d ill.

144 *Rider on Trotting Horse* circa 1882
Charcoal and black chalk, 294 × 209 mm.
Below left, Vente stamp *Degas*.
Back: Inscriptions in unidentified hands (photograph and estate numbers).
Museum Boymans – van Beuningen, Rotterdam (Cat. No. F II 128)

See the transfer of this drawing (IIIème Vente 1919, No. 95 (4)), as well as similarly foreshortened studies of horses (IVème Vente 1919, Nos. 219 a, c).

PROVENANCE: IVème Vente 1919, No. 203c ill.; Georges Viau, Paris; Paul Cassirer, Berlin; Franz Koenigs, Haarlem.

Eadweard Muybridge *Cheval au Pas, Petit Galop*,
in *La Nature* 14.12.1878

145 *Three Horses Seen from the Rear* 1883–5
Black chalk, 247 × 311 mm.
Below centre, inscribed in black chalk: 'pied droit quitte
terre/devant'; below left, Vente stamp *Degas*.
Back: Inscriptions in unidentified hands (photograph and
estate numbers).
Museum Boymans – van Beuningen, Rotterdam (Cat. No.
F II 126)

The artist's note that the horse's movement starts on the
right foot shows how closely he observed the sequence of
motion; see the pastel *Amazone et Cavalier* (Lemoisne II,
No. 671).

PROVENANCE: IV^ème Vente 1919, No. 213a ill.; Georges
Viau, Paris; Paul Cassirer, Berlin; Franz Koenigs,
Haarlem.
BIBLIOGRAPHY: Hoetink 1968, No. 79 ill.
EXHIBITIONS: Berne 1951–2, No. 166.

146 *On the Racecourse* 1883–5
Pastel, 410 × 485 mm.
Below right, signed in blue chalk: 'Degas'.
Privately owned.

In almost all his compositions with horses and jockeys,
Degas used one of two basic patterns, each with many
variations, and sometimes in combination. In the first of
these, the riders were represented within the plane of the
picture, in strict profile, i.e. parallel to the surface, a
method of composition which can be traced right back to
one of the first racecourse scenes at the start of the 1860s,
Aux Courses, le Départ (Lemoisne II, No. 76), Fogg Art
Museum, Cambridge (Mass.); see also Lemoisne II–III,
Nos. 101, 387, 461, 852, 889, 940. In the other pattern, a
grouping that cuts diagonally across the picture
predominates, as in pl. 148 below and the further instances
listed with it.

PROVENANCE: Durand-Ruel, Paris; Oskar Schmitz, Dres-
den; Vladimir Horowitz, New York.
BIBLIOGRAPHY: Paul Fechter, 'Die Sammlung Schmitz', in
Kunst und Künstler, VIII, 1910, p. 21 ill.; Arsène Alexandre,
'Essai sur Monsieur Degas', in *Les Arts*, 166, 1918, p. 4
ill.; Karl Scheffler, 'Die Sammlung Oskar Schmitz in
Dresden', in *Kunst und Künstler*, XIX, 1921, p. 186; Marie
Dormoy, 'La Collection Schmitz à Dresden', in *L'Amour
de l'Art*, October 1926, p. 348; J. B. Manson, *The Life and
Work of Edgar Degas*, London 1927, p. 52; E. Waldmann,
Documents, 6, XI, 1930, p. 320; Mauclair 1938, p. 80 ill.;
Lemoisne III, No. 850 ill., with No. 851, 852; Russoli and
Minervino 1970, No. 707 ill.; Edinburgh 1979, with No.
14; Kresak 1979, pl. 45; London 1983, with Nos. 24, 32.
EXHIBITIONS: Munich 1926, No. 12 ill.; *Sammlung Oskar
Schmitz*, Kunsthaus, Zurich 1932, No. 25; *The Oskar*

BIBLIOGRAPHY: Hoetink 1968, No. 81 ill.
EXHIBITIONS: Amsterdam 1946, No. 61.

Schmitz Collection, Galerie Wildenstein, Paris 1936, No. 25 ill.; New York 1949, No. 71; Zurich 1977, p. 388.

147 *Two Jockeys* 1883–5
Black and blue chalk, 230 × 300 mm.
Below right, Vente stamp *Degas*.
Privately owned, Switzerland.

Chalk studies for the two jockeys on the left in the pastel in pl. 148 below. They recur, without the study of a head on the right, in a drawing (III^ème Vente 1929, No. 352 (2)).

PROVENANCE: III^ème Vente 1919, No. 104 (2); Marcel Guérin, Paris; Vente Marcel Guérin, Hôtel Drouot, Paris 12 December 1936, No. 1bis; Durand-Ruel, Paris.
BIBLIOGRAPHY: Reff 1967, pp. 256, 263.
EXHIBITIONS: Berne 1951–2, No. 125; Amsterdam 1952, No. 65; Paris 1960, No. 6 ill.; St Louis–Philadelphia–Minneapolis 1967, No. 103 ill.; New York 1968, No. 53 ill.

148 *Before the Race* 1883–5 (p. 40)
Pastel, 575 × 654 mm.
Below right, signed in black chalk: 'Degas'.
The Cleveland Museum of Art, Bequest of Leonard C. Hanna Jr (Cat. No. 58.27).

This intensely colourful pastel is one of the finest examples of a spatial solution frequently applied by Degas after 1868, though usually not in quite such depth, in which the bodies of the horses are stacked diagonally from the foreground into the middle distance; see Lemoisne II–III, Nos. 184 (p. 351), 262, 502, 503, 596, 597, 597bis, 646, 649, 679, 702, 764, 896, 896bis. See also a very much later version of the present work, more closely concentrated on the detail of the figures; as well as an almost exact reversal of the subject (Lemoisne III, Nos. 756, 757). The present composition was prepared by individual studies, such as that in pl. 147 above and the charcoal drawing of three jockeys (II^ème Vente 1918, No. 270).

PROVENANCE: Henri Lerolle, Paris; Hector Brame, Paris; César M. de Hauke, New York; Jacques Seligmann, New York; Leonard C. Hanna Jr, Cleveland.
BIBLIOGRAPHY: Louis Hourticq, 'E. Degas', in *Art et Décoration*, XXXII, 1912, p. 111 ill.; Lafond 1918, after p. 126 ill.; Hertz 1920, pl. VI; Lemoisne II, No. 755 ill. with Nos. 756, 757; Los Angeles 1958, with No. 44; Cabanne 1960, p. 123, pl. 107; *The Cleveland Museum of Art Handbook*, Cleveland 1966, p. 175 ill.; Russoli and Minervino 1970, No. 703 ill.; Werner 1978, pp. 60f. ill.; Edinburgh 1979, with No. 14; Terrasse 1981, No. 460 ill.; London 1983, with Nos. 24, 25.
EXHIBITIONS: *Pastel Français*, Galerie Jacques Seligmann, Paris 1933, No. 67; Cleveland 1947, p. 10, No. 22 pl. XVII (and cover); New York 1949, No. 69 ill.; *In Memoriam Leonard C. Hanna, Jr.*, The Musuem of Art, Cleveland 1958, No. 10 ill.

149 *Nude Rider* 1884–8
Charcoal, 310 × 249 mm.
Below right, Vente stamp *Degas*.
Back: Estate stamp ATELIER ED. DEGAS: inscriptions in unidentified hands (photograph and estate numbers).
Museum Boymans – van Beuningen, Rotterdam (Cat. No. F II 129)

PROVENANCE: III^ème Vente 1919, No. 131 (2) ill.; Georges Viau, Paris; Paul Cassirer, Berlin; Franz Koenigs, Haarlem.
BIBLIOGRAPHY: Longstreet 1964, ill.; Janis 1967, p. 415, pl. 45; Reff 1967, p. 261; Hoetink 1968, No. 82 ill.
EXHIBITIONS: Amsterdam 1946, No. 62; St Louis–Philadelphia–Minneapolis 1967, No. 106 ill.; Nottingham 1969, No. 25 ill. (on cover).

150 *Jockey Leaning Back in the Saddle* 1884–8
Charcoal, 305 × 230 mm.
Below left, Vente stamp *Degas*.
Privately owned, Switzerland.

There are similarities between this drawing, in reversed position, and the rider on the left in pl. 148 above; see also charcoal drawing (III^ème Vente 1919, No. 108 (2)).

PROVENANCE: III^ème Vente 1919, No. 107 (3) ill.; Durand-Ruel, Paris; Percy Moore Turner, London; Durand-Ruel, Paris.
BIBLIOGRAPHY: Bouret 1965, p. 244; Janis 1967, p. 415 pl. 44; Reff 1967, p. 256.
EXHIBITIONS: Berne 1951–2, No. 127; Amsterdam 1952, No. 67; St Louis–Philadelphia–Minneapolis 1967, No. 104 ill.; New York 1968, No. 55 ill.

151 *Jockey in Profile to the Right* 1884–8
Black chalk and pastel, 320 × 240 mm.
Below left, Vente stamp *Degas*.
Privately owned, Switzerland.

The attitude is similar to that of the second jockey from the left in pl. 148 above, but the broad application of strokes suggests a later date.

PROVENANCE: IV^ème Vente 1919, No. 231b ill.; Charles Vignier, Paris; Albert E. Gallatin, New York; Durand-Ruel, Paris.
BIBLIOGRAPHY: Champigneulle 1952, pl. 31; Leymarie 1969, pp. 52f. ill.
EXHIBITIONS: Amsterdam 1952, No. 64; Paris 1960, No. 5; Lausanne 1964, No. 10 ill.; St Louis–Philadelphia–Minneapolis 1967, No. 105 ill.; New York 1969, No. 57 ill.

152 *Jockey and Trotting Horse Profiled to the Left* 1887–8
Red chalk, 283 × 418 mm.
Below left, Vente stamp *Degas*.
Back: Inscriptions in unidentified hands (photographic and estate numbers).

Museum Boymans van Beuningen, Rotterdam (Cat. No. F II 22).

Aaron Scharf has pointed out in his basic work *Art and Photography* that this study was drawn after a photograph of a horse called Annie G., published in Eadweard Muybridge's monumental series *Animal Locomotion, an Electro-Photographic Investigation of Consecutive Phases of Animal Movements, 1872–1885*, University of Pennsylvania 1887. Degas was prompted to produce numerous studies based on photographic experiments by Muybridge published in the Paris press (p. 379). See, among others, the transfer of the sanguine drawing Lemoisne II, No. 674bis.

PROVENANCE: III^ème Vente 1919, No. 130 (1) ill.; Gabriel Fèvre, Paris; Vente M. X (Gabriel Fèvre), Hôtel Drouot, Paris 22 June 1925, No. 41 ill.; M. Hain, Paris; S. Meller, Paris; Paul Cassirer, Berlin; Franz Koenigs, Haarlem.
BIBLIOGRAPHY: Lemoisne II, with No. 674bis; Huyghe-Jacottet 1948, pl. 96; *Art et Style* 1952, ill.; Rosenberg 1959, p. 114, pl. 217; F. Mathey, *The Impressionists*, London 1961, p. 94 ill.; Rossum 1962, pl. 20; Aaron Scharf, 'Painting, Photography and the Image of Movement', in *The Burlington Magazine*, CIV, 710, May 1962, p. 191, pl. 13; Longstreet 1964 ill.; Hoetink 1968, No. 73 ill., with No. 82; Scharf 1968, pp. 159f. pl. 153; Dunlop 1979, pl. 166; Hüttinger 1981, p. 68 ill.
EXHIBITIONS: Amsterdam 1946, No. 56; Paris–Brussels–Rotterdam 1949–50, No. 198; Berne 1951–2, No. 98; Paris 1952, No. 135; St Louis–Philadelphia–Minneapolis 1967, No. 107 ill.; Nottingham 1969, No. 24 pl. XIII.

153 *Portrait of a Lady* circa 1884
Pastel, 490 × 330 mm.
Below left, Vente stamp *Degas*.
Privately owned.

See pastel portrait (Lemoisne III, No. 802), owned by Oveta Culp, Houston.

PROVENANCE: II^ème Vente 1918, No. 86 ill.; Charles Comiot, Paris.
BIBLIOGRAPHY: Lemoisne III, No. 801 ill., with Nos. 802, 803; Russoli and Minervino 1970, No. 611 ill.
EXHIBITIONS: Paris 1931, No. 145; Paris 1975, No. 27 ill.; Tokyo–Kyoto–Fukuoka 1976–7, No. 40 ill.; *Aspects de la Peinture Française XIX^e–XX^e Siècles*, Galerie Schmit, Paris 1978, No. 17 ill.

154 *Mme Henri Rouart with a Tanagra Statuette* 1884
Pencil and pastel, 266 × 363 mm.
Below left, signed and dated in black chalk: 'Degas/84'.
Kupferstichkabinett der Staatlichen Kunsthalle, Karlsruhe (Cat. No. 1979–6).

The wife of Henri Stanislas Rouart, Degas' oldest friend, sits in an easy chair and leans on her left arm. On the table in front of her – barely recognizable in outline – is a statuette dating from the fourth or third century BC, many of which were found in the vast Greek cemetery at Tanagra from 1873 on. They soon became popular among collectors in Paris, including the sitter's brother-in-law Alexis Rouart. Degas had been planning a double portrait of Mme Rouart and her daughter Hélène, which he never carried out, and one may see in the left background a draped outline which probably takes the place of a pastel portrait of Hélène Rouart dressed as a Tanagra statuette (Lemoisne III, No. 866), County Museum of Art, Los Angeles; see also a compositional study (IV^ème Vente 1919, No. 276b). The artist mentioned plans for further portraits in a letter to Mme Rouart: 'Partly so as to see your excellent husband, I shall call upon you to-morrow, Wednesday. For I wish to put him in your place in the portrait, and it would help me if I were able to do a small design of him in relation to his daughter'; Guérin 1945, pp. 100f. Both the present work and the portrait in pl. 153 above display a technique radically different from that used in the picture-sized pastels reproduced in pls. 141, 146, 148 above. While in the latter case the intensity of the colouring is achieved by means of short, closely interwoven strokes in compact areas and hardly any parts of the surface are free of colour, the artist has been content in so far as both these portraits are concerned with the application of relatively thin coloured areas by means of long, parallel strokes which consciously bring the paper into play as a neutral background.

PROVENANCE: Henri Rouart, Paris; Louis Rouart, Paris; Edwin C. Vogel, New York; Galerie Arnoldi-Livie, Munich.
BIBLIOGRAPHY: Lemoisne III, No. 766 bis ill.; Jean Sutherland Boggs, 'Mme Henri Rouart and Hélène by Edgar Degas', in *Bulletin of the Art Division, Los Angeles County Museum*, VIII, 2, Spring 1956, pp. 13ff. pl. 2; Boggs, 1962, pp. 67f., 129 pl. 123; Russoli and Minervino 1970, No. 607 ill.; Millard 1976, p. 58 pl. 56; Reff (*The Artist's Mind*) 1976, p. 319 note 172; 'Staatliche Kunsthalle Karlsruhe, Erwerbungsbericht 1979', in *Jahrbuch der Staatlichen Kunstsammlungen Baden-Württemberg*, 17, 1980, pp. 224ff. pl. 19; Terrasse 1981, No. 430 ill.; London 1983, with No. 27.
EXHIBITIONS: *Summer Loan Exhibition*, The Metropolitan Museum of Art, New York 1968; *Master Drawings*, Wildenstein Galleries, New York 1973; Tokyo–Kyoto–Fukuoka 1976–7, No. 37 ill.; Karlsruhe 1983, No. 77 ill.

155 *Two Laundresses Reading a Letter* circa 1884
Black chalk and pastel on paper with strips pasted on at the side and below, 590 × 640 mm.
Below left, Vente stamp *Degas*.
Charles Durand-Ruel, Paris.

Study for the pastel *La Lecture de la Lettre* (Lemoisne III, No. 776), Art Gallery, Glasgow. One woman is relaxing on a large ironing table with her head resting on her crossed arms, the other reads a letter. During the first half of the 1880s, Degas repeatedly produced compositions with figures bent deep over tables; see Lemoisne III, Nos. 774, 776, 778, 864.

PROVENANCE: II^ème Vente 1918, No. 164 ill.; Ambroise Vollard, Paris.
BIBLIOGRAPHY: Lemoisne III, No. 777 ill., with No. 776; Russoli and Minervino 1970, No. 619 ill.; Edinburgh 1979, with No. 71.

156 *Hairdressing* circa 1885
Charcoal, as well as red-brown and white chalk on grey paper, 585 × 430 mm.
Above right, signed in blue chalk: 'Degas'.
Fine Arts Museum of San Francisco, Achenbach Foundation for Graphic Arts, Dr T. Edward and Tullah Hanley Collection (Cat. No. 69.30.42)

This large drawing was originally owned by an acquaintance of Degas, the well-known art critic Louis de Fourcaud, who wrote for *Le Figaro*, the *Gazette des Beaux-Arts* and *Le Gaulois*. The artist made a note of his address: '9 rue des Apennins' (Reff 1976, Notebook 32, p. 5); see similar subjects (Lemoisne II–III, Nos. 561, 628, 749).

PROVENANCE: Louis de Fourcaud, Paris; Vente Fourcaud, Hôtel Drouot, Paris 29 March 1917; Durand-Ruel, New York; Edward Hanley, New York.
BIBLIOGRAPHY: Mauclair 1938, p. 90 ill.; Guérin 1947, pl. 25; Champigneulle 1952, pl. 67; Phyllis Hattis, *Four Centuries of French Drawing in the Fine Arts Museum of San Francisco*, San Francisco 1977, No. 222 ill.

157 *Fan: Scene from the Opera 'Sigurd'* 1885
Pastel on silk, 295 × 594 mm.
Below left, signed in black chalk: 'Degas'.
Privately owned, New York.

This lunette, which probably represents the last of Degas' fan-shaped drawings and in which the inner arc also forms part of the composition, depicts – as Theodore Reff has shown – the first scene in the second act of the opera *Sigurd*, by the composer Ernest Reyer, a friend of the artist. It was first produced at the Opéra in Paris on 12 June 1885, and Degas attended its dress rehearsal; see Guérin 1945, pp. 106, 108. The present subject is a religious ceremony in the forests of Iceland. The singer in the foreground with raised arms probably represents the leading lady Rose Caron (born Monerville 1857 – died Paris 1930), whom the artist greatly admired; see the figure study in pl. 158 below, a fan (Lemoisne II, No. 594), as well as single figure studies (Reff 1976, Notebook 36, pp. 17, 19, 21, 23, 24, 30).

PROVENANCE: Paul Paulin, Paris; Privately owned, Geneva.
BIBLIOGRAPHY: Lafond, 1919, after p. 34 ill.; Lemoisne II, No. 595 ill.; Hoetink 1968, with No. 74; Russoli and Minervino 1970, No. 533 ill.; Terrasse 1973, p. 42 ill.; *European Drawings Recently Acquired, 1972–1975*, The Metropolitan Museum of Art, New York 1975–6, with no. 44; Reff 1976, Notebook 36, pp. 17, 19, 21, 23, 24, 30, 46–49; S. Monneret, *L'Impressionisme et son Epoque*, II, Paris 1979, p. 112; Kopplin 1981, pp. 89ff. pl. 97; Gerstein 1982, pp. 110, 117f.
EXHIBITIONS: *The Impressionist Epoch*, The Metropolitan Museum of Art, New York 1974–5; New York 1979, No. 14; Northampton 1979, No. 14 ill.

158 *The Singer Rose Caron with Left Arm Raised* 1885
Black chalk, 268 × 218 mm.
Above left, inscribed in black chalk: 'la natte très grosse'.
Museum Boymans – van Beuningen, Rotterdam (Cat. No. F II 53)

Study for the main figure in a fan sheet (Lemoisne II, No. 594); see pl. 157 above. The singer Rose Caron is represented in the opera *Sigurd*. This drawing is related to the figure sketches in Reff 1967, Notebook 36, pp. 46–49; see also there pp. 17, 23–26, 29. The artist appears to have been specially attracted by the singer's long, slender arms and they are the subject of a sonnet dedicated by him 'A Madame Caron, Brunehilde de *Sigurd*' and beginning with the words: 'Les bras nobles et longs . . .'; Jean Nepveu-Degas (ed.), *Huits Sonnets d'Edgar Degas*, Paris 1946, p. 37. A letter to Ludovic Halévy in September 1885 refers to Mme Caron's ability 'to raise her slender and divine arms, hold them up without any affectation and lower them again softly'; Guérin 1945, p. 100; see also pp. 108, 151.

PROVENANCE: Franz Koenigs, Haarlem.
BIBLIOGRAPHY: Longstreet 1964, ill.; Hoetink 1968, No. 74 ill., with No. 91; Reff 1976, Notebook 36, p. 17 pl. 4.
EXHIBITIONS: Amsterdam 1946, No. 57.

159 *The Opera Glass* circa 1885
Charcoal, 290 × 420 mm.
Below left, Vente stamp *Degas*.
Kunstmuseum, Berne (Cat. No. H 16)

An opera glass had become a central object of attention as an essential intermediate between the close, only partly perceived surroundings and the distant stage in the pastel *Au Théâtre* (Lemoisne II, No. 557). Much the same is true of the present study of detail for the pastel *Ballet Vu d'une Loge* (Lemoisne III, No. 828), Museum of Art, Philadelphia. Attention is focused above all on the gloved hand holding the glass, while the parapet of the box and the figure intersected by the edge of the sheet are only summarily indicated; see the same view in a drawing (IV^ème Vente 1919, No. 134 (2)).

PROVENANCE: IV^{ème} Vente 1919, No. 134 (1) ill.; Max Huggler, Berne.
BIBLIOGRAPHY: Lemoisne III, with No. 828; Browse 1949, with No. 106a.

160 *At the Milliner's* circa 1885 (p. 44)
Pastel, 460 × 600 mm.
Below left, Vente stamp *Degas*.
Privately owned.

This study for the painting *Chez la Modiste* (Lemoisne III, No. 832), The Art Institute, Chicago, is a fine example of pastels of this kind produced during the 1880s, frequently arranged diagonally along the edge of a table; see the similarly selected views in pastels (Lemoisne III, Nos. 833, 835).

PROVENANCE: II^{ème} Vente 1918, No. 169 ill.; Aubert, Paris.
BIBLIOGRAPHY: Lemoisne III, No. 834 ill., with Nos. 832, 833, 835.
EXHIBITIONS: Paris 1975, No. 30 ill.

161 *Dancer at the Bar* circa 1885
Charcoal with strip added on at the right, 320 × 285 mm.
Below left, signed in black chalk: 'Degas'.
Walter Amstutz.

PROVENANCE: Henri Lerolle, Paris.
BIBLIOGRAPHY: Lafond 1918, Vignette on title page.

162 *Seated Dancer Fastening her Shoe* 1885–7
Charcoal with white highlights added, 320 × 300 mm.
Below right, signed in charcoal: 'Degas'.
Privately owned.

The subject of dancers fastening their shoes or rubbing their ankles first came to the fore at the end of the 1870s in the pastels *Danseuses au Foyer* and *Trois Danseuses* (Lemoisne II, Nos. 530, 531); see pl. 164 below, as well as Lemoisne, Nos. 658, 698, 699. It came back into use in the mid-1880s with picture-sized compositions (Lemoisne III, Nos. 900, 902, 905, 941, 1107, 1144); see also individual studies (Lemoisne III, Nos. 826bis, 903, 904, 906–908, 913).

PROVENANCE: Galerie Boussod Valadon & Cie, Paris.
EXHIBITIONS: Paris 1975, No. 71 ill.

163 *Dancer with Arms Spread* circa 1885
Red chalk on grey paper, 310 × 220 mm.
Below left, Vente stamp *Degas*.
Stephen Hahn, New York.

PROVENANCE: III^{ème} Vente 1919, No. 259 (1) ill.; Durand-Ruel, Paris; Albert E. Gallatin, New York; Arthur Tooth & Sons, London; Lady Baillie, London; Sotheby sale, London 3 July 1969, No. 217 ill.
BIBLIOGRAPHY: Browse 1949, No. 126 ill.; Bouret 1965, p. 118 ill.; Alice Bellony-Rewald, *The Lost World of the Impressionist*, London 1976, p. 212 ill.
EXHIBITIONS: *Drawings from the A. E. Gallatin Collection*, The Metropolitan Museum of Art, New York 1924–5; Paris 1955, No. 61 ill.

164 *Seated Dancer Tying her Shoelace* 1885–7
Pastel on grey paper damaged in lower right corner, 482 × 610 mm.
The Dixon Gallery and Gardens, Memphis.

See pl. 162 above.

PROVENANCE: Durand-Ruel, New York.
BIBLIOGRAPHY: Valéry 1940, p. 167 ill.; Lemoisne III, No. 826 ill., with Lemoisne II–III, Nos. 658, 699, 826bis, 903, 904; Russoli and Minervino 1970, No. 818 ill.; *The Dixon Gallery and Gardens Newsletter*, 6, 5, September–October 1983, p. 1, ill.
EXHIBITIONS: New York 1960, No. 44 ill.; New York 1978, No. 33 ill.

165 *Dancer with Right Leg Stretched Forward* circa 1885
Dark brown chalk, 329 × 231 mm.
Below right, Vente stamp *Degas*.
Back: inscriptions in unidentified hands (photograph and estate numbers).
Museum Boymans – van Beuningen, Rotterdam (Cat. No. F II 131).

PROVENANCE: III Vente 1919, No. 81 (3) ill.; Durand-Ruel, Paris; Franz Koenigs, Haarlem.
BIBLIOGRAPHY: Browse 1949, No. 125 ill.; Longstreet 1964, ill; Hoetink 1968, No. 84 ill.
EXHIBITIONS: Amsterdam 1946, No. 64; Berne 1951–2, No. 103.

166 *Dancer Curtseying; Study of Arm* circa 1885
Black chalk with white highlights added on grey paper, 457 × 311 mm.
Below left, Vente stamp *Degas*.
Wadsworth Atheneum, Hartford, Henry and Walter Keney Fund (Cat. No. 34.293).

The grid superimposed on this drawing shows how thoroughly Degas arranged even his most spontaneous-seeming glimpses of dancers in action in accordance with strict geometric patterns. In a second pastel of almost exactly the same size, but at a somewhat narrower angle (Lemoisne II, No. 616), owned by Sidney M. Shoenberg, St Louis, the edge of the picture cuts off the figure just where the vertical line intersects the dancer's body in the present work.

PROVENANCE: III^{ème} Vente 1919, No. 367 (2) ill.; Durand-Ruel, Paris; Cornelius Sullivan, New York.

BIBLIOGRAPHY: Valéry 1940, p. 27 ill.; André 1934, pl. 3; Lemoisne II, No. 616bis ill., with No. 616; Walter Mehring, *Degas, 30 Drawings and Pastels*, New York 1948, No. 22; Rouart 1948, pl. 9; Browse 1949, No. 65 ill.; Champigneulle 1952, pl. 63; Roger-Marx 1956, No. 22 ill.; Bouret 1965, p. 252; Janis 1967, p. 413; Hüttinger 1981, p. 65 ill.

EXHIBITIONS: Cambridge (Mass.) 1957; St Louis–Philadelphia–Minneapolis 1967, No. 116 ill; *Masterworks on Paper*, Wadsworth Atheneum, Hartford 1977; Northampton 1979, No. 15 ill.

167 *Dancer with Left Leg Raised* 1885–90
Charcoal, 305 × 220 mm.
Below left, Vente stamp *Degas*.
Privately owned.

A nude study with this pose is recorded in Lemoisne II, No. 615, as dating from 'circa 1880–1885'. But the figure itself appears very much later in a compositional context, 'circa 1891', in the painting *La Salle de Danse* (Lemoisne III, 1107).

PROVENANCE: III^{ème} Vente 1919, No. 124 (1) ill.; Ambroise Vollard, Paris.

168 *Seated Dancer Pulling on Stocking* 1885–90
Charcoal and pastel on yellowish paper, 307 × 389 mm.
Below right, signed in black chalk: 'Degas'.
Privately owned, Switzerland.

This figure study, together with pls. 162 and 167 above, was used in *La Salle de Danse* (Lemoisne III, No. 1107). Degas had tried out similar poses in larger compositions since the second half of the 1880s; see Lemoisne III, No. 820, 884bis, 941 and drawings (II^{ème} Vente 1918, Nos. 217 (2), 218 (2), III^{ème}–IV^{ème} Ventes 1919, Nos. 109 (4), 112 (4), 138 (4), 148 (2), 248, 160, 270b). The painter Max Liebermann, a great admirer of Degas and the author of the earliest monograph devoted to him, was the first owner of this work.

PROVENANCE: Max Liebermann, Berlin.
BIBLIOGRAPHY: Cooper 1952, pp. 14, 25, No. 26 ill.; Janis 1967, p. 413; Tannenbaum 1967, p. 53 ill. 14.
EXHIBITIONS: Berne 1951–2, No. 104; St Louis–Philadelphia–Minneapolis 1967, No. 122 ill.

169 *Dancer at the Bar* 1885–90
Charcoal, 320 × 265 mm.
Below right, estate stamp ATELIER ED. DEGAS.
Galerie Jan Krugier, Geneva.

See almost identical drawing (II^{ème} Vente 1918, No. 228

(1)); one of these was probably traced through from the other, a process which Degas frequently used.

PROVENANCE: Lefevre Gallery, London.

170 *Dancer with Double Bass* 1885–7
Black chalk on blue paper, 311 × 243 mm.
Below left: Vente stamp *Degas*.
Back: Estate stamp ATELIER ED. DEGAS.
Museum Boymans – van Beuningen, Rotterdam (Cat. No. MB 1976/T17).

Figure sketch for the painting *La Contrebasse* (Lemoisne III, No. 900) Museum of Art, Detroit; see drawing (III^{ème} Vente 1919, No. 137 (1)).

PROVENANCE: III^{ème} Vente 1919, No. 86 (3) ill.; Nunès et Fiquet, Paris; Vitale Bloch, The Hague.
BIBLIOGRAPHY: Lemoisne III, with No. 900; Browse 1949, with No. 120.
EXHIBITIONS: Paris 1955, No. 116; *Dessins des Maîtres*, Galerie L. G. Bauguin, Paris 1959; Rotterdam 1978, No. 13 ill.

171 *Dancer Lit from the Side* 1885–90
Black chalk and some pastel with white highlights added on dark grey paper, 305 × 240 mm.
Below left, Vente stamp *Degas*.
The Baltimore Museum of Art, The Cone Collection, formed by Dr Claribel Cone and Miss Etta Cone of Baltimore (Cat. No. BMA 1950.12.659).

Degas produced numerous studies of dancers lit from the side which were ultimately only used as relatively small figures in the paintings *Danseuses Montant un Escalier* and *La Contrebasse* (Lemoisne III, Nos. 894, 900), Musée du Louvre, Paris, and Museum of Art, Detroit, respectively. See also figure study (Lemoisne III, No. 901) and drawings (II^{ème}–III^{ème} Ventes 1918–9, Nos. 220 (1), 376).

PROVENANCE: II^{ème} Vente 1918, No. 218 (1); Durand-Ruel, Paris; Claribel and Etta Cone, Baltimore.
BIBLIOGRAPHY: Lemoisne III, with Nos. 900, 996; Browse 1949, No. 193 ill., with Nos. 191, 192, 194, 195; *Handbook of the Cone Collection*, Museum of Art, Baltimore, 1955, p. 51 ill.; St Louis–Philadelphia–Minneapolis 1967, with No. 129.
EXHIBITIONS: *Selections from the Cone Collection*, The Museum of Art, Baltimore 1949, p. 32 ill.; *Paintings, Sculptures and Drawings in the Cone Collection*, The Museum of Art, Baltimore 1967, No. 177 ill.

172 *Dancer Tying her Sash* 1885–7
Pastel on grey-blue paper, 480 × 400 mm.
Below right, Vente stamp *Degas*.
Privately owned, Switzerland.

This favourite theme recurs in a gouache (Lemoisne II, No. 359), a pastel (No. 496) and charcoal drawings (IIème–IIIème Ventes 1918–19, Nos. 351, 254). It occurs in compositions, e.g. Lemoisne II, No. 625, and, above all, *La Contrebasse* (Lemoisne III, No. 900), Museum of Art, Detroit; see also Nos. 902, 905, 1012.

PROVENANCE: IIème Vente 1918, No. 204 ill.; Gustave Pellet, Paris; Maurice Exsteens, Paris.
BIBLIOGRAPHY: Bataille 1930, p. 405 ill.; Lemoisne III, No. 909 ill.; Browse 1949, with No. 121.
EXHIBITIONS: Paris 1948–9, No. 68; Berne 1960, No. 21 ill.

173 *Mary Cassatt with Small Dog* circa 1890 (p. 57)
Pastel, 665 × 515 mm.
Below left, Vente stamp *Degas*.
Privately owned, New York.

The painter Mary Cassatt, a friend of Degas, is represented in her street dress. She appears to be sitting at a café or restaurant table with a small dog on her lap; see the earlier portrait in pl. 136 above, as well as Lemoisne II–III, Nos. 533, 796, 796bis. The fascinating formulation of this genre work which in fact lacks any suggestion of genre, the oblique figure set off-balance in the composition, the features which can only be picked out in a blurred way through the dropped veil, and the complementary contrasts arising from the deep blue and bright yellow, the dark of the dress and the tonally differentiated white of the table top. All go to explain why Francis Bacon holds Degas in such high regard.

PROVENANCE: Ière Vente 1918, No. 189 ill.; Ambroise Vollard, Paris; Durand-Ruel, Paris; Jacques Seligmann, Paris; Sale of the Private Collection of Paintings and Pastels by Edgar Degas formed by Jacques Seligmann of Paris, American Art Association, New York 27 January 1921, No. 10 ill.; Mrs W. B. Force, New York; Parke Bernet sale, New York 3 December 1942, No. 11 ill.; Mrs H. Huddleston Rogers, New York; Arturo Peralta Ramos, New York.
BIBLIOGRAPHY: Lemoisne III, No. 1022 ill.; Boggs 1962, p. 112; Russoli and Minervino 1970, No. 679 ill.; A. D. Breeskin, *Mary Cassatt. A Catalogue Raisonné of the Oils, Pastels, Watercolors and Drawings*, Washington 1970, p. 12 ill.; A. D. Breeskin, *Mary Cassatt. A Catalogue Raisonné of the Graphic Work*, Washington 1979, p. 10 ill.; Terrasse 1981, No. 549 ill.; *The Art of Mary Cassatt*, Isetan Museum of Art, Tokyo, 1981, p. 116 ill.
EXHIBITIONS: Northampton 1934, No. 31; New York 1972, No. 24 ill.; Boston 1974, No. 33; Tokyo–Kyoto–Fukuoka 1976–7, No. 46 ill.

174 *The Conversation* circa 1890 (p. 48)
Pastel, 540 × 660 mm.
Below left, Vente stamp *Degas*.
Privately owned.

Five pastels, dated by Lemoisne between 1882 and 1886, represent women chatting at a rail set into the picture at a slant; see Lemoisne II–III, Nos. 710–712, 825, 879. The present work is probably the latest version of this theme. The landscape in the background, a very rare element in Degas' figure pictures, is closely related to many of his landscape monotypes dating from the early 1890s.

PROVENANCE: Ière Vente 1918, No. 165 ill.; Charles Vildrac, Paris; Alex. Reid & Lefevre Gallery, London; H. R. Stirlin, Le Boiron.
BIBLIOGRAPHY: Lemoisne III, No. 1007 ill., with Lemoisne II–III, Nos. 711, 712, 825, 879; Russoli and Minervino 1970, No. 1159 ill.
EXHIBITIONS: Thomas Agnew Gallery, London 1936, No. 32; *Trésors des Collections Romandes*, Musée Rath, Geneva 1954, No. 84; Winterthur 1955, No. 67; Lausanne 1964, No. 9 ill.; *Chefs-d'Oeuvre des Collections Suisses de Manet à Picasso*, Orangerie des Tuileries, Paris 1967, No. 9 ill.; Tokyo–Kyoto–Fukuoka 1976–7, No. 43 ill.; Paris 1983, No. 29 ill.; London 1983, No. 31 ill.

175 *Crest of Hill* 1890–92
Pastel over coloured monotype, 270 × 360 mm.
Below left, signed in red chalk: 'Degas'.
Charles Durand-Ruel, Paris.

Degas showed this landscape study printed with thinned oil paints and worked over in pastel at his first and only one-man exhibition held in the Galerie Durand-Ruel in Paris during autumn 1892 under the title *Paysages de Degas*. This and the studies that follow, probably all done from memory, were undoubtedly stimulated by a journey through Burgundy with horse and carriage in 1890. The artist wrote in December 1892: 'I have had a small, rather profitable exhibition from my point of view at Durand-Ruel's with 26 imaginary landscapes. (Fèvre 1949, p. 102). Pissarro also reported on this event to his son Lucien on 2 October 1892: 'Degas is having an exhibition of landscapes; rough sketches in pastel that are like impressions in colour, they are very interesting, a little ungainly, though wonderfully delicate in tone . . . these landscapes are very fine'. (Rewald 1943).

PROVENANCE: Durand-Ruel (bought on 16 June 1896 from the artist by Paul Durand-Ruel).
BIBLIOGRAPHY: Lafond 1919, after p. 60 ill.; Lemoisne III, No. 1049 ill.; Janis (Monotype) 1967, p. 21 note 9; Cambridge (Mass.) 1968, Checklist No. 316 ill.; Russoli and Minervino 1970, No. 980 ill.; Adhémar and Cachin 1973, p. 66.
EXHIBITIONS: Paris 1892; Paris 1924; Paris 1937, No. 150.

176 *Vesuvius* 1890–92
Pastel over coloured monotype, 250 × 300 mm.
Below left, signed in red chalk: 'Degas'.
Back: estate stamp ATELIER ED. DEGAS.
E. W. Kornfeld, Berne.

See pl. 175 above. Vesuvius appears here as a memento of the artist's frequent visits to Naples.

PROVENANCE: IIème Vente 1918, No. 199 ill.; Gustave Pellet, Paris; Marcel Guérin, Paris.
BIBLIOGRAPHY: Lemoisne 1931, p. 288 ill.; Lemoisne III, No. 1052 ill.; Cooper 1952, pp. 10, 26, No. 27 ill.; Janis (Monotype) 1967, pp. 21 note 10, 71; Cambridge (Mass.) 1968, Checklist No. 310 ill.; Russoli and Minervino 1970, No. 989 ill.; Adhémar and Cachin 1973, p. 65; Terrasse 1981, No. 544 ill.
EXHIBITIONS: Paris 1892; Berne 1951-2, No. 49; Paris 1955, No. 11

177 *Rocky Coast* 1890-92
Pastel over coloured monotype, 305 × 409 mm.
Below left, signed in black chalk: 'Degas'.
Privately owned.

See pl. 175 above. There is a second off-print also worked over in pastel (Lemoisne III, No. 1060), Neue Galerie, Vienna.

PROVENANCE: Durand-Ruel, Paris (bought on 2 June 1893 from the artist by Paul Durand-Ruel); Durand-Ruel, New York; G. Macomber, New York; Steven Innes, New York; Arthur Tooth & Sons, London; Feilchenfeldt, Zurich.
BIBLIOGRAPHY: Lemoisne III, No. 1059, with No. 1060; Janis (Monotype) 1967, p. 21 note 9; Cambridge (Mass.) 1968, Checklist No. 293 ill.; Russoli and Minervino 1970, No. 970 ill.; Adhémar and Cachin 1973, p. 65.

178 *Steep Coast* 1890-92
Pastel over coloured monotype (?), 450 × 550 mm.
Below right, signed in pencil: 'Degas'.
Galerie Jan Krugier, Geneva.

As opposed to the series of landscapes produced about 1869 (see pls. 77, 78 above) in which mostly flat areas with wide skies predominate, Degas chose in the coloured monotypes of the early 1890s to present rocky shorelines with high horizons.

PROVENANCE: Durand-Ruel, Paris.

179 *Nude from the Back Washing in a Bathtub* circa 1887
Charcoal and pastel on light brown paper (re-worked transfer of a pastel), 580 × 355 mm.
Below left, Vente stamp *Degas*.
Privately owned.

Transfer of the pastel *Le Bain* (Lemoisne III, No. 915); see also No. 916, as well as a charcoal drawing (IIIème Vente 1919, No. 244). This pastel carries a black Vente stamp, the exact counterpart of the stamp in red normally carried by works at the posthumous sale, to indicate a transfer (listed in the IIème Vente catalogue as *Impressions en Couleurs Retouchées par Edgar Degas*).

PROVENANCE: IIème Vente 1918, No. 372 ill.
BIBLIOGRAPHY: Lemoisne III, with Nos. 915, 916.

180 *Nude from the Back with Towel and Sponge* 1886-90
Pastel, 720 × 575 mm.
Below right, signed in blue chalk: 'Degas'.
Privately owned.

The theme of the female nude at her toilet, which had already appeared in some monotypes towards the end of the 1870s (see pl. 127 above), became the main subject in Degas' pictorial output during the 1880s and 1890s, together with compositions of dancers.

PROVENANCE: Mme Boivin, Paris; Marc François, Paris; Vente, Hôtel Drouot, Paris 20 March 1935, No. 2 ill.; Georges Lévy, Paris.
BIBLIOGRAPHY: Lafond 1919, p. 52; Lemoisne III, No. 883 ill.; Cabanne 1960, p. 125 pl. 118; Russoli and Minervino 1970, No. 922 ill.; Terrasse 1973, p. 62 ill.; Terrasse 1981, No. 489 ill.
EXHIBITIONS: New York 1960, No. 49 ill.; New York 1978, No. 37 ill.; *Post-Impressionism. Cross-Currents in European and American Painting 1880–1906*, National Gallery of Art, Washington 1980, No. 7 ill.

181 *Seated Nude Combing her Hair* 1887-90 (p. 61)
Charcoal and pastel, 589 × 470 mm.
Below right, signed in black chalk: 'Degas'.
Privately owned.

Most of these pastels have been constructed on a charcoal drawing which – as in this case – is brought into sharp contrast with the high colouring. The treatment of the complicated pose with legs crossed, slightly turned hips and arms held high and bent is masterly. There is a transfer in which the crayon colouring focuses on the red slipper (Lemoisne III, No. 935bis); see also Nos. 935ter, 936, as well as charcoal drawings (IIIème–IVème Ventes 1919, Nos. 314, 187).

PROVENANCE: Bernheim-Jeune, Paris; Maurice Exsteens, Paris; Francis Salabert, Paris; Paul Rosenberg, New York; Edwin C. Vogel, New York; Sotheby Parke Bernet sale, New York 17 October 1973, No. 17 ill.; Galerie Beyeler, Basle.
BIBLIOGRAPHY: Hertz 1920, p. XXIII; Lemoisne III, No. 935 ill., with Nos. 724, 848, 849, 935bis, 936, 1003, 1173, 1283, 1284; Jean Louis Vandoyer, *Der weibliche Akt*, Munich 1957, No. 119 ill.; Russoli and Minervino 1970, No. 941 ill.
EXHIBITIONS: Palais des Beaux-Arts, Ghent 1922; The Metropolitan Museum of Art, New York 1968.

182 *Nude Seated on a Sofa and Drying her Hair* 1888-92
Charcoal and paste, 480 × 630 mm.

Below left, inscribed in black chalk: 'à M. J. Stchoukine/Degas'.
Bayerische Staatsgemäldesammlung, Munich (Cat. No. 13136)

The dedication suggests that the famous Russian collector Sergei Ivanovich Shchukin may have bought this work direct from the artist. Matisse wrote about this collector, whom he had met in 1908: 'Shchukin, a Moscow importer of Western textiles, was about fifty, a vegetarian and extremely sober. He spent four months in Europe every year and travelled all over the place. He was fond of the deeper and more restful pleasures. His favourite way of spending his time in Paris was to visit the Egyptian rooms in the Louvre where he discovered similarities with Cézanne's compatriots. He regarded the Lion of Mycenae as the undeniable masterpiece of art as a whole. One day, he turned up at the Quai St. Michel to look at my pictures.' Henri Matisse, *Über Kunst*, Zurich 1982, p. 235.

PROVENANCE: Sergei Ivanovich Shchukin, Moscow; Derrick Morley, London.
BIBLIOGRAPHY: Meier-Graefe 1920, pl. 88; Lemoisne III, No. 964, ill.; Kurt Martin, *Die Tschudispende*, Munich 1962, p. 39; Bericht der Bayerischen Staatsgemäldesammlungen, in *Münchner Jahrbuch der bildenden Kunst*, 3, XXII, 1962, p. 264 pl. 9; R. Netzer, 'Edgar Degas. Nach dem Bade', in *Kunstwerke der Welt aus dem öffentlichen bayerischen Kunstbesitz*, II, Munich 1962, p. 54 ill.; *Französische Meister des 19. Jahrhunderts – Kunst des 20. Jahrhunderts. Neue Pinakothek*, Munich 1966, pp. 29f. pl. 30; Russoli and Minervino 1970, No. 955 ill.; Terrasse 1981, No. 565 ill.; *Neue Pinakothek, Erläuterungen zu den ausgestellten Werken*, Munich 1981, pp. 74f. ill.
EXHIBITIONS: Munich 1972, No. 673 ill.

183 *Maid with a Cup* circa 1890
Charcoal, 1067 × 787 mm.
Below left, Vente stamp *Degas*.
National Gallery of Canada, Ottawa (Cat. No. 18770).

Lemoisne lists a total of fourteen large pastels produced between 1883 and 1900/1905 representing women at their toilet to whom a maid is bringing a cup; see Lemoisne III, Nos. 724, 926, 979, 980, 1086, 1150–1152, 1160, 1161, 1204–1206, 1382, 1393. However, the subject of a servant carefully carrying a cup to the bathroom (see pl. 189 below) is reproduced in its present form only in the pastel *Le Petit Déjeuner à la Sortie du Bain* (Lemoisne III, No. 724), owned by Stavros Niarchos, London. The present study may be a copy intended for use in a later version, such as Lemoisne III, No. 1086. See the almost identical charcoal drawing (Lemoisne III, No. 725), owned by T. M. Sterling, Toronto, which should be dated later than '1883' on stylistic grounds.

PROVENANCE: III^{ème} Vente 1919, No. 295 ill.; Durand-Ruel, Paris; Phyllis B. Lambert, Chicago.

BIBLIOGRAPHY: Lemoisne III, with No. 724.
EXHIBITIONS: New York 1958, No. 14 ill. (cover).

184 *Nude on Edge of Bath Drying her Legs* circa 1890
Charcoal on tracing paper, 480 × 600 mm.
Below left, Vente stamp *Degas*.
Victoria and Albert Museum, London (Cat. No. 3689-1919).

The figure at the edge of the bath became a standard motif in Degas' late work; see Lemoisne III, Nos. 917, 918, 1136–1139, 1380–1384, 1421, as well as drawings (I^{ère}–II^{ème} Ventes 1918, Nos. 333, 336, 291, 307, 343, III^{ème}–IV^{ème} Ventes 1919, Nos. 183, 250, 270, 271, 311, 186).

PROVENANCE: III^{ème} Vente 1919, No. 388 ill.; Galerie Knoedler, Paris.
BIBLIOGRAPHY: Lemoisne III, with No. 1383; Pickvance 1965, p. 229 ill.
EXHIBITIONS: Nottingham 1969, No. 27 pl. XV; Tokyo–Kyoto–Fukuoka 1976–7, No. 79 ill.

185 *Seated Nude Drying her Neck and Back* 1890–95
Charcoal and pastel on tracing paper with piece added below, 1210 × 1010 mm.
Below left, Vente stamp *Degas*.
Staatsgalerie Stuttgart, Graphische Sammlung (Cat. No. C 59/912)

This pastel probably came about as a work in its own right in connection with the figure composition *Le Petit Déjeuner après le Bain* (Lemoisne III, Nos. 979, 980).

PROVENANCE: II^{ème} Vente 1918, No. 116 ill.; Ambroise Vollard, Paris; Percy Moore Turner, London; Hanning Philipps, London; Galerie des Arts Anciens et Modernes, Schaan.
BIBLIOGRAPHY: *Kunst und Künstler*, XXIII, 1925, p. 287 ill.; Lemoisne III, No. 981 ill, with Nos. 979, 980, 1166; 'Staatsgalerie Stuttgart. Erwerbungsbericht 1945–1963', in *Jahrbuch der Staatlichen Kunstsammlungen in Baden-Württemberg*, I, 1964, p. 78 note 35; Peter Beye–Kurt Löcher, *Katalog der Staatsgalerie Stuttgart. Neue Meister*, Stuttgart 1968, pp. 48f. ill.; Gauss 1976, No. 169 ill.
EXHIBITIONS: Paris 1937, No. 160 pl. XXVIII; London 1952, No. 27; *Neuerwerbungen*, Staatsgalerie, Stuttgart 1960, No. 7 ill; Stuttgart 1960, No. 32 pl. 24; Stuttgart 1969, No. 30.

186 *Girl Resting on Bed* circa 1893 (p. 65)
Pastel, 505 × 650 mm.
Above left, signed in black chalk: 'Degas'.
Privately owned.

It says much for the high standard of Max Liebermann's collection that it should contain, among all else (see, for instance, pl. 168 above), this pastel which is exceptional in

both its composition and its combination of luminous colours. For a second version of this subject, see Lemoisne III, No. 1141.

PROVENANCE: Durand-Ruel, Paris; Max Liebermann, Berlin; Kurt Rietzler, New York.
BIBLIOGRAPHY: René Huyghe, 'Degas ou la Fiction Réaliste', in *L'Amour de l'Art*, XII, July 1931, p. 277 pl. 20; Mauclair 1938, p. 157 ill.; Lassaigne 1945, p. 8 ill.; Rouart 1945, pp. 35 ill., 72 note 54; Lemoisne III, No. 1142 ill, with No. 1141; Russoli and Minervino 1970, with No. 1011; Hüttinger 1981, p. 53 ill.
EXHIBITIONS: Paris 1937, No. 153; *Art. Golden Gate International Exhibition*, Palace of Fine Arts, San Francisco 1940, No. 259 ill.; New York 1949, No. 81 ill.

187 *Seated Girl Combing Her Hair* circa 1894
Charcoal and pastel, 690 × 830 mm.
Below right, Vente stamp *Degas*.
Privately owned, Bremen.

PROVENANCE: III^ème Vente 1919, No. 58 ill.; Claude Roger-Marx, Paris; Vente Anonyme, Hôtel Drouot, Paris 24 February 1926, No. 11 ill.; Fiquet, Paris; Galerie Nathan, Zurich; Privately owned, Bonn; Graphisches Kabinett Wolfgang Werner KG, Bremen.
BIBLIOGRAPHY: Lemoisne III, No. 1163, ill., with No. 1162.

188 *Two Girls Reading and Combing their Hair* circa 1894
Pastel, 480 × 620 mm.
Below left, Vente stamp *Degas*.
Privately owned, Switzerland.

As in pl. 187 above, the artist has contrasted richly differentiated red, yellow, orange and brown chalks with some blue along the edge. For an inverted version of this subject with a slightly wider perspective, see Lemoisne III, No. 1132.

PROVENANCE: II^ème Vente 1918, No. 105 ill.; Ambroise Vollard, Paris; Paul Cassirer, Berlin; Galerie Thannhauser, New York; Galerie Nathan, Zurich.
BIBLIOGRAPHY: Lemoisne III, No. 1133 ill., with No. 1132.

189 *Refreshments after the Bath* circa 1894 (p. 69)
Pastel, 995 × 590 mm.
Below left, Vente stamp *Degas*.
Gift of the Gilman Foundation, New York, to the Tel Aviv University and the Tel Aviv Museum (Cat. No. 82.111).

The pastel *Le Petit Déjeuner à la Sortie du Bain* (Lemoisne III, No. 724), owned by Stavros Niarchos, London,

Toyonobu *Courtesans after the Bath* circa 1755

Eadweard Muybridge *Female lifting towel*, in *Animal Locomotion . . .*, IV, Ill. 411, 1887

Later Tori School, *Girl in the Bath* circa 1750

dating from about 1883, provided the starting point for a series of highly varied versions of a nude drying herself with a maid in attendance (see pl. 183 above), produced in particularly large numbers during the 1890s. As the outlines and proportions within the present work are virtually identical with those in Lemoisne III, No. 1150, it seems likely that one of these two works is a tracing of the other.

PROVENANCE: I^{ère} Vente 1918, No. 188 ill.; Durand-Ruel, Paris; Ambroise Vollard, Paris.
BIBLIOGRAPHY: Lemoisne I, III, p. 166, No. 1151 ill., with Nos. 1150, 1152; London 1970, with No. 16; *The Tel Aviv Museum Annual Review*, 1, 1982, p. 53 ill.; *Masters of Modern Art*, Museum, Tel Aviv 1982, No. 34 ill.; Mordechai Omer, *The Gilman Collection*, University Gallery, Tel Aviv 1982, No. 1 ill.

190 *Hairdressing* 1892–5
Charcoal on tracing paper, 335 × 448 mm.
Below left, Vente stamp *Degas*.
Privately owned.

Design for the *La Coiffure* compositions (Lemoisne 1127–1130). Some drawings (III^{ème}–IV^{ème} Ventes 1919, Nos. 177 (2), 359) were probably based on transfers from the present sheet; see also charcoal studies (III^{ème}–IV^{ème} Ventes 1919, Nos. 318, 168).

PROVENANCE: II^{ème} Vente 1918, No. 317 ill.
BIBLIOGRAPHY: Lemoisne III, with No. 1128.

191 *Seated Nude from the Back, Combing her Hair* circa 1897
Charcoal and pastel on brown card, 705 × 705 mm.
Below left, Vente stamp *Degas*.
Kunsthaus, Zurich (Cat. No. 1950/8).

The origin of this drawing may have been a transfer of a charcoal study (Lemoisne III, No. 936).

PROVENANCE: I^{ère} Vente 1918, No. 277 ill.; Ambroise Vollard, Paris; Maurice Loncle, Paris.
BIBLIOGRAPHY: Lemoisne III, No. 1283 ill., with Nos. 1003, 1306, 1422; *Le Vie del Mondo*, III, 1960; ill., Russoli and Minervino 1970, No. 1034 ill.; Terrasse 1981, No. 638 ill.
EXHIBITIONS: Berne 1951–2, No. 62; Amsterdam 1952, No. 50; Zurich 1977, No. 171 ill.

192 *Jockeys Training* 1894 (p. 72)
Pastel, 479 × 628 mm.
Below left, signed and dated in black chalk: 'Degas/94'.
Thyssen-Bornemisza collection, Lugano.

This last of the compositions with horses and jockeys quoted in Lemoisne is among the few pastels dated by

Degas. Two works were produced ten years earlier which are almost identical with it in the arrangement of the horses and riders, the painting *Chevaux de Courses* and the pastel *Avant la Course* (Lemoisne III, Nos. 767, 878), Museum of Modern Art, New York and privately owned there, respectively; the pastel now carries a signature and date which cannot be seen on the reproduction of the work in Lemoisne. Although the dimensions of the pastels coincide, the riders in the present, later version dominate the picture to a greater extent; the colouring and treatment of the colour medium are also radically different.

PROVENANCE: Durand-Ruel, Paris; Louisine Havemeyer, New York; Mrs James Watson-Webb, New York; Dunbar W. Bostwick, New York.
BIBLIOGRAPHY: Georges Grappe, 'Degas', in *L'Art et le Beau*, 3, I, 1911, p. 26 ill.; Meier-Graefe 1920, pl. 91; Arsène Alexandre, 'La Collection Havemeyer', in *La Renaissance*, XII, October 1929, p. 484 ill.; *H. O. Havemeyer Collection*, Portland 1931, p. 379 ill.; Lemoisne I, III, p. 163, No. 1145 ill, with Nos. 767, 878; Maurice Serullaz, *Les Peintres Impressionistes*, Paris 1959, p. 109 ill. (detail); Cabanne 1960, pp. 30, 123 pl. 106; Russoli and Minervino 1970, No. 1164 ill.; Terrasse 1981, No. 590 ill.
EXHIBITIONS: The Grolier Club, New York 1922, No. 72; Philadelphia 1936, No. 53 ill.; New York 1960, No. 62 ill.

193 *Alexis Rouart* 1895 (p. 81)
Charcoal and pastel on yellow paper, 565 × 410 mm.
Below right, signed in black chalk: 'Degas'; above right, inscribed: 'Alexis Rouart/Mars 1895'.
Privately owned, New York.

Alexis was the eldest son of Degas' friend Henri Rouart. This drawing served as a study for the painting *Henri Rouart et son Fils Alexis* (Lemoisne III, No. 1176), Bayerische Staatsgemäldesammlungen, Munich. See the more narrowly viewed half-length portrait of Alexis Rouart (Lemoisne III, No. 1178), as well as the pastel No. 1177. It may be that the double portrait of father and son was conceived as a substitute for a portrait of Mme Henri Rouart and her daughter Hélène, planned a decade earlier; see pl. 154 above.

PROVENANCE: L. Heim, Paris; Mme Bloch, Paris.
BIBLIOGRAPHY: Terrasse 1973, p. 65 ill.
EXHIBITIONS: Berne 1951–2, No. 110; New York 1972, No. 25 ill.; *Centennial Fair in Celebration of the Philadelphia Museum of Art's 100th Birthday*, Museum of Art, Philadelphia 1975; Tokyo–Kyoto–Fukuoka 1976–7, No. 50 ill. New York 1979, No. 15.

194 *The Dancing Examination* 1890–95
Charcoal, 558 × 1030 mm.
Below left, Vente stamp *Degas*.
The Nelson-Atkins Museum of Art, Gift from Harald Woodbury Parsons, Kansas City (Cat. No. 31-101).

During the second half of the 1880s, Degas' interest in wide paper formats increased, especially in connection with ballet compositions, so that the variations of movement could be 'reeled off', not unlike a photographic sequence; see pl. 201 below. The present drawing, as well as the figure sketch in pl. 195 below, represents a study for the painting *Danseuses au Foyer* (Lemoisne III, No. 996), Bührle Collection, Zurich; see also Nos. 997–1000, as well as drawings (IIème Vente 1918, Nos. 276, 277, 282, IIIème–IVème Ventes 1919, Nos. 117 (1), 142 (1), 169, 172, 214 (2), 220, 231, 267, 317, 322, 329, 265b).

PROVENANCE: Ière Vente 1918, No. 246 ill.; Henri Fèvre, Monte Carlo; Marczell de Nemès, Budapest; Auction, Munich 16 June 1931, No. 100.
BIBLIOGRAPHY: Lemoisne III, No. 999 ill., with Nos. 996–998, 999bis.

195 *Dancer Slightly Leaning Forward* 1890–95
Charcoal, 500 × 440 mm.
Below left, Vente stamp *Degas*.
Mr and Mrs John W. Warrington, Cincinnati.

See p. 194 above.

PROVENANCE: IVème Vente 1919, No. 164 ill.; Kennedy & Co., New York.
BIBLIOGRAPHY: Lemoisne III, with No. 996.

196 *Two Nude Dancers on a Bench* circa 1896
Charcoal on tracing paper, 800 × 1067 mm.
Privately owned.

The low upholstered bench was probably part of Degas' studio equipment, as it crops up in many of his ballet pictures; see, among others, pl. 197 below. Lemoisne listed a total of seven pastels in which the dancers are similarly represented in the nude and in costume (Lemoisne III, Nos. 1254–1259bis); see also individual studies (Nos. 1260, 1260bis), as well as drawings (IIIème–IVème Ventes 1919, Nos. 208, 215, 275, 299, 299, 346). The origin of all these figure representations may be found in a pastel produced at the end of the 1860s, *Deux Danseuses Assises sur une Banquette* (Lemoisne II, No. 559).

PROVENANCE: Durand-Ruel, Paris; Browse & Delbanco, London.
EXHIBITIONS: Tokyo–Kyoto–Fukuoka 1976–7, No. 77 ill.

197 *Two Dancers on a Bench* circa 1896
Pastel, 830 × 1070 mm.
Privately owned.

The charcoal study in pl. 196 above and the present work are approximately of the same size. The puffed out ballet skirts appear to merge into the entirely abstract colour formations in the background.

390

PROVENANCE: Ambroise Vollard, Paris.
BIBLIOGRAPHY: Degas 1914, pl. LXXX: Lemoisne III, No. 1256 ill., with Nos. 1254, 1257, 1258, 1259bis.
EXHIBITIONS: Tokyo–Kyoto–Fukuoka 1976–7, No. 53 ill.

198 *Two Dancers in Body Stockings* 1890–95
Charcoal on tracing paper, 278 × 230 mm.
Above right, inscribed: 'rajouter 4c à gauche/2c à droite/3c en bas'; below left, Vente stamp *Degas*.
Museum Boymans – van Beuningen, Rotterdam (Cat. No. F II 217).

The tracing paper was fastened in accordance with the artist's instructions on to a larger piece of card (360 × 300 mm) so that more space was created along the edges, probably in order to extend the representation of the figures; hence the inscription on the sheet. This is a study for the painting *Arlequin et Colombine* (Lemoisne III, No. 1111); see also pastels Nos. 1112, 1113, as well as drawings (IIème Vente 1918, No. 340, IIIème–IVème Ventes 1919, Nos. 179, 323, 395 (1), 155, 263b, 281b). The date 'circa 1886' proposed in the St Louis–Philadelphia–Minneapolis catalogue is probably too early. The broad, constantly reworked outlines and the virtually Expressionist simplification of the forms mainly occur from the mid-1890s onwards.

PROVENANCE: IIIème Vente 1919, No. 265 ill.; Nunès et Fiquet, Paris; Bernheim-Jeune, Paris; Paul Cassirer, Berlin; Franz Koenigs, Haarlem.
BIBLIOGRAPHY: Lemoisne III, with No. 1111; Longstreet 1964, ill.; Reff 1967, pp. 255, 260, 262; Hoetink 1968, No. 89 ill.
EXHIBITIONS: Rotterdam 1933–4, No. 52; Basle 1935, No. 156; Amsterdam 1946, No. 67; Paris 1952, No. 136; St Louis–Philadelphia–Minneapolis 1967, No. 123 ill.

199 *Two Dancers* 1890–95 (p. 85)
Charcoal with green and white chalk on light brown paper, 600 × 430 mm.
Below left, Vente stamp *Degas*.
Privately owned.

Figure study for the painting *Danseuses sur la Scène* (Lemoisne III, No. 987); see also pastel No. 989, as well as a drawing (IIIème Vente 1919, No. 394).

PROVENANCE: IIème Vente 1918, No. 57; Jos. Hessel, Paris.
BIBLIOGRAPHY: Lemoisne III, No. 990 ill., with Nos. 987, 989; Browse 1949, with No. 256.
EXHIBITIONS: Paris 1983, No. 114, ill.

200 *Dancer Leaning on a Pillar* 1895–8
Charcoal, 690 × 530 mm.
Below left, Vente stamp *Degas*.
Museum Folkwang, Essen.

Figure study for the painting *Danseuses au Foyer* (Lemoisne III, No. 1200); see pl. 201 below.

PROVENANCE: IIème Vente 1918, No. 286 ill.; Emil Georg Bührle, Zurich.
BIBLIOGRAPHY: Lemoisne III, with No. 1200.

201 *Dancers in a Rehearsal Room* 1895–8
Charcoal and pastel on brown paper with added strip above, 460 × 890 mm.
Below left, Vente stamp *Degas*.
Bridgestone Museum of Art, Ishibashi Foundation, Tokyo.

Design for the painting *Danseuses au Foyer* (Lemoisne III, No. 1200); see also Nos. 1202, 1203, 1226, 1294, 1307, 1308, 1368, as well as the earlier, wide format *La Salle de Danse* (Lemoisne III, No. 1107). This composition was undertaken again after 1900; see Lemoisne III, Nos. 1394–1396.

PROVENANCE: Ière Vente 1918, No. 162 ill.; Privately owned, Paris; Vente Anonyme, Hôtel Drouot, Paris 29 April 1921, No. 14 ill.; Georges Petit, Paris.
BIBLIOGRAPHY: Lemoisne III, No. 1201 ill., with Nos. 1200, 1202, 1203; *Kindai Kaiga loonen*, Tokyo 1951, p. 8; Bernard Dorvial, 'Un Musée Japonais d'Art Français', in *Connaissance des Arts*, November 1958, p. 59; *Bridgestone Gallery*, Tokyo 1959, ill.; *Bridgestone Gallery*, Tokyo 1965, No. 24 ill.
EXHIBITIONS: *3rd France Gendai Bijutsu*, Tokyo 1924; *France Bijutsu*, Tokyo 1931, No. 59.

202 *Dancer with Bare Torso and Raised Arms* 1895–1900
Black chalk, 325 × 233 mm.
Below left, Vente stamp *Degas*.
Den Kongelige Kobberstiksamling, Copenhagen (Cat. No. tu 33.4)

This sheet was framed together with those in pls. 204 and 205 when it was sold for 700 francs at the IVème Vente.

PROVENANCE: IVème Vente 1919, No. 141b ill.
BIBLIOGRAPHY: Borchsenius 1944, p. 11 ill.; Fischer-Sthyr 1953, p. 102 ill.
EXHIBITIONS: Copenhagen 1939, No. 25; Copenhagen 1948, No. 116; Copenhagen 1967, No. 41 ill.

203 *Three Dancers in Front of a Landscape Backdrop* 1895–8
Pastel, 820 × 530 mm.
Below left, Vente stamp *Degas*.
Privately owned, Switzerland.

A charcoal drawing (IIème Vente 1918, No. 287) shows the same dancers dressed in body stockings; see also a pastel seen from a somewhat different angle (Lemoisne III, No. 1209).

PROVENANCE: I^ère Vente 1918, No. 235 ill.; Ambroise Vollard, Paris; M. Deacon, Paris; Galerie Beyeler, Basle.
BIBLIOGRAPHY: Lemoisne III, No. 1210 ill., with No. 1209; Russoli and Minervino 1970, No. 1108 ill.

204 *Torso of Dancer with Arms Crossed Behind her Head* 1895–1900
Black chalk, 361 × 239 mm.
Below left, Vente stamp *Degas*.
Den Kongelige Kobberstiksamling, Copenhagen (Cat. No. tu 33.3)

See sketches (IV^ème Vente 1919, Nos. 140a–c, 142a).

PROVENANCE: IV^ème Vente 1919, 141c ill.

205 *Torso of Dancer with Arms Crossed Behind her Head* 1895–1900
Black chalk, 362 × 228 mm.
Below left, Vente stamp *Degas*.
Den Kongelige Kobberstiksamling, Copenhagen (Cat. No. tu 33.5)

See pl. 204 above.

PROVENANCE: IV^ème Vente 1919, No. 141a ill.
BIBLIOGRAPHY: Borchsenius 1944, p. 11 ill.; Fischer Sthyr 1953, p. 102 ill.
EXHIBITIONS: Copenhagen 1939, No. 24; Copenhagen 1948, No. 114; Copenhagen 1967, No. 42.

206 *Seated Dancer with Raised Right Leg* 1897–1900
Charcoal and pastel (re-worked transfer of a pastel), 541 × 441 mm.
Below left, Vente stamp *Degas*.
Galerie Beyeler, Basle.

This is not, as Browse and Lemoisne have suggested, a pastel over monotype, but rather a differently coloured transfer of a pastel of dancers (Lemoisne III, No. 1302); see also pastels Nos. 1158, 1222, 1299–1301, 1397 (pl. 219 below), 1398. For the black Vente stamp, see pl. 179 above.

PROVENANCE: II^ème Vente 1918, No. 361 ill.; Gustave Pellet, Paris; Maurice Exsteens, Paris; Justin K. Thannhauser, Lucerne; The Solomon R. Guggenheim Museum, New York; Sotheby Parke Bernet sale, London 31 March 1982, No. 64 ill.
BIBLIOGRAPHY: Rouart 1945, p. 74 note 89; Lemoisne III, No. 1303 ill., with Nos. 1158, 1299–1301, 1398; Browse 1949, No. 203 ill.; *A Picture Book of the 19th and 20th Century Masterpieces from the Thannhauser Foundation*, The Solomon R. Guggenheim Museum, New York 1972, p. 14 ill.; Vivian Endicott Barnett, *The Guggenheim Museum, Justin K. Thannhauser Collection*, New York 1978, No. 11, ill.

207 *Dancer with Right Arm Raised* 1895–1900
Charcoal and black chalk (transfer of a charcoal drawing), 582 × 465 mm.
Below left, Vente stamp *Degas*.
Back: estate stamp ATELIER ED. DEGAS.
Mr and Mrs Walter Bareiss, New York.

The transfer of a charcoal drawing (II^ème Vente 1918, No. 274), Museum of Art, Santa Barbara, worked over in black chalk; see earlier works with the 'primary' figure (Lemoisne III, Nos. 942–945, 1066), as well as later figure compositions (Nos. 1223, 1321, 1452bis, 1452ter) and charcoal studies (II^ème Vente 1918, No. 283, III^ème–IV^ème Ventes 1919, No. 167, 232, 239, 147, 298). Yet the figure of the dancer does not occur in any of these in its present, reversed form. For the black Vente stamp, see pl. 179 above.

PROVENANCE: II^ème Vente 1918, No. 384 ill.
BIBLIOGRAPHY: Rouart 1945, p. 74 note 89; Browse 1949, with No. 209; St Louis–Philadelphia–Minneapolis 1967, with No. 151.
EXHIBITIONS: Munich 1965, p. 25, pl. 3.

208 *Torso of Dancer Fastening her Shoulder Strap* 1896–9
Pastel on brown card, 475 × 370 mm.
Below right, signed in black chalk: 'Degas'.
Kunsthalle, Bremen (Cat. No. 04/1)

This drawing forms part of a series of studies prepared in connection with the large canvas *En Attendant l'Entrée en Scène* (Lemoisne No. 1267), National Gallery, Washington; see pastels (Lemoisne III, Nos. 1235, 1268, 1269, 1272, 1273, 1352–1357, 1359, 1361, 1362) and drawings (III^ème–IV^ème Ventes 1919, Nos. 185, 392, 349, 368). The figure composition in pl. 209 below probably also developed from this painting.

PROVENANCE: A. W. von Heymel, Bremen.
BIBLIOGRAPHY: *Impressionnistes et Romantiques Français dans les Musées Allemands*, Musée de l'Orangerie, Paris 1951, No. 28; *Handbuch der Kunsthalle Bremen*, Bremen 1954, p. 76.
EXHIBITIONS: Bremen 1969, No. 60 pl. V.

209 *Torsos of Four Dancers* 1899
Pastel, 680 × 620 mm.
Below right, signed in red chalk: 'Degas'.
Musée des Beaux-Arts, Lyons.

Similar groups of figures, although involving only three dancers, appear in pastels of virtually the same size: Lemoisne III, Nos. 1344 (Museum of Art, Toledo), 1345, 1347; see also single studies and variants (Lemoisne III, Nos. 1270, 1271, 1274, 1348–1359), as well as drawings (III^ème–IV^ème Ventes 1919, Nos. 117 (3), 144, 334, 382, 351).

PROVENANCE: Ambroise Vollard, Paris.
BIBLIOGRAPHY: Degas 1914, pl. LXXXXV; Lemoisne III, No. 1346 ill., with Nos. 1344, 1345; Bremen 1969, with No. 61; Nottingham 1969, with No. 28.

210 *Seated Nude Drying Herself* 1895–1900
Charcoal on brown paper, 740 × 550 mm.
Above right, signed in pencil: 'Degas'.
Privately owned.

A similar pose, seen in steeper perspective, occurs in pastels Lemoisne III, No. 1011 (Courtauld Institute of Art, London) and Nos. 1340–1343.

PROVENANCE: Ambroise Vollard, Paris; Christian de Galéa, Paris.

211 *After the Bath* 1895–8
Pastel, 945 × 805 mm.
Below left, Vente stamp *Degas*.
Back: estate stamp ATELIER ED. DEGAS.
Kunstmuseum, Solothurn, Dübi-Müller-Stiftung (Cat. No. C 80.6).

See similar representations (Lemoisne III, Nos. 925, 926, 1204–1206, 1393), as well as a drawing (III^{ème} Vente 1919, No. 289) which may be based on a tracing of the present work.

PROVENANCE: II^{ème} Vente 1918, No. 180 ill.; Ambroise Vollard, Paris: Bernheim-Jeune, Paris.
BIBLIOGRAPHY: Lemoisne III, No. 1207 ill., with Nos. 925, 926, 1204–1206; Cabanne 1960, p. 128 pl. 138; Russoli and Minervino 1970, No. 1031 ill.; *Kunstmuseum Solothurn Dübi-Müller-Stiftung, Josef Müller-Stiftung*, Solothurn 1981, No. 74 ill.
EXHIBITIONS: *Hundert Jahre Malerei aus Solothurner Privatbesitz*, Kunstmuseum, Solothurn 1950, No. 62.

212 *Nude Stepping into Bath* 1895–1900 (p. 88)
Pastel, 730 × 640 mm.
Below left, signed in black chalk: 'Degas'.
The National Museum of Wales, Cardiff.

See pastels Lemoisne III, Nos. 1392, 1404. There is a virtually identical charcoal drawing under No. 32 in the London 1958 catalogue.

213 *Nude in Bath with Raised Right Leg* 1895–1900
Charcoal on tracing paper, 360 × 300 mm.
Below left, Vente stamp *Degas*.
Back: inscriptions in unidentified hands (photograph and estate numbers).
Museum Boymans – van Beuningen, Rotterdam (Cat. No. F II 132).

See virtually equivalent charcoal drawings (III^{ème} Vente 1919, Nos. 176 (2), 327 (2)), Art Institute, Williamstown.

PROVENANCE: III^{ème} Vente 1919, No. 313 ill.; Durand-Ruel, Paris; Franz Koenigs, Haarlem.
BIBLIOGRAPHY: Huyghe-Jacottet 1948, pl. 97; John Rewald, *Edgar Degas*, Mühlhausen O. J., pl. 50; Haverkamp and Begemann 1957, No. 80; K. Edschmid, *Aktzeichnungen grosser Meister*, Vienna 1963, pl. 56; Longstreet 1964, ill.; Haverkamp and Begemann etc. 1964, p. 85, pl. 69; H. R. Hoetink, 'Three Centuries of French Art', in *Apollo*, LXXXVI, 1967, p. 55 ill.; Hoetink 1968, No. 85 ill.; Leymarie 1969, p. 57 ill.
EXHIBITIONS: Haarlem 1935, No. 40; Amsterdam 1946, No. 65; Paris–Brussels–Rotterdam 1949–50, No. 200; Berne 1951–2 No. 166a; Paris 1952, No. 137.

214 *Nude on Edge of Bath Drying her Legs* 1900–05
Charcoal and Pastel, 680 × 360 mm.
Below left, Vente stamp *Degas*.
Dr Peter Nathan, Zurich.

This drawing, and especially the next (pl. 215 below), are closely related to a pastel (Lemoisne III, No. 1421), Museu de Arte, São Paolo, dated '1903' by the artist, both by the drawing, which concentrates entirely on formal expression, and by its vigorous modelling.

PROVENANCE: II^{ème} Vente 1918, No. 53 ill.; Ambroise Vollard, Paris.
BIBLIOGRAPHY: Lemoisne III, No. 1383 ill., with Nos. 917, 918, 1136, 1137, 1380–1384, 1421; St Louis–Philadelphia–Minneapolis 1967, with No. 139; Nottingham 1969, with No. 27.
EXHIBITIONS: *Figures Nues d'Ecole Française*, Galerie Charpentier, Paris 1953.

215 *Nude on the Edge of Bath Drying her Legs* 1900–05
Charcoal on tracing paper, 400 × 540 mm.
Below left, Vente stamp *Degas*.
Staatsgalerie Stuttgart, Graphische Sammlung (Cat. No. C 50/161).

See pl. 214 above.

PROVENANCE: II^{ème} Vente 1918, No. 315 ill.; M. Schöne, Stettin; Galerie Thannhauser, Munich–Lucerne; Galerie Aktuaryus, Zurich; Wilhelm Heinrich, Frankfurt am Main; Stuttgarter Kunstkabinett R. N. Ketterer sale, Stuttgart 10–12 May 1950, No. 968 ill.
BIBLIOGRAPHY: Lemoisne III, with No. 1384; Reff 1967, p. 262; Gauss 1976, No. 170 ill.; Serullaz 1979, p. 35 ill.
EXHIBITIONS: Munich 1926, No. 19 ill.; Zurich 1935, No. 22; Stuttgart 1960, No. 33 pl. 23; St Louis–Philadelphia–Minneapolis 1967, No. 140 ill.; Stuttgart 1969, No. 31.

216 *Nude Drying her Hair* 1900–05
Charcoal and pastel, 770 × 750 mm.
Below left, Vente stamp *Degas*.
Musée Cantonal des Beaux-Arts, Lausanne (Cat. No. 1032).

See pastels Lemoisne III, Nos. 1422–1427.

PROVENANCE: I^{ère} Vente 1918, No. 278 ill.; Henri Fèvre, Monte Carlo; Galerie Vallotton, Paris; A. Widmer, Valmont-Territet.
BIBLIOGRAPHY: Lemoisne III, No. 1425 ill, with Nos. 1423, 1423bis, 1424bis, 1426, 1427.
EXHIBITIONS: Berne 1951–2, No. 70.

217 *Nude from the Back, Bending Forward and Drying her Legs* 1900–05
Charcoal on paper with strip added below, 880 × 555 mm.
Below right, signed in black chalk: 'Degas'.
Yoshii Gallery, Tokyo.

See charcoal drawing (Lemoisne III, No. 837).

PROVENANCE: Ambroise Vollard, Paris; Armand Gauthier, Paris; Jacques Seligmann, New York.
EXHIBITIONS: *Nineteenth Century Master Drawings*, Museum of Art, Newark 1961, No. 43 ill.

218 *Two Washerwomen and Horse* circa 1902 (p. 97)
Charcoal and pastel on paper with strip added below, 840 × 1070 mm.
Below left, Vente stamp *Degas*.
Musée Cantonal des Beaux-Arts, Lausanne (Cat. No. 333)

Degas turned again to the subject of washerwomen about 1902 and added a second figure to another, with a laundry basket, developed a decade earlier (see Lemoisne III, Nos. 960, 961); see also pastel studies (Lemoisne III, Nos. 1419–1420), as well as a transfer of the two figures (Vente 1919, No. 357).

PROVENANCE: I^{ère} Vente 1918, No. 182 ill.; Paul Rosenberg, Paris; M. Snayers, Brussels; Brussels sale, 4 May 1925, No. 45 ill.; A. Widmer, Valmont-Territet.
BIBLIOGRAPHY: Lemoisne III, No. 1418 ill., with Lemoisne II–III, Nos. 410, 960, 961, 1419, 1420; Browse 1949, No. 235a ill.; Cooper 1952, pp. 14, 28, No. 31 ill.; Cabanne 1960, with Nos. 73, 101; Janis (Monotype) 1967, p. 22 note 14; Russoli and Minervino 1970, No. 1192 ill.; Terrasse 1981, No. 669 ill.
EXHIBITIONS: Berne 1951–2, No. 69; Amsterdam 1952, No. 56; *De Cézanne à Picasso*, Musée de l'Athénée, Geneva 1967.

219 *Two Dancers Backstage* circa 1901 (p. 101)
Pastel on paper with strips added below and on the left, 734 × 582 mm.
Below left, Vente stamp *Degas*.
Privately owned.

The seated dancer, whose position has been inverted in relation to that in pl. 206 above, is combined with a second figure in this richly orchestrated pastel; see a figure study (Lemoisne III, No. 1398), as well as drawings (III^{ème}–IV^{ème} Ventes 1919, Nos. 237, 184).
A similar composition also occurs in pastels (Lemoisne III, Nos. 1101–1103), as well as in a drawing (II^{ème} Vente, 1918, No. 288).

PROVENANCE: I^{ère} Vente 1918, No. 269 ill.; Ambroise Vollard, Paris; Paul Cassirer, Amsterdam.
BIBLIOGRAPHY: Lemoisne III, No. 1397 ill.; Browse 1949, with No. 205; Russoli and Minervino 1970, No. 1143 ill.
EXHIBITIONS: Rotterdam 1933–4, No. 22; Amsterdam (Stedelijk) 1938, No. 110a; Paris 1939, No. 13.

220 *Four Dancers in the Wings* circa 1903
Pastel, 750 × 610 mm.
Below left, Vente stamp *Degas*.
Galerie Beyeler, Basle.

This work belongs to a series of pastels with a striking intensity of colour. The radical simplification of forms brings about an almost abstract dynamic colour pattern composed of luminous blue, deep violet and dark green. The construction is familiar from a number of variants extending over the late 1880s; see Lemoisne III, Nos. 942, 1066, 1067, 1223, 1304, 1305, 1321, 1431–1433, 1435, 1452bis, as well as charcoal drawings (I^{ère} vente 1918, Nos 318, 319, 322).

PROVENANCE: I^{ère} Vente 1918, No. 236 ill.; Ambroise Vollard, Paris; Jacques Seligmann, New York.
BIBLIOGRAPHY: Lemoisne III, No. 1434 ill., with Nos. 1304, 1431–1435; Browse 1949, with No. 230; Cabanne 1960, with No. 148; *Autour de l'Impressionnisme*, Edition Beyeler, Basle 1970, No. 35 ill.
EXHIBITIONS: *The French Impressionists*, Wildenstein Gallery, London 1963, No. 18; *Manet–Degas–Monet–Cézanne–Bonnard*, Galerie Beyeler, Basle 1977, No. 9 ill.; *Portraits et Figures*, Galerie Beyeler, Basle 1982, No. 27 ill.

221 *Four Dancers in the Wings* 1900–05
Pastel, 800 × 1100 mm.
Privately owned.

This pastel is typical of Degas' later ballet compositions in which sections of stage scenery frequently appear as elements that divide and break up space; see the almost identical design in Lemoisne III, No. 1379, the similar

394

compositions and figure studies Nos. 1371–1378, and drawings (I^ère–II^éme Ventes 1918, Nos. 331, 250, III^éme–IV^éme Ventes 1919, Nos. 189, 234, 272, 391, 148, 197).

PROVENANCE: Christian de Galéa, Paris; Jacques Dubourg, Paris.
EXHIBITIONS: Paris 1975, No. 43 ill.; Tokyo–Kyoto–Fukuoka 1976–7, No. 44 ill.; *Choix d'un Amateur, XIX^e–XX^e Siècles*, Galerie Schmit, Paris 1977, No. 24 ill.; Paris 1983, No. 30 ill.

222 *Three Dancers in the Wings* 1904–6
Pastel on paper with strips added above and below, 840 × 595 mm.
Below left, Vente stamp *Degas*.
Mr and Mrs Edgardo Acosta, Los Angeles.

This subject was repeatedly varied, relocated and complemented over a period of some fifteen years; see pastels (Lemoisne III, Nos. 1015–1019, 1250–1253, 1445, 1447–1449).

PROVENANCE: I^ère Vente 1918, No. 215 ill.; Gumaelius, Paris; Durand-Ruel, Paris; A. E. Pleydell-Bouverie, London; O'Hana Gallery, London; Maurice Harris, Geneva; Sotheby Parke Bernet sale, London 11 July 1980, No. 41 ill.; Christie's sale, New York 13 November 1984, No. 122 ill.
BIBLIOGRAPHY: Lemoisne III, No. 1446 ill. with Nos. 1015, 1447–1449; Browse 1949, with No. 211; Gerstein 1982, p. 115.
EXHIBITIONS: Tokyo–Kyoto–Fukuoka 1976–7, No. 64 ill.

223 *Three Russian Dancers* 1900–05
Charcoal and red chalk, 990 × 750 mm.
Below left, Vente stamp *Degas*.
Mr and Mrs Alexander Lewyt, New York.

See No. 224 below.

PROVENANCE: III^éme Vente 1919, No. 286 ill.; Ambroise Vollard, Paris; Christian de Galéa, Paris.
BIBLIOGRAPHY: Lemoisne III, with No. 1190; Browse 1949, with No. 243; Janis 1967, p. 414.
EXHIBITIONS: St Louis–Philadelphia–Minneapolis 1967, No. 154 ill.; Northampton 1979, No. 18 ill.

224 *Russian Dancer* 1900–05
Charcoal and pastel on brown tracing paper, 800 × 650 mm.
Below left, Vente stamp *Degas*.
Privately owned.

A study for pastels (Lemoisne III, Nos. 1190, 1191). It will probably never prove possible to establish with any degree of certainty exactly when this sequence of fourteen *Russian Dancers* pastels and five drawings were produced, since there is a gap of nearly fourteen years between the various estimates. Lemoisne dated all the pastels (Nos. 1181–1194) '1895', on the assumption that these

represented a Russian folk dance troupe which had appeared at the Folies-Bergères at that time. Since then, the opinion has prevailed that these works should be dated after 1900. Lilian Browse was the first to suggest a connection between this ballet sequence and the first appearance in Paris of the Russian choreographer and impresario Sergei Diaghilev in 1908, when he achieved a runaway success at the Théâtre du Châtelet. One must, however, face the fact that the first date might well be too early, while 1909 or later is ruled out because, owing to his failing eyesight, Degas could no longer have created such uncommonly forceful and elaborate compositions. Stylistic considerations make it highly likely that these works were produced no earlier than the first five years of the new century, even though there was no corresponding event during that period to stimulate their inception. It is a fascinating thought that only a few years after the creation of Degas' *Russian Dancers*, Matisse was to produce a counterpart for them, equal in merit and opening new approaches to figurative representation, with his monumental *Dance* sequence. This was probably commissioned in 1909 by the Russian collector Shchukin, whom Degas may have known (see pl. 182 above).

PROVENANCE: III^éme Vente 1919, No. 307 ill.; Henri Lerolle, Paris.
BIBLIOGRAPHY: Lemoisne I, III, p. 165, No. 1192 ill., with Nos. 1190, 1193; Browse 1949, with No. 242; Cabanne 1960, with No. 144; Russoli and Minervino 1970, No. 1085a.
EXHIBITIONS: Paris 1937, No. 180; Paris 1939, No. 17.

225 *Dancers on Stage* 1906–8
Charcoal and pastel with tracing paper added above and below, 650 × 700 mm.
Below left, Vente stamp *Degas*.
Von der Heydt Museum, Wuppertal (Cat. No. KK 1961/64)

This work plainly reveals the difficulties with which the draughtsman now had to contend and what it cost this man who was nearly blind and gave up drawing about 1908, to master the wealth of forms and movements involved; see pl. 226 below, to large and broad pictures (Lemoisne III, Nos. 1459, 1460) and a drawing (III^éme Vente 1919, No. 287).

PROVENANCE: II^éme Vente 1918, No. 81 ill.; Durand-Ruel, Paris; Eduard von der Heydt, Ascona.
BIBLIOGRAPHY: Lemoisne III, No. 1462 ill., with Nos. 768–770, 1459–1461; Browse 1949, with No. 233; Wachtmann 1965, No. 42 ill.; Aust 1977, p. 284, pl. 177.
EXHIBITIONS: Berne 1951–2, No. 71; Wolfsburg 1961, No. 42.

226 *Dancers on Stage* 1906–8
Charcoal and red chalk on brown paper, 568 × 603 mm.
Below left, Vente stamp *Degas*.
E. V. Thaw & Co. Inc., New York.

See pl. 225 above, pastels (Lemoisne III, Nos. 768–770) and drawings (IIème Vente 1918, No. 344, IIIème–IVème Ventes 1919, Nos. 242, 139, 170, 171).

PROVENANCE: IIIème Vente 1919, No. 60 ill.; Durand-Ruel, Paris; Galerie Knoedler, Paris; Mrs John H. Winterbotham, New York; Theodora W. Brown and Rue W. Shaw, Chicago.
BIBLIOGRAPHY: Lemoisne III, No. 1461 ill., Nos. 768–770, 1459, 1460, 1462; Browse 1949, No. 255 ill., with No. 254.
EXHIBITIONS: St Louis–Philadelphia–Minneapolis 1967, No. 156 ill.; Boston 1974, No. 90.

ADDENDUM

227 *Dancer with Arms Raised* circa 1874
Thinned oil paint and sepia on card, 445 × 285 mm.
Below right, Vente stamp *Degas*.
Privately owned.

See pl. 96 above.

PROVENANCE: IIIème Vente 1919, No. 212 ill.; Nunès et Fiquet, Paris.

Photographic Acknowledgments

The photographs were kindly supplied by the owners or drawn from the archive of DuMont Buchverlag Köln. Photographic sources not listed below are given in the Index of Plates.

Foto-Studio M. Abel-Menne, Wuppertal: 77, 225.
Bellman Gallery, New York: 224.
Frequin-Photos, Voorburg: 45, 48, 49, 51, 53, 58, 70, 71, 79, 81, 90, 91, 109, 142, 144, 145, 149, 152, 158, 165, 170, 198, 213.
Studio Grünke, Hamburg: 143.
Guttmann, New York: 125.
Leo Hilber, Fribourg: 147, 150, 151.
Foto-Studio H. Humm, Zurich: 1, 15, 31, 36–39, 56, 65, 68, 69, 72, 89, 101, 112, 135, 190, 219.
E. Irving Bloomstrann, New Britain: p. 346.
Errol Jackson, London: 196.

Bruce C. Jones, Rocky Point, New York: 74.
Studio Bernard Lontin, La Tour-de-Salvagny: 209.
Cliché des Musées Nationaux, Paris: 46, 64, 93, 106, 126, pp. 345f., pp. 357f.
Hans Petersen, Copenhagen: 118, 119, 129, 202, 204, 205.
Eric Pollitzer, Garden City Park, N.Y.: 28, 29, 92, 95.
Foto-Studio van Santvoort, Wuppertal: 22.
Schopplein Studio, San Francisco: 8, 11, 13, 20, 25, 33, 139.
Scott Photographic Services, Montgomery: p. 351.
Foto Liselotte Witzel, Essen: 200.
The pictures on pp. 356 and 388f. are taken from: Aaron Scharf, *Art and Photography*, London 1968, and Richard Lane, *Ukiyo-e Holzschnitte*, Zurich 1978.

Chronology

1834
Edgar Degas born in Paris on 19 July at 8 rue Saint-Georges. His father, a well-to-do banker, came from Naples, while his mother originated from New Orleans and was of Creole descent.

1845–1853
Attends the Lycée Louis-le-Grand.

1847
Death of his mother.

1852
Becomes acquainted through his father with the leading art collectors of the period, among them Edouard Valpinçon, the Romanian Prince Soutzo and Louis Lacaze.

1853
Short interlude at the Faculty of Law during the autumn.

1853–1855
Studies art under Lamothe and Flandrin, both pupils of Ingres.

1855
Studies in Lyons and southern France.

1856–1859
Travels extensively in Italy, especially Naples, Rome and Florence. Visits relatives in Naples and Florence.

1860–1861
Produces a series of set portraits and narrative paintings.

1862–1865
Friendship with Manet leading to acquaintance with Renoir, Monet, Zola and others, who meet regularly at the Café de Bade near the centre of town and, later, at the Café Guerbois near the Place de Clichy.

1865–1870
Degas shows his works at the so-called Salon, the most important art exhibition of the period, held annually in the Palais de l'Industrie.

1868
Growing interest in the world of the theatre.

1869
Series of landscape pastels.

1870–1872
War service as artilleryman in one of the Paris forts. Residence in Normandy during the Commune.
First pictures of dancers in the rehearsal rooms of the old Paris Opéra.

1872–1873
Visits relatives in New Orleans.

1874
Father's death. Degas active in the preparation of the first exhibition of painters who were his friends but were pilloried by the press critics as 'Impressionists'; the exhibition opens on 15 April in the former studio of the photographer Nadar on the Boulevard des Capucines. Degas shows ten works, and continues to take part regularly in the Impressionist exhibitions until 1886.

1875
Journeys to Naples, Florence, Pisa and Genoa.

1876
Second Impressionist exhibition in the gallery of the art dealer Durand-Ruel, at which twenty-four works by Degas are shown.

1877
Twenty-five works by Degas appear at the third Impressionist exhibition.

1878
Purchase of *The Cotton Firm*, painted in New Orleans, by the museum at Pau.

1879–1880
Collaborates with Pissarro and Mary Cassatt on graphic work. Degas contributes a large number of paintings, pastels, drawings and graphic works to the fourth and fifth Impressionist exhibitions.

1881
At the sixth Impressionist exhibition, Degas shows, among other works, the near life-size wax statuette of a fourteen-year old dancer. In addition to numerous monotypes, pastel comes to occupy an ever-increasing place in his output.

1882
Several pastels dealing with fashion houses are produced, as well as the first large female nudes at their toilet. This is a subject which ultimately comes to dominate his entire output, together with ballet scenes.

1884
Meets Gauguin, who admires Degas.

1885
Deteriorating eyesight.

1886
At the eighth and last Impressionist exhibition, Degas shows a series of nudes bathing, washing, drying themselves, combing their hair, or having it dressed.

1890
Produces a series of coloured landscape monotypes in connection with a trip to Burgundy.

1892
First and only one-man exhibition by Degas. It is held at the Galerie Durand-Ruel in Paris and consists entirely of recently produced landscape monotypes.

1893–1895
Eyesight continues to deteriorate and makes work ever more difficult. Degas is devoting more and more time to his art collection, which continues to grow and includes, among other things, large numbers of works by Ingres, Delacroix, Daumier, Manet, Pissarro, Cézanne and Van Gogh.

1897
Visits Montauban to inspect Ingres' work kept there.

1898–1908
Lives in retirement and receives only a few friends in his studio. Forced to give up drawing about 1908 because of poor eyesight.

1917
Dies aged eighty-three. In accordance with his wishes, the only thing said at his graveside in Montmartre is: 'Il aimait beaucoup le dessin!'

Henri de Toulouse-Lautrec, *Edgar Degas in Profile* circa 1896 Bibliothèque Nationale, Paris (Dortu No., 4294)

Bibliography

Detailed bibliographical references may also be found in P. A. Lemoisne, *Degas et son Oeuvre*, I, Paris 1946, pp. 265ff.

Adhémar and Cachin 1973: Jean Adhémar and Françoise Cachin, *Edgar Degas. Gravures et Monotypes*, Paris 1973.

Adhémar and Cachin 1974: Jean Adhémar and Françoise Cachin, *Degas. The complete etchings, lithographs and monotypes*, London 1974.

André 1934: Albert André, *Degas*, Paris 1934.

Aust 1977: Günter Aust, *Das Von der Heydt-Museum in Wuppertal*, Recklinghausen 1977.

Bataille 1930: Marie Louise Bataille, 'Zeichnungen aus dem Nachlass von Degas', in *Kunst und Künstler*, XXVIII, 1930, pp. 399ff.

Berger 1949: Klaus Berger, *Französische Meisterzeichnungen des XIX. Jahrhunderts*, Basle 1949.

Boggs 1955: Jean Sutherland Boggs, 'Edgar Degas and the Bellellis', in *The Art Bulletin*, XXXVII, 2, June 1955, pp. 127ff.

Boggs 1958: Jean Sutherland Boggs, 'Degas Notebooks at the Bibliothèque Nationale', in *The Burlington Magazine*, C, 662–664, May–July 1958, pp. 163ff., 196ff., 240ff.

Boggs 1962: Jean Sutherland Boggs, *Portraits by Degas*, Berkeley and Los Angeles 1962.

Boggs 1963: Jean Sutherland Boggs, 'Edgar Degas and Naples', in *The Burlington Magazine*, CV, 723, June 1963, pp. 273ff.

Borchsenius 1944: Kaj Borchsenius, *Franske Tegninger i Dank Eje*, Copenhagen 1944.

Bouret 1965: Jean Bouret, *Degas*, Paris, Gütersloh and London 1965.

Browse 1949: Lillian Browse, *Degas Dancers*, London 1949.

Burnell 1969: D. Burnell, *Degas and his 'Young Spartans Exercising'*, in *The Art Institute of Chicago Museum Studies*, 4, 1969, pp. 56f.

Cabanne 1960: Pierre Cabanne, *Edgar Degas*, Munich 1960.

Champigneulle 1952: Bernard Champigneulle, *Degas Dessins*, Paris 1952.

Chialiva 1932: J. Chialiva, 'Comment Degas a changé sa Technique du dessin', in *Bulletin de la Société de l'Histoire de l'Art Français*, 24, 1932.

Cooper 1952: Douglas Cooper, *Pastelle von Edgar Degas*, Basle 1952.

Cooper 1954: Douglas Cooper, *Pastels by Edgar Degas*, New York 1954.

Coquiot 1924: Gustave Coquiot, *Degas*, Paris 1924.

Degas 1898: *Degas. Vingt Dessins, 1861–1896*, Paris 1898 (album assembled by Goupil & Cie, J. Boussod, Manzi and Joyant & Cie).

Degas 1914: *Degas. Quatre-Vingt-Dix-Huit Reproductions Signées par Degas. Peintures, Pastels, Dessins et Estampes*, Paris 1914 (album assembled by Ambroise Vollard).

Delacroix 1948: *The Journal of Eugène Delacroix*, New York 1948 (reprinted 1961); original edition London 1938.

Dufwa 1981: Jacques Dufwa, *Winds from the East. A Study in the Art of Manet, Degas, Monet and Whistler 1856–86*, Uppsala 1981.

Dunlop 1979: Ian Dunlop, *Degas*, London 1979.

Dunstan 1972: Bernard Dunstan, 'The Pastel Techniques of Edgar Degas', in *American Artist*, XXXVI, 362, September 1972, pp. 41ff.

Fèvre 1949: Jeanne Fèvre, *Mon Oncle Degas*, Geneva 1949.

Fischer and Sthyr: Eric Fischer and Jorgen Sthyr, *Seks Aarhundreders Europaeisk Tegnekunst*, Copenhagen 1953.

Fries 1964: Gerhard Fries, 'Degas et les Maîtres', in *Art de France*, IV, 1964, pp. 352ff.

Gauguin 1912: Paul Gauguin, 'Degas', in *Kunst und Künstler*, X, March 1912, pp. 333ff.

Gauss 1976: Ulrike Gauss, *Die Zeichnungen und Aquarelle des 19. Jahrhunderts in der Graphischen Sammlung der Staatsgalerie Stuttgart*, Stuttgart 1976.

Gerstein 1982: Marc Gerstein, 'Degas's Fans', in *The Art Bulletin*, LXIV, 1, March 1982, pp. 105ff.

Giacomazzi 1982: Giorgio Giacomazzi, 'Versuch über die Visualität in der Moderne. Benjamin, Degas und der Impressionismus', in *Notizbuch*, 7, 1982, pp. 151ff.

Graber 1942: Hans Graber, *Edgar Degas. Nach eigenen und fremden Zeugnissen*, Basle 1942.

Grappe 1936: Georges Grappe, *Degas*, Paris 1936.

Growe 1981: Bernd Growe, *Zur Bildkonzeption Edgar Degas'*, Frankfurt am Main 1981.

Guérin 1931: Marcel Guérin (ed.), *Dix-Neuf Portraits de Degas par Lui-Même*, Paris 1931.

Guérin 1945: Marcel Guérin (ed.), *Lettres de Degas*, Paris 1945.

Guérin 1947: Marcel Guérin (ed.), *Degas Letters*, Oxford 1947 (enlarged English edition).

Halévy 1949: Daniel Halévy, *Album des Dessins de Degas*, Paris 1949.

Halévy 1964: Daniel Halévy, *My Friend Degas*, London 1964.

Hausenstein 1948: Wilhelm Hausenstein, *Degas*, Berne 1948.

Haverkamp-Begemann 1957: Egbert Haverkamp-Begemann, *Vijf Eeuwen Tekenkunst*, Rotterdam 1957.

Haverkamp-Begemann etc. 1964: Egbert Haverkamp-Begemann etc., *Drawings from the Clark Art Institute. A Catalogue Raisonné*, I–II, New Haven 1964.

Hertz 1920: Henri Hertz, *Degas*, Paris 1920.

Hertz 1922: Henri Hertz, 'Degas et les Formes Modernes. Son Dessin, sa Sculpture', in *L'Amour de l'Art*, April 1922, pp. 105ff.

Hoetink 1968: H. R. Hoetink, *Franse Tekeningen uit de 19e Eeuw. Catalogus van de Verzameling in het Museum Boymans – van Beuningen*, Rotterdam 1968.

Hüttinger 1981: Eduard Hüttinger, *Degas*, Munich 1981.

Huyghe and Jacottet 1948: René Huyghe and Jacottet, *Le Dessin Français au XIXe Siècle*, Lausanne 1948.

Huyghe 1953: René Huyghe, *Edgar Hilaire Germain Degas*, Paris 1953.

Jamot 1924: Paul Jamot, *Degas*, Paris 1924.

Janis 1967: Eugenia Parry Janis, 'Degas Drawings', in *The Burlington Magazine*, CIX, 772, July 1967, pp. 413ff.

Janis (Monotype) 1967: Eugenia Parry Janis, 'The Role of the Monotype in the Working Method of Degas', in *The Burlington Magazine*, CIX, 766–767, January–February 1967, pp. 20ff., pp. 71ff.

Jeanniot 1933: Georges Jeanniot, 'Souvenirs sur Degas', in *La Revue Universelle*, October–November 1933, pp. 152ff., pp. 280ff.

Keyser 1981: Eugénie de Keyser, *Degas. Réalité et Métaphore*, Louvain-la-Neuve 1981.

Kopplin 1981: Monika Kopplin, *Das Fächerblatt von Manet bis Kokoschka. Europäische Traditionen und japanische Einflüsse*, Saulgau 1981.

Kresak 1979: Fedor Kresak, *Edgar Degas*, Prague 1979.

Lafond 1918–1919: Paul Lafond, *Degas*, I–II, Paris 1918–1919.

Lassaigne 1945: Jacques Lassaigne, *Edgar Degas*, Paris 1945.

Lay 1978: Howard G. Lay, 'Degas at Durand-Ruel, 1892. The Landscape Monotypes', in *The Print Collector's Newsletter*, 9, 5, November–December 1978, pp. 142ff.

Lefébure 1981: Amaury Lefébure, *Degas*, Paris 1981; London 1982.

Lemaître 1962: Baudelaire, *Curiosités esthétiques, L'Art Romantique et autres Oeuvres Critiques*, ed. Lemaître, Paris 1962.

Lemoisne 1921: Paul André Lemoisne, 'Les Carnets de Degas au Cabinet des Estampes', in *Gazette des Beaux-Arts*, 63, 1921, pp. 219ff.

Lemoisne 1931: Paul André Lemoisne, 'A propos des Degas dans la Collection de Marcel Guérin', in *L'Amour de l'Art*, XII, July 1931.

Lemoisne I–IV: P. A. Lemoisne, *Degas et son Oeuvre*, I–IV, Paris 1946.

Lévêque 1978: Jean Jacques Lévêque, *Edgar Degas*, Paris 1978.

Leymarie 1948: Jean Leymarie, *Les Dessins de Degas*, Paris 1948.

Leymarie 1969: Jean Leymarie, *Impressionistische Zeichnungen von Manet bis Renoir*, Geneva 1969.

Liebermann 1899: Max Liebermann, *Degas* (offprint from the periodical *Pan*), Berlin 1899.

Longstreet 1964: Stephen Longstreet, *The Drawings of Degas*, Alhambra 1964.

Matt and Rewald 1957: Leonard von Matt and John Rewald, *Degas. Das plastische Werk*, Zurich 1957.

Mauclair 1938: Camille Mauclair, *Degas*, Paris 1938.

Mayne 1966: J. Mayne, 'Degas's Ballet Scene from "Robert le Diable",' in *Victoria and Albert Museum Bulletin*, II, 1966, pp. 148ff.

Meier-Graefe 1920: Julius Meier-Graefe, *Degas*, Munich 1920.

Millard 1976: Charles W. Millard, *The Sculpture of Edgar Degas*, Princeton 1976.

Mongan 1932: Agnes Mongan, 'Portrait Studies by Degas in American Collections', in *Bulletin of the Fogg Art Museum*, I, 4, May 1932, pp. 63ff.

Mongan 1938: Agnes Mongan, 'Degas as Seen in American Collections', in *The Burlington Magazine*, LXXII, June 1938, pp. 290ff.

Mongan and Sachs 1940: Agnes Mongan and Paul J. Sachs, *Drawings in the Fogg Museum of Art*, I–II, Cambridge (Mass.) 1940.

Moore 1890: George Moore, 'Degas. The Painter of Modern Life', in *Magazine of Art*, September 1890, pp. 416ff.

Moore 1906: George Moore, *Reminiscences of the Impressionist Painters*, Dublin 1906.

Pecirka 1963: Jaromir Pecirka, *Edgar Degas. Zeichnungen*, Prague 1963.

Pickvance 1963: Ronald Pickvance, 'Degas's Dancers: 1872–6', in *The Burlington Magazine*, CV, 723, June 1963, pp. 256ff.

Pickvance 1964–1965: Ronald Pickvance, 'Drawings by Degas in English Public Collections', in *The Connoisseur*, 157, 632–633, October–November 1964, pp. 82f., pp. 162f. and *The Connoisseur*, 159, 641–642, July–August 1965, pp. 158f., pp. 228f.

Pool 1963: Phoebe Pool, 'Degas and Moreau', in *The Burlington Magazine*, CV, 723, June 1963, pp. 251ff.

Pool 1964: Phoebe Pool, 'The History Pictures of Edgar Degas and their Background', in *Apollo*, 80, 1964, pp. 306ff.

Reff 1963: Theodore Reff, 'Degas's Copies of Older Art', in *The Burlington Magazine*, CV, 723, June 1963, pp. 241ff.

Reff 1964: Theodore Reff, 'New Light on Degas's Copies'. in *The Burlington Magazine*, CVI, 735, June 1964, pp. 250ff.

Reff 1965: Theodore Reff, 'Addenda on Degas's Copies', in *The Burlington Magazine*, CVII, 747, June 1965, pp. 320, 323.

Reff 1967: Theodore Reff, 'An Exhibition of Drawings by Degas', in *The Art Quarterly*, XXX, 3–4, 1967, pp. 253ff.

Reff 1971: Theodore Reff, 'Further Thoughts on Degas's Copies', in *The Burlington Magazine*, CXIII, 822, September 1971, pp. 534ff.

Reff 1976: Theodore Reff, *The Notebooks of Edgar Degas. A Catalogue of the Thirty-Eight Notebooks in the Bibliothèque Nationale and other Collections*, Oxford 1976.

Reff (*The Artist's Mind*) 1976: Theodore Reff, *Degas. The Artist's Mind*, New York 1976 (in which the following articles are reprinted: 'The Butterfly and the Old Ox', pp. 15ff.; 'Three Great Draftsmen', pp. 37ff.; 'Pictures within Pictures', pp. 90ff.; 'The Artist and the Writer', pp. 147ff.; 'My Genre Painting', pp. 200ff.; 'To Make Sculpture Modern', pp. 239ff.; 'The Artist as Technician', pp. 270ff.)

Reff 1977: Theodore Reff, 'Degas. A Master among Masters', in *The Metropolitan Museum of Art Bulletin*, XXXIV, 4, 1977.

Rewald 1943: John Rewald (ed.), Camille Pissarro, *Letters to his Son Lucien*, London 1943.

Rewald 1961: John Rewald, *The History of Impressionism* (revised and enlarged edition), New York 1961.

Rich 1952: Daniel Catton Rich, *Edgar-Hilaire-Germain Degas, 1834–1917*, New York and London 1952.

Rivière 1922–1923: Henri Rivière, *Les Dessins de Degas Reproduits en Facsimile*, I–II, Paris 1922–1923; reprinted, in a cheap modern edition, as *Degas' Drawings*, New York 1973.

Rivière 1935: Georges Rivière, *M. Degas. Bourgeois de Paris*, Paris 1935.

Roger-Marx 1956: Claude Roger-Marx, *Degas Danseuses*, Paris 1956.

Rosenberg 1959: Jakob Rosenberg, *Great Draughtsmen from Pisanello to Picasso*, Cambridge (Mass.) 1959.

Rossum 1962: C. C. van Rossum, *Ruiter en Paard*, Utrecht 1962.

Rouart 1945: Denis Rouart, *Degas. A la Recherche de sa Technique*, Paris 1945.

Rouart 1948: Denis Rouart, *Degas Dessins*, Paris 1948.

Rouart (*Monotypes*) 1948: Denis Rouart, *E. Degas. Monotypes*, Paris 1948.

Rouart 1957: Denis Rouart (ed.), *The Correspondence of Berthe Morisot*, London 1957.

Russoli and Minervino 1970: Franco Russoli and Fiorella Minervino, *Degas*, Milan 1970.

Scharf 1968: Aaron Scharf, *Art and Photography*, London 1968.

Schwabe 1948: Randolph Schwabe, *Degas the Draughtsman*, London 1948.

Serullaz 1979: Maurice Serullaz, *L'Univers de Degas*, Paris 1979.

Shapiro 1980: Michael Shapiro, 'Degas and the Siamese Twins of the Café-Concert: The Ambassadeurs and the Alcazar d'Eté', in *Gazette des Beaux-Arts*, XCV, 6, 1980, pp. 153ff.

Shinoda 1957: Yujiro Shinoda, *Degas. Der Einzug des Japanischen in die französische Malerei*, Cologne 1957.

Shoolman and Slatkin 1950: Regina Shoolman and Charles E. Slatkin, *Six Centuries of French Master Drawings in America*, New York and Oxford 1950.

Sickert 1917: Walter Sickert, 'Degas', in *The Burlington Magazine*, CLXXVI, XXXI, November 1917, pp. 183ff.

Steingräber 1974: Erich Steingräber, 'La Repasseuse. Zur frühesten Version des Themas von Edgar Degas', in *Pantheon*, XXXII, 1, January–March 1974, pp. 47ff.

Szabo 1980: George Szabo, *19th Century French Drawings from the Robert Lehman Collection*, New York 1980.

Tannenbaum 1967: Libby Tannenbaum, 'Degas. Illustrious and Unknown', in *Art News*, 65, 9, January 1967, pp. 50ff.

Terrasse 1974: Antoine Terrasse, *Edgar Degas*, London 1974.

Terrasse 1976: Antoine Terrasse, 'Degas et la Danse', in *L'Oeil*, 257, December 1976.

Terrasse 1981: Antoine Terrasse, *Edgar Degas*, I–II, Frankfurt am Main, Berlin and Vienna 1981.

Thomson 1979: Richard Thomson, 'Degas in Edinburgh', in *The Burlington Magazine*, CXXI, 919, October 1979, pp. 674ff.

Troendle 1925: Hugo Troendle, 'Das Monotype als Untermalung. Zur Betrachtung der Arbeitsweise von Degas', in: *Kunst und Künstler*, XXIII, 1925, pp. 357ff.

Valéry 1960: Paul Valéry, *Degas, Manet, Morisot*, London 1960.

Vitali 1963: Lamberto Vitali, 'Three Italian Friends of Degas', in *The Burlington Magazine*, CV, 723, June 1963, pp. 266ff.

Vollard 1924: Ambroise Vollard, *Degas (1834–1917)*, Paris 1924.

Vollard 1928: Ambroise Vollard, *Degas. An intimate portrait*, London 1928.

Wachtmann 1965: Hans Günter Wachtmann, *Von der Heydt-Museum Wuppertal. Verzeichnis der Handzeichnungen, Pastelle und Aquarelle*, Wuppertal 1965.

Walker 1933: John Walker, 'Degas et les Maîtres Anciens', in *Gazette des Beaux-Arts*, X, 6, 1933, pp. 172ff.

Werner 1978: Alfred Werner, *Degas Pastels*, New York 1978.

Wick 1959: Peter A. Wick, 'Degas' Violinist', in *Bulletin of the Museum of Fine Arts, Boston*, LVII, 310, 1959.

Wilson 1983: Michael Wilson, 'Degas at Artemis', in *The Burlington Magazine*, CXXV, 968, November 1983, pp. 713.

EXHIBITIONS AND EXHIBITION CATALOGUES

Amsterdam 1938: *Fransche Meesters uit de XIXe Eeuw. Teekeningen, Aquarellen, Pastels*, Galerie Paul Cassirer, Amsterdam 1938.

Amsterdam (Stedelijk Museum) 1938: *Honderd Jaar Fransche Kunst*, Stedelijk Museum, Amsterdam 1938.

Amsterdam 1946: *Teekeningen van Fransche Meesters 1800–1900*, Stedelijk Museum, Amsterdam 1946.

Amsterdam 1952: *Edgar Degas*, Stedelijk Museum, Amsterdam 1952.

Baltimore 1962: *Manet, Degas, Berthe Morisot and Mary Cassatt*, The Museum of Art, Baltimore 1962.

Basle 1935: *Meisterzeichnungen französischer Künstler von Ingres bis Cézanne*, Kunsthalle, Basle 1935.

Berlin 1913: *Degas–Cézanne*, Galerie Paul Cassirer, Berlin 1913.

Berlin 1929–1930: *Ein Jahrhundert französischer Zeichnung*, Galerie Paul Cassirer, Berlin 1929.

Berlin 1965: *Der Japonismus in der Malerei und Graphik des 19. Jahrhunderts* (catalogue compiled by Leopold Reidemeister), Haus am Waldsee, Berlin 1965.

Berne 1951–1952: *Degas* (catalogue compiled by Fritz Schmalenbach), Kunstmuseum, Berne 1951.

Berne 1960: *Choix d'une Collection Privée*, Galerie Klipstein und Kornfeld, Berne 1960.

Boston 1935: *Independent Painters of 19th Century Paris*, Museum of Fine Arts, Boston 1935.

Boston 1974: *Edgar Degas. The Reluctant Impressionist* (catalogue compiled by Barbara S. Shapiro), Museum of Fine Arts, Boston 1974.

Bremen 1969: *Handzeichnungen französischer Meister des 19. Jahrhunderts. Von Delacroix bis Maillol* (catalogue compiled by Günter Busch, Christian Lenz, Jürgen Schultze), Kunsthalle, Bremen 1969.

Buenos Aires 1934: *Degas*, Buenos Aires 1934.

Buffalo 1935: *Master Drawings*, Albright Art Gallery, Buffalo 1935.

Cambridge (Mass.) 1929: *Exhibition of French Painting of the Nineteenth and Twentieth Centuries*, Fogg Art Museum, Cambridge (Mass.) 1929.

Cambridge (Mass.) 1931: *A Loan Exhibition of Paintings and Pastels by Degas*, Fogg Art Museum, Cambridge (Mass.) 1931.

Cambridge (Mass.) 1957: *Degas Dancers*, Fogg Art Museum, Cambridge (Mass.) 1957.

Cambridge (Mass.)–New York 1965–1967: *Works of Art from the Collection of Paul J. Sachs*, Fogg Art Museum, Cambridge (Mass.) – Museum of Modern Art, New York; Cambridge (Mass.) 1965.

Cambridge (Mass.) 1968: *Degas Monotypes* (catalogue compiled by Eugenia Parry Janis), Fogg Art Museum, Cambridge (Mass.) 1968.

Chicago–Minneapolis–Detroit–San Francisco 1955–1956: *French Drawings. Masterpieces from Seven Centuries*, Art Institute, Chicago–Minneapolis Institute of Arts–Detroit Institute of Arts–California Palace of the Legion of Honor, San Francisco, Chicago 1955.

Cincinnati 1959: *The Lehman Collection, New York*, Art Museum, Cincinnati 1959.

Cleveland 1947: *Works by Edgar Degas*, Museum of Art, Cleveland 1947.

Copenhagen 1939: *Franske Haandtegninger fra det 19. og 20. Aarhundred*, Statens Museum for Kunst, Copenhagen 1939.

Copenhagen 1948: *Degas*, Ny Carlsberg Glyptotek, Copenhagen 1948.

Copenhagen 1967: *Hommage à l'Art Français* (catalogue compiled by Hanne Finsen), Statens Museum for Kunst, Copenhagen 1967.

Copenhagen 1983: *Degas og familien Bellelli* (catalogue compiled by Hanne Finsen), Ordrupgaardsamlingen, Copenhagen 1983.

Detroit 1941: *Masterpieces of 19th and 20th Century French Drawings*, Institute of Arts, Detroit 1941.

Detroit 1951: *French Drawings of Five Centuries from the Collection of the Fogg Art Museum*, Institute of Arts, Detroit 1951.

Edinburgh 1979: *Degas 1879* (catalogue compiled by Ronald Pickvance), National Gallery of Scotland, Edinburgh 1979.

Haarlem 1935: *Fransche Impressionisten*, Frans Hals-museum, Haarlem 1935.

Karlsruhe 1983: *Die französischen Zeichnungen 1570–1930* catalogue compiled by Johann Eckart von Borries), Staatliche Kunsthalle, Karlsruhe 1983.

Lausanne 1964: *Chefs-d'Oeuvre des Collections Suisses de Manet à Picasso*, Palais de Beaulieu, Lausanne 1964.

London 1928: *Works by Degas*, Alex. Reid & Lefevre Gallery, London 1928.

London 1950: *Degas*, Lefevre Gallery, London 1950.

London 1952: *Degas*, Tate Gallery, London 1952.

London 1953: *The Art of Drawing 1500–1950*, Wildenstein Gallery, London 1953.

London 1958: *Degas. Monotypes, Drawings, Pastels, Bronzes* (Foreword by Douglas Cooper), Lefevre Gallery, London 1958.

London 1970: *Edgar Degas 1834–1917* Foreword by Dennys Sutton), Lefevre Gallery, London 1970.

London 1978: *Selected Works from the Andrew Gow Bequest*, Galerie Hazlitt, Gooden & Fox, London 1978.

London 1983: *Edgar Degas*, (catalogue compiled by Ronald Pickvance), David Carritt Ltd. Gallery, London 1983.

Los Angeles 1958: *Edgar Hilaire Germain Degas* (catalogue compiled by Jean Sutherland Boggs), County Museum, Los Angeles 1958.

Minneapolis 1948: *Degas. Portraits of his Family and Friends*, Institute of Fine Arts, Minneapolis 1948.

Munich 1926: *Edgar Degas. Pastelle, Zeichnungen, das plastische Werk*, Galerie Thannhauser, Munich 1926.

Munich 1965: *Sammlung Walter Bareiss*, Neue Staatsgalerie, Munich 1965.

Munich 1972: *Weltkulturen und moderne Kunst* (catalogue compiled by Siegfried Wichmann et al.), Haus der Kunst, Munich 1972.

New Orleans 1965: *Edgar Degas. His Family and Friends in New Orleans* (catalogue compiled by James B. Byrnes), Isaac Delgado Musuem, New Orleans 1965.

New York 1922: *Degas. Prints, Drawings and Bronzes*, The Grollier Club, New York 1922.

New York 1930: *Drawings by Degas*, Jacques Seligmann Gallery, New York 1930.

New York 1943: *Collection Erich Maria Remarque*, Knoedler Galleries, New York 1943.

New York 1945: *Edgar Degas*, Buchholz Gallery, New York 1945.

New York 1947: *Loan Exhibition*, Century Club, New York 1947.

New York 1949: *Loan Exhibition of Degas* (catalogue compiled by Daniel Wildenstein), Wildenstein Galleries, New York 1949.

New York 1958: *Renoir–Degas*, Charles E. Slatkin Galleries, New York 1958.

New York 1959: *French Drawings from American Collections. Clouet to Matisse*, The Metropolitan Museum of Art, New York 1959.

New York 1960: *Degas*, Wildenstein Galleries, New York 1960.

New York 1964: *19th and 20th Century Master Drawings*, E. V. Thaw Gallery, New York 1964.

New York 1968: *Degas' Racing World* (catalogue compiled by Ronald Pickvance), Wildenstein Galleries, New York 1968.

New York 1972: *Faces from the World of Impressionism and Post-Impressionism*, Wildenstein Galleries, New York 1972.

New York 1975: *Ingres and Delacroix through Degas and Puvis de Chavannes. The Figure in French Art, 1800–1870*, Shepherd Gallery, New York 1975.

New York–Cleveland–Chicago–Ottawa 1975–1976: *Drawings from the Collection of Mr. and Mrs. Eugene V. Thaw* (catalogue compiled by Felice Stampfle and Cara D. Denison), The Pierpont Morgan Library, New York–The Museum of Art, Cleveland–The Art Institute, Chicago–The National Gallery of Canada, Ottawa; New York 1975.

New York 1977: *Degas in the Metropolitan* (catalogue compiled by Charles S. Moffett), The Metropolitan Museum of Art, New York 1977.

New York 1978: *Edgar Degas* (Foreword by Theodore Reff), Acquavella Gallery, New York 1978.

New York 1979: *French Pastels*, Wildenstein Galleries, New York 1979.

Northampton 1933: *Edgar Degas*, Smith College Museum of Art, Northampton (Mass.) 1933.

Northampton 1979: *Degas and the Dance* (catalogue compiled by Linda D. Muehlig), Smith College Museum of Art, Northampton (Mass.) 1979.

Nottingham 1969: *Degas. Pastels and Drawings* (catalogue compiled by Ronald Pickvance), University Art Gallery, Nottingham 1969.

Paris 1892: *Paysages de Degas*, Galeries Durand-Ruel, Paris 1892.

Paris 1924: *Degas* (Foreword by Daniel Halévy, catalogue compiled by Marcel Guérin), Galeries Georges Petit, Paris 1924.

Paris 1931: *Degas. Portraitiste, Sculpteur* (Foreword by Paul Jamot, catalogue compiled by Charles Sterling, Paul Vitry), Musée de l'Orangerie, Paris 1931.

Paris 1937: *Degas* (catalogue compiled by Jacqueline Bouchot-Saupique, Marie Delaroche-Vernet), Orangerie des Tuileries, Paris 1937.

Paris 1938: *Degas*, Galerie Mouradian et Vallotton, Paris 1938.

Paris 1939: *Degas. Peintre du Mouvement (Foreword by Claude Roger-Marx), Galerie André Weil, Paris 1939.*

Paris 1948–1949: *Danse et Divertissements*, Galerie Charpentier, Paris 1948.

Paris–Brussels–Rotterdam 1949–1950: *Le Dessin Français de Fouquet à Cézanne*, Musée du Louvre, Paris–Palais des Beaux Arts, Brussels – Museum Boymans – van Beuningen, Rotterdam; Paris 1949.

Paris 1952: *Dessins du XVe au XIXe Siècle, Musée Boymans de Rotterdam*, Bibliothèque Nationale, Paris 1952.

Paris 1952–1953: *Cent-Cinquante Ans de Dessins*, Galerie Bernheim-Jeune, Paris 1952.

Paris 1955: *Degas dans les Collections Françaises* (catalogue compiled by Daniel Wildenstein), Gazette des Beaux-Arts, Paris 1955.

Paris 1960: *Edgar Degas 1834–1917* (Foreword by Agathe Rouart-Valéry), Galeries Durand-Ruel, Paris 1960.

Paris–Amsterdam 1964: *Le Dessin Français dans les Collections Hollandaises*, Institut Néerlandais, Paris 1964; *Franse Tekeningen uit Nederlandse Verzamelingen*, Rijksmuseum, Amsterdam 1964.

Paris 1969: *Degas, Oeuvres du Musée du Louvre. Peintures, Pastels, Dessins, Sculptures* (catalogue compiled by Hélène Adhémar), Orangerie des Tuileries, Paris 1969.

Paris 1975: *Degas 1834–1917* (Foreword by Jean Cau), Galerie Schmit, Paris 1975.

Paris 1980: *Degas. La Famille Bellelli*, Musée Marmottan, Paris 1980.

Paris 1983: *Lumières sur la Peinture XIXe–XXe Siècles*, Galerie Schmit, Paris 1983.

Philadelphia 1936: *Degas 1834–1917* (catalogue compiled by Agnes Mongan), The Pennsylvania Museum of Art, Philadelphia 1936.

Pittsburgh 1933: *Old Master Drawings*, Junior League, Pittsburgh 1933.

Richmond 1952: *French Drawings from the Fogg Art Museum*, Virginia Museum of Fine Arts, Richmond 1952.

Rotterdam 1933–1934: *Teekeningen van Ingres tot Seurat*, Museum Boymans – van Beuningen, Rotterdam 1933.

Rotterdam–Paris–New York 1958–1959: French Drawings from American Collections: Clouet to Matisse, Museum Boymans – van Beuningen, Rotterdam – Musée de l'Orangerie, Paris – Museum of Modern Art, New York; Rotterdam 1958.

Rotterdam 1978: *Legaat Vitale Bloch*, Museum Boymans – van Beuningen, Rotterdam 1978.

St Louis 1932: *Drawings by Degas*, City Art Museum, St Louis 1932.

St Louis–Philadelphia–Minneapolis 1967: *Drawings by Degas* (catalogue compiled by Jean Sutherland Boggs), City Art Museum, St Louis–Philadelphia Museum of Art – The Minneapolis Society of Fine Arts, St Louis 1966.

San Francisco 1947: *19th Century French Drawings*, California Palace of the Legion of Honor, San Francisco 1947.

Stuttgart 1960: *Zeichnungen des 19. und 20. Jahrhunderts, Neuerwerbungen seit 1945* (catalogue compiled by Johann Eckart von Borries), Staatsgalerie Stuttgart, Graphische Sammlung, Stuttgart 1960.

Stuttgart 1969: *Von Ingres bis Picasso, Französische Zeichnungen des 19. und 20. Jahrhunderts* (catalogue compiled by Ulrike Gauss), Staatsgalerie Stuttgart, Graphische Sammlung, Stuttgart 1969.

Stuttgart 1976: *Eadweard Muybridge*, Württembergischer Kunstverein, Stuttgart 1976.

Toledo 1950: *Degas Exhibition*, Museum of Art, Toledo 1950.

Toyko–Kyoto–Fukuoka 1976–1977: *Degas* (catalogue compiled by François Daulte), Seibu Museum of Art, Tokyo–Musée de la Ville de Kyoto–Centre Culturel de Fukuoka, Tokyo 1976.

Tokyo 1979: *European Master Drawings from the Fogg Art Museum*, Tokyo 1979.

Washington 1940: *Modern Drawings*, Phillips Gallery, Washington 1940.

Washington 1947: *Loan Exhibition of Drawings and Pastels by Edgar Degas*, Phillips Memorial Gallery, Washington 1947.

Williamstown 1970: *An Exhibition of the Works of Edgar Degas, at the Sterling and Francine Clark Art Institute*, Williamstown 1970.

Winterthur 1955: *Europäische Meister 1790–1910*, Kunstmuseum, Winterthur 1955.

Wolfsburg 1961: *Französische Malerei von Delacroix bis Picasso*, Stadthalle, Wolfsburg 1961.

Zurich 1935: *Degas* (Foreword by Gotthard Jedlicka), Galerie Aktuaryus, Zurich 1935.

Zurich 1977: *Malerei und Photographie im Dialog, 1840 bis heute* (catalogue compiled by Erika Billeter), Kunsthaus, Zurich 1977.

AUCTION CATALOGUES

Ière–IVème Vente 1918–1919: *Catalogue des Tableaux, Pastels et Dessins par Edgar Degas et Provenant de son Atelier . . .*, Ier–IVème Vente, Galerie Georges Petit, Paris 6–8 May 1918 (Ier Vente); 11–13 December 1918 (IIème Vente); 7–9 April 1919 (IIIème Vente); 2–4 July 1919 (IVème Vente).

Vente 1927: *Succession de M. René de Gas. Tableaux, Pastels, Dessins par Edgar Degas . . .*, Hôtel Drouot, Paris 10 November 1927.

Vente 1934: *Collection de Mlle J. Fèvre. Catalogue des Tableaux, Aquarelles, Pastels, Dessins, Estampes, Monotypes par Edgar Degas . . .*, Galerie Jean Charpentier, Paris 12 June 1934.

Vente 1976: *Important Ensemble de Dessins par Edgar Degas . . . Provenant de l'Atelier de l'Artiste et d'une Partie de la Collection Nepveu-Degas*, Drouot Rive Gauche, Paris 6 May 1976.

Index

407